CONTENTS

COLOR ILLUSTRATIONS

ACKNOWLEDGMENTS

It is a privilege to acknowledge here the many individuals and institutions whose very gracious cooperation has made this book possible.

INSTITUTIONS

Abby Aldrich Rockefeller Folk Art Center, Williamsburg, Virginia: Barbara Luck; Addison Gallery of American Art, Phillips Academy, Andover, Massachusetts; Adirondack Museum, Blue Mountain Lake, New York; *Antique Monthly*, Tuscaloosa, Alabama; The Magazine *Antiques*, New York; The Art Institute of Chicago, Chicago, Illinois; The Art Museum, Princeton University, Princeton, New Jersey; The Bennington Art Museum, Bennington, Vermont; The Brooklyn Museum, Brooklyn, New York; Museum of Art, Carnegie Institute, Pittsburgh, Pennsylvania; The Century Association, New York; Chicago Historical Society, Chicago, Illinois; Cincinnati Art Museum, Cincinnati, Ohio: Dr. Carol Macht, Mary L. Meyer; The Cleveland Museum of Art, Cleveland, Ohio; The Corcoran Gallery of Art, Washington, D.C.; Christie, Manson & Woods International Inc., New York; The Corning Museum of Glass, Corning, New York; Crandall Library, Glens Falls, New York; The Currier Gallery of Art, Manchester, New Hampshire: Melvin E. Watts; Department of State, Washington, D.C.; Detroit Public Library, Detroit, Michigan; Ford Archives, Greenfield Village and Henry Ford Museum, Dearborn, Michigan; Frick Art Reference Library, New York; Glasgow Art Gallery and Museum, Kelvingrove, Glasgow, Scotland; Grand Rapids Public Museum, Grand Rapids, Michigan; Greenfield Village and Henry Ford Museum, Dearborn, Michigan; Heritage Plantation of Sandwich, Sandwich, Massachusetts; Historic Chattahoochee Commission, Chattahoochee, Florida; The Historic General Dodge House, Council Bluffs, Iowa; Inkster, Michigan, Public Library; International Silver Company Historical Collection, Meriden, Connecticut: E. P. Hogan; The Jefferson Medical College of Philadelphia, Philadelphia, Pennsylvania; Samuel Kirk & Son, Inc., Baltimore, Maryland; The Library Company of Philadelphia, Philadelphia, Pennsylvania; The Library of Congress, Washington, D.C.; Lockwood-Mathews Mansion Museum, Norwalk, Connecticut; Lyman Allyn Museum, New London, Connecticut; Lyndhurst, National Trust for Historic Preservation, Tarrytown, New York; Mark Twain Memorial, Hartford, Connecticut; Marshall Historical Society, Marshall, Michigan; Maryland Historical Society, Baltimore, Maryland; The Metropolitan Museum of Art, New York; The Minneapolis Institute of Arts, Minneapolis, Minnesota; Munson-Williams-Proctor Institute, Utica, New York; Museum of American Folk Art, New York; Museum of Art, Rhode Island School of Design, Providence, Rhode Island; Museum of Fine Arts, Boston, Massachusetts; Museum of the City of New York, New York; National Collection of Fine Arts, Smithsonian Institution, Washington, D.C.; The Newark Museum, Newark, New Jersey; Newark Public Library, Newark, New Jersey; New Haven Colony Historical Society, New Haven, Connecticut; New Jersey State Museum, Trenton, New Jersey; The New-York Historical Society, New York; The New York Public Library, New York; New York State Court of Appeals, Albany, New York; New York State Historical Association, Cooperstown, New York; Olana State Historic Site, Taconic State Park Commission, New York State Office of Parks and Recreation, Hudson, New York; Pennsylvania Academy of the Fine Arts, Philadelphia, Pennsylvania; Philadelphia Museum of Art, Philadelphia, Pennsylvania; Portland Museum of Art, Portland, Maine; The Preservation Society of Newport County, Newport, Rhode Island; Providence Art Club, Providence, Rhode Island; Readfield Public Library, Readfield, Maine; Rochester Museum and Science Center, Rochester, New York; The Rushlight Club, Vernon, Connecticut: Harry W. Rapp, Jr.; Sag Harbor Whaling Museum, Sag Harbor, New York; San Antonio Museum Association, San Antonio, Texas; Seagram County Court House Archives, The Library of Congress, Washington, D.C.; Shelburne

Museum, Inc., Shelburne, Vermont; Smith College Museum of Art, Northampton, Massachusetts; Smithsonian Institution, Washington, D.C.; The State Historical Society of Colorado, Denver, Colorado; The Margaret Woodbury Strong Museum, Rochester, New York; Sunnyside, Sleepy Hollow Restorations, Inc., Tarrytown, New York; The Toledo Museum of Art, Toledo, Ohio; University of Michigan Graduate Library, Ann Arbor, Michigan; Victoria and Albert Museum, London, England; Victoria Mansion (Morse-Libby House), Portland, Maine; Henry Francis du Pont Winterthur Museum, Winterthur, Delaware.

DEALERS AND COLLECTORS

America Hurrah Antiques, New York; Morley Baer; Richard A. Benizio; Berry-Hill Galleries, Inc., New York: Henry D. Hill; George O. Bird; Gray D. Boone; Hazel and Carleton Brown; Mrs. Charles L. Bybee; Mr. and Mrs. David Claggert; Mrs. William Clegg; Patricia Coblentz; Philip Davis; Frederick Di Maio: Inglenook Antiques, New York; Eileen Dubrow Antiques, Bayside, New York; Martin Eidelberg; R. Esmerian, Inc., New York; Mr. and Mrs. Dean A. Fales, Jr.; James Frink; Pie Galinat; Patrick W. Grace, Kennebunk, Maine; Mr. and Mrs. Charles V. Hagler; Mr. and Mrs. Michael D. Hall; Mr. and Mrs. George R. Hamell; Thomas Hannan, Brattleboro, Vermont; Mr. and Mrs. Gary Hawk; Helga Photo Studio, New York; Lucile Henzke; Peter Hill, United States Antiques, Washington, D.C.; Hirschl & Adler Galleries, New York; Dorothy Jean Horr, Winterport, Maine; Jay Johnson: America's Folk Heritage Gallery, New York; Edgar J. Kaufmann, Jr., Mr. and Mrs. James A. Keillor; Kelter-Malcé Antiques, New York; Dr. and Mrs. Robert Koch; Nina Fletcher Little; Richard A. Manoogian; Mrs. David Mathews; Moss Antiques, New Orleans, Louisiana; Lillian Nassau, Ltd., New York; Kenneth M. Newman, The Old Print Shop, New York; Tony Orlando; David M. S. Pettigrew; Henry J. Prebys; Mr. and Mrs. John P. Remensnyder; Marguerite Riordan, Stonington, Connecticut; George E. Schoellkopf Gallery, New York; Mr. and Mrs. Samuel Schwartz; Sotheby Parke Bernet Inc., New York; David Stockwell, Inc., Wilmington, Delaware; Elsie Suffron; James T. Thomason; V. Stephen Vaughan; Willow Corners Antiques, Lisbon, Connecticut; Mr. and Mrs. William E. Wiltshire III; Thos. K. Woodard: American Antiques & Quilts, New York; and several private collectors.

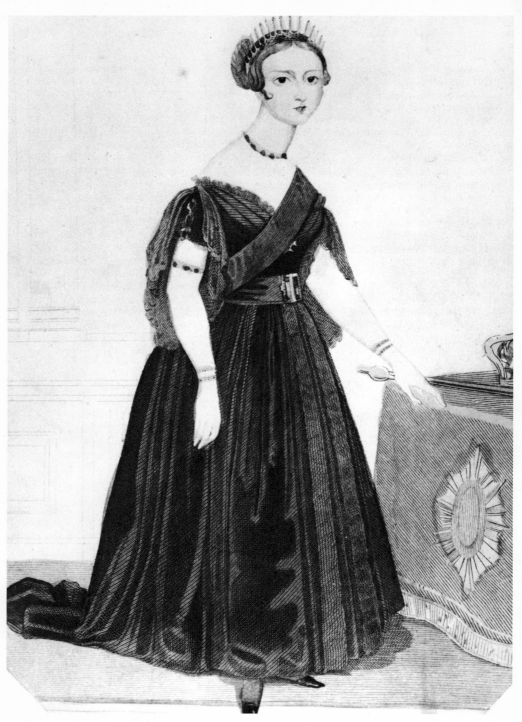

1 (above). Portrait of Queen Victoria published in the March 1838 issue of *Godey's Lady's Book*. The editors noted the young queen was "in the bloom and beauty of youth." Victoria's influence on the American way of life grew to astounding proportions by the time of her death in 1901. (Private collection)

INTRODUCTION

Victoria, Queen of England, exerted an astonishing influence on every aspect of American life during her reign from June 20, 1837, to January 22, 1901. American dependence upon England in matters of taste and style was not new, for during almost the entire Colonial period the Colonists had attempted to approximate British modes of living.

As America struggled for her independence, an intense interest in French politics developed. Many American tastemakers, such as Thomas Jefferson, turned to Paris for inspiration. Consequently, Parisian fashions and taste dominated the American scene for much of the last quarter of the eighteenth century and for the first decades of the nineteenth century.

Under Victoria, England once again became a fountainhead of style and taste for Americans. At the time of her coronation, American periodicals enthusiastically predicted a new prosperity and an era of peace in her reign. In the March 1838 issue of *Godey's Lady's Book,* the editor exuberantly reported,

> The "reign of intellect and feeling" should be ushered in by a woman. Victoria has come to the throne under many peculiar advantages. She is in the bloom and beauty of youth, when, as woman, she would be sovereign over men's affections. She brings to her high station all the intelligence which the most careful education could bestow, to fit her for her duties. . . . she has also the inestimable privilege of living in an age when the moral power of right principles, of truth in its simplicity is, in a measure, understood—when woman is taking her true place, side by side, with man, his companion and helper in the work of civilization and Christian progress . . . Victoria has now the opportunity of securing such a wreath of bright honour for herself as no queen ever before enjoyed. Let her bear in mind that every added degree of respect to which she can entitle her sex will proportionally exalt her own character. May she prove, by her own pure example, that a woman is worthy to sway the sceptre of the greatest empire in the world.[1]

Victoria ascended the throne in a period of agitated social and economic development. The benefits of the Industrial Revolution became increasingly evident as the machine provided new capabilities for mankind. The rich grew richer and the poor were forced to resign themselves to the new miseries that were inherent in rampant industrialization.

In America the effects of the Industrial Revolution were perhaps more positive than in England. Furthermore, it was still possible for a man who was dissatisfied with his lot to leave the cities and seek a new life on the frontier.

While Victoria reigned, the difference between art and ornament became confused. This confusion caused social critics like Ralph Nicholson Wornum (1812–1877) to suggest new ways of utilizing machine power to create a better

standard of living. Wornum noted in an essay for *The Crystal Palace Exhibition Illustrated Catalogue London (1851),*

> Style in ornament is analogous to hand in writing . . . There are, of course, many varieties of every great style; but so long as the chief characteristics remain unchanged, the style is the same. From this point of view, therefore, the styles become comparatively few. We shall find that nine will comprise the whole number of the great characteristic developments which have had any influence on European civilisation: namely—three ancient, the Egyptian, the Greek, and the Roman; three middle-age, the Byzantine, the Saracenic, and the Gothic; and three modern, the Renaissance, the Cinquecento, and the Louis Quatorze . . . That there is nothing new in the Exhibition in ornamental design; not a scheme, not a detail that has not been treated over and over again in ages that are gone; that the taste of the producers generally is uneducated, and that in nearly all cases where this is not so, the influence of France is paramount in the European productions; bearing exclusively in the two most popular traditional styles of that country—the Renaissance and the Louis Quinze—with more or less variation in the treatment and detail . . .[2]

International exhibitions became popular during Victoria's reign. The idea was not new, for in 1797 there had been an exposition of the national industry of France at St. Cloud. The success of this fair caused the promoters to repeat it several times through the years. Attendance grew and the number of exhibitors multiplied to 4,499 in 1849, when over five acres of displays were shown at the Champs Élysées.

The Spanish had also been active in the preparation and presentation of fairs for the express purpose of promoting new products made available by technological advancements. The Spanish Industrial Bazaar of 1827 was especially noteworthy, for the implications of the Industrial Revolution were much in evidence.

The Crystal Palace saga is one of the most remarkable success stories of the mid-nineteenth century. Prince Albert, Victoria's consort and president of the Society of Arts, and his friend, Henry Cole, were elated by the success of the Society of Arts exhibition held in England in 1847. After a visit to the 1849 Paris Quinquennial, Cole convinced Prince Albert that England should stage the first international exposition. The London Crystal Palace, one of the most dazzling, innovational architectural structures ever built, was erected to house the gigantic international exposition, "The Industry of All Nations." The Crystal Palace, designed by Joseph Paxton (1801–1865), was the largest prefabricated edifice, which was not only demountable but remountable, that the world had ever seen. As *The Illustrated Exhibitor* noted in the first issue, June 7, 1851, "Other triumphs have been won, and other victories celebrated, but none greater or more glorious than this." [3]

Victoria agreed. The entry in her journal expressed her intense joy.

The Park presented a wonderful spectacle, crowds streaming through it,—

carriages and troops passing, quite like the Coronation, and for *me*, the same anxiety. The day was bright and all bustle and excitement. At ½ p. 11 the whole procession in 9 State carriages was set in motion . . . The Green Park and Hyde Park were one mass of densely crowded human beings, in the highest good humour and most enthusiastic . . . The glimpse, through the iron gates of the Transept, the waving palms and flowers, the myriads of people filling the galleries and seats around, together with the flourish of trumpets as we entered the building, gave a sensation I shall never forget, and I felt much moved . . . The sight as we came to the centre where the steps and chair (on which I did *not* sit) was placed, facing the beautiful crystal fountain was magic and impressive. The tremendous cheering, the joy expressed in every face, the vastness of the building, with all its decoration and exhibits, the sound of the organ (with 200 instruments and 600 voices, which seemed nothing) and my beloved husband, the creator of this peace festival "uniting the industry and art of all nations of the earth," all this was indeed moving, and a day to live for ever. God bless my dearest Albert, and my dear Country, which has shown itself so great to-day.[4]

On the humorous side, the queen was fascinated by the oddities and found a collection of stuffed frogs from Württemberg "really marvellous."[5] These ludicrous feats of the taxidermist included a vignette of one frog shaving another.

America was well represented at the 1851 London Crystal Palace. Many of her products inspired enthusiastic admiration, especially those that demonstrated the American "practical" approach to design. Americans won the highest prizes for their machinery and especially for their machines that made machines, but their fine and decorative arts exhibits were severely criticized.

The London Crystal Palace and the displays it contained inspired many imitations. Certainly the most significant for Americans was the Crystal Palace erected at New York City in 1853, which housed the impressive international show, "The World of Art and Industry."

Incredible as it may seem, in the two years that separated the London display and its American counterpart, American manufacturers utilized the lessons taught by the earlier exposition. Mass-produced decorative arts exhibited in "The World of Art and Industry" exhibition could now be offered competitively in the international marketplace.

Although expositions continued to be held in the ensuing years, none excited the American imagination as much as the Centennial Exposition held at Philadelphia in 1876. Out of that exhibition grew a deeper awareness of America's history, her arts, and her decorative arts. One nostalgic display, titled "A New England Kitchen of 1776," was constructed with a beamed ceiling, leaded casement windows, and a cavernous fireplace. The women who furnished this period room used pieces dating from the seventeenth, eighteenth, and early nineteenth centuries. This immensely popular presentation had far-reaching implications. The ensuing craze for collecting and decorating in the "Colonial" or "Early American" style caused manufacturers, quick to sense the possibility of big

profits, to turn their workmen from crafting French- and English-inspired Victorian pieces to reproducing American "antiques."

A national fervor for antiques caused many new collectors to seek authentic examples of early American decorative arts. The massive, simple forms of the Pilgrim Century (1620–1720), the more sensuous Queen Anne (1720–1755), and Chippendale (1755–1790) pieces were eagerly sought. These sturdy, straightforward styles represented a distinct break with the many revival styles of the Early Victorian period.

Toward the end of the century a world grown tired of a never-ending medley of revivals saw in the work of Charles Rennie Mackintosh, a Scotsman, a new answer to decorative design and architecture. The Art Nouveau or Modern style grew out of special exhibitions mounted by S. Bing in his Salon Art Nouveau at Paris. In America Art Nouveau expression did not influence architecture greatly; it did, however, permeate and dominate every aspect of the decorative arts. Artists and designers, like Louis Comfort Tiffany, and graphic artists, like Will Bradley, interpreted the international Art Nouveau style for Americans.

While Victoria reigned, the Industrial Revolution reached new heights. Technological developments introduced products that altered the life-style of everyone in the civilized world. Perhaps the single greatest development in the last quarter of the nineteenth century was electricity. Thomas Alva Edison's historic demonstration of the practical use of electricity on January 1, 1876, at Menlo Park, New Jersey, heralded a brighter age. The practicality of his inventions was made known on a broader scale and to a greater audience at the World's Columbian Exposition held at Chicago in 1893. Enthusiastic critics in unabashed rapture viewed the City of Light and the electrical kitchen display that it housed as the dawn of a new era—and indeed it was!

Although Victoria had little personal contact with America and her people, her influence upon their life-style, their architecture, their art, and their decorative arts cannot be overstated. Her personal convictions and attitudes became the attitudes of a world changing from handcraftsmanship to machined arts.

Upon Victoria's death in 1901 *The American Monthly Review of Reviews* in its February issue noted that

> Queen Victoria had for many years past exerted an almost unbounded moral control over the larger policies of the British empire. She was industrious and methodical, patient and tactful, with a memory that was a great storehouse of knowledge of things past and present. She had retained the full possession of her rare power of judgment and discernment up to the very last. A monarch who had seen fifteen successive parliaments elected, and who had dealt with a full score of different ministries under the headship of ten different individual prime ministers, might be expected to know something of parliamentary institutions and executive government. Her accumulated experience, indeed, was so vast that the deference of English statesmen to her superior knowledge had for the past twenty-five or thirty years of her reign been a genuine rather than an assumed attitude. . . .

She had seen lord chancellors and chief justices come and go, and had outlived two generations of judges who dispensed justice in her name. And she had known hundreds of sovereigns and rulers. She had witnessed most of the process of the real development of the present British empire, and she had seen such growth of its population and power as made it admittedly the foremost of modern states.[6]

While Victoria reigned, England changed and America changed as well. This book, in its sixteen chapters, is a pictorial documentation of that change. The book also extensively surveys a way of life and the objects and attitudes characteristic of it, which formerly were in disfavor. Happily, Victorian Americana is once again being enthusiastically appreciated for the real beauty and fascination so much of it possesses.

2 (below). The southern entrance to the transept of the London Crystal Palace published in *The Crystal Palace Exhibition Illustrated Catalogue London (1851)*. This prefabricated, easily assembled, disassembled, and reusable structure of iron and glass housed the first international exposition, "The Industry of All Nations." (Private collection)

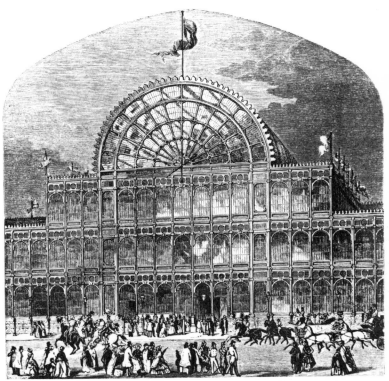

3 (above). Interior of the New York Crystal Palace from *The World of Science, Art and Industry Illustrated,* published in 1851. An equestrian figure of George Washington dominated the central apse. Exotic rugs formed part of the unidentified display on the second floor left balcony. On the main floor an extensive collection of paintings and sculpture gave many Americans their first real look at European art. (Private collection)

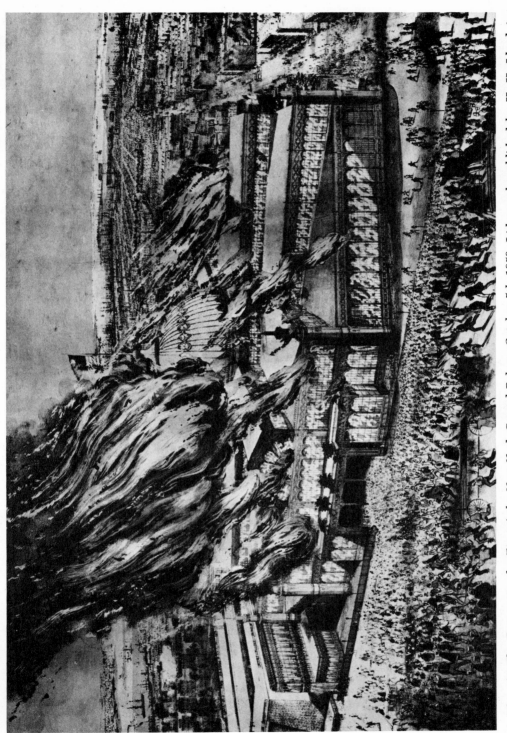

4 (above). *The Destruction by Fire of the New York Crystal Palace, October 5th 1858.* Lithograph published by H. H. Lloyd & Co., also by Spearing & Stutzman, New York. (Private collection)

5 (opposite). *The Rocky Mountains. Emigrants Crossing the Plains.* Lithograph published by Currier & Ives, New York, 1866. The ill effects of rapid industrialization caused many American city dwellers to flee to the frontier in search of a better way of life. Countless men, women, and their families made the long trek westward, often carrying with them their most prized possessions in covered wagons. (Greenfield Village and Henry Ford Museum)

6 (right). Pressed-glass covered compote in the Liberty Bell pattern. United States. 1876. H. 10″. Innumerable souvenirs were sold at the Philadelphia Centennial, which celebrated America's one-hundredth birthday. (Greenfield Village and Henry Ford Museum)

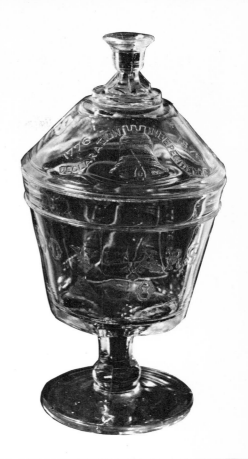

7 (below). "Bird's-eye View of the Columbian Exposition Grounds" at Chicago, Illinois, in 1893, published in the *History of the World's Fair* by Benjamin Cummings Truman. Among the most significant developments at the World's Columbian Exposition were the exhibition of the electric kitchen and the concentrated effort by women to call attention to their capabilities as artists, architects, and thinkers. The Woman's Building was designed by Miss Sophia G. Hayden of Boston and housed numerous displays of feminine achievements. (Private collection)

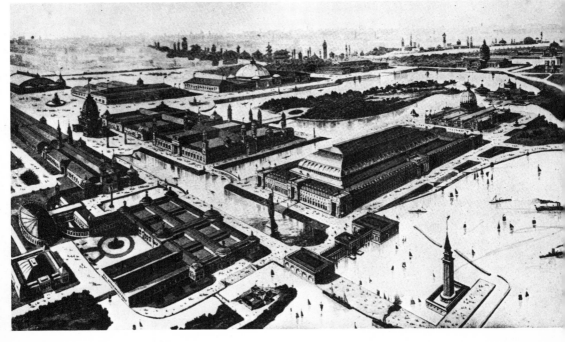

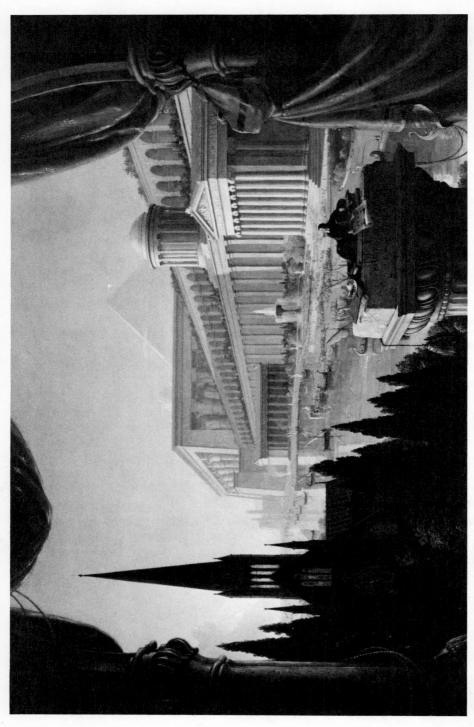

8 (above). *The Architect's Dream* painted by Thomas Cole (1801–1848) for Ithiel Town. 1840. Oil on canvas. 54″ x 84″. This painting indicates the prevailing eclectic taste in architecture as the Victorian period opened. *The Architect's Dream* contains an assemblage of Egyptian, Greek, Roman, Gothic, and Moorish styles. Town, one of the architects of the original Wadsworth Atheneum in Hartford, Connecticut, rejected the painting when it was completed. (The Toledo Museum of Art; Gift of Florence Scott Libbey, 1949)

ARCHITECTURE

A 264-year retrospective look at American domestic architecture in 1884 by the publishers of *Our Homes and Their Adornments* inspired the zealous comment, "That grand old Saxon word, *Home,* has for ages held a peerless place wherever the English language is spoken. And thus do we find it, under every zone, embalmed in song, cherished in the memory, and enshrined in the heart!"[1]

Perhaps Victorians, living in an era of constantly increasing affluence, did have cause for such a joyous attitude toward their modern homes, for certainly life-styles in both the East and Midwest had improved since the time when many of the earliest settlers in the Massachusetts Bay Colony were forced to "burrow themselves in the Earth for their first shelter under some Hill-side."[2] Victorians, after all, felt that they were the heirs to all that was admirable in the Medieval, Georgian, and Federal phases of American architectural development.

The first efforts at colonization are always difficult and those who chose to follow the westward-moving frontier saw history frequently repeat itself. The primeval struggle with nature and the bold attempts to improve the technology of an iron age that dominated seventeenth-century Colonial existence were relived on the western frontier some two hundred years later. Just as the seventeenth-century Spanish, French, Dutch, German, and English had attempted to transplant a microcosm of their homeland cultures into the New World, migrating easterners struggled, many times in vain, to establish life-styles in the wilderness that followed East Coast patterns.

At the dawn of the eighteenth century the American Colonies, each with its own special characteristics, which it would long retain, possessed one common trait: the inhabitants all looked to London for guidance in matters of architecture. Thus a somewhat similar architectural style, with a multitude of regional variations or accents caused by the great diversity of climate and the backgrounds of the settlers, developed.

During the first half of the century, domestic builders often absorbed ideas from English pattern books like William Salmon's *Palladio Londinensis: or The London Art of Building* (1734), Batty Langley's *Workman's Treasury of Designs* (1740), and William Halfpenny's *Modern Builder's Assistant* (1742). Over eighty different English and European pattern books are known to have been in use in America prior to the Revolution.

The careers of Richard Taliaferro (1705–1779), praised in 1749 by the acting governor of Virginia as one of the most skillful architects in the colony; Peter Harrison (1716–1775); Robert Smith (1722–1777); John Ariss (c.1725–1799); William Buckland (1734–1774); and Samuel McIntire (1757–1811) parallel those of countless other more or less self-taught overseers and contractors aspiring to the title, "architect."

Mr. M'Intire was originally bred to the occupation of a housewright (his father's trade), but his vigorous mind soon passed the ordinary limits of his profession, and aspired to the highest departments of the interesting and admirable science of architecture . . . To a delicate native taste in this art, he had united a high degree of that polish which can only be acquired by an assiduous study of the great classical masters; with whose works, notwithstanding their rarity in this country, Mr. M. had a very intimate acquaintance.[3]

Contrasting with the craftsmen-artisans, many of whom later became recognized paid professionals, were such patricians as the later-day Renaissance man, Thomas Jefferson, who considered the putting up and pulling down of buildings one of his favorite avocations. His ambitious, architectural masterpiece Monticello, his home built at Charlottesville, Virginia, was first conceived in 1767 when he executed preparatory sketches. At the time of his death, fifty-nine years later, he was still making alterations to the house and gardens. For Jefferson, no practical detail was too small. Careful attention to every aspect of the planning and construction caused the inclusion of such features as a weathervane with indoor dials, an elaborate self-winding clock, double-acting doors, automatic dumbwaiters, and storm windows.

Borrowing from English Georgian prototypes that were in turn based upon Palladian adaptations of antiquity, American architecture during the eighteenth century slowly evolved into a full-blown neoclassical style that had become cohesive by 1800. Attention to overall symmetry and the inclusion of carefully calculated effects in a predetermined plan were increasingly evident as the fever for archaeological correctness, inspired by the excavations at Herculaneum and Pompeii, became more widespread.

This newly discovered classicism allowed latitude for experimentation. The use of Chinese and "Gothick" motifs demonstrated that novelty need no longer be suspect as it had been in seventeenth-century New England. Nearly everything in nature was acceptable within a framework of universal classical principles.

Americans were exuberant in their hopes for the new nation and came to expect and demand the balanced stability found in the architecture and furnishings of the ancient world. Increasingly, the quest for the "good life" dictated the shape and character of domestic architecture.

City dwellings were customarily made four stories high but in 1797 a Boston house, built to a height previously unknown in the city, soared to five stories. Country houses at this time were two stories high, for rural land was not so dear as that in the cities.

Benjamin Henry Latrobe (1764–1820), an Englishman, arrived in America in 1796, a fully trained professional architect with strong predilections for the classical style. Rich patrons were delighted with this gifted artist and awarded him important commissions; thus he had the opportunity to create many of the most beautiful buildings of the period. The Philadelphia waterworks of 1801 and his reconstruction of the Capitol at Washington, D.C., after its blazing

destruction in 1814, alone would have secured for this "bigoted Greek" a preeminent place in the annals of American architecture. It was Latrobe, however, who built the first Gothic Revival house in America. It was a country seat designed for the Philadelphia merchant, William Crammond, in the "pointed style" that remained popular throughout the nineteenth century.

Charles Bulfinch (1763–1844), returning from Europe to his native Boston in 1787, utilized features of the "Anglo-Greco-Roman" style then popular in England. Through his many influential commissions he transformed the provincial New England city into an elegant, beautiful capital. His dwellings set new standards of convenience, for they displayed a flexibility of arrangement and contained innovations such as dressing rooms, butlers' pantries, closets, and, frequently, indoor privies. His Tontine Crescent at Boston, although only partially completed, was one of the first instances in America in which the several buildings in an entire city block were of a similar or identical design.

Bulfinch had many imitators; however, none was as significant as Asher Benjamin (1773–1845), a Connecticut carpenter-builder who, until the early nineteenth century, earned his living through commissions executed in the Connecticut River Valley and Vermont.

Benjamin's book, *The Country Builder's Assistant: Containing a Collection of New Designs of Carpentry and Architecture*, was published at Greenfield, Massachusetts, in 1797. This pioneer effort, the first original American architectural publication, brought to its author a degree of success and notoriety that, by 1803, enabled him to move to Boston. In that same year he was listed in the city directory as a "housewright."

He became the coauthor of *The American Builder's Companion: or a New System of Architecture Particularly Adapted to the Present Style of Building in the United States of America* with Daniel Raynard. The book was first published in Boston in 1806; a second edition appeared in 1811 with Benjamin's name alone. Through the years six editions were made available to American builders, the benefactors of a rapidly expanding economy. Other texts like Stuart and Revetts' *On the Antiquities of Athens*, published in four volumes from 1762 to 1816, promoted the Greek Revival style, which was not only an architectural vogue but also a three-dimensional expression of social and political purpose. It became the prevailing mode of building, and in 1830 Benjamin noted that since his latest publication the Roman school of architecture had been entirely changed for the Grecian.

Little wonder that the architectural critic Arthur Channing Downs, Jr., observed,

> The better sort of detached country house have [sic] generally a portico of four or six wooden columns, occasionally on two stories, with wooden floors and steps, left unpainted, supporting a lean-to shingled roof, or the main roof continued on the same or a less acute angle. Gables are invariably used instead of hipped roofs; and, in the largest specimens, the gable is often made a regular pediment, with a more solid portico underneath it. Wooden models of Grecian Doric temples are common in the village

churches; and very pretty lodges for the toll-keepers at the steam-boat stations on the Hudson River are frequently met with, remarkably resembling the architectural forms in the Herculaneum paintings, built entirely of joiner's work.[4]

In 1837 Benjamin was one of the founders of the American Institute of Architects and by 1843, when he published the last of his many books, *The Elements of Architecture,* his ideas dominated American architecture. Benjamin's influence extended to every state and territory. Country carpenters and their patrons seldom constructed a home without consulting one of his "bibles."

Charles A. Goodrich (1790–1862), an author of stature during the 1830s, in a capsule survey of American architecture observed that in a country with such extensive territory, with climates and circumstances so dissimilar, the types of buildings varied greatly. He saw New England, with its houses made chiefly of wood, as a series of communities, each centered around a village green. In the Middle Atlantic states ancient houses of Flemish design, tiled, with gables on the street, were most typical; however, in western New York many wooden dwellings were painted white and surrounded by verandas. He praised cosmopolitan New York City, Philadelphia, and Baltimore for their elegant brick edifices that expressed a direct simplicity through the Greek Revival. And in the west, ". . . we see occasionally structures like those of the East—some towns are even built of brick, but generally there is very little good architecture. Though the villages often look well, you may see in most of them, the log-houses of the first settlers. Remote from towns, the log-house is still the most common building." [5]

There were two distinct levels of Victorian architecture: one was sophisticated, created by well-known architect-artists for patrons from the upper class; the other, less ambitious, was developed by anonymous builder-carpenters for the common man. Victorian architecture is most easily understood when divided into three periods.

Early Victorian architecture lasted from the 1820s well into the 1850s. Architects were expected to be knowledgeable in several of the revival styles and to possess the capability of using any one of them in a "pure" or symbolic way.

High Victorian architecture was a potpourri of several historical styles in the same structure. This movement began to gain in popularity in the 1840s and continued into the 1880s when, in a naïve quest for a truly "American Style," John Moser, an architect from Alabama, proposed a building for the American Institute of Architects in New York "where every epoch in architectural history shall be represented by details from the best examples now obtainable, following each other in a regular and orderly sequence." [6]

High Victorian architects strove to create eclectic buildings with "picturesque" outlines that would satisfy the general principles of design that nouveau-riche patrons believed were necessary for the proper display of their wealth.

The Late Victorian period was dominated by popular "tastemakers" who for the most part reacted against the picturesque eclecticism of the High Victorian

style. The Queen Anne style, followed by the devastating effects of the Classical Revival at the World's Columbian Exposition in Chicago in 1893, helped to solidify a movement toward the Colonial Revival, which by 1915 all but dominated conventional American residential architecture.

Coexistent with the popular Late Victorian styles, a basis for modern architecture was developed in Chicago by Louis Sullivan and his disciples. Frank Lloyd Wright's Prairie style, however, did not become fully realized until after the close of the Victorian era.

The Victorian period saw the emergence of the architect as a recognized professional. No longer was he the "housewright" like Asher Benjamin—a craftsman whose education consisted of practical experience and experiment—nor the patrician, Thomas Jefferson, working primarily for himself and as a favor for his peers. The new architect was a scholar whose knowledge of historical buildings enabled him to borrow from the past what suited his purpose and to utilize the best of it freely to achieve a pictorial symbolism.

By the early 1840s critics saw in American architecture

> . . . a great improvement of taste . . . every successive period of twenty years, exhibits a manifest advance towards a better state of things. The more modern churches are in the chaste Grecian style, some of the Doric, and some of the Ionic order. The University on Washington Square is a fine specimen of the Gothic; and the great hotel of Astor House has all the massiveness, simplicity, and chasteness of design adapted to such an edifice.[7]

Admiration for such a variety of styles probably was the inspiration for *The Architect's Dream* (fig. 1), a painting commissioned from Thomas Cole (1801–1848) by Ithiel Town (1784–1844), one of America's most prominent architects. It is obvious that not all artists interpreted the lessons that history had to teach in the same way, for Town refused the picture when it was completed. Cole, a distinguished and respected painter, complained to Asher B. Durand (1796–1886), another painter of importance,

> Do you know I have received a letter from Town, telling me that neither he nor his friends like the picture I have painted for him, and desiring—expecting me to paint another in place of it, composed of *rich and various landscape, history, architecture of different styles and ages, etc.,* (these are his words) *or ancient or modern Athens?* . . . After having painted him a picture as near as I could accommodate my pictorial ideas to his prosaic voluminousness,—a picture of immense labour, . . . he expects me again to spend weeks and weeks in pursuit of the uncertain shadow of his approbation.[8]

Without being conscious of the precedent he was setting, Asher Benjamin established a pattern that would prevail throughout America for nearly a century. Taking up the pen, architects became authors and their books of designs,

patterns, and building suggestions dispersed information to carpenters and housewrights in a nation that, in the main, remained rural.

Andrew Jackson Downing (1815–1852),one of the most important Early Victorian landscape architects, developed a worldwide reputation as a discerning critic and author. He was probably more significant as a popularizer than as an innovator. Downing's 1842 publication, *Cottage Residences or A Series of Designs for Rural Cottages and Cottage-Villas and their Gardens and Grounds Adapted to North America,* which included detailed plans, served as a guide to the many styles that were vying for popular acceptance. The contents lists the following: Suburban Cottage; Cottage in the English, or Rural Gothic Style; Cottage in the Pointed, or Tudor Style; Ornamental Farm-House; Cottage in the Bracketed Mode; Irregular Villa in the Italian Style; Bracketed, Irregular Cottage in the Old English Style; Villa in the Italian Style; Cottage in the Italian, or Tuscan Style; Villa in the Gothic, or Pointed Style; Cottage for a Country Clergyman; Villa in the Elizabethan Style; Small Cottage for a Toll-Gate House; Cottage in the Rhine Style; Carriage-House and Stable in the Rustic Pointed Style; as well as several chapters devoted to landscaping and related aspects of horticulture. In other words, here was a profusely illustrated guide that could be used by even the most inexperienced builder. Downing preferred the Gothic Revival style, which had replaced the Greek Revival of the 1820s and 1830s, and he expressed nothing but contempt for "those architects who give us copies of the temple of Theseus, with its high, severe colonnades, for dwellings . . ." [9]

By the time *The Architecture of Country Houses Including Designs for Cottages, and Farm-Houses, and Villas, with Remarks on Interiors, Furniture, and the Best Modes of Warming and Ventilating* was published by Downing in 1850, he had, in collaboration with his famous friend, the architect Alexander Jackson Davis (1803–1892), developed a cohesive rhetoric that did much to codify domestic architecture further and to spread general acceptance of the Gothic style.

The Gothic Revival in the United States was a self-conscious attempt to evoke a romantic image. It was based upon a continuation of an English medieval strain that had, even in the seventeenth century, been acknowledged on American soil; St. Luke's, a tiny, brick church built at Smithfield, Virginia, in 1632, contained buttresses and pointed-arch windows. By the mid-nineteenth century the Gothic Revival had won wide acceptance, and a freer attitude replaced the formal restraint so evident in the neoclassical structures. Asymmetrical designs created by Davis brought to America a poetic style of architecture characterized by picturesque villas and cottages undulating with crockets, cusps, oriel windows, pointed arches, towers, trellises, and turrets. The style became so popular that earlier houses were "modernized" by the application of Gothic motifs and "gingerbread." The two most notable instances of this updating are at Kennebunk, Maine, where a foursquare, brick farmhouse was encased in Gothic tracery and has come to be known as "The Wedding-Cake House"; and at Tarrytown, New York, where Gothic motifs were lavished on a simple farmhouse when it was renovated by the author Washington Irving (1783–1859).

Ithiel Town and A. J. Davis formed the architectural partnership Town and Davis in 1829. Despite the fact that William Strickland (1787?–1854) was responsible for the Second Bank of Philadelphia in 1820, Davis claimed in his diary that the highly successful firm of Town and Davis constructed the first "Greek Temples" in America and the first cast-iron shop fronts in New York City.

The Tuscan Revival, a composite style derived from domestic architecture of the Roman Campagna, competed for popularity with the Gothic. Davis freely used it and Downing's publications conspicuously promoted Roman and Tuscan villas indiscriminately labeled Lombard Italian, Roman of Pliny and Palmyra, Vitruvian, Etruscan, Norman, and Suburban Greek. After Town's death in 1844 Davis continued the practice; however, in postbellum days commissions decreased. The country, no longer content with architecture in the various revival styles, turned to the international potpourri known as picturesque eclecticism.

The North emerged from the Civil War confident of a long-range prosperity. A constantly expanding frontier would provide new materials for production and a market for finished goods. Many daring speculators gambled and won; consequently millionaires seemed to burgeon everywhere. The curious homes they built followed no single style. Leopold Eidlitz, a Vienna-trained architect, discordantly noted that Americans possessed "the art of covering one thing with another thing to imitate a third thing which, if genuine, would not be desirable." [10]

The Mansard style flourished in America after additions were made to the Louvre at Paris during the French Second Empire. American adaptations of the seventeenth-century Gallic style were based upon the original designs of François Mansart (1598–1666) whose innovational roofs provided more headroom and more light to attic spaces. Samuel Sloan (1817–1907), a mid-nineteenth-century architectural innovator, observed, "The French roof is in great request. Public and private dwellings and even stables are covered with it and no man who wants a fashionable home, will be without it." [11]

Despite many efforts to establish a national style of American architecture, mavericks continued to introduce bastard designs.

P. T. Barnum, a showman, promoter, and circus owner, after a visit to Brighton, England, in 1846, where he was "greatly pleased" with George IV's exotic Pavilion, returned to America and began to erect an even more exotic house at Bridgeport, Connecticut.

. . . I determined, first and foremost, to consult convenience and comfort. I cared little for style, and my wife cared still less; but as we meant to have a good house, it might as well, at the same time, be unique. In this, I confess, I had "an eye to business," for I thought that a pile of buildings of a novel order might indirectly serve as an advertisement of my various enterprises . . . I . . . engaged a London architect to furnish me a set of drawings in the style of the Pavilion, differing sufficiently to be adapted to the spot of ground selected for my homestead . . . The whole was finally completed to my satisfaction. My family removed into the premises, and on

the fourteenth of November, 1848, nearly one thousand invited guests, including the poor and the rich, helped us in the old-fashioned custom of "house-warming." [12]

Barnum's "Oriental Villa," Iranistan; Samuel Colt's Armsmere finished at Hartford, Connecticut, in 1862; and other Eastern-inspired styles including the "hindoo," "Moorish," "Saracenic," and "Persian" were joined by octagon houses during the 1860s. *The Octagon House, A Home for All* (1858) by Orson S. Fowler (1809–1887) included numerous features in which scholars see an early instance of the "form follows function" theory. These structures brought to American architecture many "sensible" improvements that social reformers much admired. Progressive Victorians, especially in the South and Midwest, utilized Fowler's designs, which were accompanied by schemes for running water, hot-air heating, dumbwaiters, speaking tubes, and indoor water closets, Fowler proclaimed the aesthetic and functional advantages of the eight-sided home, which avoided the harsh angles of the pointed style.

One of Fowler's most innovational theories was the use of what he called "gravel wall," a method of construction similar to modern-day poured concrete. Builders on Cape Cod might well have been delighted to learn of Fowler's idea since, like many other areas of the country, it had problems peculiar to its location. Henry David Thoreau observed, during a trip to sandy Provincetown in 1849, ". . . the wells and cellars of the Cape are generally built of brick . . . The cellars, as well as the wells, are made in a circular form, to prevent the sand from pressing in the wall. The former are only from nine to twelve feet in diameter, and are said to be very cheap, since a single tier of brick will suffice for a cellar of even larger dimensions. Of course, if you live in the sand, you will not require a large cellar to hold your roots." [13]

By mid-century progressive technology provided cast-iron storefronts; houses in the same material were not uncommon. Many foundries, including one owned by James Bogardus (1800–1874) in New York City, specialized in this type of production, which became increasingly popular after the gigantic exhibition building, the Crystal Palace, built at Forty-second Street and Fifth Avenue, in New York in 1853, sparked the American imagination. Five years prior to the erection of this mammoth iron-and-glass structure, Peter Naylor of 13 Stone Street, New York, had a successful business based on the use of prefabricated iron.

The galvanized iron houses constructed by me for California, having met with so much approval, I am thus induced to call the attention of those going to California to an examination of them. The iron is grooved in such a manner that all parts of the house, roof and sides, glide together, and a house 20 x 15 can be put up in less than a day. They are far cheaper than wood, are fireproof, and are much more comfortable than tents. A house of the above size can be shipped in two boxes . . . the freight on which would be about $14 to San Francisco. There will also be no trouble in removing from one part of the country to another, as the house can in a few

hours be taken down and put up. By calling upon the subscriber a house of the above size can be seen.[14]

One of the most impressive examples of the Italianate style is the Morse-Libby House (Victoria Mansion) (figs. 22 and 23), completed in Portland, Maine, in 1863 at a cost of nearly $400,000. It was modeled after Osborne House, a favorite residence of Queen Victoria, located on the Isle of Wight, England. The Italianate style continued to be popular across the nation, for in 1872 Sarah Wood Kane, a traveler to Provo, Utah, visited

> . . . a villa built in that American-Italian style which Downing character-izes as indicating "varied enjoyments, and a life of refined leisure." On its broad piazza our hostess stood ready to greet us; a buxom, black-haired, quick-eyed dame, who gave us a becoming welcome, . . . as she led the way into her large parlor . . . She conducted me over her house afterward, with a justifiable pride in its exquisite neatness and the well-planned con-venience of its arrangements. She showed me its porte-cochère for stormy weather, its covered ways to barn and wood-shed, and the never-failing stream of running water that was conducted through the kitchen and dairy. I noticed the plump feather-beds in the sleeping-rooms, the shining black-ness of the stoves (each with its teakettle of boiling water), that no speck dimmed her mirrors, and not a stray thread littered her carpets . . .[15]

American inventiveness spurred an unending search for better methods of construction and for the utilization of new materials that would decrease build-ing costs. At Plimoth Plantation, established late in 1620, rude cottages were roofed with thatch. Because thatch was highly flammable, shingles were quickly introduced. The problem of how to roof a house continued to plague the Col-onists and in 1767 a leather roof was much praised by Henry Guest, a tanner by profession.

> . . . [L]et me as a Mechanick, presume to lay before you, a Matter that, I think, may be of particular Use to the Publick, and especially to your City. You are now building a spacious Church, which I am informed the Gentle-men Trustees would cover with Copper: But as the Metal has a consider-able attraction with the Lightning, they are affraid of ill Consequenses attending it; and that they are convinced, from Experience, that Slate, or tiles, is too heavy for large and extended Roofs. I some few Days ago, proposed to Mr. Willis, the Undertaker of the Stone-Work, an Expedient that I conceive would answer the end, both to make a tight, light, lasting, and I might have added, a handsome Roof, that would have no more Attraction than Shingles and at the same Time it would be as secure from Fire as Copper. The Materials I have proposed was Sole Leather . . . dressed in a Manner that I think myself Master of . . . I have been in-formed that Leather is an Non-electric . . . in the End it will be cheaper than Shingles . . .[16]

The search for a durable roofing material continued during the Victorian period. A cast-iron dome was installed on the Baltimore, Maryland, City Hall in 1875. John H. B. LaTrobe, in an address at the dedication of the building, observed that "Excited by the popular demand for ornamental architecture, ingenuity brought iron into competition with granite, sandstone and marble, and then the facilities of the foundry soon gave us all manner of designs, whether gothic or classic, and even reproduced ancient statuary as the last refinement of ornamentation." [17]

Although cast iron provided one form of protection against fire, the Greensboro Tile Manufacturing Co., at Greensboro, Green County, Pennsylvania, in 1876 offered an alternative that was lighter than slate, cost as little as the best pine shingles, and was fireproof, clean, and free from decay. Their solution, of course, was pottery tiles.

Richard M. Hunt, eminent architect and one of the Jurors at the Philadelphia Centennial Exposition of 1876, reported enthusiastically on the great diversity of the building materials exhibited, "The display of building-materials at the Centennial Exhibition was remarkable rather for extent and variety than for novelty. The great natural wealth of the United States was in this respect well represented. American labor-saving machinery, too, in building appliances compared most favorably with that of other nations." [18]

Probably for nearly as long as man has lived in a civilized state he has collected. Therefore, it is not surprising that even after America had been a nation for only seventy-five years man would look back to the Colonial period and attempt to gather artifacts from that era. A. J. Downing, observing this tendency, said: "We will not . . . shut our eyes to the fact which no observer of men will dispute, that in every age and country are born some persons who belong rather to the past than the present—men to whom memory is dearer than hope—the by-gone ages fuller of meaning than those in the future." [19]

Such attitudes increased with time, and some of the displays at the Philadelphia Centennial were furnished with what were thought to be authentic antiques from the Colonial period. Colonial Revival tendencies are evident in the architecture of the period, too. *The American Architect and Building News* in 1877 wrote about the "Queen Anne" style:

> The so-called revival grows apace, and whether we like it or not, forces itself more and more on our attention. Almost every month new buildings are completed, which brilliant in red brick, tile roofs, and white sashes, claim kinship with the now fashionable style originally begun by a few very clever men . . . It is all very well to laugh at bric-à-brac, at the blue-china mania, at the rage for Japanese fans, at the craze for "collecting"; but each and all of these "fads" is but an evidence of an advance in matters of art, of which they are outcomes,—an advance which has been developed and fostered mainly through the artists of the so-called Queen Anne school . . . as Mr. Peabody before the Boston Society of Architects . . . says . . . "there is no revival so little of an affectation on our soil, as that of the beautiful work of the colonial days." [20]

The Queen Anne style was especially popular for it could be adapted to any level of artistic pretension. By increasing the number of verandas and balconies, with their steep-pitched roofs, the size and impressiveness of a home could be increased.

The revival of Colonial architecture often carried a high price tag, especially at the hands of Charles Follen McKim (1847–1909) and Stanford White (1853–1906) who, after visiting several parts of the Eastern Seaboard on a "Colonial Tour" in 1877, convinced many of their patrons that Colonial Revival was chic. The faddists who built and lived in vague approximations of Colonial dwellings favored a pseudo-Georgian style. It could be adapted to provide monumental homes that, in their very ostentation, were demonstrations of the owners' enviable financial status. The shuttered window and the four-paned sash, the second-story balcony, the widow's walk on the roof, and the revival of the Palladian window are all details evocative of the Colonial period. Most often when such details were incorporated into a dwelling, they only remotely approximated the originals. It was not until the twentieth century, after so many of the eighteenth-century originals had been destroyed in the name of progress, that Americans attempted to re-create exact duplicates of mid-eighteenth-century Connecticut farmhouses and Massachusetts saltbox houses in Phoenix, Arizona, and Pasadena, California.

The fascination with Oriental styles prevailed throughout the last third of the century. No American house of this period equals Olana, built by the painter Frederic Edwin Church (1826–1900) at Hudson, New York, in 1870. The artist, in his quest for the exotic, toured Palestine and Syria where he gathered art objects for the incredible dwelling that rejoices in a breathtaking view of the Hudson River and a 327-acre estate carefully planned by the eminent landscape architect, Frederick Law Olmsted (1822–1903). Olana, which means "Our Place on High" in Arabic, is an assemblage of Persian, Moorish, Saracen, Chinese, and Japanese motifs successfully blended to satisfy even the most expansive Victorian taste for evocative, picturesque architecture.

Lockwood DeForest (1850–1932), author of *Indian Domestic Architecture* (1885), filled his New York City apartment with imported Indian woodwork. Encouraging others to follow suit, he advised, "It rests with us . . . whether we are going to allow arts to die out which have taken centuries, with all the advantages [sic] of the caste system of the East, to bring to perfection." [21]

Many found his ideas sound; another New Yorker commissioned the reproduction of a seventeenth-century balcony from Ahmadabad, India. The carving was executed in India and installed as a bay window at 7 East Tenth Street, where it still causes the passerby to stare in wonder.

Few American architects of the nineteenth century inspire the praise showered on Henry Hobson Richardson (1838–1886). Studying first at Harvard to become a civil engineer, he was accepted in 1860 at the prestigious École des Beaux Arts in Paris where he entered the atelier of Louis Jules André. His first architectural efforts, executed in Paris, were in the "neo-Grec" style. After returning to America, friends in Boston encouraged him to submit church plans for competitions in Springfield and West Medford, Massachusetts. His proposals

won. By 1870 Richardson's reputation and practice had grown sufficiently for him to be asked to submit designs in a competition for Trinity Church in Boston. This, too, he won, and it was through this important commission, where he employed a modified French and Spanish Romanesque style, that he first achieved international fame.

Richardson is best known for his public buildings. This might be expected from a man who could say that the things he wanted most to design were a grain elevator and the interior of a great river steamboat. In his large domestic dwellings, which are primarily in the Shingle style, an element of indecision often appears, as though he could never really decide if he should bow to prevailing fashion or strike out on a daringly new path. Probably his best house is the summer cottage built for the Reverend P. Browne at Marion, Massachusetts, in 1881. In this unassuming shingled structure he created a truly American type that was admirably suited to its function and site. Richardson's influence dominated native architecture from 1880 until the 1893 Chicago World's Columbian Exposition.

The Shingle style, a refinement of the Queen Anne, was without architectural pretensions. Architects utilized this style primarily in New England to create homes of an organic character. Many of the most gifted architects who used the Shingle style were also responsible for elegant French and Italian Renaissance châteaus in both New York City and Newport, Rhode Island, the summer watering place of the immensely wealthy.

Charles McKim and Stanford White, as well as many of their competitors, boasted an École des Beaux Arts background. In the years immediately following the Philadelphia Centennial Exposition no American architect was as successful as Richard Morris Hunt (1827–1895) whose millionaire clients attempted to outdo one another in the size and opulence of their houses. Hunt experimented with numerous styles; however, in all his work there is evidence of the Beaux Arts training.

Most Americans probably first became aware of the English Arts and Crafts Movement, spearheaded by William Morris (1834–1896) in the third quarter of the nineteenth century, through Great Britain's displays at the Philadelphia Centennial. In the United States the popular expression of this movement was the furniture created by Gustav Stickley (1857–1942). There were isolated architectural manifestations of the style, Unquestionably the most important was the work by members of the Art Workers' Guild led by Sydney R. Burleigh (1853–1928), John G. Aldrich (1864–1952), and Charles W. Stetson (1858–1914) at Providence, Rhode Island. The Fleur-de-Lys Studios building was designed by Burleigh who solicited the assistance of his two friends. The elaborately decorated facade culminates in representations of the artistic graces, "Painting," "Sculpture," and "Architecture." In the lowest tier of panels it is possible to discern a spirited forecast of the Art Nouveau style.

William Dean Howells (1837–1920) was but one of many social critics who deplored the proliferation of French flats during the last twenty years of the nineteenth century. He believed that these high-class tenements would bring about the breakdown of family consciousness and create confinement without

coziness. Despite such predictions of the ultimate destruction of family life, increasing numbers of city dwellers moved to elegant apartment houses where heating, plumbing, and electricity provided new comforts.

At the close of the nineteenth century Midwestern and western cities with vast populations were more or less willing to support innovational architects like Louis Sullivan (1856–1924) and his disciple, Frank Lloyd Wright (1869–1959). In 1901 Wright designed "A small House" with "Lots of Room in it" that was published in Edward Bok's influential magazine, *The Ladies' Home Journal.* Because of Bok's influence during the early twentieth century, houses became simpler and more closely related to the daily lives of the people who resided in them. Woodrow Wilson, on a visit to Denver, observed, "It is really a beautiful place, full of the most elegant residences. It gives one a singular impression, however. It seems a sort of museum or experiment ground in all the modern styles of dwelling architecture. Every style that architects have conceived since 1879 is here to be seen within the compass of a few city blocks. You seem to be in a sort of architectural exhibit, such as the World's Fair might have contained, had there been space and means enough." [22]

9 (below). The Greek Revival residence of Harold C. Brooks at Marshall, Michigan, built by Jabez Fitch in 1838. The successful and the ambitious at the beginning of the Victorian period usually chose the Greek Revival style when building their houses. Its grandeur imparted a sense of elegant stability that appealed to the rising middle class. (Marshall Historical Society)

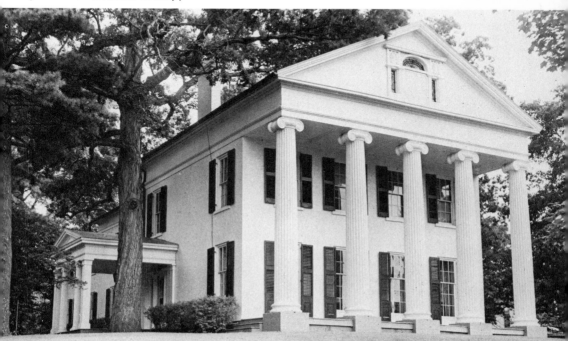

10 (left). This capital, a beautifully carved, ebullient interpretation of the Greek Revival style, is in the parlor of the Sag Harbor Whaling Museum, a mansion built in 1845 for Benjamin Huntting, who owned whaling ships. Photograph courtesy James T. Thomason. (Sag Harbor Whaling Museum)

11 (below). Lyndhurst, Gothic Revival style villa, built at Tarrytown, New York, by Alexander Jackson Davis for William Paulding, Mayor of New York, between 1838 and 1841. The facade of Lyndhurst as shown in this print was greatly altered when Davis redesigned and made additions to the country mansion for George Merritt in 1864. (Lyndhurst, National Trust for Historic Preservation)

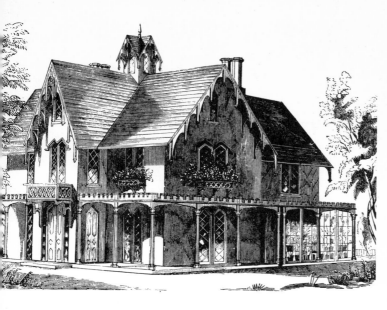

12 (left). "Model Cottage" published in *Godey's Lady's Book*. c. 1850. Gothic Revival motifs characterize this modestly priced house. (Shelburne Museum, Inc.)

13 (right). Old Whaler's Church, Sag Harbor, New York. 1841–1843. A local version of the Greek Revival style (lacking its steeple, which was destroyed in the 1938 hurricane), this is a masterpiece of vernacular architecture. Photograph courtesy James T. Thomason.

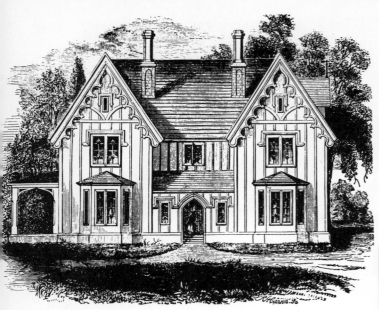

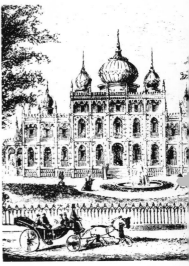

15 (below). Oriental-style Iranistan, built by the Viennese architect Leopold Eidlitz for Phineas T. Barnum at Bridgeport, Connecticut, in 1848. Illustrated in the book, *Struggles and Triumphs,* written by P. T. Barnum in 1869. (Private collection)

14 (above). Design for a plain timber cottage-villa illustrated in the *Architecture of Country Houses* by Andrew Jackson Downing, 1850. The board-and-batten exterior finish evident in this sketch became popular soon after the book was published and was used on extravagant homes as well as on modest dwellings. (Detroit Public Library)

16 (below). A design for a southern villa in the Romanesque style illustrated in *Architecture of Country Houses* by Andrew Jackson Downing, 1850. The exclamation of one Victorian periodical, "the vast accumulation of historical precedents, and the convenient publication of them in books, prints, and photographs, so that they are accessible to every student," [1] helps explain the eclecticism found in much Victorian architecture. (Detroit Public Library)

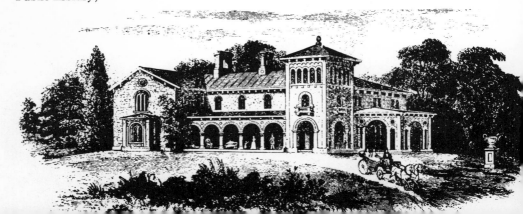

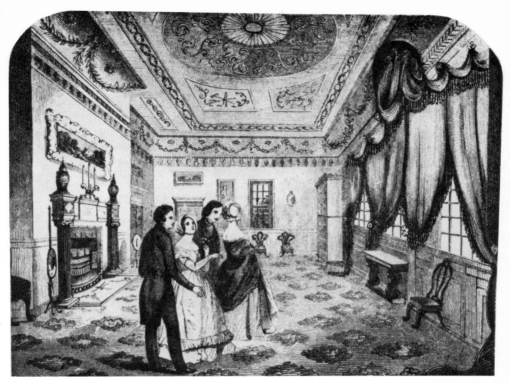

17 (above). The Great Hall at Mount Vernon. c. 1850. Victorian Americans were fascinated with historically significant architecture. Many made the pilgrimage to see the home of the "Father" of their country. (Readfield Public Library)

18 (below). Castlewood House at Llewellyn Park, West Orange, New Jersey, designed and built by A. J. Davis. 1852–1869. Llewellyn Park was the first of the garden suburbs; the houses were nestled in a picturesque landscape traversed by winding roads .(Readfield Public Library)

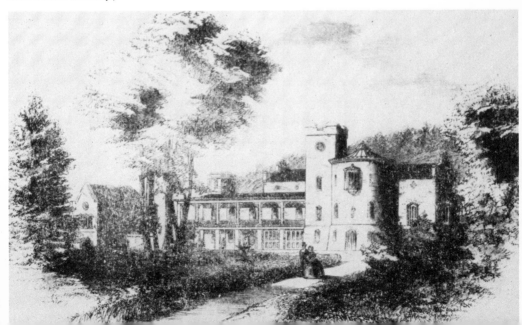

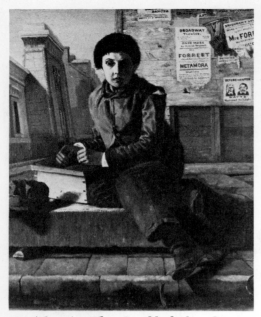

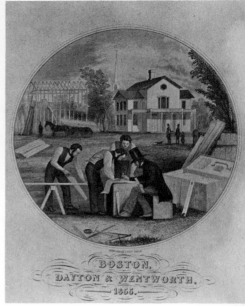

19 (above). *The Bootblack* by George Henry Yewell. 1852. Oil on canvas. 14″ x 12″. The Egyptian Revival style in America was used primarily for cemetery entrances and churches. The building in the left background of this painting is the old "Tombs" prison in New York City. (The New-York Historical Society)

20 (above). Illustration from *The Modern Architect* by Edward Shaw, engraved by W. W. Wilson. 1855. Mid-Victorians utilized balloon-frame construction because it provided design flexibility. (The Metropolitan Museum of Art; Harris Brisbane Dick Fund)

21 (below). Prefabricated facade for a store or office building advertised by the Badger Architectural Iron Works. New York. c. 1855. By the mid-1850s cast-iron store fronts were not uncommon in East Coast metropolitan areas. (The New York Public Library)

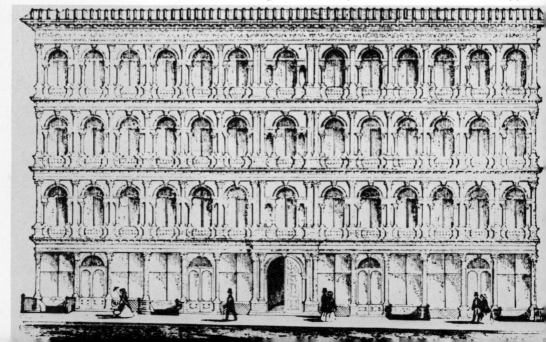

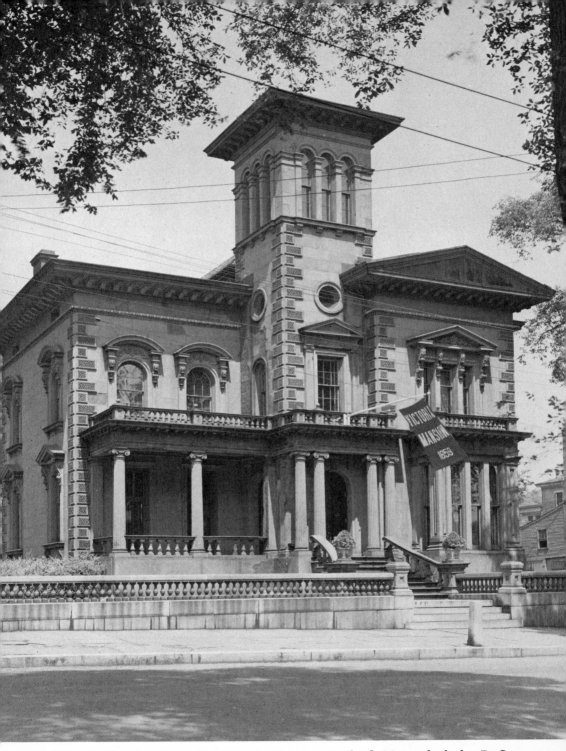

22 (above). The Italianate villa, Victoria Mansion, Portland, Maine, built for R. S. Morse by Henry Austin in 1859. This house is perhaps one of the most beautiful examples of its type in America. (Victoria Mansion, Portland, Maine)

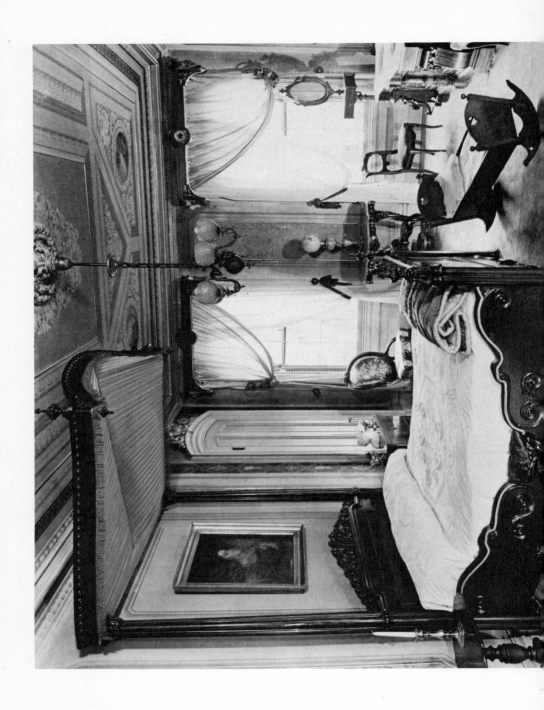

23 (opposite page). The guest bedroom of the Victoria Mansion. Most of the furnishings in this house are in the Rococo Revival style. When the house was first constructed, it cost over $400,000. (Victoria Mansion, Portland, Maine)

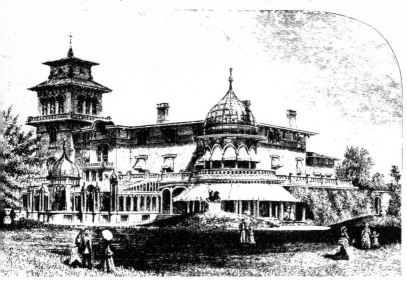

24 (left). Armsmere, the home of Samuel Colt, built in Hartford, Connecticut, in 1862. *The Art Journal* observed that the home was a "long, grand, impressive, contradicting, beautiful, strange thing." [2] (Private collection)

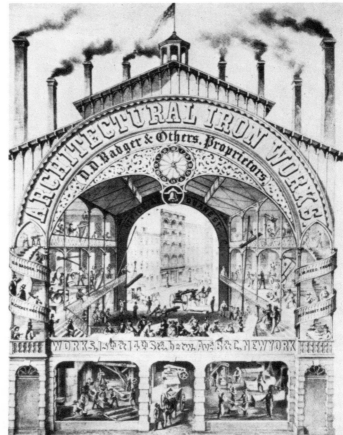

25 (right). Cover from the *Architectural Iron Works* catalogue published by D. D. Badger & Others, Proprietors, in 1865. The firm's office building, located at 42 Duane Street, New York City, is visible in the central view. (Private collection)

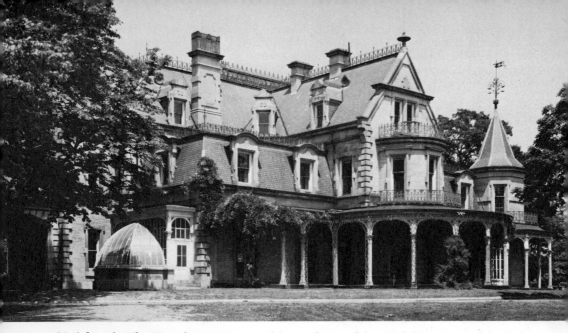

26 (above). The French Renaissance château designed by Detlef Lienau and built for LeGrand Lockwood at Norwalk, Connecticut, in 1869. The floor plan for this mansion was in the form of a Greek cross. In addition to living quarters, the dwelling contained some fourteen bathrooms, two billiard rooms, a bowling alley, a theatre, a library, an art gallery, and was equipped with "every convenience that ingenuity can suggest or the most generous expenditure procure," [3] including a dry-cell burglar alarm system. (Lockwood-Mathews Mansion)

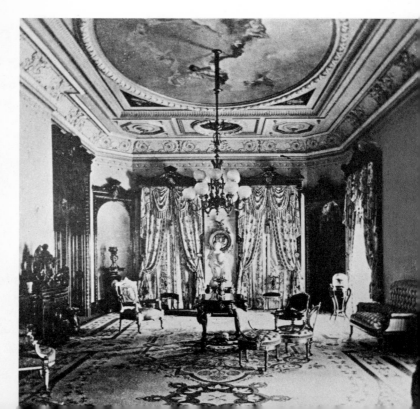

27 (right). Interior of the LeGrand Lockwood House. Lockwood traveled throughout the world in search of priceless art treasures for his new mansion, which was decorated by the French emigrant, Leon Marcotte. (Lockwood-Mathews Mansion)

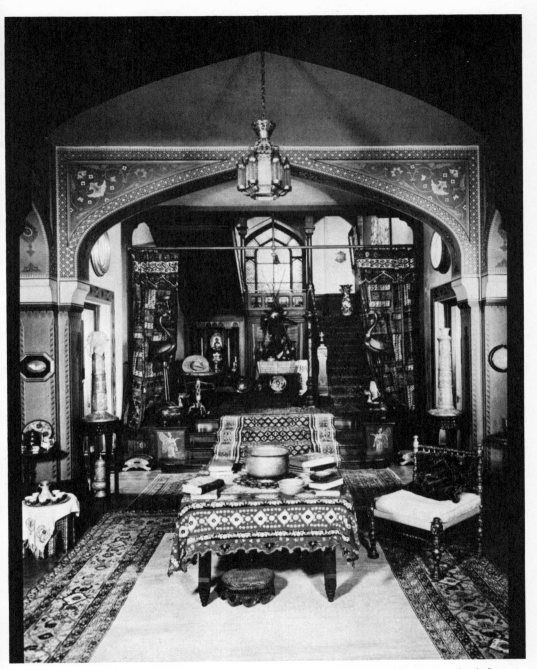

28 (above). The central hall and staircase of Olana, the "Persianized" mansion built by the artist Frederic Edwin Church (1826–1900) at Hudson, New York. Construction began in 1870, and the Church family moved in some two years later. Few American homes possess the exoticism of Olana. Even the location is dazzling, for it is situated on a hilltop overlooking the Hudson River and the magnificent, spacious grounds were laid out by the great landscape architect, Frederick Law Olmsted, (Olana State Historic Site, Taconic State Park Commission, New York State Office of Parks and Recreation) 43

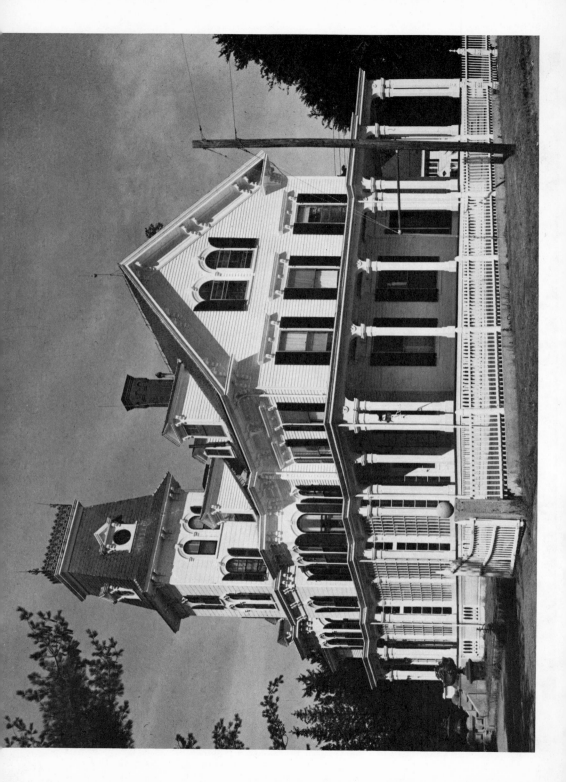

44

29 (opposite). Frank Jones Mansion, Portsmouth, New Hampshire. 1876. Frank Jones was a brewer, railroad magnate, and builder of Wentworth-by-the-Sea, and his many-columned mansion was situated on a 1,000-acre property. Photograph courtesy Patrick W. Grace.

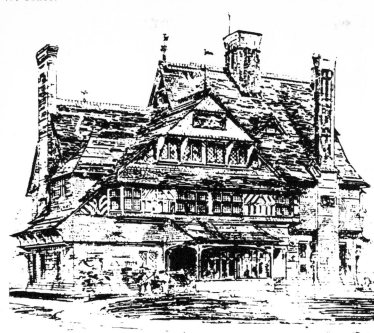

30 (left). Exterior of the Watts Sherman House, Newport, Rhode Island, designed by Henry Hobson Richardson in 1874. This sketch was drawn by Stanford White for *The New York Sketch Book of Architecture* (1875). In this structure Richardson expressed a new realism that became popular during the 1870s when American architects frankly attempted to indicate the materials that they were using in construction. (The New York Public Library)

31 (below). Entrance hall of the Watts Sherman House. This sketch emphasizes the exposed ceiling beams, paneling, and other features that represented a revival of seventeenth-century New England architecture combined with Victorian Romanesque eclecticism. (The New York Public Library)

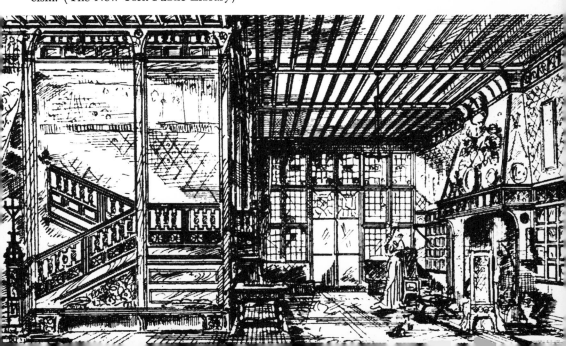

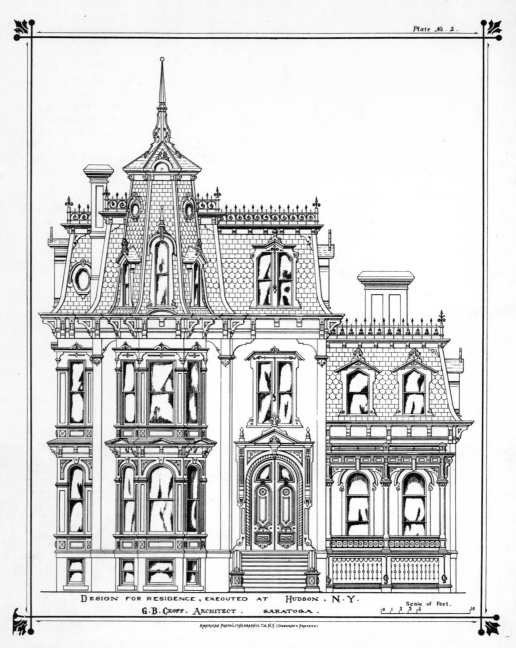

DESIGN FOR RESIDENCE, EXECUTED AT HUDSON, N.Y.

G.B. CROFF. ARCHITECT . SARATOGA .

Scale of Feet.

AMERICAN PHOTO-LITHOGRAPHIC CO. N.Y. (OSBORNE'S PROCESS.)

32 (above). Design for a house to be erected at Hudson, New York, by G. B. Croff, architect, illustrated in Croff's *Progressive American Architecture,* published in 1875. Many mansard roofs like those on this building were covered with slate shingles. This style of roof became popular in America during the 1860s and can be seen on the LeGrand Lockwood House. (The New York Public Library, Art Division)

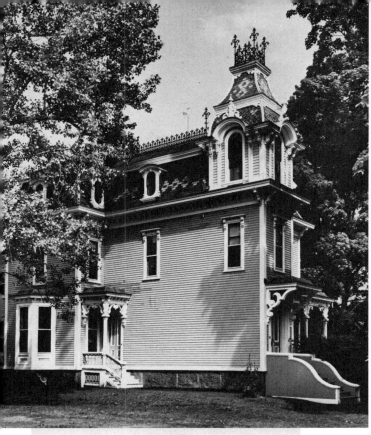

33a and 33b (left, above and below). House in Kennebunk, Maine, built in 1875. The iron "lace" on the cupola and the ridgepole is especially graceful. Note the patterns formed by the painted shingles. Photographs courtesy Patrick W. Grace.

34 (below). Cast-iron roof ornament from a Victorian house. c. 1875. H. 38½". Photograph courtesy Jay Johnson: America's Folk Heritage Gallery. (Private collection)

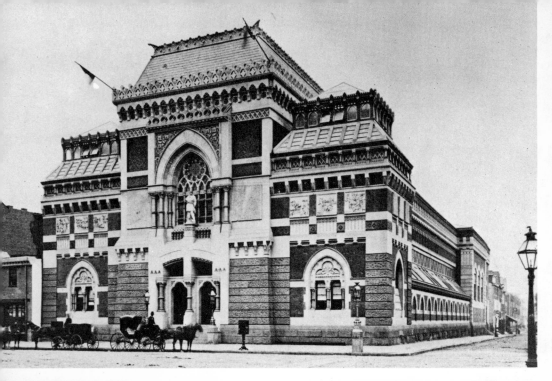

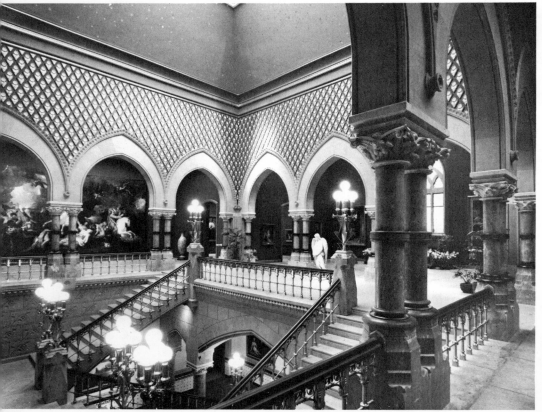

35a and 35b (opposite, above and below). Pennsylvania Academy of the Fine Arts, Broad and Cherry Streets, Philadelphia, Pennsylvania. 1871–1876. Architects: Frank Furness and George W. Hewitt. The 1976 restoration of this magnificent Victorian amalgam of Gothic, English, and French architectural details is a triumphant example of infusing vibrant new life into a worthy old edifice. The sensational stairhall sparkles with gold leaf on the walls and silver stars set into a ceiling of blue. (Pennsylvania Academy of the Fine Arts)

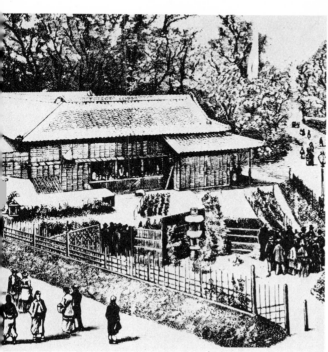

36 (above). Japanese Building and Garden at the Philadelphia Centennial Exposition. 1876. The Japanese displays at this international exposition caused more comment than nearly any of the others and inspired the vast appreciation of Oriental things that followed during the 1880s. The Japanese craze lasted to the end of the Victorian period. Illustrated in *Frank Leslie's Illustrated Historical Register of the U.S. Centennial Exposition*. (Private collection)

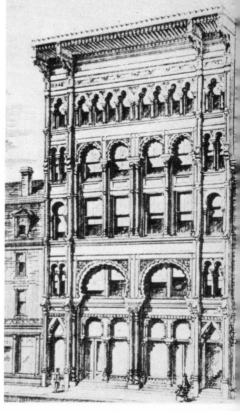

37 (right). "Moorish style iron building" designed by Richard Morris Hunt, taken from the *American Architect and Building News*, July 15, 1876. Although Turkish and Moorish smoking corners and dens were a necessary feature in every fashionable household, the style was not especially popular with architects. (Private collection)

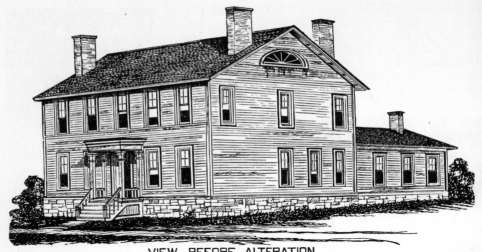

VIEW BEFORE ALTERATION.

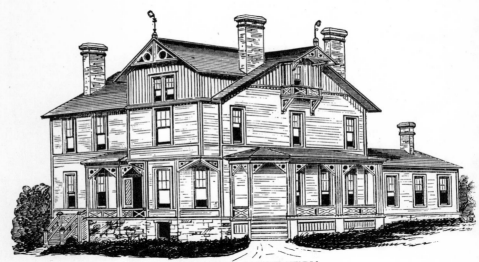

VIEW AFTER ALTERATION.

We offer the cuts represented on this and the following pages as an example of remodeling. The cut on this page is an exceedingly plain yet substantial structure, such as may be found in any New England village. That on page 13 represents the same building modernized sufficiently to meet the requirements of present tastes, and is a good example of remodeling at small expense. On the right of the house is a piazza connecting with the adjacent room by French Windows opening to the floor.

For further examples of remodeling, both exterior and interior, we refer to the work from which this house is taken—Woollett's "Old Homes Made New." A neat little oblong volume of 22 plates, just published. Price $1.50. [Original text that ran with figures 38a and 38b.]

38 (above). The suggestion for "modernization" shown above comes from the *Specimen Book of One Hundred Architectural Designs* (showing Plans, Elevations and Views of Suburban Houses, Villas, Sea-Side and Camp-Ground Cottages, Homesteads, Churches and Public Buildings) published by A. J. Bicknell & Co., New York, 1878.

39 (above). "Design for a Country House," reproduced from the *Specimen Book of One Hundred Architectural Designs*, published by A. J. Bicknell & Co., New York, 1878.

40 (above). Drawing of a model New York tenement built on First Avenue between Seventy-first and Seventy-second streets, New York City, in 1880. The passage of the Tenement House Law in 1879 sought to eliminate the "railroad" style apartments that had public toilets on the landings of each floor. Illustrated in *Tenement House Reform in the City of New York* by James Gallatin, 1881. (The New York Public Library)

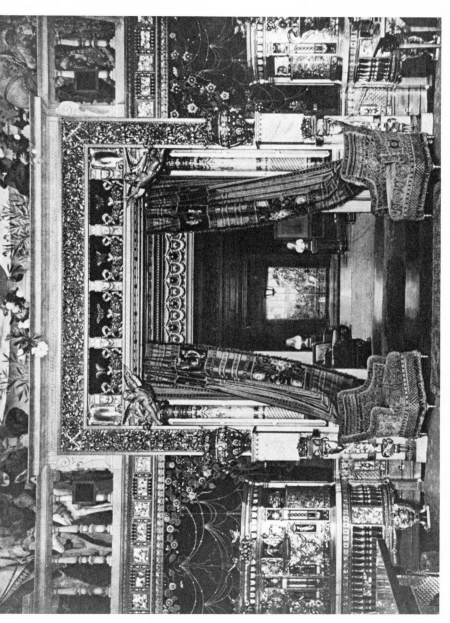

41 (above). Interior of the William H. Vanderbilt house built in New York City in 1882. Sculpture, imported porcelain urns, curio cabinets stuffed with treasures, and gaudy wall decorations all play a secondary role to the painted mural that served as a decorative frieze in this costly mansion. The taste for painted and decorated walls provided the New York firm of Louis C. Tiffany and Associated Artists numerous lucrative commissions, including the wonderful Mississippi River steamboat house built by Mark Twain in Hartford, Connecticut, in 1874. (The Metropolitan Museum of Art)

42 (right). Design for a Queen Anne villa illustrated in *Modern Low-Cost Houses* published by the Co-Operative Building Plan Association, New York City, in 1884. The catalogue explained, "The elevation is noble and dignified and yet homelike suggesting the comfort and taste of the interior. This beautiful design is one that meets the needs of a large family of cultivated taste. With our working plans and specifications, it can be built, complete, for $6000." [4] (Private collection)

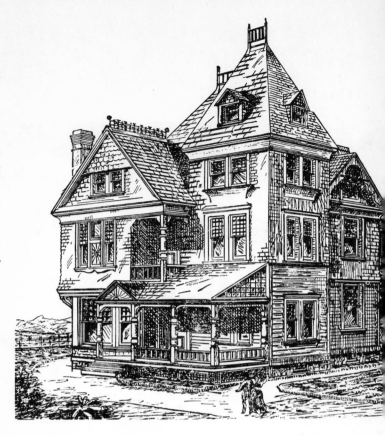

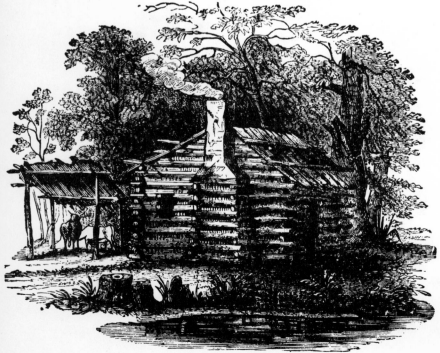

43 (left). Illustration of a log cabin from *Our Homes and Their Adornments* by Almon C. Varney. 1884. Despite the fact that every corner of the country had developed a keen awareness of international architectural styles by the Late Victorian period, many Americans still continued to live in modest homes. In rural areas the log cabin remained a familiar sight. (Private collection)

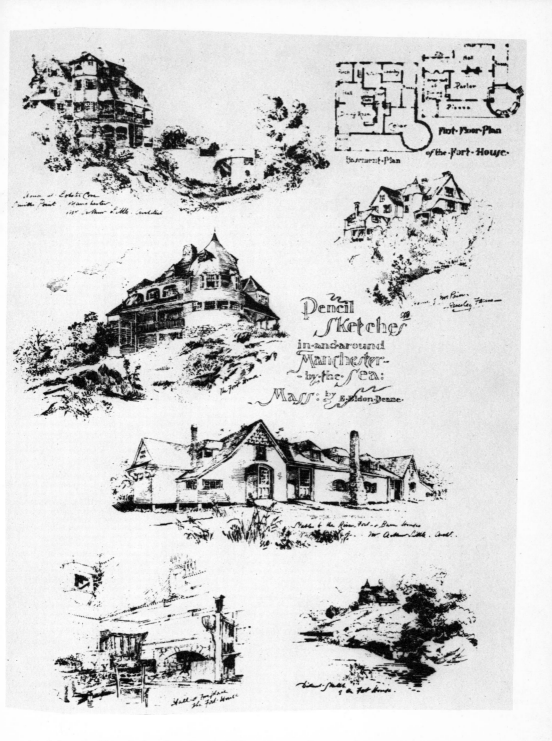

44 (above). Pencil sketches by E. Eldon Deane showing houses designed by Arthur Little, a prominent Massachusetts architect. These houses are in the Shingle style. Illustrated in *American Architect and Building News*, January 10, 1885. (The New York Public Library)

45 (right). Sketch of the J. J. Glessner house, Chicago, Illinois, designed by H. H. Richardson and built between 1885 and 1887. Richardson's Romanesque style was not easily adapted to domestic architecture. The Glessner house represents one of his most successful attempts. Illustrated in *Harper's Magazine*, volume 83, 1891. (The New York Public Library)

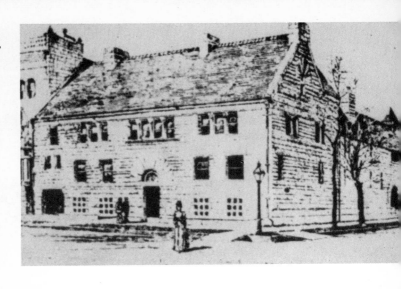

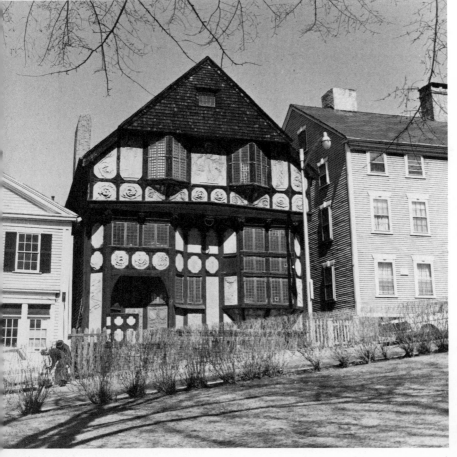

46 (left). The Fleur-de-Lys Studios building designed by Sydney R. Burleigh; Stone, Carpenter, and Willson, architects. Built in 1885 at Seven Thomas Street, Providence, Rhode Island, and now the home of the Providence Art Club. The Fleur-de-Lys Studios housed the activities of the Art Workers' Guild—a group of Providence arts-and-crafts-oriented artists including Burleigh and his two friends, John C. Aldrich and Charles Walter Stetson. (Providence Art Club)

47 (right). The fireplace in the entrance hall of the Henry Villard residence designed by the New York firm of McKim, Mead and White and built in New York City in 1885. America's rich were fascinated with European art treasures and eagerly collected and filled their homes with both authentic antique pieces and well-made reproductions. (The New-York Historical Society)

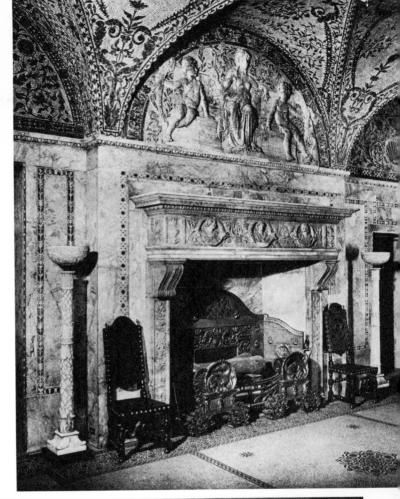

48 (below). Interior of The Casino designed by McKim, Mead and White and built in Newport, Rhode Island, in 1881. During the Victorian period Newport became a summer watering place for the very rich. (The New-York Historical Society)

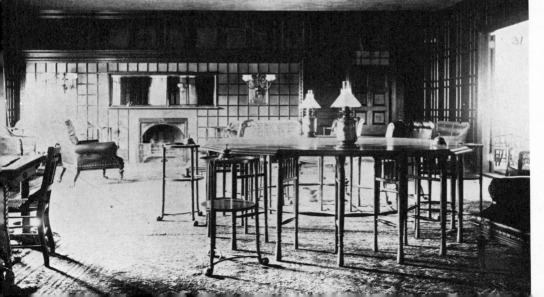

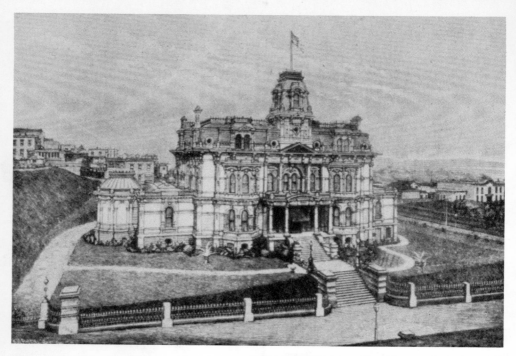

49 (above). Residence of Charles Crocker, San Francisco, California. Illustrated in *Marvels of the New West* by W. M. Thayer, published in Norwich, Connecticut, in 1887. Thayer enthusiastically exclaimed that the Crocker house was "large enough and good enough for a king . . . one of the kings found among the sovereign people of America, where all are sovereigns. Outside, inside, and surroundings are as complete and near perfection as money could assure . . ." [5] (Private collection)

50 (right). Stained-glass window designed by Paul Ranson and executed by L. C. Tiffany. La Moisson Fleurie was exhibited at the Salon de Champs-de-Mars in 1895 and later installed at S. Bing's Le Maison de l'Art Nouveau in Paris in December 1895. Tiffany, an internationally recognized artist and craftsman, was commissioned to execute many windows of this type. (Current whereabouts unknown)

51 (above). Dudley-Newton House, Newport, Rhode Island. 1897. Newton designed his own neo-Colonial or Georgian Revival home. Soon after the Philadelphia Centennial, architects began to look to the past and to reinterpret Georgian and Colonial architecture. Georgian Revival buildings are usually rectangular in plan and have symmetrical facades. (The Preservation Society of Newport County)

52 (below). Watercolor design for a room interior in the Art Nouveau style by Edward Colonna. Late nineteenth or early twentieth century. Colonna, an American, traveled to Paris where he became one of the leading designers in the Art Nouveau style. (Newark Public Library)

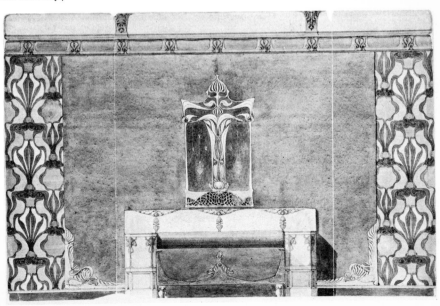

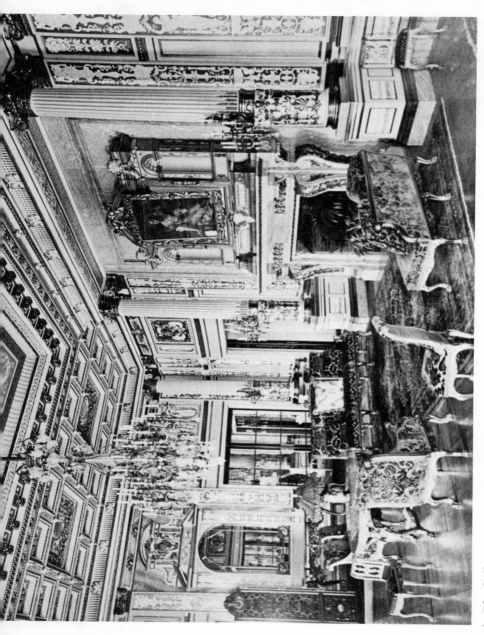

53 (above). The ballroom in The Breakers designed by Richard Morris Hunt and built at Newport, Rhode Island, for Cornelius Vanderbilt II between 1892 and 1895. Most rich Americans believed that Louis XV-style furniture was the only appropriate style for their domestic palaces. They were, however, not overly discriminating and seldom cared if the pieces were authentic or only reproductions of the style. (The Preservation Society of Newport County)

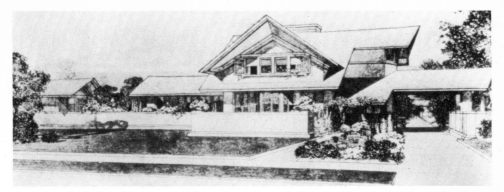

54 (above). "A small house with lots of room in it" designed by Frank Lloyd Wright in 1901 and published in the *Ladies' Home Journal*. Wright's model Prairie-style house contained dining and living room areas that were formed out of free-flowing space. This dwelling was intended to be built for $5,800. (Detroit Public Library)

55 (below). Arts and Crafts house designed by Will Bradley and illustrated in the *Ladies' Home Journal* for 1901 and 1902. Bradley became one of America's leading poster artists and his covers for popular magazines represent a high point in the American graphic arts. He was commissioned by Edward Bok to design houses, room interiors, and even furniture, and his designs became a popular feature in the *Ladies' Home Journal*. It was Bradley who helped to popularize the Colonial Revival style. (Robert Hudson Tannahill Research Library, Greenfield Village and Henry Ford Museum)

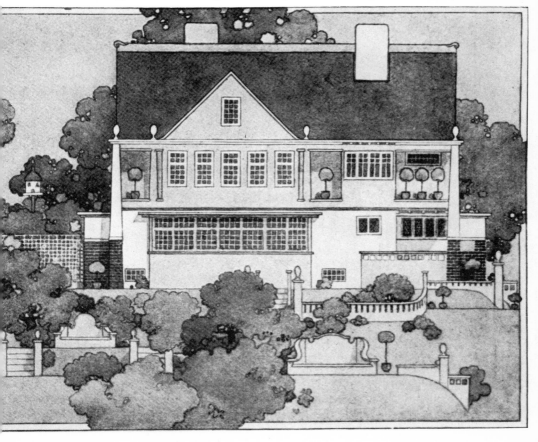

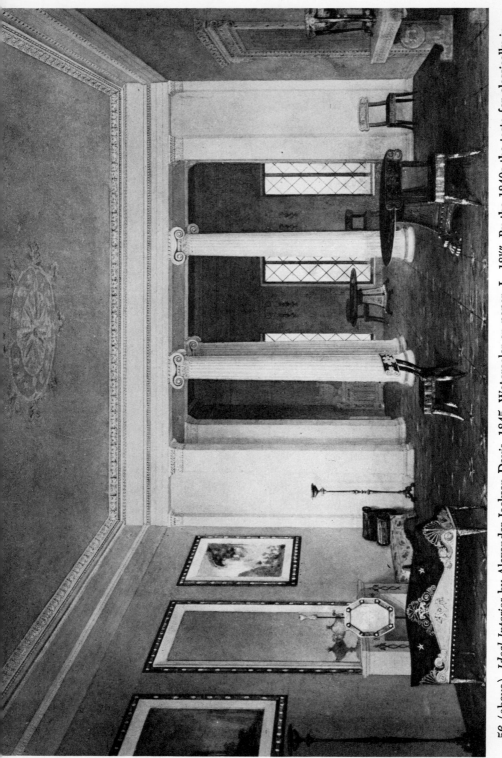

56 (above). *Ideal Interior* by Alexander Jackson Davis. 1845. Watercolor on paper. L. 18⅛". By the 1840s the taste for classically inspired designs and architectural furniture began to wane. Davis was captivated by the possibilities of the Gothic Revival and much of his later work is in that style. In this watercolor, columns, friezes, and moldings, as well as the klismos-type chairs, the sofas, the lamps, and even the fire screen are reminiscent of pieces originating in ancient Greece. (The New-York Historical Society)

THE VICTORIAN HOUSE

In America until about the mid-nineteenth century the interior decorator as we know him today probably did not exist. Before this time there were elegant salons maintained by furniture makers or retailers where the new rich might obtain assistance in the selection of furniture and decorative accessories. Nearly all of the earliest decorators would be invited to furnish a set or two of furniture and ultimately would completely "do" the house.

Emporiums of tasteful things were most often established by Europeans, for nearly everyone acknowledged that Americans were inferior in such matters. Pottier & Stymus began operation in New York City in 1859–1860 and Herter Brothers, also of New York, started their business in 1865–1866.

Many architects, even the most eminent, seldom concerned themselves with interior decoration. Probably the greatest exceptions to this were A. J. Davis (1803–1892), Henry Hobson Richardson (1838–1886), Will Bradley (1868–1962), and Frank Lloyd Wright (1869–1959), who skillfully integrated exterior and interior designs and even provided drawings for furniture and its arrangement.

For those who could not afford, or chose to do without, a decorator, the newest commercial institution, the department store, provided an alternative. W. & J. Sloane in New York City maintained a decorating department that was preeminent for years. They purchased the collection of rugs sent by the Turkish government for exhibition at the Philadelphia Centennial Exposition in 1876; the dispersal of this collection is considered to be the beginning of the vogue for Oriental rugs in America.

The Centennial had far-reaching effects on domestic architecture and interior decoration. Because of increased transportation facilities, the attendance far outstripped that of the New York World's Fair at the Crystal Palace some twenty-three years earlier. At the Centennial many Americans for the first time saw people and styles from far-off lands. They quickly attempted to introduce elements of what they saw into their homes. Charles Dudley Warner (1829–1900) in his 1889 publication, *Studies in the South and West*, noted this tendency:

> Americans are the quickest people in the world to adapt themselves to new situations. The Western people travel much, at home and abroad, and they do not require a very long experience to know what is in bad taste. They are as quick as anybody—I believe they gave us the phrase—to "catch on" to quietness and a low tone. Indeed, I don't know but they would boast that if it is a question of subdued style, they can beat the world. The revolution which has gone all over the country since the Exposition of 1876 in house-furnishing and decoration is quite as apparent in the West as in the East. The West has not suffered more than the East from eccentricities of archi-

tecture in the past twenty years. Violations of good taste are pretty well distributed, but of new houses the proportion of handsome, solid, good structures is as large in the West as in the East, and in the cities I think the West has the advantage in variety. It must be frankly said that if the Easterner is surprised at the size, cost, and palatial character of many of their residences, he is not less surprised by the refinement and good taste of their interiors. There are cases where money is too evident, where the splendor has been ordered, but there are plenty of other cases where individual taste is apparent, and love of harmony and beauty. What I am trying to say is that the East undervalues the real refinement of living going along with the admitted cost and luxury in the West.[1]

By 1890 the heyday of the decorator had arrived. Just three years earlier the "Editor's Table" of *Appleton's Journal* reported:

On all sides now we hear of household and decorative art. It is one of the forms in which color has revived—in which a long-dormant passion for art and beauty has awakened and taken possession of us. Why a cloud came over the race and for so many decades obscured its sense of color and of splendor, we cannot now inquire; but it is certain that the old mediaeval delight in form, and light and shadow, and pomp, has come back to us— with many modifications, of course, but with much of its old sense of beauty for beauty's sake. It is curious to watch and see the manifestations of this latest renaissance. A whole new literature has grown out of it; new armies of artisans have been marshaled as its servants; and even new, or rather revived, sets of rules have been formulated. "It is against my principles," replied an artisan, upon being asked by one not within the radius of the new light to make for him a certain ornament for a bookcase. "Your principles!" exclaimed the astonished applicant, "why, have you principles?" "Assuredly," replied the disciple of Eastlake and Morris; "it is my rule never to construct ornament—I only ornament construction." And in this way the artisans, mastered by the new passion, deeply read in Owen Jones, disciples at the feet of Eastlake, Clarence Cooke, and Elliott, filled, no doubt, with Matthew Arnold's "sweetness and light," are banishing from our apartments ugly forms and bare walls, overthrowing white paint and colorless washes of all sorts, and overwhelming us with the charm of their studies of colors, their *ensemble* of sumptuous effects, their transformation of dull rooms into paradises of beauty . . . Better designs in furniture appear in the shops; there are really good wall-papers to be found—and perhaps carpets, too, but here one must search for good artistic design. Here and there one finds a truly exquisitely furnished and decorated room; and everywhere there are attempts made to wed Art and Beauty to the places where we abide.[2]

Grand town houses, equally imposing country retreats, and even summer homes at expensive watering places could only be made sumptuous enough to

satisfy nouveau-riche Americans through the aid of the fashion-conscious, style-dictating decorator.

For those who lacked funds to match their taste, hundreds of do-it-yourself publications flooded the market. Even the periodicals specifically devoted to other subjects nearly always carried helpful hints for creating a more beautiful place to live. *The American Architect and Building News, Appleton's Journal, Appleton's Home Books, The Decorator and Furnisher,* and, of course, *Godey's Lady's Book* and *The Ladies' Home Journal* all chirped a merry tune for most amateur decorators. Typical of their advice is the driveling prose offered by Ella Rodman Church in 1877 to budget-minded housewives,

> In furnishing a house very few people know what to do with their money. There is just so much, or so little, as the case may be, to spend, and a certain line of things common to every one that has to be bought. But it is just many of these things common to every household that should be avoided. To say that a room looks like a picture is considered a high meed of praise— a delicate, violet-scented sort of compliment not often to be had; but there is no reason, either in prose or rhyme, why a whole house should not be a poem. And this, too, whether the sum spent on its furnishings be five thousand or five hundred dollars, or even the half of the latter. It might be rash, perhaps, to undertake it for less; but we would venture upon blank verse, at least, with almost any sum of three figures; only stipulating that the house should be a small-sized cottage rather than a "brown-stone front." [3]

By the close of the Victorian era it is possible to observe in the decorative arts a move toward simplicity. This tendency can easily be observed in the architectural efforts of the Chicago School and in the beginning popularity of unadorned, rectilinear Mission furniture. Even the popular magazines of the period began to note the attractiveness of simplicity, for the October 1900 issue of *House Beautiful* reported, "Thinking women are rebelling against the unnecessary work caused by the effort to be ornamental which characterizes the design of almost every article in use in the average house, with results as unpleasant to the eye as they are irritating to the temper. Housekeeping is wearing enough at best, and the efforts of those who manufacture furniture and utensils should be to ease its burdens rather than to increase them." [4]

It is not surprising in a country where industrial goods were frequently mistaken for fine art that an absolute love of mechanical conveniences developed early. Indoor plumbing, well-operating heating systems, elevators, and finally the many developments made possible by Thomas Edison's (1847–1931) practical application of electricity, all brought a degree of comfort that even today remains unequaled in many parts of the world. In 1878 one juror who had served at the Philadelphia Centennial Exposition boasted, "We have much to learn from abroad in detail of design, and in fineness and delicacy of carving, but in economical mechanical appliances, and in the production of furniture suggestive of comfort and luxury, we are second to no other country; and in justice to some of our

manufacturers, whose contributions attracted much attention, we must add that, as illustrations of a rapid advance to a high grade in artistic decorative art, these houses can compete with the best in foreign lands." [5]

Running water in American buildings began to appear in isolated instances just after 1800. The Markoe House, a Philadelphia hotel, offered such a luxury in 1810. During the 1840s New York City began piping water from the Croton River, and soon after ambitious advertisements by plumbers began to appear in the local newspapers. J. & F. W. Ridgway at 145 Broadway, plmbers and hydraulic engineers for the Croton Water Works, and Thomas Dusenbury at 269 Water Street continued to utilize advertisements illustrated with Greek Revival bathrooms and advanced pumping systems over the next several years.

Window decorations in the Victorian period consisted of a multiple-layered, complex barricade of shutters, blinds, or shades, muslin curtains, velvet draperies, and tasseled valances. Little wonder, since Victorian men considered milk-white-flesh-toned women the most beautiful of all.

Painted window shades can be both decorative and useful for collectors who are attempting to restore a Victorian home. Usually the painting on them relates directly to the furniture styles that were popular in the period they were made. The more frequently encountered semiabstract, conventionalized floral patterns, gothic tracery designs, and geometric arabesques contrast with the rare romantic scenes and naturalistic landscapes. Because even the simplest painted shades required handwork and were modestly expensive, cheaper substitutes for the lower classes were sought by keen-eyed, market-watching manufacturers. The *General Report of the British Commissioners* on the 1853 New York Industrial Exposition mentioned a substitute, "A peculiar article in paper-hangings is largely manufactured for the Western States. This is about 35 inches wide, and is known as 'curtain paper.' An ornament, within a panel, is printed, extending to the length of about 1½ yard, and those are cut off and used as substitutes for roller blinds, by a large class of people in the West." [6]

Obtaining proper curtains has always plagued the homemaker. The meticulous Thomas Jefferson finally designed his own and imported from France gorgeous fabrics that would have been both expensive and difficult to find in America. An inventory taken at the time of his death in 1826 included "10 chintz and calico counterpanes, 7 checked blue and white counterpanes, 4 white knotted cotton do., 2 white homespun do., 2 dimity do., 6 sets of curtains and the draperies to 2 windows, 3 curtains for the lower parts of the windows." [7]

By the opening of the nineteenth century Americans with taste looked to England and the Continent for drapery designs. Publications such as *Ackermann's Repository of Arts*, published in England between 1809 and 1826, and Mésangère's *Meubles et objets de Goût*, published in France between 1802 and 1830, illustrated decorating ideas that were freely adapted. No publication proved to be more influential than the American periodical, *Godey's Lady's Book*, begun in 1830. Nearly every issue included decorating ideas. In 1870 *Harper's Bazaar* began publication and it too featured articles on beautifying the American home

and included several on drapery design. Those attempting to re-create a Victorian interior will find both of these sources of great value.

Handsome leaded-glass windows became popular in the 1890s when the international Art Nouveau style reached America from Europe. Many artists from the United States traveled abroad where they learned about this developing style firsthand.

Imported Chinese, French, and English wallpapers, although not common, were used in eighteenth-century American homes. It was not until the close of the century that domestic manufacturers successfully marketed such products in any quantity. One of the first American firms to compete in this trade was Plunket Fleeson who worked in Philadelphia as early as 1739. Shortly after, similar establishments began in Boston, New York, and Albany. Papers from the mid-eighteenth century reflect an interest in repeating patterns of naturalistic designs and acknowledge the French Rococo style. At the close of the eighteenth century Zechariah Mills announced the opening of his paper-staining manufactory in Hartford, Connecticut. Fragments of papers bearing Mills's imprint are known, and the design of the paper appears to be based upon an English prototype called Buckingham House. Most papers from the late eighteenth century through the opening of the Victorian period reflect the current interest in classical designs. The Buckingham House paper shows Britannia enthroned amid columns, arches, and classical urns. The taste for classicism lasted over an extended period of time; ultimately other types of patterns became popular and in 1835 J. C. Loudon, in *An Encyclopaedia of Cottage, Farm, and Villa Architecture and Furniture,* noted,

> The variety of papers for rooms is almost endless; beginning with a flat shade of colour, and rising through patterns of one, two, or three, or more, to twenty or thirty different colours, or shades of colours, as in the printed landscapes, some years since introduced into manufacture by the French. All this variety may either be printed on the paper in water colours, or colours in which oil is introduced, so as to admit of their being washed with soap and water. The figures on papers may be classed as architectural, either in the Gothic, Grecian, or other styles; as imitations of nature, either plants or animals, or combinations of these in landscape scenery; or as historical or biographical, and, consequently, either groups of figures or portraits. As the fashions of most of these papers change as frequently as those of printed cottons, it would serve little purpose to offer designs of them, either for the choice of the builder or the direction of the manufacturer." [8]

Loudon's rapture over fine papers might have set Edgar Allan Poe on edge, for about 1840 he criticized the taste of New Englanders for such elegant fineries: "In the internal decoration . . . of their residences . . . Yankees alone are preposterous . . . The walls [of their homes] are prepared with a glossy paper of a silver-gray tint, spotted with small Arabesque devices of a fainter hue of the

prevalent crimson. Many paintings relieve the expanse of the paper. These are chiefly landscapes of an imaginative cast . . . such as the fairy grottoes of Stanfield, or the lake of the Dismal Swamp of Chapman." [9]

Although the use of wallpaper elicited disdain from fashion-conscious people, it continued to grow in popularity. By 1860 the use of "paper-hangings" had superseded hand-finished and painted walls in most city dwellings. In that year over fifteen hundred tons of paper were used in wallpaper mills located in Philadelphia, New York, and Boston alone. Even the expensive interior decorator joined the wallpaper bandwagon. Charles Wyllys Elliott, dean of the American tastemakers during the mid-1870s, became known as "Apostle Elliott of American Interiors." *Appleton's Journal* reported that Elliott "has written a book, last and greatest of knightly efforts" in which wallpapers not unlike those being designed by the Englishman William Morris were praised. Americans appear to have been keenly aware of English wallpaper designs, for shortly after the 1860s conventionalized patterns began to replace naturalistic flowers. During the 1880s the twelve-color wallpaper printing machine began to be used in the largest plants, and in 1881 the *Scientific American* reported that "papers for the finest and most costly mansion, and papers for the little nest of a cottage" were available at prices ranging from twenty-five cents to twelve dollars a roll, "thus suiting all purses and tastes." As a result, mass-production and mass-marketing techniques caused wallpaper to be a major carrier of decorative style from the East Coast to the West.

By 1880 a rigid scheme of paper decoration had fully developed. The wall was divided into three areas, each with its own patterns—the frieze, a fill pattern, and a dado, all distinctly defined by coordinating borders.

Besides being used to enrich interiors, wallpaper was also manufactured for the decoration of bandboxes. The bandbox was nothing more than a pasteboard and paper box made as a storage box or a carrier for a hat. Bandboxes are especially collectible today. The period of their greatest popularity was the second quarter of the nineteenth century.

Although urban Americans could and often did afford exciting wallpapers, country cousins frequently were forced to be satisfied with painted and stenciled walls. Itinerant decorators traveled from town to town seeking commissions for elaborate hand-painted murals. Even this could be more expensive than a rural farmer might wish to afford. If this were the case, stencils in attractive patterns were available. Sometimes all of the wall would be decorated. Other times, only a repeated pattern just under the ceiling might be used.

Elegant city homes occasionally were embellished with painted decoration, and toward the end of the period this practice became more popular with the fashion conscious. As early as 1854 Fendall Hall, the house built by Edward R. Young at Eufaula, Alabama, received such a treatment by a French artist named LeFranc, who came as an "artist in residence" and remained some six months while he completed handsome wall, ceiling, and door decorations in oil paints.

The vogue for such interior decoration continued to be popular for Tiffany Studios, Louis J. Millet, and Louis H. Sullivan (1856–1924), during the Late Victorian period, utilized painted and stenciled decorations.

Turkish carpets appear on tables in late seventeenth- and early eighteenth-century paintings. The idea of using a rug on the floor did not occur until somewhat later; they were simply too expensive.

The most popular floor covering in eighteenth- and nineteenth-century America was the floorcloth, a close-woven canvas that had been given a smooth, durable, and often decorative surface by the application of numerous coats of bright, colorful paint.

Because even a floorcloth represented a sizable investment, ingenious Americans attempted to discover inexpensive alternatives. The September 3, 1822, edition of the Middlebury, Vermont, *National Standard* announced, "A new carpeting substance has been invented in Philadelphia. It consists of paper, highly varnished and painted after any pattern. It is called 'prepared varnished paper,' and when finished has the appearance of the best and most elegant oil cloth. A pattern for an ordinary room which would take $50 worth of oil cloth may be covered by this material for $12.50—and at the end of 5 years you can lay down a new pattern for the interest of the sum which the oil cloth cost. It is cool and very pleasant, and will wear handsomely for five years at least." [10]

The elite in sophisticated urban cities failed to appreciate domestic goods. President Martin Van Buren purchased Brussels, Wilton, and Saxony carpets and Imperial rugs for which he received bills in the sum of $4,050.81. Mr. Ogle, a member of Congress from Pennsylvania and a strong Harrison man, objected and in 1840 moved to strike an item for additional furniture for the president's house because "excessive importations have plunged the country in embarrassments: Why do you not buy the furniture of your house—its carpets, its sofas, its curtains, etc., etc.,—from the products of American artisans instead of crowding it with the costly fripperies of Europe?" [11]

Mr. Ogle's complaint obviously struck home, for in 1844 the floor of the United States Senate was covered not with an imported but with a superb Brussels carpet with scarlet ground and yellow stars made at Germantown, Pennsylvania. In the same year the president's room was also fitted with a new carpet "made in Thompsontown. An extensive manufactory of Brussels carpeting and rugs is carried on in the Sing Sing prison." [12]

Carpeting continued to concern Congress and in 1889 members once again were grappling with the problem. At that time it took some twenty-two hundred yards of carpet to cover the floor of the House of Representatives and its galleries alone. For the sake of economy the hall was finished one year and the galleries the next.

As an alternative to carpeting many Victorians actually preferred a bare, well-polished parquet floor. At the Philadelphia Centennial in 1876 several manufacturers displayed examples of parquet designs in expensive woods. The publication, *Gems of the Centennial Exhibition*, noted: "Among the many beautiful

decorations in household art which have taken a strong hold on public taste, as represented among the wealthier classes, within a few years, parquetry, or tessellated wood-flooring, is entitled to a foremost place. The rich effect of this inlaid-work, its permanence, its harmony with the best taste in furnishing, give it a high claim on the attention of persons of taste." [13]

Godey's Lady's Book agreed that wood floors in parquet designs (known as wood carpets) were to be preferred to Turkey carpets or other textile floor coverings. In 1884 they advised their readers:

As we pass from the vestibule into the hall, the first feature that attracts our attention, is the wood carpeting of oak, beautifully polished. There are perhaps few inventions for household comfort that contribute more to health than that of wood carpeting, as oftentimes for months and years ordinary carpets of textile fabrics have been known to harbor impregnating germs of disease and death; but with the wood carpeting the feature of a retention or of an absorption of this character is entirely removed, as well as many other objections, such as the collecting of dust, or the retention of soiled marks from anything being spilled thereon; while in addition to their health-fulness they present the advantage of being readily cleaned and to keep them looking new and fresh, requires simply the application of an oiled cloth. In patterns beautiful and artistic, these may be seen at the ware-rooms of Messrs. Boynton, Peet & Co., No. 16 East 18th St., New York, and we can fully recommend a visit to their ware-rooms—and in this connection we will say that we propose in these articles to not only illustrate the designs, but to tell where and how to buy—and our readers may be assured of a courteous treatment to their applications by mail or otherwise.[14]

Although the hooked rug enjoyed a small degree of popularity early in the nineteenth century, it was not until the second half of the century that it became a familiar part of every household decoration. Hooked rugs and braided rugs were most popular in rural homes, where they were made by housewives during their free time. The hooked rug many times is a superb piece of folk art and reflects the individual creativity of an untrained artist; other times it is merely the slavish execution of prepared patterns that were hawked throughout rural areas by ambitious peddlers.

The problem of ceiling decoration in homes could be solved in several ways. Without question, most ceilings were plastered and painted a single color throughout the entire Victorian period. This method of finishing a room had been used almost exclusively during earlier periods, and in 1788 it was recorded, "Sheared my mongrel dog Rover, and made use of his white hair in plaster for ceilings. His coat weighed four ounces. The N.E. wind makes Rover shrink." [15]

During the 1830s, 1840s, and 1850s many arbiters of taste piously recommended Gothic interiors and in several instances, such as at Lyndhurst, the

Gothic Revival mansion built at Tarrytown, New York, by A. J. Davis, this enthusiasm for the medieval style caused the incorporation of plaster ribbed ceilings in pointed and arched designs.

By 1860 when the robust, undulating Rococo Revival style became popular, many Gothic ceiling decorations of the earlier period were pulled down and replaced by plaster medallions at the center of the ceilings and cast moldings. The taste for this type of decoration soon passed, and during the late 1870s and 1880s painted geometric designs and elaborate arabesques became the vogue.

For those who could not afford such luxuries, the pressed tin ceiling was developed. It seems surprising that the tin ceiling did not remain popular, for it was inexpensive and did not require plastering, and when painted could be very handsome.

57 (left). *Girl Coming Through a Doorway* by George Washington Mark. Greenfield, Massachusetts. c. 1845. Oil on canvas. H. 71½″. Because so many Victorians were fond of oak, they frequently had doors, windows, and other woodwork grained to simulate it. (Greenfield Village and Henry Ford Museum)

58 (below). Victorian parlor in the Rococo Revival style. 1850–1860. High-style Rococo Revival furniture made by the famous firm of John Henry Belter, New York City, is usually either mahogany, rosewood, or walnut. Belter's furniture was complemented by ornate mantels, and mirror and picture frames. The plasterwork on the ceiling is especially noteworthy. (The Metropolitan Museum of Art)

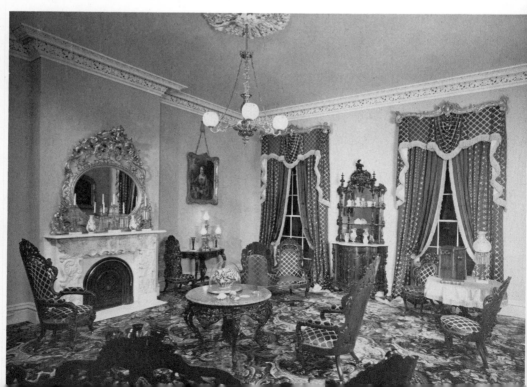

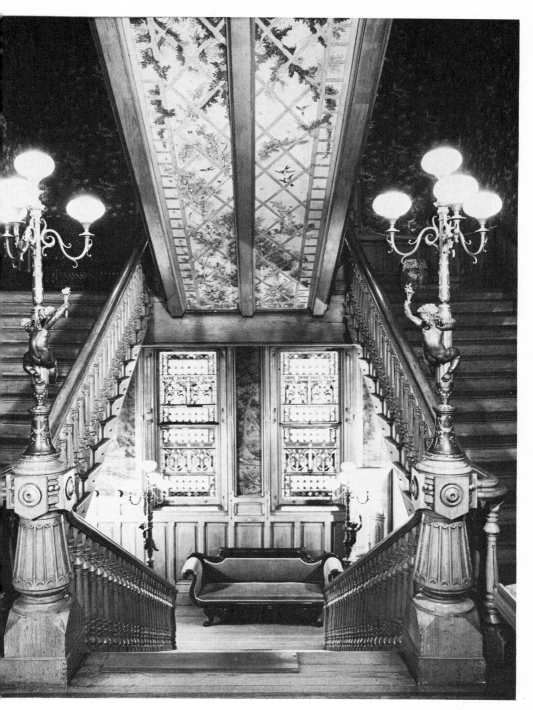

59 (above). Staircase at Château-sur-Mer, Newport, Rhode Island, built 1851–1852 for William S. Wetmore and enlarged in 1872 by Richard Morris Hunt for George P. Wetmore. The painted trellis with foliage and birds and the stained-glass windows enhance the charm of this staircase. (The Preservation Society of Newport County)

60 (right). Bedroom from the imposing mansion built at Norwalk, Connecticut, by Le-Grand Lockwood in 1869. The three-dimensional geometric decorations on the ceiling anticipate a vogue that was to become quite popular later in the century. (Lockwood-Mathews Mansion)

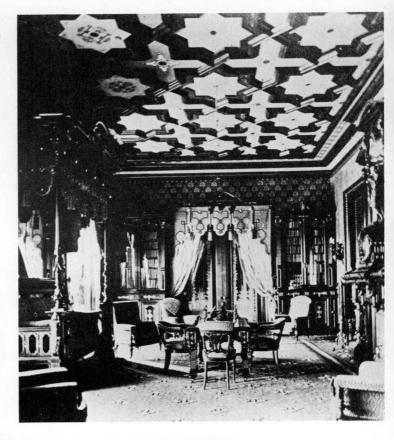

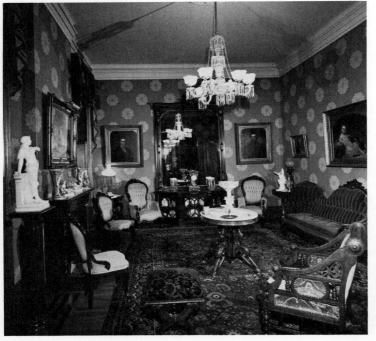

61 (left). Back parlor at The Historic General Dodge House, Council Bluffs, Iowa. c. 1870. Note the pier glass in Renaissance Revival style against the back wall, the Rococo Revival sofa and chairs and the carved Eastlake-style chair in the right foreground. (The Historic General Dodge House)

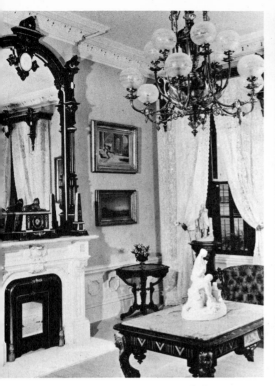
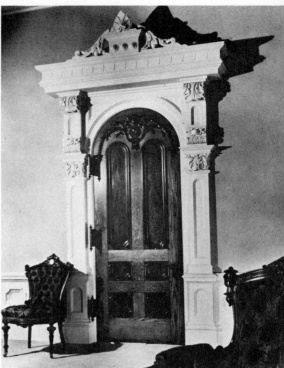

62a and 62b (above). Two views of the sitting room in Renaissance Revival style from the Jedediah Wilcox House, Meriden, Connecticut. 1868–1870. Mother-of-pearl cameos decorate the resplendent overmantel mirror and matching valances in 62a and the crests of the chairs in 62b. The marble-topped center table in 62a is shown in color in plate 20. (The Metropolitan Museum of Art)

63 (right). Plate VI from a special series, titled "Studies of Interior Decoration," in the *American Architect and Building News,* May 5, 1877, illustrates a taste both for elaborate paneled "woody" interiors and for exotic carpets with floral decoration. (The New York Public Library)

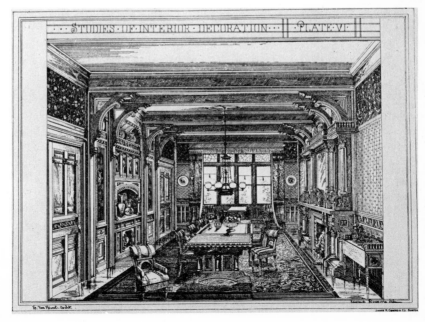

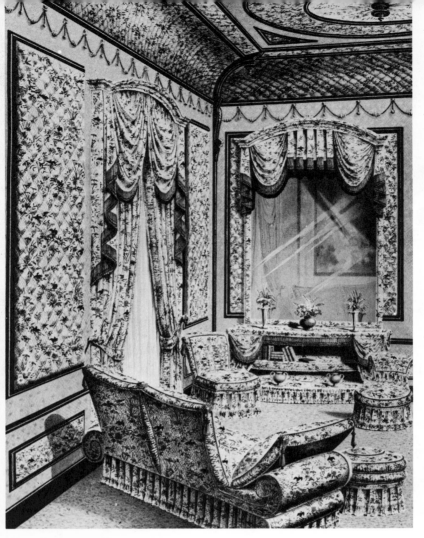

64 (left). Advertisement of Carrington, De-Zouche & Company, Philadelphia. 1876. This firm caused visitors to the Philadelphia Centennial to marvel at the colorful interior created from gaily printed floral fabrics trimmed with red binding and accented by red and black fringes and tassels. Victorians obviously appreciated such padded interiors for the firm continued in operation for many years. (Private collection)

65 (right). The August 1883 issue of the *American Architect and Building News* featured a spread on The Berkshire, an apartment house designed by Carl Pfeiffer and built at Fifty-second Street and Madison Avenue, New York. The interior contained a multitude of spindles, bobbins, and knobs, which would have pleased Charles Eastlake, the Englishman who wrote *Hints on Household Taste,* a publication that achieved immense popularity in America. (The New York Public Library)

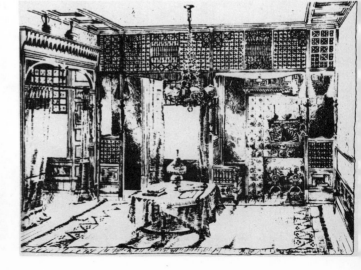

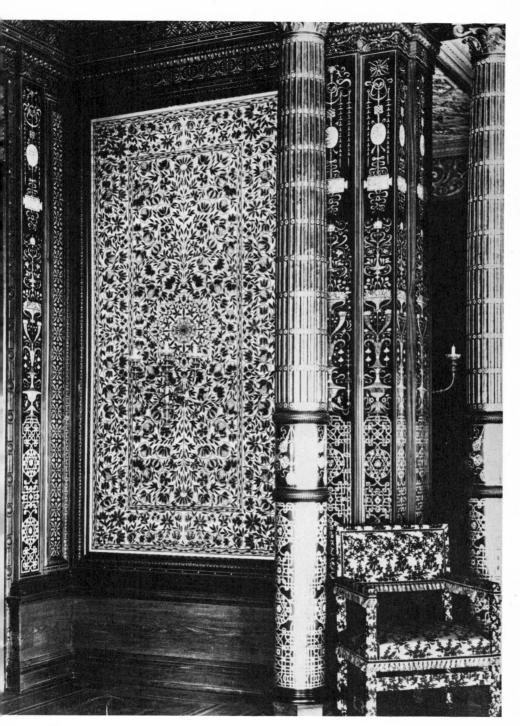

66 (above). A detail of the hall in the Henry Villard residence, New York City. 1885. Villard's home was executed by the fashionable firm of McKim, Mead and White. With almost chameleonlike dexterity, the architects could change their style to suit their client. (The New-York Historical Society)

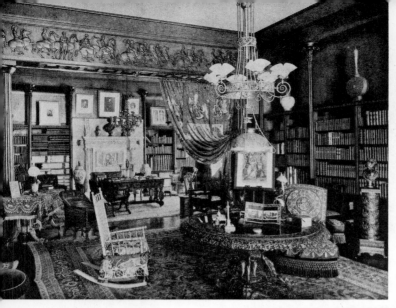

67 (left). The drawing room of the H. J. Willings residence at Rush and Ontario streets, Chicago, in 1884. Oriental carpets cover the floor and are used as a covering for a library table. An elaborate curtain is draped at one side of the large doorway. Note the three wicker chairs so popular with Victorians and extensively used in all types of interiors. (Chicago Historical Society)

68 (right). The dining room of the home of W. R. Garrison, Esq., Tuxedo Park, New York, taken from the *American Architect and Building News*, March 24, 1900. As the nineteenth century drew to a close, Americans were increasingly preoccupied with ornately carved furnishings and interiors. The furniture in this room was probably marketed at the time as either "Spanish" or "French." (The New York Public Library)

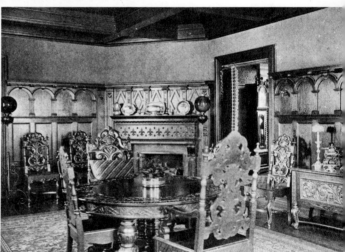

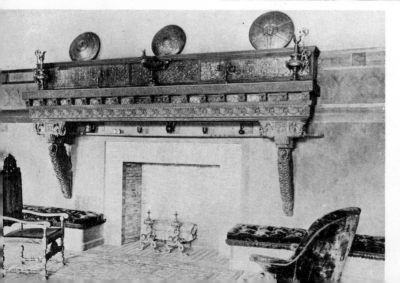

69 (left). Upper half of the Tiffany house on Seventy-second Street, New York. 1885. L. C. Tiffany's taste for the exotic caused him to collect many things from foreign countries and was probably responsible for the installation of the unusual fireplace mantel. (The New-York Historical Society)

70 (right). Will Brad-
ley's design for a child's
room includes many
elements of the Art
Nouveau and Arts and
Crafts movements. Ed-
ward Bok, editor of the
Ladies' Home Journal,
featured a special series
of interiors and furni-
ture designs by Bradley
in 1901 and 1902. (Pri-
vate collection)

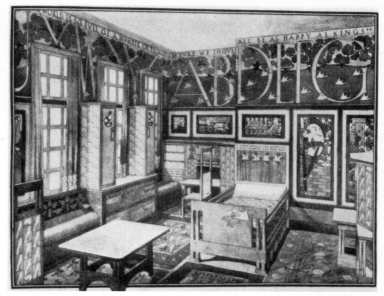

71 (below, left). Advertisement for J. & F. W. Ridgway, New York City. 1844. Litho-
graph. Although the bathroom was an innovation that was known prior to the Victorian
period, it was not until the 1860s and 1870s that it became common in most American
homes. (The Library of Congress)

72 (below, right). Window curtains from *Beautiful Homes* by Henry T. Williams and
Mrs. C. S. Jones, published in New York in 1878. The Victorian love for full draperies,
rich textiles, and a multitude of pleats, tassels, and fringes is evident in this charming
illustration. Curtain tiebacks and brass cornices were especially popular at this time.
(Private collection)

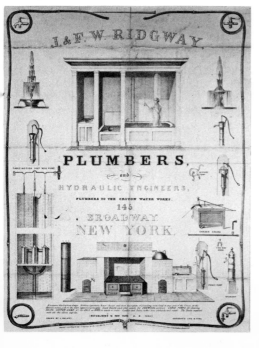

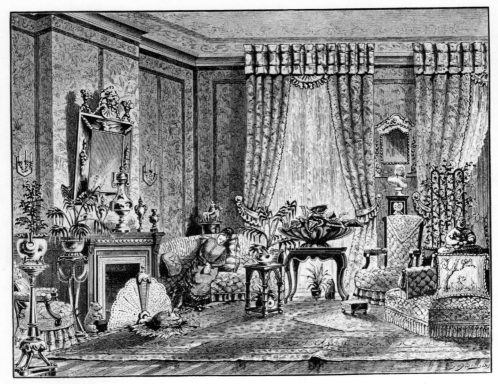

73 (above). This boudoir in the residence of James P. Kernochan, Esq., taken from volume 5 of the 1879 *Art Journal*, abounds with tassels, frills, and overstuffed furniture. As the accompanying text states: "A very pretty room is Mrs. Kernochan's boudoir. Here Japan has been invaded for her rich stuffs and monsters. They come in well with the gaily-painted *cretonne* which forms the curtains, the covering of the wall, and the edges of the mirror-frames and chairs. All is *upholstered*, tufted, and covered; there are no sharp angles here. A delicious sense of repose follows one into this comfortable room, where one should read only Tennyson's 'Lotus-Eaters.'" [1] (The New York Public Library)

74 (below). Trade card for City Interiors, Philadelphia. c. 1880. City Interiors appears to have been a conglomerate of several designers and furniture dealers who specialized in decorating elegant Philadelphia homes. The upholstered tête-à-tête, conversational chairs, and the armchair by the fireplace are of the Turkish Frame variety. (The New-York Historical Society)

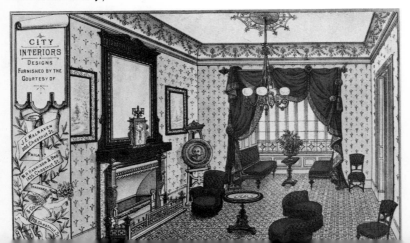

75 (right). Advertisement for "Imperial" Porcelain and Porcelain-Lined Baths, Foot Baths, Water Closets, Etc., manufactured by The J. L. Mott Iron Works, 88 and 90 Beekman Street, New York. 1883. Soon after the Civil War all modern city homes included a completely equipped bathroom with running water, both hot and cold, and a dependable sewage system. (The New York Public Library)

76 (below). Window shade. c. 1850. Watercolor on fabric. H. 72". This room interior is one of four paintings depicting the benefits of union membership and was prepared for use by recruiters for The Order of United American Mechanics. The union working-man could expect to live in a comfortable home that included such niceties as a marble fireplace, a mantel clock, and elegant window shades with painted decorations. Victorians often used painted window shades in their homes. Some are rather crude and naïvely painted; others are extremely sophisticated. (James Frink)

77 (above). Design for a decorated window shade manufactured by F. J. Kloes & Co., New York. Illustrated in *The Decorator and Furnisher*, August 1886. "The evolution of the window shade, as set forth in the warerooms of Messrs. F. J. KLOES & Co. is especially interesting. The complicated processes through which the raw material must pass before a length of muslin becomes a finished window shade, are but little understood by the consumer or even by the trade that handles them. There are many grades of goods used for shade foundations, among the finest of which are Lonsdale cambric and a light weight nainsook, that is employed for transparent effects. Many plain shades of fine material are used, the only decoration being a netted lissen fringe of the same color as the curtain. This style is specially popular with a certain class of conservative people, who always study a quiet effect, not only in furnishings but everything else about their belongings." [2] (Private collection)

78 (left). Advertisement taken from *The Decorator and Furnisher*, May 1883. During the 1880s taste dictated the division of the wall surface into a frieze, a fill pattern, and a dado, all defined by coordinating borders. That same division is evident in this advertisement for the Chicago firm of J. J. McGrath located on Wabash Avenue. (Private collection)

79 (right). Painted and decorated ceiling and walls from Fendall Hall at Eufaula, Alabama. A French artist named Le Franc came to the house in 1859 and remained for six months while he painted the handsome interior. (Historic Chattahoochee Commission; photograph courtesy *Antique Monthly*)

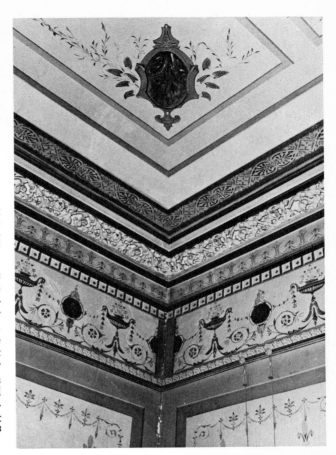

80 (below). Design for a "cheap stencil ceiling" published in *The Decorator and Furnisher*, August 18, 1886. The accompanying article explained: "The custom of papering ceilings has gone entirely out of fashion and out of use among persons who have any pretensions whatever to good taste, a simple tone or a cheap but neat and unobtrusive stencil ornament is far better than any papering that can be devised. The wide or deep frieze will always be popular, although it has been in part displaced recently by a narrow border; the selection of either is a matter of taste and may be left very much to the personal preference of the occupant of the house to be decorated." [3] (Private collection)

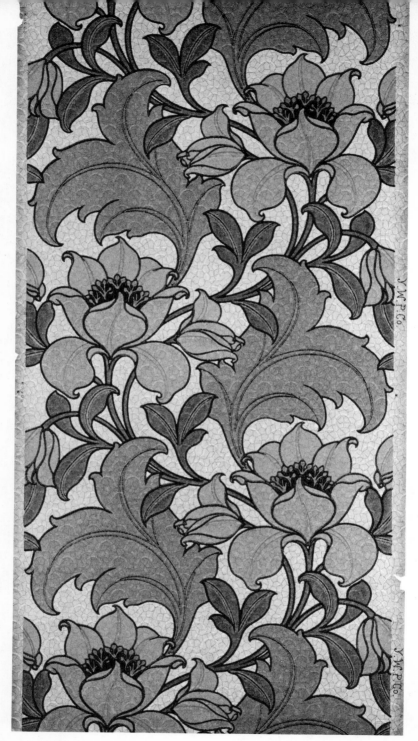

81 (above). Wallpaper manufactured by the York Wall Paper Company, York, Pennsylvania, after 1895. H. 38⅝". This handsome motif was printed in various shades of blue. Although it is much simpler, its obvious inspiration was a design by the Englishman William Morris, who is noted for his work in this field. (Philadelphia Museum of Art; Gift of the Horace M. Pryor Company)

82 (above). Painted floorcloth executed by Captain Edwin Rumill for his wife Lettie Anna. Maine. c. 1900. L. 40". Floorcloths were especially popular in New England. Geometric designs are enlivened with a painted anchor initialed *H* for hope, a cross lettered *F* for faith, and a heart with the letter *L* for love. The center panel is monogrammed *LAR*, the initials of Mrs. Rumill. (Private collection)

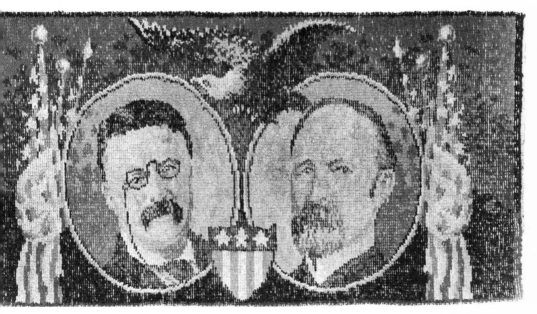

83 (above). Woven rug made by the Olson Rug Company for use in the campaign headquarters of Theodore Roosevelt during the 1901 campaign for the presidency. L. 56". Roosevelt and his running mate, Charles W. Fairbanks, are framed by American flags; an American eagle watches above them, and a stylized shield is between them. (Collection of Hazel and Carleton Brown)

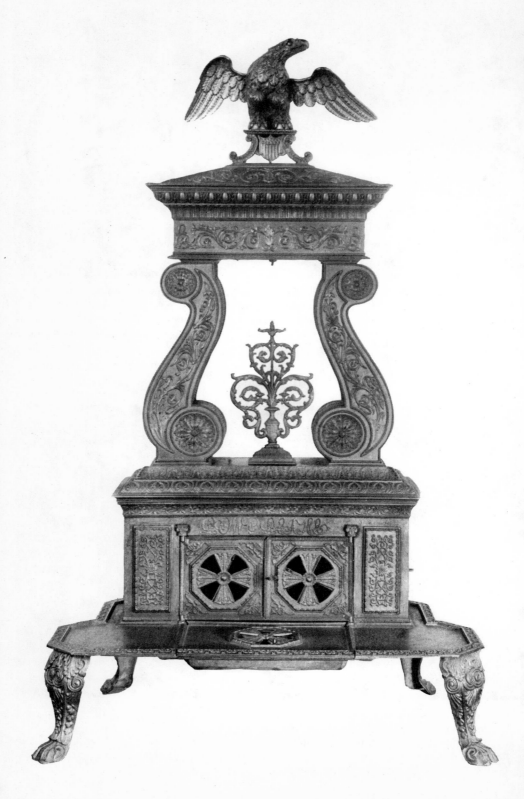

HEATING

The typical seventeenth- and early eighteenth-century home in America was constructed following age-old traditions. Most dwellings mirrored earlier English structures and were heated by cavernous fireplaces where roaring blazes scorched the fronts of those brave enough to stand close while their backs froze from icy drafts. Cotton Mather, writing during the difficult winter of 1697 in Massachusetts, noted that in "a great Fire . . . the Juices [were] forced out at the end of short billets of wood by the heat of the flame on which they were laid, yett froze into Ice on their coming out." [1]

Winter life unquestionably centered around the massive fireplace in the "hall" where families gathered during waking hours, and on frequent occasions, slept. Parlors and bedchambers usually contained a small fireplace, but it seldom provided sufficient heat for complete physical comfort.

In time a gradual specialization of rooms evolved and new methods of heating developed. Sand-cast iron firebacks became popular during the early eighteenth century, for they not only protected the masonry in the chimney, but retained heat and reflected it back into the room. Perhaps inspired by the success of the fireback, stoves, made of five, six, or ten sand-cast plates bolted together, enjoyed popularity in Pennsylvania. Benjamin Franklin, on several occasions, referred to five-plate or jamb stoves as "Dutch" or "Holland Stoves." He was critical of them because there was "no sight of the fire which is in itself a pleasant thing." [2]

As Americans developed an increasing awareness of the English Georgian style of architecture, they adapted it for their own dwellings. *The British Architect* (1745), issued by Abraham Swan at London, was reprinted in Boston and Philadelphia in 1775. This publication and many others like it greatly influenced Colonial interiors. The numerous illustrations served as guides for New World craftsmen in the construction and decoration of the most up-to-date fireplaces and mantels. For instance, the design of an ornate fireplace and chimney surround in the parlor of the Jeremiah Lee house built in 1768 at Marblehead, Massachusetts, nearly duplicates a plate in the Swan publication.

While parlor fireplaces in urban homes became elegant, the kitchen hearth remained simple and functional. Obtaining stylish fireplace equipment preoccupied many well-to-do Colonials. Brass andirons, fenders, and fire tools reflected the fashions and prevailing styles of the time. As wood became scarce and expensive in highly populated areas, coal, imported from England, was used as a substitute in many cities. Brass and iron coal grates appeared in America during

84 (opposite). Stove made by Low & Leake, Albany, New York. 1844. Cast iron. H. 48". The firm was in business from 1843 to 1848 and specialized in two-column stoves that were fueled at the side. The S-scroll shape of the columns relates to the then-popular pillar-and-scroll furniture style. (Greenfield Village and Henry Ford Museum)

the mid-eighteenth century and by the time of the founding of the United States were in more or less general use in many wealthy urban households. Peter Kalm, a Swedish visitor to New York in 1748, observed that coal was used in both kitchens and parlors.

During the early nineteenth century coal mines in Pennsylvania provided anthracite that was shipped by way of the new railroads and canals to distant markets. With the development of domestic mines and improved means of shipping coal, it decreased in cost and increased in popularity.

German emigrants brought with them the idea of a freestanding stove made from pottery tiles. Cast-iron stoves were soon introduced. Because they radiated heat more efficiently than ceramic models, they immediately gained great popularity.

The quest for warmth interested many minds. Benjamin Franklin in 1742 designed a complex device that he called the Pennsylvanian Fire-Place. Outside air was taken in through a duct, warmed in a series of passages, and finally released into the room. This intricate heat generator in time was simplified and evolved into the familiar Franklin stove, which is little more than a cast-iron fireplace.

The Franklin stove has remained popular ever since its introduction. Sarah Anna Emery, recalling a visit to her Aunt Betsey Bartlett's Newburyport, Massachusetts, parlor during the 1790s, noted, "It was handsomely furnished, for that period, with a mahogany desk and book-case, two mahogany card tables, and a light-stand to match . . . A Franklin stove had been set in the fireplace, in which glittered a highly polished brass fire-set." [3]

By the close of the eighteenth century small stoves, flask-cast in a single piece, offered winter comforts heretofore unknown. Their success was based upon the concentration of a heat source within a greatly reduced space. They provided considerably more heat while consuming less wood than a fireplace. A 1799 engraving of the Pennsylvania State House shows firewood stacked outside and stovepipes protruding from the windows indicating that stoves were in use in public buildings as well as in private homes.

The American-reared Benjamin Thompson (1753–1814), better known as Count von Rumford, developed indirectly heated ovens and built large ranges for Bavarian nobility, aristocrats, and various public facilities. His dominant theory, that the heat source should be contained within the smallest possible compass, was relayed to America at the opening of the nineteenth century through many voluminous essays including, "On the Construction of Kitchen Fireplaces and Kitchen Utensils, Together with Remarks and Observations Relating to the Various Processes of Cooking and Proposals for Improving that most Useful Art" and "Of the Management of Fire and the Economy of Fuel." Rumford was a creative scientist whose practical mind was as interested in "small ovens for poor families" [4] as it was in grandiose oval ranges for military hospitals.

Not everyone considered Rumford's theories sound. *The New Cyclopaedia*

of Domestic Economy, and Practical Housekeeper (1872) recommended an opposing opinion about domestic heating:

> In contriving the mode of warming a house, attention should be paid not merely to economy of fuel, but to the preservation of a salubrious atmosphere. A chimney fireplace or grate is preferable to a stove, which is apt to give the air a close or disagreeable smell, and produce headache and stupor. Count Rumford imagined that the hot iron roasted the dust that settled on it, which dust was composed of all sorts of animal and vegetable matters; others complain of the extreme dryness of the air . . . all close stoves are liable to the objection, that in using them it is difficult to change the air continually, or procure proper ventilation.[5]

Because the cast-iron stove from 1830 to 1880 was visually altered by successive stylistic changes and made functionally more efficient by an unending series of patented improvements, it reigned supreme in the American home. No other country ever produced the stove or range in such a wide variety of models. Many times two or three different manufacturers would market nearly identical stoves. Stove molds were expensive, and when a manufacturer went out of business, they were often purchased by a competitor.

Philo Penfield Stewart (1798–1868), a missionary and teacher who was instrumental in the founding of Oberlin College in Ohio in 1833, took out a patent the following year for a cast-iron stove that he named "Oberlin" after the college. He appeared certain of the success of his stove, for he assigned his patent rights and the resulting royalties to the college. In the late 1830s Stewart went to Troy, New York, and in a period of some thirty years manufactured over ninety thousand stoves. Although many improvements were perfected by other stovemakers from the 1850s through the 1880s, the Oberlin remained popular with Victorian housewives.

In an effort to protect the floors from the intense heat generated by stoves, many of the earliest models probably stood on pottery tiles or, more often, on less expensive bricks. During the beginning of the Victorian period an ingenious manufacturer marketed a sheet of metal designed especially for this purpose. Rubens Peale (1784–1865), a member of the Philadelphia clan of painters, owned such a device and it was included by Jane Peale in her painting of his studio. When art pottery became popular during the 1870s, elaborate tiles were designed to add visual interest to architectural floor-to-ceiling fireplaces. They were also used as floor protectors under parlor stoves. Occasionally, ceramic tile was included in the design of a stove.

In 1877, *The Art Journal,* on a verbal tour of the stately house on Fiftieth Street in New York City, owned by Walter S. Gurnee, commended his display of good taste because each room prepared the senses for further surprises: "The fireplace, always a beautiful object, and a necessary concession to our climate,

too often neglected, is of that ornate order of French decoration which we asso-
ciate with the chateaux of the seventeenth and eighteenth centuries . . . [it was]
fitted with tiles, surrounded with dark wood . . ." [6]

Many Victorians, especially those of means, were reluctant to give up the
impressive display a fireplace could make, in spite of the fact that central plants
provided the heating for their elegant rooms. Clarence Cook, one of America's
most eminent art critics and tastemakers, enthusiastically supported this attitude:

> . . . let us be glad of anything almost that keeps alive the sentiment of
> the fire-place, especially since we see how much has been done of late to
> re-instate the open fire in public favor. People have been finding out that
> though a furnace may be an excellent thing in the long-continued cold of
> winter, yet there are days in early spring and late fall when a fire of logs
> is much pleasanter and seems to go more directly to the right spot. And
> then all the accompaniments of the open fire are of an ornamental character;
> the fire-dogs, or the taller andirons, the tiles that border the opening, the
> brass fender of open-work, the very shovel and tongs, with the bellows,—
> all these are the shining armor of the god of fire, and he likes to let his
> sparkling eye roam over them in the twilight, as he recalls a thousand mem-
> ories of the days that are no more, or feeds a thousand hopes for the days
> that are to come.[7]

When Louis Comfort Tiffany (1848–1933), in conjunction with McKim,
Mead and White, designed a house for his parents, which was erected in 1885
on Seventy-second Street and Madison Avenue in New York City, he included
a studio for himself at the top. This exotic retreat was filled with hanging
Oriental pots and lamps clustered about a fireplace that probably functioned
more as a decorative focal point than as a source of warmth.

It was the expatriate American investor Jacob Perkins (1766–1849), while
living in England, who first developed a portable steam-and-hot-water central
heating system. His concepts were studied and improved upon, and, finally in
1845 or 1846, the Eastern Hotel in Boston became the first American steam-heated
building.

Just four years later A. J. Downing (1815–1852), in *The Architecture of
Country Houses* . . . , complained about heating with a hot-air furnace. Despite
the fact that it offered "a very complete means of warming a house of any size—
since, by means of hot-air pipes and registers, one fire, in the lowest part of a
house, may be made to warm a large column of heated air, which, with its
natural tendency to rise, may be distributed to every room in the house," the
hot-air furnace could affect "adversely not only the olfactory nerves, but the
pulmonary organs" [8] as well.

Other experts agreed, ". . . difficulties prevail . . . in warming a house by
a furnace, and the dryness of the air is often productive of discomfort. Steam
might afford an agreeable and convenient method of warming apartments. Of
all the modes usually adopted, the advantage seems to lie with the open fire.

The temperature should be steady and not too high: say 60° or 62°. Apartments in our cities are generally kept at a dangerous degree of heat." [9]

Downing had personally examined several hot-air furnaces before installing in his own house a model manufactured by Chilson of Boston. After a five-month trial, he commended the Chilson heating unit for the remarkable purity, freshness, and mildness of the warm air it delivered.

Downing also encouraged prospective home builders to consider hot-water heating, "This is the most healthful and perfect mode of heating buildings yet invented; but as it is an expensive mode, costing about five times as much as heating by hot air, it has, as yet, been confined to town houses of the first class, in our cities . . . We hope to see more attention paid to heating by hot water, so that, if possible, it may be rendered simple and cheap enough to come within the reach of persons of moderate circumstances." [10]

Some thirty-four years later Almon C. Varney, author of *Our Homes and Their Adornments* (1884), agreed with Downing and expressed severely critical views of hot-air furnaces: "The old fire-place, with its cheery blaze and glowing bark log, and coals that assume ten thousand fantastic shapes and pictures, all giving out an abundance of heat, cannot be outdone by any inventions of modern progress . . ." [11] Varney, too, much preferred the steam method of heating dwellings, even though it still was considered ". . . comparatively new and not very generally used yet outside of large cities." [12]

Varney might possibly have been familiar with *The American Woman's Home* . . . (1869), a book chock-full of domestic advice and homemaking tips, written by Catharine E. Beecher and her famous sister, Harriet Beecher Stowe, for he echoed their admiration for the fireplace: "The open fire warms the person, the walls, the floors, and the furniture by radiation, and these, together with the fire, warm the air by connection . . . Thus in a room with an open fire, the person is warmed in part by radiation from the fire and the surrounding walls and furniture, and in part by the warm air surrounding the body." [13]

From 1880 until the end of the Victorian era the gas stove and range won increasingly popular acceptance. Perhaps this was the indirect result of up-to-date public demonstrations of gas cooking in England during the 1850s and 1860s that were much discussed by discerning American newspaper editors.

General acceptance of the gas stove came slowly, as is evidenced by a statement in an 1889 catalogue for the Jewel Gas Stove sold by George M. Clark & Co. at Chicago, Illinois: "For eight years we have been manufacturing the Jewel. We were among the first to appreciate that gas was to be the fuel of the future. Is the use of gas . . . an extraordinary luxury? No, it is an economical necessity. The popular prejudice is gradually giving way." [14]

This popular prejudice had been encouraged by such as the Beecher sisters who in 1869 warned their readers, "There is no more dangerous mode of heating a room than by a gas-stove. There is inevitably more or less leakage of gas which it is unhealthful to breathe." [15]

Once Edison demonstrated the practical application of electricity in 1879,

Americans became fascinated with the possibilities of a flameless heat source. At the World's Columbian Exposition in Chicago in 1893 electricity was everywhere. One excited visitor breathlessly related,

> Toward the east, darkness is setting over the waters of the lake. Northward and to the west a heavy pall of smoke broods over the great midcontinental metropolis, and far to the south the lurid flames of a blast furnace are faintly visible on the dusky horizon. Suddenly a beam of light shoots like a falling star from the lofty dome of the Administration building, and a moment later its symmetrical outlines stand out in tracery of fire. At its base is a circling wheel of light, and a hundred torches further relieve the black abyss beyond. Meanwhile a thousand lamps, clustered around the central avenue, have turned the night into day.[16]

A number of displays promoted recent developments in the field of electricity, but probably none fascinated and intimidated the Victorian homemaker as much as the "Model Electric Kitchen," which included an electrified range, an electric boiler, several electric kettles; and of course a spiderlike electrical chandelier. By the end of the Victorian period few households had converted to electricity for heating and cooking. It was not until the close of the 1920s that it became generally popular.

85 (right). Stove made by J. S. & M. Peckham, Utica, New York. 1845. Cast iron. H. 55". The ornate decoration includes grapes and other fruits, vegetables, roses, leaves, morning glories, and two children holding a chain with a dish-shaped medallion bearing the manufacturer's name. The stove is raised off the floor on four leaf-scrolled feet. (Greenfield Village and Henry Ford Museum)

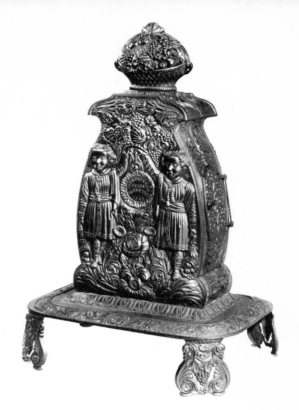

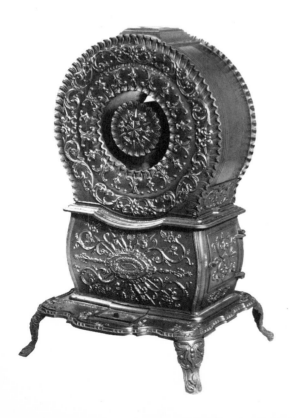

86 (left). Stove made by E. Huntington, Elmira, New York. c. 1847. Cast iron. H. 29". Stoves that were manufactured in two parts, like this model, were more efficient for they provided a greater heating surface. This parlor stove has a hinged door on the side and a platform base with an ashpan. (Greenfield Village and Henry Ford Museum)

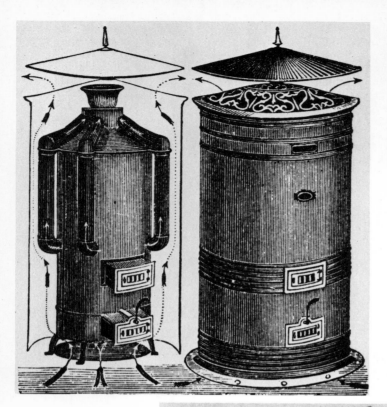

87 (left). Clark's Patent Ventilating Stove illustrated in *Architecture of Country Houses* by A. J. Downing, published in 1850. By mid-century many houses were warmed by hot-water systems. (Greenfield Village and Henry Ford Museum)

88 (right). Patent design by H. Tucker for a cast-iron fireplace with glass panels. c. 1850. Hiram Tucker, the manufacturer, located at Cambridge, Massachusetts, claimed that he was the first to utilize glass inserts in an iron frame "to imitate the finest marbles or other articles." [1] As the century progressed, the use of cast-iron mantels and fireplace surrounds increased. (Private collection)

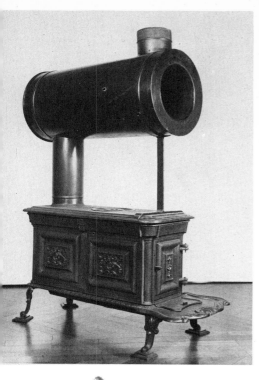

89 (left). Stove made by Jewett & Root's Stove Works, Buffalo, New York. 1851. Iron. H. 65″. The flue at the rear connects to a pipe that leads into a long drum-shaped cylindrical heating unit that is supported above the stove by a metal stand. Stove manufacturers continually attempted to improve their products by devising ways of increasing heating capabilities. (Greenfield Village and Henry Ford Museum)

90 (below, left). Stove made by Vose & Co., Albany, New York. 1854. Cast iron. H. 44″. This charming parlor stove was manufactured in the shape of a small Gothic house or cottage. (Greenfield Village and Henry Ford Museum)

91 (above). Stove made by Wheeler & Bailey, Utica, New York. 1856. Cast iron. H. 38″. This model has two cooking units on the top. Oftentimes people kept teakettles on the stove constantly so that hot water would be available at all times. (Greenfield Village and Henry Ford Museum)

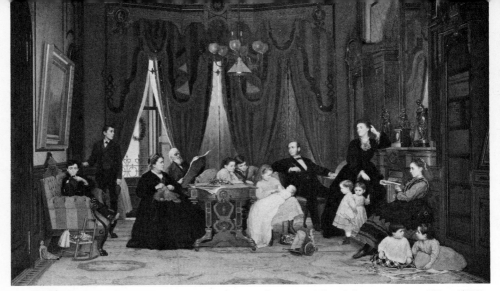

92 (above). *The Hatch Family* by Eastman Johnson. 1871. Oil on canvas. 48″ x 73⅜″. The Hatch family resided at Park Avenue and Thirty-seventh Street, New York. Their house was decorated with furniture in the latest style, including a fine Renaissance Revival center table. Like many New York dwellings, the parlor was heated by a fireplace. (The Metropolitan Museum of Art; Gift of Frederick H. Hatch, 1926)

93 (below, left). Cover illustration from a catalogue published by Jerome Babbitt, Taunton, Massachusetts. 1863. In addition to stoves, iron teakettles and pots and copper boilers were available at Mr. Babbitt's establishment. (Greenfield Village and Henry Ford Museum)

94 (below, right). Stove manufactured by the Murdock Parlor Grate Co., Boston, Massachusetts. c. 1873. H. 27″. The upright, box-shaped stove is covered on top, front, and sides with floral-decorated pottery tiles. It was designed especially for yachts, but advertised for domestic use as well. (Greenfield Village and Henry Ford Museum)

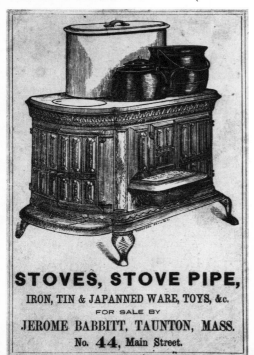

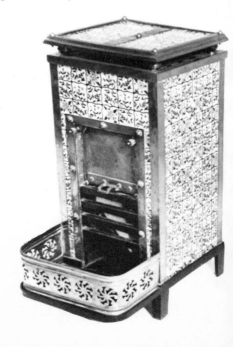

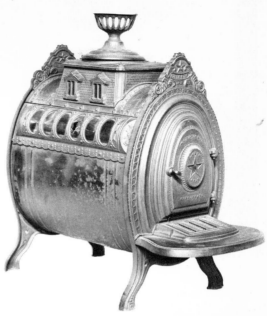

95 (above). Illustration of a mantel and other fireplace equipment from *Beautiful Homes* by Henry T. Williams and Mrs. C. S. Jones, published in New York by Henry T. Williams in 1878. The ornate marble fireplace was made more beautiful by the use of elaborate drapery. Note the beswagged urn to the left of the fireplace, which is actually a coal scuttle incognito. (Private collection)

96 (above). Stove made by W. C. Davis & Co., Cincinnati, Ohio. 1876. Cast iron and sheet metal. H. 39″. This North Star model was built from cast iron and sheet metal and featured six small oval openings covered with isinglass. The center part of the top is designed to resemble a mansard roof and has two small Gothic windows with isinglass panes on each side. (Greenfield Village and Henry Ford Museum)

97 (below). Chromolithograph by L. Prang & Company, Boston, Massachusetts. 1874. L. 21¾″. This illustration of a tinsmith's shop provides a detailed view of a workroom as well as a glimpse of a salesroom that displayed stoves, stovepipes, birdcages, and various sized pots, pans, and miscellaneous cooking utensils. (Greenfield Village and Henry Ford Museum)

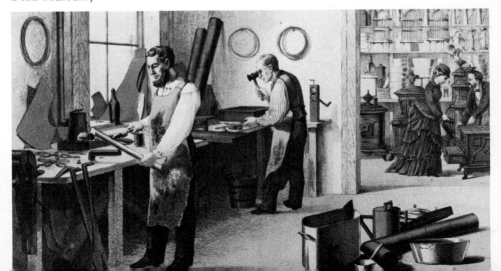

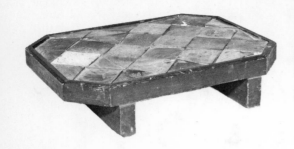

98 (left). Stove platform. c. 1880. W. 22″. The wooden frame holds green, brown, gray, and yellow pottery tiles that are laid in a diamond design. Such devices provided increased protection for costly carpets and floors. (Greenfield Village and Henry Ford Museum)

99 (below, left). Stove made by Cribben & Sexton Co., Chicago, Illinois. c. 1880. Cast iron and nickel plate. H. 63½″ Heavily decorated with nickel plate, the top of the stove boasts a copper finial. (Greenfield Village and Henry Ford Museum)

100 (below, right). Illustration of a steam radiator from *The Decorator and Furnisher*. Although such modern conveniences were recommended for their efficiency, the "grim aggressiveness" of the steam radiator represented an obstacle that had to be overcome by the home decorator. (Private collection)

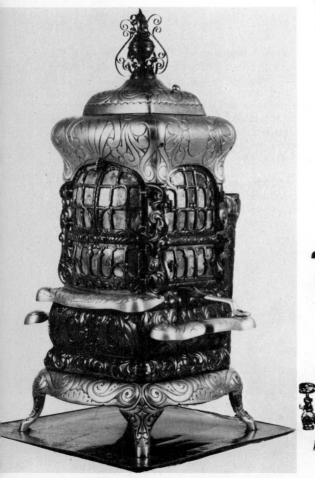

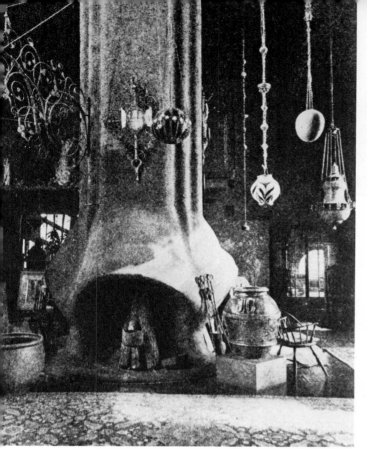

101 (left). Fireplace in Louis C. Tiffany's studio at the Seventy-second Street mansion in New York that belonged to his parents, designed by Tiffany in conjunction with McKim, Mead and White in 1885. (Photograph courtesy Dr. and Mrs. Robert Koch)

102 (below). Illustration from *The Decorator and Furnisher*. 1885. This hot-air furnace was the source of heat for the much-recommended "Sentry Central Heating System." (Private collection)

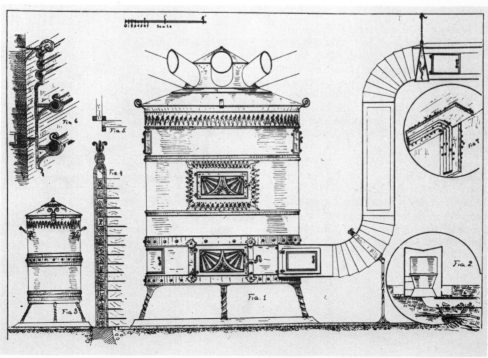

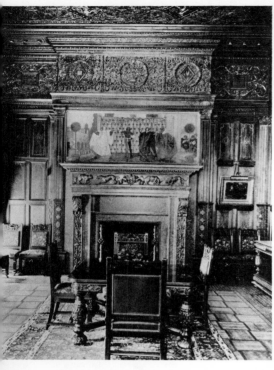

103 (above). Dining room of the Henry Villard residence, New York City. 1885. McKim, Mead and White were capable of working in many different historical styles. This elaborate interior was an attempt to take the best of them and combine them in a new way, thus creating a unique Victorian home. (The New-York Historical Society)

104 (right). Stove made by the Sill Stove Works, Rochester, New York. 1886. Iron. H. 46½". Colored glass tiles provide a decorative accent for the ornate surface. (Greenfield Village and Henry Ford Museum)

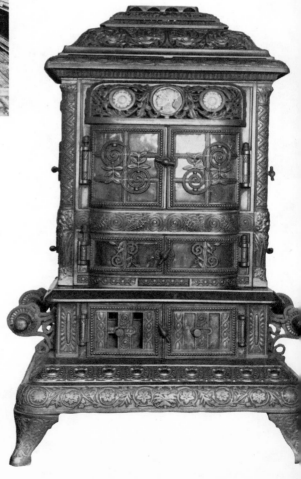

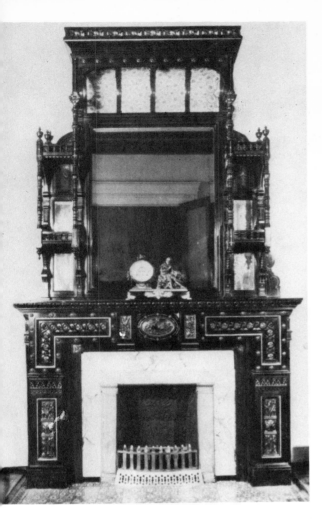

105 (left). Mantel and mirror overmantel from the Tompkins-Buchanan house, Louisville, Kentucky. 1880. They are executed with superb craftsmanship in ebonized wood, gilded leather, hand-painted tiles, and brass inlaid with copper. (Photograph courtesy Helga Photo Studio, Inc.)

106 (below). Stove made by the Danville Stove & Manufacturing Company, Danville, Pennsylvania. c. 1895. Cast iron. H. 51½". The potbellied stove was a familiar part of the furnishings of nearly every rural general store and post office during the late nineteenth century. This example was fitted with railings on which one could prop his feet for easy warming. (Greenfield Village and Henry Ford Museum)

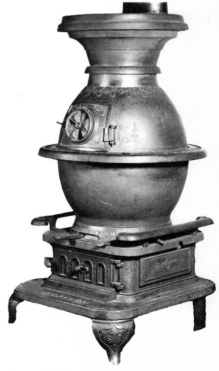

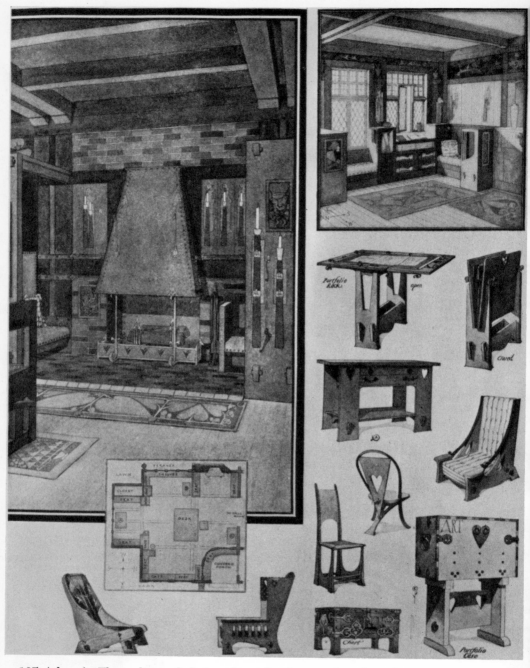

107 (above). Floor plan and designs for a fireplace, inglenook, and various pieces of furniture drawn by Will H. Bradley. Published in the *Ladies' Home Journal*. 1901 and 1902. Bradley was one of the few American designers who attempted to reconcile the Mission, the Arts and Crafts, and the Art Nouveau styles and at the same time to create a definite style of his own. (The New York Public Library)

108 (above). Fireboard covered with wallpaper. c. 1880. H. 39¼". The pictorial insert illustrates an elaborate home in what was probably considered to be the Tuscan style. (Greenfield Village and Henry Ford Museum)

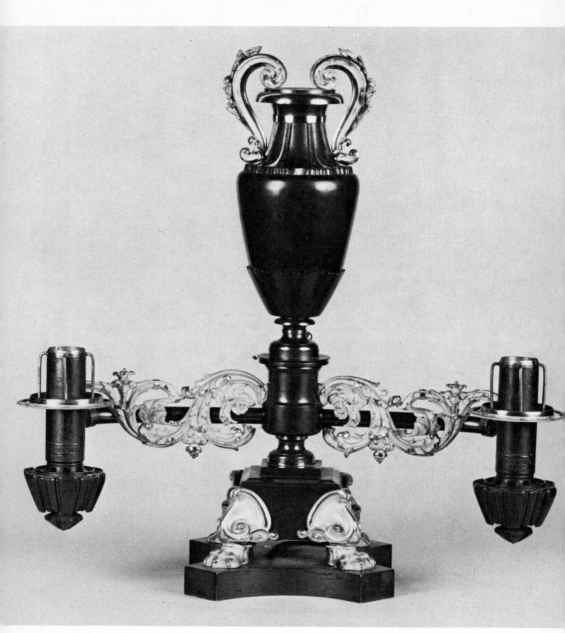

109 (above). Argand lamp labeled by Baldwin Gardiner, New York. 1835–1840. H. 17⅞". The center oil font is in the shape of a Greek amphora. It is possible to discern elements of early Rococo design in this piece. (The Metropolitan Museum of Art; Gift of John C. Cattus, 1967)

LIGHTING

In the earliest cultures the first form of artificial illumination was achieved by using natural objects. Shells and hollowed out stones served as lamps; animal, fish, and vegetable fats and oils provided the fuel for wicks made from bits of seaweed and other marine growths.

In Egypt, Greece, and Rome lighting devices were generally fashioned from clay. The addition of a spout and a handle made these pottery lamps more practical and abstract designs or overall patterns and scenes made them more attractive. By the third century A.D. metal spout lamps began to appear. To achieve increased illumination, lamps with multiple wicks and spouts were developed.

From the time of the great flowering of the classical cultures in the ancient world until well into the Victorian period, the history of lighting is devoid of real technological progress.

American versions of the earliest forms continued to be produced; Colonial alternatives to grease and fat lamps were few. In 1621 Edward Winslow, an early Colonist in America, wrote home to England advising future settlers to bring cotton yarn to use as wicks in their spout lamps.

Francis Higginson, another seventeenth-century immigrant, observed that although splints, tiny slices of thin wood held in iron holders, burned "clear as a torch," they were bothersome because their "fuliginous smoak" deposited a "pitchy kind of substance" wherever used.[1]

The Colonists cut rush in late summer or early autumn; while still green, it was stripped to a small spine and dried; subsequent immersion in tallow converted it into an illuminant. Rush could only be burned successfully at approximately a forty-five-degree angle. Most rush and splint holders, like the Betty or grease lamps, were fashioned from iron.

Lighting devices were designed to fit a variety of purposes. Short ones stood on tables, fireplace mantels, or specially designed stands that could be easily moved to light out-of-the-way corners. Tall, freestanding versions were less frequently made because metal was precious. Wall sconces and hanging devices were also developed to provide additional light.

The candle, like the rushlight, was based upon the principle of a wick coated with a solid fuel. Candles in Colonial America were expensive, and Benjamin Franklin, in his usual practical way, offered the opinion that the best approach to artificial illumination was to do without it. However, his axiom, "Early to bed, early to rise," expressed through the nom de plume Poor Richard, was not followed by many. By the mid-eighteenth century the demand for more adequate lighting caused the growth of a vast whaling industry. The sperm whale, the source for spermaceti, a white, waxy "head matter" consisting of esters of fatty acids, was avidly pursued. In 1749 spermaceti candles, although very expensive, were considered second to none.

Sperma-Ceti Candles, exceeding all others for Beauty of Sweetness of Scent when Extinguished and Duration being more than double with Tallow Candles of Equal Size and Dimension of Flame near 4 times more. Emitting a Soft easy Expanding Light, bringing the object close to the Sight rather than causing the Eye to trace after them, as all Tallow Candles do, from a Constant Dimnes which they produce. One of these Candles serves the use and purpose of 3 Tallow Candles, and upon the whole are much pleasanter & cheaper.[2]

Candlemaking developed into an important industry with markets both at home and abroad. The United Company of Spermaceti Chandlers, formed in 1761, included manufacturer-members from Boston, Newport, and Providence. This highly successful trade combine dominated production until the Revolution drove whaling ships from the oceans. During the second, third, and fourth decades of the nineteenth century some five hundred whaling voyages were made in renewed efforts to seek out the whale and extract his precious oils for the marketplace. Despite the introduction of numerous alternatives to the candle during the Early Victorian period, it remained the primary source of artificial light in American homes until the introduction of kerosine about 1860.

Soon after the Revolution, the candle and candle holder were used in new ways. They were placed in hanging glass lamps with cut or engraved designs. These pieces, most often used in hallways, were usually brass or bronze mounted. A glass bell often protected the ceilings from smoky residue. Well-to-do homeowners placed elaborately decorated hurricane shades over candles to prolong their burning in drafty parlors and dining rooms. Because candles were so expensive, a chandelier was a luxury that few Americans chose to afford. "In 1793 a theatre in Federal Street, Boston, lighted by '3 glass chandalears,' . . . consumed 56 pounds of spermaceti and tallow candles each night." [3]

During the early part of the nineteenth century elegant brass or glass chandeliers were nearly always imported. On occasion, however, rural blacksmiths fashioned domestic examples of modest design. Despite their exorbitant cost, even after the introduction of inexpensive kerosine, chandeliers lighted by candles continued to be used.

By the opening of the nineteenth century candlewicks were greatly improved; braided cotton provided a trim-free wick that is still popular today. In time, fuels also improved; beeswax, vegetable and berry waxes, and animal and whale fats were replaced by an extraction of stearine that produced a relatively smoke-free, odorless, bright flame.

When Benjamin Franklin and Thomas Jefferson returned from Paris in the late 1780s, they brought to America several Argand lamps, which dramatically altered the possibilities of artificial illumination. Aimé Argand (1755–1803), a Swiss inventor, first marketed his newly developed lighting device around 1783. The innovational design of the burner allowed air to circulate to both the inner

and the outer surface of a tubular wick. Glass chimneys improved combustion, thus providing a quantity and quality of light previously unobtainable. Some models of the Argand had elevated fuel containers that fed oil to the wick. These produced little smoke, satisfying even the most particular late-eighteenth-century housewife.

Argand lamps were used over an extended period of time. Robert Michael Ballantyne recalled a Christmas dinner of 1843, ". . . this was quite a snug and highly decorated apartment. True, there was no carpet on the floor, and the chairs were home-made; but then the table was mahogany, and the walls were hung round with several large engravings in bird's-eye maple frames . . . [the room] was illuminated by an Argand lamp, and the table covered with a snow-white cloth . . ." [4]

The astral or sinumbra (without shadow) lamp, first developed in France, was perhaps the most popular version of the Argand in America during the 1830s and 1840s. This lamp had an oil font that formed a ring about the burner. A glass shade minimized shadows. Dietz, Brother & Company, a general manufacturer of lamps and lamp parts located at 13 John Street, New York City, and 62 Fulton Street, Brooklyn, in an 1845 advertisement touted their various wares, which included "Improved camphene lamps, solar lamps, girandoles, hall lamps and lanterns, astral and solar shades . . ." [5] It seems curious that even though gaslights and fixtures had been in general use for about twenty-five years none is mentioned.

Argand-type lamps continued to be popular throughout the nineteenth century and many of the brass "student lamps" of the 1880s and 1890s were fitted with similar burners.

Many believed that gas provided a viable substitute for candles and burning fluids, and in 1796 experiments with this form of illumination were made at Philadelphia. By 1816 a company had been organized for the distribution of gas at Baltimore and during the late 1820s many cities across the nation converted streetlights to utilize this easily regulated illuminant. Despite its frequent use in public places, gas for a long period of time was considered ill-suited for domestic lighting.

Edgar Allan Poe, complaining in 1840, found gas "totally inadmissible within doors. Its harsh and unsteady light is positively offensive . . . no man having both brains and eyes will use it." [6]

Not everyone agreed. Mrs. A. W. Smith's parlor in her Philadelphia boardinghouse in 1853 was lighted by a gas lamp that stood on a table with cast-iron supports similar to those used on sewing machines. A rigid pipe projecting from the wall supplied the fuel for the lamp in this thoroughly middle-class room. By the third quarter of the century gas had gained a prominent position as a source of illumination. An unidentified "tastemaker" in The Art Journal in 1877 joyously reported, "Probably there is nothing in the wide range of our American Art-industries which has been so rapidly developed during the last ten years as that of metal-work, and as evidence of it we take great pleasure in calling atten-

tion to the accompanying illustrations of gas-fixtures, which are after designs executed by Messrs. Mitchell, Vance and Co., of New York . . . In the manufacture of gas-fixtures, perhaps, more than any other department of metal Artwork, the designs have become more and more skilful and elaborate until it would appear as if the genius of the designers was almost exhausted." [7]

Even after electricity had been successfully introduced, gas continued to enjoy popularity in the Midwest. Annie R. White, Chicago social advisor during the 1890s, indicated the duties of a hostess toward a houseguest. "Do not forget a small basket for scraps of paper and combings of hair. This should be emptied every morning. And the match-box—keep it filled. What a lovely feeling it will give, if you are restless and wish to rise; you try to light the gas, and there are no matches to be found. The careful hostess will look to it that all these simple details are attended to." [8]

Many collectors of American lighting devices and lamps have focused upon patent lamps because they can be documented relatively easily. The Franklin Institute in Philadelphia, beginning in 1826, lists patents awarded each month. The *Patent Office Report* supplies descriptions of every patent issued between 1848 and 1871. The *Patent Office Gazette* offers the same material for patents issued after 1871. Anyone who owns a lamp marked with a name, date, and patent number can obtain copies of the original patent papers from the Office of the Commissioner of Patents at Washington, D.C.

The Argand lamp of 1784 was closely followed by a lamp patented in 1787 by John Miles of Birmingham, England. This "agitable lamp," with a totally enclosed font and central wick supported by a tube and flange burner, prevented the fuel from easily spilling. American patents included such unusual devices as Prentice Sargent's "improvement in lamps for burning rosin oil," [9] developed in 1856 and the Star Tumbler Lamp, patented on July 13, 1875, which consisted of an ordinary drinking tumbler fitted with a small tin lamp and hinged tin chimney.

The popularity of whale-oil lamps during the first half of the nineteenth century created a market that gave new impetus to the whaling industry. Whale oil became one of the most favored types of lighting fuel in America. Many infringements upon the Miles patent brought to the consumer new types of whale-oil burners. Joseph Howe, advertising in the *Columbian Centinel*, Boston, in 1800, offered "AGITABLE LAMPS, Which are so constructed as to prevent the oil from spilling, although the lamp should be overturned, or thrown in any direction; made after the much approved ones called 'Miles' Patent Lamps,' and warranted to be equal to them in every particular." [10]

Whale-oil lamps, whether tin, pewter, brass, silver, or glass, are all fitted with metal wick tubes that project about one-quarter of an inch above the lamp and extend approximately one inch into the font. The wick is adjusted through a small slot in the wick tube. Many whale-oil lamps have but one wick tube; the majority, however, have two. Nearly all lamps fitted with whale-oil burners could utilize almost any lighting fuel and in Europe, where whale oil was very expensive, many people substituted vegetable oils.

The ever-increasing demand for lamps and lighting devices greatly affected the glass industry. Most of the earliest glass lamps are blown or blown-in-a-mold. When lacy pressed glass became popular for tableware, it was also utilized for lamp production. Lamps with free-blown fonts and stems were often mounted on lacy cup plate bases that had been made especially thick to provide added stability.

By the mid-nineteenth century an extensive variety of burning fluids had been patented as the result of far-reaching efforts to increase the efficiency of artificial illumination. A burning fluid nearly always contained alcohol and camphene in varying proportions. Naphtha and benzine, both highly volatile, occasionally were included in the formulas for burning fluids. At this time many new types of burners were developed and manufactured to replace whale-oil burners in existing lamps. The new burners had tall tapered tubes that did not project far down into the burning fluid, as they had done on whale-oil burners. The tubes were splayed at the top when there were multiple wicks. Small metal caps prevented evaporation of the fuel.

Lard and lard oil competed with whale oil and burning fluids as a lamp fuel during the mid-nineteenth century. Because it was inexpensive and easily obtained, lard oil was especially popular in rural areas. Lard-oil lamps were infinitely more successful in the warm climates of the South than they were in the North where it was necessary to incorporate into the design of the burners special heat conductors to liquefy the lard oil. The wicks on lard-oil lamps were usually flat and wide; occasionally they were of the tubular Argand type.

Almost immediately after the discovery of petroleum deposits in western Pennsylvania in 1859, kerosine came into general use. For the first time it was possible to achieve clean, efficient, and inexpensive artificial lighting. Kerosine, because of its light weight, was capable of climbing a long wick through capillary action. The initial American patent for a kerosine lamp was granted in 1859. That same year an additional forty patents were processed and granted. Almost overnight the kerosine lamp became an integral part of the American home. The kerosine era, terminating about 1900 in urban areas, extends to today in Appalachian Mountain dwellings and in the isolated Penitente villages of New Mexico and Arizona.

Between 1860 and 1870 some 2,000 patents pertaining to lighting inventions and improvements were granted by the United States Patent Office. This seemingly large number in a single decade is even more impressive when we realize that there were only 556 patents issued for lighting devices between 1790, when Joseph Sampson secured a patent for the manufacture of candles, and 1860.

Through the years lamps with a special purpose were developed. Parade torches in the shape of rifles, patriotic eagles, and stars gave light to political campaigns and rallies. Special lanterns for railroad signaling were developed. Coaches, buggies, bicycles, and finally the automobile were fitted with lanterns to illuminate the way along rutty dirt roads. Maritime lights with gimbal mountings were developed to insure constant, uninterrupted light aboard ships, even in the roughest sea. Travelers could equip themselves with small personal

lights in the form of folding candlesticks, folding lanterns, and folding lamps. The Ready Light firm at Portland, Maine, in 1885, patented a tin pocket case containing four "self-lighting" candles with wicks terminating in match heads.

Lights to work by, lights to go to bed by, even lamps fitted with a chimney-top heater for irons with which to curl milady's hair—all are part of the story of Yankee ingenuity and the struggle to improve the American way of life through invention.

No single development has had such far-reaching consequences as Edison's perfection of the incandescent lamp. On New Year's Eve 1879, he gave a demonstration of practical electricity in Menlo Park, New Jersey, where he lighted not only the many buildings in his Menlo Park compound, but also a boarding-house kept by Mrs. Sarah Jordan. This house, where several members of Edison's staff lived, achieved recognition as one of the first homes in America to be lighted by the newly perfected electrical system.

Although the architecture at the 1893 World's Columbian Exposition in Chicago looked to the past and did much to promote historical revivalism, the fair also served as a herald for the modern age of electricity. True, a few cities had already installed electric streetlights and the electric trolley was a familiar sight to some, but for most Americans electric light was only something they had read about in newspapers.

Most of the exhibits relating to electricity were contained in the Electricity Building, which *Shepp's World's Fair Photographed* claimed was "one of the richest looking structures on the grounds." The building was especially constructed to provide a dramatic display for electricity. Over 24,000 incandescent and nearly 4,000 arc lights were included in the exhibits of both America and foreign countries. The Electricity Building was also lighted on the outside. Eight thousand arc lamps of over 2,000 candlepower and about 130,000 incandescent bulbs of 16 candlepower were used. The single greatest spectacular effect probably was created by flashing lights in the tall towers on the grounds. The exterior was given historical perspective by a colossal statue of Benjamin Franklin, his face turned upward, his hand holding the key with which he drew electricity from the sky. An entry in the Shepp's catalogue provides a verbal tour:

> We enter the building, and our first impression is of its vastness, for here are buildings, each of considerable size, within it. Before us is a Greek temple resembling the Erechtheum at Athens, guarded by two winged sphinxes, reminiscences of ancient Egypt. We pass up the steps, and enter a cool hall, on the sides of which we see photographs of the principal telegraph buildings of the world; the wings of the building also contain an exhibit; without, is a pillared court, and fountains on either side lead us, for a moment, to forget that we are in one of the most remarkable buildings of the world. Before us spreads a long vista of machinery; to the left is an

electric car, complete in all its appurtenances, and in the centre is a brilliantly-lighted revolving pavilion with a high tower, also crowned with a globe of light. The two ends of the structure are ornamented with great stars, plaques and shields, in electric lights that scintillate every moment, now faint and dim, now bright as the noonday sun. We know that everything here is for use, and that the dominating idea is a commercial one, yet all is beautiful; each machine seems to be tended lovingly by affectionate hands, and shines with gratification. What electricity cannot do would be easier to state than what it can do.[11]

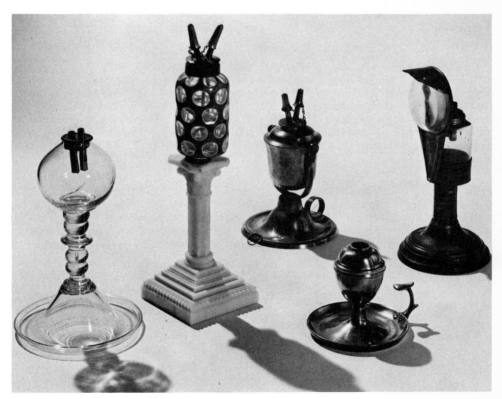

110 (above). Whale oil and camphene lamps. *Left to right:* Clear blown glass made by the Boston and Sandwich Glass Company, Sandwich, Massachusetts, 1830–1840, H. 8½″, double whale-oil burner; rose and white overlay glass peg lamp, c. 1850, H. 12½″, brass camphene burners with pewter caps; pewter table lamp with font held on copper pins, 1840–1850, H. 7″, camphene burners with pewter caps, brass ring for wall hanging; brass table lamp with lemon-shaped font, 1830–1850, H. 3¾″, saucer base with finger grip; tin table lamp, 1835–1850, H. 9¼″, heavy cast-iron base supports tin shaft and attached glass bull's-eye lens, separate clear blown-glass reservoir with double whale-oil burners. (Greenfield Village and Henry Ford Museum)

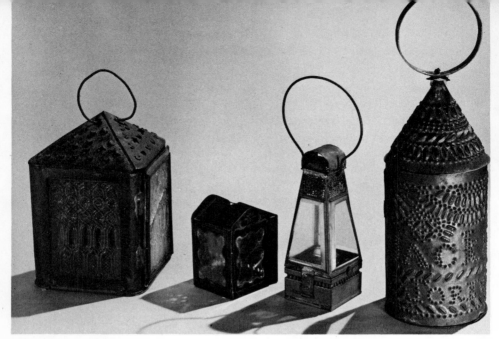

111 (above). American lanterns. *Left to right:* Tin, 1830–1840, H. 9¾", pierced top with ring handle, hinged door, one panel set with clear pressed-glass pane with Gothic design, candle socket; folding pocket lantern of stenciled tin, marked "Minor's Patent, Jan. 24th, 1865," two panels filled with isinglass, hinged back has compartments for candles and matches; tin, 1860–1875, H. 12¾", four panels of beveled glass, removable tin kerosine lamp; pierced tin, c. 1830, H. 17¼", hinged door, socket for candle, geometric piercing with inscription, "Jackson Forever." (Greenfield Village and Henry Ford Museum)

112 (below). Candelabra. 1840–1860. Bronze and marble. H. of the center piece 17". The gilded bronze figures of an elegantly dressed woman and child gathering grapes are mounted on a rectangular marble block. Cast sockets ornamented with leaves are surrounded by an oval latticework ring of morning glories from which hang triangular glass prisms. (Greenfield Village and Henry Ford Museum)

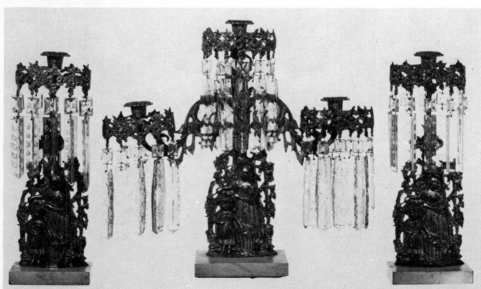

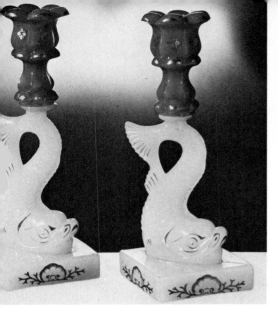
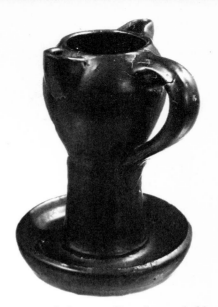

113 (above, left). Dolphin-shaped, blue-and-white pressed-glass candlesticks, probably made at the Boston and Sandwich Glass Company, Sandwich, Massachusetts, 1840–1850. H. 10⅜". (The Metropolitan Museum of Art; Bequest of Anna G. W. Green)

114 (above, right). Pottery grease lamp made by S. Routson, Doylestown, Ohio. c. 1840. H. 6⅛". At the same time that elegant East Coast homes were being lighted by expensive and beautiful lamps and candles, many frontier dwellings were illuminated by rather crude, smoky grease lamps. (Greenfield Village and Henry Ford Museum)

115 (below). Glass lamps with pressed bases and blown fonts. Probably from the Boston and Sandwich Glass Company, Sandwich, Massachusetts. 1840–1850. H. of the center lamp 10". All three of these lamps were made to burn whale oil and are of the early variety that used a single burner held in place by a cork. Classical motifs are incorporated into the pressed lacy bases. (Richard A. Benizio)

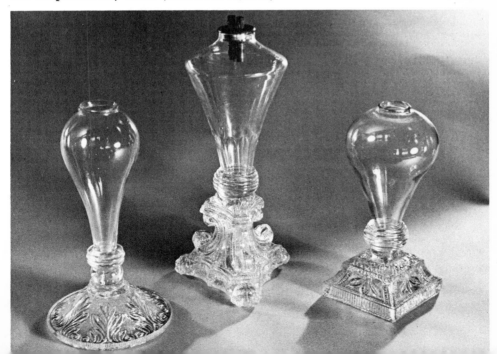

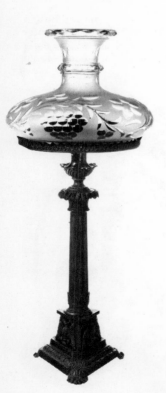

116 (above, left). Betty lamp made by Peter Derr, Berks County, Pennsylvania. 1848. Brass, copper, and iron. H. 9½″. (Greenfield Village and Henry Ford Museum)

117 (below, left). Sinumbra lamp. 1840–1845. Brass and glass. H. 25½″. The frosted shade is beautifully decorated. (Greenfield Village and Henry Ford Museum)

118 (below, right). Advertisement for Dietz, Brother & Co., located at 62 Fulton Street, Brooklyn, and 13 John Street, New York. c. 1845. The Dietz firm produced nearly every type of lighting device popular at the time. (Private collection)

119 (opposite, above). Grease and lard lamps. *Left to right:* Grease lamp, stamped on font supports "1855" and "P.D." for Peter Derr, Berks County, Pennsylvania, H. 10″; tin lard lamp on cast-iron base, stamped "SN and HC Ufford/117 Court St./Boston/Kinnears/Patent/Feb. 4, 1851"; tin grease lamp with iron plunger for forcing fuel from reservoir into font, stamped on plunger "I. Smith," patented August 8, 1854. (Greenfield Village and Henry Ford Museum)

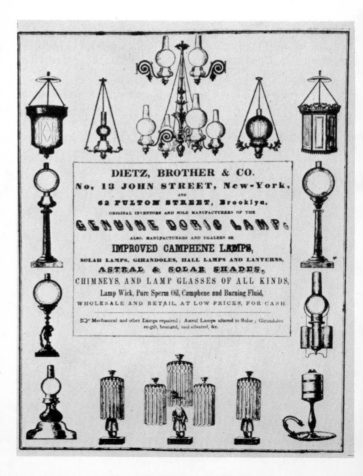

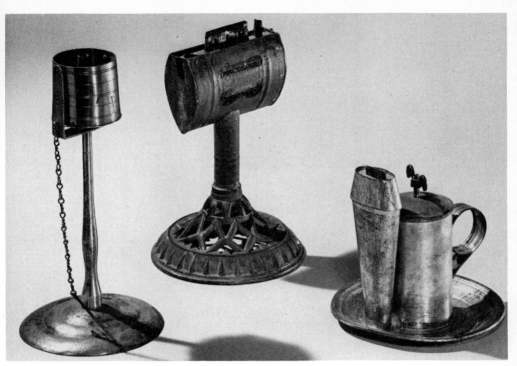

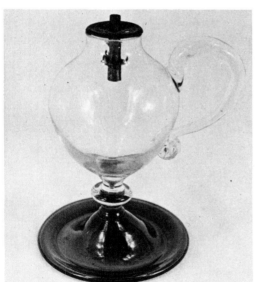

120 (above). Free-blown glass hand lamp. c. 1850. H. 5". The applied handle provides a convenient way of carrying this small chamber lamp, which has a cobalt-blue base. (The Rushlight Club)

121 (right). Presentation hand lantern. New England. c. 1850. Brass and glass. H. 16½". The clear glass chimney is decorated with engraved floral motifs and the name "J. D. Leland." (Greenfield Village and Henry Ford Museum)

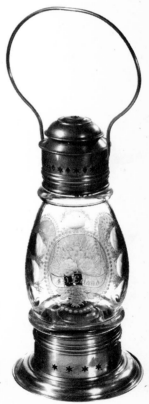

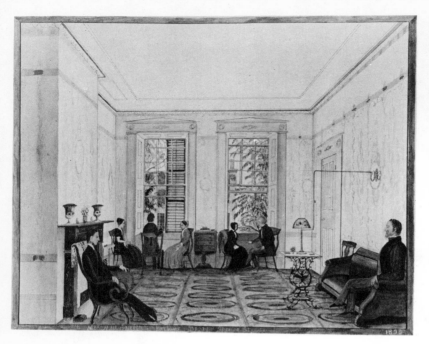

122 (left). Water-color of *Mrs. H. W. Smith's Parlor, Broad & Spruce Streets* by Joseph Shoemaker Russell. 1853. W. 10¼". A stand with a cast-iron base similar to that found on sewing machines supports a gas lamp that is fueled by a rigid pipe projecting from the wall. (Private collection)

123 (below). Kerosine lamp of pressed cobalt-blue glass. c. 1860. H. 9¾". These elaborate lamps were made about the time of the Civil War. They generally burned kerosine and were fitted with a glass chimney and shade. (Richard A. Benizio)

124 (below). Whale-oil lamp with marble base and opaque starch-blue glass font in the Star and Cable design. Attributed to Boston and Sandwich Glass Company, Sandwich, Massachusetts. c. 1860. H. 11". The design of this lamp commemorates the laying of the Atlantic Cable. (Richard A. Benizio)

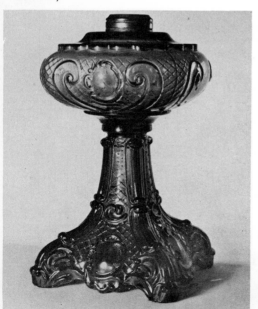

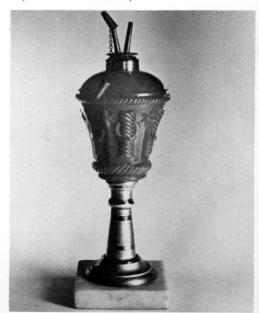

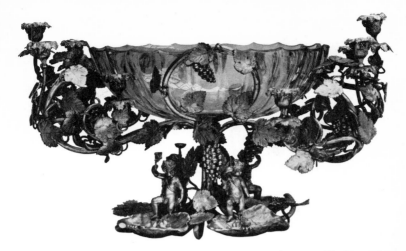

125 (above). Centerpiece for a table. 1855–1865. Gilt bronze. H. 22″. This elaborate table decoration, which is a splendid example of the Rococo Revival style, includes candle sockets on either side of the crystal bowl. (The Metropolitan Museum of Art; Gift of Mrs. F. Carrington Weems, 1955)

126 (below). Drawing room in the Victoria Mansion, Portland, Maine. 1859. This sumptuous house, one of the most beautiful to remain intact, contains nearly all its original furnishings. The drawing room has an especially handsome gas chandelier. (Victoria Mansion)

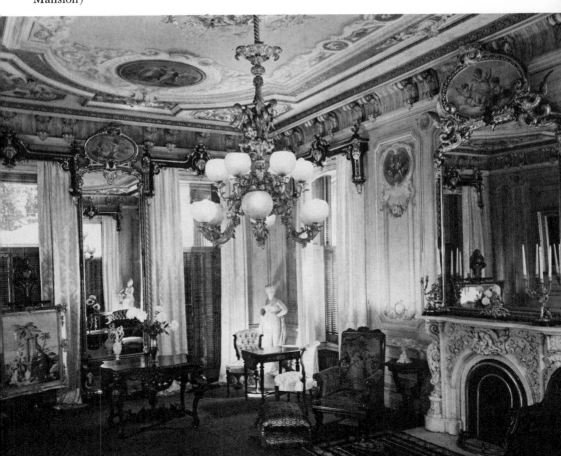

127 (above, left). Campaign parade torch. New England. c. 1850. Brass. Overall L. 32". Campaign torches were manufactured in a variety of forms and were generally intended to be carried on long sticks at parades and political gatherings. Usually they were made from tin or brass. (Greenfield Village and Henry Ford Museum)

128 (below, left). Overlay lamp made by the Boston and Sandwich Glass Company, Sandwich, Massachusetts. 1867. H. 19". Opaque white glass was laid over ruby glass and then cut away to produce this elegant piece, which was given to William E. Kern as a reward for his achievements in working with the process for combining white and ruby glass. (The Metropolitan Museum of Art; Funds from various donors, 1967)

129 (below, right). Kerosine lamp made by the Boston and Sandwich Glass Company, Sandwich, Massachusetts. 1875. Bronze and glass. H. 24½". Gothic motifs abound on the font of this graceful lamp. (Greenfield Village and Henry Ford Museum)

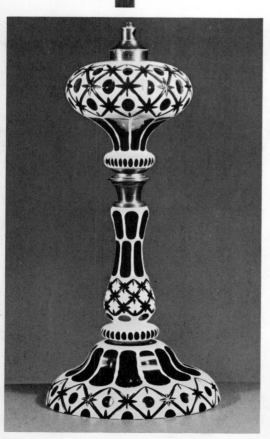

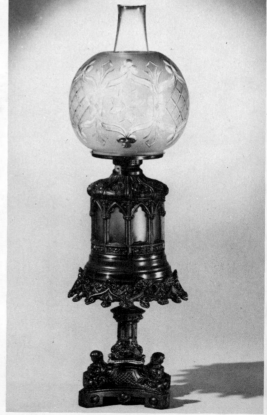

130 (above, right). Chandelier manufactured by Cornelius & Sons, Philadelphia, Pennsylvania. Illustrated in *Masterpieces of the Centennial Exposition, 1876* by Professor Walter Smith, published by Gebbie & Barrie, Philadelphia, 1875. This elaborate 72-light chandelier was gilded and was considered to be in the Greco-Medieval style. (Private collection)

131 (below, left). Traveling lantern manufactured by John Stevens, Orange, New Jersey. 1875. H. 5¾". Many traveling lanterns were collapsible. This version has a small access door and an extendable thumb wheel that permit lighting and adjusting without disassembly. (The Rushlight Club)

132 (below, right). Incandescent lamp made at Edison's Menlo Park Laboratory, Menlo Park, New Jersey. 1879. "The Wizard of Menlo Park" experimented with several different filaments before he finally achieved a fully operative incandescent lamp. The filament in this lamp was made from bamboo. (Greenfield Village and Henry Ford Museum)

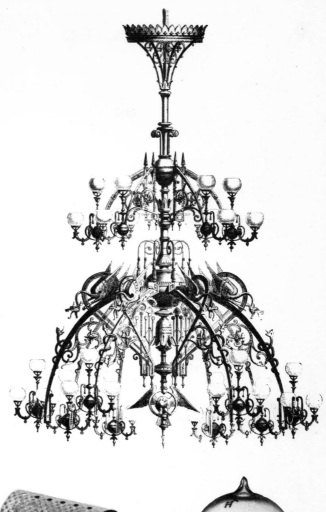

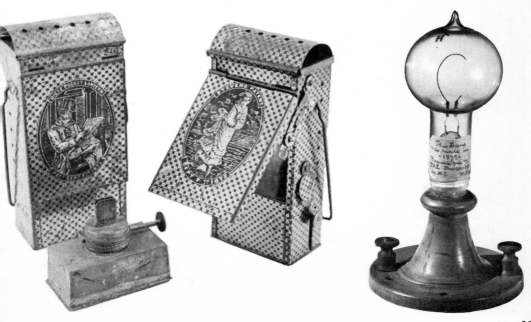

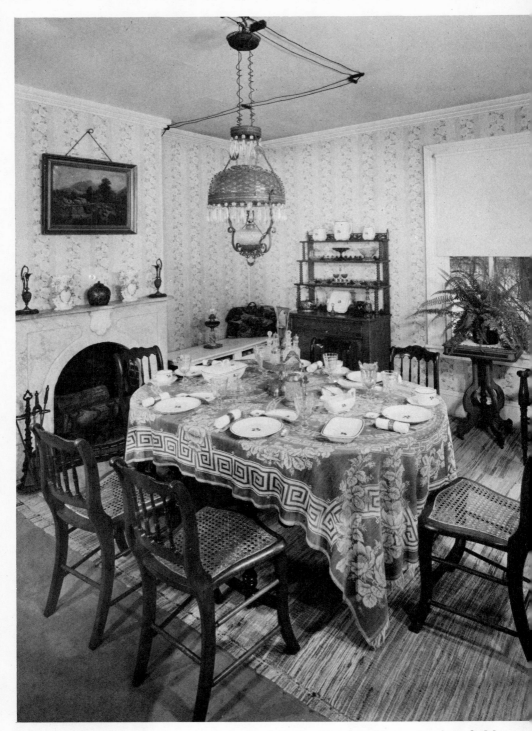

133 (above). Dining room of the Sarah Jordan Boarding House. An electrified kerosine chandelier is attached to the exposed wiring. (Greenfield Village and Henry Ford Museum)

134 (right). Front page from the January 3, 1880, edition of *The Daily Graphic*. This New York newspaper carried illustrations of the first public demonstration of Thomas Edison's electrical engineering system, which subdivided electricity into heat, light, power, and communication. This presentation was viewed on New Year's Eve 1879 by 3,000 special visitors at Menlo Park, New Jersey. (Greenfield Village and Henry Ford Museum)

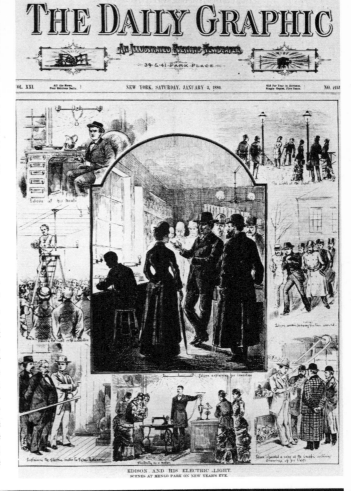

135 (below). Candelabra, probably made as a special order by T. G. Hawkes and Company, Corning, New York. c. 1885. H. 11^{11}⁄$_{16}$″. These brilliant-cut pieces are in the Russian pattern, a refinement of the older Star and Hobnail pattern. The name is derived from the fact that a huge banquet service was ordered for the Russian Embassy in Washington shortly after the pattern was introduced. (The Metropolitan Museum of Art; Edgar J. Kaufmann Charitable Foundation Fund, 1969)

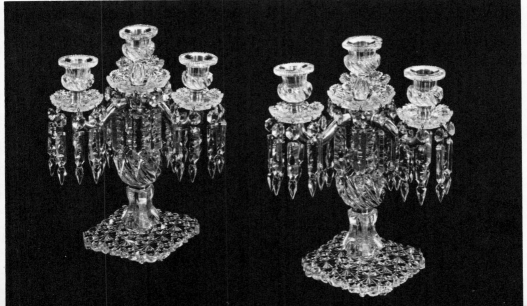

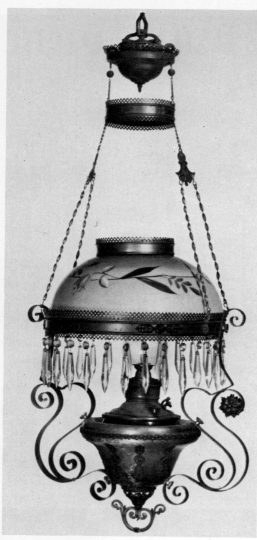

136 (above, left). Hanging lamp. 1890–1900. Overall L. of lamp with chain 42″. This type of inexpensively produced lighting fixture was used in virtually every American home of modest pretension. Because so many were produced, they abound in antique shops today. (Greenfield Village and Henry Ford Museum)

137 (below, left). Student lamp marked "Berlin." Late nineteenth century. H. 20¼″. Student lamps were especially useful for desks because they not only rotated but also were vertically adjustable on a tall central shaft. (The Rushlight Club)

138 (below, right). Pendant double angle lamp. c. 1890. Nickel plate, glass. H. 14″. Angle lamps are fueled through a central reservoir that feeds two, and in some examples three or even four, angle burners by the Cardan principle. The angle burner, aided by a reflecting chimney and clear glass bowl, produced a shadowless light that made it ideal for stores, offices, and public areas. Some angle lamps were manufactured to be mounted on the wall. (The Rushlight Club)

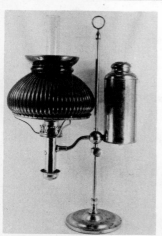

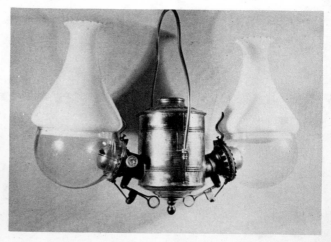

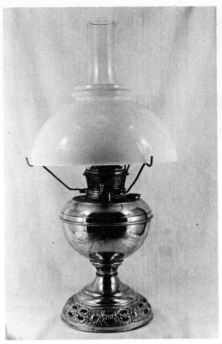

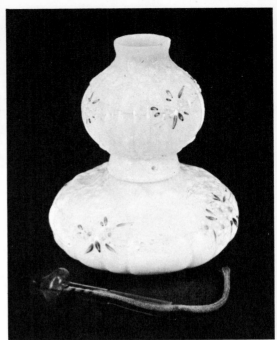

139 (above, left). Parlor lamp labeled "B & H." c. 1890. H. 21". Near the end of the Victorian period nickel-plated brass became popular for utilitarian, inexpensive table and study lamps. Opal reflecting shades reduced glare and helped to distribute light over a wide area. (The Rushlight Club)

140 (above, right). Glow lamp patented August 27, 1895. Milk glass with painted flowers. H. 5". The glow lamp, like a fairy lamp, was a miniature night-light. They were designed to provide a soft illumination. (The Rushlight Club)

141 (below, right). Tiffany Favrile glass and gilt bronze lamp. The shade is impressed "Tiffany Studios, New York." 1899–1920. H. 54". This lamp and table, one of a pair, were originally part of the furnishings of the Manhattan Hotel, New York City. The lamp has a dome shade composed of radiating bands of green glass tiles enclosed by gilt bronze banding. (Sotheby Parke Bernet Inc.)

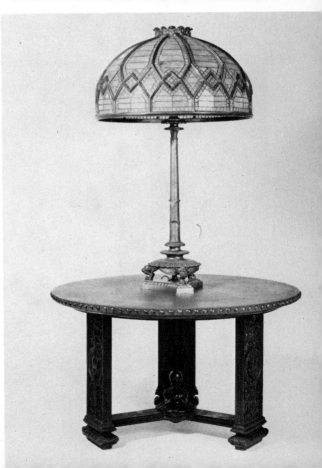

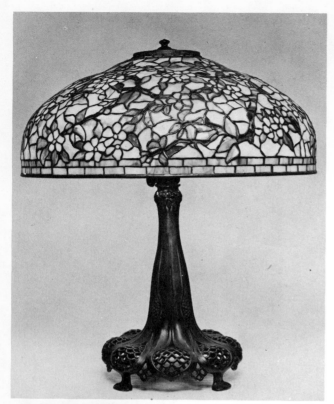

142 (left). Cherry blossom lamp. Both the shade and the base are impressed "Tiffany Studios, New York." 1899–1920. Favrile glass and bronze. H. 29". The overall pattern on this handsome shade is one of cherry blossoms and foliage in tones of green, white, and pink against a mottled blue fractured-glass ground. (Sotheby Parke Bernet Inc.)

143 (below). Student lamp with green-and-white overlay shades. c. 1900. Bronze. W. 21". This handsome piece is perhaps one of the most beautiful of its kind. (Greenfield Village and Henry Ford Museum)

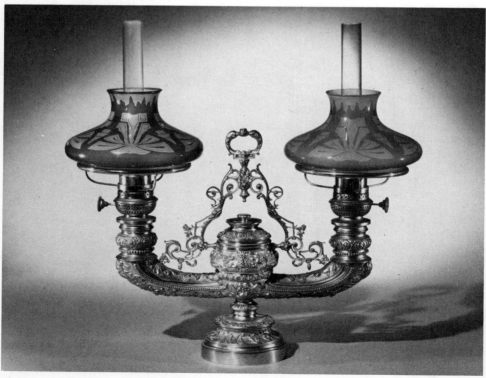

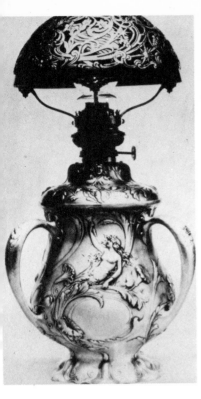

144 (above left). Martele silver kerosine lamp from a Gorham Manufacturing Company trade catalogue. c. 1900. The Martele pieces were hand-finished and represent top-of-the-line products. (Private collection)

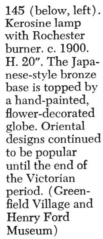

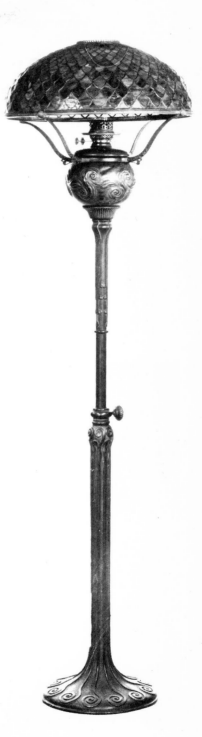

145 (below, left). Kerosine lamp with Rochester burner. c. 1900. H. 20″. The Japanese-style bronze base is topped by a hand-painted, flower-decorated globe. Oriental designs continued to be popular until the end of the Victorian period. (Greenfield Village and Henry Ford Museum)

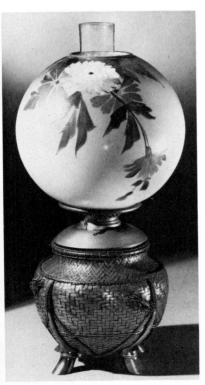

146 (right). Adjustable floor lamp by Tiffany Studios, New York. c. 1900. Bronze. H. 74½″. This handsome lamp with a telescoping shaft was fitted with a double-wick burner to provide more light. (Greenfield Village and Henry Ford Museum)

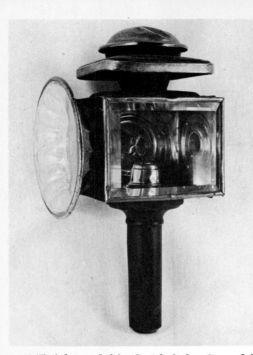 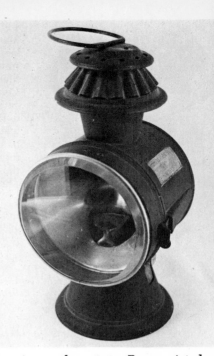

147 (above, left). Coach light. Second half of the nineteenth century. Brass painted black with nickel-plated trim. H. 12″. The earliest coach lights were spring-loaded candle holders. (The Rushlight Club)

148 (above, right). Buggy light manufactured by the White Manufacturing Co., Bridgeport, Connecticut. c. 1880. H. 11″. The cylindrical-shaped body of this kerosine lamp served as a prototype for later automobile lamps. (The Rushlight Club)

149 (below). Bronze candelabra attributed to Tiffany Studios, New York. Favrile glass and bronze. c. 1900. H. 15″. The upper portion of the decorative center shaft is fitted with a snuffer that can be removed to extinguish the candles. (Sotheby Parke Bernet Inc.)

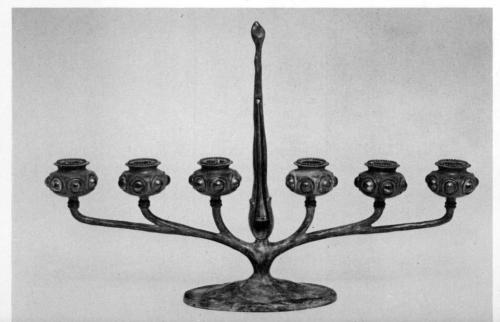

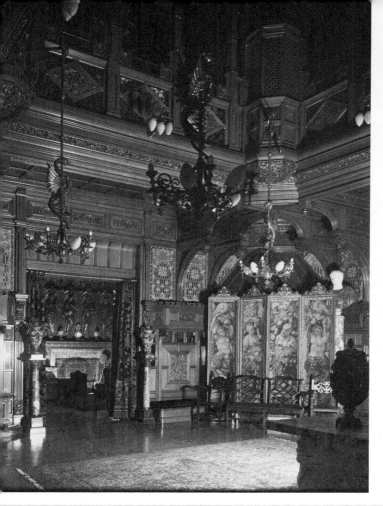

150 (left). Stair hall in the Potter Palmer residence built at 1350 Lake Shore Drive, Chicago, Illinois, in 1885. During the 1890s ornate brass and wrought-iron chandeliers with fantastic dragons and sea serpents were especially popular. Many of these lighting fixtures originally burned gas and during the later part of the decade were converted to electricity. (Chicago Historical Society)

151 (below). Exterior of the Electricity Building at the World's Columbian Exposition, Chicago, Illinois, 1893. Illustrated in *Shepp's World's Fair Photographed* by James W. and Daniel B. Shepp. This building housed the many electrical displays that gave rise to the statement, "What electricity cannot do would be easier to state than what it can do." [1] (Private collection)

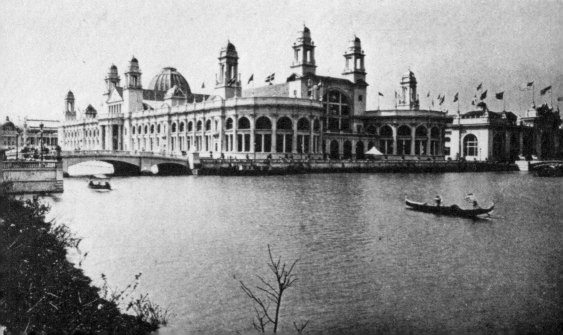

152 (above). Portrait of Jane Rebecca Griffith. Painted by Oliver Tarbell Eddy (1816–1848). 1835–1840. Oil on wood panel. H. 33⅜". When the Victorian period opened, the pillar-and-scroll style had been popular for nearly a decade. Most large pieces of furniture made in this style were constructed of pine and finished with an elegant mahogany veneer. Chairs and other small pieces were generally made from solid wood. (Maryland Historical Society)

FURNITURE

Throughout the entire American Colonial period, with relatively few exceptions, furniture designs were based upon English prototypes emanating from London. To be sure, the Spanish in the Southwest, the Dutch in the Hudson River Valley, the French to the north and down the Mississippi River Valley, the Germans in Pennsylvania, and the Swedes in the Delaware River Valley all attempted to transplant European life-styles to the New World. Their success, however, was limited to a brief flowering followed by an extended period of dissolution as social pressures caused them to adopt English modes of living, including costume and household furnishings.

By the 1760s the designs of Thomas Chippendale (1718–1799), a London cabinetmaker, were freely copied and adapted by Colonial craftsmen in both northern and southern cities. *The Gentleman and Cabinet-Maker's Director* (1754) illustrated furniture in the Chinese, the Gothic, and the "Modern" or French Rococo taste. Chippendale's designs were not innovational; they merely recorded the most popular English styles.

In London during the late eighteenth century the solid, ornately carved, mahogany pieces favored at mid-century were gradually replaced by more delicate, richly veneered and inlaid pieces. The inspiration for much of this furniture, with its elegant, slender lines, can be traced to the work of Robert Adam (1728–1792). During and after the 1760s he often used the Greek key, guilloche, and cameolike medallions as decoration on furniture. Adam utilized motifs borrowed from ancient Greece and Rome to create a fashion for the "classical" style.

Adam's designs were adapted for wide public use by George Hepplewhite (d. 1786) in *The Cabinet-Maker and Upholsterer's Guide of 1788* and by Thomas Sheraton (1751–1806) in *The Cabinet Maker and Upholsterer's Drawing Book of 1791–1794.* Just as Chippendale's *Director* had dominated American furniture design from about 1755 through 1790, the effects of Sheraton's and Hepplewhite's efforts permeated every cabinetmaking establishment in the new nation from about 1790 through 1800.

A second wave of classicism swept the American nation during the opening years of the nineteenth century when Paris replaced London as the source of inspiration for American cabinetmakers. French craftsmen became familiar with furniture used by the Greeks and Romans by studying the vase paintings and artifacts excavated at ancient sites. They borrowed the Greek klismos shape with the incurved saber leg and the curule chair with a cross-base support. The monopodia, winged caryatids, griffins, mermaids, and numerous animal forms became often-used features on lavishly carved Empire furniture.

A final phase of classicism occurred between 1830 and 1850 when, once again following the French lead, American furniture makers made the pillar-and-scroll style popular. Pieces in this style were ample in scale and notable for their broad, plain, veneered surfaces. Flattened-vase, C-scroll, and S-scroll pedestals

and feet echoed the ogee and cyma curves that appeared on drawer fronts and on the doors of case pieces.

At this time the power machine, which for many years had been only tentatively employed in the manufacture of furniture, became the style dictator in industrialized nations. During the first quarter of the nineteenth century few machines being used for the production of American furniture were of domestic manufacture; most were imported from England, where sometime after 1791 Jeremy Bentham, at Queen's Square Palace, Westminster, maintained a business fully entitled "to the distinction of being called the first general factory of such machines." [1]

The Bentham establishment "constructed machines for all general operations in wood-work, including planing, moulding, rebating, grooving, mortising, and sawing, both in course and fine work, in curved, winding, and transverse directions, shaping wood in complicated forms . . . so that nothing remained to be done by hand but put the component parts together." [2]

Between 1825 and 1850 Yankee ingenuity developed for America a preeminence in the science of designing and manufacturing of woodworking machinery. In fact, by 1844 William Furness of Liverpool, England, imported from the United States and patented in England most of the machines being made by C. B. Rogers and Company. At the Great Exhibition at the London Crystal Palace, "The performance of the 'wood framed' American machines was such as to create astonishment." [3]

Between 1835 and 1850 the American manufacturing community developed an entirely new system of woodworking machines that were more productive and less costly to operate than their European counterparts. Soon after mid-century even more complicated forms in wood were produced at a lower cost and with an accuracy that was unattainable by hand.

Despite the use of power machinery, handmade furniture continued to be fashioned by craftsmen in both cities and country towns. The Newark cabinet-maker, John Jelliff (1813–1893), between 1836 and 1890, created masterpieces in both the Gothic Revival and Renaissance Revival styles for prominent New Jersey families.

The W. M. Stees furniture store and factory, situated at Third and Minnesota streets, Saint Paul, offered, "Two dozen chairs, as many bedsteads and tables, [which] were deemed a considerable store of furniture . . . they made most of their furniture, and the bed-posts were turned by a turning lathe which was a liberal perspiration-generator and human legs the motive power." [4] Captain Stees, proprietor of this earliest furniture store in the area, one time went "to put up a bedstead for A. L. Larpenteur and the presence of a pretty lady so embarrassed him that he sawed off the slats entirely too short and had to go back after new ones." [5]

The history of furniture production during the Victorian period is synonymous with the application of steam power to all branches of manufacturing. An 1833 broadside printed by Endicott & Swett for the firm of Joseph Meeks & Sons, a New York City furniture dealer, illustrated over twenty pieces in the

pillar-and-scroll style. The Meeks products, like those of nearly all their contemporaries, were designed so that the machine could be freely used in the construction of even their most expensive furniture. The famous cabinetmaker, Duncan Phyfe (1768–1854), a prominent competitor of the Meeks firm, considered such productions "butcher" furniture and yet, when called upon to provide a parlor suite for the new home of the distinguished New York attorney Samuel A. Foot, in 1837, utilized C-scroll and S-scroll supports on the mahogany pieces.

The pillar-and-scroll style was made even more popular through *The Cabinet Makers' Assistant* (1840) by John Hall, Architect, from Baltimore. This book, profusely illustrated with 198 plates, noted, "As far as possible, the style of the United States is blended with European taste, and a graceful outline and simplicity of parts are depicted in all the objects . . . Throughout the whole of the designs in this work, particular attention has been bestowed in an economical arrangement to save labor; which being an important point, is presumed will render the collection exceedingly useful to the cabinet-maker." [6]

During the Victorian period there was a continual attempt by most Americans to copy European taste and culture. A succession of revivals, vaguely based upon earlier European styles, confound the student of Victorian life. Often two or even three furniture styles gained favor at the same time. Many flourished only for a brief moment and quickly faded; others, like the Late Classical (1830–1900) and the Gothic Revival (1830–1900), enjoyed national popularity for several decades.

Many features are common to nearly all Victorian furniture. There was a general striving toward elegance. The use of veneer; wood, metal, and mother-of-pearl inlay; incising, often accompanied by gilt decoration; and metal mounts all added a lavish accent to furniture. Edgar Allan Poe noted the American love of splendor about 1840: "The cost of an article of furniture has at length come to be, with us, nearly the sole test of its merit in a decorative point of view . . ." [7]

A move toward comfort is evident early in the period, and overstuffed chairs and sofas, in the Turkish style of the 1880s, culminate a quest for physical ease.

Although eastern cabinetmaking establishments and furniture manufacturers specialized in gaudy furniture for the rising middle class, many Americans preferred the familiar pieces that seemed always to have been part of their lives. A European traveler on a trip through the Alleghenies in 1842 observed "waggons of emigrants from Pennsylvania, of German origin, each encumbered with a huge heavy mahogany press or 'schrank,' which had once, perhaps, come from Westphalia. These antique pieces of furniture might well contain the penates of these poor people, or be themselves their household gods, as they seem to be as religiously preserved." [8]

During much of the first half of the nineteenth century, this pattern continued to exist. On the Eastern Seaboard elaborate styles flourished; on the westward-moving frontier people made do with treasured remnants brought with

them during their migrations. By mid-century the pattern began to change. At Cincinnati, Saint Louis, and New Orleans, populations became large enough to support cabinetmakers of more than ordinary merit. They produced pieces for the most successful members of the community that the common man admired and more often than not aspired to.

Eastern manufacturers more often than not maintained French craftsmen on their payrolls. These immigrant workers introduced new forms to the American furniture industry. *Godey's Lady's Book* of 1850 listed several, including: "*Fauteuils médaillons* (medallion arm-chairs); *Tête-à-têtes* (sofas); *Chaises légères* (reception chairs); *Canapés à trois dossiers* (sofas with three backs); *Chaises chauffeuses* (ladies' arm-chairs); *Etagères* (what nots); *Consoles* (pier tables); *Buffets* (sideboards); *Ecrans* (fire screens); *Bibliothèques* (bookcases); *Toilettinettes* (ladies' toilet tables); *Armoires* (wardrobes); *Bureauz de dâmes* (ladies' work-stands); *Lits droits* (French bedsteads)." [9] Commenting further, the magazine explained in detail the requisite piece necessary for every proper Victorian household, "And now we come to the étagère, or 'what not' as this article of furniture is usually denominated . . . The plain ones of black walnut, with simply a beaded carving around the edges, are the most convenient article imaginable for a sitting-room, library, or nursery . . . In most houses, elegantly bound books, and *bijouterie* of all descriptions, fill the different stories." [10]

English productions also influenced American interior decorating and furnishings. The Day Dreamer, a papier-mâché easy chair with buttoned upholstery, was designed by H. Fitz Cook and made by Jennings and Bettridge of London and Birmingham, England. This exotic innovation was cited by many critics when exhibited at the London Crystal Palace. An *Art Journal* reviewer observed,

> The manufacture of Papier-mâché into a great variety of useful articles of large size is the result of the efforts made, within a comparatively recent period by the various artisans who have devoted their attention to this important branch of the industrial arts. It is not many years since the limits of the trade were circumscribed to a tea-tray, but now we find articles of furniture not only of a slight and ornamental character, such as ladies' work-tables or boxes, but of a more substantial kind, in chairs and sofas for the drawing-room or the entire castings of pianofortes. All such examples of the variety and comprehensive nature of *papier-mâché* works are exhibited by Messrs. Jennens [sic] & Bettridge . . . and our pages testify to their beauty.[11]

By the time of this first international exposition in 1851 Americans were familiar with papier-mâché through boxes and other small articles of general utility imported from Persia and the Orient. During the eighteenth century Parisian craftsmen perfected the process of mixing paper pulp with glue or paste, molding the material into the desired object while it was still moist, and then painting or varnishing the finished product after it had dried.

German and English processes for manufacturing papier-mâché were developed during the early nineteenth century and by mid-century American firms were producing a limited variety of objects in the medium. Around 1850 the Litchfield Manufacturing Company of Litchfield, Connecticut, offered painted, gilded, and shell-decorated boxes, and their 1852 catalogue included eight-day marine clocks beautifully mounted in papier-mâché and wood cases. Few American firms ever developed the facility for large-scale papier-mâché production. Perhaps it was less expensive to import pieces in this medium than to manufacture them at home.

The Rococo Revival style, popular from the 1850s through the 1900s achieved its most impressive flowering in the products manufactured by John Henry Belter (1804–1863) in New York City. In 1856 he applied for a patent to protect a process of laminating thin sheets of wood and, through the use of steam, molding them into the desired shape. The resulting plywoodlike blanks were especially strong and because of their extreme thickness could be pierced with ornate, overall carving in naturalistic designs.

Belter's patents were almost immediately infringed upon. Charles A. Baudouine, a New York City competitor, circumvented them by manufacturing chairs with a center seam in the back.

In 1859 I. Lutz at his Eleventh Street, Philadelphia, establishment utilized

> an ingenious method . . . to prevent the liability of carved Mahogany to break. In carved Chair work, for instance, he divides the Mahogany into several lateral parts, and joins them by glue in such a manner that the grain of the wood runs in different directions. The strength of the wood is, by this method, increased in proportion to the number of times it is divided; and in the manufacture of Sofas, large Arm-chairs, &c., its advantages are especially apparent.[12]

Whereas Belter's firm—one of the largest in America—employed several hundred workers during its zenith, it was noted that Lutz employed "fifty hands, and has supplied Furniture for some of the finest mansions in this city. Two Sofas, furnished to order, at a cost of $175 each, then on exhibition at his ware rooms, were remarkable specimens of elegant workmanship."[13]

The Renaissance Revival style, emerging about 1850 on the East Coast and lasting until near the end of the century at Grand Rapids, Michigan, was essentially a French-inspired movement. One of New York's most successful firms producing fine Renaissance Revival furniture was that of the Parisian émigré Leon Marcotte. His dramatic pieces were said to possess "The highest degree of refinement and luxury."[14]

At Grand Rapids, which by the close of the nineteenth century became the "furniture metropolis of the world," the Berkey and Gay Furniture Company produced beautiful pieces in the grand style not only for Midwestern consumption but for the international trade as well. Their jasper-topped and walnut-veneered bedroom suite displayed at the Philadelphia Centennial Exposition in 1876 won a medal.

The success of Grand Rapids products did not meet with everyone's approval; *The American Architect and Building News* complained,

> We sincerely hope that such an array of vulgarity in design as emanated from the thriving city of Grand Rapids will never again bring disgrace upon the American name at an international exhibition. The Renaissance work of L. Marcotte & Co., of New York, and the Pottier and Stymus Manufacturing Co., has been brought up to the highest degree of refinement and luxury that it would seem possible to produce . . . The exhibit of Marcotte & Co. was on the whole a splendid illustration of the latest phases of decorative art, as employed by the French in the adornment of house interiors. It was the best effort of the kind in the American department.[15]

By 1850 American manufacturers had developed a proficiency in the handling of metal that enabled them to utilize cast iron in the production of furniture. Countless patented devices in this "stronger than wood" material flooded the market. Even *Godey's Lady's Book* in 1853 touted the "everyday actualities" of healthful vibrating chairs, sofas that converted to bathtubs, and fireplace mantels that, with but a flick of the wrist, turned into comfortable beds. The use of metal for the construction of furniture became an American obsession in this period.

Metal also affected American furniture in another way. Treadle-operated scroll saws mounted on intricate cast-iron bases enabled faddists with an artistic bent to fashion all the lighter articles of household decoration. Demonstrations at the Philadelphia Centennial illustrated how Sorrento, or jigsaw-cut, furniture could be produced even by a novice.

A. J. Downing in his influential publication, *The Architecture of Country Houses* . . . (1850), expressed admiration for Elizabethan Revival style "cottage furniture." He found it to be "remarkable for its combination of lightness and strength and for its essential cottage-like character. It is very highly finished, and is usually painted drab, white, gray, a delicate lilac, or a fine blue—the surface polished and hard like enamel."[16]

Bobbin, spool, and spindle turnings abound on these pieces, which hark back to seventeenth-century English prototypes constructed during the reigns of Charles I and Charles II. Small bedside tables with spool-turned legs and the familiar spool-decorated "Jenny Lind" bed continued in favor throughout the last half of the nineteenth century.

Downing also did much to further rustic and organic furniture. In *Cottage Residences, Rural Architecture & Landscape Gardening* (1844), he advised, "Rustic seats, placed here and there in the most inviting spots, will heighten the charm, and enable us to enjoy at leisure the quiet beauty around."[17]

Alexander J. Davis (1803–1892), a close personal friend of Downing, agreed, and several illustrations of furniture made from tree stumps and driftwood accompanied an article that he wrote in 1858 for *The Horticulturist,* a periodical founded by Downing.

This taste for "natural" and trophy furniture included such exotic fantasies as elephant skins processed and converted into chairs and settees built from steer horn. Horn and hide furniture was especially popular in such masculine retreats as hunting lodges and smoking dens.

Furniture in the Egyptian and "neo-Grec" styles, after its first wave of popularity early in the nineteenth century, never achieved preeminence, although pieces in both styles appear from the 1860s through the 1880s. American manufacturers seem to have borrowed only details of these styles and seldom attempted to achieve the architectural correctness sought by the English and French.

European taste and styles continued to permeate American designs. At the Crystal Palace in New York in 1853 the single most-publicized piece of furniture was the unbelievably ornate sideboard exhibited by Bulkley & Herter of New York. Its lavish ornament was merely a recasting of countless pieces exhibited by European manufacturers at the Great Exhibition at the London Crystal Palace two years earlier.

> The . . . truly magnificent Buffet . . . executed by E. Plassman . . . in American oak, which in color and every other artistic requirement, is seen in this work to be admirably suited for ornamental furniture . . . It is one of the most noticeable objects that challenge the attention of the visitor to the Exhibition, and one which will repay a careful study as much as any other among the thousand articles of luxury there displayed.[18]

In a summary review of the Centennial Exposition at Philadelphia in 1876, an unidentified critic observed that the American department "was largely crowded with badly-designed, tawdry, and vulgar work, only fit, at the best, for the drawing-room of a *parvenu,* or the glittering saloon of a North River steamboat." [19]

The French furniture manufacturers exhibited pieces in the Louis XVI Revival style and in the next few years the fashion for such pieces prevailed.

Harriet Prescott Spofford (1835–1921), an American tastemaker, said proudly in 1878, "At present the Louis Seize furniture is made in America with a nicety and a purity quite equal to that which characterizes the best examples, and its wonderfully beautiful carving is unrivalled by any that comes from abroad." [20]

Throughout the 1840s and 1850s astute writers occasionally sensed America's interest in its past. More than one author observed isolated efforts at antiques collecting. The zeal for great-grandmother's furniture gained momentum and the Old Log Cabin at the Centennial displayed, to some extent, historical American furnishings. The New England Log House and Modern Kitchen, a blatantly commercial effort that served meals at "very moderate rates," was staffed by "about twenty ladies, dressed in the costume of a hundred years ago, [who] did the honors of this establishment and conducted the visitors through the different rooms, explaining with courtesy the wonderful articles of furniture . . ." [21]

Encouragement for backward-looking moderns was provided in 1878: "It is frequently remarked that new houses have a stiff, uncomfortable look, and that people moving into them are continually conscious of their newness and want of home-like feeling. The practice, however, of reviving old fashions does away with much of this." [22] The Colonial Revival movement gained momentum and by 1915 all but dominated American furniture design.

The American Eastlake style grew from the "principles of taste for the popular guidance of those who are not accustomed to hear such principles defined" [23] expounded by the English author and critic, Charles L. Eastlake in his influential book, *Hints on Household Taste in Furniture, Upholstery and Other Details* (1868). An accurate definition of the American Eastlake style is difficult, for even during the 1870s and 1880s it represented something different to everyone. It would appear that manufacturers of American furniture indiscriminately utilized an Eastlake label for a wide variety of forms. Generally speaking, massive, rectangular pieces were decorated with carved designs, incising, and turned members that emphasized and enhanced vertical lines.

The Philadelphia Centennial served as a catalyst for American manufacturers. The Japanese Bazaar, with its exotic architecture and appointments, caused the style-conscious to adopt Orientalism. Parlor and bedroom suites made of simulated bamboo incorporated bits of modern "antique" pottery and gaudy colored porcelain. Japanese fans were hung as wall decorations and crossed samurai swords were mounted over doorways, and the Japanese print invaded the American parlor. Reed, willow, and rattan furniture for both parlor and porch enjoyed a popularity during the 1880s that continues even today. *The Art Journal*, a prominent arbiter of Victorian taste, stated:

> From all authorities of taste we learn that a room should have, first comfort, warmth, harmony, and light; then colour and picturesque association . . . Then should come knowledge; he (the authority of taste) must tell us where to go, he will send us to that rich, real, untaught, but naturally gifted intelligence of the East, for our carpets and our curtain-stuffs; untaught colourists with Eastern temperaments can never be surpassed. He will send us to the Japanese for our lacquerwork and screens . . .[24]

During the last twenty years of the Victorian period, several new styles blossomed, quickly to fade again. Turkish Frame furniture provided a unique opportunity for the upholstery industry. Coil springs for chairs, sofas, and daybeds enabled furniture firms like Sears, Roebuck, in 1897, to hawk "unprecedented comfort." The Turkish Frame style was only one manifestation of a general interest in exotica. It was popular in the parlor as well as in smoking dens, where gentlemen of means could escape the incessant chatter of Victorian matrons and enjoy Turkish pipes, a cigarette, or even a cigar. Rare indeed was the woman who would allow her husband a leisurely smoke in the sitting room. Lace curtains, fragile furniture, and costly bric-a-brac were too easily contaminated by "nasty tobacco fumes."

Americans probably first became aware of bentwood furniture at the Lon-

don Crystal Palace Exhibition in 1851 where the products of the Thonet Brothers, an Austrian firm, were much admired for their slenderness and great strength. They were merchandised through American outlets in subsequent years. Numerous domestic manufacturers, including the Sheboygan Chair Company of Sheboygan, Wisconsin, imitated Thonet products. Even though their productions were less expensive, they were never as popular as the pieces from the European firm, which is still in operation.

Early in the 1880s several English artists, furniture designers, and craftsmen, inspired by William Morris, gathered together in guildlike organizations for the purpose of uniting the fine and applied arts in the manufacture of furniture. The resulting Arts and Crafts Movement strongly influenced American decorative arts. At Providence, Rhode Island, the Art Workers' Guild, led by Sydney R. Burleigh, Charles W. Stetson, and John G. Aldrich, handcrafted and painted furniture in a style that would have been acceptable to William Morris. Their "craft pieces" were not unlike the designs of Will Bradley (1868–1962) that were published by Edward Bok in *The Ladies' Home Journal* in 1901 and 1902.

Gustav Stickley (1857–1942), propagator of the Mission style in the United States, was editor and publisher of *The Craftsman*, begun in 1901. Through his untiring efforts, Mission furniture became popular. Elbert Hubbard's (1856–1915) Roycrofters at East Aurora, New York, and the Limbert Arts and Crafts Furniture Company at Grand Rapids and Holland, Michigan, were the two other major producers of high-quality Mission furniture. The style flourished until World War I when Americans, in a fervent display of nationalism, turned inward and the Colonial Revival triumphantly dominated the marketplace.

Until recently scholars have tended to regard the Mission style as a revival of primitive seventeenth- and eighteenth-century Southwestern prototypes that were handmade by Indians. Additional research probably will alter this popular view, for it seems more likely that the clean lines of the Mission style were really a precursor of twentieth-century furniture design.

The American Art Nouveau style was essentially confined to decorative accessories and to the graphic arts. With the exceptions of the furniture produced by Tiffany Glass and Decorating Company and the extraordinary pieces of S. Karpen & Brothers Furniture Company of Chicago and New York, little has come to light. Perhaps Gustav Stickley expressed the American attitude when he wrote in 1900,

> My frequent journeys to Europe . . . interested me much in the decorative use of plant forms, and I followed the suggestion . . . After experimenting with a number of pieces such as small tables giving in their form a conventionalized suggestion of such plants as mallow, the sunflower and the pansy, I abandoned the idea . . . Conventionalized plant-forms are beautiful and fitting when used solely for decoration, but anyone who starts to make a piece of furniture with a decorative form in mind, starts at the wrong end. The sole consideration at the basis of the design must be the thing itself and not its ornamentation.[25]

153 (right). Gothic Revival armchair. c. 1845. Mahogany. H. 55¾". The Gothic style in furniture was first introduced into America by Thomas Chippendale in his 1754 publication, *The Gentleman and Cabinet-Maker's Director.* The Gothic Revival style began to enjoy real popularity by 1820 and continued until about 1900. The pointed arches and quatrefoil on this chair are typical design elements. (Smithsonian Institution)

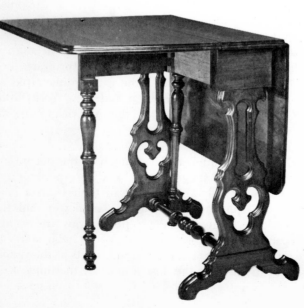

154 (left). Gothic Revival drop-leaf table. c. 1850. Walnut. H. 29". Sinuously curved legs and handsomely turned supports for the leaves combine to make this an elegant and striking example of the Gothic Revival style. Photograph courtesy Frederick Di Maio: Inglenook Antiques. (Private collection)

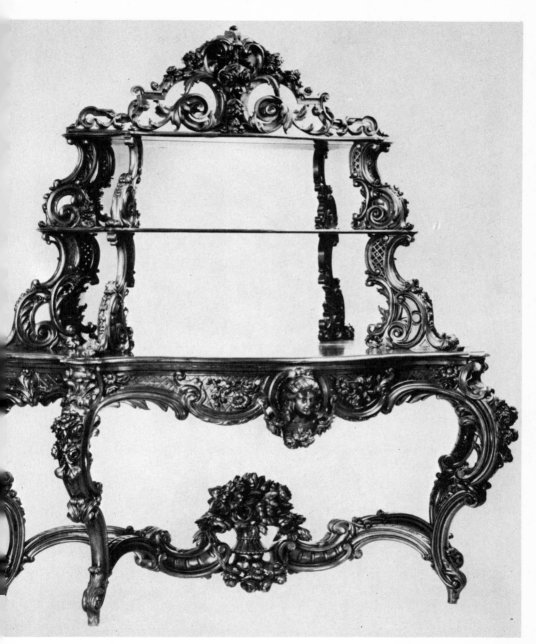

155 (above). Rococo Revival pier table with mirrored étagère manufactured and labeled by Alexander Roux, New York City. c. 1850. Rosewood. H. 80″. Roux, a French emigrant, made some of America's most important furniture in the Rococo Revival style. He proved to be a strong competitor for John Henry Belter who patented a process for laminating thin layers of wood together and shaping them in a steam press. (Peter Hill)

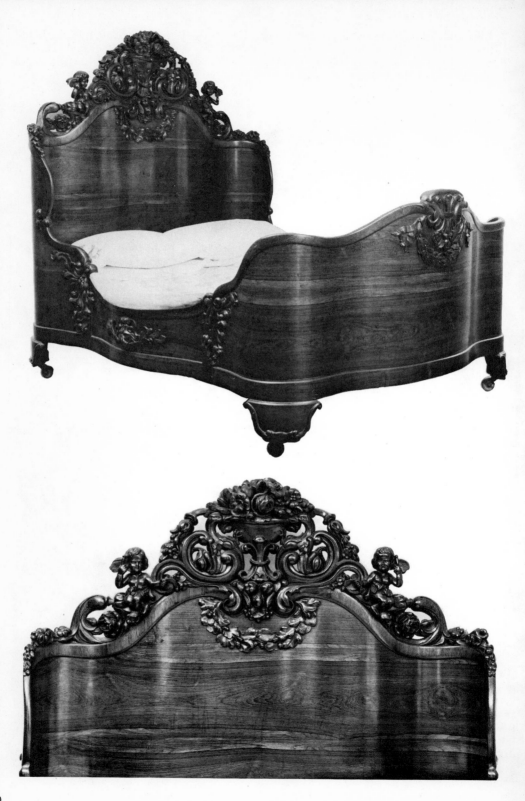

156a and 156b (opposite, above and below). Bed in the Rococo Revival style attributed to John Henry Belter. New York City. c. 1850. Carved, laminated rosewood. H. 72″; L. 90″. The extraordinary quality of Belter's craftsmanship is easily seen in the detail photograph of the bed's headboard. (Eileen Dubrow Antiques)

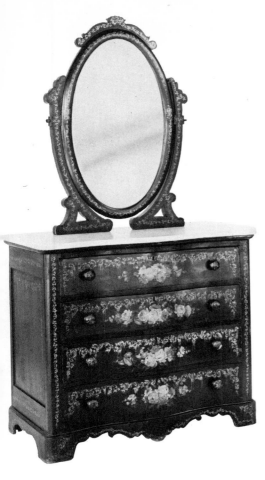

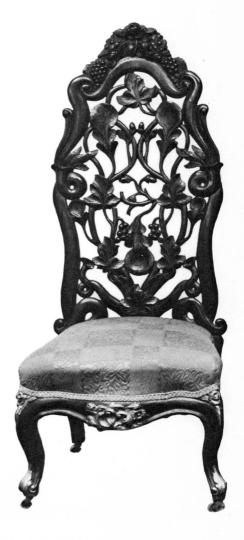

157 (above). Cottage bureau painted black with gold scrollwork and polychrome flowers. c. 1850. Made by Hart, Ware Company, Philadelphia. W. 42½″. (Philadelphia Museum of Art)

158 (right). Slipper chair in the Rococo Revival style attributed to John Henry Belter. New York City. c. 1850. Carved, laminated rosewood. H. 37¼″. The chair is noteworthy for the open, airy feeling of the back. (Eileen Dubrow Antiques)

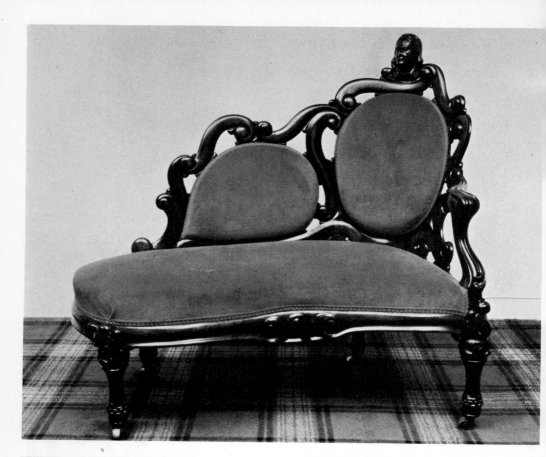

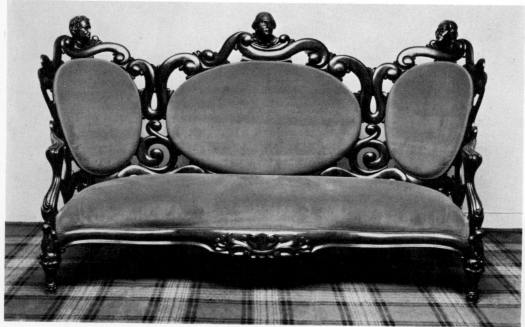

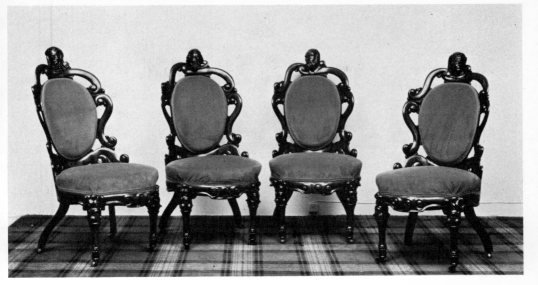

159a and 159b (opposite, above and below), 159c (above). Parlor suite in the Rococo Revival style attributed to John Henry Belter. New York City. c. 1850. H. of chairs, 39″. The busts of Washington, Franklin, and Jefferson are included in the decoration of this rare set. (Eileen Dubrow Antiques) (Below). Gothic Revival parlor table. Possibly New York City. c. 1850. Rosewood veneer on pine with white marble top. W. 44″. This splendid table has great elegance of form and fine, crisp details. (The Margaret Woodbury Strong Museum)

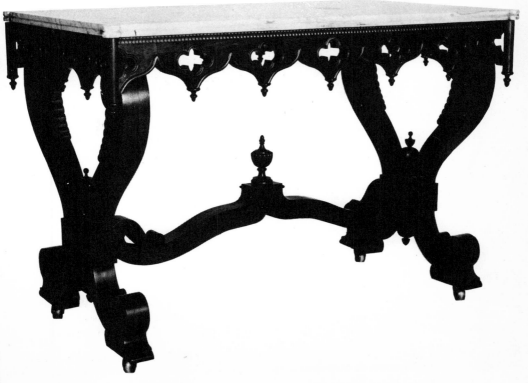

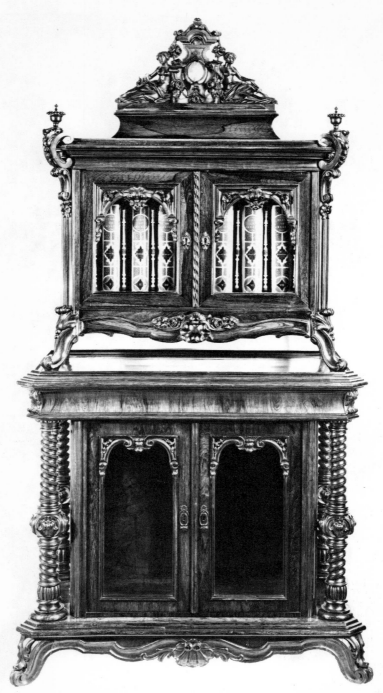

160 (above). Elizabethan Revival bookcase made by the Brooks Cabinet Warehouse, 127 Fulton Street, Brooklyn, New York. 1850. Rosewood. H. 72″. The twisted columns on this handsome piece, which was given to Jenny Lind by the New York firemen, were considered by most Victorians to be an Elizabethan feature. Like much Victorian furniture, a medley of revival styles is evident on this dramatic piece. (Museum of the City of New York; Gift of Arthur S. Vernay)

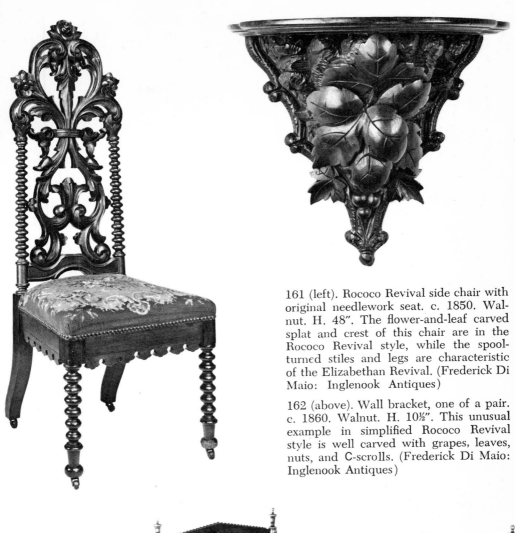

161 (left). Rococo Revival side chair with original needlework seat. c. 1850. Walnut. H. 48". The flower-and-leaf carved splat and crest of this chair are in the Rococo Revival style, while the spool-turned stiles and legs are characteristic of the Elizabethan Revival. (Frederick Di Maio: Inglenook Antiques)

162 (above). Wall bracket, one of a pair. c. 1860. Walnut. H. 10½". This unusual example in simplified Rococo Revival style is well carved with grapes, leaves, nuts, and C-scrolls. (Frederick Di Maio: Inglenook Antiques)

163 (right). Elizabethan Revival spool bed. 1860–1890. Maple and walnut. L. 79". Jenny Lind, the "Swedish Nightingale," captivated the American people with her beautiful voice and great charm. Because she is believed to have slept in a "spool" bed at the time of her visit, they are frequently referred to as "Jenny Lind beds." (Greenfield Village and Henry Ford Museum)

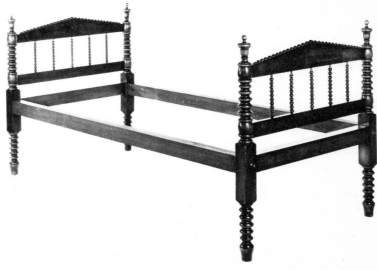

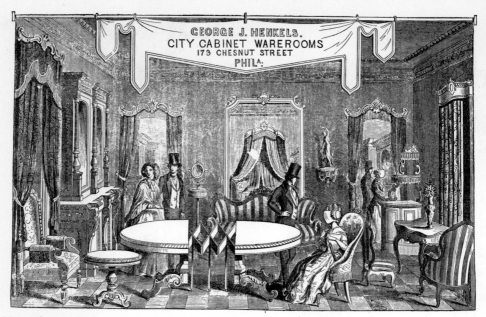

164 (above). Advertisement from an 1850 copy of *Godey's Lady's Book*. The merchandise offered by the City Cabinet Warerooms of George J. Henkels, Philadelphia, is probably typical of most upper-class furniture dealers. Several different revival styles are represented in the illustration. The extension dining table is Renaissance Revival; the chairs on the right, the card table, and sofa, Rococo Revival; and the chair on the left with its spool-turned uprights, Elizabethan Revival. Curtain valances like those in the illustration frequently were manufactured from stamped brass in the Victorian period. (The New York Public Library)

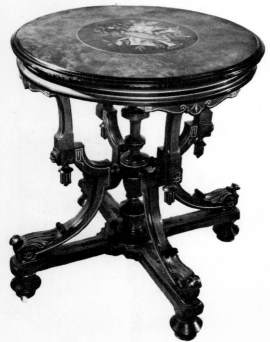

165 (left). Renaissance Revival center table by Berkey and Gay, Grand Rapids, Michigan. c. 1870. Walnut, burl walnut, and various imported woods. H. 29½". The circular top is inlaid with an elaborate multicolored marquetry design representing a musical trophy. The pendent tassels and scrolled apron often appear on Renaissance Revival pieces. (Grand Rapids Public Museum)

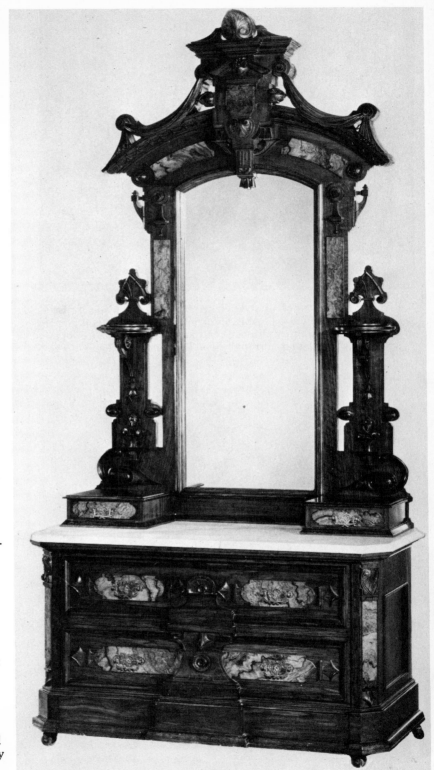

166 (right). Dressing chest in the Renaissance Revival style. Possibly Grand Rapids, Michigan. c. 1870. Walnut and burl veneer with marble top. H. 104⅛". Almost nine feet high, this is a wonderfully imposing example of Victorian cabinetwork. (Greenfield Village and Henry Ford Museum)

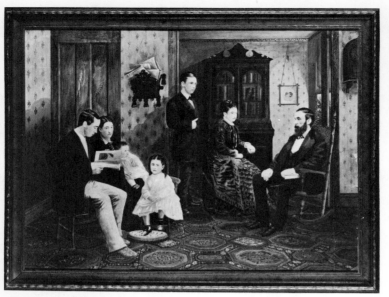

167 (left). Victorian family group. c. 1875. Watercolor on cardboard. W. 17¼". The Renaissance Revival style was first used in America by manufacturers of expensive, elegant furniture. By 1870 it had been adapted and modified by small manufacturers across the entire country. The secretary and wall pocket in this painting represent modest interpretations of the style. (Greenfield Village and Henry Ford Museum)

168 (below). Louis XVI style chairs and pedestal made by Leon Marcotte, New York City. c. 1860. Ebonized maple and fruitwood with applied gilt and bronze. H. of chairs 37¾". By mid-century French craftsmen like Marcotte offered to America's elite sumptuous pieces that mirrored the latest Parisian fashions. (The Metropolitan Museum of Art)

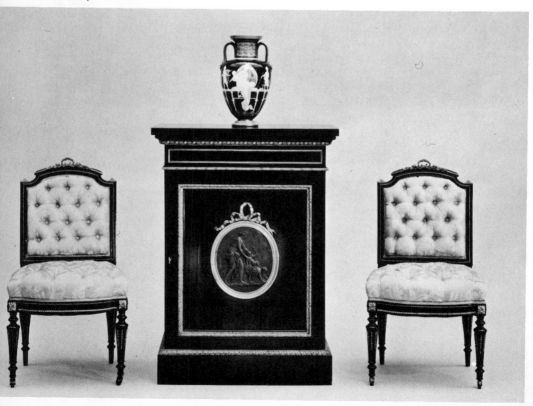

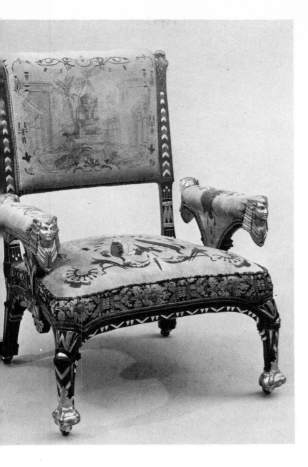

169 (left). Armchair in the Egyptian Revival style. Probably New York City. c. 1870. Rosewood with burl-maple borders, gilt, incised decoration, and gilded heads. H. 37″. The Egyptian Revival style, of which this is such a marvelous example, was a subdivision of the Renaissance Revival style in American decorative arts in the 1870s. Note the handsome pictorial upholstery on this chair, especially the sphinx depicted on the back. (The Metropolitan Museum of Art)

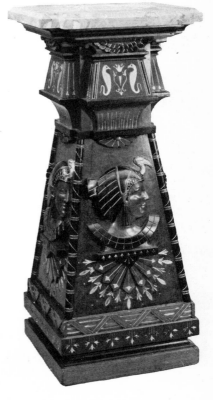

170 (right). Pedestal in Egyptian Revival style. Probably New York City. c. 1870. Walnut with gilt decoration and marble top. H. 39″. A very impressive companion to this pedestal would be the bust of Cleopatra shown in figure 248. (The Metropolitan Museum of Art)

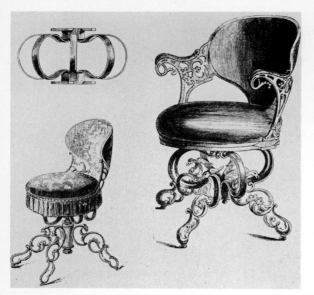

171 (left). Illustration of metal-frame chairs manufactured by the American Chair Company, Troy, New York, taken from *The Art Journal Illustrated Catalogue, The Industry of All Nations 1851,* published in London by George Virtue. Many American firms exhibited at the Great Exhibition in the London Crystal Palace. Few American exhibits excited more favorable comment than the innovational metal-frame chairs developed by the American Chair Company. Manufacturers who produced cast-metal parts for furniture often included in their general line reinforced-steel-wire benches and tables for garden and cemetery use. (Private collection)

172 (below, left). Desk made by Herter Brothers, New York City. c. 1882. Ebonized cherry. H. 54". The Herter firm produced some of America's most exciting Victorian furniture. The floral decoration on this marvelous piece is inlaid. This desk originally cost $550. (The Metropolitan Museum of Art; Gift of Paul Martini, 1969)

173 (below, right). Cabinet made by Charles Tisch, New York City. 1884. Rosewood with metal inlays. H. 82¾". Tisch's design parallels English designs of a slightly earlier period. This rather ornate, architectural cabinet is not unlike mantels and overmantels that were classified as Oriental or Anglo-Japanese. (The Metropolitan Museum of Art; Gift of Charles Tisch, 1889)

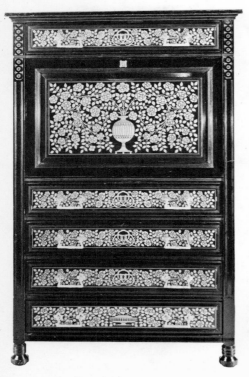

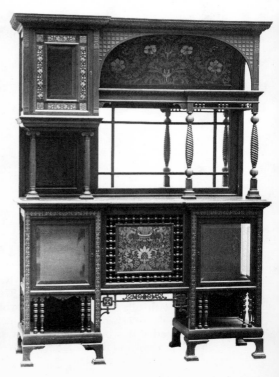

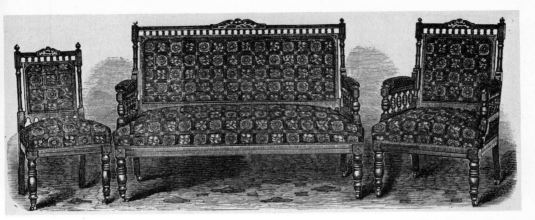

174 (above). Parlor suite "in the Queen Anne style, covered with raw silk." Queen Anne style is another name for the Eastlake style. Illustration reproduced from the *Specimen Book of One Hundred Architectural Designs*, published by A. J. Bicknell & Co., New York, 1878.

175 (below). Table in the Japanese Revival style. Possibly New York City. c. 1880. Maple painted black with incised lines and finely detailed carving and with a marble top. The spirit of Charles L. Eastlake's highly influential *Hints on Household Taste* (1868) is very evident in the rectilinear lines and flat carving of this handsome piece. (Greenfield Village and Henry Ford Museum)

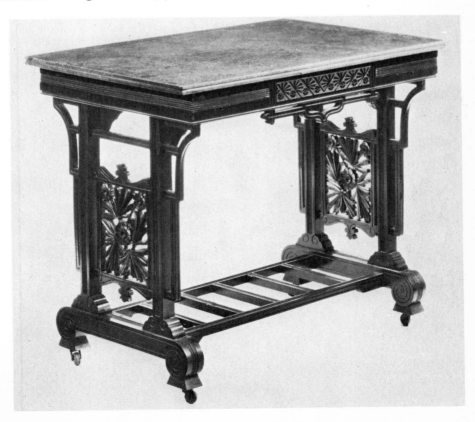

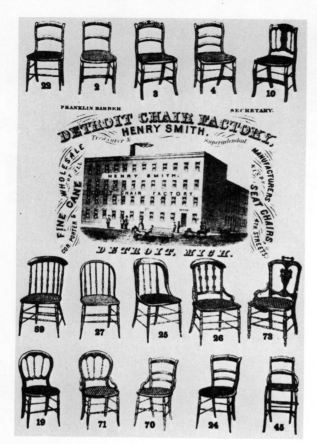

176 (left). Advertisement from the *Detroit City Directory, 1872/1873,* for the Detroit Chair Factory located at Detroit, Michigan. Soon after the mid-century factories that specialized in the production of a single kind of furniture sprang up in nearly every major city. The Detroit Chair Factory began production in 1865 and through 1878 produced a number of chairs that were constructed from interchangeable parts. (Detroit Public Library)

177 (below). "Organic" tête-à-tête. 1860–1880. Tree roots and driftwood. L. 66". *The Horticulturist,* a popular magazine during the 1860s, featured articles on the construction of outdoor seating pieces. (Lyndhurst, The National Trust for Historic Preservation)

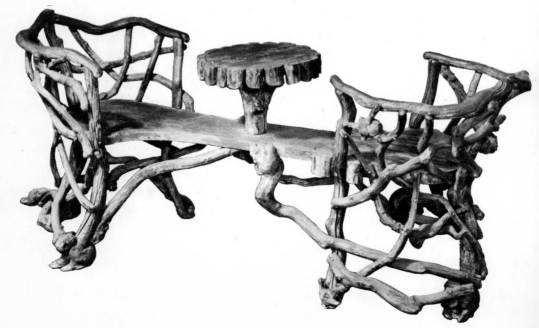

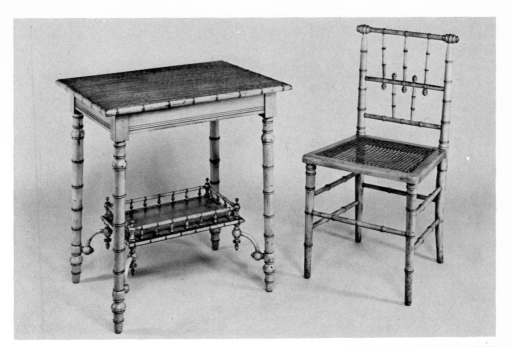

178 (above). Japanese-style side chair and table. c. 1885. Maple. H. of chair 33⅞". American furniture makers were quick to meet the demand for Oriental-like pieces. The rings on the simulated bamboo turnings have been highlighted to create a realistic effect. (The Metropolitan Museum of Art)

179 (right). Advertisement, c. 1874, for the Viennese firm, Thonet Brothers, who manufactured and exported to American depots bentwood furniture in a variety of forms. Usually the Thonet products were not assembled until they reached the depot showrooms. (The New York Public Library)

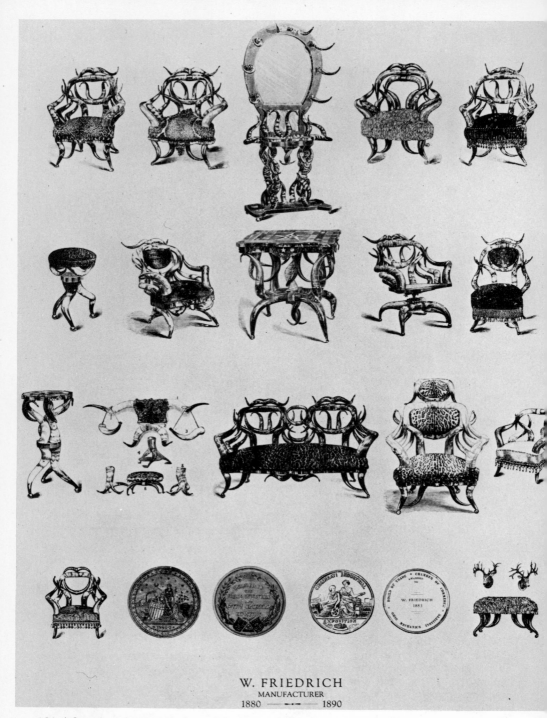

W. FRIEDRICH
MANUFACTURER
1880 ——•—— 1890

180 (above). Advertising placard for Wenzel Friedrich, San Antonio, Texas. After 1890. Friedrich specialized in horn furniture and was awarded a gold medal at the New Orleans World's Industrial and Cotton Centennial Exposition, 1884–1885, and at the Cincinnati Industrial Exposition of 1883. (San Antonio Museum Association; Gift of Mrs. C. D. Cannon)

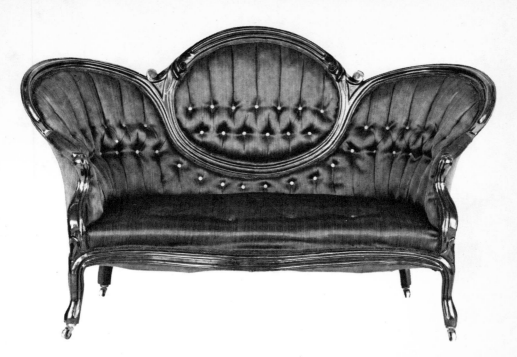

181 (above). Rococo Revival sofa. c. 1870. Mahogany. L. 62″. The Rococo Revival in its simplest form lasted throughout the nineteenth century. This example is upholstered in black horsehair, a very popular upholstery fabric with Victorians. (Greenfield Village and Henry Ford Museum)

182 (below). Early photograph of a Turkish Frame sofa that was displayed at the World's Columbian Exposition, Chicago, Illinois, 1893. Such exotic pieces were constructed of metal coil springs enclosed within a hidden frame. They provided a degree of seating comfort previously unavailable. (Private collection)

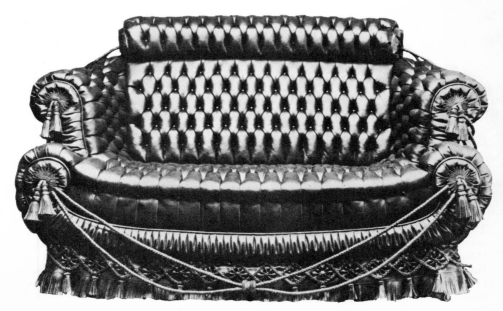

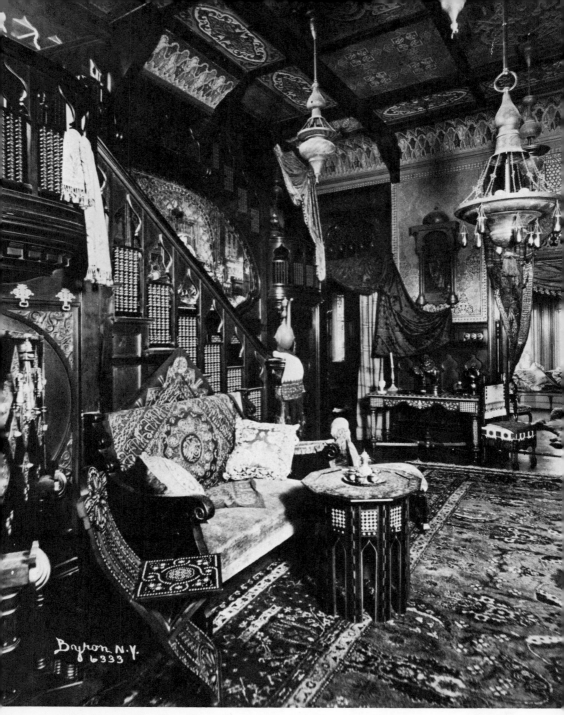

183 (above). Photograph of the hall in the home of Edward Lauterbach, 2 E. 78th Street, New York City. 1899. Turkish corners and Moorish smoking rooms and entrance halls were a perfect way for the wealthy to display their sometimes highly eclectic taste. Rich inlay, gaudy painted and grained decoration, and bright, shiny brass chandeliers are but a few of the appointments that were imported for such exotic rooms. (Museum of the City of New York)

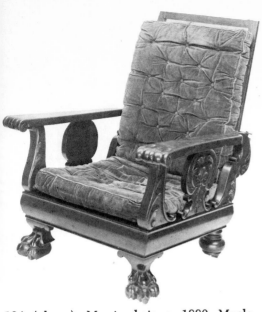

185 (below). Colonial Revival desk. Late nineteenth century. Mahogany and pine. H. 41¾". Colonial Revival pieces began to be produced in the late 1860s. Usually they were only vague approximations of the prototypes upon which they were based. (Greenfield Village and Henry Ford Museum)

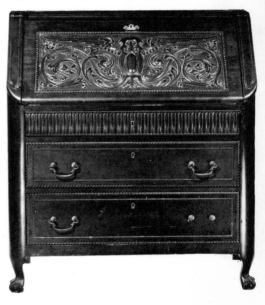

184 (above). Morris chair. c. 1880. Maple and birch. H. 41". The English designer, William Morris, in 1866 produced a chair with an adjustable back, which came to be known as the Morris chair. This ornate American adaptation retains its original green velvet cushions. (Smithsonian Institution Furnishings Collection)

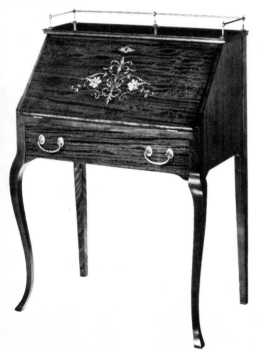

186 (left). French Empire fall-front lady's desk. Probably Grand Rapids, Michigan. c. 1900. Birch with various imported woods used for the inlay. H. 41". By 1880 Grand Rapids had become one of the largest furniture manufacturing cities in the world. Aggressive merchants shipped their products to both domestic and international markets. (Greenfield Village and Henry Ford Museum)

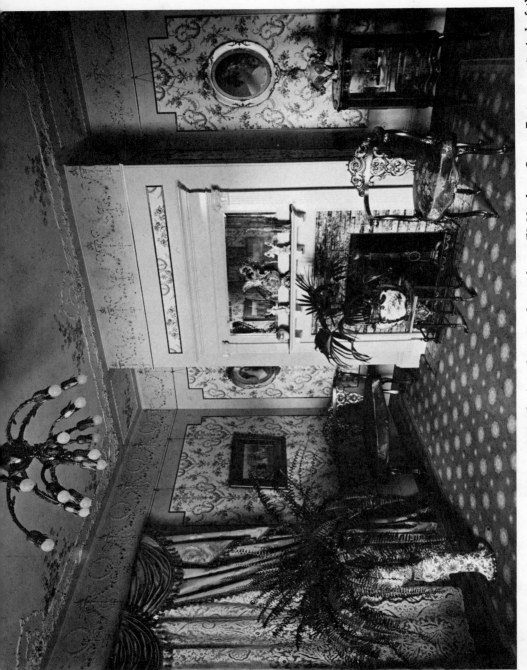

187 (above). Photograph of room interior. c. 1900. The furnishings in this parlor at 73 Newbury Street, Boston, are typical of those created by American manufacturers in their attempt to develop a "French" high style at the close of the century. The settee, armchair, and display case are vaguely in the French Louis XV style. (The Library of Congress)

188 (below). Lieutenant Governor's chair designed by H. H. Richardson (1838–1886) in the Eastlake style from the Albany, New York, State House. 1880. Mahogany. H. 65″. Photograph courtesy Museum of Fine Arts, Boston. (State of New York)

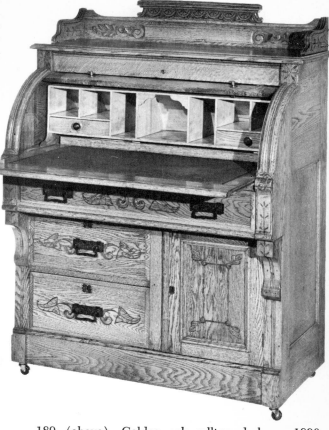

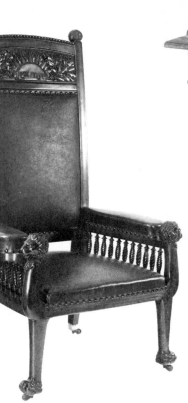

189 (above). Golden oak rolltop desk. c. 1890. H. 50½″. During the late nineteenth century the rolltop desk became a status symbol that no ambitious social climber could afford to do without. This example is decorated with incised carvings, relating it to the American interpretation of the Eastlake style. (Greenfield Village and Henry Ford Museum)

190 (right). "Eastlake" méridienne. Probably Grand Rapids. 1880–1900. Walnut. L. 69″. Because the frame of this piece of lounging furniture is decorated with incised lines, stamped patterns, and applied balls, it represents the American Eastlake style. (Greenfield Village and Henry Ford Museum)

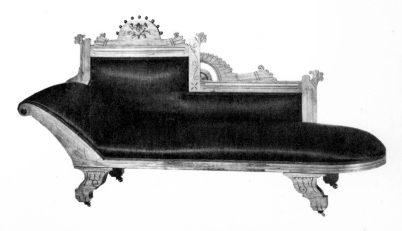

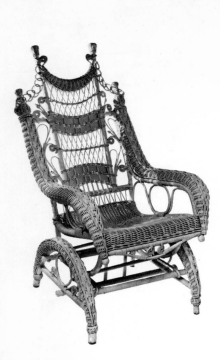

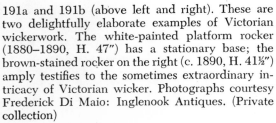

191a and 191b (above left and right). These are two delightfully elaborate examples of Victorian wickerwork. The white-painted platform rocker (1880–1890, H. 47″) has a stationary base; the brown-stained rocker on the right (c. 1890, H. 41½″) amply testifies to the sometimes extraordinary intricacy of Victorian wicker. Photographs courtesy Frederick Di Maio: Inglenook Antiques. (Private collection)

192 (right). Étagère. c. 1899. H. 63¼″. Crafted in natural wicker, this jaunty étagère is a great rarity. Made by the Heywood Brothers and Wakefield Company, Wakefield, Massachusetts. Photograph courtesy Frederick Di Maio: Inglenook Antiques. (The Metropolitan Museum of Art)

193 (right). Arts and Crafts sideboard made and decorated by Sydney Burleigh, Providence, Rhode Island. c. 1900. Mahogany. H. 56 1/16″. Burleigh, a member of the Art Workers' Guild at Providence, was one of the leaders of the American Arts and Crafts Movement, which enjoyed great popularity in that city. (Greenfield Village and Henry Ford Museum)

194 (below, left). Armchair made by the Tiffany Glass and Decorating Company, New York City. 1890–1900. Maple with metal inlays. H. 35⅝″. Much of the Tiffany furniture sits upon tiny glass ball feet encased in metal claws. The crest rail is sensitively carved with naturalistic floral designs. (The Metropolitan Museum of Art; Gift of Mr. and Mrs. Georges Seligmann, 1964)

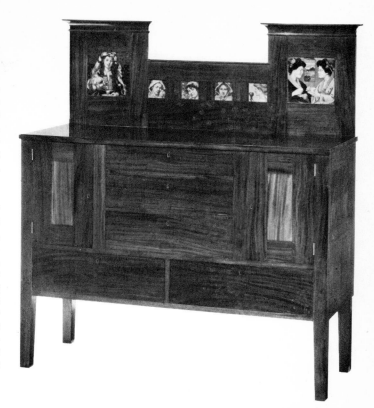

195 (below, right). Art Nouveau side chair made by S. Karpen and Brothers, Chicago and New York. c. 1900. Mahogany. H. 40½″. The crest rail of this chair is centered with a carving representing the American dancer Loie Fuller. Karpen and Brothers were noted for their elegant, expensive pieces that were considered to be the "triumph of artists skilled in woodcraft."[1] (Mr. and Mrs. Gary Hawk)

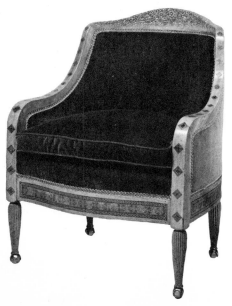

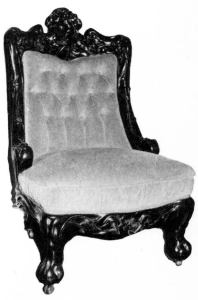

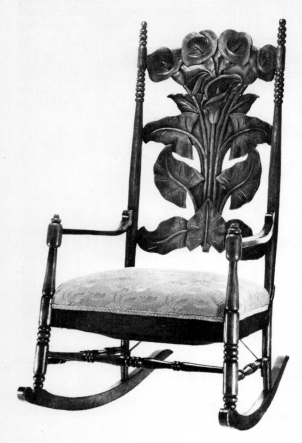

196 (left). Art Nouveau rocking chair. Probably Grand Rapids, Michigan. c. 1900. Maple and ash. H. 47½". The popularization of the French-inspired Art Nouveau style resulted in many extraordinary designs. The back of this unusual chair represents a bouquet of calla lilies. (Mr. and Mrs. Charles V. Hagler)

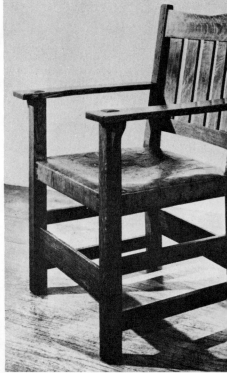

197 (right). Mission-style armchair by Gustav Stickley. 1898–1901. Oak. H. 37". Stickley, Elbert Hubbard, and the Limbert Arts and Crafts Furniture Company were the most important manufacturers of furniture in this style. It remained popular until about 1915 when most Americans demanded Colonial Revival furniture. Stickley attempted to "substitute the luxury of taste for the luxury of costliness; to teach that beauty does not imply elaboration or ornament; to employ only those forms and materials which make for simplicity, individuality and dignity of effect." [2] (Current whereabouts unknown)

198 (left). Illustration from a sales catalogue published by Limbert Arts and Crafts Furniture Company, Grand Rapids and Holland, Michigan. c. 1900. The Limbert firm specialized in the production of handcrafted furniture in the Mission style. (Greenfield Village and Henry Ford Museum)

199 (below). Modern chairs designed by Frank Lloyd Wright. c. 1895. Poplar. H. of armchair 29⅛"; H. of side chair 42¹⁄₁₆". The Milwaukee, Wisconsin, cabinetmaker George Niedecken was commissioned by Wright to execute many of his most progressive furniture designs. These pieces are probably from the Niedecken shop. Although they are similar to Mission-style pieces, they anticipate modern design concepts. (Edgar J. Kaufmann, Jr.)

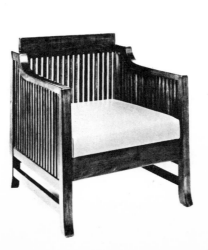

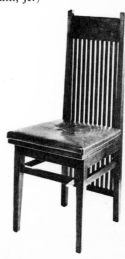

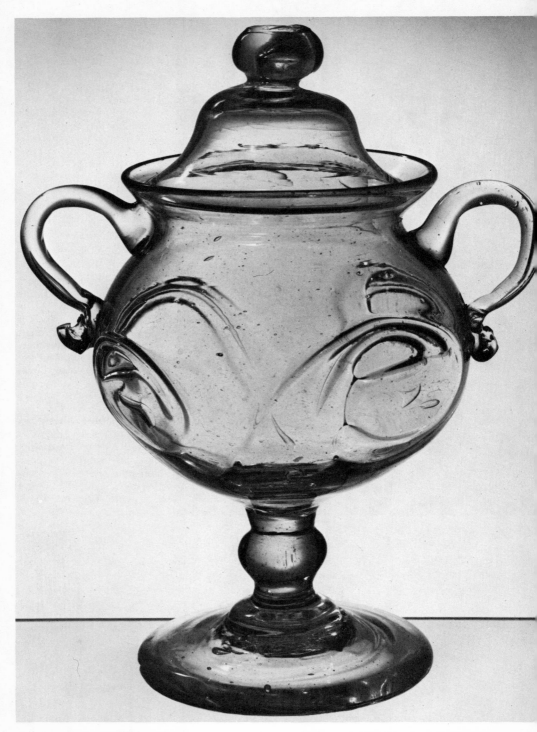

200 (above). Blown-glass sugar bowl made at the Harrisburg Glass Works, Harrisburg, New York. 1841–1843. H. 8⅜″. This aquamarine piece has an applied circular foot and two applied handles. (Greenfield Village and Henry Ford Museum)

GLASS

Until about 1820, when ingenious American craftsmen developed and perfected a practical, mechanical pressing machine, the techniques of glassmaking had not changed for nearly two thousand years.

The use of the blowpipe appears to have originated in Syria about the dawn of the Christian era. It is a long, hollow, tubular device used for expanding a gather of molten glass. Research indicates that glassware decorated with cut designs was relatively common in well-to-do early Roman households. While excavating a Roman glass furnace at Warrington, England, workmen discovered a stone cutting wheel and cut-decorated fragments.

Although most late eighteenth- and early nineteenth-century American glasshouses were primarily established to meet an unending demand for windowpanes and containers for liquids, they also produced other utilitarian objects. Flasks, bottles, bowls, pans, and pitchers appeared in various hues of aquamarine or amber. Many factory craftsmen shaped pieces quite similar in form to first-century objects. Following the ancient tradition, nearly all glasshouses allowed the blowers to use the residue glass that was left at the end of the day to fashion individual pieces, or "whimsies," of their own design as gifts for friends.

To compete with costly English and Irish imported wares, glassblowers at the factory established by "Baron" William Henry Stiegel (1729–1785) at Manheim, Pennsylvania, in 1763, utilized the "pattern-molding" process on a large scale. The technique consisted of gently blowing a gather of glass into a specially constructed one-piece mold that was wider at the top than at the bottom. An impression of the mold was transferred to the molten glass. A workman quickly withdrew the glass from the mold and expanded it with the blowpipe. This process later became popular in Midwestern glasshouses.

One of the earliest nineteenth-century manufacturers west of the Alleghenies was Benjamin Bakewell who established a glasshouse at the "boom town," Pittsburgh, Pennsylvania, in 1808. He produced clear glass of exceptional quality; much of it was cut and decorated with elegant designs. Bakewell's glass was of such sophistication that President James Monroe, upon visiting the plant in 1817, ordered a service engraved with the arms of the United States for use at the White House.

A French visitor to America in 1821 observed that nearly every American possessed "a mechanic in his soul." [1] Mechanical ingenuity certainly did, in numerous respects, provide solutions for the ever expanding, westward-moving nation.

Some unknown, enterprising glassblower developed a full-sized, multisectioned, hinged mold that permitted increased production, decreased cost, and a more standardized product. The mold into which a gather of glass was blown

could be unfolded and removed, much like the peel from an orange. Designs were intricate. Blown-in-the-mold pieces found acceptance with the American consumer because they could be purchased for much less than an imported or even a domestic cut-glass piece. Most glass plants adopted this timesaving technique, which produced a greater variety of patterns.

About the same time goblet bases and other small forms were shaped in a "lemon-squeezer" or handpress. As an outgrowth of the hand-pressing process, by the early 1820s American glasshouses had perfected a way of mechanically pressing molten glass between two very precisely made metal dies. For the first time in the modern world mass production of glass was possible. Once proved technically and economically feasible, practically all glasshouses incorporated the method that produced a new variety of forms. Manufacturers discovered that most pressed glass lost its clarity when shaped in a metal mold, and they searched for a solution. "Lacy glass" with an overall pattern set against a stippled background provided the answer, and demonstrated again the power of American ingenuity. Because lacy pressed glass was relatively inexpensive, it became popular with the common man.

In time the mold designers and cutters gained a proficiency that enabled glasshouses to manufacture products possessing a high degree of sophistication, although lacking the quality of hand-produced glassware.

With the introduction of pressed pieces the American glass industry came of age. It could, at last, begin to fulfill the needs of a rapidly increasing population. The Boston and Sandwich Glass Company at Sandwich, Massachusetts, employed some 225 workmen by 1829 whose production totaled over $300,000 in value. Mechanically pressed glass virtually ended the production of free-blown and blown-in-the-mold cut-decorated glass.

During the second quarter of the nineteenth century pressed-glass plates, cup plates, saltcellars, sugar bowls, cream pitchers, and even windowpanes illustrated that through the use of carefully prepared iron or brass molds Americans could manufacture inexpensive, attractive pieces and compete in the world market.

Bottles and flasks represented an important facet of glass production. Many firms relied upon this branch of the industry for a major portion of their income. The techniques for fashioning bottles and flasks followed the same evolutionary process as other glass forms. At first they were simply blown bottles; after the early 1820s blown-in-the-mold pieces appeared; and finally pressed versions flooded the marketplace. Because they were intended to be disposable, few flasks were made of fine glass.

The vigorous temperance societies of the nineteenth century proved to be thorns in the side of glass manufacturers. Because flasks were generally intended to contain "ardent spirits," many plant owners were strongly criticized by local do-gooders. One factory owner, perhaps acknowledging such pressures, inscribed his flask, "USE ME BUT DO NOT ABUSE ME." E. G. Booz, a Pennsylvania dealer in Old Cabin Whiskey, packaged his product in a bottle shaped like a log cabin. Booze, the popular term for alcoholic beverages, did not orig-

inate with Mr. Booz; it is derived from a Middle English word meaning "to drink sottishly."

Whether they record a popular historical event, bow to a commercial theme, or sport the portrait of a famous American founding father, flasks are particularly colorful American artifacts that are much collected and prized today.

After the 1840s inexpensive, pressed tableware in a multitude of patterns and colors became available to nearly every housewife. Pattern glass, often incorporating a realistic figural representation, was made in matched sets. Fierce competition existed between manufacturers: as soon as a new pattern demonstrated any kind of real success in the marketplace, competitors pirated the design, producing nearly identical variants. Over 350 individual patterns have been researched and identified.

Lead and other fluxes produced a clarity in American glass that European plants found difficult to duplicate. Because lead was relatively expensive, substitutes were sought and in 1864 a new soda-lime glass formula was introduced by William Leighton, Jr., at the J. H. Hobbs, Brockunier Glassworks at Wheeling, West Virginia. Because of this innovation production costs decreased by about two thirds. Through the 1870s and 1880s American manufacturers became even stiffer competition for European glasshouses.

Most nineteenth-century glass plants were staffed by European immigrants who had journeyed to America seeking a better life. They brought with them a taste for the decorative and a pride in their craftsmanship that greatly influenced American production. Quantities of ornamental glass emanated from the factories where they worked. One popular form that perfectly suited mid-Victorian taste was the paperweight. Novel built-up designs were especially salable; ornate, colorful weights became treasured objects.

By the mid-nineteenth century American glass manufacturers were creating dazzling pieces that compared favorably with the world-renowned ruby glass exported from Bohemia. One visitor to a New England glass factory in 1852 observed, ". . . most of the exquisite, richly colored and decorated glass ware, which is so admired under the name of 'Bohemian Glass,' is manufactured at these works." [2]

By 1861 the importation of Bohemian-type glass was so extensive that a tariff was imposed to protect domestic products. The earliest Bohemian glass and American imitations were generally elaborately cut and engraved overlay pieces. A layer of ruby glass was superimposed on a clear main body. An engraver or "cutter" removed portions of the colored coating, thus creating a pattern in the clear glass. In 1855 the New England Glass Company at Cambridge, Massachusetts, employed over ninety men in their cutting room. The large number of workers indicates the firm's vast production at mid-century. Ruby glass was expensive to produce and the New England Glass Company, like its many competitors, developed a wide range of additional colors that it used for "show" pieces.

"Poor man's silver," or mercury glass, was a modest substitute for the precious metal. Mercury glassware was exhibited at the New York World's Fair

at the Crystal Palace in 1853, where a manufacturer described the production technique for the ware, "The glass vessels are double, and between the layers the silver solution is poured in, and a solution of grape-sugar added. The latter reduces the silver in contact with it, and it is thrown down with a bright metallic surface on the glass." [3] The solution was then removed and the blown piece sealed.

Although mass-produced pressed glass could be marketed to the rising middle classes at unbelievably low prices, the one-of-a-kind free-blown specialty piece continued to be created by artist-craftsmen for the well-to-do. Between 1870 and 1901 a Renaissance of taste caused popular critics to look upon art glass as the "fine summer of perfected art." [4] Editorials in newspapers and periodicals fanned appreciation for decorative glass. Both blown and pressed pieces, marketed under exotic trade names, dominated the salesrooms. Agata, Amberina, Burmese, Crown Milano, Hobnail, Peachblow, Pomona, Royal Flemish, Satin or Mother-of-Pearl, and Spangled are but a few of the more successful wares.

Silver-plate manufacturers sensed in the high enthusiasm for art glass a new way of promoting their own products. Around 1885 many of them commissioned large quantities of ornately blown and decorated glass forms that they then embellished with silver-plated mountings and stands. Brides' baskets, gaudy fruit bowls, and revolving castor sets designed as table centerpieces all perfectly satisfied the late Victorian love for lavish ornament.

Charles L. Eastlake advised his readers, "Next to a good display of china on the table or sideboard, there is nothing which lends greater grace to the appointments of a dining room than delicate and well-designed glass." [5]

The Victorian enthusiasm for formality resulted in many customs that seem amusing today. Soon after the Civil War an elaborate protocol for calling cards was introduced from Europe. A silver-mounted glass calling-card holder became a necessity for any properly furnished household. The Meriden Britannia Company at Meriden, Connecticut, in 1886 alone, offered in their catalogue fifty-eight designs for such stylish novelties.

The efforts of one man stand preeminent in the saga of American Victorian glass. Louis Comfort Tiffany (1848–1933) at the age of eighteen became a student of the then-famous painter George Inness (1825–1894) and through him was exposed to the great artists of the day. A subsequent trip to Europe with brief study in the studio of the distinguished French artist, Leon Bailly (1825–1883), and a jaunt to North Africa with the American artist, Samuel Colman (1832–1920), completed his formal training. Returning to America in 1870, Tiffany opened his own studio. Although his European and African scenes received favorable criticism, his complex, flamboyant personality required additional outlets for fulfillment. Following a second trip to France in 1875, he turned to "decorative work," for "I believe there is more in it than in painting pictures." [6]

The Louis C. Tiffany & Company Associated Artists, primarily a decorating

firm, began operation in 1879 with Samuel Colman, Lockwood DeForest (1850–1932), and Candace Wheeler (1827–1923) joining Tiffany.

Evidence indicates that Tiffany experimented with glass in the early 1870s. His interest in the decorating firm continued until the end of the century; however, his preoccupation with glass became an obsession. "By the aid of studies in chemistry and through years of experiments, I have found means to avoid the use of paints, etching, or burning, or otherwise treating the surface of the glass so that it is now possible to produce figures in glass of which even the fleshtones are not superficially treated—built up of what I call 'genuine glass.'" [7]

By 1893 Tiffany's glass techniques had been perfected to such a degree that his Byzantine-style chapel at the World's Columbian Exposition in Chicago caused great admiration. Over a million minuscule bits of iridescent and opalescent glass, studded with semiprecious stones set in white and black marble, formed the chapel walls, ceiling, and floor. The breathtaking structure contained twelve stained-glass windows lighted by a dazzling, jeweled glass sanctuary lamp.

Although many Americans in the second half of the nineteenth century experimented with glass windows, only a few attained the goal expressed by one critic of the World of Art and Industry Exhibition at the New York Crystal Palace in 1853, "The modern glass painter must remember in choosing his design that he lives in the nineteenth century . . . We cannot see why this beautiful art, susceptible of so many beautiful applications, should be confined always to churches. Its true field, and the widest range of subjects in future, will be found, we think, in the decoration of secular buildings. At least, this application is worth the serious attention of the artist." [8] The artist John La Farge (1835–1910) and Louis Comfort Tiffany brought this form of art to new heights.

Tiffany perfected innovational techniques that ultimately enabled him to create a special line of decorative and artistic glass. His Favrile pieces represent the epitome of nineteenth-century handcraftsmanship. They were so popular that by 1898 it was necessary to maintain an inventory of five thousand pieces in his storerooms.

Tiffany's glass relates directly to the Art Nouveau style. When Samuel Bing (1838–1905) opened the Paris Salon de l'Art Nouveau in 1895, it contained several examples of Tiffany's work. To supply the constant demand for his glass, Tiffany formed the Tiffany Studios in 1900. This enterprise employed hundreds of craftswomen who produced a variety of "properly beautiful" objects ranging from miniature ceramic trays to ornate bronze and glass electric lamps. Although the work of Tiffany and his contemporaries passed from favor for a brief period, these examples of the decorative arts are avidly collected and greatly prized today.

Art Nouveau design accomplished what many nineteenth-century critics had long hoped for. It elevated the decorative arts to a position of importance previously reserved only for the fine arts. Pieces with sterling-silver mounts by Tiffany and other eminent manufacturers caused both social and art critics to discuss enthusiastically such everyday objects as hand mirrors and candlesticks.

During the 1890s novelty glass vases and decanters, overlaid with swirling patterns of thin silver coating, were marketed by the Gorham Manufacturing Company and other firms. These whimsical, decorative pieces were just one of the popular applications of a style that was eclectic by nature.

At the close of the century a revival of interest in cut glass occurred. As one late nineteenth-century company catalogue noted: "At no previous time have its uses been so many and its variety so numerous. While the common glass is cheap beyond precedent, the finer glass, made from the best materials and highly wrought by hand, has exquisite beauties to which the world's markets attach high values. It has the luminous brilliancy of colorless crystal, made by skillful cuttings to sparkle with white light of prismatic colors." [9]

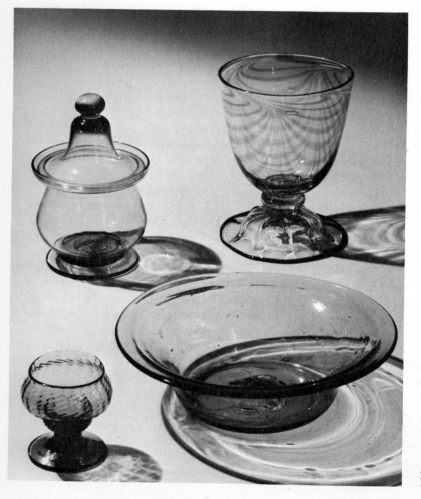

201 (left). Midwestern blown glass consisting of a sugar bowl, vase, saltcellar, and pan. Sugar bowl, 1825–1840, H. 8"; vase, c. 1850; saltcellar, c. 1850; pan, 1835–1843. (Greenfield Village and Henry Ford Museum)

202 (above, left). Lacy pressed, clear glass windowpane made by the Bakewell, Pears & Company, Pittsburgh, Pennsylvania. 1840. H. 6^{15}/$_{16}$″. This Gothic-style piece is stamped "Bakewell." (Greenfield Village and Henry Ford Museum)

203 (above, right). Pressed-glass cup plate made by the Boston and Sandwich Glass Company, Sandwich, Massachusetts. c. 1841. Diam. 3¾″. A representation of Bunker Hill Monument centers this piece. (Greenfield Village and Henry Ford Museum)

204 (right). Blown amber whimsy in the form of a bottle. 1800–1850. L. 8¼″. (Greenfield Village and Henry Ford Museum)

205 (right). Pressed-glass bottle made by the Whitney Glass Works, Glassboro, New Jersey. 1840–1850. H. 7¾". The original printed paper label duplicates the design of the glass beneath. (Greenfield Village and Henry Ford Museum)

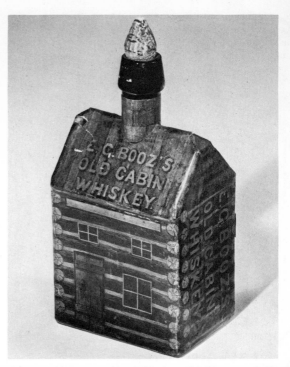

206 (below). Pressed-glass bottles and flasks. *Left to right:* Clear pint flask with sunburst in oval panel, 1815–1830, H. 6"; citron half-pint flask marked "Corn for the World," c. 1840, H. 7"; aquamarine flask with concentric-ring eagle, c. 1850, H. 6"; deep aquamarine Jenny Lind lyre bottle from the 1850s, H. 7¼". The earliest flasks and bottles were blown; later examples were pressed by machine. (Greenfield Village and Henry Ford Museum)

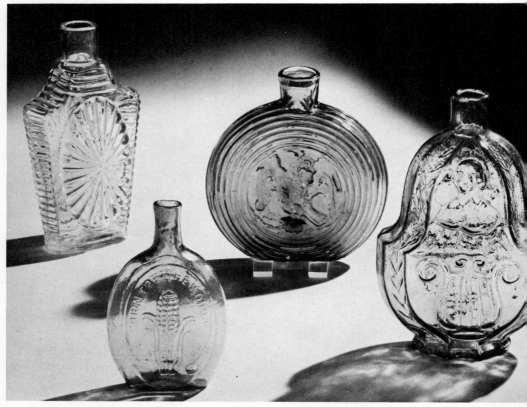

207 (right). Cut-glass vase with cover made by the New England Glass Company, Cambridge, Massachusetts. c. 1845. H. 29¾". This extraordinary piece has ruby flashing over clear glass. (The Toledo Museum of Art; Gift of Frank W. Gunsaulus, 1913)

208 (below). Illustration of a glass-pressing machine from *Curiosities of Glass-Making* by Apsley Pellatt, published in 1849. The workman on the right has shears in his right hand. The presser detaches a portion of glass (b) from the assistant's punty. His left hand holds aloft the arm (d) that operates the plunger (c). (The New York Public Library)

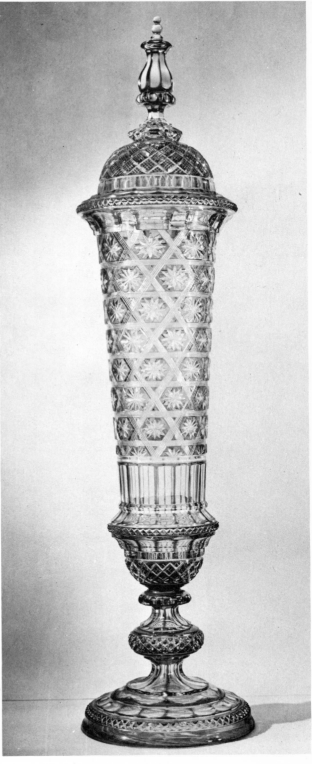

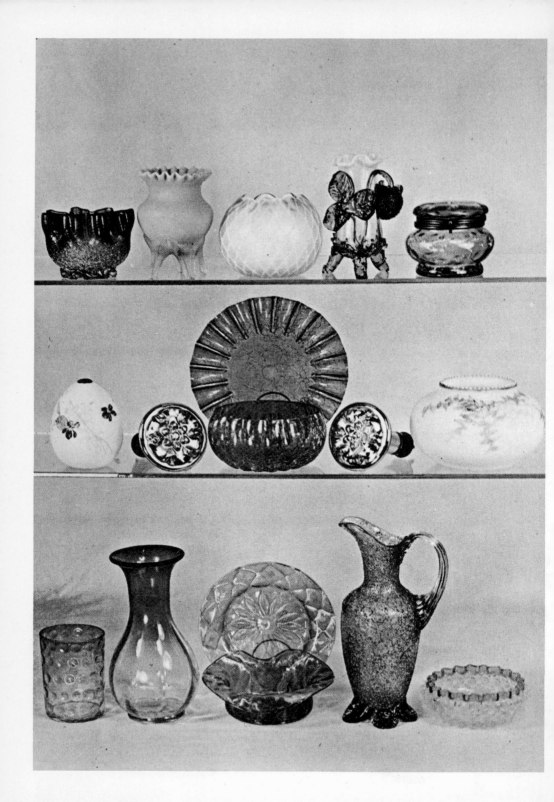

209 (opposite). By the 1860s art glass began to be popular. *Top row:* 1. Amethyst overshot fluted bowl, clear, crimped foot. Boston and Sandwich Glass Company, Sandwich, Massachusetts. 1860–1870. H. 2¾". Overshot is made by rolling a gather of molten glass in crushed glass, then shaping the piece. 2. Sandwich Peachblow vase. Boston and Sandwich Glass Company, Sandwich, Massachusetts. H. 4½". 3. Rainbow Mother-of-Pearl Satin glass rose bowl in the Diamond Quilted pattern. Phoenix Glass Works, Beaver Falls, Pennsylvania. 1885. H. 3½". Variations of this popular ware were made by most important glassworks in America and England. 4. Opalescent vase with amber feet. Probably Boston and Sandwich Glass Company, Sandwich, Massachusetts. 1880s. The applied decorations include a stained, overshot strawberry. 5. Mary Gregory covered powder box. Cranberry glass decorated with white enamel. Boston and Sandwich Glass Company, Sandwich, Massachusetts. H. 3". This type of decoration bears the name of one of the many decorators at the Sandwich factory. Much was made elsewhere, including quantities in England. *Middle row:* 1. and 5. Decorated opaque white glass sometimes called Alabaster Ware. Mount Washington Glass Works, South Boston, Massachusetts. 1880s. H. of cologne bottle 4"; H. of bowl 3½". 2. and 4. Pair of silvered glass tiebacks. Marked N.E. Glass Co. Cambridge, Massachusetts. Diam. 3". 3. Craquellé glass finger bowl and fluted plate. Hobbs, Brockunier & Co., Wheeling, West Virginia. 1883. Diam. of bowl 4¾"; Diam. of plate 6¾". *Bottom row:* 1. Rubina Verde tumbler in the Inverted Thumbprint pattern. Hobbs, Brockunier & Co., Wheeling, West Virginia. 1880s. H. 4". 2. Rubina crystal vase. Attributed to Dorflinger Glass Works, White Mills, Pennsylvania. H. 7⅝". 3. Threaded glass bowl and matching plate. Expanded diamond cranberry glass, threaded with amber glass. H. of bowl 2¼"; Diam. of plate 6". Frequently attributed to Nicholas Lutz at Sandwich, Massachusetts, this ware was also produced in quantity elsewhere, including England. 4. Metallic overshot ewer, stained with oxides. Boston and Sandwich Glass Company, Sandwich, Massachusetts. 1880s. H. 9¼". 5. Camphor glass bowl in the Hobnail pattern. Amber stained. Hobbs, Brockunier & Co., Wheeling, West Virginia. 1880s. Diam. 5". (The Bennington Art Museum)

210 (below). Five pieces of cut glass made at the Boston and Sandwich Glass Company, Sandwich, Massachusetts, and given to Deming Jarves upon his retirement from that firm in 1858. H. of vase 9". (Greenfield Village and Henry Ford Museum)

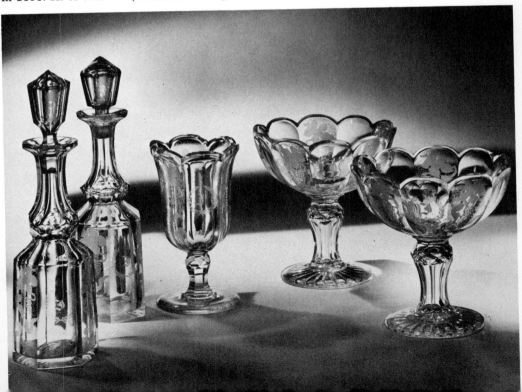

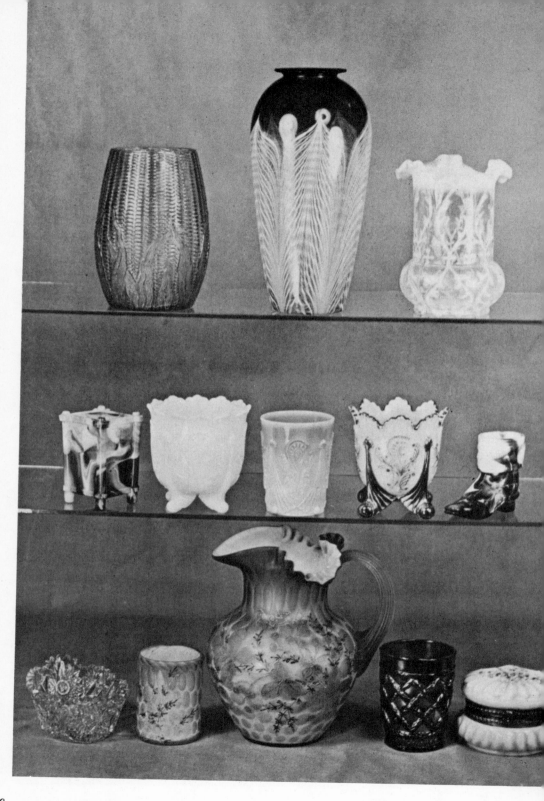

211 (opposite). By the 1880s inexpensive art-glass novelties were used as gifts and had become a popular way of promoting the sale of expensive merchandise. *Top row:* 1. Maize pattern glass vase. W. L. Libbey & Son Co., Toledo, Ohio. 1889. H. 6⅜″. This piece is transparent, stained amber and blue-gray although the ware is frequently produced in opaque white, pale yellow, or pale green with painted red or green leaves. 2. Durand vase. Vineland, New Jersey. c. 1928. H. 10″. 3. Spanish Lace vase. Beaumont Glass Company, Martin's Ferry, Ohio. 1895–1905. H. 6¼″. *Middle row:* 1. Caramel Slag toothpick holder. H. 3⅜″. Slag glass is variegated and fused, with a marbleized appearance. 2. Opalescent white jam jar. H. 4¼″. Inverted Fan and Feather pattern. 3. Pink Slag tumbler. H. 3⅞″. Inverted Fan and Feather pattern. 4. Opalescent Custard footed vase. H. 4½″. Inverted Fan and Feather pattern. 5. Purple Slag boot. Challinor, Taylor and Co., Tarentum, Pennsylvania. 1870–1880. H. 3⅛″. *Bottom row:* Cut-glass bowl marked "Libbey." 1890s. H. 2¼″. 2. and 3. Mother-of-Pearl Satin glass tumbler and pitcher. 1890s. H. of tumbler 3⅝″; H. of pitcher 8¾″. This popular ware was made by all glasshouses in America and England. 4. Carnival or Taffeta Glass tumbler. H. 4⅛″. This was originally a cheap, inferior, but popular imitation of expensive iridescent wares. It was made in the 1910s and 1920s in many colors, by several makers, the most famous of which was the Northwood Co. 5. Wavecrest hinged powder box. C. F. Monroe Company, Meriden, Connecticut. c. 1898. H. 3″. This is a painted, opaque opal glassware. The Monroe Company bought its molded blanks from other manufacturers and decorated them. Wavecrest is their trademark, issued May 31, 1898. (The Bennington Art Museum)

212 (below). Cross section of a hinged mold for pressing a footed glass bowl, taken from an 1869 patent specification. The letters on the sketch represent (*a*) body of mold; (*b*) core-plate of base; (*c*) removable rim, ring, or cap plate; (*d*) plunger; (*e*) hinge-pin; (*f*) bolt-pin; (*g*) matrix (which outlines the shape of articles to be formed). Worth noting is the large volume of metal constituting the mold in relation to the free space into which the molten glass was to be forced by the plunger. (The New York Public Library)

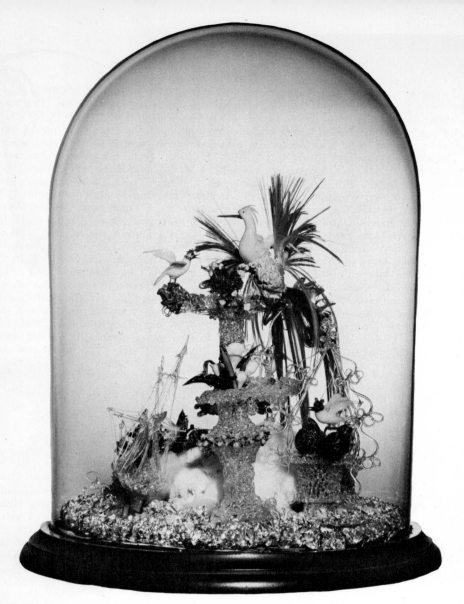

213 (above). Glass dome filled with blown- and crocheted-glass ornaments. c. 1876. H. 19″. T[...] central pillar with plumed bird and nest is surrounded by two ships, a fountain, a vase wi[...] flowers, a basket with strawberries, and a table with a nesting bird. (Greenfield Village a[...] Henry Ford Museum)

214 (opposite, above left). Cut-glass decanter and wine glasses. Dorflinger Glass Works, Whi[...] Mills, Pennsylvania. 1876. H. of decanter 11⅞″. The decanter is decorated with a United Stat[...] shield and the motto, "Liberty and Union, Now and Forever, One and Inseparable." It w[...] made for the Philadelphia Centennial Exposition where it received the highest award. (Phil[...] delphia Museum of Art)

215 (opposite, above right). Pressed-glass pitcher in the Three-Face pattern. Made by Georg[...] Duncan & Sons, Pittsburgh, Pennsylvania. c. 1874. H. 6⅞″. This clear piece has a frosted Three[...] Face base. A clear mask is below the lip and at the base of the handle. (Greenfield Village an[...] Henry Ford Museum)

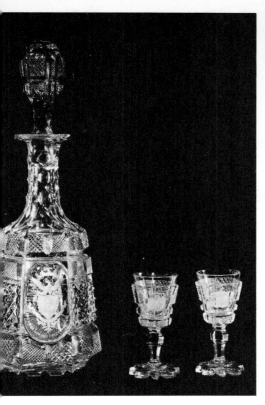

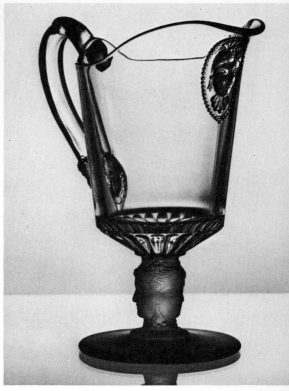

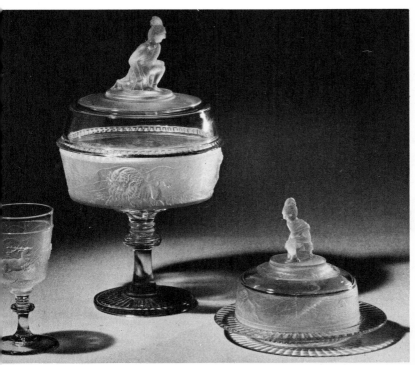

216 (left). Pressed-glass pieces in the Westward Ho pattern. Gillinder and Sons, Philadelphia, Pennsylvania. Late 1870s. H. of compote 14¾″. The Westward Ho pattern was one of the most popular Victorian pressed-glass designs. (Greenfield Village and Henry Ford Museum)

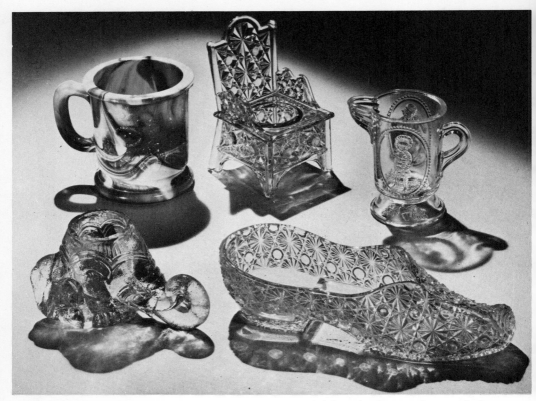

217 (above). Group of pressed-glass novelties. 1870–1900. L. of shoe 7¼″. The shoe and the chair are in the Daisy and Button pattern, one of the most popular and lasting Victorian designs. (Greenfield Village and Henry Ford Museum)

218 (left). Amberina cracker jar made by the New England Glass Company, Cambridge, Massachusetts. H. 8⅜″. Amberina was described by Joseph Locke of the New England Glass Company in the patent granted on July 24, 1883, "Starting with amber glass as a base, I have been enabled by the action of heat alone to develop on a part of the article composed of homogeneous stock a more or less deep ruby color, and also develop in the said article a violet shade, and greenish, and a blueish, and other tinges."[1] The jar retains a paper label reading: "N E G W/Amberina/Pat'd/July 24, 1883." (The Metropolitan Museum of Art; Gift of Mrs. Emily Winthrop Miles, 1946)

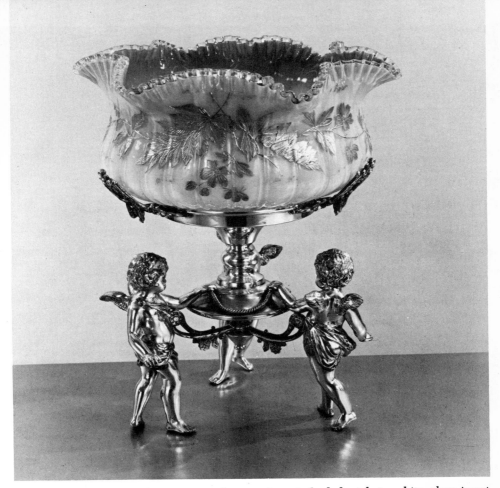

219 (above). Fruit bowl consisting of a translucent shaded pink to white glass insert with an applied crystal edge, gold decoration, and a silver-plated stand made by the Wilcox Silver Plate Company, Meriden, Connecticut. 1886. H. 12½". Quadruple-plated stands were ordered by several glass manufacturers in an attempt to create a broader market for their wares. (The International Silver Company)

220 (right). Pressed-glass covered dish made by Atterbury & Co., Pittsburgh, Pennsylvania. L. 11¼". This white, or milk-glass, piece, in the form of a duck is marked on the bottom with raised letters "Pat⁴ March 15, 1887." (Greenfield Village and Henry Ford Museum)

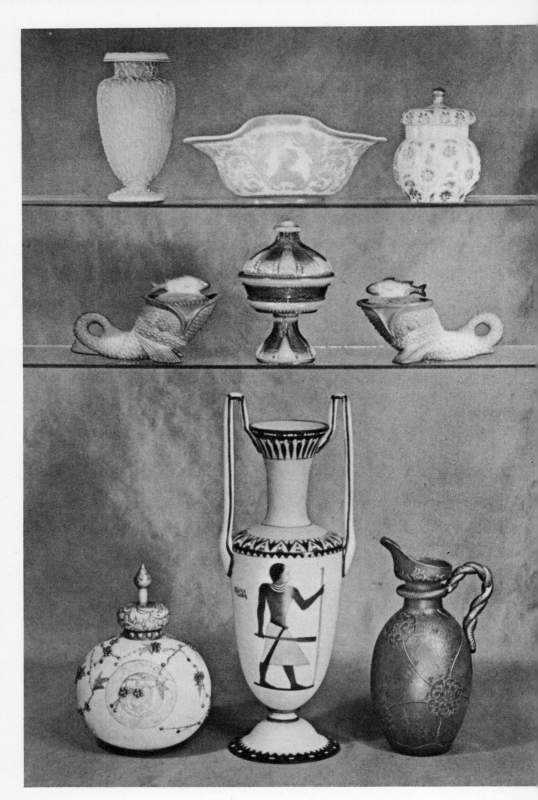

221 (opposite). The taste for elegant glass continued during the 1880s and 1890s. *Top row:* 1. Coralene vase. H. 7¾". This name was given to a type of decoration rather than a kind of glass. The design usually resembled seaweed or coral, hence the name: Coralene. Usually the decoration was applied to an acid-finished piece, only occasionally to a polished one. The design was applied with an adhesive, to which were stuck thousands of tiny glass beads. This was done in many factories in America and England. 2. Cameo glass bowl. Mount Washington Glass Company, South Boston, Massachusetts. H. 4½". Cased glass with the design etched to resemble the very elaborate, true Cameo glass. 3. Findlay or Onyx glass covered jar. Dalzell, Gilmore and Leighton Company, Findlay, Ohio. 1889. H. 6". This plated ware has platinum luster decorations on raised, daisylike flowers and leaves. *Middle row:* 1. Chocolate glass dolphin mustard container. Indiana Tumbler and Goblet Company, Greentown, Indiana. Designed by Charles E. Beam and produced from 1900 to 1903. L. 7⅛". 2. Holly Amber covered jelly. Indiana Tumbler and Goblet Company, Greentown, Indiana. Originally called Golden Agate Ware, this plated glass was made only from January 1, 1903, to June 13, 1903. H. 7½". 3. Dolphin mustard jar with sawtooth edge completely around top. Indiana Tumbler and Goblet Company, Greentown, Indiana. L. 7⅛" *Bottom row:* 1. Crown Milano covered jar. Mount Washington Glass Company, New Bedford, Massachusetts. 1886–1888. H. 10¼". Raised decoration in gold enamel on a white opal glassware. 2. Burmese vase. Mount Washington Glass Company, New Bedford, Massachusetts. This is one of the few known pieces signed by Albert Steffin, superintendent of the factory. H. 17½". 3. Royal Flemish ewer. Mount Washington Glass Company, New Bedford, Massachusetts. After 1889. H. 11⅜". The name was patented in 1894. This is semitransparent glass with acid-finish, superimposed with gold relief. (The Bennington Art Museum)

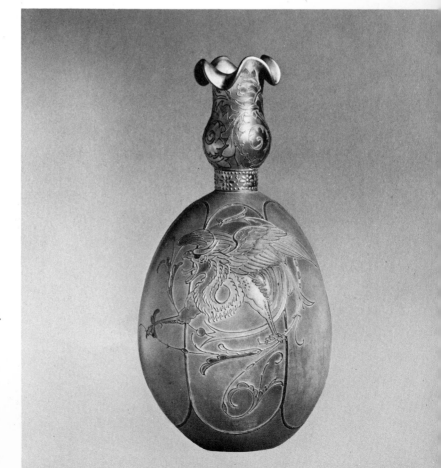

222 (right). Royal Flemish bottle, blown, enameled, and gilded, manufactured by the Mount Washington Glass Company, New Bedford, Massachusetts. c. 1890. H. 13". Royal Flemish glass was patented in 1894. This ornate example is decorated with a stylized dragon reflecting the current interest in Oriental motifs. (The Corning Museum of Glass)

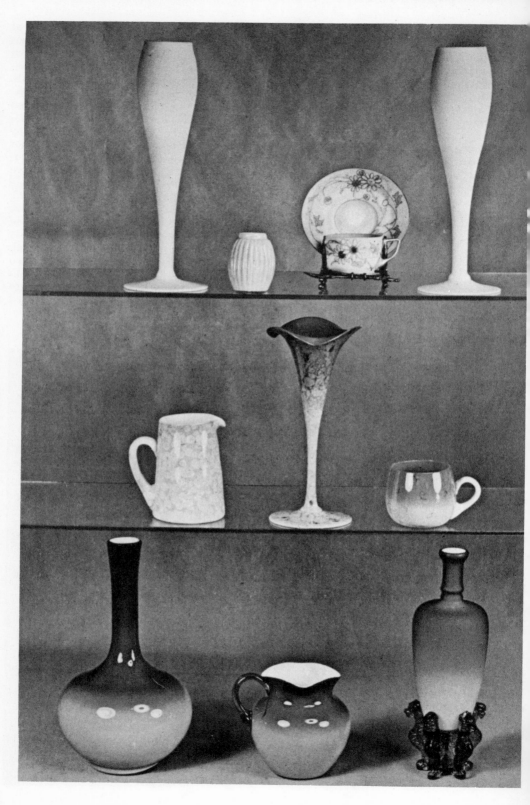

223 (opposite). *Top row:* Mount Washington Peachblow, shading from a delicate rose-pink at the top to a light blue-gray at the bottom, is among the rarest of American art glass. It was made at the Mount Washington Glass Company, in New Bedford, Massachusetts, only between 1886 and 1888. It is a solid glass without a lining of any color, being the same composition inside and out. Almost all of this glass was given an acid bath to produce the soft, satin finish. When decorated, it was either with painted designs or with pinpoints of enamel, or with both, usually in flower forms and frequently with verses lettered in Old English script. 1. and 4. Rare pair of footed vases. H. 10½". 2. Rare polished, ribbed, salt shaker. H. 2½". This piece was never acid finished. 3. Cup with matching saucer in Burmese. This design is frequently called the Queen's Pattern. H. of cup 1½"; Diam. of saucer 4¼". *Middle row:* Agata was made for less than one year, in 1887, only by the New England Glass Company at Cambridge, Massachusetts. Its spotted finish was applied to a piece of New England Peachblow. The finished piece was coated with a metallic stain and spattered with alcohol, which evaporated and left a speckled effect that was fired more or less permanently on the piece. 1. Pitcher, underfired, which makes it resemble a cased or lined glass. H. 4¼". 2. Brilliant colored Lily vase with rare paper Agata label. H. 8½". 3. Punch cup. H. 2⅜". *Bottom row:* Wheeling Peachblow was the original peachblow and was made at Wheeling, West Virginia, by J. H. Hobbs, Brockunier & Co., commencing soon after 1883. It is really an Amberina glass, lined or cased inside with an opaque, milk-white or opal glass and is a type of plated glassware. It was made in two finishes, polished, or acid-finish. H. 10". 1. Stick vase, polished. H. 10". 2. Square-top pitcher with applied amber handle. H. 4⅝". 3. Wheeling copy, in acid-finished glass, of a famous Chinese porcelain vase that sold for $18,000 in 1886. Called the "Morgan Vase" after the original owner, the widow of J. P. Morgan, it is 10 inches high, including its five-footed, gargoyle-shaped, pressed, amber stand. (The Bennington Art Museum)

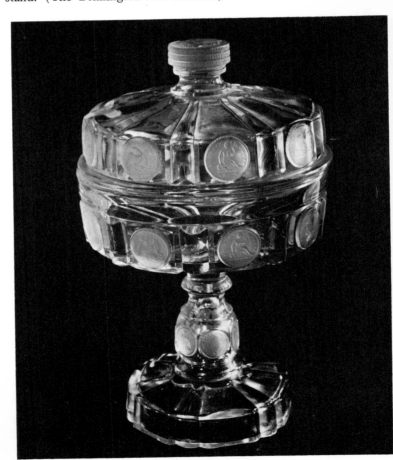

224 (right). Pressed-glass covered compote in the United States Coin pattern. 1893. H. 10¼". On the top of the knob there is a reproduction of a silver dollar. Many articles were made in this pattern at the time of the World's Columbian Exposition in 1893. (Greenfield Village and Henry Ford Museum)

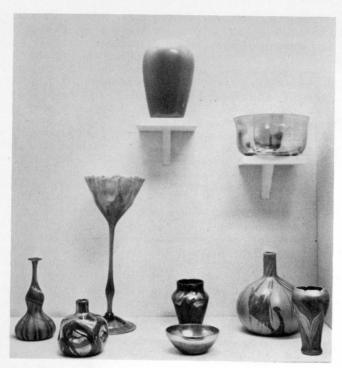

225 (left). Part of a collection of Tiffany glass purchased from the Tiffany Glass and Decorating Company at 333–341 Fourth Avenue, New York City, in 1897 by the Cincinnati Museum Association, Cincinnati, Ohio. The twenty-nine pieces cost $512.40. (Cincinnati Art Museum; Gifts of A. T. Goshorn and Elizabeth Wilson)

226 (below). Favrile glass punch bowl exhibited by L. C. Tiffany at the Exposition Universelle in Paris in 1900. H. 14¼". The *American Art Annual III* (1900) reported, "Among the collection of Favrile glass sent by the Tiffany Company the most important piece was a punch bowl . . . about thirty inches in diameter. The glass is encased in a frame of chased and wrought golden metal [actually brass with gold plating], the design of the base suggesting the effect of breaking waves, while from their foaming crests spring six arms of peacock-hued Favrile glass, they in turn support the uprights of the frame, becoming a richly ornamental band at the top. Three of the supports end in quaintly twisted finials of luster glass from which hang ladles of metal and iridescent glass." [2] (Dr. and Mrs. Robert Koch)

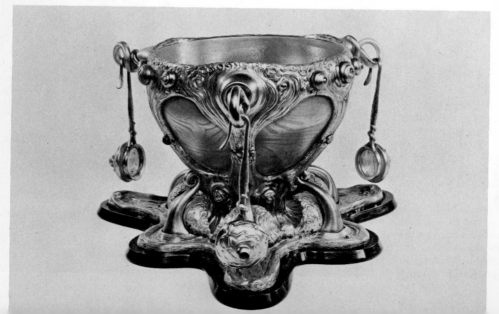

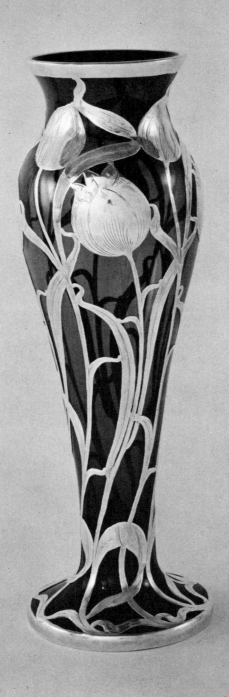

227 (above). Silver-overlay vase attributed to the Alvin Manufacturing Company, Providence, Rhode Island. Late nineteenth or early twentieth century. H. 12¼″. The silver-deposit process, first developed in the 1880s, was most popular between 1890 and 1910. It especially suited the Art Nouveau style in vogue at this time. (The Metropolitan Museum of Art; Purchase, 1968, Edgar J. Kaufmann Charitable Foundation)

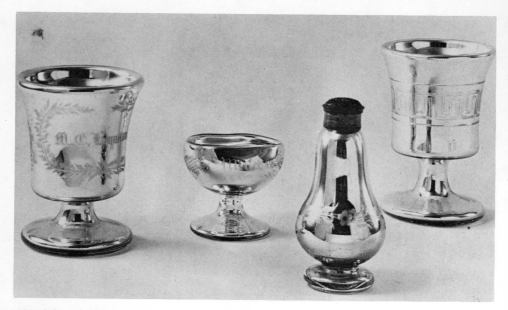

228 (above). Blown silver, or mercury, glass spooner, or footed tumbler, match cellar, shaker, and goblet. Late nineteenth century. H. of goblet 5½". Similar inexpensive substitutes for silver were shown as early as 1853 at the New York World's Fair at the Crystal Palace. (The Currier Gallery of Art, Manchester, New Hampshire)

229 (below). Glassmaking tools, and paperweights and bottle stoppers made by Ralph Barber, an employee of Whitall, Tatum & Company in Millville, New Jersey, during the early 1900s. Barber's weights are among the most collectible. (Greenfield Village and Henry Ford Museum)

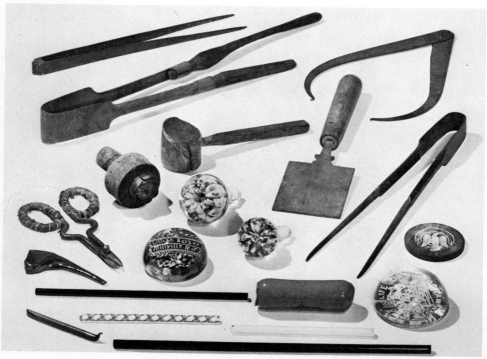

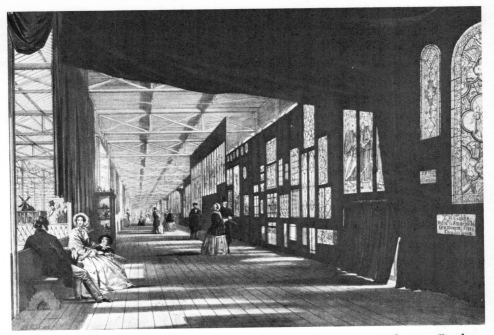

230 (above). Colored lithograph by Joseph Nash, published by Dickenson Brothers, London, England. 1854. L. 23″. The stained-glass gallery at the London Crystal Palace, 1851. By the mid-nineteenth century, glass-staining had been revived by many firms throughout the world. (Greenfield Village and Henry Ford Museum)

231 (right). Illustration from a page of the 1896 catalogue published by the Libbey Glass Company, Toledo, Ohio. Cut pieces in the "brilliant period" usually are regular and balanced, and the patterns are geometric. (Private collection)

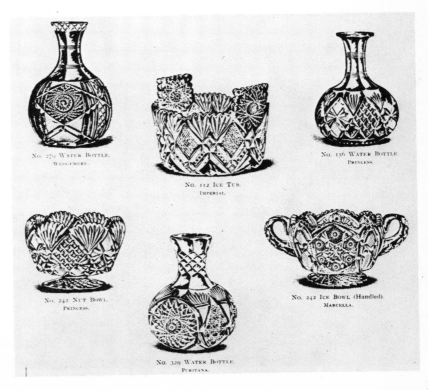

NO. 279 WATER BOTTLE. WEDGEMERE.

NO. 112 ICE TUB. IMPERIAL.

NO. 156 WATER BOTTLE. PRINCESS.

NO. 242 NUT BOWL. PRINCESS.

NO. 329 WATER BOTTLE. PURITANA.

NO. 242 ICE BOWL (Handled). MARCELLA.

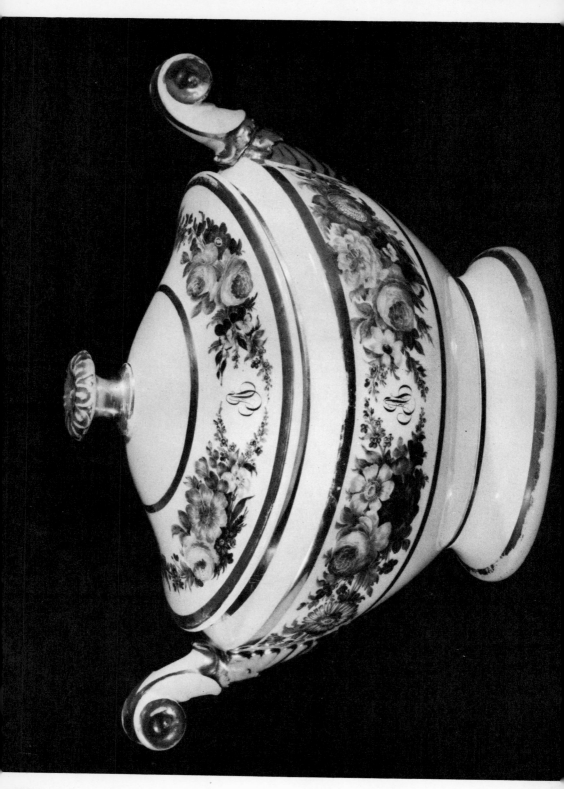

CERAMICS

Porcelain was developed in China during the Tang dynasty (A.D. 618–907). It is stronger than other ceramics and has always been admired for its translucence, a quality created by the fusing of a special mixture of kaolin and feldspar at extremely high temperatures. The Western world probably learned about porcelain during the twelfth century, and sometime near the middle of the Ming dynasty (1368–1644) began to imitate the body, design, and decoration of the Oriental wares. These first European efforts to create porcelain produced "soft paste," a product that looked like "true" or hard porcelain, but did not have its strength. A fine quality stoneware was developed by Johann Friedrich Böttger in Saxony during the seventeenth century, and in 1671 John Dwight, an Englishman, manufactured a type of stoneware that he called porcelain even though it was very brittle. Finally, in 1713 at the Meissen factory near Dresden, Saxony, Böttger discovered a successful formula for true porcelain, which in time was carried across Europe by workmen who left the Meissen firm for work at other locations.

Between 1720 and 1730 enterprising English potters developed a relatively inexpensive substitute for the costly porcelain by covering stoneware pieces with a salt glaze. At nearly the same time other high-fired earthenwares with a glaze-decorated white body were introduced.

Whieldon, named after Thomas Whieldon, an eighteenth-century Staffordshire potter, was one of the most popular mid-eighteenth-century English tablewares. Earthenware blanks were covered by a cream-colored glaze by the English potter Josiah Wedgwood. "Queen's ware," named in honor of Queen Charlotte, his patron, became a status symbol in late eighteenth-century American homes.

The Dutch settlers in the Hudson River Valley were probably the first to introduce Delft to America. This tin-glazed earthenware, usually decorated with blue-and-white designs, was also manufactured in England where emigrating colonists might have purchased it prior to leaving for America. Dr. Daniel Cox, a proprietor of the Colony of West New Jersey, wrote in 1689, "I have erected a pottery at Burlington for white and Chiney ware, a great quantity to ye value of 1200 li [English pounds] have been already made and vended in ye County, neighbor colonies and ye Islands of Barbados and Jamaica . . ."[1]

Despite Dr. Cox's apparent success, his firm could not begin to supply the demand, for "Hogsheads of Handsome Delft Ware"[2] continued to be docked

232 (opposite). Porcelain covered tureen manufactured by William Ellis Tucker. Philadelphia, Pennsylvania. 1825–1838. H. 10⅝". This piece is decorated with the initials A T, which are believed to stand for Anne Tucker, niece of the potter. (Greenfield Village and Henry Ford Museum)

and advertised in the local newspapers of seaport communities throughout the eighteenth century.

Enterprising Americans persevered in their attempts to produce true porcelain. Some were successful. The governor of Georgia noted in 1739, "Andrew Duché is the Potter at Savannah who goes on very well there is one of the most industrious in the Town and had made several Experiments which seem to look like the making of China." Duché agreed. He considered himself ". . . the first man in Europe, Africa or America that ever found the true material and manner of making porcelain or China ware." [3]

By the opening of the eighteenth century nearly every American settlement of moderate size supported a potter. Most often these craftsmen were limited by their facilities to the production of such utilitarian stoneware pieces as jugs, bowls, and pans.

Domestic goods seldom rivaled such imported wares as those advertised by Mehetabel Kneeland of Boston in 1737:

> Just Imported and to be Sold Reasonably . . . A choice Sortment of Delph, Stone, and Glass Ware, Viz. Bowls of divers Sizes, Plates of all Sorts, and Dishes, Cups and Sawcers, Breakfast Bowls, Strayners, Mugs of divers Sorts, &c. Wine Glasses double and single Flint, Jellys, Whip Sullibubs, Baskets, Punch Ladles, Cream Pots pearl'd and plain, Bird Fountains, Tankards and Salvers, &c. By Wholesale or Retail. Where may also be had Choice Tea and Coffee, and other Sorts of Grocery.[4]

Because of constantly increasing taxes on imported luxuries, it became economically feasible for domestic producers, whose manufacturing costs were higher than those of English or European firms, to compete in this market. From mid-century on, many potters attempted to establish firms capable of producing high-quality porcelain. One of the most notable of these was the firm of Bonnin & Morris of Philadelphia, which, on December 29, 1769, announced:

> New China Ware. Notwithstanding the various difficulties and disadvantages which usually attend the introduction of any important manufacture into a new country, the proprietors of the China-works now erecting in Southwark have the pleasure to acquaint the public that they have proved to a certainty that the clays of America are as productive of good porcelain as any heretofore manufactured at the famous factory in Box near London . . .[5]

Although the firm begun by Gousse Bonnin and George Morris lasted only until 1772, examples of its work have survived. Probably the most impressive piece that survives is a four-part bonbon dish of shell design marked *P* in blue under the glaze. It is now in the collections of The Brooklyn Museum.

Between the closing of the Bonnin & Morris firm and the opening of a porcelain manufactory by William Ellis Tucker (1800–1832) at Philadelphia in 1826, numerous attempts at fine pottery production were made in both Pennsyl-

vania and New Jersey. These efforts were encouraged by the great artist and museum proprietor Charles Willson Peale (1741–1827) who advertised his

> . . . wishes to collect into one view, specimens of various kinds of wood growing in America, they may be in cubes of two or three inches; all sorts of fossils, minerals spares, stone, sand, clay, marble, and earthly substances; from a better knowledge whereof the arts will derive improvement, especially in the manufacturing of Porcelaine, earthen, and stone wares, and in the various useful metals.[6]

Potteries were established in nearly every state in the new union prior to 1825. Potters sought to make their products popular through the introduction of novel wares.

> A new Manufactory of yellow or cream Ware, such as never was made in this country before, has been established at Red Hook landing, on the east bank of the North River, under the name of Tivoli Ware, where any command for all sorts and shapes of ware, with different colored edges. Likewise compleat table and tea sets, strong pickle, pomatum and druggist pots, white varnished, will be executed . . . The above Ware will be sold at a great deal cheaper then any imported for cash or approved notes. A few apprentices wanted, who will be taught by the most skillful European hands, in that useful trade.[7]

Unquestionably, the most important American porcelain of the first half of the nineteenth century was that produced by William Ellis Tucker and his various associates, and finally by his successors, at Philadelphia. It seems certain that Tucker first became interested in the production of china when he decorated imported European blanks for his father Benjamin, who had a china shop there. The white bodies of undecorated Tucker pieces relied upon fine profiles for their beauty. Decoration consisted of either sepia and charcoal landscapes; gold or gold-and-buff bands; or brilliantly polychromed flowers, landscapes, or special subjects, trimmed with gold.

The Tucker pottery was begun in 1826 and lasted some twelve years. Its high-quality porcelain products were the first in America to be successfully manufactured and marketed over an extended period of time.

Mrs. John Farrar, writing in 1838, scolded Early Victorian housewives for their "keep it for best" practices.

> Now would it not be far more refined and dignified, as well as more honest and comfortable, to live better every day, and make less parade before company? Instead of using ordinary crockery and parts of several broken sets of different patterns, when alone, and having a very expensive set of French porcelain in the best-chamber closet for state occasions, would it not be better to have . . . ware . . . that can always be matched, and by

using the same as best and common, you will never have a motley assemblage of dishes and plates to be used up. If you can afford to have expensive table furniture laid by for company, you can afford to use whole dishes and handsome spoons every day, and by so doing, you will escape a great many uncomfortable feelings, and be far more likely to be hospitable and friendly . . . If you think it right to use any utensil of glass or china after it has been marred by accident, do it openly, care not who sees it, if you are ashamed to have it seen, be ashamed to use it at all, a proper self-respect requires this.[8]

The design of American pottery and porcelain tended to be conservative until the mid-1840s. Profiles were vaguely reminiscent of the Greek and Roman prototypes popular during the Classical Revival that began about 1800.

As the nineteenth century continued, attempts were made to include naturalistic details in all the decorative arts. This is evident in the products of the Jersey Porcelain and Glass Company and in the fine pottery manufactured by its successor, the American Pottery Company, which operated from 1825 to 1845 at Jersey City, New Jersey. These firms always faced direct competition from foreign manufacturers.

In 1847 Christopher W. Fenton, at Bennington, Vermont, introduced Parian, a new type of porcelain that had been developed a few years earlier in England. His evident interest in naturalism is expressed in statuary and undulating ornamental wares that anticipated the Rococo Revival style of the 1850s and 1860s.

Just as Tucker operated with a succession of business associates, Fenton also entered into several partnerships. In 1849 he began operation of a new plant at Bennington, and by 1853 the products were marketed under the name United States Pottery Company. Although many of this firm's wares are reminiscent of European prototypes, some were distinctly American and catered to domestic taste.

In an attempt to attract potential customers, Fenton exhibited porcelain, flintware, and various other products at the New York World's Fair at the Crystal Palace in 1853. A reporter from *Gleason's Pictorial Drawing-Room Companion* commented:

. . . The neighborhood of Bennington, Vermont, is one well adapted for the establishment of a pottery manufacture, as there is a considerable deposit of plastic clay, which is met with in large quantities, and of a great purity, in at least a dozen other places in Vermont. Indeed, there is no State in the Union better adapted for manufacturing porcelain and other earthen wares, containing all the mineral elements, and also ores of iron and manganese. These, however, in themselves, constitute but a portion of the success of any branch of manufacture, and it is to the untiring industry and skill of Mr. C. W. Fenton that this country is indebted for the establishment of this art, at Bennington . . . At the sacrifice of time and health he has also succeeded in introducing the manufacture of Parian Ware in

this country; produced the Flint Enamel Ware, for which he has secured a patent; and is engaged in extension of porcelain manufacture—which has been followed by other establishments in this country, but by no means to the same satisfactory development as by him . . .[9]

Although Americans could not help but admire European porcelain at the Crystal Palace, their most enthusiastic praise was reserved for domestic wares. Charles Cartlidge and his partner, Herbert Q. Ferguson, operating as Charles Cartlidge and Company in 1848, took a prize for the fine quality of their wares manufactured at Greenpoint, New York. The Cartlidge firm is noted for its colorful pieces decorated with a multitude of patriotic American symbols.

William Bock & Brothers, a Greenpoint, New York, firm that began operation about 1850, also exhibited at the Crystal Palace, where they enjoyed popular success. Other manufacturing firms controlled by this company used the trade names Union Porcelain Works, which Thomas C. Smith took over in 1862, and Empire.

The Civil War was responsible for the closing of many potteries during the early 1860s. An exception was the firm of Bloor, Ott and Booth, formed at Trenton, New Jersey, in 1863, which produced mainly high-fired earthenwares. Becoming Ott and Brewer in 1871, they employed professional sculptors to create porcelain and Parian exhibition pieces. Just as the products of most of their competitors were eclectic in their decoration, much of the Ott and Brewer pottery indiscriminately combined several earlier styles. This is a common characteristic of the Victorian period.

Showy exhibition porcelains like the Century Vase, designed by the German emigrant, Karl Muller, for the Union Porcelain Works, began to preoccupy pottery manufacturers. They had discovered that popular displays at national and international fairs often brought in large orders. The original Century Vase exhibited at the Philadelphia Centennial Exposition in 1876 was over seven feet high. No wonder nearly every visitor marveled at this technical achievement!

Other aspects of American ceramic production were singled out for praise. M. Arnoux, writing for a handbook to accompany the British Manufacturing Industries presentation, praised the exhibits in the southeast portion of the main building at Philadelphia. Arnoux, art director for the prestigious English firm of Minton, was paraphrased in the popular American magazine, *The American Architect and Building News,*

. . . Allusion is made to the excellent quality of the white-granite ware (known by the popular designation of ironstone china) produced in America, as a sufficient motive to withholding French and English shippers from a trade that must one day prove ruinous to them . . . The chief centers of production are Trenton in New Jersey, and East Liverpool in Ohio; but though the clays that are needed could probably be found in the States where those potteries are established, those actually used are obtained chiefly from neighboring States. The merits of the American white-granite

ware have been known for some years, far more extensively in England than in the home of its production; and the protective tariff, under which foreign manufacturers are subject to duties on importation into this country, has wrought incalculable mischief to native industry and morality; giving a factitious [*sic*] value to the foreign goods, it insures a large demand and sale for them, which the home producers can hope to turn to their profit and advantage only by the forgery of English trade-marks. The sooner this practice shall be abandoned, the better will it be for America; and those among our New Jersey and Ohio manufacturers who have combined for a joint personal representation of their interests, who stamp their goods with their own marks, and who announce the places from whence they derive their clays, etc., deserve well at the hands of their fellow countrymen and women.[10]

By mid-century a keen interest in the products of the Orient became evident in England. Americans making the grand tour noticed the popularity of Chinese and Japanese styles and, in an attempt to display their modishness, brought home exotic pieces.

The Japanese Bazaar at the Philadelphia Centennial Exposition, constructed by a Japanese crew from over fifty carloads of building materials and display objects, increased this new interest in Oriental and exotic Near Eastern styles, and it spread like wildfire.

". . . [A]ntique bronzes, curious specimens of porcelain, and pottery, wood and ivory carvings, and lacquer work . . ." [11] impressed the public as well as the American manufacturing community, which sensed the interest and incorporated Oriental motifs into the designs of their products. When Americans captured the essence of Oriental design, it was generally in the field of ceramics. More often, however, weak approximations of the exotic transformed traditional Occidental pieces into ill-conceived monstrosities. Numerous pseudo-"Oriental" trinkets, including awkwardly designed ceramic fans with gaudy embellishments, saturated the market. Few were marked, enabling fast-talking retailers to pass them off to undiscriminating buyers as authentic Oriental ceramics. Even the more staid firms catered to popular Victorian taste, which demanded many elaborate details. The Union Porcelain Works joined its competitors and applied naturalistic lizards, bugs, butterflies, and other insects to their ornately painted and decorated Oriental-inspired pottery. Charles L. Eastlake, in the fourth edition of his *Hints on Household Taste* (1878), might well have had such extravagant wares in mind when he observed: "From the earliest periods of civilisation down to the present time there is, perhaps, no branch of manufacture which has undergone such vicissitudes of taste and excellence of workmanship as that of pottery." [12]

During the late 1870s and throughout the 1880s another wave of exoticism enjoyed a special popularity with elite East Coast decorators and their clients. The Turkish corner, crammed with authentic imported antiques, contemporary objects from far-off lands, and domestic pieces, approximated the Turkish style.

Enthusiasm continued unabated. To satisfy the popular demand for exotica, new ceramic operations sprang forth from all corners. In 1877 John Gardner Low, and his father John Low, a civil engineer, formed a partnership for the manufacture of ceramic tiles. Construction of their factory at Chelsea, Massachusetts, began that same year. Their first firing was on May 1, 1879, and within a few months Low products were awarded a silver medal at the Cincinnati Industrial Exposition. Low's patent application reveals the diversity of the operation:

> Decorative tiles may be classified according to their decorations, into four general sorts: First, those made with flat surfaces, and either of a natural or artificial monochrome without designs, called "self-colored tiles," or ornamented with surface-enamel, or painting in outline, monochrome, or polychrome; second, those made with flat surfaces, inlaid in chromatic patterns to a slight depth; otherwise known as "encaustic tiles"; third, those made with designs in relief; fourth, those made with irregular, incised, indented, or depressed designs, having texture in the depressions.[13]

The Low Art Tile Works became one of the largest mass-producers of decorative and "art" tiles. One special branch of production, "plastic" sketches, earned an international reputation for the firm. These portrait tiles were similar to low-relief sketches and when exhibited at the Fine Arts Society in London were admired by the *London Court Journal,* where an unidentified critic said: "This gentleman has invented a new species of keramic ware. The first which America has produced in any high order." [14]

A Mr. W. H. DeForest of New York City was especially fond of tiles. *The Art Journal* in 1879 approvingly recounted:

> Mr. DeForest's house is a paradise of tiles. In the neat and original hallway they begin, forming that union of line and colour which really seems to have been preserved to us from Pompeii, and they go judiciously through the house. In all cases their formal suggestiveness is a great corrective of a sometimes exuberant taste. The only wonder is, that the architects ever allowed them to go out of use, when, in the early history of the art of architecture, they were so well understood, and in our own pre-Revolutionary times they were built into every old Puritan and Virginia fireplace . . . His tiles are of the highest order of modern Art. [Mr. DeForest] has, as Whistler would say, "symphonies in red and blue," "nocturnes in black and white," and, we might add, overtones in the fashionable peacock-green, in his tile-decoration.[15]

Another new form of ceramic art was noted in 1878. *Demorest's Monthly Magazine* observed:

> A new and very beautiful ware is the "Belleek." Some idea of its exquisite

delicacy may be given by saying that it looks like the finest mother-of-pearl. It has a glaze so brilliant that it presents the colors of mother-of-pearl and a lustre like fine glass. The delicacy of this ware is fairy-like. It is not transparent, but it gives an effect of transparency from its brilliance of polish or "glaze" . . . It will certainly become popular . . . for it is so excessively delicate in appearance that no majolica can approach it in that respect . . . But it must be seen to be appreciated . . .[16]

One of the most famous American producers of Belleek was Walter Scott Lenox who founded the Lenox Pottery at Trenton, New Jersey, in 1896. He had experimented with that ware when he worked as art director for Ott and Brewer. Knowles, Taylor and Knowles of East Liverpool, Ohio, marketed Lotusware in the late 1880s and 1890s. This translucent bone china was similar to Belleek.

Probably no American ceramic art is better known or collected than the pieces that came from the Rookwood Pottery, founded in 1880 by Mrs. Maria Longworth Nichols at Cincinnati, Ohio. This prestigious firm grew from a class in china painting organized in 1874 by Benn Pitman, a local schoolteacher. "Idle gentlewomen" of the city decorated several pieces that were exhibited at the Philadelphia Centennial, where they were praised. The ladies continued their "artistic" endeavors under the direction of M. Louise McLaughlin who in 1879 founded the Pottery Club of Cincinnati. Mrs. Nichols, later Mrs. Bellamy Storer, a member of the club in 1880, began the Rookwood Pottery and headed it until her retirement in 1890. The Rookwood plant, which its owners considered "America's Contribution to the Fine Arts of the World," [17] employed an impressive galaxy of decorators. Albert R. Valentien who joined the firm in 1880 was the first paid decorator. By 1883 the firm was prosperous enough to employ the talents of William McDonald, Matthew A. Daly, and a Japanese artist, Kataro Shirayamadani. Artus Van Briggle (b. 1869), who founded his own Art Nouveau pottery at Colorado Springs, Colorado, in 1900, also decorated for Rookwood during the 1890s.

Rookwood wares were primarily ornamental and until 1900 were all handthrown. Because the form and decoration were of such high quality, the pottery was considered to be as beautiful as Oriental productions.

Not everyone appears to have appreciated Rookwood, for an article in *The Beautiful House* lamented: "Our land is rich in clays and feldspar; for some unaccountable reason, the divine breath of art has not touched this vast field of industry, or if it has . . . the contact has been tentative, brief and without reward. The history of pottery in this country is nothing but pathetic . . ." Fortunately, the author, H. J. Whigham, held out some hope, "The Chelsea Pottery, or, as it was distinctively called, 'The Keramic Art Works' . . . made a high bid for popularity and remuneration, but the world was not yet ready for them . . ." and the "Dedham Pottery had its moments of glory . . ." [18]

The first version of the Dedham Pottery was established at Chelsea, Massachusetts, by Alexander Robertson, in 1866. In 1868 Hugh Robertson, Alex-

ander's brother, joined the firm, and in 1872 their father, an English potter, became a principal in the effort that then became known as the Chelsea Keramic Works. The Chelsea factory created pieces of high quality, which were recognized even by the conservative Boston Museum of Fine Arts, for they acquired several pieces for their collection during the 1870s and 1880s. The firm moved to Dedham, Massachusetts, in 1895, some three years later after the introduction of their famous Rabbit pattern.

During the 1890s an exceptional art department at Newcomb College, the women's division of Tulane University in New Orleans, produced students with uncommon talents. In 1895 Professor Ellsworth Woodward persuaded the trustees to institute a program that would provide a commercial outlet for the hand-thrown, hand-decorated pieces being created there. Today, Newcomb pieces are ranked with the products of Rookwood, Van Briggle, and William H. Grueby. Newcomb pottery has a style of its own, for Professor Woodward enforced his belief that Newcomb women should decorate their pieces only with motifs found in the nearby bayou country.

The Grueby Faience Company, organized in South Boston in 1897 by William H. Grueby, produced high-quality pieces that are distinguished by matte green and tan glazes. Grueby lamp bases were often fitted with Tiffany shades. In 1901, at the Pan-American Exposition in Buffalo, New York, Grueby pottery was exhibited with the Mission-style furniture of United Crafts from Eastwood, New York.

The Roseville Pottery, located eleven miles south of Zanesville, Ohio, prospered from the start. It was incorporated in 1892 and within three years it had purchased the William and McCoy Pottery at Zanesville and the Midland Pottery of Kildow, Ohio. In 1898 it moved to Zanesville and acquired the Clark Stoneware Company, and in 1902 the Mosaic Tile Company became part of the vigorous conglomerate. Roseville is most famous for Rozane Royal, which was glaze-slip painted under a high glaze. Because ceramic artists moved from one plant to another in Ohio, the Midwestern center of American ceramic production, it is often impossible to distinguish the early products of Weller, Rookwood, Owen, and Roseville unless they are clearly marked.

Although Eastern tastemakers concerned themselves with decorative, high-style ceramic and porcelain imports and the domestic wares that they inspired, utilitarian pieces constitute the bulk of American ceramic production. One domestic ware that appealed to popular taste was majolica, even though it was considered "low, vulgar, even barbarous" by one critic at the Philadelphia Centennial Exposition. The Griffen, Smith & Hill Company of Phoenixville, Pennsylvania, specialized in a product called Etruscan Majolica, which was offered as a premium with the purchase of baking soda.

From the seventeenth century till the close of the nineteenth century the country potter fashioned honest everyday pieces that played an important role in nearly every household. During the eighteenth and much of the nineteenth centuries slip-decorated redware from Pennsylvania, New England, the South

and the Midwest provided an inexpensive alternative to pewter or the more expensive high-style ceramics.

Stoneware, often embellished with incised patterns and freehand shaped and molded decorations, was made more colorful by the addition of slip decoration in various hues of blue and magenta. Most frequently the slip decoration was in the form of conventionalized floral and bird motifs; occasionally it became more elaborate and included whimsical animals and idealized representations that collectors consider a true expression of folk idioms.

233 (below). Redware pottery in the form of a plate, a large covered bowl, a mug, and a pitcher. Plate, slip-decorated, impressed "W. Smith Womelsdorf," made by Willoughby Smith, Berks County, Pennsylvania, 1862–1900, Diam. 7¼"; covered bowl, slip-decorated, attributed to John Nase, Tylersport, Montgomery County, Pennsylvania, 1829–1850, Diam. 8½"; mug, slip-decorated, made by John Bell, Waynesboro, North Carolina, 1883–1890, H. 4½"; pitcher, slip-decorated, 1825–1850, H. 4". Simple pottery forms with bright slip decoration are among the most eagerly collected forms of American pottery. (Greenfield Village and Henry Ford Museum)

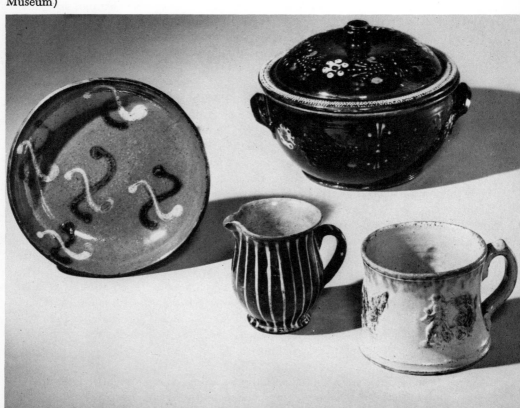

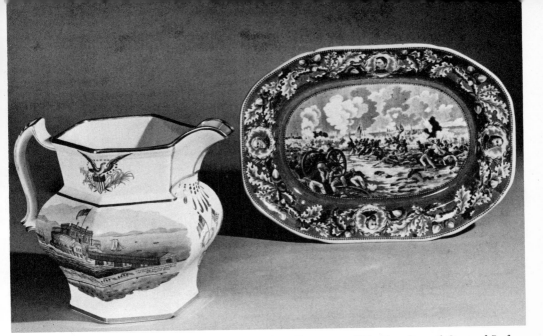

234 (above). Transfer-printed earthenware pitcher illustrating "The Landing of General Lafayette," attributed to the American Pottery Company, Jersey City, New Jersey, 1843–1850, H. 8½"; transfer-printed earthenware platter representing "Pickett's Charge at Gettysburg," attributed to Edwin Bennett Pottery Company, Baltimore, Maryland, c. 1895, L. 13". American historical events continued to be popular for pottery and porcelain decoration throughout the entire Victorian period. (Greenfield Village and Henry Ford Museum)

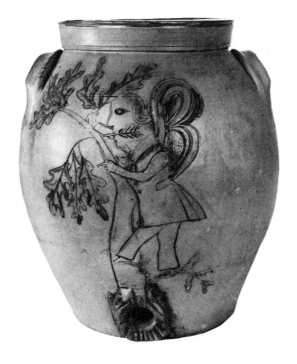

235 (left). Stoneware cooler. Albany, New York. c. 1840. H. 16". The incised decoration on this piece is an illustration of the poem "The Arrow." (Mr. and Mrs. John P. Remensnyder)

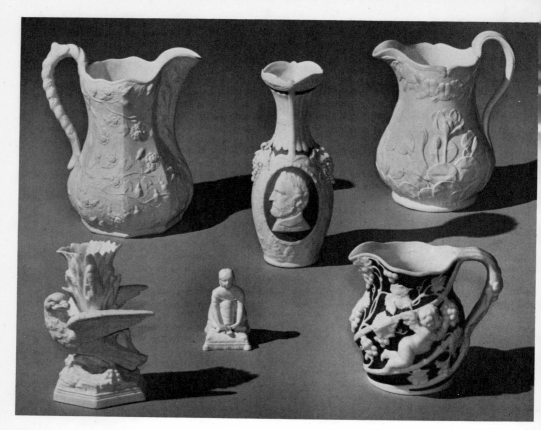

236 (above). Group of Parian ware pieces. White pitcher decorated with roses and foliage, made by Fenton, Bennington, Vermont, 1845–1847, H. 11"; blue and white vase, one of a pair, with portrait medallion, 1850–1858, H. 10½"; water-lily pitcher made by United States Pottery Company, Bennington, Vermont, 1852–1858, H. 9⅝"; eagle vase, 1850–1858, H. 7"; figure of a girl lacing her shoe, 1847–1858, H. 3¾"; blue and white pitcher in cherub and grape pattern, 1852–1858, H. 6¼". (Greenfield Village and Henry Ford Museum)

237 (right). Glazed redware figure of a seated minstrel with dog. Attributed to Samuel Bell, Strasburg, Virginia. Mid-nineteenth century. H. 6½". This charming piece is covered with an olive-toned glaze. (Mr. and Mrs. William E. Wiltshire, III)

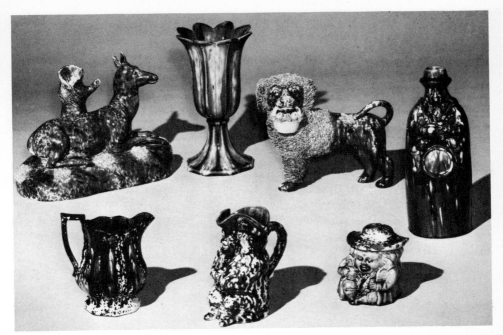

238 (above). Group of Rockingham and flint-enamel pieces. Flint-enamel doe made by Fenton, Bennington, Vermont, 1849, H. 9½"; tulip vase with flint-enamel glaze, c. 1850, H. 10"; poodle with Rockingham glaze, c. 1850, L. 9½"; Rockingham Toby barrel bottle made by Fenton, Bennington, Vermont, 1849, H. 10"; pitcher with flint-enamel glaze made by United States Pottery Company, Bennington, Vermont, 1853–1858, H. 6"; Rockingham Toby pitcher made by Fenton, Bennington, Vermont, 1849, H. 7"; Rockingham Toby snuff jar made by Fenton, Bennington, Vermont, 1849, H. 4½". (Greenfield Village and Henry Ford Museum)

239 (below). Porcelain tea service with gold decoration. 1850–1858. H. of pot 9½". Durable, utilitarian, white porcelain pieces were often imported from England by American tradesmen. These ironstone pieces were frequently copied by American manufacturers who often, like their English counterparts, decorated their wares with gold and luster designs. (Greenfield Village and Henry Ford Museum)

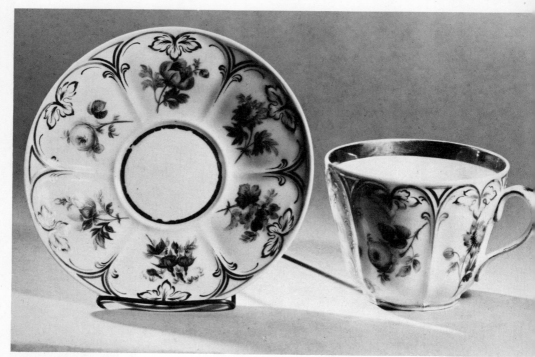

240 (above). Porcelain cup and saucer made by Charles Cartlidge and Company, Greenpoint, New York. c. 1850. Diam. of saucer 7". Realistic flowers framed by a gold arcade relate the decoration on these pieces to the prevailing Rococo Revival style. The designs used by American decorators were generally less fussy than those used by Europeans. (The Brooklyn Museum; Gift of Mrs. Henry W. Patten)

241 (right). Buff-colored pottery bowl and pitcher made by Solomon Purdy or his associates. Tuscarawas County, Zoar, Ohio. 1840. Diam. of bowl 17"; H. of pitcher 11¹¹⁄₁₆". The bowl is impressed "Zoar" on one handle and "1840" on the other. (Greenfield Village and Henry Ford Museum)

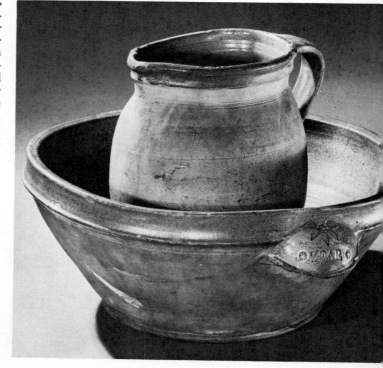

242 (right). Stoneware grotesque cup. Probably Virginia. Mid-nineteenth century. H. 4½". (Mr. and Mrs. Michael D. Hall)

243 (below). Pair of porcelain vases manufactured by Kurlbaum & Schwartz, Philadelphia, Pennsylvania. c. 1853. H. 19⅞". The gilt bronze handles and bases of these polychrome, floral-decorated pieces were probably made by Cornelius & Company, Philadelphia. (Greenfield Village and Henry Ford Museum)

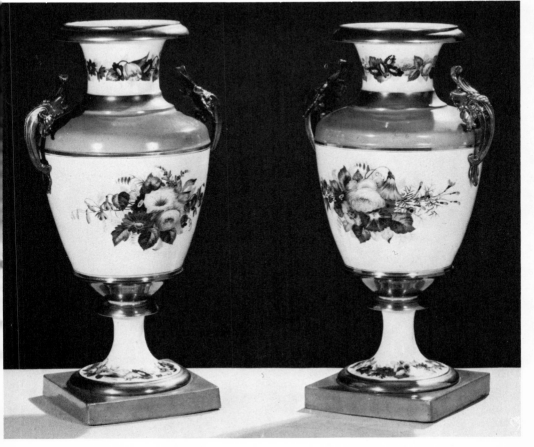

244 (right). Scroddleware wash bowl and pitcher attributed to the United States Pottery Company, Bennington, Vermont. c. 1855. H. of pitcher 11″. Numerous manufacturers produced similar wares and marketed them under the trade names Granite and Marble. (Greenfield Village and Henry Ford Museum)

245 (below). Haviland china service made for and used by President Abraham Lincoln at the White House. France. 1861. L. of platter 13″. Numerous American presidents ordered their official state china from Europe. After political agitation supported "Buy American" policies, they usually commissioned American firms to produce their special orders. (Greenfield Village and Henry Ford Museum).

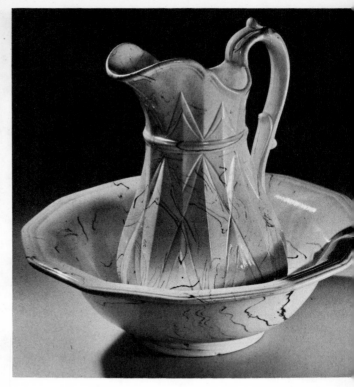

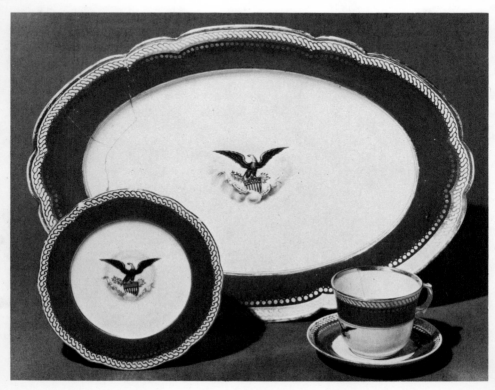

246 (above, left). Stoneware jug made by E. Hall, Newton Township, Tuscarawas County, Ohio. 1858. H. 17″. This fully signed and wonderfully documented piece is decorated with applied decoration and further embellished with punched designs in the form of circles, moons and stars, rosettes, and hearts. (Greenfield Village and Henry Ford Museum)

247 (above, right). Earthenware teapot manufactured by the Southern Porcelain Company, Kaolin, South Carolina. c. 1865. H. 5″. Nearly every American pottery produced a romantic rendition of "Rebecca at the Well." (Greenfield Village and Henry Ford Museum)

248 (right). Porcelain bust of Cleopatra made by Isaac Broome for Ott & Brewer Co., Trenton, New Jersey. 1875. H. 21″. This three-dimensional sculpture in blue and black and decorated with gold is a particularly handsome example of the Egyptian Revival style. (New Jersey State Museum Collection)

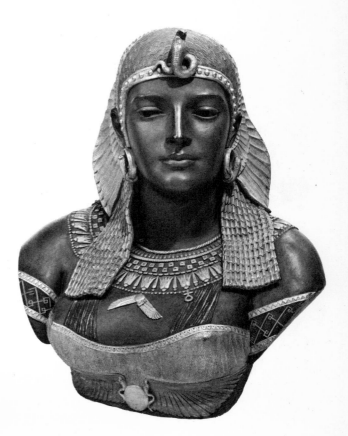

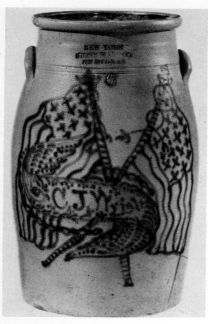

249 (left). Stoneware churn made by the Stone Ware Co., Fort Edward, New York. c. 1876. H. 18¾₆". The slip decoration includes a banner bearing the name "C. J. Wright" and crossed American flags. (Greenfield Village and Henry Ford Museum)

250 (below). Porcelain tea set made by the Union Porcelain Works, Greenpoint, New York. c. 1876. H. of teapot 6¾". Karl Muller, one of the most prolific and respected Victorian porcelain designers, created this exotic service. (The Brooklyn Museum; Gift of Franklin Chase)

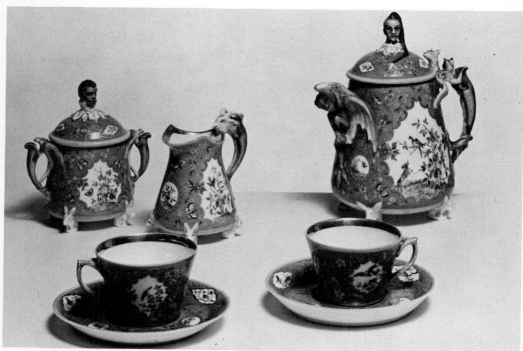

251 (opposite). Hard-paste porcelain vase designed by Karl Muller and manufactured at the Union Porcelain Works, Greenpoint, New York. 1876. H. 22¼". This monumental piece, made for display at the Philadelphia Centennial Exposition, was titled "The Century Vase." A relief profile of George Washington and a gilded eagle indicate the patriotic theme. Events from American history are depicted in the six biscuit panels, and painted vignettes illustrate contemporary machines that were contributing to America's progress. (The Brooklyn Museum; Gift of Carll and Franklin Chase)

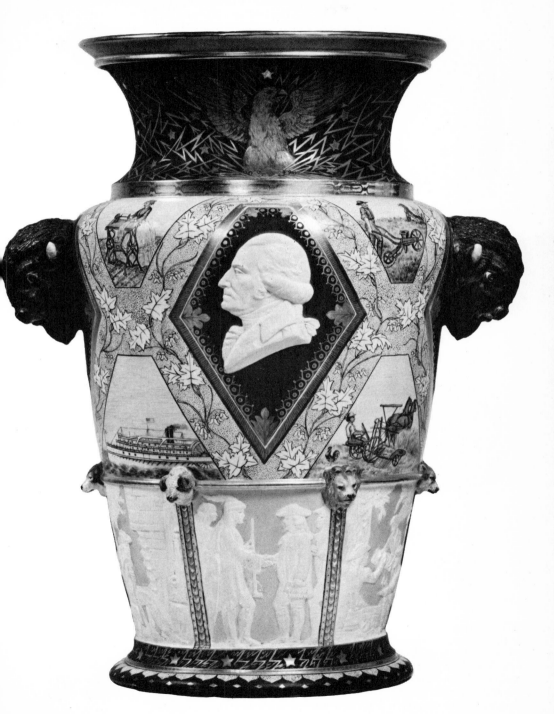

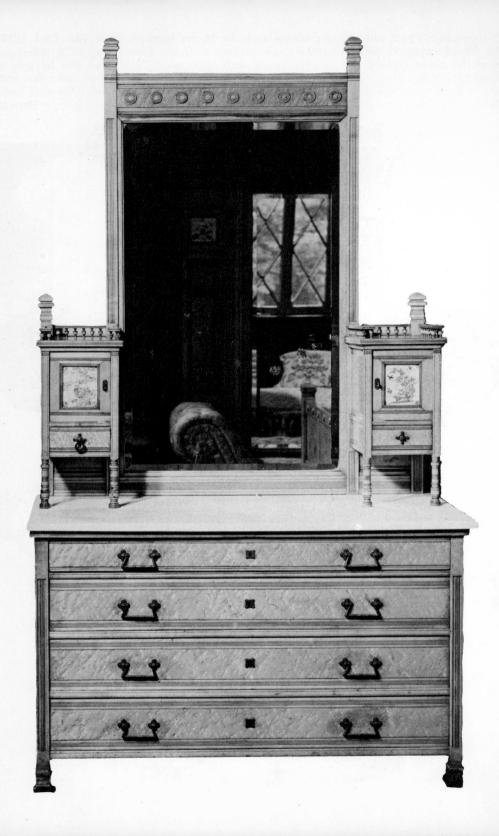

252 (opposite). Chest with dressing mirror made by Herter Brothers, New York City. 1877–1880. Blond maple. H. 86½″. Clarence Cook, writing in *House Beautiful* in 1878, struck out against the use of ceramic tiles in conjunction with light wood, "cold blue tiles let into its surface–tiles, things that, except for actual utility; have no right to be used in connection with wood."[1] Despite such criticism from one of America's most successful and influential taste-makers, the popularity of furniture set with Japanese-inspired tiles continued to grow through the 1880s. (Lyndhurst, National Trust for Historic Preservation)

253 (right). Porcelain vase made by the Union Porcelain Works, Greenpoint, New York. c. 1877. H. 5⅞″. Victorian designs were often based on naturalistic forms. (Greenfield Village and Henry Ford Museum)

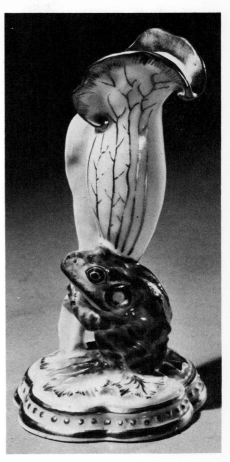

254 (below). Pottery vase made by the Chelsea Keramic Art Works, Chelsea, Massachusetts. 1876. H. 13⅛″. The Chelsea firm consciously attempted to retain the traditions of handcraftsmanship that were fast being replaced by modern technology during the Victorian period. The design of this earthenware vase is based upon the Greek hydra. (Museum of Fine Arts, Boston; Gift of James Robertson and sons)

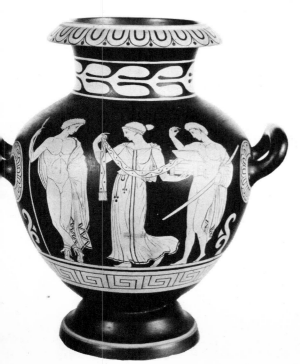

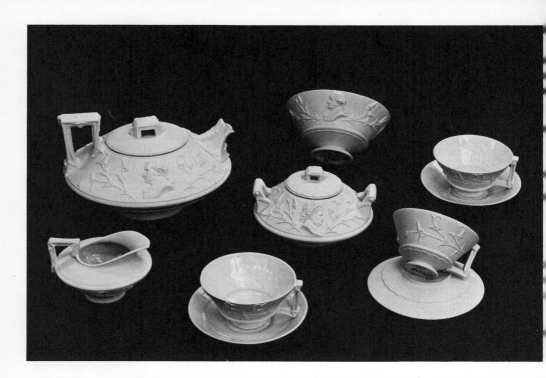

255 (above). Bisque tea set in the George and Martha Washington design created by Isaac Broome and manufactured by Ott & Brewer Co., Trenton, New Jersey. 1876. H. of teapot 5″. The exhibits at the Centennial abounded with representations of George Washington. (New Jersey State Museum Collection)

256 (right). Tile decorated by Winslow Homer. Signed and dated 1878. 7¾″ square. Homer was one of America's most important painters of the Late Victorian period. (Lyman Allyn Museum)

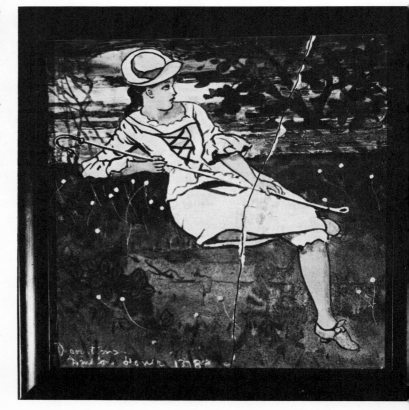

257 (right). Porcelain platter ordered by Mrs. Rutherford B. Hayes for the White House. Produced at Limoges, France. c. 1878. L. 19¾". This piece was decorated by Theodore R. Davis and is part of a 1,000-piece set that was realistically painted with American motifs. (Greenfield Village and Henry Ford Museum)

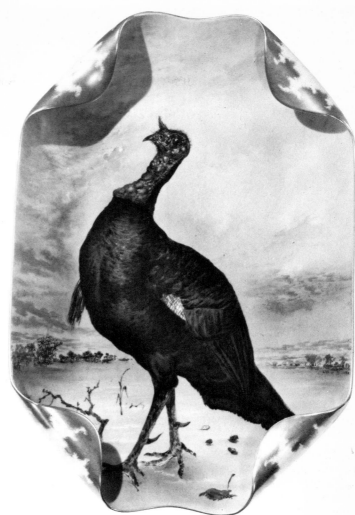

258 (left). Ceramic vase in the shape of a fan made at the Kezonta Pottery, Cincinnati, Ohio. c. 1879. W. 13¼". This piece reflects the great popularity of Oriental designs in Victorian America. (Cincinnati Art Museum)

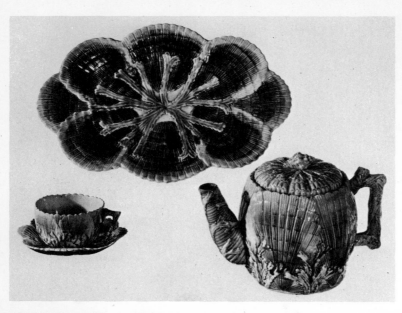

259 (left). Etruscan Majolica teapot, cup and saucer, and serving plate in the Shell and Seaweed pattern, manufactured by Griffin, Smith & Hill at Phoenixville, Pennsylvania. 1881–1892. H. of teapot 6½"; L. of plate 14". Muted greens, yellows, blues, and mauve were used for the decoration of nineteenth-century majolica pieces. Many of them were finished on the inside with a pink glaze. (Greenfield Village and Henry Ford Museum)

260 (below, left). Ceramic ginger jar made by William Fry at the Rookwood Pottery, Cincinnati, Ohio. 1881. H. 5¾". The artist increased the three-dimensional effect of the applied floral decoration by incising the body of the piece. (Cincinnati Art Museum; Gift of the Women's Art Museum Association, 1881)

261 (below, right). Pottery vase made by L. F. Plimpton and decorated by Mrs. C. A. Plimpton, Cincinnati, Ohio. 1881. H. 16½". This exotic, Moorish-style piece was made from several different colored clays found in the Ohio River Valley. The decoration includes a romantic Arabic city on one side and a man on a camel on the reverse. What better treasure could you find for a Turkish corner! (Cincinnati Art Museum; Gift of the Women's Art Museum Association, 1881)

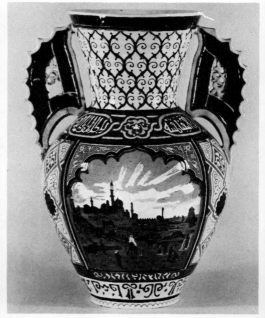

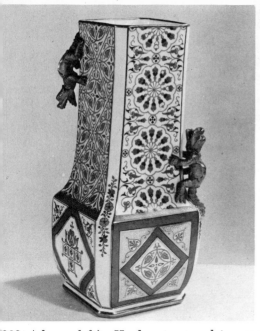
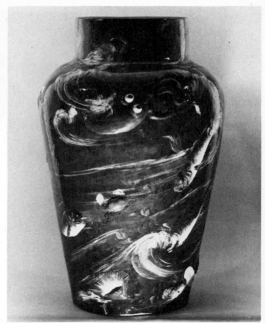

262 (above, left). Hard-paste porcelain vase made by the Union Porcelain Works, Greenpoint, New York. 1884. H. 15″. Grotesque lizards provide an unusual decorative accent to this vase inspired by Oriental wares. (The Brooklyn Museum; Gift of Franklin Chase)

263 (above, right). Ceramic vase made at the Rookwood Pottery, Cincinnati, Ohio. 1883. H. 29⅝″. This Oriental-inspired vase is marked "A.R.V." for Albert R. Valentien, the man in charge of the decorating department at Rookwood from 1881 to 1905. (Cincinnati Art Museum; Gift of Rookwood Pottery)

264 (below). Two pottery tiles made at the J. G. and J. F. Low Art-Tile Works, Chelsea, Massachusetts. 1881–1890. 4¼″ square. Low products were highly respected in America. Decoration was usually in the form of molded relief and often included conventionalized flowers and leaves. (Private collection; photograph courtesy The Art Museum, Princeton University)

265 (right). Porcelain pitcher made by Ott & Brewer Co., Trenton, New Jersey. 1888. H. 9⅜″. Walter Scott Lenox, who founded the Lenox Potteries in 1896, designed this piece while he was art director for the Ott & Brewer firm. Like all Belleek pieces, this vase is finished with an iridescent glaze. (The Newark Museum)

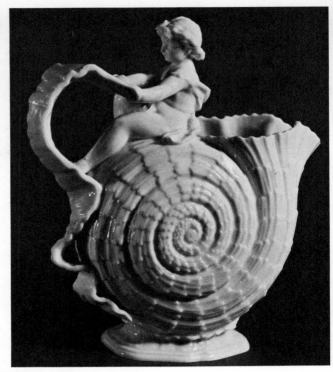

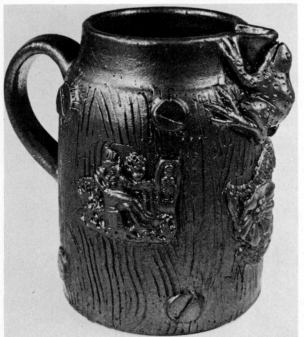

266 (left). Salt-glazed stoneware pitcher made by William Hirzel, Rochester, New York. 1890. H. 7⅛″. Utilitarian and decorative objects made of this material have in recent years come to be called sewer-tile pieces, for a similar body was used in the manufacture of commercial ceramic piping. (Collection of Mr. and Mrs. George R. Hamell; photograph courtesy Rochester Museum and Science Center)

267 (opposite). Earthenware vase made by Joseph Lycett at the Faience Manufacturing Company, Greenpoint, New York. 1889. H. 26⅝″. This vase was especially made for Dr. Edwin Atlee Barber, one of the earliest American scholars to study the American ceramic arts. (Greenfield Village and Henry Ford Museum)

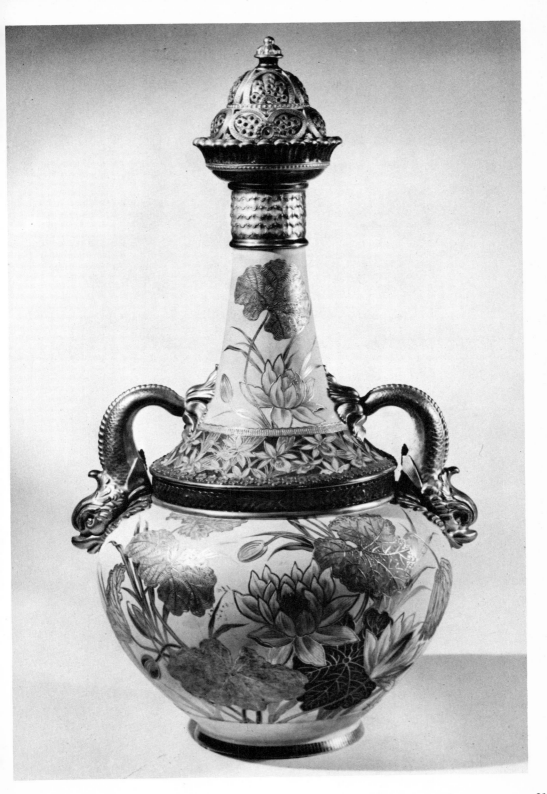

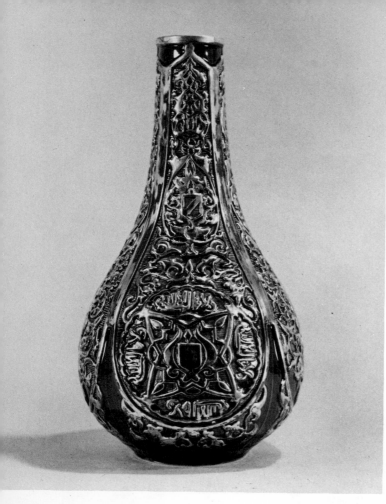

268 (left). Ceramic vase made by the Art Pottery Company, Cincinnati, Ohio. Late nineteenth century. H. 18½". This long-necked piece is one of a pair; the blue-glazed surface is embellished with gold decorations in the panels. The original label bears the legend "Matt Morgan Cinti.O. Art Pottery Co." (Cincinnati Art Museum; Bequest of Mrs. W. F. Boyd)

269 (right). Pottery vase made by William J. Walley, West Sterling, Massachusetts. 1890–1917. H. 6¾". This bulbous, small-mouthed, red clay piece has brown-black matte glaze and an overglaze in green. (Greenfield Village and Henry Ford Museum; Gift of the Mid-States Ceramics Study Group)

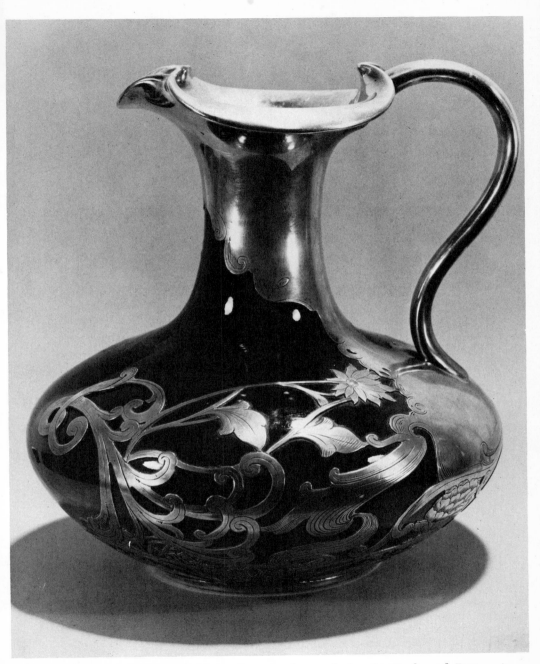

270 (above). Pottery ewer with a silver overlay made by the Rookwood Pottery in Cincinnati, Ohio. 1890. H. 9½″. Kataro Shirayamadani designed this handsome Art Nouveau piece. Gorham Manufacturing Company is known to have supplied the Rookwood Pottery with silver overlays for many of their works. (Cincinnati Art Museum)

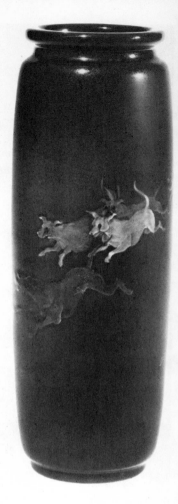

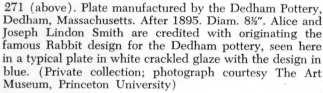

271 (above). Plate manufactured by the Dedham Pottery, Dedham, Massachusetts. After 1895. Diam. 8½". Alice and Joseph Lindon Smith are credited with originating the famous Rabbit design for the Dedham pottery, seen here in a typical plate in white crackled glaze with the design in blue. (Private collection; photograph courtesy The Art Museum, Princeton University)

272 (above, right). Pottery vase made at the Rookwood Pottery, Cincinnati, Ohio. 1891. H. 10". Artus Van Briggle, the famous decorator, finished this shaded, dark brown body with a slip-painted pack of running dogs. (Greenfield Village and Henry Ford Museum)

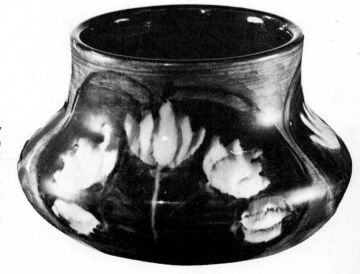

273 (below, right). Pottery vase made by Mary Chase Stratton at the Revelation Pottery, Detroit, Michigan. c. 1892. H. 3⁵⁄₁₆". The Revelation firm continued operation until 1907 when Mrs. Stratton renamed it the Pewabic Pottery Company. (Greenfield Village and Henry Ford Museum)

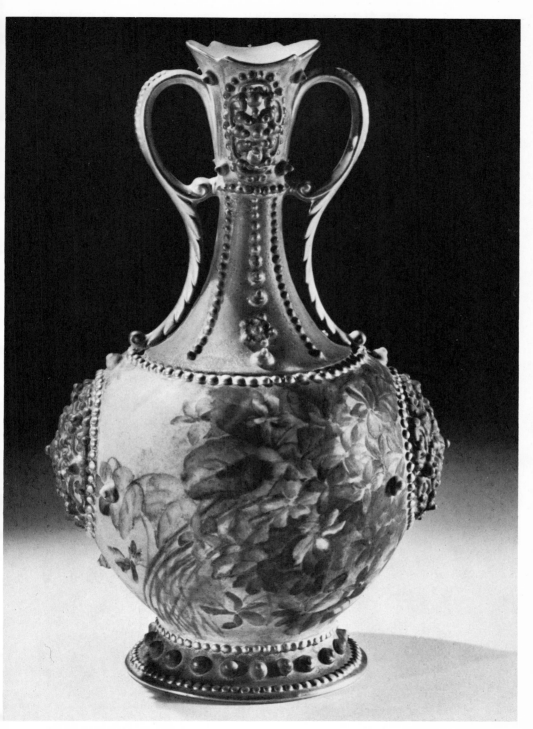

274 (above). Porcelain vase made by Knowles, Taylor & Knowles, East Liverpool, Ohio. c. 1890. H. 10⅜". This Belleek extravaganza was marketed under the trade name Lotusware. (Greenfield Village and Henry Ford Museum)

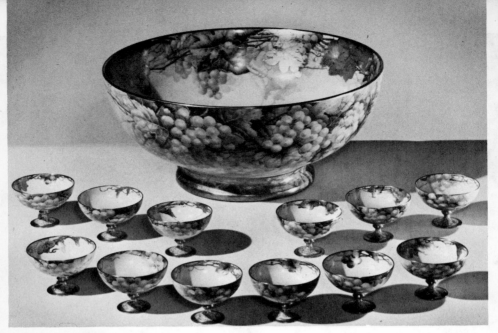

275 (above). Porcelain punch bowl and punch cups manufactured at Limoges, France. 1893. Diam. of bowl 17¾". This set was hand-decorated by George Leykauf, Detroit, Michigan, and won a medal at the World's Columbian Exposition at Chicago in 1893. Americans frequently imported porcelain blanks that they decorated with naturalistic motifs. (Greenfield Village and Henry Ford Museum)

276 (below, left). Pottery vase made by the Grueby Faience Company, Boston, Massachusetts. 1898–1902. H. 11⅛". George P. Kendrick, the designer, chose a dark green matte glaze for this exquisitely modeled piece. (Private collection; photograph courtesy The Art Museum, Princeton University)

277 (below, right). Pottery vase made at Newcomb College, New Orleans, Louisiana. c. 1899. H. 5½". The simple folk quality of many of the Newcomb pieces contrasts with the commercial wares of the day. This piece has a light green glaze on the upper section; the lower section is unglazed reddish-brown. (Museum of Fine Arts, Boston)

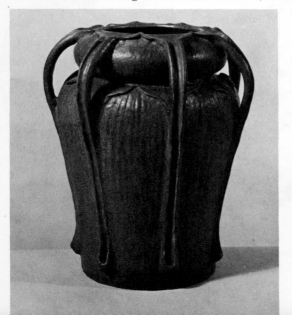

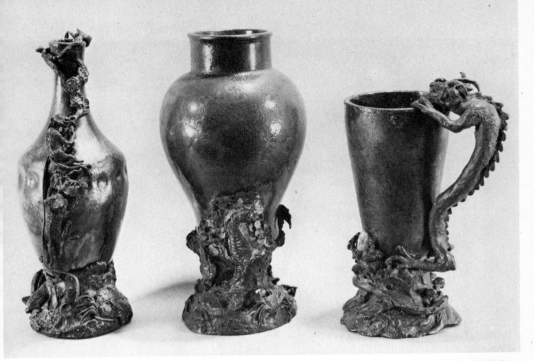

278 (above). Pottery vases with bronze mounts made by Maria Longworth Nichols Storer. Cincinnati, Ohio. 1898. H. of vases, left to right, 10⅚″, 10″, 7¾″. The influence of Oriental wares is particularly strong in these unusual vases. (Cincinnati Art Museum; Gift of Mrs. Storer)

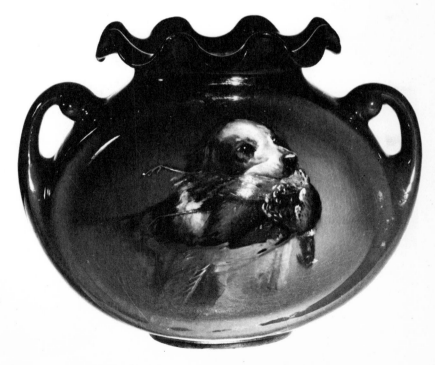

279 (right). Pottery vase made by the Roseville Pottery at Zanesville, Ohio. c. 1900. H. 9″. Animal portraits are uncommon on the Roseville Rozane Royal pieces. (Lucile Henzke)

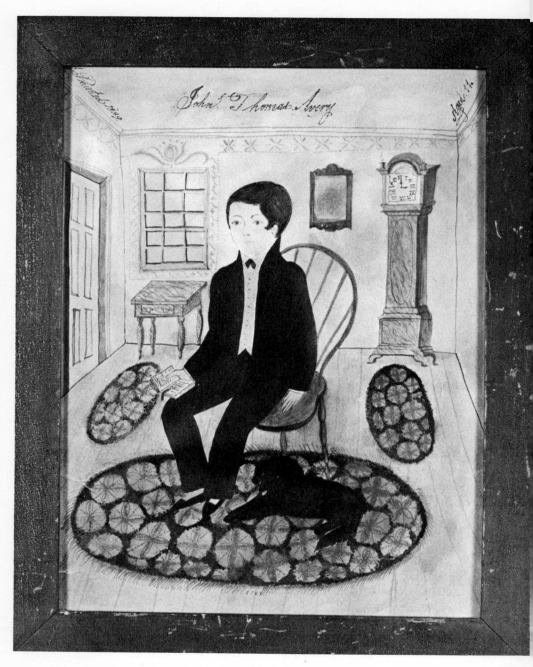

280 (above). Portrait of John Thomas Avery. 1839. Watercolor. H. 15½″. When the Victorian period began in 1837 the tall case clock was no longer as popular as the smaller, more easily transportable timepieces. This delightful watercolor is a fascinating historical document for students of the American decorative arts. (Mr. and Mrs. Samuel Schwartz)

CLOCKS

The period when man began to record the passing of the hours by developing a time indicator has been lost forever; however, experts agree that it was long before the birth of Christ. Chapter 20, verse 11, of the Second Book of Kings, refers to such a timepiece. "And Isaiah the prophet cried unto the Lord; and he brought the shadow ten degrees backward, by which it had gone down on the dial of Ahaz." Sundials, one of the first timekeeping instruments, were used in Babylonia as early as 2000 B.C. Surviving Greek and Roman examples have been dated to about 400 B.C.

The mechanical clock is one of the most important inventions in the history of mankind. The Benedictine monk, Gerbert (940?–1003), who later became Pope Sylvester II, is credited with its invention. One of the earliest mechanical clocks still in existence was made for Glastonbury Abbey in Somerset, England, in 1335 by Peter Lightfoot. This elaborate timepiece indicated the hours of the day and the phases of the moon, and was embellished with articulated horsemen that moved when the clock struck.

Before 1500 clocks were always weight-driven. With the development of the spring-driven movement sometime between 1500 and 1520 the timepiece could be made smaller and portable.

In America there were five major types of timepieces: the tower clock, the tall case clock, the wall clock, the shelf clock, and the watch.

Following the fourteenth-century European example of placing clocks where all the community could see them, several Colonial cities by 1650 had constructed tower clocks that were housed either in public buildings or in the towers of churches. The tower clock remained popular throughout the Victorian era in both urban and rural areas. Because they were well cared for and kept in good repair, tower clocks usually lasted a long time. The First Church and Parish of North Andover, Massachusetts, built a new meetinghouse that was dedicated on June 1, 1836. The old meetinghouse was dismantled; but, the ancient clock was reconditioned, "Resolved, That Whereas, in 1762, Mr. Benjamin Barker, a worthy citizen in the North Parish of Andover, did present to the said Parish a clock for the meeting-house: in grateful Remembrance of the said Benjamin Barker, the Inhabitants of said parish, for the purpose of keeping in repair the said clock, have expended three hundred dollars upon the same, under the direction of Mr. Simon Willard, clock-maker, in Boston." [1]

Tower clocks remained popular in Victorian America and became a necessary adjunct to depots serving the new steamboat and railroad lines.

Although the inventory taken of the estate of Captain Daniel Fisher of Dedham, Massachusetts, on November 19, 1683, records "It. a Clock. 40ˢ," [2] timepieces were indeed rare in the American home during the seventeenth

century. It was not until the eighteenth century that homes of even more than modest prosperity could boast such a luxury. The tall case clock was unquestionably the most popular type of timepiece in Colonial America. Even so, a clock remained costly for it had to be made entirely by hand. The crafting of a clock by a clockmaker usually took several months. Few clockmakers actually made the cases; cabinetmakers filled orders to the specifications of the clockmaker.

Because tall case clocks remained so expensive, numerous clockmakers attempted to develop a smaller, cheaper timepiece that could be purchased by everyone. In the opening years of the nineteenth century the wall clock proved popular. The banjo clock developed by the Willards at Grafton, Massachusetts, and the wag-on-the-wall clock popular in Pennsylvania were two of the most widely accepted types that evolved.

During the early nineteenth century wooden works for timepieces became common. Until this time the brass works had been one of the factors that made clocks expensive.

Eli Terry (1772–1852) of East Windsor, Connecticut, was perhaps the first to devise a successful method of mass production for nonmilitary goods, and his plant produced about sixty clocks per day. By 1806 he had developed production capabilities to such a high degree of perfection that he could fill an order for four thousand clocks. So successful was Terry's operation that he has been called "the last of the Craftsmen and the first of the Industrialists." [3] Terry devised a shelf clock that he patented in 1816. This small, inexpensive timepiece became the prototype for the Victorian clockmaking industry. After the opening of the Victorian period nearly all clocks were factory-made products.

The immense popularity of the shelf clock caused the production of tall case clocks to be nearly phased out by the time of the Civil War. The form became popular again during the later part of the nineteenth century. Henry Hobson Richardson (1838–1886), probably America's greatest architect working during the Victorian period, designed for the New York State Capitol building at Albany a handsome tall case clock in red oak that was installed in 1884. Tiffany & Co., during the 1880s, also produced several one-of-a-kind or limited-production tall case clocks for their clients.

Nearly every clockmaker has had the problem of producing a reliable timekeeper. The first book in English on clocks was brought out in 1674 by John Smith, an Englishman. *Horological Dialogues* is an imaginary conversation between a clockmaker and a clock owner and it indicates the many complex problems of setting up and maintaining a timepiece. A similar problem is discussed some one hundred and fifty years later in a letter from A. Benjamin of the Nashua Manufacturing Company to Messrs. Simon Willard & Son:

Gentlemen sometime in the summer of 1824, Colo. Jenkins bought a Timepiece of you . . . I have tried every expedient to induce it to keep true time, but all in vain, the geering is placed at so great a distance that the teeth, hardly come in contact with each other & in cold weather the oil

cools & the clock stops & it is worse than useless to us. I therefore send it back to you, hoping that you may make it useful but I beg that you will not ever let us see it again. I will be obliged to you to send us two Time pieces, which will keep time exactly, let them be plain but of the common shape, do them up so that the Stageman can take them with safety. I know you do make the best Time pieces of any one, for I have one in my House, which was made by you about 20 yrs. ago & no man ever had a better one. If you have not 2 which you can warrant, on hand, send us one for we cannot well do without it. Please call on Mr. Limist your neighbor for your pay & agree with him on the price. I am Yours Respectfully A. Benjamin Agt. N.M. Co.[4]

American Victorian shelf clocks and mantel clocks were every bit as good as examples imported from England and France. They failed to attract rich East Coast purchasers who preferred the more costly imported timekeepers because of the elaborate cases in which they were housed, especially if the decorative motifs could be associated with ancient cultures.

Clarence Cook, popular social critic, in his 1878 book, *The House Beautiful*, complained,

Hardly anything in the modern parlor is so uninteresting as the mantel-piece . . . A clock finds itself naturally at home on a mantel-piece, but it is a pity to give up so much space in what ought to be the central opportunity of the room, to anything that is not worth looking at for itself, apart from its merely utilitarian uses. It is very seldom worth while to look at a clock to know what time it is, and, as a rule, it would be much better to keep clocks out of our dining-room, though, for that matter, it is hard to say where they are not an impertinence. In the dining-room they are a constant rebuke to the people who come down late to breakfast, and they give their moral support to the priggishness of the punctual people, while they have, no doubt, to reproach themselves for a good share in the one bad American habit of eating on time. In a drawing-room a clock plays a still more ill-mannered part, for what can he do there but tell visitors when to go away, a piece of information the well-bred man is in no need of, and which the ill-bred man never heeds. So that, if a clock must usurp the place of honor on a mantel-piece, it ought to have so good a form, or serve as the pedestal to such a bit of bronze, or such a vase, as to make us forget the burden of time-and-tide in the occasional contemplation of art eternities. We get this habit of clocks, with their flanking candlesticks or vases, on all our mantel-pieces, from the French, who have no other way, from the palace to the bourgeois parlor. But they get rid of the main difficulty by either making sure that the clock does not keep good time,—the best French clocks being delightfully irresponsible in this particular,—or by having clocks without any insides to them, a comfortably common thing, as every one used to Paris "flats" knows. Ever since Sam Slick's day, America has been known as the land where cheap clocks abound. If we were a legend-making people,

we should have our Henry IV, who would have said he wished every peasant might have a clock on his mantel-piece. But, though we have cheap clocks enough, we have no pretty ones, and we are therefore thrown back on those of French make, which are only to be endured when they are mere blocks of the marble they polish so finely, of which we can make a pedestal to support something we like to look at.[5]

The alarm clock came into general use around 1880. At first it was fitted with a bell on the top; later versions have the bell at the back. Just as the Victorian era drew to a close, Sears, Roebuck, and Co. in Chicago offered numerous alarm clocks "made by the following concerns, namely: Waterbury Clock Company, Waterbury, Conn.; New Haven Clock Company, New Haven, Conn.; Ansonia Clock Company, Ansonia, Conn.; and the Seth Thomas Clock Company, Thomaston, Conn. . . ." [6]

The pocket watch first appeared at the close of the seventeenth century. Although none from this period survives, some fifty years later a few are recorded in American diaries and inventories. By the Victorian period the pocket watch had become sufficiently common for it to be included in a tirade against the Yankee peddler by Thomas Hamilton in his book, *Men and Manners in America,* "The whole race of Yankee peddlers in particular are proverbial for dishonesty. They go forth annually in the thousands to lie, cog, cheat, swindle, in short to get possession of their neighbors property in any manner it can be done with impunity. Their ingenuity in deception is confessedly great. They warrant broken watches to be the best timekeepers in the world; sell pinchbeck trinkets for gold; and always have a large assortment of wooden nutmegs and stagnant barometers." [7]

The Victorian demand for personal timepieces was so great that numerous firms specialized in this branch of the trade. E. V. Roddin & Co. of Chicago in 1895 offered to take orders by "Long Distance Telephone" for their several hundred pocket watches for men, women, boys, and girls. The top of their line was represented by such extravagant timekeepers as the " 'P. S. Bartlett' (Waltham), Fine Nickel Movement, 15 jewels, 4 pairs in gold settings, chronometer balance, finely adjusted, patent regulator, Breguet hair spring, quick train and straight line escapement, in 14 carat case, weighing 60 dwt., at $200." [8]

That was a princely sum for the day. Even their more modest watches averaged over forty dollars, far in excess of the modern Timex.

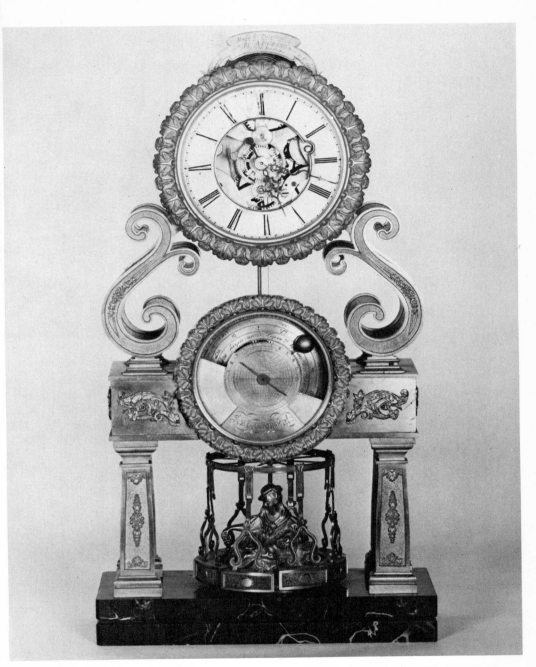

281 (above). Astronomical clock made by A. D. Crane, Newark, New Jersey. 1829–1858. H. 21″. This ornate gilt-bronze timepiece is mounted on a black marble base. The central dial shows the signs of the zodiac, days of the month, and tidal conditions. (Smithsonian Institution)

282 (right). Ogee clock made by D. S. Crosby, New York City. c. 1850. H. 18½". Most ogee clocks are spring-driven and have a reverse-painted scene on a lower panel of glass in the door. (Greenfield Village and Henry Ford Museum)

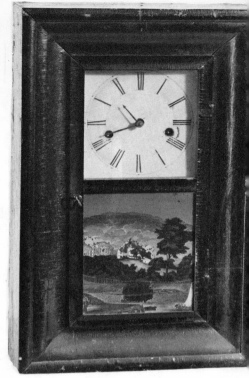

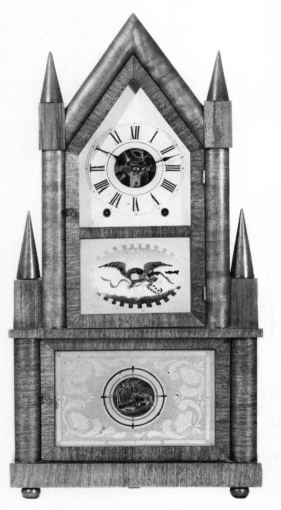

283 (left). Shelf clock made by Birge and Fuller, Bristol, Connecticut. c. 1846. H. 27¼". This double-steeple shelf clock has an eight-day brass movement with a wagon spring that provides the power. (Greenfield Village and Henry Ford Museum)

284 (opposite). Mantel clock made by the American Clock Co., New York City. c. 1850. H. 21⅜". Like all "screen" clocks, the painted cast-iron facade of this piece conceals a plain, rectangular box that contains the mechanism. (Greenfield Village and Henry Ford Museum)

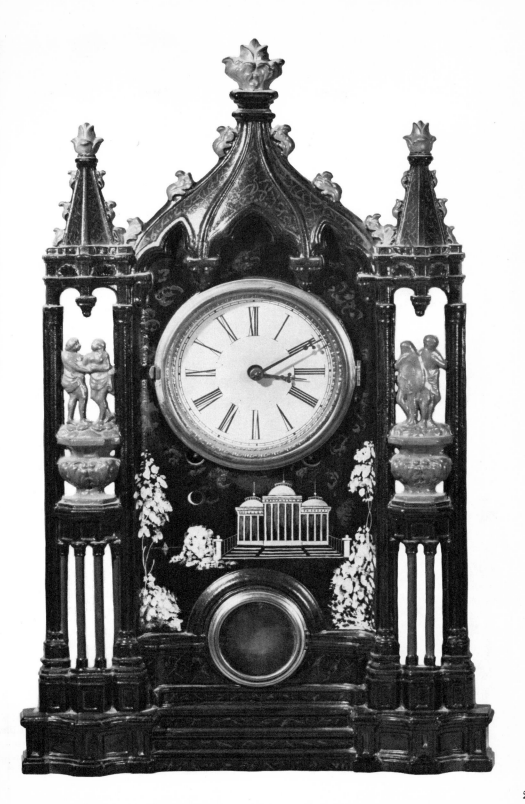

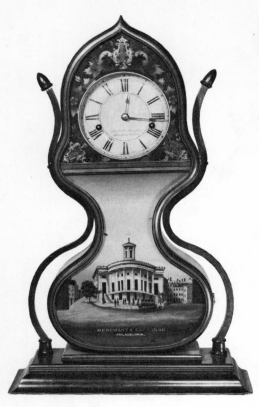

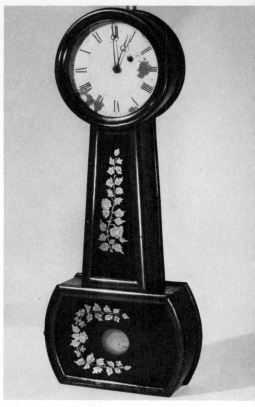

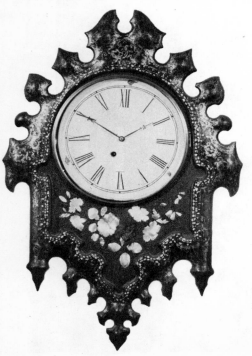

285 (above, left). Acorn clock manufactured by Forestville Manufacturing Company, Bristol, Connecticut. c. 1850. H. 24¼". The front of this mahogany-veneered piece is made of two pieces of glass. The upper section is painted green with stenciled decoration. The lower tablet shows the Merchants' Exchange in Philadelphia. (Greenfield Village and Henry Ford Museum)

286 (above, right). Wall clock. c. 1850. H. 34". This papier-mâché timepiece with mother-of-pearl inlay has a pendulum movement. One of the largest and most important manufacturers of papier-mâché clocks was the Litchfield Manufacturing Company, Litchfield, Connecticut, which was first formed in 1850. (Greenfield Village and Henry Ford Museum)

287 (left). Shelf clock made by Chauncey Goodrich, Forestville, Connecticut. 1850–1857. H. 13¼". This clock has an eight-day movement. The facade is decorated with gilt and mother-of-pearl inlay. (Greenfield Village and Henry Ford Museum)

288 (below). Shelf clock invented by T. R. Timby and made by Lewis E. Whiting, Saratoga Springs, New York. 1865. H. 26½". This solar shelf clock was fitted with a globe manufactured by Gilman Joslin, Boston, Massachusetts. Joslin, a Boston mapmaker, designed his globe so that it would make a complete rotation every twenty-four hours. (Greenfield Village and Henry Ford Museum)

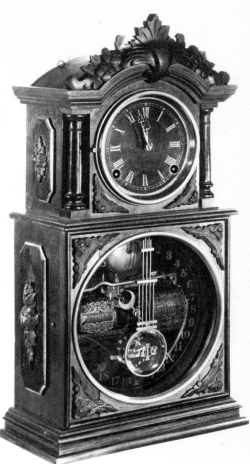

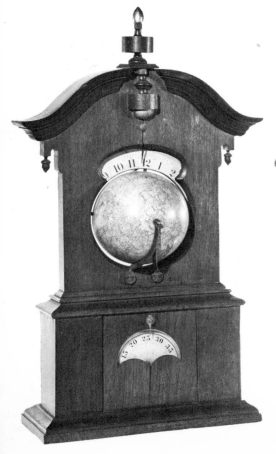

289 (above). Calendar clock produced for the Ithaca Calendar Clock Co., Ithaca, New York. c. 1875. H. 20¼". By the 1870s nearly all clock manufacturers had in their lines a clock with an eight-day movement and an hour strike, like this example. (Greenfield Village and Henry Ford Museum)

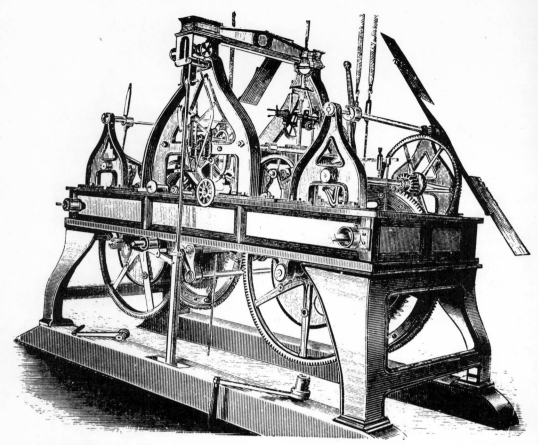

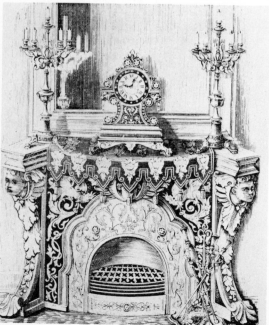

290 (above). Illustration from *Masterpieces of the Centennial Exposition 1876*, Vol. III, by Joseph M. Wilson. The great clock in Machinery Hall, produced by the Seth Thomas Clock Company, was driven by a 14½-foot, 500-pound pendulum. This gigantic timepiece, which weighed over 7,000 pounds, struck the hour and the quarter hour upon two mammoth bells. An ingenious arrangement made it possible to run 26 additional clocks, powered from this main clock, at various locations throughout the building. (Private collection)

291 (left). Illustration of a mantel clock and candelabra from *Beautiful Homes* by Henry T. Williams and Mrs. C. S. Jones, published by H. T. Williams, New York. 1878. Mantel clocks and flanking garnitures were frequently made en suite. (Private collection)

292 (right). Shelf clock, model "Litta," made by E. N. Welch Co., Forestville, Connecticut. c. 1880. H. 22". Rather crude incised lines and punched decoration relate the case of this piece to the popular Eastlake style. The painted tablet with its exotic seascape in the roundel was probably thought of as being Japanese. (Greenfield Village and Henry Ford Museum)

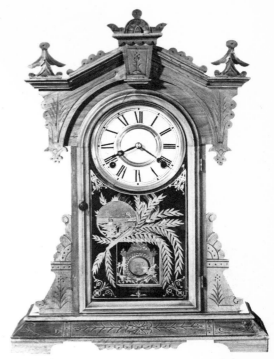

293 (below). Mantel clock made by the Ansonia Clock Company, New York City. c. 1880. H. 10½". This cast white-metal timepiece was copied from European prototypes. Many of the manufacturers who supplied these cases to the clock firms cast cigar-store Indians and show figures in white metal as well. (Greenfield Village and Henry Ford Museum)

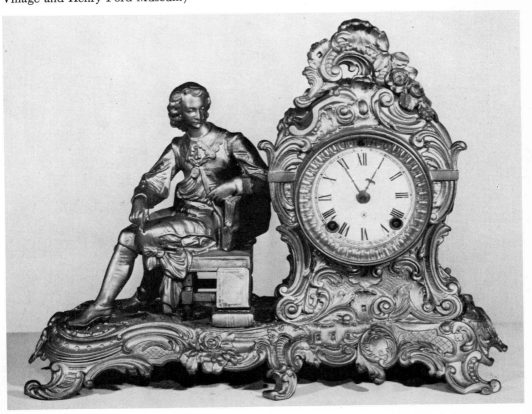

294 (below, left). Shelf clock made by E. Ingraham & Company, Bristol, Connecticut. c. 1880. H. 12¼". This "Count" model was marketed in a black iron case and featured a half-hour bell and an hour cathedral gong strike. (Greenfield Village and Henry Ford Museum)

295. (right). Tall-case clock manufactured by Tiffany & Co., New York City. Patented November 7, 1882. H. 105". Edward C. Moore, both a partner and the chief designer in the Tiffany firm, was one of the main forces behind the appreciation of Orientalia in the United States. (The Metropolitan Museum of Art; Gift of Mary J. Kingsband, 1906)

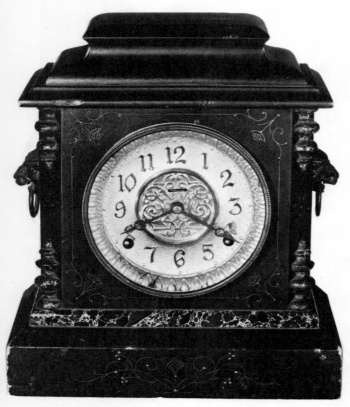

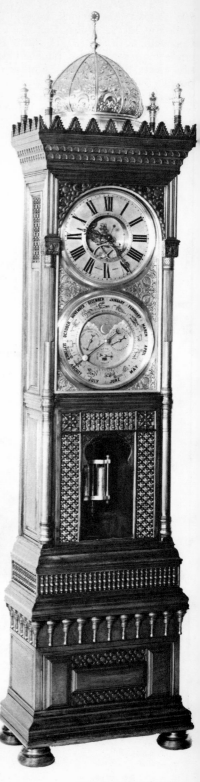

296 (opposite, above). Illustration from *The Decorator and Furnisher*, 1882, of the Chestnut Street, Philadelphia, showroom of George W. Smith & Co. A tall case clock stands in the far left corner and the mantel sports a Gothic clock and flanking garniture. (Private collection)

297 (opposite, below). Early photograph of the Michigan Central Station, Detroit, Michigan, built in 1883. New England church congregations installed tower clocks in the white-spired towers of their meetinghouses. In the Midwest they more frequently appeared on railroad stations and other public buildings. (Ford Archives, Greenfield Village and Henry Ford Museum)

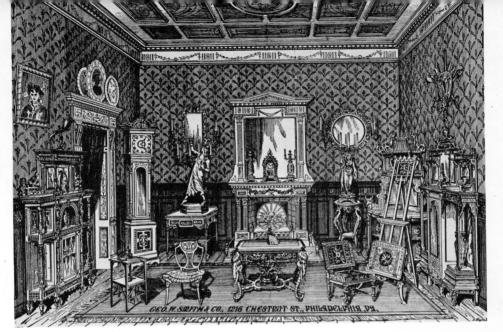

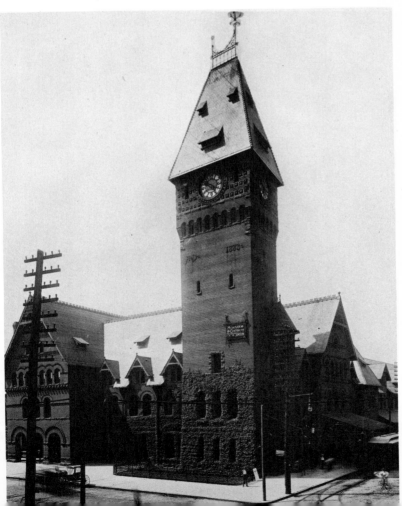

237

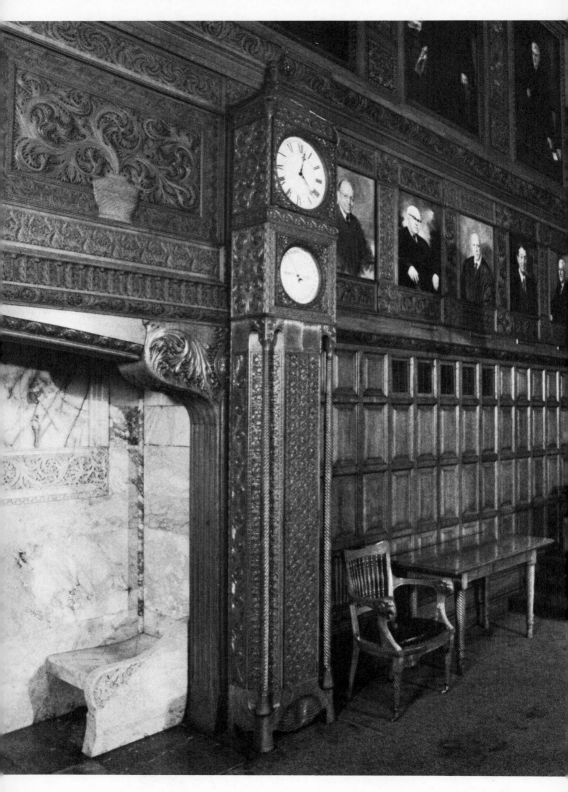

298 (opposite). Tall-case clock designed by Henry Hobson Richardson and installed in the Court of Appeals Chamber, New York State Capitol Building, Albany, New York, in 1884. H. 154″. Richardson, America's greatest architect to work in the Romanesque style, utilized Byzantine motifs both for the interior of the chamber and for the design of his clock. (New York State Department of Commerce; photograph courtesy New York State Court of Appeals)

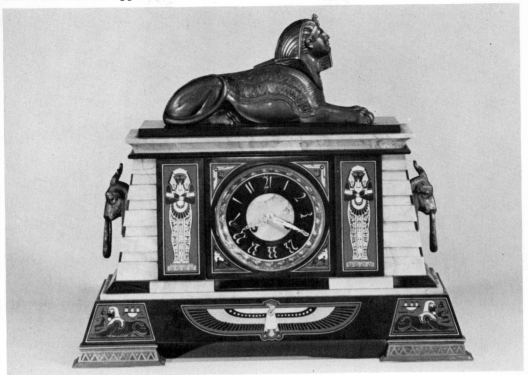

299 (above). Clock from a mantel garniture made by Tiffany & Co., New York City. c. 1885. The decoration on this ormolu and marble clock and pair of obelisks represents an idealized rather than an archaeological concept of Egyptian art. The hieroglyphs and other decorative motifs are simply vague approximations of Egyptian designs. In February 1881 the obelisk known as Cleopatra's Needle was installed in Central Park, New York City. This event renewed popular interest in Egyptian artifacts. (The Metropolitan Museum of Art; Edgar J. Kaufmann Charitable Foundation Fund, 1968)

300 (right). Trade sign for the Oliver & Connell clock repair shop. 1860–1880. Tin. H. 20″. (Greenfield Village and Henry Ford Museum)

301 (left). Wall clock. 1892. Walnut case with pine works. H. 14″. The wood face of this unusual hanging clock is decorated with a portrait of Christopher Columbus and the inscriptions "Columbus" and "1492." This piece was powered by a cast-iron weight. Columbus clocks were manufactured for sale at the World's Columbian Exposition held in Chicago in 1893. (Greenfield Village and Henry Ford Museum)

302 (above). Wall clock manufactured by the Ansonia Clock Company in their New York factory at 99 John Street, Brooklyn. c. 1900. H. 24⅞″. (Greenfield Village and Henry Ford Museum)

303 (below). Illustration from the 1895 catalogue issued by E. V. Roddin & Co., Chicago. The Roddin firm, which was established in 1855, maintained a large inventory that included watches, clocks, and jewelry. This advertisement shows two alarm clocks and a one-day calendar inkstand clock with a brass finish that sold for $7.00. The nickel alarm clock could be purchased for $2.00 and the small bracket alarm for $5.30. (Private collection)

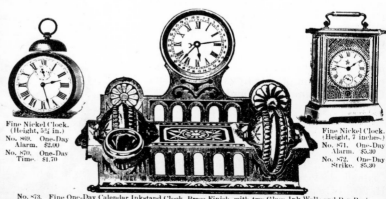

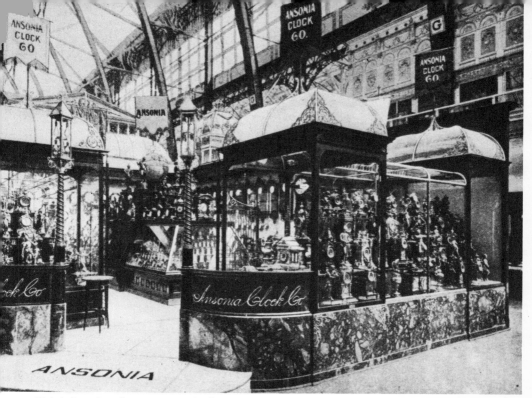

304 (above). The Ansonia Clock Company exhibit, Department of Liberal Arts at the World's Columbian Exposition, Chicago, 1893. Illustrated in *History of the World's Fair* by Major Ben Truman, published by the Standard Publishing Company, Philadelphia, 1893. (Private collection)

305 (below). Interior by Will Bradley. 1901–1902. Will Bradley's designs in the Art Nouveau style are immensely decorative. A clock is visible to the right of the chandelier. (Private collection)

306 (above). Cast-iron settee designed by Washington Irving. 1836. L. 47½". Gothic designs permeate this garden piece, which was used at Irving's "little nookery," Sunnyside, in Tarrytown, New York. (Sunnyside, Sleepy Hollow Restorations)

METALS

Among the earliest settlers in the New World were craftsmen who fashioned silver, gold, and pewter pieces that mirrored European designs of the same period. During the seventeenth century the term *goldsmith* referred to a craftsman who worked with both silver and gold; nearly all possessed the capability to handle either metal skillfully.

In 1652 the General Court of Massachusetts hired John Hull (1624–1683), a local goldsmith, to serve as master of its newly established mint. This Colonial facility, in direct defiance of restrictions from the mother country, coined shillings, sixpence, and threepenny bits. The metal for the early pine-tree, oak-tree, and willow-tree shillings generally came from melted-down English and European coins. Hull chose Robert Sanderson (1608–1693) as a partner and several of their hollow ware pieces remain today. In 1659 Hull took "Jerime Dumer & Samuell Paddy" as apprentices for eight years. Paddy soon left but Dummer (1640–1718) in time became one of New England's leading silversmiths.

The silversmith also provided another valuable service to the Colonists. His skills turned precious metals into objects that could be used to establish credit in the community. William Fitzhugh, Lieutenant Colonel of Virginia, wrote in 1688, "I esteem it as well politic as reputable, to furnish my self with an handsom Cupboard of plate which gives myself the present use & Credit, is a sure friend at a dead lift, without much loss, or is a certain portion for a Child after my decease . . ." [1]

Conversion of metal into decorative household objects also provided a hedge against inflation. A single ounce of silver in 1710 New England possessed a value of eight shillings and just twelve years later had risen to seventeen shillings. In addition, silver could be personalized by engraving and thus discourage theft.

Silver pieces were used also as racing trophies or awards for outstanding service to the Colonies. *The Boston News-Letter* in 1744 recorded, "On Friday last several of the Merchants of this Town made an Entertainment for Capt. *Richard Spry,* Commander of his Majesty's Sloop the Comet-Bomb, and presented him with a handsome Piece of Plate, in Gratitude for his gallant Behaviour and good Conduct in taking a French Privateer Ship, commanded by Capt. *Le Grotz,* from Cape Breton, which had for some Time infested our Coast." [2]

By the opening of the eighteenth century regional characteristics began to appear in the designs of both metalwork and furniture. This prevailed in silver, gold, and pewter until the beginning of the Victorian era when improvements in transportation and communications tended to break down cultural barriers established by ethnic groups.

With the increased use of forks during the first half of the seventeenth century, the introduction of tea drinking in the second half of the seventeenth century, and the rise in popularity of coffee in the early eighteenth century, the

demand for new forms in silver created a "boom" situation for the silversmith. *The Boston Gazette,* perhaps noting the recently occurring changes in New England life-styles, on April 5, 1734, spoke caustically against modern times, "It is too well known how our Extravagance in Apparel and Luxury at our Tables, are hastening the ruin of our Country, and are evils which call loudly for a remedy." [3]

Some fifty years later the same writer probably would have been horrified at the plenitude in America. The Chippendale style gave everyday objects a curvaceous, undulating shape that closely followed French and English taste. Certainly Paul Revere (1735–1818) remains the most famous of all American silversmiths. His midnight ride unfortunately has overshadowed a well-deserved reputation as a skilled craftsman. Revere's work bridges two styles, the Chippendale—popular throughout most of the second half of the eighteenth century—and the classical style that replaced it beginning about 1790. In addition to "hammering out" such diverse household objects as andirons for the fireplace and gold thimbles for the ladies' sewing baskets, Revere, like most silversmiths, was a skillful engraver. His depiction of *The Bloody Massacre* (1770) is one of the most sought-after Colonial American prints.

Contemporary records, wills, and inventories reveal that gold, because of its great value, was generally reserved for jewelry and cane tops. Occasionally children's playthings, like a whistle and coral, were fashioned. Gold hollow ware of the Colonial period is extremely rare.

The types and shapes of early American pewter closely follow silver. Pewter is a relatively soft alloy with a high tin content. Local ordinances were passed regulating the content of pewter in many Colonial communities. Antimony, bismuth, and copper were sometimes used as minor ingredients. Unscrupulous pewterers occasionally included larger amounts even though this could result in food poisoning and lead to severe illness or even death. Because pewter is so easily melted down, pieces were nearly always reworked. Consequently, little pewter made before the mid-eighteenth century still survives.

A pewter style, once firmly established, tended to last over an extended period of time. One explanation for this slow evolution was the great cost of the brass molds in which the molten pewter was cast. Some molds continued to be used for nearly a hundred years.

Tin, the basic ingredient of pewter, remained expensive in Colonial America, for the London Worshipful Company of Pewterers attempted at every turn to limit its supply. This politically powerful group of craftsmen even persuaded Parliament to levy an ad valorem tax. It was soon repealed, however, because of agitation by tin suppliers from Cornwall.

Tinware was ultimately adopted for popular general use because it cost so much less than silver or even pewter. Firms specializing in cutlery in general usually offered an assortment of tin merchandise.

Almost as soon as settlements were permanently established, ambitious Colonists sought to discover a domestic source for iron ore. John Winthrop, Jr.

(1606–1676), during the 1640s, established the Saugus Ironworks at Saugus, Massachusetts. This facility was equal to almost any similar English ironworks and included a blast furnace, forges, and a slitting mill, which could produce bar as well as cast iron. By the 1650s it was in full operation and capable of casting ironware, including pots. Hollow ware was one of the chief products of most early American ironworks. Although Winthrop's scheme for a mill town failed, others in New England enjoyed enviable success. An advertisement from *The Boston Gazette* in 1742 indicates a sizable industrial complex:

> To be Sold a good Penniworth, a Slitting Mill compleatly finished and furnished, scituated in the middle of near 20 Forges in the Compass of 12 Miles, with a well built Forge with Two Fires, and conveniency for a third; together with a well built and well accustomed Grist Mill, all standing on one Dam; on as constant a stream as this Land affords; with accommodations for other Water Works; A good Dwelling House, Coal House, and above 6 Acres of Land, and a good Orchard upon it, said Works stand on Namasket River in Middleborough, 13 Miles from Plymouth, and 10 from Taunton. All finely scituated for a Country Seat; and now Lets for 379 Pounds per Annum . . .[4]

Because rich deposits of ore had been discovered in Pennsylvania, over eighty ironworks were operating there at the start of the Revolution. As a result of their production, America could arm herself for her struggle for independence.

The iron industry in Pennsylvania continued to grow strongly. *Godey's Lady's Book* in 1853 reported: "Pennsylvania is remarkable for the extent and superiority of her iron ore, and it is computed that there is not less than $15,-000,000 invested in the production of iron, exclusive of about $6,000,000 invested in rolling-mills and similar works for the conversion of metal into forms of use, making the aggregate of about $21,000,000. The number of persons dependent simply upon the mining of iron ore in this State is said to be two hundred and eighty thousand."[5]

Most iron household goods were fashioned by the blacksmith. Lighting devices, roasters, toasters, trivets, and trammels were all an integral part of every kitchen hearth.

To a limited extent, brass, bronze, and copper were also used in Colonial America. Brass, an alloy of copper and zinc with various small amounts of other metals, was fashioned into andirons and lighting devices as well as numerous cooking utensils.

Nicholas Vandyck, living on Dock Street near the Ferry stairs in New York City in 1747, made and sold "Brass Buckles, wholesale or retail, as also Brass Boxes for Mill Brushes, with sundry other Things in the Brass Foundry Way, all expeditiously and at reasonable Rates."[6]

Furniture makers probably represented the brass foundries' best customers.

Drawer pulls and handles often "dressed up" a modest piece, thus making it more desirable.

Copper in its pure state serves as an ideal heat conductor. Both bronze and brass are alloys of this corrosion-resistant metal. Copper cooking utensils required a liner and many tinsmiths carried on this branch of the trade, too. John Graham of New York City in 1770 advertised in *The New-York Gazette and the Weekly Mercury* that he made and mended all kinds of tin, was capable of the many branches of coppersmithing, and "makes brass buckles, tins copper and brass in the best manner." [7]

Throughout the entire Colonial period the designs and objects fashioned from the more precious metals reflected the prevailing taste; elements of the most recent English style were nearly always visible.

During the first half of the nineteenth century advanced technology simplified the metalsmith's tasks. Rolled sheets of thin silver could be more easily shaped into hollow ware. Die-stamped ornamental bandings replaced time-consuming decorative hand engraving.

By the 1820s it was evident that some upper-class urban Americans were dining pretentiously. *The American Chesterfield,* published at Philadelphia in 1828, discussed proper dining "furniture":

Every person at the table should be provided with knife and fork, plate, bread, etc.; and before every meat dish, a carving knife, fork and spoon; and a spoon before every dish of vegetables. At the corners of the table spoons, a salt cellar, and small spoon for the salt; and, if pickles are there placed, a small knife and fork. If the table is large, the furniture of the corners should likewise be placed at short and convenient intervals. It has lately become common, in our Atlantic towns, and particularly at tables where light wines are used with water as a long drink, to place, at convenient distances around the table, bottles of Sauterne, Claret or other light wine . . . and goblets of water. This is found, by experience, to be an admirable arrangement for convenience, and gives the waiters more time to attend, among other duties, to the frequent changes of plates which modern refinement has now introduced. On the sideboard should be arranged, in order, all those articles of furniture which are necessary for the table. These are, the great supplies of knives and forks, plates of different sizes, spoons, bread, etc.; but, in a particular manner, the castors. These should always consist of five bottles, at least; viz; cayenne pepper, black pepper, mustard, vinegar and sweet oil. Let the castors be FILLED—not half filled—with condiments of good quality, that is, the sweet oil not rancid, nor the vinegar SWEET nor the pepper in grains like hailstones, nor the mustard stale; and one word more, madame, before we dismiss the castors— A LITTLE SPOON FOR THE MUSTARD,—AND—REMEMBER THE SALT SPOONS.[8]

Mid-Victorians developed a fondness for grandiose silver pieces that they

sometimes thought to be art. G. J. Cayley, while reporting on the International Exhibition of 1867 in Paris, suggested a compromise between art and trade: "It is a question whether high Art-sculpture is practically an appropriate form of ornament in plate, which, if used, is liable to bruises from all the natural shocks which dinner-services and tea-trays must encounter; and, if not used, might just as well be statuary on a small scale, unencumbered by an unnecessary adaptation for holding salt, tea, coffee, sugar, or claret." [9]

Despite such observations, "artistic" silver predominated in American exhibits at the Philadelphia Centennial Exposition. Incredible pieces, undulating with exuberant ornament, elevated commercial design to new heights. Certainly no piece of American silver received as much attention as the show-stopping Century Vase exhibited by Gorham of Providence, Rhode Island. This monument of allegorical symbolism was "executed in *solid silver* of sterling quality, and stands four feet two inches in height, with a base of five feet four inches in extent. The design is by Mr. George Wilkenson and Mr. Thomas J. Pairpoint, artist of the company." [10] The vase weighed 2,000 ounces and in 1876 was valued at $25,000. Runners-up were the Progress Vase displayed by Reed & Barton of Taunton, Massachusetts, and the Bryant Vase executed by Tiffany of New York and given to William Cullen Bryant on his eightieth birthday by the Century Club.

American contributions to the international Art Nouveau movement are well known in the fields of graphic arts, glass, pottery, and silver. Unger Brothers, a Newark, New Jersey, firm specialized in Art Nouveau metalwork between 1890 and 1910, including such objects as silver letter openers, brooches, and belt buckles.

By 1901 the Gorham Manufacturing Company had introduced their Martele line. These decorative pieces, chiefly in the prevailing Art Nouveau style, were made of silver that was softer and purer than sterling. Many were handmade.

Britannia, a strong, inexpensive metal similar to pewter, was developed in England soon after the mid-eighteenth century. Between 1830 and 1860 inexpensive domestically manufactured Britannia pieces enabled even the most modest household to enjoy a durable teapot or coffeepot. Britannia usually consisted of one hundred and fifty parts tin, three parts copper, and ten parts antimony, which gave strength and provided a bright sheen. Because Britannia was tougher than pewter it could be rolled into thin sheets and then spun into a variety of shapes on a lathe. It was also possible to stamp component parts on a press. Pewter, which had been cast in brass molds, all but disappeared from the market as Britannia gained in popularity. Thomas Webster enthusiastically observed in *An Encyclopedia of Domestic Economy* (1845) that Britannia "takes a high polish, and does not readily tarnish: when kept perfectly bright it has great beauty, far excelling pewter, and approaching in lustre to silver." [11]

Although many could purchase Britannia who were not able to afford silver, there were some who could only afford tin. Inexpensive tinwares were marketed

throughout the entire Victorian period, many times by rural peddlers whose wagons might also offer an extensive variety of goods not easily obtained in isolated areas. Possibly no single tinsmith of the nineteenth century has received as much attention as Zachariah Stevens (1778–1856), who worked at Stevens Plains, near Portland, Maine. His well-made, brightly painted pots, canisters, and document boxes anticipate the factory-produced containers of the late nineteenth and early twentieth centuries.

The custom of giving special gifts and holding parties for wedding anniversaries gave rise to the idea of a tin gift for the celebration of ten years of marriage. Some time during the mid-nineteenth century tinsmiths individually fashioned whimsical gifts that were given to the celebrants. By the 1880s, however, firms such as F. A. Walker & Co. specialized in the mass production of over fifty-five machine-stamped objects designed for this purpose.

Impressive advancements in the founding and milling of iron during the Victorian period caused it to be used in a multitude of new ways. Cast-iron architectural embellishment for porches, windows, balconies, fences, and gates gained nationwide popularity during the 1830s. These substitutes for the earlier, more costly handwrought examples were especially popular in the South. Many dwellings in Lebanon, Ohio, home of the Lebanon Phoenix Foundry during the 1830s, are decorated with cast "iron-lace" in the patterns of grapes and grapevines, oak leaves and acorns, wreaths and flowers, Greek frets and scrolls, and stars and harps. In Mobile, Alabama, and New Orleans, Louisiana, the frequent use of ornamental cast iron has caused many mistakenly to associate its production with those cities. Local documents reveal otherwise. Most of the earliest cast iron, with the exception of the railings on the famous Pontalba buildings at New Orleans, was cast in Philadelphia and New York. Some firms, in hopes of capturing the immensely lucrative Southern market, opened sales outlets there. By 1858, for instance, the Philadelphia firm of Wood & Perot had established a showroom in New Orleans. Wood, Miltenberger & Company maintained a large showroom as well as shops for finishing work actually manufactured in Philadelphia.

By mid-century the coke-fueled furnace all but replaced the charcoal blast furnace in large ironworks. Many of the smaller charcoal plants abandoned the production of hollow ware and turned to such decorative objects as small mirrors, bookends, and doorstops. The larger foundries continued to produce machine parts.

In time, iron foundries expanded their capabilities and by the close of the Victorian period most were able to offer a broad selection of goods. The Eagle Iron Works Co. at Buffalo, New York, is typical. Their products included patent rolling iron shutters, store columns, window and door caps and sills, steam engines, boat windlasses, and hoisting machines. They even offered to produce special machinery and mill gearing to specification.

An interest in brass, bronze, and copper reoccurred during the 1880s, and

by 1900 bronze objects had become status symbols. Tiffany used bronze extensively for lamp bases that he crowned with colorful shades of leaded glass. His studios also used bronze, copper, and glass for innumerable desk sets consisting of as many as fourteen matched pieces. Bronze vases and ewers, bronze statues, and even bronze carriage lamps were also produced.

The brass bed enjoyed wide popularity during the second half of the nineteenth century. The elaborate imported examples from England and France inspired American manufacturers to produce simplified versions at modest prices. Nearly every middle-class American home sported at least one highly polished example. The European beds were often made from a very high grade metal, whereas American versions were just plated.

Electroplating greatly affected American silver production just after the Civil War. As early as 1860 Reed & Barton was commended for its products:

> Their show room presents a brilliant array of specimens of their workmanship that would attract attention and extort admiration even in an exhibition of Solid Silver Ware. Within the last five years, this firm have [*sic*] made important additions to their list of manufactures, and now produce, besides Britannia and Silver-plated wares, all kinds of Electroplated Nickel Silver Table Ware, and Albata Spoons and Forks, that can only be surpassed by solid silver . . . It is one of the advantages of electro-plating that all ornaments, however elaborate, or designs, however complicated, that can be produced in silver, are equally obtainable by this process, and one of the benefits that such firms as Reed & Barton confer upon the country, is that they familiarize the American people with forms of beauty and elevate the standard of public taste. An American artisan can now command exact copies of the choicest plate in the repertory of kings.[12]

Contemporary evaluation of the electroplated card recivers, water pitchers, spoon holders, butter dishes, figural napkin rings, pickle jars, revolving castors, and assorted flatware that flooded the market between 1855 and 1901 can only inspire wonder at the king's taste made popular by the mail-order house.

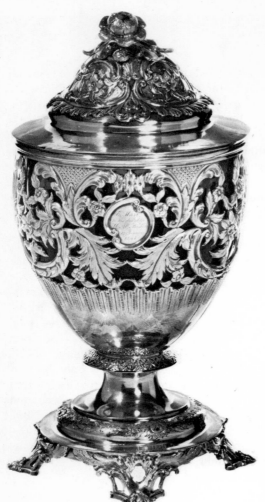

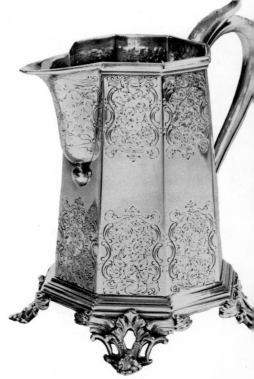

308 (below). Silver cream pitcher in the Rococo Revival style. Marked Ball, Tompkins & Black, New York. 1835–1845. H. 6″. The chased decoration features the C-scrolls and floral motifs so typical of the Rococo Revival style. Note that the feet on this pitcher are virtually identical to those on the sugar vase in figure 307. (Private collection)

307 (above). Silver sugar vase in Rococo Revival style made by William Forbes. New York. 1841. H. 10¾″. The covered bowl with openwork floral body and feet contains its original amethyst glass liner. The piece is inscribed "E. Hart./to his daughter/H. M. Fiedler/1st January/ 1841." The vase was retailed by Ball, Tompkins & Black, an eminent New York firm, between 1839 and 1850. (Grenfield Village and Henry Ford Museum)

309 (opposite). Silver ewer, one of a pair, retailed by Ball, Tompkins & Black. New York City. 1839–1851. H. 15¾″. (Greenfield Village and Henry Ford Museum)

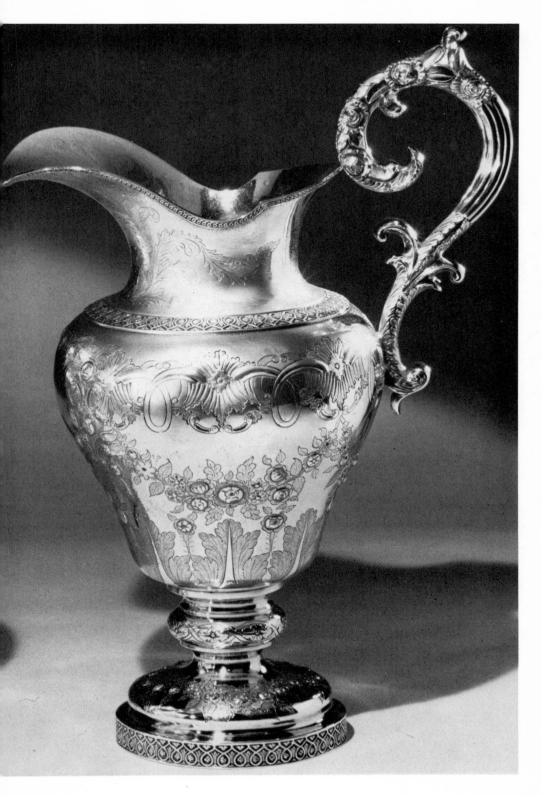

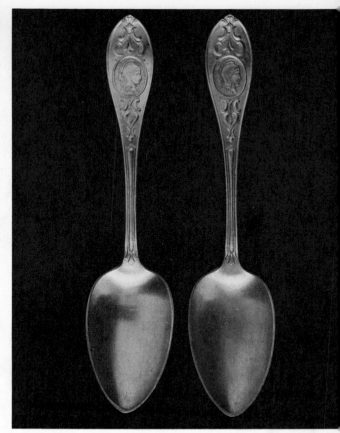

310 (right). Pair of pewter tablespoons in Classical Revival style made by Sage & Beebe. St. Louis, Missouri. c. 1849. L. 8⅝₁₆″. Pewter pieces were seldom as ornate as these handsome spoons, which are decorated with scroll designs and the head of a warrior in profile. (Greenfield Village and Henry Ford Museum)

311 (below). Pair of gold goblets made by Wood & Hughes. New York City. c. 1850. H. 5½″. The oviform bowls have molded rims on trumpet feet. The bowls are finely chased and lightly embossed with medallions of grapes and leaves encircling unusually fine engravings of a steam engine. (Department of State, Washington, D.C.; Gift of Philip H. Hammerslough)

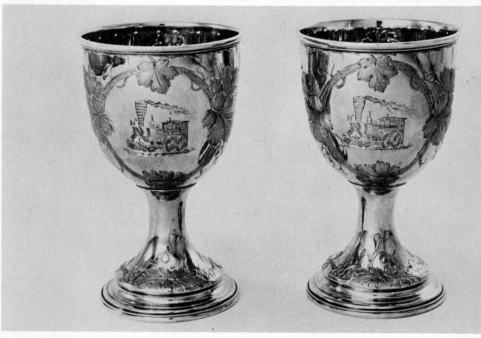

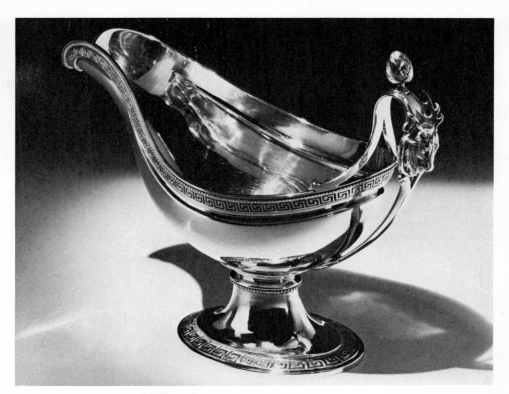

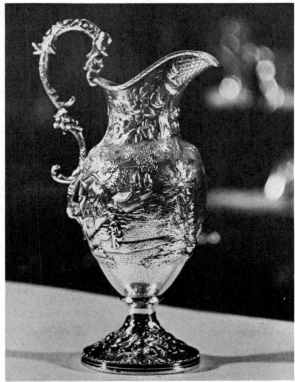

312 (above). Silver gravy boat in Classical Revival style made by William Gale, Jr., and Co. New York. c. 1850. L. 9⅛". Animal motifs began to be used as decorative devices during the 1840s and their popularity increased throughout the remainder of the century. (Greenfield Village and Henry Ford Museum)

313 (left). One of a pair of silver pitchers made by Samuel Kirk & Son, Baltimore, Maryland, for use in the Cambridge, Massachusetts, home of Abbott Lawrence Lowell, President of Harvard University. c. 1850. H. 15¼". It is decorated with repoussé landscape scenes. The Kirk firm is best known for its elaborate repoussé ornamentation. (Samuel Kirk & Son)

314 (right). Silver trowel by Francis W. Cooper. New York City. c. 1850. L. 14½". Victorians were especially fond of presentation silver. This ivory-handled piece is inscribed "Used in laying the corner stone of the new hall for the Tammany Society or Columbian Order July 4th 1867 by John T. Hoffman Grand Sachem." (Greenfield Village and Henry Ford Museum)

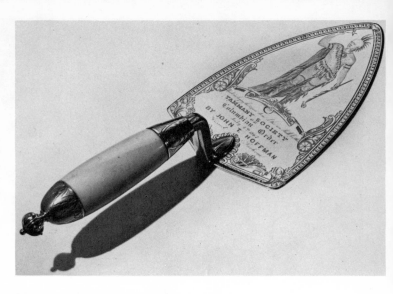

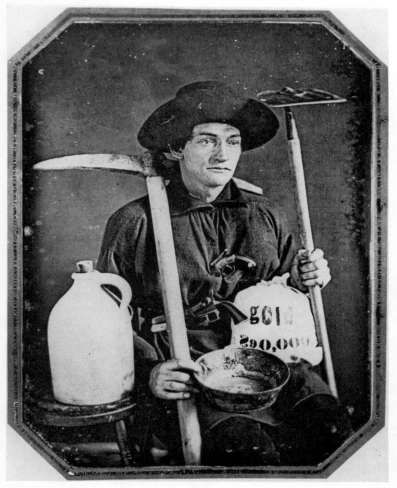

315 (left). Daguerreotype of George W. Northrup, a Minnesota frontiersman, miner, mission schoolteacher, fur trader, and Army scout. c. 1850. Northrup is equipped with all the necessary accouterments for working a successful claim—a pick, a hoe, a pan, a stoneware jug, and two pistols. (Current whereabouts unknown)

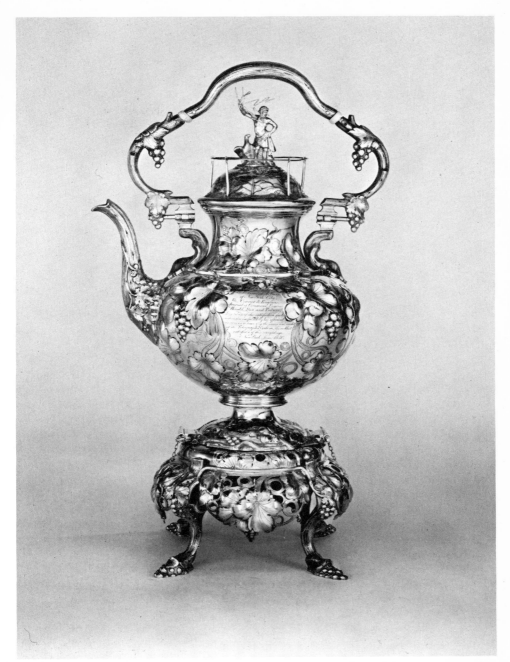

316 (above). Elaborately repoussé silver hot water kettle and stand from a presentation tea service made by John Chandler Moore for Ball, Tompkins & Black. New York City. c. 1850. H. 17⁵⁄₁₆". The side of this piece is inscribed "To MARSHALL LEFFERTS, ESQ. President of the New York and New England and New York State Telegraph Companies," and "From the Stockholders and Associated Press of New York City . . . As a token of . . . his . . . advancing the cause and credit of the Telegraph System, the noblest enterprise of this eventful age . . ." (The Metropolitan Museum of Art; Gift of Mrs. F. R. Lefferts, 1969)

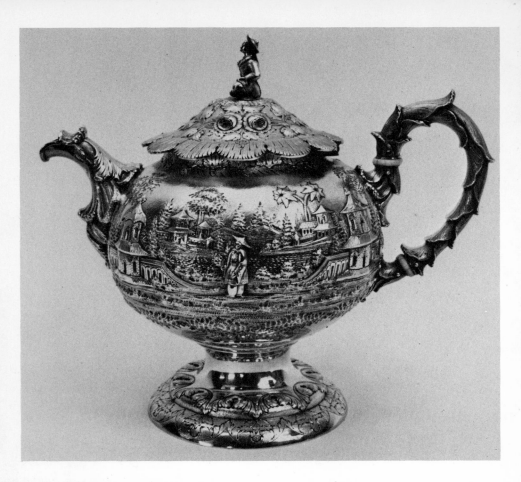

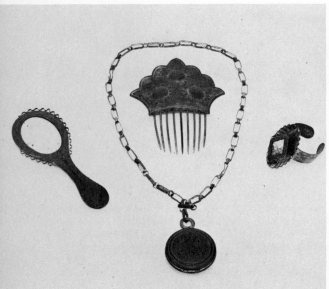

317 (above). Silver coffeepot in the Rococo Revival style. Marked Bailey & Co., Philadelphia. c. 1850. H. 10″. This delightful fantasy in repoussé silver features the chinoiserie motifs so beloved of the first Rococo period in the eighteenth century. See plate 23 for another example of Victorian chinoiserie. (Dorothy Jean Horr)

318 (left). Tin gifts for a tenth wedding anniversary. Last half of the nineteenth century. H. of comb 9½″. Several firms specialized in the production of inexpensive tin objects intended as presents for anniversary celebrations. These pieces generally are oversized and many of them are extremely well made. (Mr. and Mrs. James A. Keillor)

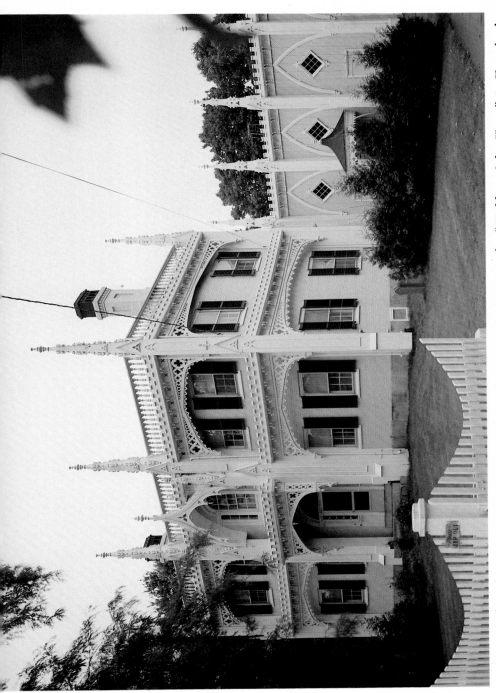

Plate 1 (above). One of the most famous architectural treasures in America, the "Wedding Cake House" in Kennebunk, Maine, was built in 1826 by George W. Bourne as a foursquare brick house. About 1855, keeping up to date with the latest fashion, Bourne applied the marvelous hand-carved pinnacles and lacy decoration in the Gothic Revival style.

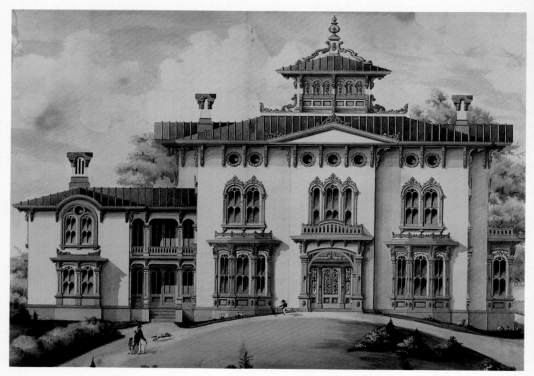

Plate 2 (above). Very possibly an architect's rendering, this beautiful watercolor of a very grand Victorian mansion shows decorative elements in the Tuscan, Gothic Revival, and Rococo Revival styles. c. 1850. 19″ x 27″. (Marguerite Riordan)

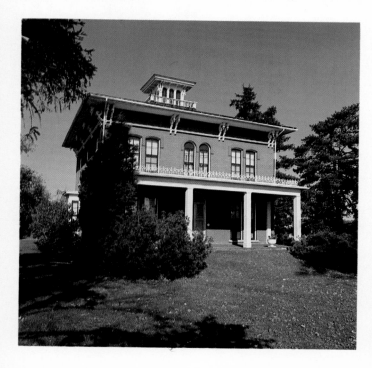

Plate 3 (left). Butler House, built in 1860 in Marshall, Michigan, by Edward Butler. This is a fine example of Victorian domestic architecture in a simplified style. Photograph courtesy The Magazine *Antiques*.

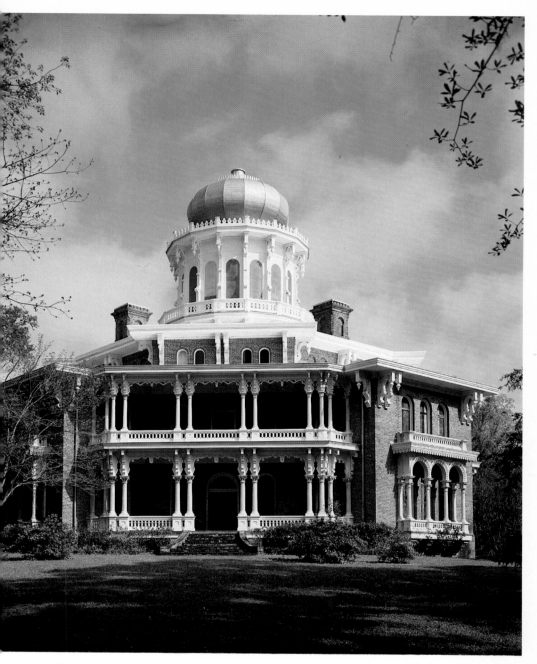

Plate 4 (above). Built in Natchez, Mississippi, 1855–1861 (but never completed because of the Civil War), Longwood was designed by Samuel Sloan for Haller Nutt and is a spectacular octagon house, a type of Victorian architecture made popular by Orson Fowler in his book *The Octagon House: A Home for All* (1853). Photograph courtesy The Magazine *Antiques*. (Pilgrimage Garden Club)

Plate 5 (right). Colonel Walter Gresham House. 1886–1893. Galveston, Texas. Designed by Nicholas J. Clayton, a Galveston architect, this house was clearly inspired by French château architecture. Colonel Gresham ordered and got a very handsome castle of his own. Photograph courtesy The Magazine *Antiques*.

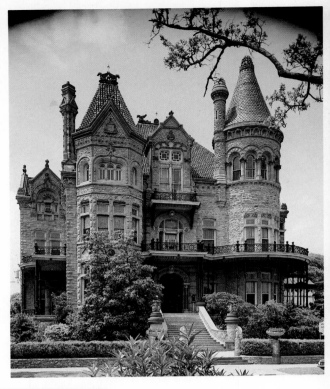

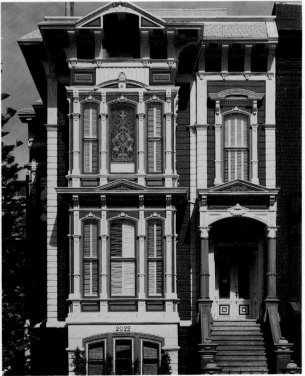

Plate 6 (left). House in the Stick/Eastlake style at 2022 California Street, San Francisco. 1885. This wonderfully decorative Victorian house was expertly restored in 1976 by Ben Franklin of Franklin Design. Photograph © 1978 by Morley Baer.

Plate 7 (opposite). One of the finest rooms in America in the Gothic Revival style, the dining room at Lyndhurst in Tarrytown, New York, is one of the additions to the house that Alexander Jackson Davis, the original designer, made in 1864–1865 for George Merritt. Photograph courtesy the Magazine *Antiques*. (Lyndhurst, National Trust for Historic Preservation)

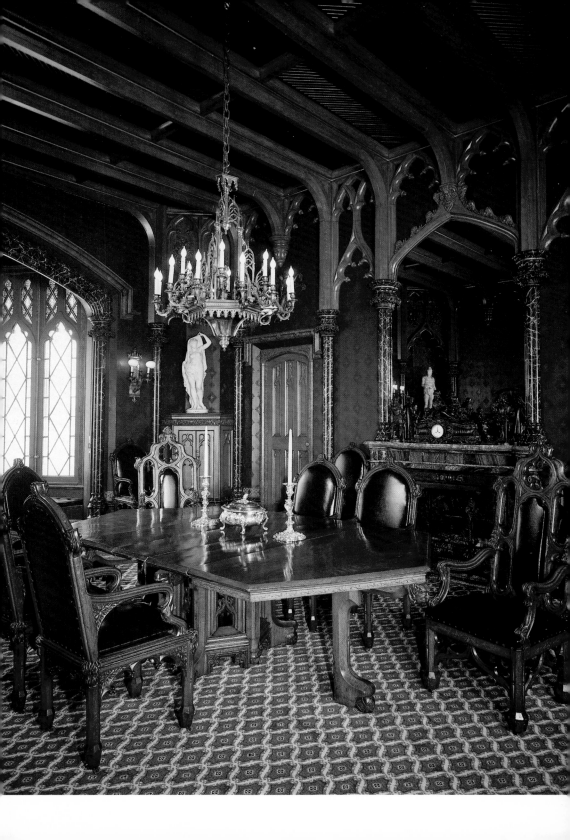

Plate 8 (below). Parlor from the Colonel Robert J. Milligan House, Saratoga Springs, New York. 1855. An exemplary statement of the Rococo Revival style, this parlor features chairs made by Galusha Brothers, Troy, New York. (The Brooklyn Museum)

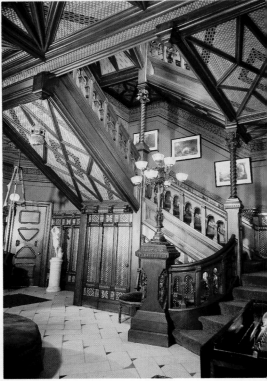

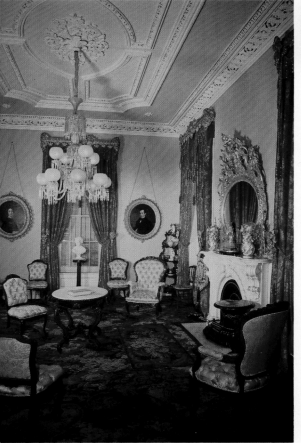

Plate 9 (above). Entrance hall at Mark Twain Memorial, Hartford, Connecticut. 1874. This hall, which was redecorated by the firm Associated Artists in 1881, features woodwork stenciled in silver in imitation of mother-of-pearl inlay. (Mark Twain Memorial)

Plate 10 (opposite, above). Dining room (looking toward the library) at Mark Twain Memorial, Hartford, Connecticut. 1874. Also redecorated in 1881 by Associated Artists, the dining room has wallpaper embossed with lilies and gold-stenciled woodwork. (Mark Twain Memorial)

Plate 11 (opposite, below). *The Parlor on Brooklyn Heights of Mr. and Mrs. John Bullard, Overlooking East River and New York City* by Edward Lamson Henry (1841–1919). 1872. Oil on panel. 14⅝″ x 16⅞″. This beautiful painting is a great document of the Renaissance Revival style in Victorian America. Photograph courtesy Hirschl & Adler Galleries. (Richard A. Manoogian)

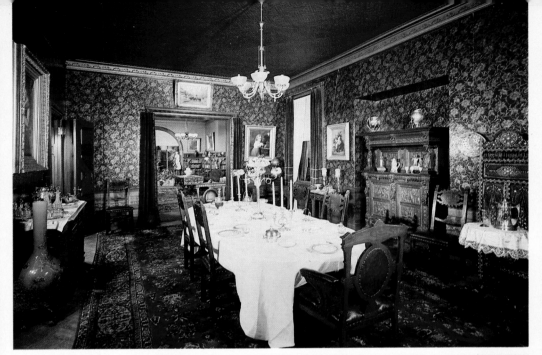

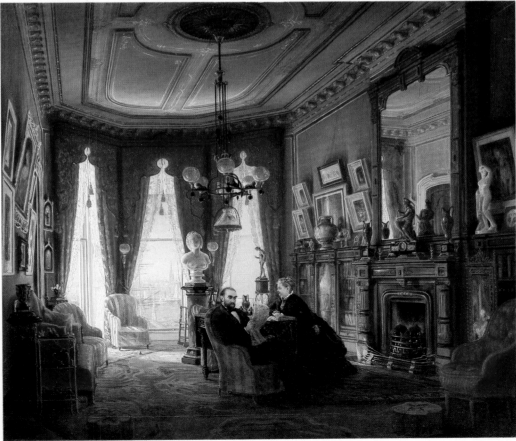

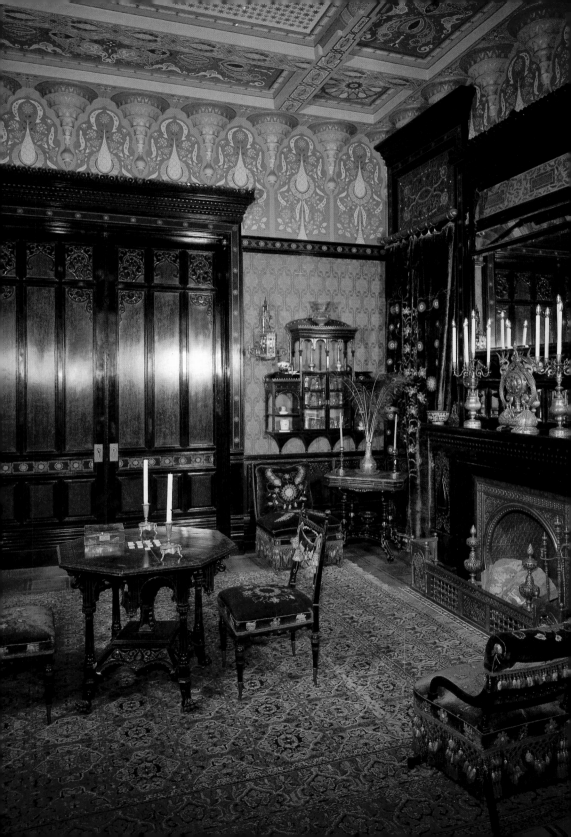

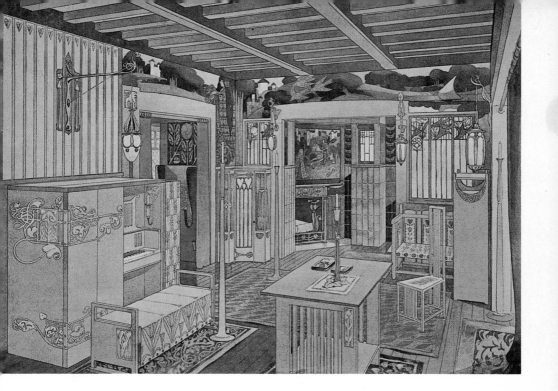

Plate 12 (opposite). Moorish smoking room from the John D. Rockefeller House, 4 West 54th Street, New York City. c. 1885. Ebonized, carved furniture, carved and inlaid woodwork and mantels, and painted and gilded ceilings combine with rich, colorful fabrics to create an exotic splendor worthy of a very rich man's home. (The Brooklyn Museum)

Plate 13 (above). Reception or living room designed in the Art Nouveau style by the famous American graphic artist Will Bradley in 1901–1902 for *The Ladies' Home Journal*. (The New York Public Library)

Plate 14 (right). Gas chandelier. c. 1850. Bohemian-style blue-over-clear glass and gilt bronze. H. 54″. This Rococo Revival fixture was very probably made by the Boston and Sandwich Glass Company or the New England Glass Company. (The Metropolitan Museum of Art, Rogers Fund, 1969)

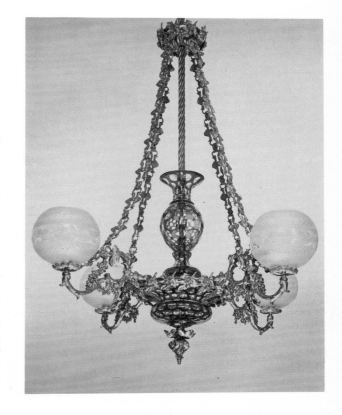

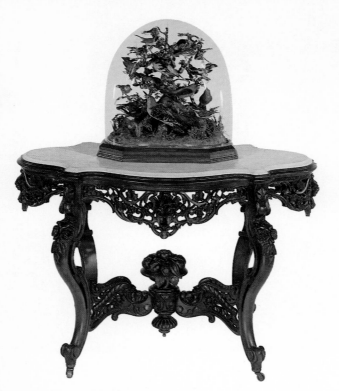

Plate 15 (left). Center table in the Rococo Revival style attributed to John Henry Belter, New York City. c. 1850. Laminated rosewood and marble. H. 30¾″. This table is from a suite of parlor furniture used in Abraham Lincoln's Springfield, Illinois, home. (Greenfield Village and Henry Ford Museum)

Plate 16 (below). "Square" piano made by Robert Nunns and John Clark, New York City. 1853. Rosewood. W. 88¼″. This extravagant creation, which boasts keys made of mother-of-pearl and tortoise shell, appears to be a very florid and weighty example of the Rococo Revival style. Note the extremely fine carving of the strapwork music rack. (The Metropolitan Museum of Art; Gift of George Lowther, 1906)

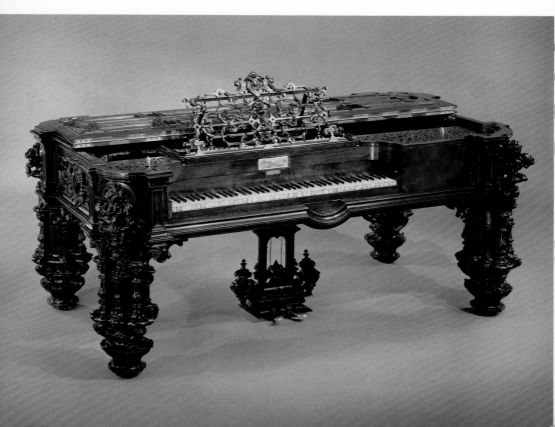

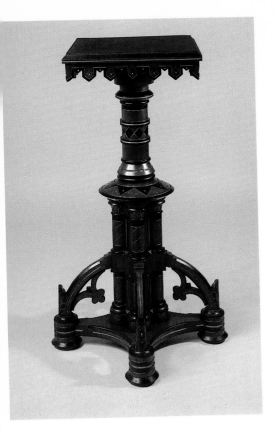

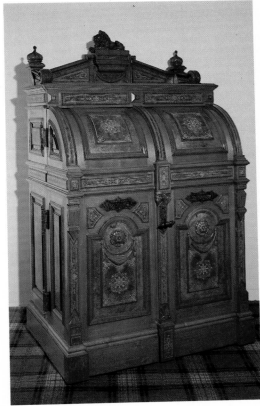

Plate 18 (below). Wooton patent secretary manufactured by W. Wooton, Indianapolis, Indiana. 1874. Walnut, burl walnut, and satinwood. H. 72". This particular desk was made as a presentation piece for Queen Victoria, and the photograph shows the quality of the craftsmanship lavished on it. Figure 379 shows another Wooton desk in both open and closed positions. (Eileen Dubrow Antiques)

Plate 17 (above). Pedestal. c. 1875. Walnut with ebonizing and gilt, incised lines. H. 36½ ". Combining both Gothic and Renaissance Revival elements, this pedestal was undoubtedly used to display a marble sculpture. (Frederick Di Maio: Inglenook Antiques)

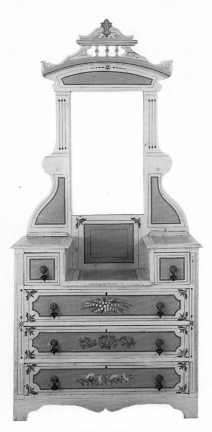

Plate 19 (left). Cottage bureau with painted decoration. Probably New England. 1860–1870. H. 83½″. This is a handsome, colorful example of a type of furniture much used in modest homes after about 1850. (Philip Davis and Thomas Hannan)

Plate 20 (below). Center table in Renaissance Revival style. Probably New York City. c. 1870. Rosewood with some ebonizing, gilt, incised lines, and a marble top. W. 46¾″. The fascination with Egypt in this period of American decorative arts is evident in the use of the gilded Egyptian heads and the painted sphinx on the porcelain plaque in the center of the table. (The Metropolitan Museum of Art, Anonymous Gift Fund, 1968)

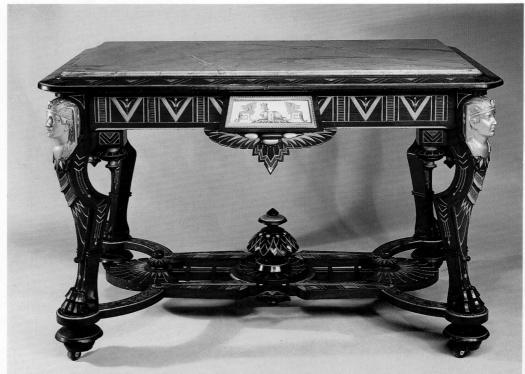

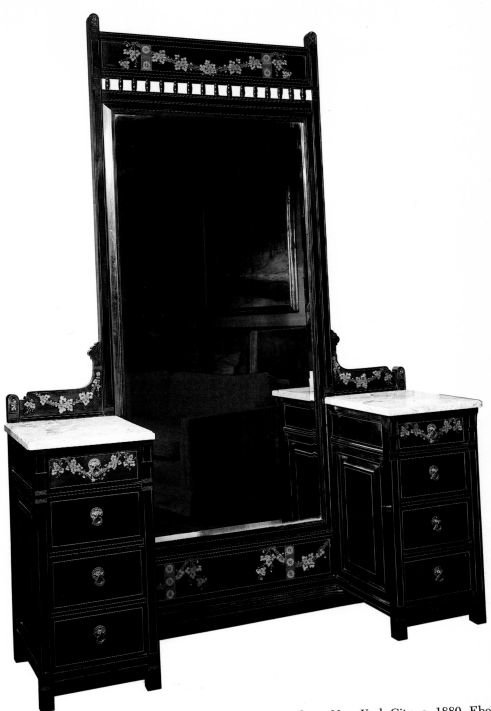

Plate 21 (above). Dressing chest made by Herter Brothers, New York City. c. 1880. Ebonized wood with floral inlay. H. 87″. This chest shows the rectilinear shape, turned spindles (at the top), and flat decoration made popular by Charles L. Eastlake. (David M. S. Pettigrew)

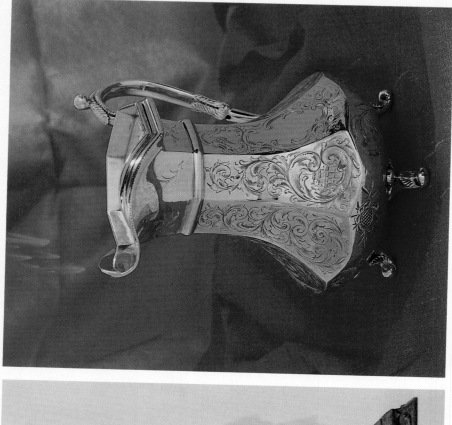

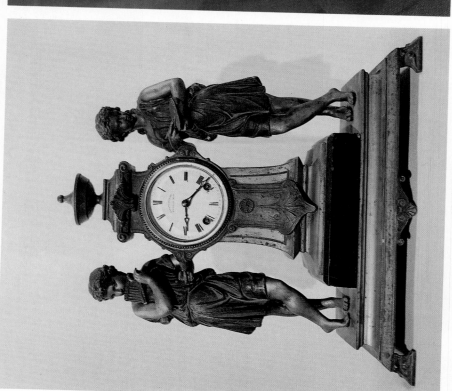

Plate 22 (above). Statue shelf clock made by Seth Thomas Sons and Company, Thomaston, Connecticut. c. 1870. Painted metal case in the Renaissance Revival style; porcelain dial. H. 17¼". (Private collection)

Plate 23 (above). Silver cream jug marked Gelston & Co., New York. 1835–1840. H. 5¾". This example of early Victorian chinoiserie includes exotic birds, Chinamen, and pagodas in the engraved decoration. (Private collection)

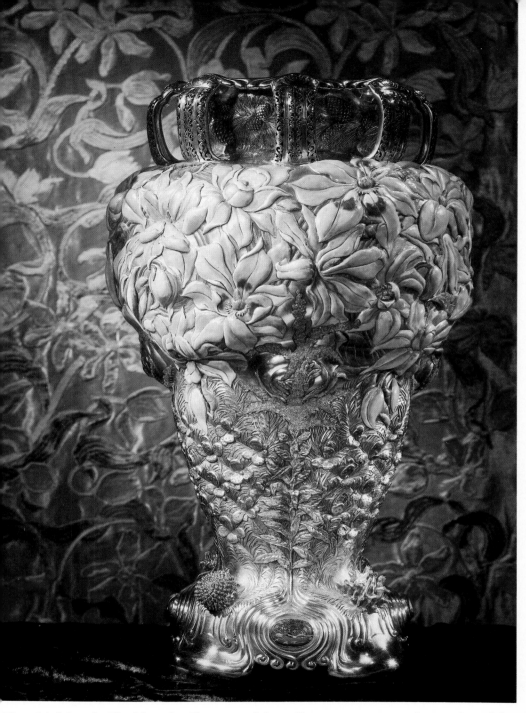

Plate 24 (above). The Magnolia Vase created by Tiffany & Co., New York City, for exhibition at the World's Columbian Exposition, Chicago, 1893. Silver, enamel, gold, and opals. H. 31″. Magnificent craftsmanship and opulent materials combine to make this an extraordinary symbol of Victorian high style in America. The portiere in the background is of cloth of silver with applied velvet flowers, and it was made by Candace Wheeler of Associated Artists. (The Metropolitan Museum of Art; Gift of Mrs. Winthrop Atwell, 1899)

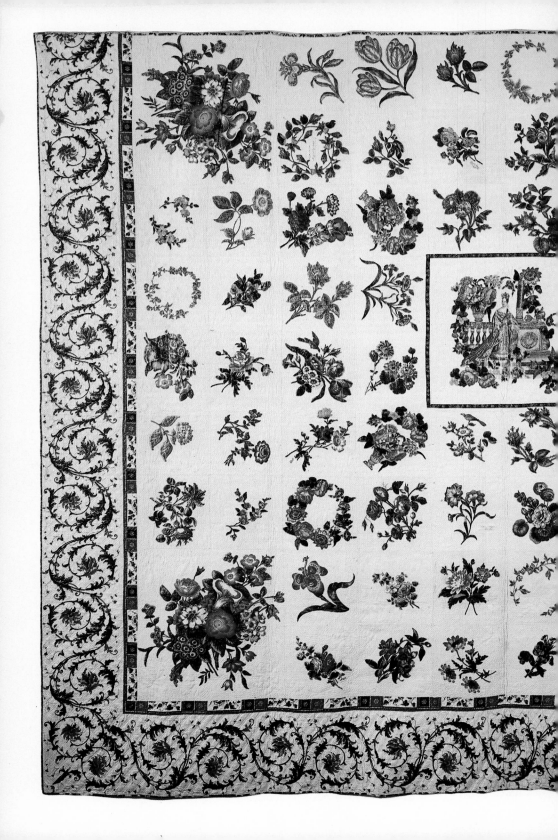

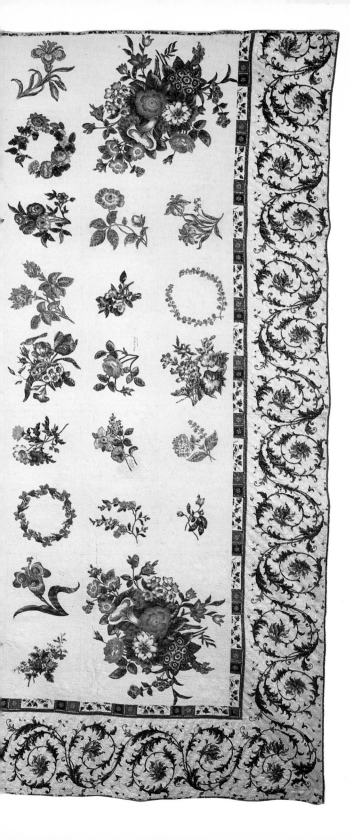

Plate 25 (left). Appliqué quilt with chintz cutouts, signed and dated 1844, Shippensburg, Pennsylvania. 93″ x 112″. The beauty of this quilt is enhanced by a fabric portrait of the young Queen Victoria framed in the center. Photograph courtesy Thos. K. Woodard: American Antiques & Quilts. (Private collection)

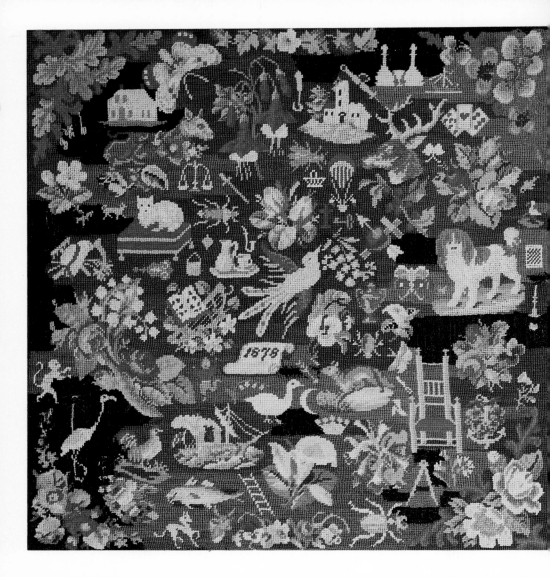

Plate 26 (above). Needlework fire screen panel. Dated 1878. 22¼ " x 21½ ". Here is a wonderful mélange of objects; the inclusion of the chair in a late seventeenth-century style possibly indicates that the needleworker had been made aware of Colonial furnishings by the exhibition at the Philadelphia Centennial Exposition in 1876. (New Haven Colony Historical Society)

Plate 27 (opposite, above). Crazy quilt from New Jersey. c. 1890. 70″ x 70″. The rich fabrics, handsome designs, and extraordinarily fine embroidery make this a superlative example of a Late Victorian crazy quilt. Photograph courtesy George E. Schoellkopf Gallery. (Private collection)

Platé 28 (opposite, below). *Domestic Sewing Machines.* Advertising poster for the Domestic Sewing Machine Co., Broadway at 14th Street, New York City. c. 1874. 18½ " x 24⅝ ". Here is High Victorian fashion available to any lady with the intelligence to purchase and the talent to use a Domestic Sewing Machine! (The New-York Historical Society)

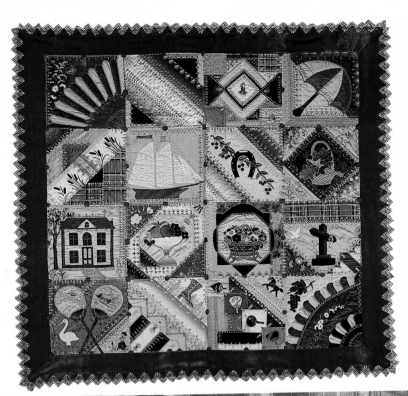

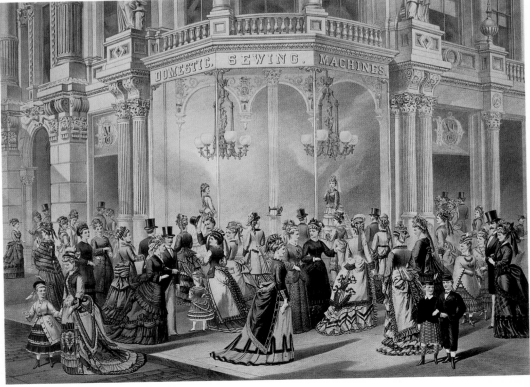

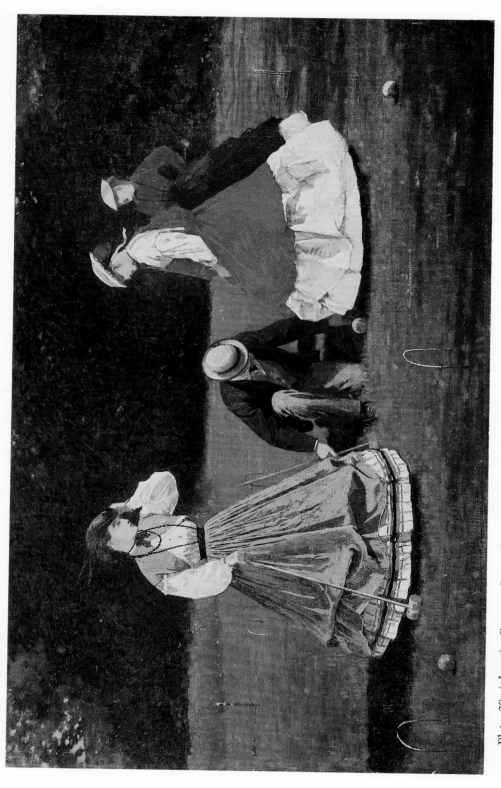

Plate 29 (above). *Croquet Scene* by Winslow Homer (1836–1910). 1866. Oil on canvas. 15⅞″ x 26⅛″. Homer has given us here a gorgeous interpretation of a favorite Victorian pastime. (The Art Institute of Chicago; Friends of American Art Collection)

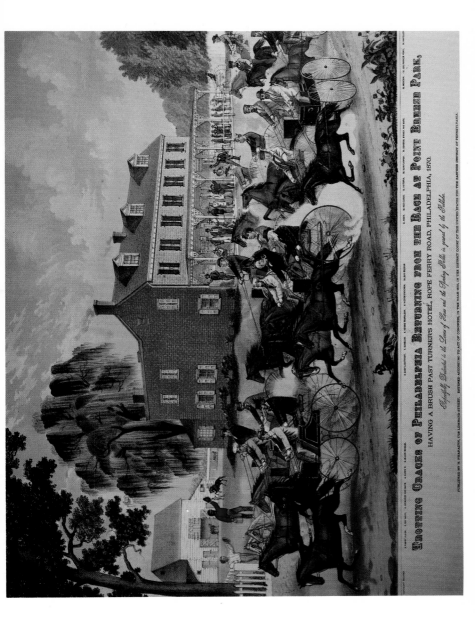

TROTTING CRACKS OF PHILADELPHIA RETURNING FROM THE RACE AT POINT BREEZE PARK,

HAVING A BRUSH PAST TURNERS HOTEL, ROPE FERRY ROAD, PHILADELPHIA, 1870.

Respectfully Dedicated to the Lovers of Horses and the Sporting Public in general by the Philada.

Plate 30 (above). *Trotting Cracks of Philadelphia Returning from the Race at Point Breeze Park.* Published by H. Pharazyn. 1870. Lithograph with watercolor. 23⅝″ x 29⅛″. The unknown artist has captured beautifully the bustle and excitement of the trotters; Point Breeze Park was a popular race track in South Philadelphia. (The Library Company of Philadelphia)

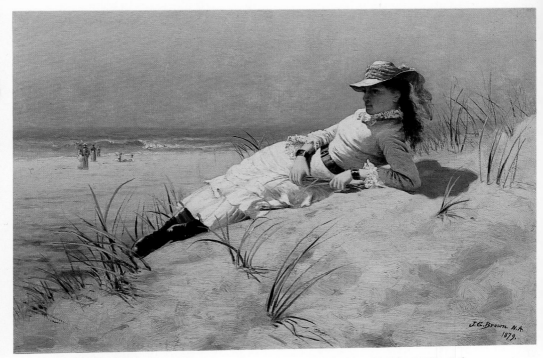

Plate 31 (above). *A Day at the Seashore* by J. G. Brown (1831–1913). 1879. Oil on canvas. 13¼″ x 19¾″. One of the most popular and successful artists of his day, Brown made his fortune turning out paintings of street urchins; so this very beautiful scene seems to be particularly inspired. (Private collection)

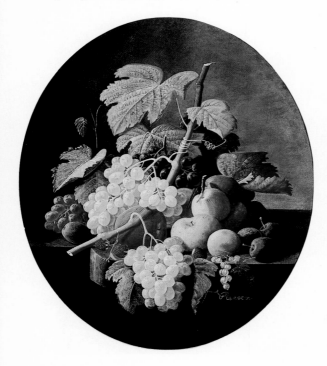

Plate 32 (left). *Fruit* by Severin Roesen (?–c. 1871). c. 1855. Oil on canvas. 25″ x 21¼″ (oval). Roesen was a prolific painter of still lifes, such as this very attractive example. (Hirschl & Adler Galleries)

Plate 33 (opposite). *Twilight in the Wilderness* by Frederic E. Church (1826–1900). 1860. Oil on canvas. 40″ x 64″. This sublime masterpiece has been eloquently described by David C. Huntington: *"Twilight in the Wilderness* is the ultimate wilderness landscape—high art rooted in the depths of American experience. . . . Ecstatic agitation and profound calm. Celestial purgation and earthly peace. . . . The spectator engaged in the supreme moment of cosmic time. *Twilight in the Wilderness* was the natural apocalypse." [1] (The Cleveland Museum of Art, Purchase, Mr. and Mrs. William H. Marlatt Fund)

Plate 34 (above). *Owl's Head, Penobscot Bay, Maine* by Fitz Hugh Lane (1804–1865). 1862. Oil on canvas. 16″ x 26″. How intensely we experience this scene, almost as if each form and object had become sculpture through the poetry of the artist's light. (Museum of Fine Arts, Boston; M. and M. Karolik Collection)

Plate 35 (below). *View of Northampton, Massachusetts,* artist unknown. 1864–1866. Oil on canvas. 29⅛″ x 36″. This is a marvelous panorama with great detail. Photograph courtesy Old Sturbridge Village. (Smith College Museum of Art)

Plate 36 (above). *Flight and Pursuit* by William Rimmer (1816–1879). 1872. Oil on canvas. 18″ x 26¼″. One of the most fascinating paintings to come from Victorian America, this exotic scene perplexes and intrigues us with the air of menace within the shadowy halls. It has been called an allegory of man and his conscience; we can never really know. (Museum of Fine Arts, Boston; Bequest of Miss Edith Nichols)

Plate 37 (below). *Glens Falls, New York* by Henry Augustus Ferguson (1843/45–1911). 1882. Oil on canvas. 15″ x 26″. This is an impressive depiction of a factory town. (Crandall Library)

Plate 38 (above). *Mourning Picture* by Edwin Romanzo Elmer (1850–1923). c. 1889. Oil on canvas. 28″ x 36″. Elmer created this haunting painting as a memorial to his daughter Effie, shown in the foreground with her pets and toys, who died when she was just eight. The artist and his wife are shown sitting in front of the house Elmer and his brother built in 1876 at Shelburne Falls, Massachusetts. (Smith College Museum of Art)

Plate 39 (above). *The Red Bridge* by J. Alden Weir (1852–1919). 1895. Oil on canvas. 24¼" x 33¾". This lyrical painting is a particularly fine example of American Impressionism. (The Metropolitan Museum of Art; Gift of Mrs. John A. Rutherfurd, 1914)

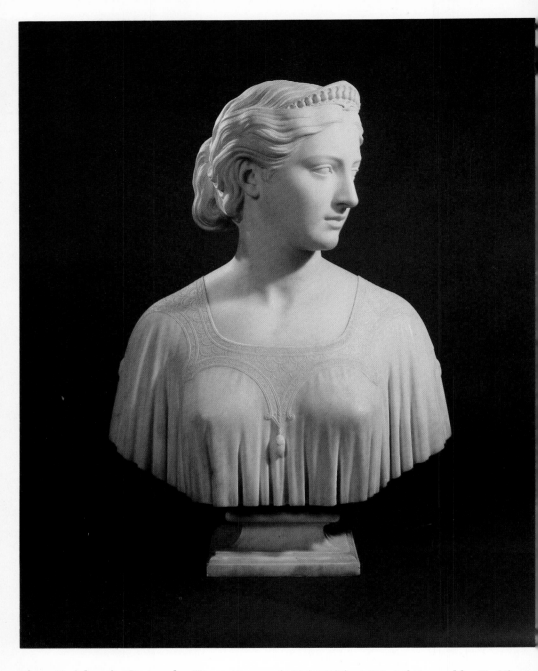

Plate 40 (above). *Ginevra* by Hiram Powers (1805–1873). 1868. White marble. H. 27⅛″. "Ginevra," a Florentine legend of the Middle Ages, served as a popular subject for artists and writers during the nineteenth century. Photograph courtesy Christie, Manson & Woods International Inc. (Private collection)

Plate 41 (opposite). *Adams Memorial* by Augustus Saint-Gaudens (1848–1907). 1886–1891. Bronze. H. 70″. In this great sculpture the artist has succeeded in symbolizing the mystery of life and death. (Rock Creek Cemetery, Washington, D.C.)

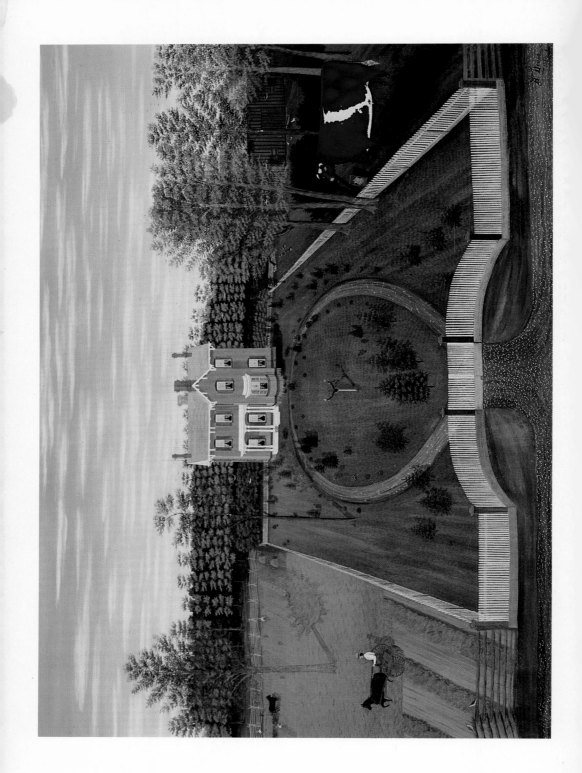

Plate 42 (opposite). *Indiana Farm* by H.
Dousa. 1875. Oil on canvas. 34" x 48".
On the canvas at far right an inscription in-
forms us that the bull's name is William
Allen, that it is five years old, and that it
weighs 2,300 pounds. Photograph courtesy
George E. Schoellkopf Gallery. (Mr. and
Mrs. William E. Wiltshire III)

Plate 43 (right). Armchair. Maine. c. 1890.
Carved and painted wood. H. 41". This
fascinating piece, which appears to have
been inspired by a Morris chair, was cre-
ated by a retired ship's captain. (Jay
Johnson: America's Folk Heritage Gallery)

Plate 44 (below). Painted cannonball bed
with sponged decoration. Eastern Connecti-
cut. 1835–1840. L. 84". The boldness of
the turned posts and the beauty of the deco-
rative painting make this a masterful ex-
ample of the country style. (Private collec-
tion)

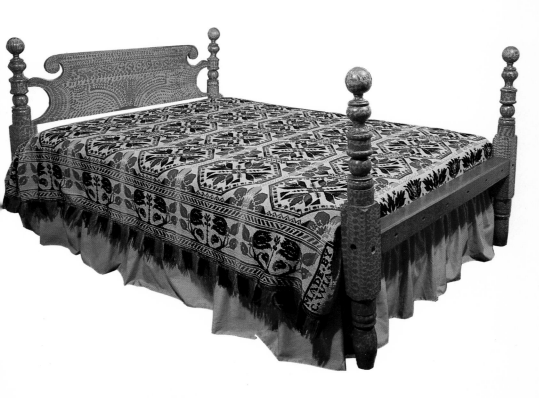

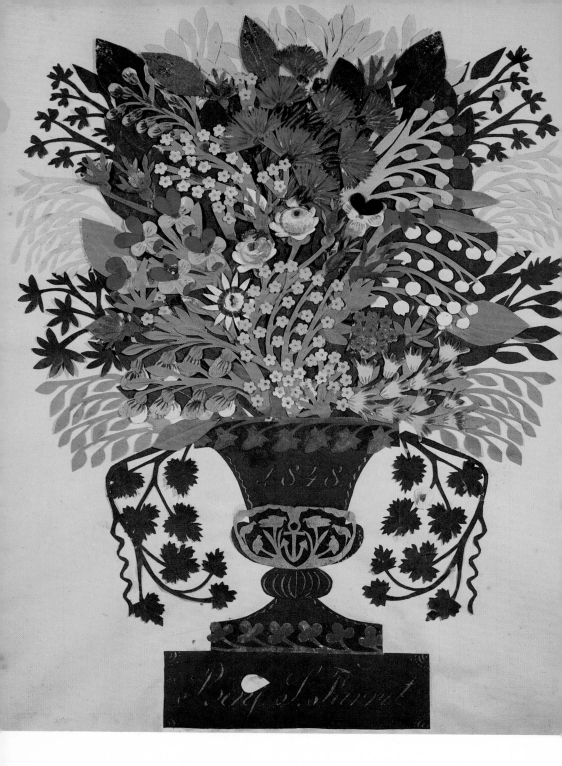

Plate 45 (above). *Vase of Flowers* by Benjamin S. Farret. 1848. Painted, cut, and pasted paper. 14⅞″ x 12″. This is an especially pleasing composition—detailed and colorful. (Private collection)

319 (right). Advertisement for Gorham and Company. 1850–1860. Photograph courtesy V. Stephen Vaughan.

320 (below). What proper Victorian bird could not fail to be impressed by this sumptuous cast-iron bird house in the Gothic Revival style? Baltimore, Maryland. c. 1850. H. 13″. Photograph courtesy *Ohio Antique Review*.

321 (right). Tin tray. c. 1850. L. 24¼". Simple, utilitarian pieces such as this brightly painted and decorated tray are often excellent indicators of the things and events that fascinated people within a given period. In many areas of rural America during the mid-century the train was still a novelty. (Greenfield Village and Henry Ford Museum)

322 (below). Group of pewter consisting of a syrup jug and caster marked "Homan & Co/Cincinnati" and a coffeepot and teapot marked "Sellew & Co/Cincinnati." 1830–1860. H. of coffeepot 10½". Pewter forms remained unchanged over an extended period of time since the high cost of producing the molds discouraged faddish innovations. (Greenfield Village and Henry Ford Museum)

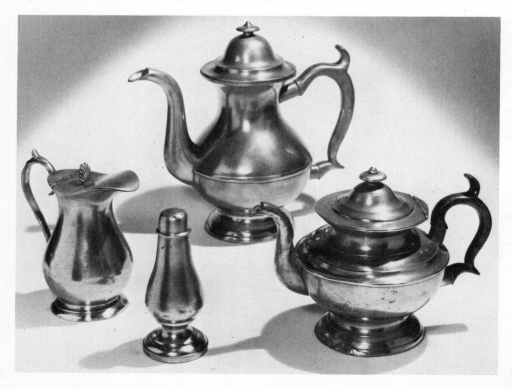

323 (above, left). Cast-iron fire-tool stand, waffle iron, and trivets. c. 1880. H. of stand 24½″. At one time nearly every utilitarian object was made of cast iron—doorstops, curtain tie-backs, bookends, sadirons, apple parers, muffin tins, etc. (Greenfield Village and Henry Ford Museum)

324 (above, right). Mirror with cast-iron frame patented by S. Sailor, November 25, 1862. H. 20″. This piece was apparently made to commemorate the personal success of a military leader in the Civil War. (Greenfield Village and Henry Ford Museum)

325 (right). Cast-iron hitching posts, door knocker, and foot-scraper. Second half of the nineteenth century. H. of the darky hitching post 23″. Once technology had made it feasible, nearly every American home was equipped, both outside and in, with decorative cast-iron accouterments. (Greenfield Village and Henry Ford Museum)

326d (above, left to right). Silver berry spoon in Oriental style attributed to John R. Wendt & Co. c. 1865. Pierced silver serving spoon in Egyptian Revival style made by Gorham Mfg. Co. c. 1870. "Persian" silver tablespoon in Oriental style made by Tiffany & Co. Patented 1872. Silver letter opener in Oriental style made by Gorham Mfg. Co. c. 1870. 326e (opposite, left). "Heraldic" silver serving fork in Renaissance Revival style made by William B. Durgin & Co. Patented 1891. "Versailles" silver-gift fish knife in Renaissance Revival style made by Gorham Mfg. Co. Patented 1888. 326f (opposite, right). Silver letter opener in Naturalistic style made by G. W. Shiebler & Co. c. 1885. Silver butter knife in Naturalistic style made by Ford & Tupper. c. 1870. 326g (opposite, bottom). Silver butter knife in Renaissance Revival style made by Ball, Black & Co. c. 1870. All photographs courtesy V. Stephen Vaughan.

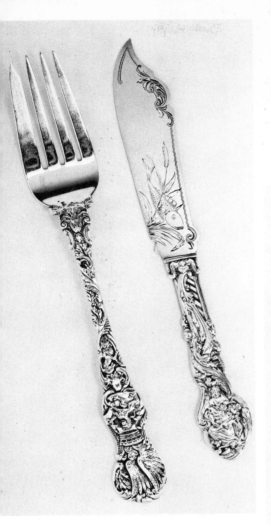

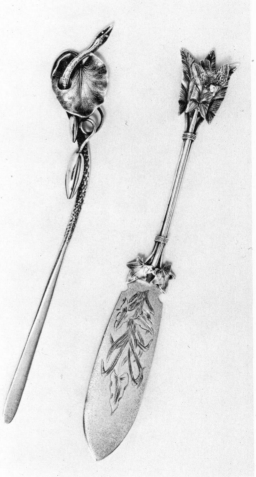

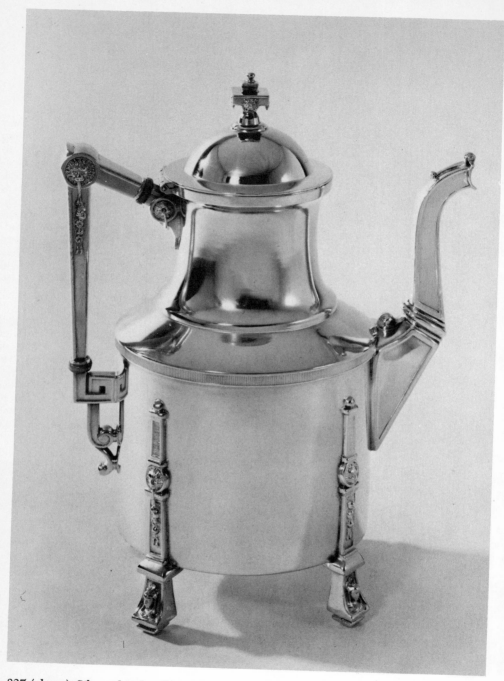

327 (above). Silver-plated coffeepot in Classical Revival style by an unknown maker. Patented 1869. H. 10½". One seldom finds an example of Victorian silver with such restrained, uncluttered lines and plain surfaces. Obviously, the unknown designer took to heart the spirit of classicism. (Private collection)

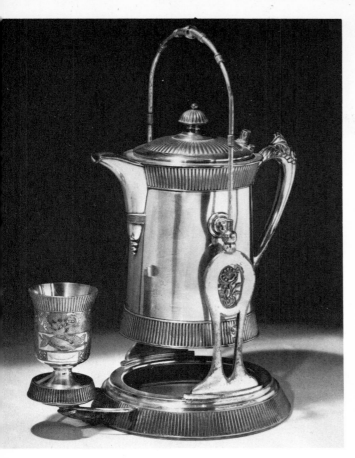

328 (left). Silver-plated water pitcher on stand and cup made by the Meriden Britannia Company, Meriden, Connecticut. 1868. H. 20″. The plating on silver-plate pieces has frequently worn through, exposing the base metal as seen in this photograph. Modern collectors, who like to use their silver pieces, often have them replated. (Greenfield Village and Henry Ford Museum)

329 (below). Silver-plated coffee service. c. 1870. H. of coffeepot 12¼″. Elements of the Renaissance Revival style are evident on these pieces. The hoofed feet and the engraved decoration relate to furniture designs of the same period. (Greenfield Village and Henry Ford Museum)

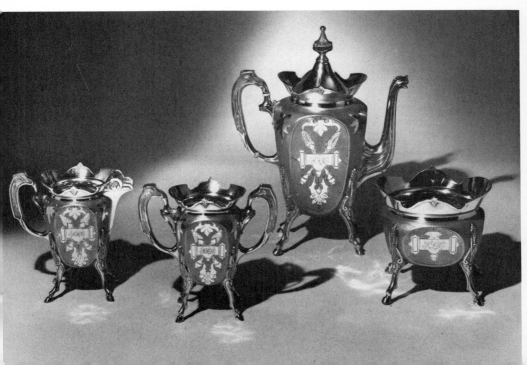

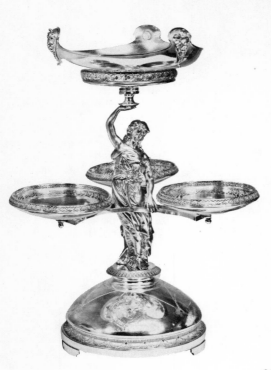

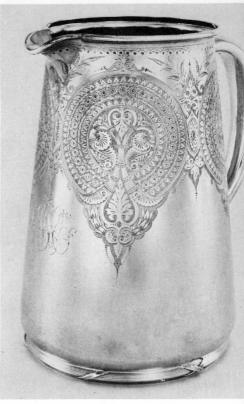

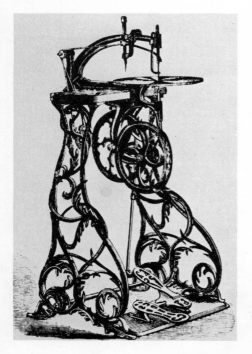

330 (above, left). Silver epergne, parcel gi
made by Thomas Kirkpatrick and sold by Gorha
Manufacturing Company, Providence, Rho
Island. 1871. H. 19½". This presentation piece
decorated with bright-cut engravings of a fer
on the Hudson River and a barge on the Er
Canal. (David Stockwell, Inc.)

331 (above, right). Silver water pitcher in Orient
style made by Gorham Mfg. Co. 1874. H. 9
It is the engraving using Persian motifs that giv
such interest to this piece. (Museum of the City
New York; gift of Miss Mary Thurston Cockcro
1940)

332 (left). Illustration of a treadle-operated scroll
sawing machine taken from *Harper's New Monthl*
Magazine for March 1878. Such devices were usec
to fashion jigsaw or Sorrento work pieces. The
bases for these machines, as well as for sewing
machines, were usually made of cast iron. (The
New York Public Library)

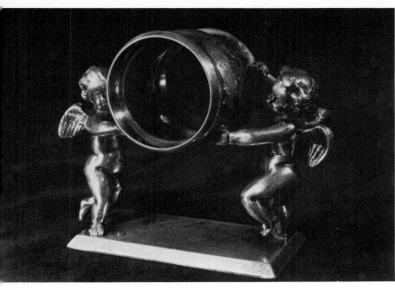

333 (left). Silver napkin ring made by the Meriden Britannia Company, Meriden, Connecticut. c. 1875. W. 4½". (Mrs. David Mathews)

334 (below). *The Buffalo Hunt,* made by the Meriden Britannia Company, Meriden, Connecticut. 1876. Originally cast in bronze, then in silver plate. L. 28". This piece was designed for display at the Philadelphia Centennial and afterward was widely exhibited at other fairs and expositions. In 1882 and again in 1886 it was made a standard catalogue item, and priced at $315 in "old silver" finish and at $325 in "gold inlaid." It was also made in a small size, measuring 9½ inches high, and offered for $23.50; the buffalo was sold alone as a 4½-inch-high paperweight for $5.50. (The International Silver Company Historical Collection)

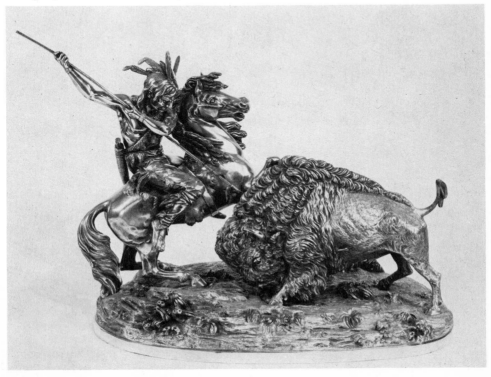

335 (opposite). Interior of Mrs. George Pullman's bedroom at Fairlawn, Elberon, New Jersey. 1875. Typical Victorian appointments abound in this cluttered boudoir. Brass beds were both imported from France and manufactured domestically. Their prices varied from a few dollars to several hundred. The more expensive types were made from the solid metal, the less expensive were plated. A "Gone with the Wind" lamp sits on a round table in front of the mantel and a Turkish Frame tête-à-tête is appropriately draped with fringe and lace doilies. (Chicago Historical Society)

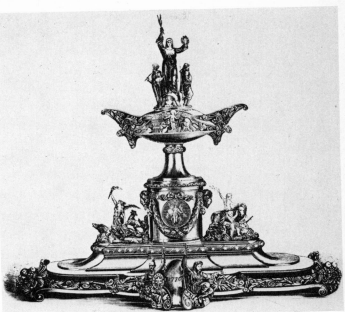

336 (above). Silver Century Vase produced by the Gorham Manufacturing Company, Providence, Rhode Island, for exhibition at the Philadelphia Centennial in 1876. H. 50". Although American tastemakers readily admitted the "ambitious pretension of our designs, overloaded as they too often are with meretricious ornament," [1] the Century Vase was the hit of the exhibition. Abundant symbolism, including allegorical figures and historical emblems caused *Godey's Lady's Book* to complain, "no one goes so far astray in elaborate ornamentation." [2] (Detroit Public Library)

337 (above). Dining room of the Sarah Jordan Boarding House, moved from Menlo Park, New Jersey, to Greenfield Village at Dearborn, Michigan. Thomas Edison's research assistants at Menlo Park lived at the Jordan house. It was one of the first buildings lighted by his newly developed lighting system. The dining table is set with a quadruple-plated caster set of the 1880s filled with canary-colored glass bottles in the Daisy and Button pattern. The Daisy and Button pickle jar has a silver-plated holder and the plated napkin rings are engraved. (Greenfield Village and Henry Ford Museum)

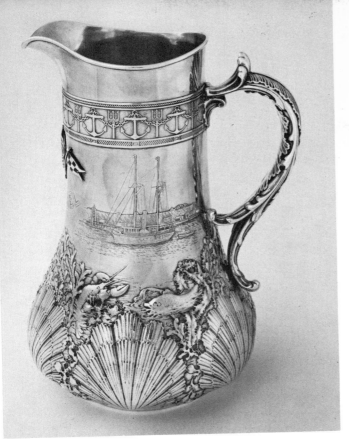

338 (left). Silver presentation pitcher made by Gorham Mfg. Co. 1890. H. 11". The friends of Charles Fletcher presented this very beautiful pitcher to him in 1890 on the occasion of his acquiring his sailing yacht *Sentinel*, which is engraved on the side of the piece. Photograph courtesy Nina Fletcher Little.

339 (right). Cast-iron medallion, bronze plated. Designed by George Grant Elmslie for Louis H. Sullivan. 1879. Diam. 2⅜". The elevator doors of the Schlesinger & Mayer Department Store (now Carson, Pirie, Scott & Company) in Chicago are decorated with these medallions. (The Art Institute of Chicago; Gift of the Graham Foundation for Advanced Studies in the Fine Arts)

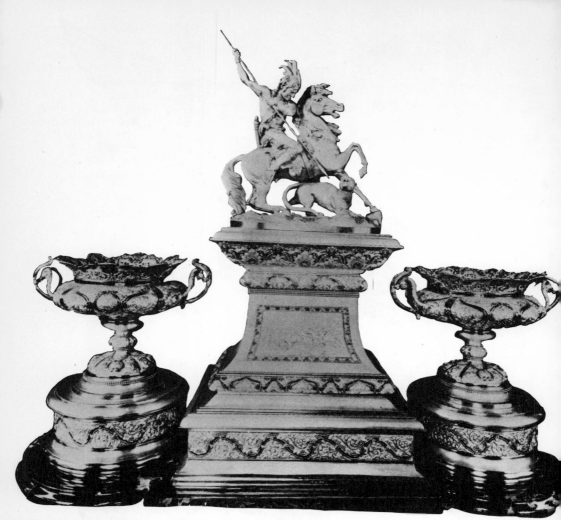

340 (above). Illustration from the *Book of the Fair*, published by Bancroft and Co., Chicago, Illinois, 1893. The rapture with which the author describes the pavilion containing over 800 pieces of electroplated ware is astonishing: "The pride and glory of the collection is the exhibit our picture illustrates. It needs no description, as its beauty speaks eloquently for itself. That hard metal should so yield to art as to enable man to produce a work so remarkably true to life, is marvelous. The plunging horse frightened by the puma, the great cat crouching in snarling terror, the stern-faced Indian driving the savage spear straight home with unerring force, form a picture on which the eye rests with pleasure. The two side-pieces are gems of beauty, and help to lend artistic association to the central group. The other articles in this exhibit also deserve attention; the art of every land has been called upon to serve in the decoration of many of the spoons; Assyrian, Etruscan, Egyptian, Grecian, Roman, and many other designs are embossed on them. There are also souvenir spoons of most of the great cities and noted scenes of the world, and the World's Columbian Exposition is not omitted. . . ." [3] Private collection)

341 (right). Brass-plated and tin political device. Patented September 10, 1891. New York. W. 27". A stamping machine was used to shape the brass-plated eagle that tops the painted tin shield. Similar machines were used to produce brass and brass-plated window cornices, curtain tiebacks, and other decorative appointments for the home. (Collection of Hazel and Carleton Brown)

342 (below). Basket and berry or preserve dish in glass with silver-plated stands. The basket was made by the Wilcox Silver Plate Company. Meriden, Connecticut. c. 1896. The bowl is cased pink over opal glass and is decorated with gold leaves and flowers. H. 12½". The berry or preserve dish with a pressed blue glass Daisy and Button pattern bowl was manufactured by the Meriden Britannia Company. c. 1896. H. 9". (The International Silver Company)

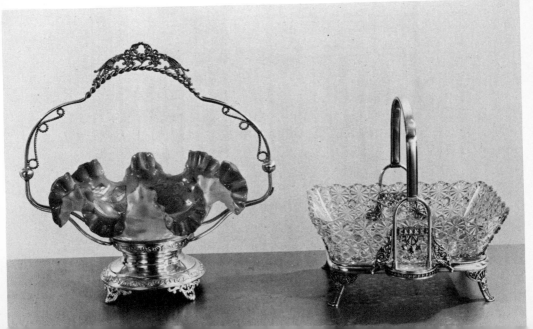

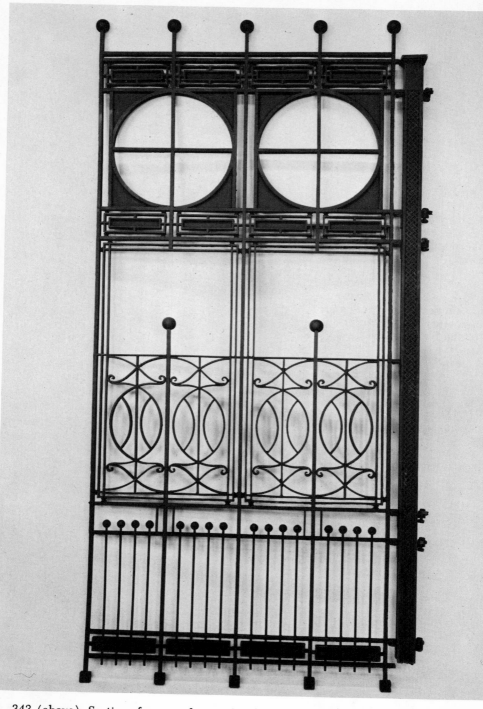

343 (above). Section of a wrought-iron fence designed by Frank Lloyd Wright in 1895. H. 98″. Used at the Francis Apartments in Chicago. Wright once explained, "From the very beginning my T-square and triangle were easy media of expression for my geometric sense of things." [4] (The Art Institute of Chicago; Gift of the Graham Foundation for Advanced Studies in the Fine Arts)

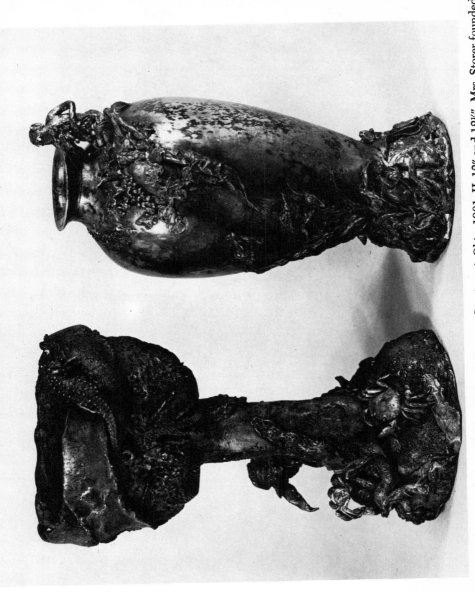

344 (above). Bronze vases made by Maria Longworth Storer. Cincinnati, Ohio. 1901. H. 12″ and 12¾″. Mrs. Storer founded the Rookwood Pottery of Cincinnati, Ohio, in 1880 and headed it until her retirement in 1890. These pieces are interesting examples of Late Victorian design. (Cincinnati Art Museum)

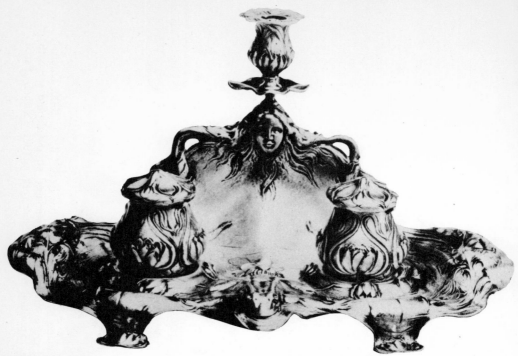

345 (above). Illustration of a Martele inkstand taken from an old trade catalogue of the Gorham Manufacturing Company, Providence, Rhode Island. c. 1900. The silver used in the Martele line was softer and purer in grade than sterling. It was hammered into shapes that reflected the Art Nouveau style. The Martele pieces were, for the most part, handcrafted and tool marks were usually left undisguised on the plain surfaces. (Private collection)

346 (below). Bronze and glass box from a desk set made by Louis Comfort Tiffany. New York. Early twentieth century. H. 3″. Elaborate suites of desk furniture in the pine-needle design sometimes contain as many as twenty-four pieces and include letter holders, letter openers, paperweights, and various boxes. (Cincinnati Art Museum)

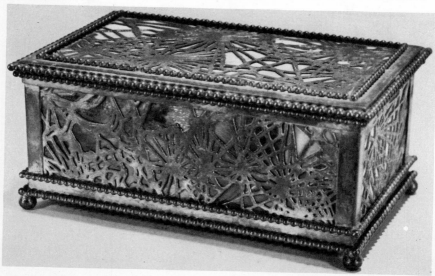

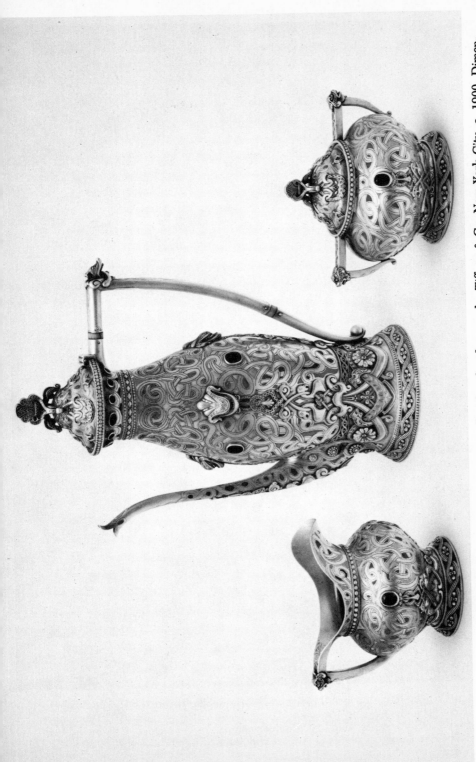

347 (above). Silver and enamel three-piece coffee set mounted with colored stones by Tiffany & Co. New York City. c. 1900. Dimensions unavailable. This set in the Oriental style is decorated with pink and green enamel within interlaced strapwork and set with colored stones. It probably was created for exhibition at the Pan-American Exposition in Buffalo, New York, in 1901. (Sotheby Parke Bernet Inc.)

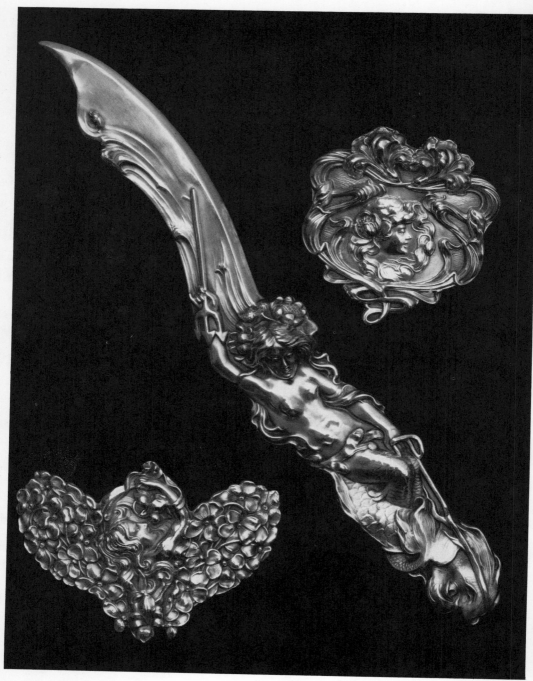

348 (above). Silver letter opener, brooch, and belt buckle made by Unger Brothers, Newark, New Jersey, between 1881 and 1910. L. of letter opener 9⅞". The Unger Brothers firm was but one of many small silver companies that specialized in the production of fine Art Nouveau pieces. (The Metropolitan Museum of Art; Gift of Ronald S. Kane, 1967)

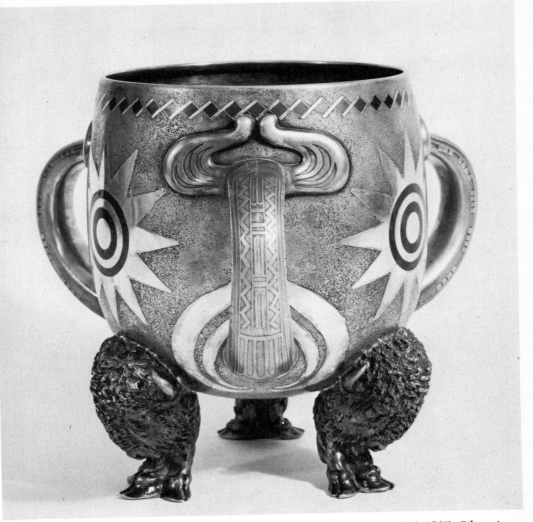

349 (above). Three-handled bowl or tyg made by Tiffany & Co. 1895–1905. Silver in-laid with copper, brass, and black enamel. H. 10". American Indian motifs—note the bison heads and hooves forming the feet—are featured in the decoration of this piece, but just to be safely in fashion Tiffany's added an Art Nouveau swirl at the top of each handle. Photograph courtesy Martin Eidelberg.

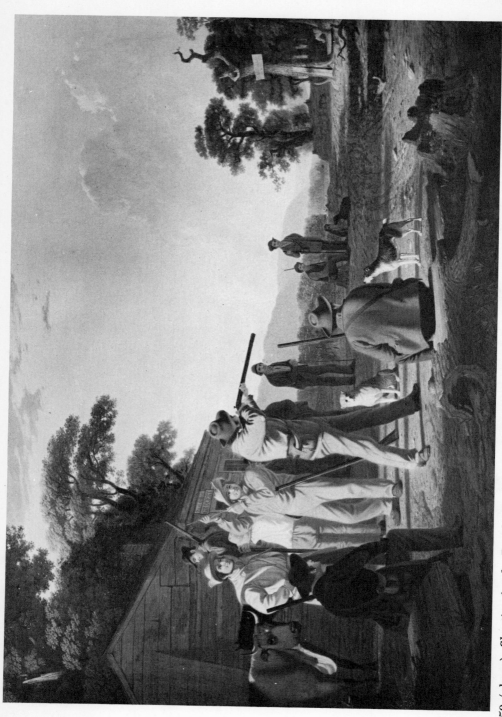

350 (above). *Shooting for the Beef* by George Caleb Bingham. 1850. Oil on canvas. 33½″ x 49¾″. The steer at the left in the painting is the prize for the victor of this shooting match. (The Brooklyn Museum; Dick S. Ramsay Fund)

MAN'S WORLD

Victorian America was a land of opportunity where ambitious and clever men frequently rose from modest beginnings to positions of prominence and power. The various careers of Samuel Wilder, while perhaps more colorful than most, indicate the flexibility available to the ingenious citizen.

Among many other avocations [Samuel Wilder] had been proprietor of a circus or two, a dealer in real estate, an entrepreneur of acrobats, a wholesale jeweller, a trader in mining stock, a proprietor of coaches, and I believe at one time a banker. He was a capital illustration of the adaptability of the American to any pursuit, a peculiarity which forms a national characteristic. Apprenticeship to any art or calling is not thought to be required in the United States. A Yankee learns a trade in six months to which an English youth is apprenticed for seven years. In professions, instead of a man waiting till he is middle-aged before he commences to practise, he gallops through all the sciences he has to learn, or makes a *coup-de-main* on all the art he has to acquire, and begins his profession and his manhood together. Should he commence as a doctor and not like his calling, he will probably turn to be a lawyer. If still dissatisfied, he will possibly try hotel-keeping, horse-dealing, or architecture. None of these suiting, he will attempt something else. Before he is forty he may have been a soldier, captain of a vessel, proprietor of a theater, contractor, stone-merchant, and piano-forte manufacturer. By the time he attains his climacteric, he may have exhausted all the professions and tried every trade.[1]

With the proliferation of new cities during the 1830s and 1840s many single men and women moved to boardinghouses or hotels in order to be closer to their places of employment. Social critics found this variation on family life a great menace to the future of the country. They deplored both the increase in drinking and the increase in prostitution.

One disgruntled patron of a hotel dining room in New York during the 1830s, complained,

The dressed dishes were decidedly bad, the sauces being composed of little else than liquid grease, which to a person like myself, who have an inherent detestation of every modification of oleaginous matter, was an objection altogether insuperable . . . Brandy bottles were ranged at intervals along the table, from which each guest helped himself as he thought proper. As the dinner advanced, the party rapidly diminished . . . Though brandy was the prevailing beverage, there were many also who drank wine, and a small knot of three or four . . . were still continuing the carousal when I left the apartment.[2]

Most American men who were not "Bible lovers" on occasion tipped the bottle. Mrs. Frances Trollope later recalled that on her trip in America she "heard it said by American ladies, that the hours of greatest enjoyment to the gentlemen were those in which a glass of gin, cock-tail, or egg-nog, receives its highest relish from the absence of all restraint whatever; and when there were no ladies to trouble them." [3]

The manufacture of firearms provided a significant impetus to the development of America. Factories specialized in the manufacture of interchangeable parts. This idea appears to have been devised by Eli Whitney (1765–1825) at New Haven, Connecticut, and fostered through government requirements and private contractors.

By the mid-nineteenth century hunting was generally pursued as a sport in the East. On the western frontier shooting also represented a form of amusement. *Shooting for the Beef*, painted by George Caleb Bingham (1811–1879), records a frequent western test of skill. Edmund Flagg, an eastern visitor to the frontier, described a shooting match, "The regulations I found to be chiefly these: A bulls' eye, with a centre nail, stands at a distance variously of from forty to seventy yards, and those five who, at the close of the contest, have most frequently driven the nail, are entitled to a fat ox divided into five portions." [4]

For the Victorian hunter, advancements in technology provided new and better firearms. The Pennsylvania or "Kentucky" rifle had reached its peak of development in the two decades following the American Revolution. It continued in general use until about 1835 when it was superseded by the heavy-barrel, half-stock plains rifle of the Hawken type and by other inexpensive substitutes reaching the marketplace just prior to the Civil War.

Crude, homemade powder horns were replaced by handsome metal powder flasks. Not only were they easier to carry, but they kept the powder dry even on rainy days because they were fitted with caps that screwed securely into place.

Just prior to 1880 President Timothy Dwight (1826–1916) of Yale College observed: "In both New England, and New York *every man is permitted,* and in some, if not all the States, *is required to possess fire arms.*" [5] Perhaps this was for personal safety in an era of limited police protection.

At the same time almost every fashionable gentleman of means could boast of owning a hunting lodge or at least possessing membership in a socially respectable hunt club. Trophy rooms, jammed full of stuffed heads, and furniture fashioned from animal antlers and horns became status symbols. By the late nineteenth century, fox hunting had been all but abandoned for duck shooting.

Harper's Weekly in 1882 related one major hazard for any hunter. He could be "driven mad from listening year after year to the same stories told over and over again by his partner." [6]

Like American sporting guns, the fly-fishing rod of the nineteenth century set a world standard that even modern technology has been hard-pressed to better. Most early fishermen required no more than a pole cut from the limb of a tree, string, a sinker and a hook, and bait. There were wooden-pole manu-

facturers of distinction by 1860, and their elegant handcrafted products were sold by such firms as Andrew Clerk, J. P. Crook, and Conroy in New York City and Bradford and Anthony in Boston.

Just after the Civil War, the split-bamboo rod was introduced and by 1880 it dominated the fishing-rod industry. Bamboo rods were not easy to fashion. A. G. Wilkinson in 1876 described the process: "In making a rod, some ten or twelve feet of the butt of the cane is sawed off and split into thin pieces or strands. These pieces are then beveled on each side so that when fitted together they form a solid rod . . . The six or twelve strips, as required, being worked out, and each part carefully tested throughout its entire length by a gauge, are ready for gluing together, a process requiring great care and skill." [7]

Old or worn-out fishing rods should not be discarded advised Mrs. J. M. S. Holden in the 1884 publication, *Our Homes and Their Adornments*, "Bamboo screens and easels are very popular. We have known them to be made from fishing rods, but suppose the bamboo must now be imported on purpose." [8]

The craze for fishing and hunting in the Late Victorian period created renewed interest in trophy pictures and naturalistic representations of animals in outdoor settings.

Just as hand-carved and finally factory-manufactured wooden decoys were used by duck hunters, fish decoys were used for the same purpose by ice fishermen in the Great Lakes area. A hole was drilled in the ice and a wooden shanty moved over it. A carved wooden fish with metal or leather fins and a lead-weighted stomach was suspended through the hole on a line. When a curious fish swam by to investigate the decoy, the fisherman attempted to spear it. Hand-carved fish decoys were used during the last half of the nineteenth and first half of the twentieth century until they were replaced by machine-manufactured lures.

Most Victorians ultimately came to believe that progress was the process of continual refinement made possible by technological advancements during their age. Education, taste, culture—all had emerged from a primitive state. Adequate personal hygiene, in cities at least, became possible. Separate heated bathrooms with running water allowed bathing in comfort and complete privacy for the first time.

The Victorian gentleman's concern with fashion gave rise to elegant haberdasheries, which offered expensive clothing, and new "Hair Dressing Establishments," where each regular customer could have his own shaving mug. Salons like Phalon's, located in the St. Nicholas Hotel in New York City between 1845 and 1885, were undoubtedly the prototype for less pretentious tonsorial studios across the nation. Phalon's boasted "The washstand, with its statuary, costs $1,500. The marble floor $1,500. The magnificent shaving chairs $100 each, 15 in number, and the silver toilet services about $2,500. [The establishment] is as great a lion in its way as the palace of St. Mark in Venice." [9]

By 1887 *"Cups with labels*—Imported from France . . ." were offered by Henry Ard & Bros., Saint Louis, Missouri, who advertised, ". . . Have engaged first class artists to execute the designs of labels. Prices 75¢ to $3.00." [10]

Blank mugs arrived from Bavaria and France from the 1860s through the Gay Nineties. They were generally decorated by American artists who specialized in the craft and would personalize a mug upon request either by indicating the profession of its owner through the representation of appropriate work-oriented symbols or by lettering his name.

Maurice Francis Egan (1852–1924), in a revealing recollection of the late nineteenth century, commented on the popular use of spittoons by tobacco-chewing gentlemen. "There was in the seventies a dreadful parlour ornament—nobody spoke of drawing-rooms then—called a 'tazza.' It was a kind of ornamental bowl described as of Parian marble or of alabaster. People who possessed a tazza had been 'abroad' or some of their immediate family had been abroad, and they always despised the Rogers groups." [11]

Despite many fulminations against the dangers of tobacco, ever since the mid-seventeenth century it supported an aristocracy living on large plantations in the South. Even King James of England found the use of tobacco "A custome lothsome to the eye, hatefull to the Nose, harmefull to the Braine, daungerous to the Lungs, and in the blacke stinking fume thereof, neerest resembling the horrible Stigian smoke of the pit that is bottomelesse." [12]

Zealous temperance societies took up the cry where King James left off. With evangelical fervor, they condemned not only liquor but tobacco and gambling as well. Others so abhorred tobacco that they agitated for societies solely directed against its use. A letter to the editor of the *Cincinnati Mirror* in 1833 succinctly expressed feminine reaction to users of the weed:

Mr. Editor:—Are you a *tobacco-chewer?*—I know you are not, for I took the trouble to ascertain before I seated myself at my desk. Is it not a most abominable practice? . . . This has been called the "age of improvements," the "age of novels," the "age of lectures," &c. For my part, I think it is more especially the *age of tobacco-chewers,* than of any thing else. If a lady meet a cousin in the street, and have a question to ask him, before he can answer, out must come a black mass of the noxious weed, large enough to scent the air for a rod around. Again, if one takes a gentleman's arm for a short evening stroll, and there happens to be a slight breeze, ten to one if she don't the next day find the skirt of her dress as completely bespattered and besprinkled, as if she had been caught in a shower of tobacco juice. And if a lady be seated in the theatre by the side of one of these inveterate *chewers,* every time he addresses a word to her, her olfactories meet with such a salutation as will set her to dreaming of any thing but the aromatic flowers of Paradise. A few months since, a gentleman whom from his external appearance you would suppose to have never looked upon a tobacco-stem without shuddering, drew his chair close up to mine, and while he was asking my company at any approaching Ball at the Bazaar, he was also actually cutting a mouthful of the vile stuff from a "plug" which he had just taken from his pocket. You may be sure, Mr. Editor, that I had a "previous engagement elsewhere," for that evening . . . The particular object

of this epistle, is to recommend to the ladies of this city, the formation among themselves of a Society for the suppression of Tobacco-chewing . . .[13]

In spite of such social agitation the popularity of tobacco continued to grow, and after the Civil War its consumption became a national habit. In nearly every town at least one tobacconist, identified by a cigar store Indian or other trade figure, offered tobacco and smoking supplies including pipes, cigars, snuff and, by 1880, cigarettes.

Inside such stores cigar lighters stood on counter tops for the convenience of customers. Some were fueled by gas, others by burning fluids. Fashionable gentlemen often incorporated "smoking dens" into the design of their homes, and ladies were rarely admitted therein. By 1896, however, "ladies in the smart sets" were not above a gracious puff. Many even carried "gold cigarette-cases . . . always within reach of the fair smoker's hand." [14]

Victorian men on occasion found time for hobbies in their busy lives. Sorrento work or scroll-sawed home decorations provided one outlet for artistic expression during the 1880s and later. Promoters of pattern books suggested that such articles might even be a source of extra income: "very desirable articles can be made for Fairs, etc., which will sell quickly and at a good profit . . ." [15]

More ambitious outdoor types turned to gardening and beekeeping. Nurseries sprang up everywhere to supply nineteenth-century green thumbs with exotic specimens. Amateur horticulturists and landscape gardeners, after reading A. J. Downing's (1815–1852) many treatises, cultivated "picturesque settings" that included close-cropped, neatly trimmed lawns for their "picturesque homes."

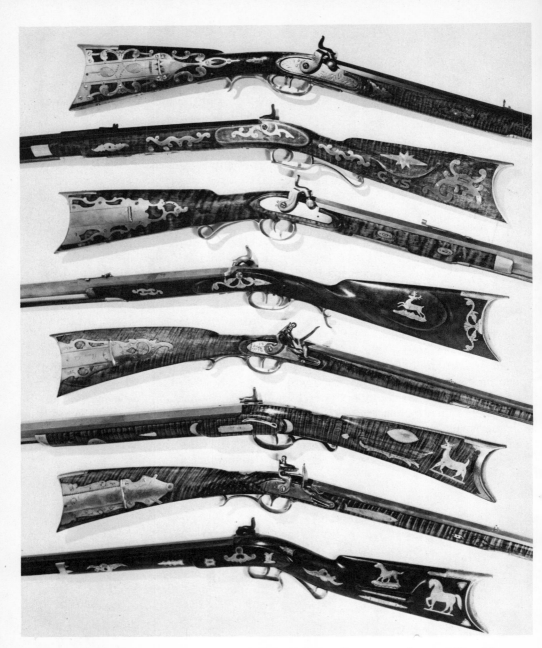

351 (above). Collection of Pennsylvania or "Kentucky" rifles. *Top to bottom:* 50-caliber percussion rifle; lock marked "George W. Tryon, Philadelphia"; curly maple stock; ornate patch box. 32-caliber half-stock percussion rifle; unusually light, possibly used by a woman or a boy; c. 1855. Heavy target rifle; octagonal barrel; brass trim; peep sight; curly maple frame; box base; c. 1815. 45-caliber Pennsylvania-type percussion rifle; octagonal barrel; German silver ornamentation; patch box; lock marked "T. Lovell"; c. 1840. Flintlock rifle; curly maple stock with brass ornamentation; lock marked "Edmunds—Warranted"; c. 1820. Percussion rifle; curly maple stock with German silver ornamentation; patch box; octagonal barrel; c. 1820. Flintlock rifle; curly maple stock; octagonal barrel; brass ornamentation; patch box; peep sight; lock made by Ketland and Company; c. 1825. 50-caliber, half-stock percussion target rifle; German silver inlay; c. 1870. (Greenfield Village and Henry Ford Museum)

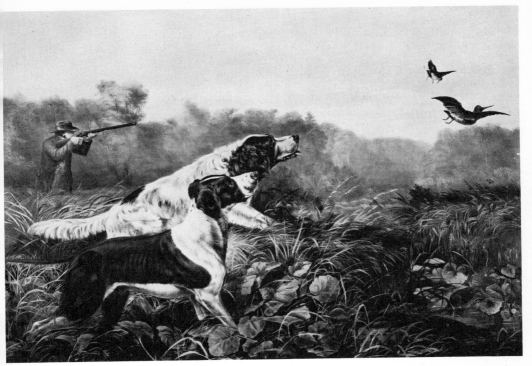

352 (above). *A Chance for Both Barrels.* 1857. Lithograph published by Currier & Ives, New York City. Based on a painting by A. F. Tait and engraved on stone by Ch. Parsons. 18½″ x 26¾″. Prints by the Currier & Ives firm are among the most popular with American collectors. (Kenneth M. Newman, The Old Print Shop)

353 (right). Cased set of revolvers made by Colt Firearms Company, Hartford, Connecticut. 1865. L. of revolvers 14″. The metal powder flask is embossed with a military trophy design that includes two crossed long guns and two crossed pistols, as well as flags and a cannon. The two packages of cartridges are marked "Pressed waterproof/cartridges for Colt's Army Pistol/Patented March 18, 1862/Manufactured by the/Hazard Powder Co./Hazardville, Conn." (Greenfield Village and Henry Ford Museum)

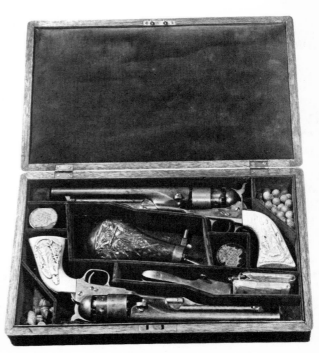

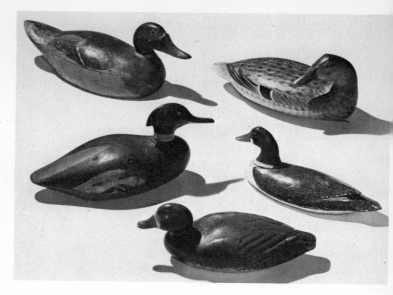

354 (right). Group of carved wooden decoys used as confidence lures in duck hunting. Late nineteenth and early twentieth century. L. of decoy at top, right, 14″. The quality of carving on a decoy greatly affects its market value. Those with original paint are considered much more desirable than those that have been repainted. (Greenfield Village and Henry Ford Museum)

355 (below). General's Sitting Room in The Historic General Dodge House, Council Bluffs, Iowa. c. 1870. This is a handsome, comfortable den. (The Historic General Dodge House)

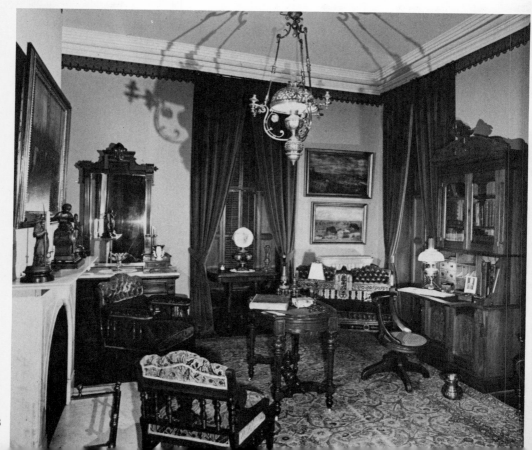

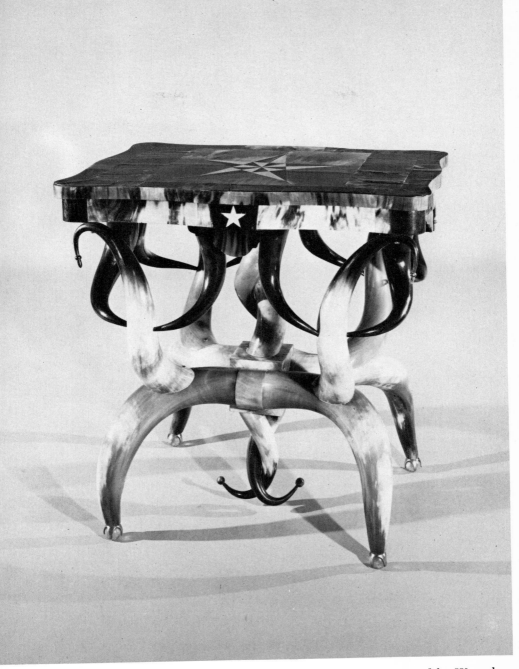

356 (above). Center table made from horn and horn veneer. Manufactured by Wenzel Friedrich, San Antonio, Texas. c. 1885. The Friedrich catalogue describes this piece as, "No. 12. Fancy Horn Veneered Center Table. This table contains 20 horns, size of top 19 x 27 inches. The entire frame work is horn veneered; special care taken in selecting veneering to make the top very attractive. All horn veneer in its natural color; price $225.00." (San Antonio Museum Association; The Gertrude and Richard Friedrich Collection)

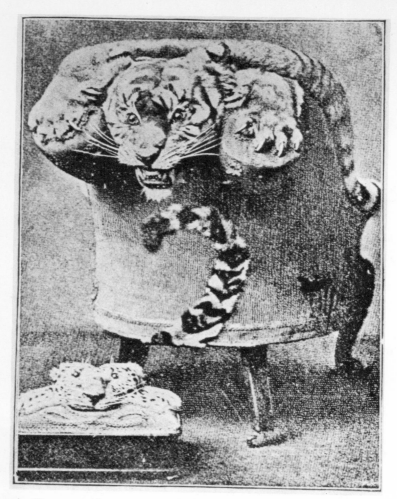

357 (above). Illustration from the *The Decorator and Furnisher*, November 18, 1896. This exotic chair, made from a tiger skin, accompanied the article, "A Curious and Interesting Fad in Furniture." Late Victorians loved furniture that displayed their prowess as hunters. (Private collection)

358 (below). Belt knife and scabbard made by Samuel Bell, San Antonio, Texas. c. 1855. Silver and steel. L. 14¼". The silver hilt has a concave, chamfered grip and a flared pommel attached to a single-edged, tempered steel blade. The scabbard is decorated with stylized engraving. (San Antonio Museum Association; Lent by Mr. and Mrs. P. H. Swearingen; photograph courtesy *Antique Monthly*)

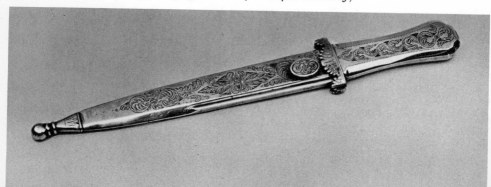

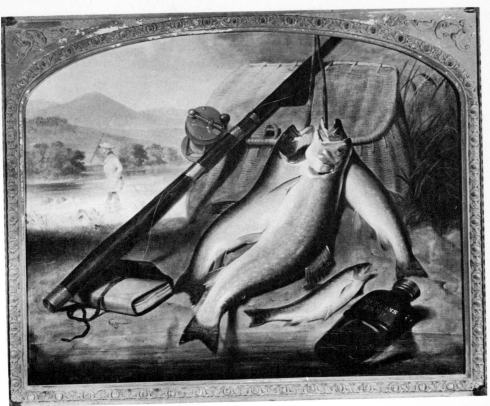

359 (above). *Still Life with Fish and Fishing Tackle* by Junius Brutus Stearns. 1853. Oil on canvas. 22″ x 33″. During the Victorian period fishing became a sport for many. (The Toledo Museum of Art)

360 (below). Fishing rods. *Top to bottom:* Four-strip, round-planed rod, c. 1870. Six-strip rod with rattan handgrip by H. L. Leonard, 1885–1890. Six-strip rod with rattan handgrip by Thomas H. Chubb, c. 1890. Solid-wood rod with celluloid handle sold by Abbey and Imbrie, c. 1885. (Adirondack Museum)

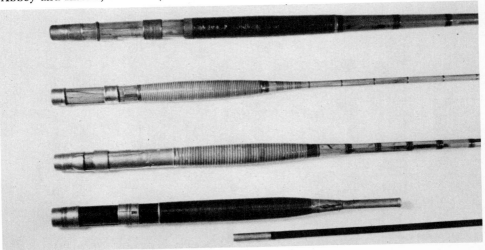

361 (right). Fish decoys. Late nineteenth century. Carved wood with tin fins and lead stomachs. L. of smallest fish 4½". Handmade fish decoys were used during the nineteenth and first half of the twentieth century almost exclusively in the Great Lakes area. Decoys vary in size from just a few inches in length to examples that are over four feet long. (Private collection)

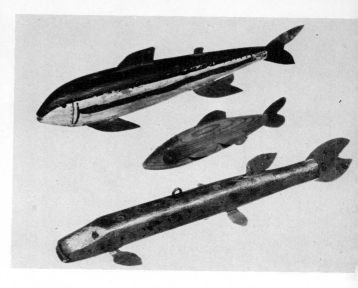

362 (below, left). Wooden barber pole in a twisted rope design. 1850–1875. H. 54⅜6". Since many barbers practiced light surgery, the barber pole was traditionally painted red and white—symbolizing a bound wound. (Greenfield Village and Henry Ford Museum)

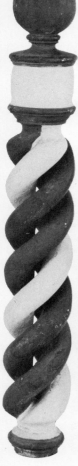

363 (below, right). Illustration of Phalon's "Hair Dressing Establishment" located in the St. Nicholas Hotel, New York City, from a broadside published by R. F. Habel. c. 1845. The Phalon establishment was one of the grandest barber shops between 1845 and 1850. (The New York Public Library)

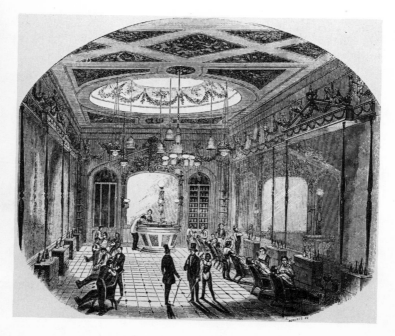

364 (above). Interior of the Charles Fowler Barber Shop in the Street of Shops at the Henry Ford Museum. The barber chair, with the attached footrest, was made by the Archer Manufacturing Company, Rochester, New York, c. 1880. Its front posts have carved swan's-head terminals. The chair on the left is of the arrow-back type and is painted. Both have adjustable headrests. On the shelves over the counter several shaving mugs are arranged. Most regular customers purchased a shaving mug and left it at the barbershop so that each time they returned it would be available. The familiar potbellied stove used to heat such establishments is visible in the mirror at the left. (Greenfield Village and Henry Ford Museum)

365 (right). Wooden shop sign of Joe Short. 1850–1875. (Greenfield Village and Henry Ford Museum)

366 (above, right). Shaving stand. c. 1880. Walnut. This elegant stand is fitted with a vertical, tilting mirror. The stepped top is hinged and opens to a storage compartment. The semicircular apron across the front is decorated with beading and carved leafage-and-shell decoration on a punched ground. (Greenfield Village and Henry Ford Museum)

367 (below). Painting of Fire Engine on Broad Street, Elizabeth, New Jersey, by E. Opper. c. 1889. Oil on canvas. W. 48″. Behind the elaborate firefighting equipment is the firm of J. Engel the Clothier. Most men of means had their suits and coats tailored. Few patronized the ready-to-wear clothing establishments. (Museum of Art, Rhode Island School of Design)

368 (left). Snuff jars, bottles, and carrying boxes, including a large stoneware container from the firm of Charles Sweetster & Sons, Saugus, Massachusetts. c. 1879. H. 9½". Snuff is a preparation of finely pulverized tobacco that can be drawn up into the nostrils by inhaling. The two brass boxes on the left are typical of the often highly decorative containers with hinged lids that were used for carrying snuff in the pocket. The two round boxes on the right have removable covers. (Greenfield Village and Henry Ford Museum)

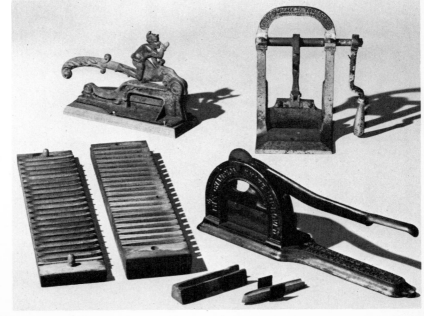

369 (right). Cast-iron and steel cigar formers and plug tobacco cutters. 1875–1900. Hundreds of firms manufactured cigar cutters. The amusing example at the top left is decorative as well as utilitarian. L. 13". (Greenfield Village and Henry Ford Museum)

370 (below, left). This fancy case is labeled "Segars" on the other side. One can only speculate as to its origin: door prize at a brothel, perhaps? (America Hurrah Antiques, N.Y.C.)

371 (right). Cigar Store Indian carved by Arnold and Peter Ruef, Tiffin, Ohio. c. 1880. Wood. H. 87". This figure, known as "Seneca John," was created in the Ruef shop at 294 South Washington Street, Tiffin. (Greenfield Village and Henry Ford Museum)

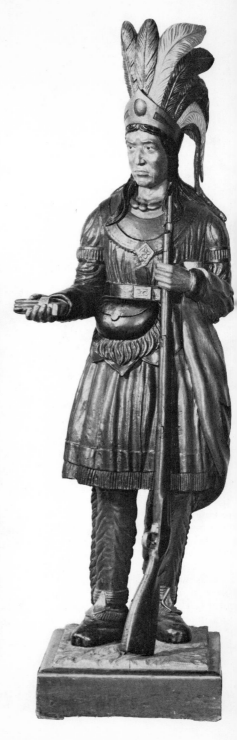

296

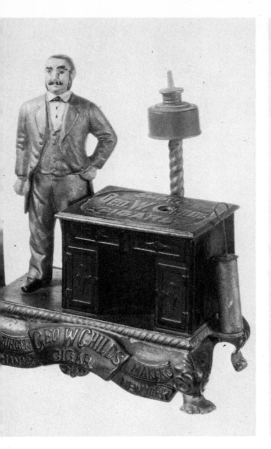

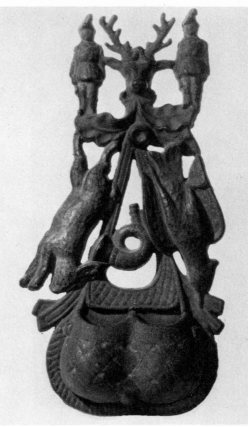

372 (above, left). Cigar lighter made by Harburger Homan & Co., New York, for the George W. Childs Cigar Company. c. 1877. H. 11″. These amusing pieces were designed to sit on the counters of tobacco shops. (Greenfield Village and Henry Ford Museum)

373 (above, right). Cast-iron match holder. c. 1880. H. 11″. After 1860 "trophy" designs were popular on furniture as well as for decorative accessories. The grooves in the pouch made it easier to strike a match. (Greenfield Village and Henry Ford Museum)

374 (left). Meerschaum pipe. Australia? 1875–1900. L. 6″. Meerschaums were especially popular with American gentlemen. This barrel-shaped, cream-colored pipe bowl is decorated with a carved vixen and her cub devouring a goose. (Greenfield Village and Henry Ford Museum)

375 (left). Stickpins. *Left to right:* Gold nugget mined near Placerville, Colorado, in 1850 by the grandfather of the owner; shell cameo, c. 1870, H. of stone 1"; amethyst, c. 1870; gold knot with diamond, c. 1890; portrait stickpin, c. 1890. (Private collection)

376 (below). Watch fobs. Early twentieth century. *Left,* gold-filled; *right,* silver, L. 4". The watch was attached to the clasp at the end of the chain. The fob was worn outside of the man's trousers; the watch fit snugly into a watch pocket that had been tailored into the trousers. (Private collection)

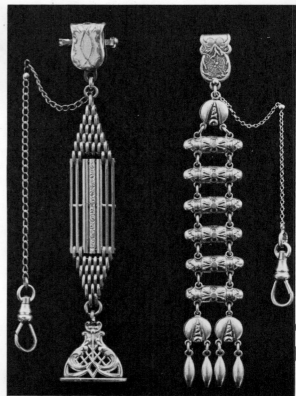

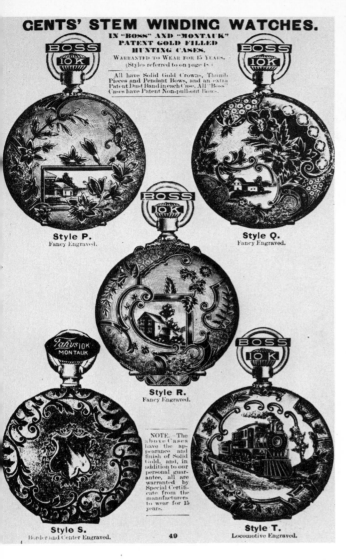

GENTS' STEM WINDING WATCHES.

IN "BOSS" AND "MONTAUK"
PATENT GOLD FILLED
HUNTING CASES.

WARRANTED TO WEAR FOR 15 YEARS.
(Styles referred to on page 48.)

All have Solid Gold Crowns, Thumb
Pieces and Pendant Bows, and an extra
Patent Dust Band in each Case. All "Boss"
Cases have Patent Non-pull-out Bows.

Style P.
Fancy Engraved.

Style Q.
Fancy Engraved.

Style R.
Fancy Engraved.

NOTE.—The
above Cases
have the ap-
pearance and
finish of Solid
Gold, and, in
addition to our
personal guar-
antee, all are
warranted by
Special Certifi-
cate from the
manufacturers
to wear for 15
years.

Style S.
Border and Center Engraved.

49

Style T.
Locomotive Engraved.

377 (left). Illustration from a sales catalogue of E. V. Roddin & Co., Chicago, Illinois. 1895. Style P. "'Elgin,' 7 jewels, chronometer balance and straight line escapement, in 'Boss' Patent Gold Filled Hunting Case, $28.00." Style T. "'Crescent Street' (Waltham), Fine Nickel Movement, 17 jewels, 4 pairs in gold settings, chronometer balance, patent regulator, double sunk dial, hardened Breguet hair spring, adjusted to heat, cold and position, in 'Boss' Patent Gold Filled Hunting Case, $68.00." (Private collection)

378 (right). Buff earthenware spittoon made by the American Pottery Co., Jersey City, New Jersey. c. 1840. Diam. 7�5⁄16". Gothic motifs including pointed arch arcades, quatrefoils, and crockets embellish this utilitarian piece. Maurice Francis Egan in *Recollections of a Happy Life* lamented that in Washington, D.C., during the Victorian period, "there were very few houses in which the spittoon was not regarded as a convenience, though sometimes not produced until asked for." [1] (Greenfield Village and Henry Ford Museum)

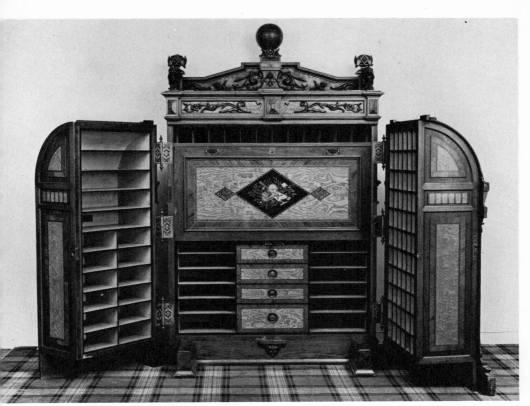

379 (opposite, above). Wooton patent secretary manufactured by W. Wooton, Indianapolis, Indiana. 1874. Walnut, burl walnut and satinwood. H. 80". Mr. Wooton, a Quaker minister, designed and built some of the most elaborate Victorian desks ever made. His advertisements stated that while seated at one of his desks, you could reach as many as 110 compartments without moving or swiveling your chair. Usually, the entire desk locked with a single key, and the lock was of a patent bank-lock type. Nearly all of the Wooton pieces are of exceptional design, and the quality of construction elevates them far above the products of competitors. The detail photographs show the beauty of the inlay work on the large panel inside the desk and the elaborate hinges for the side compartments. Plate 18 shows a Wooton desk made as a presentation piece for Queen Victoria. (Eileen Dubrow Antiques)

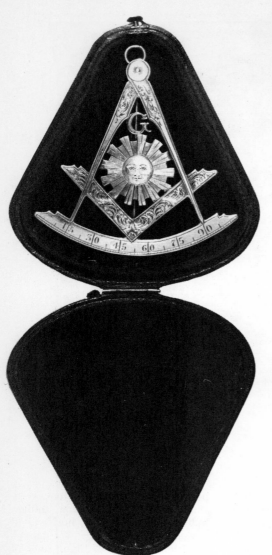

380 (left). Gold Masonic pin. c. 1855. H. 2¼". Presented by the Mt. Tabor Lodge, East Boston, Massachusetts, to Worshipful Brother Samuel L. Fowle who was elected Master in November 1855. The Masonic Lodge was one of the most popular fraternal organizations during the Victorian period. (Greenfield Village and Henry Ford Museum)

381 (right). Advertisement by Henry T. Williams, publisher, 46 Beekman Street, New York. c. 1890. Williams specialized in publishing ornamental designs for fretwork and scroll sawing. This immensely popular pastime preoccupied many a Victorian do-it-yourself type. (Private collection)

ORNAMENTAL DESIGNS
—FOR—
Fret-Work, Scroll Sawing, Fancy Carving
—AND—
HOME DECORATIONS.

Fret-Sawing has become an art of such wonderful popularity that the interest in it has shared by both amateurs and professionals to an astonishing extent. Hundreds are earning sums of pocket-money by cutting these beautiful household ornaments, and selling friends or acquaintances, or at the art stores.

Ladies and the Young Folks find in it a fasc recreation, and are making dozens of fancy at small cost, to decorate their homes in a ch manner, or to give as Holiday Presents to friend following books contain mechanical design size for immediate use, and are invaluable alike amateurs, ladies, young folks, mechanics, arc and all of professional skill.

PART 1 contains full size designs for Frames, Small Brackets, Book Racks, Fancy and Figures, Ornaments, Wall Pockets, etc. patterns worth at usual prices over $8.) Price, post-paid by mail.

PART 2 is devoted exclusively to designs of B of medium to large size, all entirely new, and most tasteful detail and execution. (Contains plans, worth at least $15.) Price $1.00, by mail paid.

PART 3 is devoted to Fancy Work, Ladies' Baskets, Easels, Crosses, Match Boxes, Pen Paper Cutters, Calendar Frames, Thermometer Watch Pockets, Fruit Baskets, Table Platter Nearly 100 designs, many of them really exce Price, $1.

The above books contain over 300 patterns, tifully printed in blue color. These books only ones yet issued in the U. S. The patte mostly original, designed expressly for these and in execution, choice selection, taste, che they may be safely esteemed the best collecti produced! The whole series of three costing but $2.75, contains upwards of 300 patterns, at usual values over $30. All sent post-paid by mail, on receipt of price.

Bracket and Fret Saw.

With this Bracket Saw, the designs and direction desirable articles can be made for Fairs, etc., while sell quickly and at a good profit. With it you car beautiful articles for presentation gifts. With it y help beautify your homes. With it you can make To parents desiring a USEFUL GIFT for their childr would call attention to this Bracket and Fret Saw. not only affords great pleasure, but it helps to culti mechanical taste.

Price with 25 bracket and ornamental designs, 6 l saw blades, also full directions for use. Sent by m $1.25.

Address HENRY T. WILLIAMS, Publisher,
46 Beekman Street, New

Part 4, Price 50 Cents.—A new book of Fret Saw designs, containing many tastef terns, entirely new and of special elegance, is now in press, and will be issued early in Octo

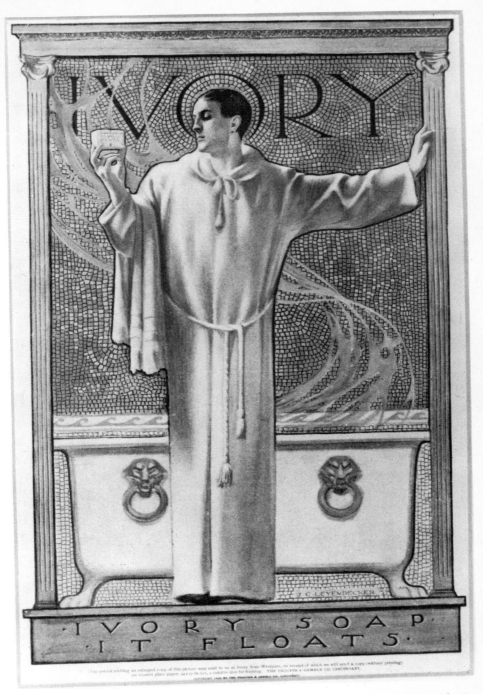

382 (above). Advertisement for Ivory Soap published by the Procter and Gamble Company, Cincinnati, Ohio. 1900. H. 16″. During the Victorian era many American firms used giveaways to promote their products. J. Leyendecker created this Art Nouveau–inspired design that was first issued as an advertisement. Customers could obtain a large-size poster by mailing twenty Ivory Soap labels to the firm. (Private collection)

383 (above). Interior of the Isabelle Bradley Millinery Shop, Street of Shops, Henry Ford Museum. Dresses, hats, hatpins, dress forms, and bustles are featured together with early Victorian furniture. The Lord & Taylor Clothing and Furnishings catalogue for 1881 illustrated simple walking dresses made from navy blue cloth at $12 and ranged to a white brocade and *satin-de-Lyon* bridal dress for $200. (Greenfield Village and Henry Ford Museum)

WOMAN'S WORLD

Women contributed vitally to the success of the early Colonies. In recognition of their valiant efforts, the Virginia legislature, soon after its first meeting, decided to award grants of land to women as well as to men.

Although women were denied the privilege of voting until 1920, during the seventeenth and much of the eighteenth centuries they, on occasion, acquired independence and self-reliance. Women spoke for themselves in courts of law, ran printshops and newspapers, inns and schools, practiced the medical profession, and even supervised plantations.

During the Federal period, immediately following the Revolution, this attitude began to change in urban areas, although it continued in rural communities. Many city women were encouraged by wealthy and prominent husbands to pursue a life of luxury that included aping English and Continental fashions.

By the 1830s the inadequacy of women's education was generally a favorite topic with public speakers. Many men desired a more complete education for women because they felt that the educated woman would make a more interesting wife and a better mother. Between 1830 and 1860 several new colleges, seminaries, and academies, especially for the education of women, were founded. At many of these institutions, however, the level of instruction left much to be desired. The instruction given by Miss Titcomb in 1869 were perhaps typical. She "exercised a general supervision over the manners, morals, and health of the young ladies connected with the institution, taught history and geography, and also gave special attention to female accomplishments. These, so far as I could observe, consisted largely in embroidering mourning pieces, with a family monument in the center, a green ground worked in chenille and floss silk, with an exuberant willow-tree, and a number of weeping mourners, whose faces were often concealed by flowing pocket handkerchiefs." [1]

Other educational facilities developed women's capabilities more fully. *Godey's Lady's Book* in 1876 observed:

The students of Wellesley [Ladies'] College, Mass., have a "fire department" of their own. The object is not merely to provide for the safety of this college, but to familiarize the students with the best modes of extinguishing fires. Twenty hand-pumps are distributed through the college building, each supplemented by six pails, kept always full of water. Every pump has its company of seven girls, one of whom is captain, and another lieutenant. All the companies are drilled at convenient times in handling the pumps, forming lines, and passing the pails. The whole department is directed by a superintendent and a secretary. There are also hose companies, organized in a similar manner, for operating the great steam fire-engine. The idea seems an excellent one. Many seminaries for young men

have no such organization as this, and they will do well to take pattern by Wellesley College.[2]

In highly organized Victorian society the educated woman frequently attached herself to one or more of the various reform movements. She agitated for abolition and the freedom of the slaves, she marched for temperance, and she zealously fought for women's rights in an attempt to better her legal status. Because of the efforts of women like Harriet Beecher Stowe (1811–1896) and Sarah Grimké (1792–1873), the course of American history was greatly altered. Although Mrs. Stowe and her sister Catharine (1800–1878) were modern women in nearly every sense of the word, they realized that the role of the American woman was being drastically altered. Like many Victorians, they lamented the passing of the simpler eighteenth century. In their popular manual for successful living, *The American Woman's Home; or Principles of Domestic Science; being a Guide to the Formation and Maintenance of Economical, Healthful, Beautiful, and Christian Homes,* they wrote,

> Then were to be seen families of daughters, handsome, strong women, rising each day to their in-door work with cheerful alertness—one to sweep the room, another to make the fire, while a third prepared the breakfast for the father and brothers who were going out to manly labor; and they chatted meanwhile of books, studies, embroidery; discussed the last new poem, or some historical topic started by graver reading, or perhaps a rural ball that was to come off next week. They spun with the book tied to the distaff; they wove; they did all manner of fine needle-work; they made lace, painted flowers, and in short, in the boundless consciousness of activity, invention, and perfect health, set themselves to any work they had ever read or thought of. A bride in those days was married with sheets and tablecloths of her own weaving, with counterpanes and toilet-covers wrought in divers embroidery by her own and her sisters' hands. The amount of fancy-work done in our days by girls who have nothing else to do, will not equal what was done by these who performed, beside, among them, the whole work of the family.[3]

The prominent early feminist agitators, Lucretia Mott, Martha C. Wright, Elizabeth Cady Stanton, and Mary Ann McClintock, called a Woman's Rights Convention in 1848 that proved to be a prototype for modern-day women's liberation efforts. Their purpose: "a convention to discuss the social, civil, and religious condition and rights of woman." [4] They gathered at Seneca Falls, New York, on July 19, and only women were allowed to attend the initial meeting. On the following day the general public was invited to hear lectures by the free-thinking Quaker housewife, Mrs. Mott, and other supporters of the cause.

The popular press failed to encourage such novel activities. Newspapers across the country questioned the propriety of even holding a woman's convention and on frequent occasions branded its leaders "sour old maids" and "child-

less prunes." The ladies persevered. Their "Declaration of Sentiments" included such revolutionary concepts as: "All men and women are created equal; that they are endowed by their Creator with certain inalienable rights, that among these are life, liberty, and the pursuit of happiness; that to secure these rights governments are instituted, deriving their just powers from the consent of the governed . . ." [5]

Many women saw their sisters' liberation efforts as the result of hysterical, warped minds. No critic was perhaps as adamant and forceful in her attempts to discourage the movement as England's Victoria. With horrified indignation she encouraged women in both England and America "to join in checking this mad, wicked folly of Woman's Rights on which my poor sex is bent, forgetting every sense of womanly feeling and propriety." [6]

While the educated, liberated Victorian woman struggled for social justice and political equality, most of her more conservative sisters either shared the male scorn for her brashness or simply did not understand or care about the "causes."

To be sure, the industrialization of the North caused many young girls and women to leave home and attempt to earn a living in the mills. Still, most women were content to be wives and mothers, each in her own way judging her success by the success of her husband and family. For the "stay at home" woman, cooking, cleaning, sewing, and other domestic arts occupied a major segment of her time. Those who were fortunate enough to "have help" developed an interest in reading and some even began to write immensely popular romances or do-it-yourself, self-improvement books.

The up-to-date city fashions were made available to women everywhere through periodicals similar to *Godey's Lady's Book,* which in 1841 carried a publisher's notice, "From Maine to the Rocky Mountains there is scarcely a hamlet, however inconsiderable, where it [the publication] is not received and read; and in the larger towns and cities, it is universally distributed . . . Both as regards its literary and its ornamental departments, we are satisfied it will be superior to any competitor . . ." [7]

Although contributions made by women were acknowledged at both the New York World's Fair at the Crystal Palace in 1853 and the Philadelphia Centennial Exposition in 1876, the Woman's Building at the World's Columbian Exposition in Chicago in 1893 culminated nineteenth-century feminine efforts to draw attention to achievements in nearly every field of endeavor. Fourteen women architects submitted plans for the Woman's Building, and those by Miss Sophia G. Hayden of Boston were accepted. The Woman's Building, over 400 feet long and some 200 feet deep, was executed at a cost of $138,000, all raised by women. The main floor of the two-storied structure contained a model hospital, a model kindergarten, a retrospective exhibit, and an area devoted to reform work and charity organizations; the second floor, ladies' parlors, dressing rooms, committee rooms, a giant assembly and club room, a model kitchen, refreshment rooms, and as a special attraction, a library that contained books written by women.

The acknowledged queen of the Exposition, world-famous Chicago social-ite, Mrs. Potter Palmer, was elected Lady President of the Fair. Displays fea-tured European as well as domestic exhibits of special interest. The Cincinnati Room, furnished as a model nineteenth-century drawing room, caused much comment: "The artistic work is all done by women. The design and execution of the frieze-work is by Miss Agnes Pitkin of Cincinnati, assisted by Miss Eva Stearnes and Miss Mary Tiwett. It is fully six feet wide; the tower design is a conventional scroll of buckeye in shaded reds . . . There is also a large quantity of bric-a-brac, and some very fine china." [8]

The women from Kentucky installed The Colonial Parlor, a gold and white Colonial Revival extravaganza containing historical records and souvenirs. The New York Room also inspired praise. Upon entering, ". . . one soon becomes impressed with the culture and diverse intelligence of the American woman; no subject seems to have been too difficult for her to grapple; astronomy, art, science in every branch, even architecture and theology have not come amiss to her omnivorous genius . . ." [9]

Women finally began to enter the commercial world. Dr. Lyman Abbott (1835–1922), writing about the new occupations of women in 1896, reported:

Two Boston girls, both graduates of a college, are said to have earned four thousand dollars last year by the sale of the old-fashioned furniture, and-irons, candlesticks, clocks, and china that they picked up in a six months' tour through some parts of New England not over-run with collectors. They fitted out a shop with the proceeds of their trip. Bureaux and sideboards, for which they paid ten dollars apiece in villages not two hundred miles from Boston, sold for ten times that amount when polished up and put in a window of a Boston bric-a-brac shop. [10]

Ambitious Victorian women continued to practice the age-old artful tech-niques of employing their physical attractiveness to further the careers of their husbands. Maurice Francis Egan (1852–1924) recalled the social customs in the nation's capital during the late nineteenth century:

One could generally tell whether the wife of a Congressman was newly arrived or not. If she had been in Washington only six months, her dress was high and seemed to be of thick silk with abundant skirts and velvet trimmings; if she had been in Washington for two years, something like a V-shaped corsage might be discerned. You knew that her husband had been a Senator or a Representative for four years at least when she ap-peared in a low-cut gown rather loose at the shoulders. Consequently, a hostess seldom made a mistake when she gave precedence to the woman with the lowest gown; she was almost certain, as rank was arranged accord-ing to the date of the election, to have the right to go before any of her political sisters. [11]

During the Victorian period the increase in mass production in America produced a seemingly endless array of gadgets and improvements designed to make the housewife's daily tasks lighter. In 1803 the first patent for an apple parer was granted to Moses Coates of Downing's Field, Pennsylvania. By 1837 cast-metal parers, cherry pitters, meat grinders, coffee mills, vegetable cutters, sausage cutters and stuffers, and even ingenious washing machines flooded the marketplace. "Improved" kitchen equipment continued to appear in such uncontrolled abundance that in 1845 one bewildered observer, after a visit to Windle's Furnishing Shop at Maiden Lane, Philadelphia, where he spent over an hour marveling at the household conveniences, recorded:

I asked for a catalogue of the shop's wares. A pamphlet of twenty-one pages was handed me, and I give you, for your despair, a few of the names of the necessary utensils by which your comfort is ministered to: "Pope's heads and eyes," "Shakers' swifts," "beefsteak pounders," "faucets and bungstarts," "bootjacks and leg-resters," "salt and spit-boxes," "Chinese swings," "Chinese punk in boxes," "sillabub-sticks," "oven-peels," "allblaze-pans," "ice-cream pagodas," "paste-jaggers and cutters," "crimping and goffering machines," "sugar-nippers and larding pins," "bread-rasps and sausage-stuffers," etc., etc., etc. This is vernacular, of course, to the ladies, but Greek to us.[12]

Every popular writer of the period had helpful hints for the modern housewife. Even the Beecher sisters from Hartford tried to capture the market with volumes of advice including *The New Housekeeper's Manual: Embracing a new revised edition of the American Woman's Home; or Principles of Domestic Science*, where they so astutely observed, "There is nothing which tends more effectually to secure good washing than a full supply of all conveniences." Obviously their suggestions were intended for owners of large homes for it would be virtually impossible even to fit into a contemporary "flat" the many utensils required for such thorough laundering:

Two wash-forms are needed; one for the two tubs in which to put the suds, and the other for blueing and starching-tubs. Four tubs, of different sizes, are necessary; also, a large wooden dipper (as metal is apt to rust;) two or three pails; a grooved wash-board; a clothes-line, (sea-grass or horse-hair is best;) a wash-stick to move clothes when boiling, and a wooden fork to take them out. Soapdishes, made to hook on the tubs, save soap and time. Provide, also a clothes-bag, in which to boil clothes; an indigo-bag, of double flannel; a starch-strainer, of coarse linen; a bottle of ox-gall for calicoes; a supply of starch, neither sour nor musty; several dozens of clothes-pins, which are cleft sticks, used to fasten clothes on the line; a bottle of dissolved gum-arabic; two clothes-baskets; and a brass or copper kettle, for boiling clothes, as iron is apt to rust. A closet for keeping all these things is a great convenience. Tubs, pails, and all hooped wooden

ware, should be kept out of the sun, and in a cool place, or they will fall to pieces . . .[13]

How pleased apartment dwellers must have been with Doty's washing machine, a single mechanical alternative. By 1895 it had been on the market some twenty-five years and was still considered to be efficient enough to be singled out for praise in *Appleton's Cyclopedia of Applied Mechanics*.

Invention altered other areas of domestic science, too. William Dean Howells (1837–1920), while visiting the Philadelphia Centennial Exposition in 1876, recorded: "serenely confident was the young lady who operated the Radiant Flat Iron in the Machinery Hall, an implement in whose hollow frame burnt a gas-flame blown hotter by a draft of air, the two elements being conveyed thither by India-rubber tubes from reservoirs under the ironing-table." Howells went on to say that when he asked the demonstrator what made the pressure of gas and air, she replied, "Oh, you see I stand on a sort of bellows, which I work by resting from one foot to the other as one always does in ironing."[14]

Visitors to the World's Columbian Exposition in Chicago frequently expressed unhappiness about the failure of exhibitors to establish a centralized display of domestic appliances and inventions. *The Popular Science Monthly* in several issues during 1893 grumbled that such exhibits had not been gathered in a separate building, as those of Transportation and Agriculture were. Like nearly all of their contemporaries, the editors of this progressive magazine could not conceal their enthusiasm for electricity:

> The greatest novelty in cooking appliances at the fair is unquestionably the apparatus for cooking by electricity . . . The electric current is conducted into plates of enamel, where it meets with resistance and is converted into heat. These plates are attached to specially constructed ovens, broilers, griddles, flatirons, etc. An ordinary stewpan, coffee or tea pot, or steam cooker may be heated on the "disk heater." An outfit of articles necessary for a private house costs $60, or $77.50 if a heater for a kitchen boiler is included.[15]

Victorian women, whether they supervised an extensive staff of servants in an eastern mansion or lived in a crude log hut on the edge of the western wilderness, were nearly all trained from childhood in needlework. Almost as soon as a little girl could hold a needle and thread, she began to sew everyday objects like aprons and simple dresses.

With the acquisition of elementary skills, encouragement to attempt more complex samplers, quilts, and decorative pieces soon came from mothers and teachers. Many samplers are signed, dated, and indicate the age of their makers. It is not unusual to find intricately stitched pieces made by girls twelve years of age or younger.

Many widows and unmarried women used needlework and sewing to fill otherwise empty lives. Often a spinster relative would "visit" for several weeks

and do much of the required sewing for a household. Gentlemen usually had their clothing made by a local tailor. Women of means preferred to have their more elegant dresses custom-made in Paris or London. James Fenimore Cooper, in 1837, remarked about American dress, "As a people, we are, beyond question, decidedly provincial, but our provincialism is not exactly one of external appearance. The men are negligent of dress, for they are much occupied, have few servants, and clothes are expensive, but the women dress remarkably near the Parisian modes. [On reaching home he found his wife, with her Parisian *toilettes*, in "surprising conformity" with others.]" [16]

During the Colonial period domestic production, usually by the housewife herself, provided fabrics for daily use. The spinning, weaving, and dyeing of wool and linen became as necessary a part of daily life as maintaining the fire in the fireplace. Colonial merchants in seaport cities did import elegant silks, damasks, and many other fine fabrics from China, Italy, and France; and fashionable dresses were stitched from these exotic imported stuffs in 1842 in Massachusetts, including "Smyrna silks and Turk satins, for Sabbath-day wear." [17] Enterprising speculators soon attempted domestic production of these opulent materials.

During the nineteenth century the developing use of controlled power spelled the end of a craft-oriented society. Steam powered the factories; water drove the turbines that then turned power gears and belts. Cheap mass-produced goods competed with the handcrafts, driving them from the marketplace by both abundance and price. The Hanks Silk Mill, now preserved at Greenfield Village and Henry Ford Museum, was built by Rodney Hanks at Mansfield, Connecticut, in 1810. This tiny factory, the first power mill to produce silk in the United States, heralded the dawn of the American textile industry.

A Georgia woman who raised silkworms and wove silk cloth maintained in 1842 that she could sell her product at double the price of French and English silks. Her explanations reflected the "buy American" attitudes so prevalent at the time: "The people of South Carolina were all for living on their own resources, and having no dependence on other countries; they, therefore, readily paid double prices for silks grown and manufactured at home, because it shut out the foreign trader, and kept all the money in the country." [18] By the time of the Great Exhibition at the Crystal Palace in London in 1851 the American silk industry had become important enough for its products to be shown.

Cotton, during the eighteenth century, represented one of America's most significant southern exports. After the invention of Eli Whitney's (1765–1825) revolutionary timesaving device, the cotton gin, it all but dominated the domestic market.

The single most important domestic, laborsaving invention of the Victorian period was the sewing machine. Several inventors experimented with elementary devices but the first to give real promise was that developed by J. J. Greenough in 1842. Some three years later Elias Howe, Jr. (1819–1867), introduced a practical example that became one of the most popular on the market.

Although the sewing machine made it possible to make clothing and other

practical pieces more quickly, handcraftsmanship continued in the form of quilts, bedcovers, hooked rugs, knitted mittens and caps, needlework pictures, etc. *Godey's Lady's Book* in 1855 informed its readers:

> Patchwork quilts, unless in silk, are rarely seen in cities, the glory of our grandmothers having passed away. "Comforters," that is to say, two widths of furniture chintz, with a layer of cotton batting between, and tacked together, or blankets, are used for winter covers. Comforters may be had at any upholsterer's from $1.50 to $3, according to the fineness of the chintz, which is about as cheap as they can be made at home, unless time is plenty; they are lighter and warmer than quilts. [19]

The editors would undoubtedly be astonished at the number of quilts that survive today. Pieced, appliqué, and crazy quilts, all represent the efforts of women who preferred to hand-make pieces that competed with the woven coverlets being produced by professional weavers on the Jacquard and other mechanical looms.

In 1859 Mrs. Pullman in *The Lady's Manual of Fancy Work* discussed a "favorite amusement with many genteel ladies." Piecing was the means by which

> they convert useless bits of silk, velvet, or satin, into really handsome articles of decoration. Of the patchwork with calico, I have nothing to say. Valueless indeed must be the time of that person who can find no better use for it than to make ugly counterpanes and quilts of pieces of cotton. Emphatically is the proverb true of cotton patchwork, *Le jeu ne vaut pas la chandelle!* It is not worth either candle or gas light. But scraps of the more expensive materials I have named, will really, with a little taste and management, make very handsome cushions, chair covers, and ottomans.[20]

Such efforts were not always appreciated. William Dean Howells, a critic of both feminine endeavors and the Philadelphia Centennial, grumbled,

> It seems not yet the moment for the better half of our species to take their stand apart from the worse upon any distinct performance in art or industry; even when they have a building of their own, some organizing force to get their best work into it is lacking; many of those pictures and pincushions were no better than if men had made them.[21]

Popular taste during the 1880s was much influenced by the Orient. This in part was caused by the Japanese Bazaar at the Philadelphia Centennial in 1876 and was furthered by the vast importation of Oriental objects in the years that followed. Nearly every ladies' magazine provided hints for decorating with Oriental motifs.

Our Homes and Their Adornments in 1884 reported on the decorating efforts of a newlywed. She was faced with a bare, cheap, new cottage:

> Money was not abundant. Old grandmother-woven indigo-blue woolen blankets were. She began sewing in little figures—stars, crescents, and odd stitches in colored silks,—and the woolen blanket became a gorgeous fabric. It was hung with wooden rings on a length of gas pipe midway of the bare hall, and so your first impressions on entering were of Eastern richness. The double blanket was more than enough (heavy materials must hang nearly plain), and a piano cover and traveling bag came out of the pieces. The embroidery was the work of time, but it was also a work of delight.[22]

Some of the more unusual developments in women's costume during the Victorian period were the hoop skirt, the bustle, the Mother Hubbard, and the bloomer skirt made popular by the emotional temperance missionary Amelia Bloomer (1818–1894). Thompson's Shirt Manufactory, one of the largest producers of hoop skirts in the United States during the late 1850s, employed some one thousand young women. They advised, "Smart girls can easily make $4 per week . . . very fair remuneration for work which is neither excessive nor unhealthy . . ."[23]

How unlike the New York City establishments Thompson's must have been. In that "city of misery" Catharine Beecher observed young girls working as seamstresses for twelve and one-half cents a day for fourteen hours of work.

The "Turkish Costume," a loose-fitting full skirt, sloping at the knees and worn with a pair of full trousers, came to be identified with liberated women after members of the Oneida Community in 1848 and temperance ladies in 1851 adopted it for daily wear. The temperance women drew large crowds. Unfortunately, many came to see their costumes and not to hear their lectures. "Bloomers" were finally discarded because of the adverse criticism they caused. Mrs. Elizabeth Cady Stanton (1815–1902), a temperance do-gooder, lamented, "The cup of ridicule is greater than we can bear."[24]

As the Victorian period came to a close, many social restrictions and customs began to fade. Rose Hartwick Thorpe (1850–1939), writing in *As Others See Us, or The Rules and Customs of Refined Homes and Polite Society*, in 1895, observed, "Custom makes iron rules, and if one defy them, he or she must become the subject of remark."[25]

Mrs. Thorpe appears to have been somewhat of a freethinker for the day. She even approved the scandalous costume, the Mother Hubbard:

> It is neither an immodest nor ugly garment in the proper time and place. Neatly belted, it can be as properly worn out of doors as any full or blouse-waisted dress. Without a belt, it is no more suitable to the street than a princess wrapper would be, as in this shape it is strictly a *negligée*. A grace-

fully made wrapper or Mother Hubbard certainly conceals the outlines of the form much more effectually than the tightly fitted tied back street costume so generally worn, and it is infinitely more modest than the full evening dress in which the women of good society display their charms to all beholders; but it is understood to belong strictly to the house, just as does an apron or breakfast cap. [26]

Fine jewelry fascinated Victorian men as well as women. Expositions, fairs, and special displays of jewels always attracted huge crowds, especially if pieces belonging to royalty were to be exhibited. At both the London Crystal Palace in 1851 and the New York Crystal Palace in 1853 American firms were represented, but it was not until the World's Columbian Exposition in Chicago in 1893 that their products were seriously considered by international connoisseurs. Before this exposition the American elite shopped for their gems in Europe or patronized firms that offered imported pieces. Mrs. William Astor, legendary social leader of Victorian society in New York, possessed beautiful diamonds made all the more fabulous by the fact that she very seldom wore them in public. They were reserved for her "four hundred," the number of guests she could accommodate in the ballroom of her Fifth Avenue palace. This queen of American Victorian society, as *The New York Times* solemnly assured the uninvited, always wore gems "with the most effective prodigality." [27]

At the Columbian Exposition the Tiffany and Gorham pavilions faced unprecedented competition from a display mounted by some twenty-nine New England firms who were manufacturing jewelers.

For the most part the articles are such as are produced in their several lines of trade, and not as at the Centennial Exposition specially made for the purpose, the space being equally divided among the exhibitors, and the groups arranged with a view to harmony of effect. With one exception all the collections are from Providence, Rhode Island, and though small in size they are choice in quality, many of them representing special lines of goods in the production of which single individuals or individual firms have millions of dollars invested, one for instance making a specialty of rings, another of watch chains, and another of trays in various patterns. While singly such exhibits would not be of special value, together they form a most interesting display, illustrating as they do the remarkable progress in this direction since the date of the Centennial Fair.[28]

Edward Colonna, an American working in Paris, is probably responsible for some of the most impressive Art Nouveau jewelry ever made. His pieces were exhibited by Samuel Bing at the Salon de L'Art Nouveau and many of them were brought to America by those returning from the grand tour. His gold serpents, dragonflies, bats, lizards, and other animal, plant, and insect forms competed

with Louis Tiffany's gold- and silver-mounted scarabs and other gems. Tiffany, vice-president of Tiffany & Co., created a new department in the firm that featured "artistic jewelry" of his own design.

By the end of the Victorian era jewelry, though not always precious, became part of every woman's dress. If a woman could not afford to shop at Tiffany's, Sears, Roebuck's mail-order wares were just a postage stamp away.

Changing tastes caused the Victorian woman, much like her modern counterpart, avidly to pursue the most current style or fashion. Little did she realize that by reading *Graham's Magazine* in 1856 she could have been saved all the trouble, for "Beauty . . . is the light, the beacon, the ultimate aim of the soul within . . ." [29]

384 (above). Basketweave hat. American(?) c. 1850. Made from woven ash. W. 10". This elaborate hat was worn by Jenny Lind during her concert tour of America in 1850. (Greenfield Village and Henry Ford Museum)

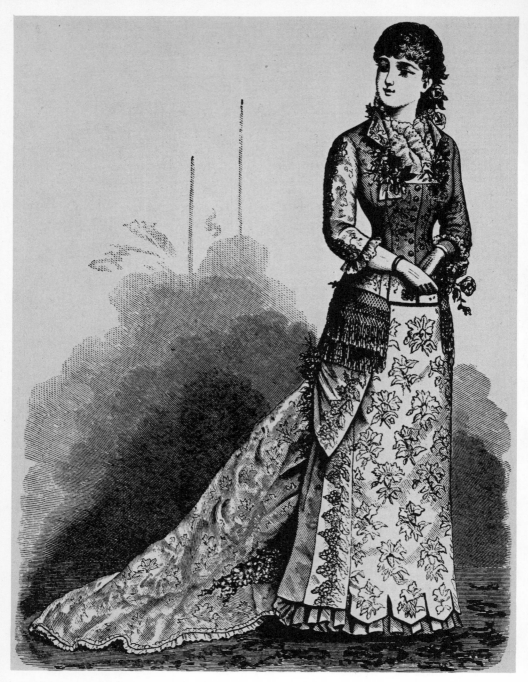

385 (above). Illustration from the Lord & Taylor Clothing and Furnishings catalogue of 1881. This bridal dress featured a princess back and basque bodice of brocade, a square neck filled with lace, brocade sleeves with inserts of crystal trimming, and pannier sides with crystal and pearl fringe. The front of the skirt was brocade cut to show pleating on the bottom and the back was finished with very narrow, shirred trimming. This elaborate garment was designed to retail at the staggering sum of $200. (The New York Public Library)

316

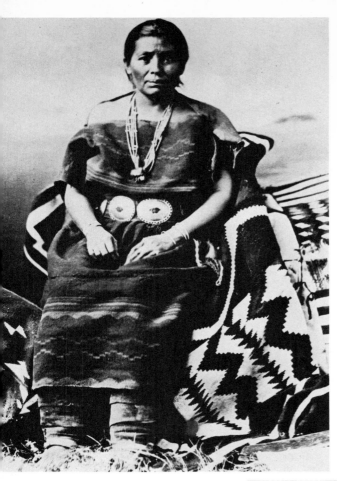

386 (left). Photograph of Juanita, wife of Manuelito, a member of the Navajo tribe. 1874. Juanita wears the traditional Navajo costume, which includes a bead necklace and a silver concho belt. The numerous rugs are typical of the kinds of Indian artifacts that Late Victorians so eagerly collected. (Smithsonian Institution, National Anthropological Archives)

387 (right). Illustration from *Beautiful Homes* by Henry T. Williams and Mrs. C. S. Jones, published by Henry T. Williams, New York, 1878. This book of helpful hints for the thrifty homemaker featured articles on ways of beautifying modern interiors. One suggestion was to cover everything with ruffles and bows as demonstrated by this illustration. (Inkster, Michigan, Public Library)

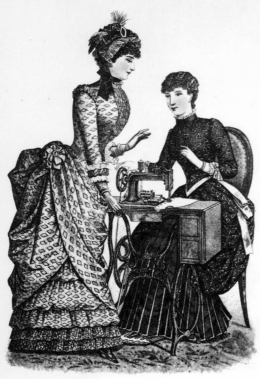

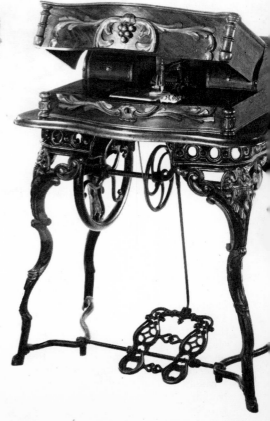

388 (above). Illustration from an 1884 issue
of Godey's Lady's Book. By the late 1870s
the sewing machine had become popular
enough for most publications aimed at
women subscribers to include patterns and
suggestions for nimble needlewomen. (Pri-
vate collection)

389 (right). Sewing machine made by
George B. Sloat & Co. c. 1858. Cast iron and
walnut. H. 37½". The development of the
sewing machine drastically altered women's
lives throughout the world. In America the
most expensive machines were housed in
elaborate veneered and decorated case
pieces. The less expensive types stood on
cast-iron bases. (Greenfield Village and
Henry Ford Museum)

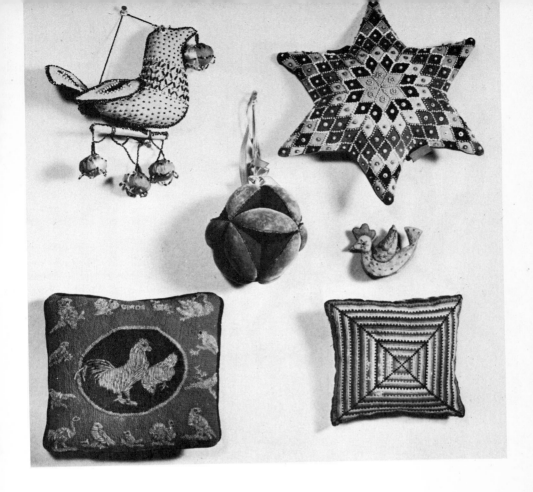

391 (below, left). Gold thimble. c. 1900. H. 1¼″. This decorative and utilitarian piece fitted into a miniature basket container woven of sweet grass. (George O. Bird)

392 (right). Sewing bird. c. 1880. Iron and copper. H. 4¾″. Sewing birds were attached to tabletops and served as a third hand, making embroidery and other exacting needlework tasks easier. The beak opened when the tail was depressed so that fabric could be inserted and held firmly. (Greenfield Village and Henry Ford Museum)

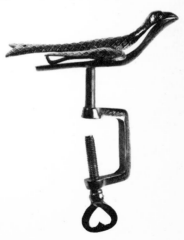

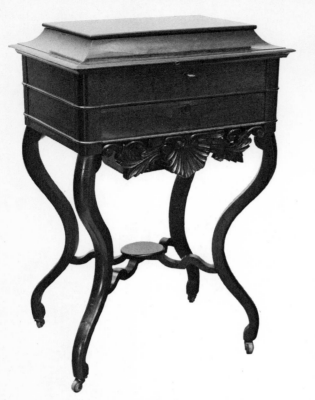

393 (left). Sewing table with drawer concealed by shell and leaf carving attributed to John Henry Belter. c. 1850. Rosewood with interior of bird's-eye maple. (Eileen Dubrow Antiques)

394 (below). Hooked rug made by Mrs. Elenore Blackstone, Lacon, Illinois. 1880–1890. 9'4½" x 7'11". Few hooked rugs exhibit the design complexity of this masterpiece. Mrs. Blackstone's tour de force depicts the Blackstone family in front of their home in Lacon. (Greenfield Village and Henry Ford Museum)

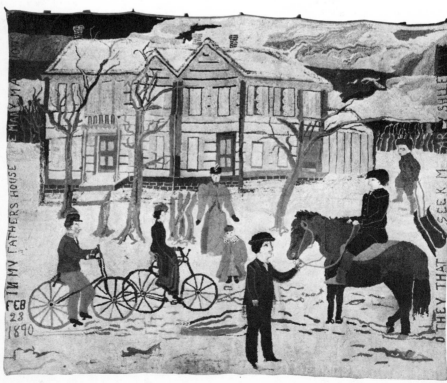

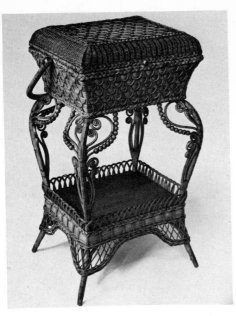

395 (left). Sewing basket. c. 1896. Natural wicker. H. 31½". The Heywood Brothers and Wakefield Company made several models of sewing baskets, of which this is the most elaborate. Photograph courtesy Frederick Di Maio: Inglenook Antiques. (Private collection)

396 (below). Sampler made by Beata Heilman. Pennsylvania. c. 1855. L. 25¼". Young girls were encouraged to demonstrate their competence in needlework on such pieces. Usually they included numbers, the alphabet, and the young girl's name. (Philadelphia Museum of Art; The Whitman Sampler Collection given by Pet Incorporated)

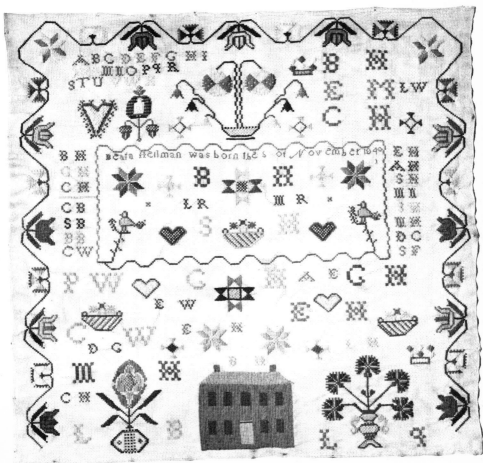

397 (right). Patriotic canvaswork. 1876. L. 14". The Victorian woman who was not overly creative could purchase fabrics that had been commercially imprinted with mottoes or inspirational verses and scenes and finish them with a variety of needlework stitches. This piece was made to celebrate the Centennial in 1876. (Philadelphia Museum of Art; The Whitman Sampler Collection given by Pet Incorporated)

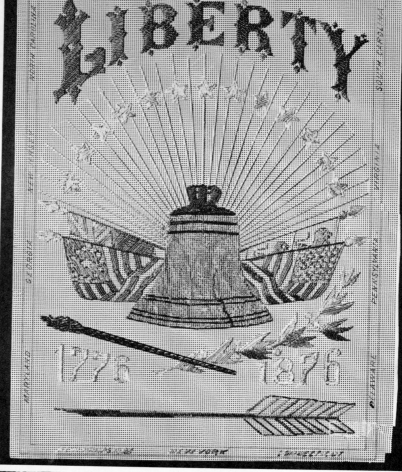

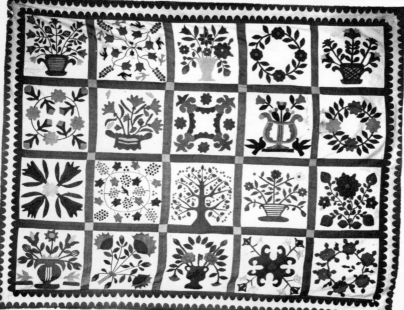

398 (left). Album quilt probably made for Frederick Vogtz. Probably Pennsylvania. 1840–1860. 84" x 103". This appliqué quilt top contains twenty square blocks, each with a different design. One block is inscribed with the name Frederick Vogtz. (Greenfield Village and Henry Ford Museum)

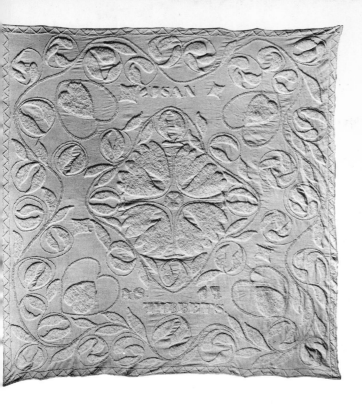

399 (left). Embroidered candlewick spread made by Susan Tibbets. Probably New England. Dated 1847. 100" x 100". Beautifully worked in rhythmic serpentine lines of French knots, this was probably intended as a wedding coverlet, since the design includes four large open hearts made of French knots, each of which encloses a smaller heart of sheared roving. Photograph courtesy George E. Schoellkopf Gallery. (Private collection)

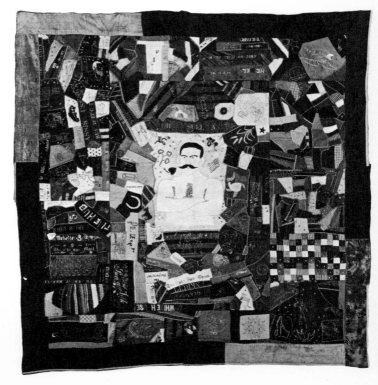

00 (right). Crazy quilt. robably made in Chicago. 1888. 79" x 76". he center figure in this andsome piece represents John L. Sullivan, he famous boxer. Quilts ith masculine subjects ere mostly used on oys' or men's beds. Private collection)

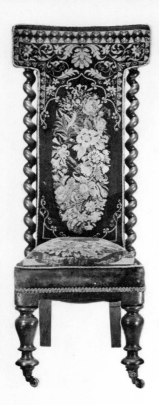

401 (left). Slipper chair in the Elizabethan Revival style with needlework upholstery. 1840–1860. Walnut. H. 41¾". (Greenfield Village and Henry Ford Museum)

402 (below). Needlework picture by Miss Zoe Van Antwerp. New York. Dated 1850. 10½" x 14". It is interesting that the background for this lively scene has been left unworked. (Private collection)

403 (opposite, above). *Rebecca at the Well*. c. 1840. Oil on canvas with applied paper faces and hands, and various wool and linen fabrics stitched onto the canvas. W. 36". Seminaries taught young women the genteel arts, which included the fashioning of artistic religious pictures such as this example. The trees, the roadway, and the rooftops are all worked with embroidery. (Private collection)

404 (opposite, below). Illustration of the interior of the New England Kitchen from Volume III of *Masterpieces of the Centennial Exposition, 1876*, by Joseph M. Wilson. Victorians were confused about their heritage. Many of the objects that were believed to be from the Colonial period were really from the early nineteenth century. Such displays at the Centennial helped fan a widespread interest in collecting antiques. (Private collection)

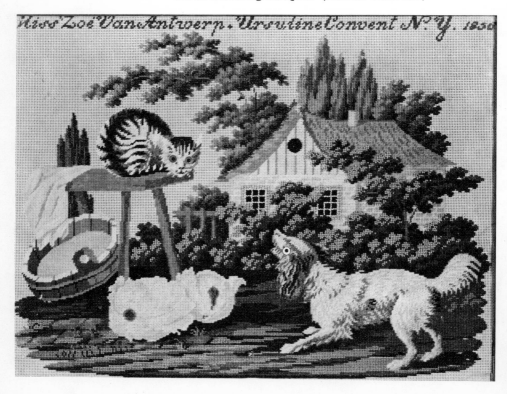

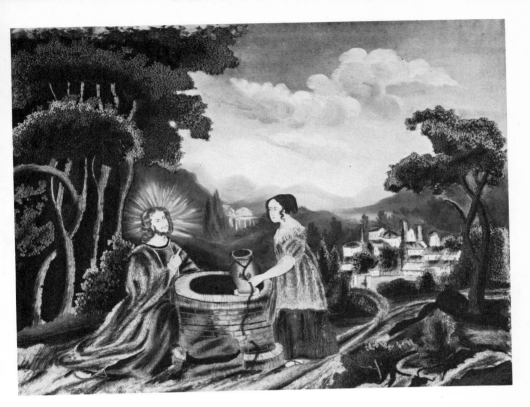

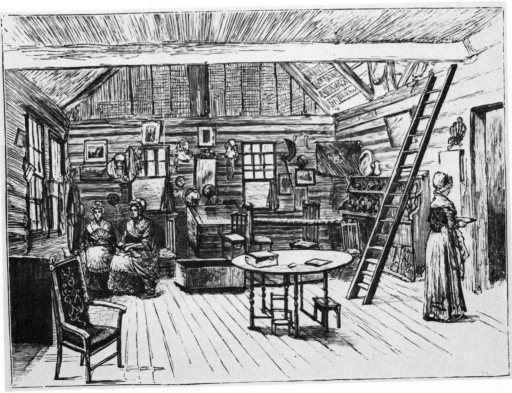

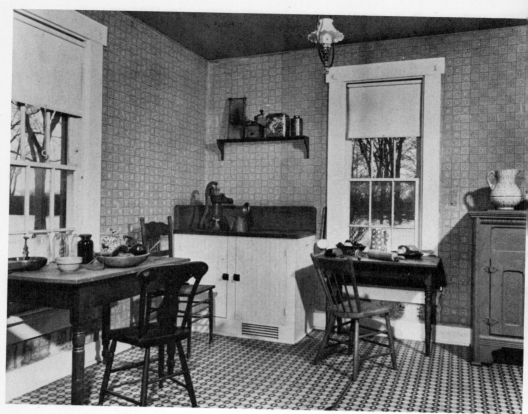

405 (above). Interior of the kitchen at the Wright Homestead built at Dayton, Ohio, in 1870. This kitchen, like those in many Midwestern homes, contained several modern conveniences, including a gas cooking stove, gas lighting fixtures, and a water pump in the sink. (Greenfield Village and Henry Ford Museum)

406 (right). The electrical kitchen from the World's Columbian Exposition in Chicago in 1893. In this futuristic display each saucepan, water heater, broiler, and boiler was connected to a separate outlet. The electric range did not become popular until about 1910. (Private collection)

407 (above, left). Lever-action butter churn made by the Champion Churn Works, Toledo, Ohio. H. 32½″. The patent for this ingenious laborsaving device was issued to E. H. Funk on September 15, 1868. Collectors of early homemaking utensils seek those that retain the original painted decoration. (Greenfield Village and Henry Ford Museum)

408 (above, right). Icebox made by the Leonard Refrigerator Company, Detroit, Michigan. c. 1881. Oak. H. 40½″. The iceman is one of the best-remembered street vendors of the nineteenth century. The ice was placed in the top of the box. (Greenfield Village and Henry Ford Museum)

409 (right). Various mid-nineteenth-century utensils for the preparation of meat. *Right:* pump-type lard press; *left:* wooden meat grinder; *bottom:* tin sausage stuffer. These utensils are but a few of those found in nearly every home. (Greenfield Village and Henry Ford Museum)

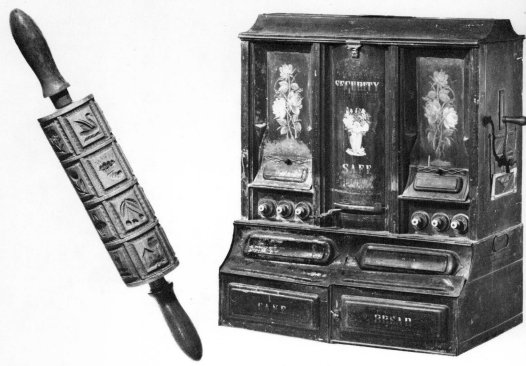

410 (above, left). Rolling pin. c. 1850. Pine cylinder pivoted on a maple shaft. L. 18½″. Twenty incised designs of flowers, fruits, animals, birds, buildings, and household objects could be transferred from this rolling pin to the cookie dough. (Greenfield Village and Henry Ford Museum)

411 (above, right). "Tin Kitchen." Third quarter of the nineteenth century. H. 38″. This security safe provided convenient storage for most of the condiments used by the Victorian housewife. (Greenfield Village and Henry Ford Museum)

412 (right). Cookie cutters. *Left to right:* Dancing Man, tin, mid-nineteenth century. H. 9″, strap handle; Stag, tin, mid-nineteenth century, Pennsylvania German, H. 7¼″, strap handle; Hand, tin, late nineteenth century, Pennsylvania German, L. 3¾″, strap handle; Eagle, tin, mid-nineteenth century, H. 3″; Tulip, tin, c. 1875, Pennsylvania German, L. 4¾″, leaf form with scalloped edge, inner design pressed on dough. (Greenfield Village and Henry Ford Museum)

413 (left). Apple parer. Connecticut. First half of the nineteenth century. Wood and metal. L. 22⅝". Many of the craftsmen who fashioned spinning wheels and Windsor chairs also produced the turned wooden parts for apple parers. The more refined versions also removed the core. (Greenfield Village and Henry Ford Museum)

414 (below, left). Wheel-operated coffee mill manufactured by the Lane Brothers, Poughkeepsie, New York. Patented February 19, 1875. H. 14". Cast-iron coffee mills were used by both grocers and housewives. (Greenfield Village and Henry Ford Museum)

415 (below, right). Milk bottle manufactured after a patent granted to A. G. Smalley & Company in 1898. H. 9". Securing pure milk was a difficult task during the nineteenth century. Many cities passed stringent legislation in an attempt to protect their citizens. (Greenfield Village and Henry Ford Museum)

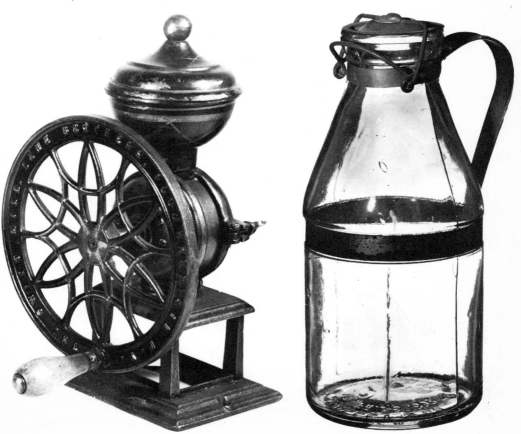

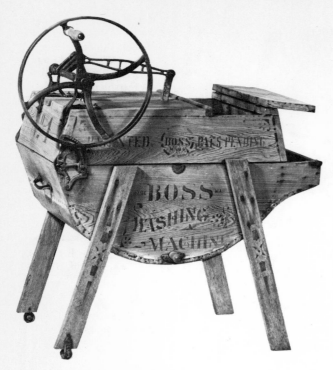

416 (left). Washing machine made by the Huenefeld Company, Cincinnati, Ohio. Patented July 5, 1888. H. 44½″. At one side of this hand-operated, cradle-shaped washing machine is an iron wheel with a wooden handle, which causes the two grooved, wooden cradles inside to rock back and forth. Such contrivances were a decided improvement over the washboard and tub. However, they were still a far cry from the electrically powered models that became popular in the early twentieth century. (Greenfield Village and Henry Ford Museum)

417 (below). *The Ironers.* c. 1845. Oil on canvas. W. 41″. Before the days of income-protection insurance policies widowed women frequently were faced with earning their own living. Victorian diaries are full of accounts of "sweatshops." (New York State Historical Association)

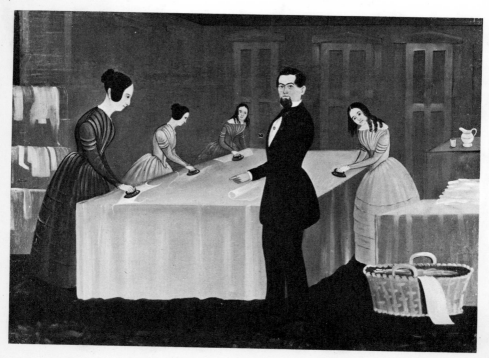

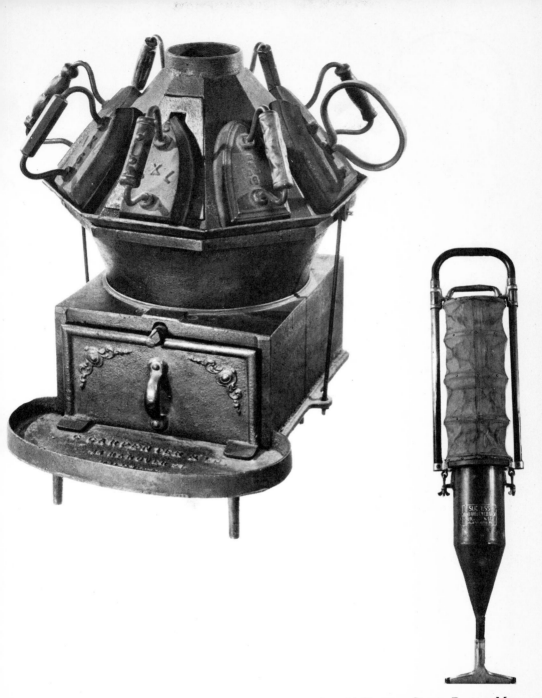

418 (above, left). Flatiron heater made by Carpenter & Co., 44 Hanover Street, Massachusetts. c. 1850. Cast iron. H. 21½". This octagonal heater was especially designed for use in laundries. (Greenfield Village and Henry Ford Museum)

419 (above, right). Success Vacuum Cleaner made by Hutchison Mfg. Co., Wilkinsburg, Pennsylvania. Early twentieth century. H. 51½". Imagine the effort it must have required to operate this contraption! (Greenfield Village and Henry Ford Museum)

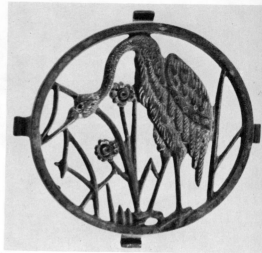

420 (above, left). Gold pendant. 1825–1850. H. 1⁵⁄₁₆″. The monogram "CJh" is worked with pearls and white beads onto a blue enamel background. (Greenfield Village and Henry Ford Museum)

421 (above, right). Trivet. c. 1885. Iron. Diam. 6″. Japanese designs permeated every aspect of the American decorative arts in the late nineteenth century. The crane and stylized flowers on this piece reflect Oriental influence. (Greenfield Village and Henry Ford Museum)

422 (right). Illustration of a wire plant stand from *Our Homes and Their Adornments* by Almon C. Varney, published by J. C. Chilton & Co., Detroit, Michigan, in 1884. (Private collection)

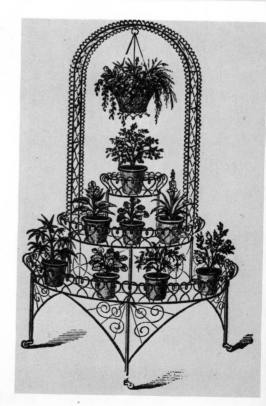

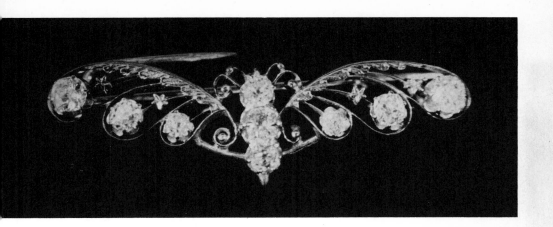

423 (above).
Gold brooch.
1830–1840.
W. 2″. Three dia-
monds form the
body of the
butterfly, and the
wings are em-
bellished with
additional dia-
monds. (Gray D.
Boone)

424 (right).
Silver-and-gilt
locket and chain.
1840–1850. H. of
locket 1⅜″; L. of
chain 17¾″. (Gray
D. Boone)

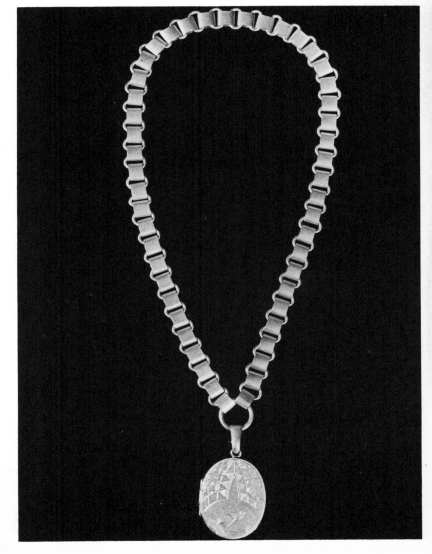

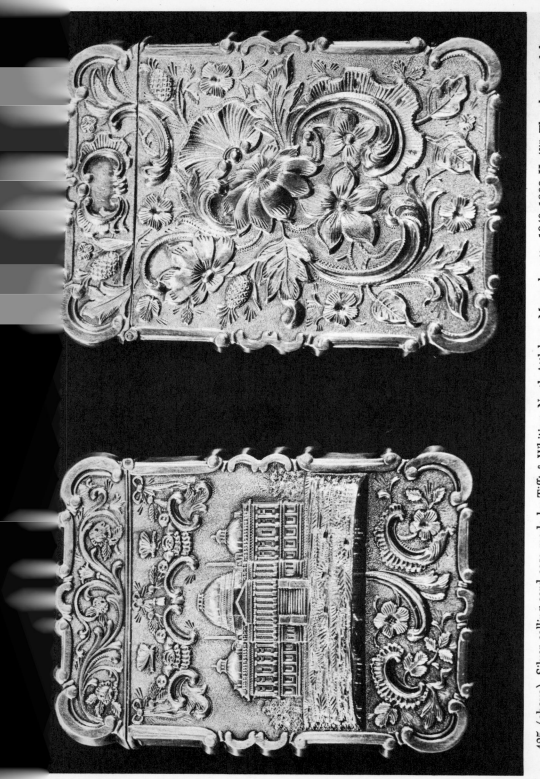

425 (above). Silver calling-card case made by Tifft & Whiting, North Attleboro, Massachusetts. 1840–1866. H. 4¾". The obverse of the case contains an impression of the U.S. Capitol building and the reverse is embellished with floral decorations. (Grav D. Boone)

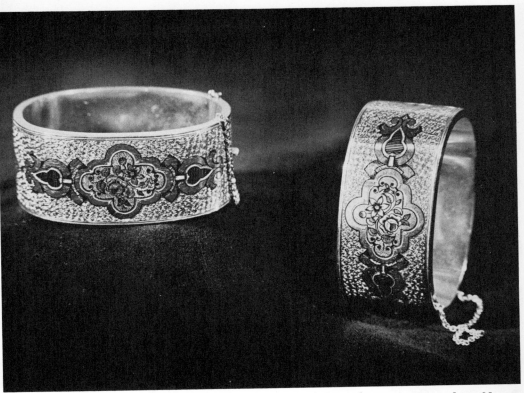

426 (above). Pair of gold bracelets with black enamel chasing. Probably made in New Orleans. 1850–1860. W. 1". (Gray D. Boone)

427 (below). *Left,* Shell cameo pin. c. 1850. H. 1½". *Right,* Gold double-picture locket. c. 1890. H. 1¼". (Private collection)

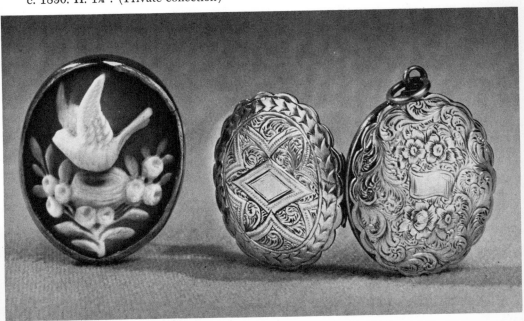

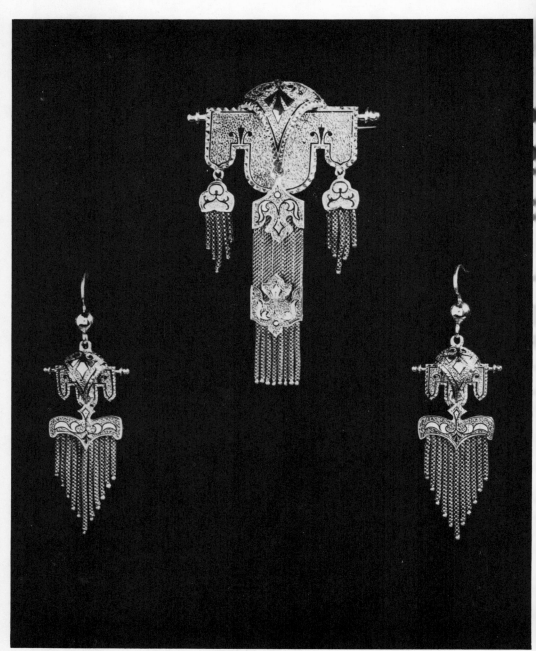

428 (above). Gold brooch and earrings. Possibly made in New York. c. 1860. (R. Es-
merian, Inc.)

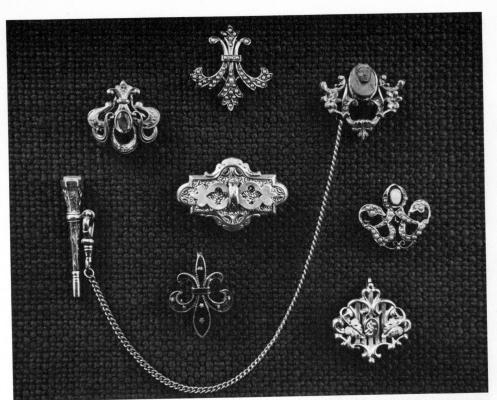

429 (above). Watch pins. *Left to right:*
Gold with enamel decoration and ame-
thyst stone, c. 1890; gold fleur-de-lis
with seed pearls, c. 1890; gold with
lava cameo, c. 1860, attached by gold
chain to a gold-filled watch key with
a sardonyx on the top, 1860–1870;
gold, c. 1860, W. 1½″; gold with seed
pearls and opal, c. 1890; blue enamel,
c. 1860; three-color gold with the
initial S, c. 1890. The watch was sus-
pended from a hook on the back of
the pin. (Private collection)

430 (right). Watch chains and slides.
Left to right: Rolled gold chain,
L. 48″, gold slide with opals and seed
pearls, c. 1890; rolled gold chain,
L. 52″, gold slide with garnet, c. 1875;
rolled gold chain, L. 56″, gold slide
with peridot, H. ⅞″, c. 1900. (Private
collection)

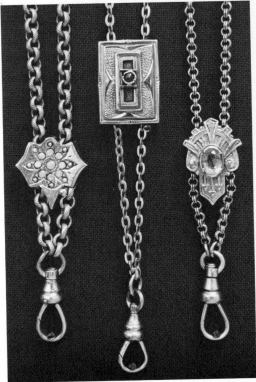

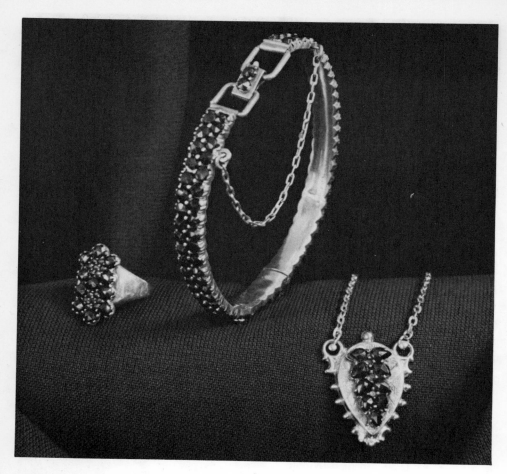

431 (above). Gold jewelry set with garnets. Ring and bracelet, c. 1890. W. of bracelet ¼". Pendant suspended on a 30" gold-filled chain, c. 1870. (Private collection)

432 (left). Brooch made of carved jet set in gold-finished metal in the style of the 1870s. L. 2¼". (Elsie Suffron)

433 (below). Solid gold necklace by Tiffany. c. 1880. The design of this piece is probably in the Egyptian Revival style. (Moss Antiques)

434 (right). Jewelry cabinet in the Renaissance Revival style designed by the American architect Bruce Price for his wife's jewelry. c. 1873. (Museum of the City of New York)

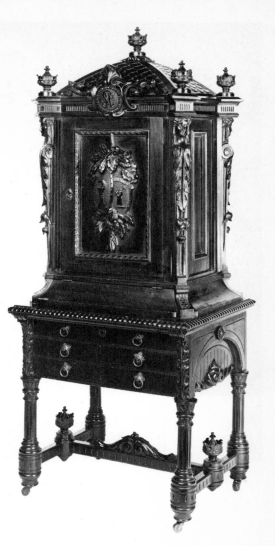

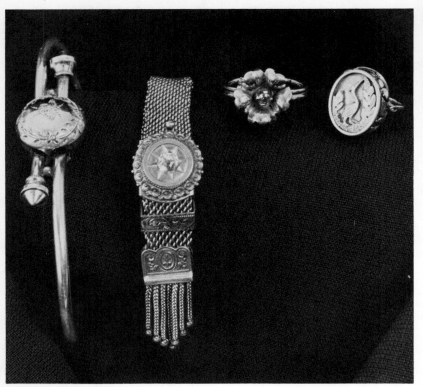

435 (left). *Left to right:* Rolled gold bracelet with three-colored gold design on top, dated 1879, W. of top ⅝"; flexible gold bracelet with zircon slide and gold chain bangles, dated 1884; gold ring set with a ruby, c. 1890; three-colored gold ring with a crane design, c. 1850, W. ⁷⁄₁₆". (Private collection)

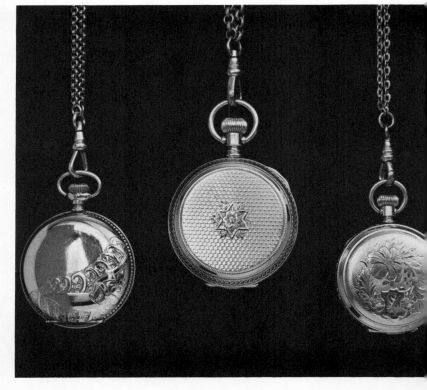

436 (right). Ladies' watches. *Left to right:* Solid gold case, size 0, stem wind, inscribed inside "J. Boss 14K," made by the Elgin National Watch Co., 1887; solid gold case, size 6, lever set, stem wind, made by Waltham, 1883, H. 2⅜"; solid gold case, size 0, stem wind, initialed S, made by the Elgin National Watch Co., 1900. (Private collection)

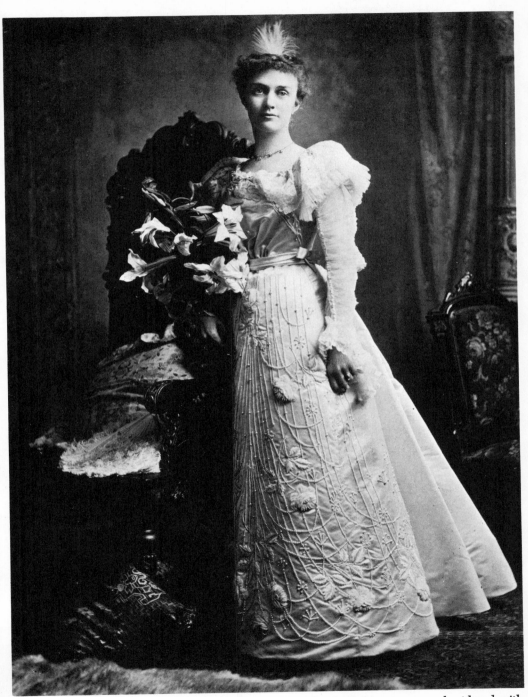

437 (above). The white satin wedding dress of Mrs. John G. Robinson was embroidered with thousands of tiny seed pearls. c. 1891. (Cincinnati Art Museum; Gift of Mrs. John G. Robinson)

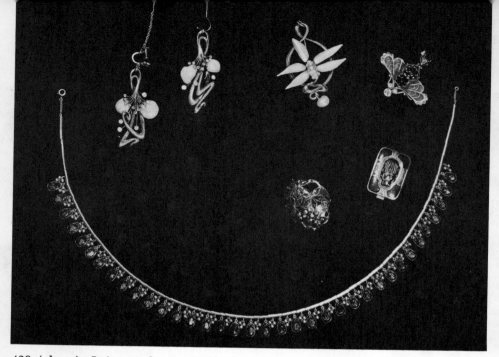

438 (above). *Left to right:* Jeweled and enameled earrings attributed to Edward Colonna; dragonfly pendant made by Edward Colonna; winged brooch made by Marcus & Co.; gold and enamel floral brooch made by Tiffany & Co.; glass scarab in gold pendant made by Tiffany; necklace made of scarabs set in gold by Tiffany. Many designers at the turn of the century created jewelry containing a mixture of precious and semi-precious stones and brilliant enamelwork. Louis Tiffany's Favrile glass scarabs achieved great popularity. (Lillian Nassau, Ltd.)

439 (left). Onyx watch chain. c. 1890. L. of chain 48". (Private collection)

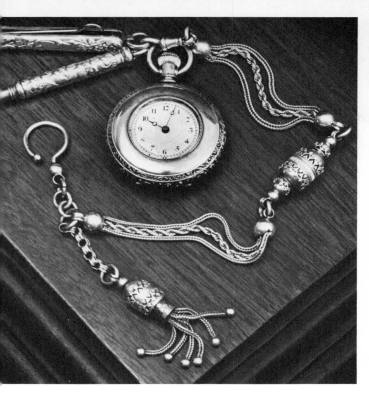

440 (left). Coin silver lady's watch with rose- and yellow-gold inlay made by the Elgin National Watch Co. 1896. Diam. of watch 1½"; L. of chain 10". A buttonhook and pencil are attached to the end of the chain. (Private collection)

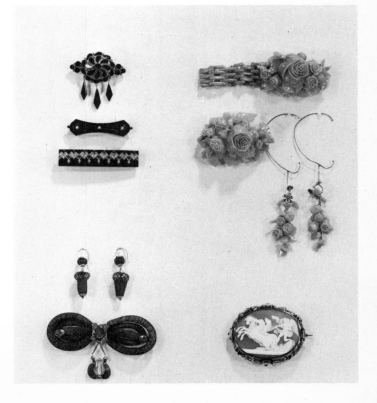

441 (right). *Left to right:* Jet and onyx brooch and pins, 1870–1890, L. of longest pin 2¼"; coral bracelet, pin, and earrings, 1855–1875, W. of bracelet 2½"; hair earrings and brooch, 1850–1860, L. of pin 3½"; cameo brooch, mid-nineteenth, century, L. 2¼". (Cincinnati Art Museum; Gifts of Blanche Ross Tucker; Mrs. Gerald J. Ficks; Mrs. Martin Low; Estate of W. W. Taylor; the family of Mrs. W. T. Lenoir and Mrs. J. S. Skinner; and Caroline Lehmer)

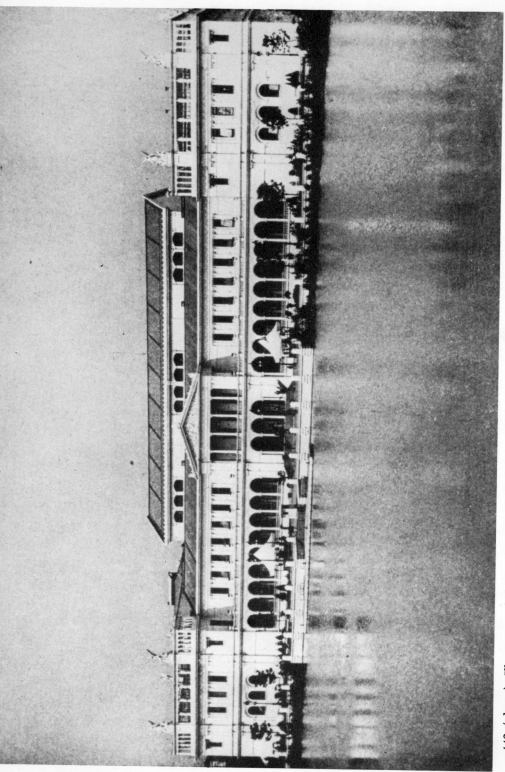

442 (above). Illustration of the exterior of the Woman's Building at the World's Columbian Exposition, Chicago, Illinois, 1893, from *Shepp's World's Fair Photographed* written by James W. and Daniel B. Shepp and published by the Globe Bible Publishing Co., Chicago, Illinois, 1893. This structure was designed by Miss Sophia G. Hayden of Boston, Massachusetts, and all the funds for its construction were raised by women. (Private collection)

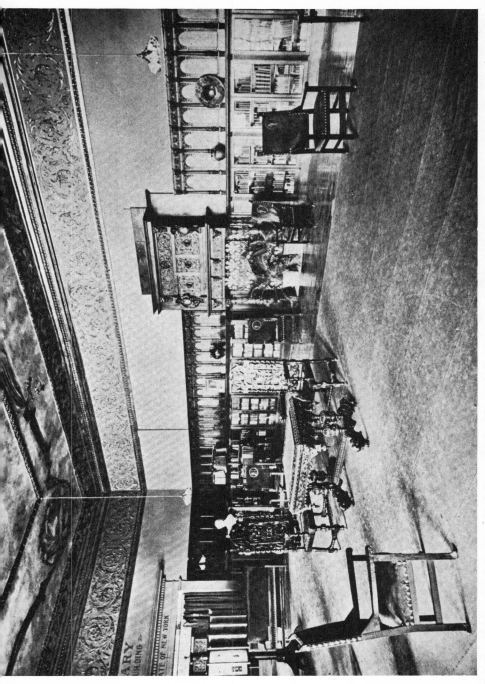

443 (above). Interior of the New York Room in the Woman's Building at the World's Columbian Exposition, Chicago, Illinois, 1893, from *Shepp's World's Fair Photographed* by James W. and Daniel B. Shepp and published by the Globe Bible Publishing Co., Chicago, Illinois. The furnishings in this room were of the very latest style. (Private collection)

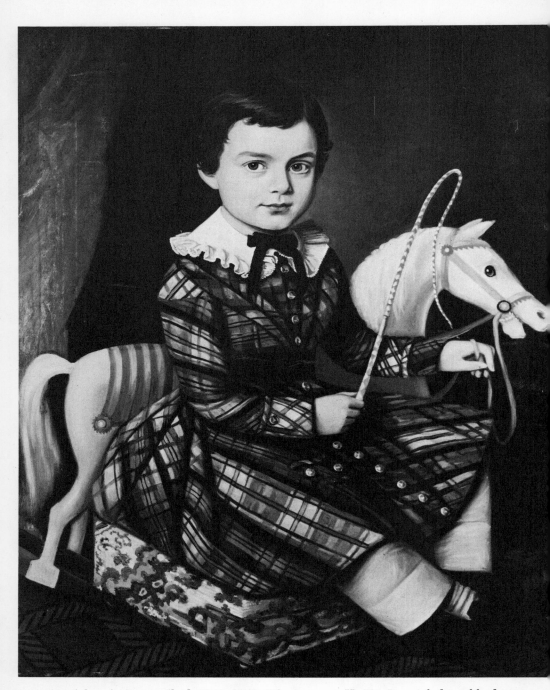

444 (above). *Boy in Plaid*. 1840–1850. Oil on canvas. H. 31″. It was fashionable during the 1850s for boys to wear plaid and to pose for their portraits with such toys as a whip or a hobbyhorse. (Abby Aldrich Rockefeller Folk Art Center)

CHILDREN'S WORLD

Queen Victoria frequently revealed in her personal diaries and letters unqualified devotion to her nine children. Even at such important events as the opening of the first international exhibition and fair at the London Crystal Palace in 1851, which had been arranged by her husband, Prince Albert, two of the children accompanied her. "The Park presented a wonderful spectacle, crowds streaming through it,—carriages and troops passing, quite like the Coronation, and for *me*, the same anxiety. The day was bright and all bustle and excitement. At ½ p. 11 the whole procession in 9 State carriages was set in motion. Vicky and Bertie [Princess Victoria and the Prince of Wales, later Edward VII] were in our carriage (the other children . . . did not go). Vicky was dressed in lace over white satin, with small wreaths of pink wild roses in her hair, and looked very nice. Bertie was in full Highland dress . . ." [1]

Although well-to-do American Victorian children were perhaps denied the priceless treasures of Victoria's offspring, their lot in life had improved considerably over their Colonial predecessors. Childhood in Colonial America had been bleak. Medieval, homemade medical potions failed to reduce significantly a high mortality rate, and education, when it existed, seldom extended over a long period of time.

Colonial playthings were usually handmade by relatives. Rag babies and crudely whittled dolls were replaced on rare occasions by imported models dressed in the latest European styles. The New York pewterer, William Kirby, in 1774 advertised he had "just come to hand, a curious and general assortment of English and Dutch toys, which he will sell wholesale and retail, at a low advance, amongst which are, a few humming tops, japan'd waiters, bread baskets, clothes and shoe brushes, hair brooms, hearth brushes, plated shoe and knee buckles, and a variety of other articles in the toy way, too tedious to mention." [2]

The earliest-known American dollhouse is believed to have been made in 1744. This delightful, simple plaything was created for a child in the Homans family of Boston and is now in the toy collection at Van Cortlandt Manor, Tarrytown, New York. Much more elaborate German dollhouses survive from the late 1500s. By the last part of the seventeenth century elegant miniature palaces and complex mansions were popular playthings for young princesses throughout Europe. Victoria, as a child, could count 132 dolls in her modest collection, which included such contrasting types as simple, wooden-jointed dolls and beautifully crafted portrait dolls representing well-known actresses of the day. Surprisingly enough, Victoria possessed a very modest dollhouse. The two-room affair contained only a kitchen and a dining room.

After Victoria's ascension to the throne, several English manufacturers pro-

duced dolls with china heads that were intended to be portraits of the queen. Many of these were fitted with cloth bodies and china hands and feet.

Early inventories indicate that babies in affluent families often enjoyed "teethers" in the form of coral-and-bells and whistle-and-bells. These playthings, fashioned from silver or gold, usually consisted of a whistle on one end, a rock crystal or coral teether on the other, and between them bells that served the same purpose as modern-day rattles.

Throughout the entire Colonial and most of the Federal period children, after they outgrew their baby clothes, were dressed as miniature adults. The costumes on little girls' dolls also reflected the prevailing fashions of the day. When fashion books and sewing manuals became popular in the Early Victorian period, clothing for children became specialized.

Self-dependence in American children caused European emigrants in 1852 to exclaim, "They run in and out and play, tumbling and dragging about books and cushions and chairs and climbing up and down just as they please . . ." [3]

Playthings at this time served a dual purpose. They represented not only a source of entertainment, but more important, they familiarized the child with the world into which he was growing.

By the 1860s educational toys marketed by wholesale suppliers had become a reality. F.A.O. Schwarz, one of the earliest American firms to specialize in the sale of toys, began their retail business in 1862. This prestigious New York firm is still probably the largest retail outlet in the United States devoted exclusively to the toy trade.

Mail-order houses during the latter part of the nineteenth century made less expensive and more sophisticated playthings available to rural areas. In Chicago Montgomery Ward & Company, founded in 1872, and Sears, Roebuck and Co., entering the field in the early 1890s, offered extensive inventories.

During the early 1870s steam-propelled toys became popular. Complex motor launches, steamrollers, and even steam locomotives served as prototypes for the later electric-powered playthings that began to appear in the toy departments of stores like Marshall Field & Co. in Chicago in 1892.

As American iron foundries developed more facile production techniques, several of them entered the lucrative toy market. Cast-iron banks, both still and mechanical; push toys; pull toys; and other ingenious playthings reflected a Victorian preference for the nearly indestructible. Because tin pieces were less expensive to produce and ship, they all but dominated the market by the late nineteenth century.

At the close of the Victorian period social forces within the United States caused a shift in popular attitudes toward children. Up to this time a youth was taught to be a miniature version of his or her parents and encouraged to pursue the same interests. Contrasting with this, the late-nineteenth-century progressive saw the child as the carrier of tomorrow's hope, whose innocence made him receptive to national education. With this new interest in youth, labor

laws were implemented curtailing many of the flagrant child abuses of the previous decades.

Enemies of child labor created an atmosphere that led to nursery schools, kindergartens, and more and improved public schools for the education of liberated children. Personal hygiene and sanitation, adequate diets and medical attention are but a few of the new benefits realized through organized agitation by Late Victorian reformers.

445 (below). Pull toys. Late nineteenth century. Carved wood, painted. H. of elephant 7"; H. of giraffe 16¾". These charming toys were obviously made by the same carver. Such handcrafted pieces are easily distinguished from mass-produced, imported European prototypes. (Abby Aldrich Rockefeller Folk Art Center)

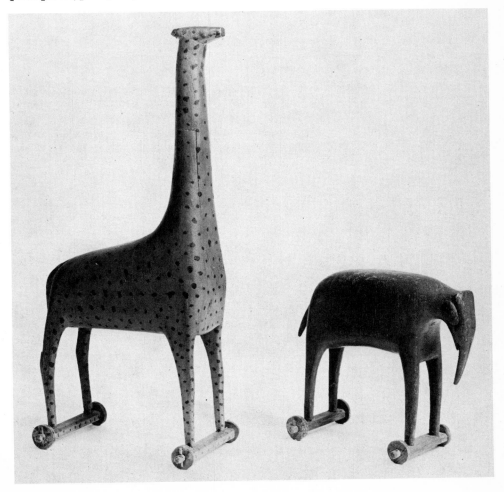

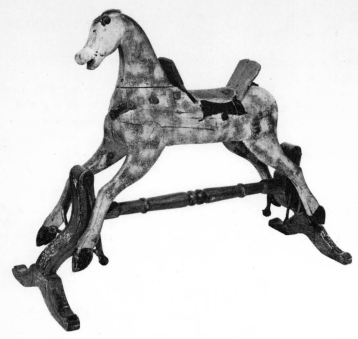

446 (above). Hobbyhorse. Horse, mid-nineteenth century; base, late nineteenth century. Pine and maple. L. 35½″. Because the rockers on many early horses were easily broken, special bases were made for remounting horses. (Private collection)

447 (below). Rocking horse. Mid-nineteenth century. Wood. Horses with their original painted decoration, such as this one, are much more desirable than those that have been stripped, refinished, or repainted. (Willow Corners Antiques)

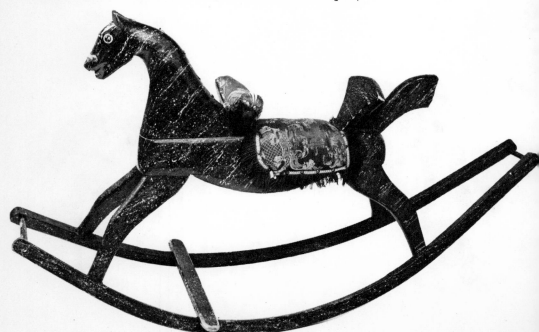

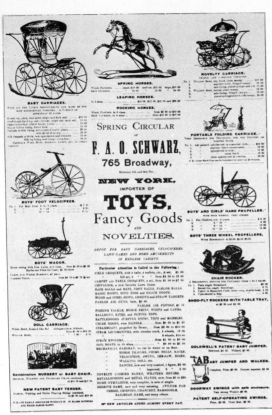

448 (left). Advertisement for the F.A.O. Schwarz Company. New York City. 1870. The Schwarz firm, during the Victorian period, grew to be the largest toy store in America. Although much of their merchandise was imported, they also handled domestically manufactured goods. (Private collection)

449 (below). Tin toys illustrating various types of American transportation. 1870–1890. (Greenfield Village and Henry Ford Museum)

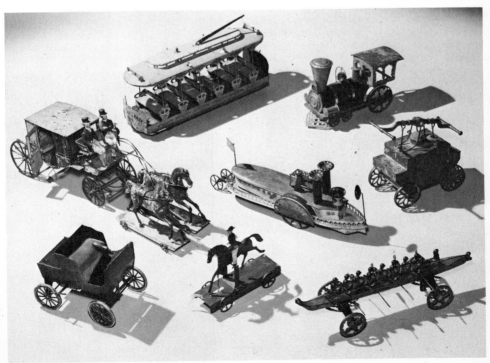

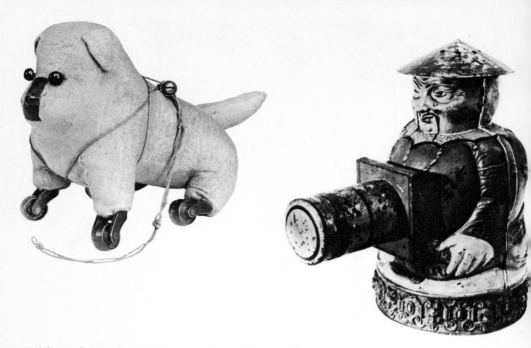

450 (above, left). Child's pull toy. 1890–1900. L. 9½″. Equipped with a bell and casters and shoe-button eyes, this pup is as much a delight today as he was when new. Photograph courtesy Kelter-Malcé Antiques. (Private collection)

451 (above, right). Magic lantern in the form of an Oriental figure. c. 1885. Painted enamel. H. 16½″. Hand-painted glass slides cost as much as $4.00 a dozen. (Private collection)

452 (below). Group of pottery pieces. Late nineteenth century. Stoneware bank in the shape of a beehive. Sewer tile baseball. Stoneware bank in the shape of a tall beehive, H. 6″. Stoneware miniature bank with blue decoration. Stoneware bank in the shape of a beehive. (Mr. and Mrs. Charles V. Hagler)

353 (above). *The Barefoot Boy*. Chromolithograph after a painting by Eastman Johnson. Published by L. Prang & Co., Boston. 1866–1867. H. 13″. The Prang firm was one of the first and most successul to utilize a chromolithographic four-color process. The firm atered to popular taste and produced many sentimental prints. (Tony Orlando)

354 (right). Sled. Maine. 1880s. Mahogany and curled maple. L. 45″. The original painted decoration includes a ship with both steam and ail capabilites. (Mr. and Mrs. Dean A. Fales, Jr.)

LINEN KILT SUITS.

From 2½ to 6 years.

One-piece linen kilt like engraving, and several other new and very stylish designs.

Plain, fancy blue or brown striped linen drilling, $1.75 1.85 2. 2.15 2.35 2.50 2.75

White Marseilles and Piqué, 3.85 4.50

No. 14

SHIRT WAISTS.
From 4 to 12 years.

No. 15

15 Colored: .20 .50 .56 .75 1. 1.10 1.25 1.50
White: .43 .67 1. 1.25 1.50 1.75 2.
Waists under 1.00 are made no larger than for boys of 10 years.

BOYS' HATS.

In ordering, please state color, material, and size.

SCALE OF MEASUREMENT.

Size,	6	6⅛	6¼	6⅜	6½	6⅝	6¾	6⅞	7
Inches around head,	19	19⅜	19¾	20⅛	20½	20⅞	21¼	21⅝	22

DERBY.

No. 1
Fine wool felt, $1.25 to 1.50
Fur felt, 1.75 to 2.50

SOFT HAT.

No. 2
Wool felt, $1.00 to 1.75
Fur felt, 2.00 to 2.50
Colors in wool and fur hats, blue, black and beaver.

TURBAN.

No. 3
Wool felt, $1.00 to 1.50
Fur felt, 2.00 to 2.50
Straw turban, 1.25 to 2.50

STRAW HAT.

No. 4
$0.75 to 1.50; 1.75 to 3.00

STRAW HAT.

No. 5
$1.00 to 1.50; 1.75 to 2.50
Colors in straw hats, tan, brown, blue and fancy mixed.

STRAW HAT.

No. 6
$1.00 to 1.50; 1.75 to 2.50

455 (left). Page from a catalogue publish by Lord & Taylor, New York City. 188 Boys today would be mortified at the pr pect of wearing the linen kilt illustrated this early advertisement. (Private collectio

456 (below). *Girl with Hoop.* 1850–18 Oil on canvas. H. 36¼". Almost every V torian child owned a stick and a hoop. (Ab Aldrich Rockefeller Folk Art Center)

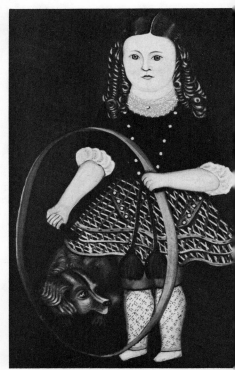

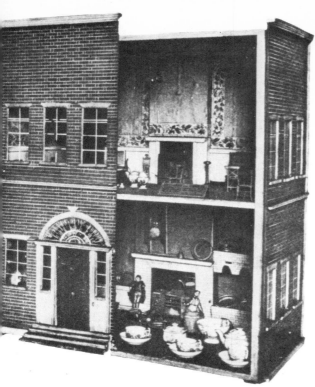

457 (left). Dollhouse owned by Queen Victoria. It seems likely that Queen Victoria had other dollhouses in addition to this modest example, for it is known that she owned 132 dolls. (Victoria and Albert Museum)

458 (below). Doll's bed attributed to Alexander Roux, New York City. c. 1853. Ebonized wood. H. of bedpost 11¼". H. of canopy post 20½". Attributed to Roux on the basis of other furniture known to have been made by him for the same family, this is a splendid example of Victorian cabinetwork in miniature. Photograph courtesy Frederick Di Maio: Inglenook Antiques.

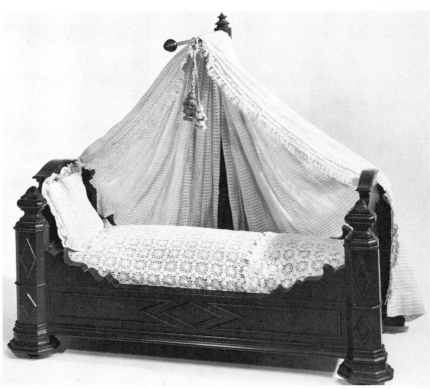

459 (above). Window of the Hadley Toy Shop in the Street of Shops at the Henry Ford Museum, Dearborn, Michigan. Doll dishes were made by many Victorian manufacturers of tableware. Late in the Victorian period painted tin doll dishes became popular as well. (Courtesy of Henry Ford Museum.)

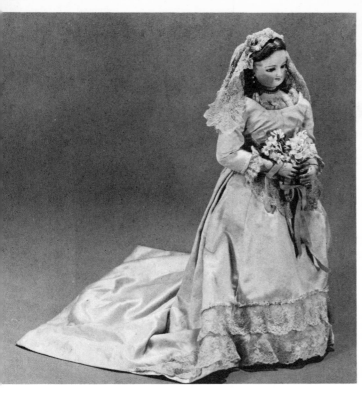

460 (left). Jumeau bisque-head doll. French. 1870s. H. 17". Many young girls were given imported dolls. Those with bisque heads like this example usually had a kid body and jointed wooden arms. (Cincinnati Art Museum; Gift of Miss Elizabeth Kellogg)

461 (below). Mechanical walking dolls. Late nineteenth century. Mechanized toys were always very expensive. (Greenfield Village and Henry Ford Museum)

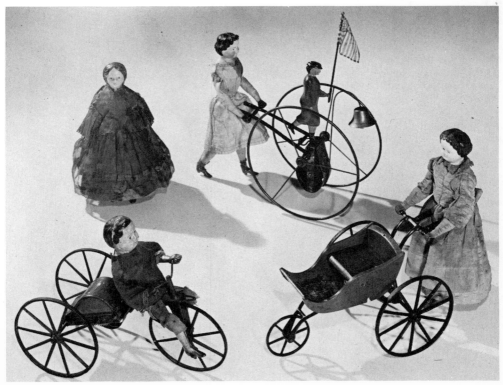

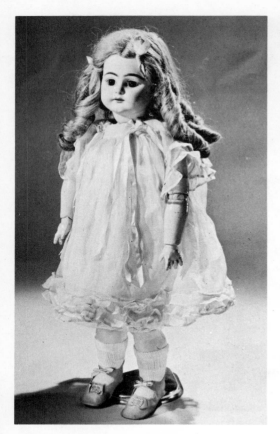

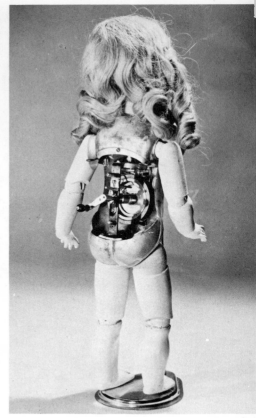

462 (above, left and right). Talking doll. Manufactured by the Edison Phonograph Works, Orange, New Jersey. First patented December 4, 1888. H. 24″. This child's toy contains a phonograph mechanism that is operated by cranking a handle. The records are interchangeable and this particular doll plays "Twinkle, Twinkle, Little Star." The *Scientific American* for April 26, 1890, had a front page of drawings illustrating the doll, clothed and unclothed. The doll has a china head, a metal body, wooden arms and legs and could be purchased fully clothed with dress, cape, hat, stockings, and shoes. (Greenfield Village and Henry Ford Museum)

463 (right). Dollhouse made by R. Bliss Manufacturing Co., Pawtucket, Rhode Island. c. 1890. Wood covered with lithographed paper. H. 26¾″. The walls of this dollhouse in "Queen Anne" style are hinged, and the isinglass windows have tiny curtains of real lace. (The Margaret Woodbury Strong Museum)

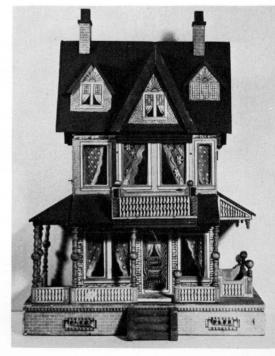

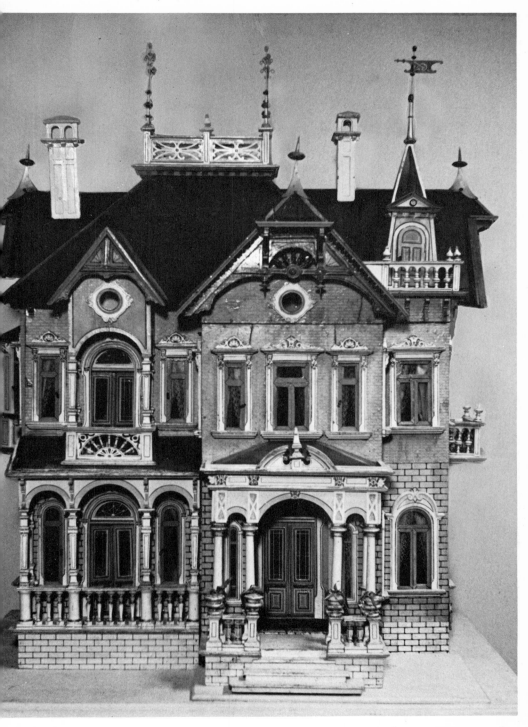

464 (above). Dollhouse made in Germany for the American market. c. 1880. Wood covered with lithographed paper. H. 54½″. This is not just a dollhouse, it is a veritable dolls' mansion! (The Margaret Woodbury Strong Museum)

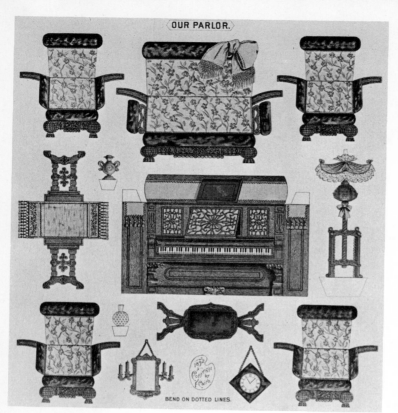

465 (left). Cardboard parlor furniture manufactured by F. Cairo. 1892. The designs of the furniture on this cardboard sheet indicate the prevailing taste. These pieces were intended to be cut out and assembled by a little girl. (Private collection)

466 (below). Humpty Dumpty penny bank manufactured by Shepard Hardware Co. 1882. H. 7″. The clown depicted by the bank was a highly popular character created by a famous nineteenth-century pantominist. (Private collection)

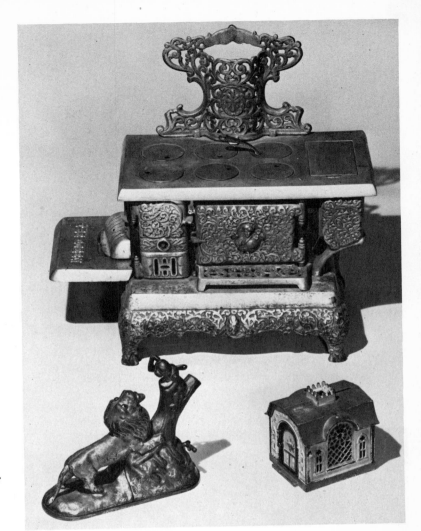

467 (above, right). Cast-iron toy stove, stationary bank, and mechanical bank. In 1892 a similar Jewel toy range sold for $7.50. Mechanical banks are much rarer than the stationary types. (Greenfield Village and Henry Ford Museum)

468 (right). Child's thimble. 1857. Silver. H. ⅞" Made by Samuel Bell, San Antonio, Texas, for his daughter Margaret. It is still accompanied by a small paper box with label marked "J. G. & D. Bell, Manufacturers & Dealers in Jewelry, Silver-Ware, Watches, &c. San Antonio, Texas." (Mrs. William Clegg; photograph courtesy *Antique Monthly*)

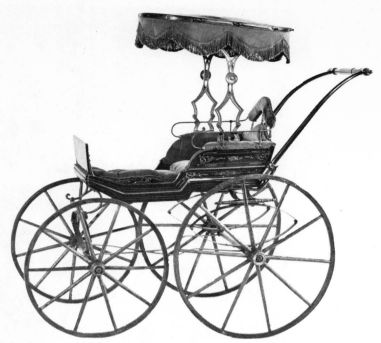

469 (above). Baby buggy. c. 1875. L. 52″. The canopy has an elaborate fringe and painted decorations outline the shape of the body. (Greenfield Village and Henry Ford Museum)

470 (below). Child's coat in hand-embroidered white cotton. c. 1870. Length, collar to hem, 21½″. It was a patrician child of the Hudson River Valley who owned this example of minute elegance. Photograph courtesy Kelter-Malcé Antiques. (Private collection)

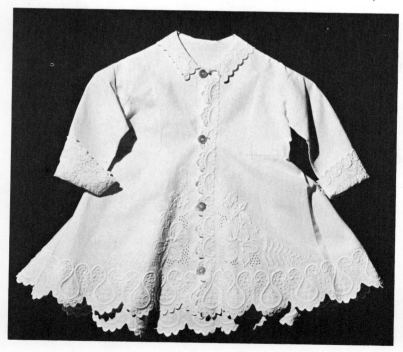

471 (right).
Paper cutout
made by John
Walker Brown.
Michigan. 1882.
11½" x 7⅜". This
whimsical cutout
celebrates the
birth of "Mr. C.
L. Long Born
Nov. the 13.
1881" shown in
the oval photo-
graph. (Green-
field Village and
Henry Ford Mu-
seum; Gift of Mr.
Rex Lamoreaux)

472 (below).
Child's coat deco-
rated with bright
patches of mate-
rial. c. 1860.
Length, collar to
hem, 12". Joseph
seemingly was of
humbler back-
ground than the
child whose coat
is shown oppo-
site, but his is just
as captivating.
(America Hurrah
Antiques, N.Y.C.)

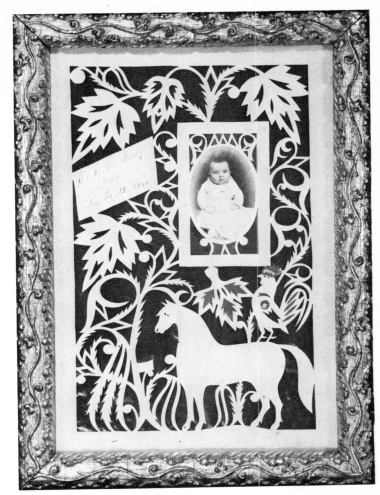

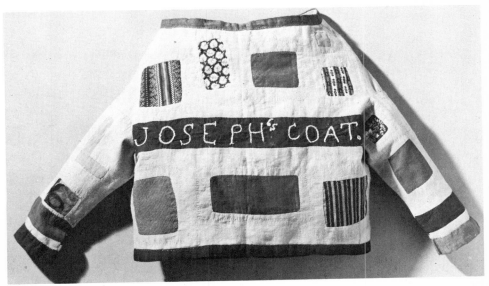

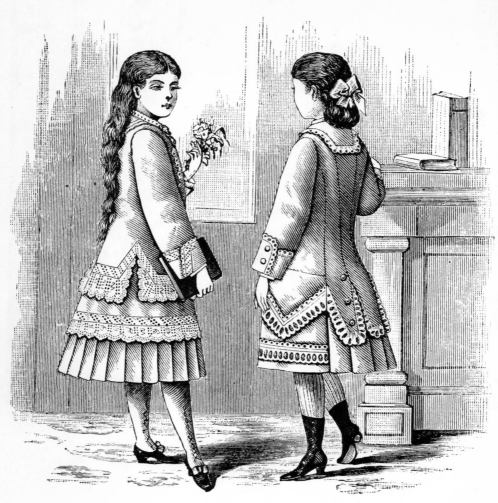

No. 7. No. 8.

7 Piqué, two-piece suit: plaiting of material on skirt with ruffle of embroidery and insertion above; jacket with vest front trimmed with embroidery to match skirt.

| 8 years, $6.25 | 12 years, 7.50 |
| 10 7.00 | 14 8.00 |

8 Piqué, princess dress: double-breasted, trimmed with embroidery on each side of front; back made to form a jacket.

| 4 years, $4.25 | 8 years, 5.00 |
| 6 4.50 | 10 5.50 |

473 (above). Illustration from a catalogue published by Lord & Taylor, New York City. 1881. (Private collection)

474 (below, left). *The Christmas Tree,* an illustration from the December 1850 issue of *Godey's Lady's Book,* shows a Victorian family gathered about a traditional tree. Pennsylvanians seem to have been the first in America to trim a tree during the Christmas season with paper cornucopias, marzipan cakes, and candle cups. (Private collection)

475 (above, right). Letter from Edsel Ford, son of Henry and Clara Ford, to Santa Claus, dated December 24, 1901. Edsel would have been eight years old at the time this letter was written. (The Ford Archives, Henry Ford Museum)

476 (below, right). Blown-glass Christmas tree ornament. c. 1900. L. 8½". Early Christmas tree ornaments are popular with modern collectors. (Greenfield Village and Henry Ford Museum)

477 (above). Interior of a one-room school, c. 1858, furnished with desks and chairs mounted on cast-iron bases. This type of desk replaced those with plank tops and seats in many rural schools. (Greenfield Village and Henry Ford Museum)

478 (above). *The Wonderful Wizard of Oz,* written by L. Frank Baum and published by George M. Hill Co., Chicago, Illinois. The first edition of this book was published in 1900 and was illustrated by W. W. Denslow. It was an instant success and has remained in print ever since. (Greenfield Village and Henry Ford Museum)

479 (above). *The Great Race on the Mississippi*. Lithograph published by Currier & Ives, New York City. 1870. 18½" x 29". The famous race on the Mississippi between the steamers *Robert E. Lee* and *Natchez* began at New Orleans on June 30, 1870; only four days later the victorious *Lee* arrived at St. Louis. Such ships not only served as conveyors of freight, but provided luxurious transportation. Many of them were fitted out as pleasure palaces as well. (Kenneth M. Newman, The Old Print Shop)

PLEASURES AND PASTIMES

Amusements during the seventeenth and eighteenth centuries were few in comparison to those in the Victorian era, when the proliferation of special parks and pleasure palaces provided an unprecedented opportunity for diversion.

The popularity of the amusement park in Victorian America reflected major social changes. The Industrial Revolution brought better transportation, which made it easier for people to travel farther to enjoy their leisure time. It also provided new machinery to power mechanized rides, such as carousels, which became immensely popular at the close of the nineteenth century.

American fascination with the carved, wooden "flying horses" was possibly an extension of equestrian interests. Horse racing, steeplechasing, fox hunting, and polo were but a few of the popular sports. By 1875 the now-famous Kentucky Derby had begun. This grueling mile-and-a-quarter course soon became the most glamorous and famous horse race in America.

During the Late Victorian period there developed a large upper class based on recently acquired wealth. These nouveaux riches delighted in any sport that would allow them the opportunity of visibly displaying their financial success. Flashy clothes and elegant carriages, buggies, and sleighs drawn by handsome horses were familiar sights in every town and city. Toward the end of the century Washington, D.C., remained a provincial city devoid of social amenities; however:

> the women made calls . . . assiduously . . . Distances were so great that a sort of zoning system, partly geographical and partly official, had been devised to save time. Cabinet ladies received on Wednesdays; wives of representatives on Tuesdays, senators' wives and the residents of Georgetown on Thursdays; the ladies of the Supreme Court and other courts and residents of Capitol Hill on Mondays. Visiting hours were from two o'clock until five. The few street-car lines were a help, but their routes were not comprehensive, and the cars themselves, in winter when windows rattled and the floors were covered ankle-deep with straw, were neither comfortable nor clean. Frugal ladies therefore combined to hire a carriage from their favorite liveryman, and wrapped in velvet dolmans or India shawls and furs, went forth together on conscientious rounds. If there happened to be a vacant seat in the carriage a little daughter might be taken along for the outing and left, with a book, to while away the time that her elders were indoors. Many a child received her first impression of Washington society as a mingling of frosty February air, "best" dresses, dust blowing in clouds along sunlit streets, darky drivers jockeying for positions in front of official residences, fragments of grown-up gossip, and doors opening and closing upon groups of well-dressed people.[1]

Perhaps the August 1884 issue of *Godey's Lady's Book* reveals the changes in popular diversion more than any other primary document. Mlle. Bon Ton reports,

Coaching has become so common that one hardly thinks of mentioning that. Ladies have grown so fond of it, that they will not hear to riding inside, unless they be old or invalided. Seats with the postillion are coveted, and now and then you will find some spirited girl who carries the horn herself. To drive a coach and four is the high ambition of such young women, who generally distinguish themselves by sporting the ribbons of a drag or dog-cart, or reining up a tandem, whenever occasion permits. It is a common thing at this season to see a girl in gay costume with a jaunty hat, long mousquetaire gloves and a fluttering knot on her shoulder, handling the reins, while the favored owner of the vehicle holds over her head a red parasol, and waves with a devotional air a brilliant-hued Japanese fan.

Then there is horseback riding, which has of late years risen to such great popularity as to amount almost to a craze. Every city has its riding-schools, and it is held a part of every girl's education that she turn out a fair equestrienne, even if she cannot boast of a mount she can call her own. To ride after the hounds is the ambition of most young women who ape the English aristocracy and hail with delight the advent of the fox-hunt in this country. We have a number of clubs already, but it is not at all likely that this rather cruel and reckless sport will ever be pursued in America with great success. We haven't the right to ride rough-shod over our neighbors' lands, breaking down their fences, trampling through their wheat and corn-fields, and sacrificing all respect for property in the hot pursuit of a poor, terror-stricken beast, that flies for its life before a troop of hallooing riders, who are hunting him down for mere sport. Still we have some fox-hunting, and the ladies affect it largely. One of the most brilliant "affairs" lately given by our modern Beau Brummels was a Hare and Hound's Ball at which all of the ladies appeared in their habits, the skirts being prettily kilted up over gay petticoats. The gentlemen were all in top-boots and velvet coats, wearing the various emblems of the sport. The room in which the Ball was given, was hung with horse blankets and saddle-cloths, festooned with pretty harness and ornamented with artistic groups of saddles, whips, gloves, jockey caps, and what not. The repast that was served on this occasion took up the pre-vailing idea. There were horses and hares, hounds and foxes modeled out of colored ices, of pastry and confections, forming most superb *pieces montées*. The favors were beautiful trinkets such as silver spurs, horseshoe pins, whip handles and other riding toggery.

Tennis and archery and all that sort of thing is a tame kind of diversion, only to be indulged in when active sports are out of the question. Among the dear delights of the young women of the period let us reckon pedes-trianism. Walking clubs are among the popular organizations this summer.

A coaching club is more or less of an expense, but the highways are free to foot-passengers. A number of clubs composed entirely of young ladies have been organized for brief summer rambles of a day's duration. The costume adopted is usually a rough-and-ready mountain suit, with a helmet hat, stout shoes, perhaps of alligator skin, with a small knapsack and walking stick. When the party is formed for a tour through the mountains or the lakes, there is usually an addition of gentlemen and chaperones. The gentlemen adopt a knickerbocker costume, which is found to be of service also in "wheel parties" or bicycle meets. (Call it bi-sigh-cle, not bi-sick-le, please). The tricycle is rapidly coming into favor, being largely used in the parks, where the double-seated ones are ridden by ladies and gentlemen in company. There are single-seated ones, however, in which ladies ride at ease, either alone or with a companion bicycle. There is very little skill required in the management of a tricycle. A loose costume and a broad-brimmed hat comprise the only equipment necessary. After the tricycle comes the swimming suit, the extremely abbreviated garments which take the place of a bathing-dress. It is quite as high an accomplishment to swim well as to ride well, and the natatoria are patronized by the most elegant ladies, who frisk about in picturesque suits of China silk prettily made and ornamented. Bathing at the seashore, unless one swims, is rather slow, at least so the energetic young damsel of the period thinks, and her opinion generally rules the fashion.[2]

Although less vigorous, Victorians adored indoor amusements as well. No game or pastime, not even cards, enjoyed the popularity of the musicale, occasionally accompanied by dancing. Because Americans were so fond of music there developed a very sophisticated group of musical instrument manufacturers. By 1862 they had managed to surpass European makers at every international exhibition for a period of thirty years. The American firms of Chickering and Steinway were singled out by many who considered their pianos superior to those manufactured by Broadwood of London, whose pianos often cost over $6,000.

Albert S. Bolles reported in his *Industrial History of the United States* (1892) that by 1870 there were 156 piano factories in the United States, employing some 4,200 workmen and producing 24,306 pianos worth $8,330,000. By the time his book was published, the number of factories had not increased, but the production had nearly doubled.

Bolles claimed the cabinet organ was an American invention and maintained that it had sprung from the accordion. Like most American musical instruments, they were manufactured at either New York City, Boston, or Philadelphia, the undisputed centers for the production of such pieces.

Nearly every American Victorian of the middle and upper classes was expected to possess an education of at least "respectable duration" and to support, even if not understand, the arts. National literacy grew as education became integrated into the daily lives of the people. With the increased interest in read-

ing, the vogue for book collecting, both personal and institutional, grew. By the opening of the Victorian period The Library of Congress contained over 35,000 volumes. The sum of $5,000 was annually appropriated for the acquisition of new titles that included numerous imported books.

Augustus James Pleasonton, a disgruntled taxpayer and congressional critic, lamented, "Many books of this library are much injured by the members of Congress and their families who take them to their lodgings and amuse their children with them. Books of prints of the most costly price have been plentifully smeared with honey, sweetmeats, and butter by these juvenile amateurs." [3]

When Anthony Trollope in the early 1860s recorded examining the rooms of America without finding books or magazines in them, he conceded that such a condition would also be true in England. He went on to praise the "signs of education" in the United States.

> Men and women of the classes to which I allude talk of reading and writing as of arts belonging to them as a matter of course, quite as much as are the arts of eating and drinking. A porter or a farmer's servant in the States is not proud of reading and writing. It is to him quite a matter of course. The coachmen on their boxes and the boots as they sit in the halls of the hotels, have newspapers constantly in their hands. The young women have them also, and the children. The fact comes home to one at every turn, and at every hour, that the people are an educated people. The whole of this question between North and South is as well understood by the servants as by their masters, is discussed as vehemently by the private soldiers as by the officers. The politics of the country and the nature of its constitution are familiar to every labourer. The very wording of the Declaration of Independence is in the memory of every lad of sixteen. Boys and girls of a younger age than that know why Slidell and Mason were arrested, and will tell you why they could have been given up, or why they should have been held in durance. The question of the war with England is debated by every native paviour and hodman of New York. [4]

America's high degree of literacy produced keen interest in new editions of books. In 1861 Charles Sumner (1811–1874), a distinguished member of the Senate and of the American Antiquarian Society, proposed that books that had been printed thirty years before or earlier should be admitted free of duty. A colleague from Oregon advanced the opinion that

> a new edition of a book (of Shakespeare for example) is better than any old one, and that a man who is fool enough to pay a great price for what can be had for a small one ought to pay the duty. In this opinion *a senator from North Carolina* concurred; and not only advanced the theory, that, "if all the books one hundred years old were destroyed, no valuable knowledge would be lost," but declared that "there is nothing in an old book, of any value, that has not been republished in our own time." *A senator from*

Missouri also was clear, that "if a work has been published thirty years, and has not been introduced into the United States, it is sufficient evidence that it is not fit to come here," and that, if introduced, "the reprint here is better than the original print in the foreign country"; adding some remarks not complimentary to the good sense of those who pay high prices for old manuscripts and original editions.[5]

American theatre, prior to the Victorian era, had been rather elementary. Even as late as 1876 knowledgeable critics of *Conscience*, a new play presented at New York's Union Square Theater, grumbled, "If it fails to really add anything to the fame of the American drama, it at least contributes nothing to its disgrace—and in view of the past history of our stage this is a good deal to say. 'Conscience' is commonly free from the rawness and crude vulgarity of the ordinary American comedy. There is little originality in any of the characters, but they have considerable fidelity to Nature; and the people talk and conduct themselves very much as they do in our average social life." [6]

The Victorian love of melodrama carried over into the motion-picture industry, which was in its infancy at the opening of the twentieth century.

480 (below). *A Disputed Heat*. Lithograph published by Currier & Ives. Printed by Heppenheimer & Maurer. New York City. 1878. 17¾" x 26¾". Both running and trotting races were popular during the Victorian period. (Kenneth M. Newman, The Old Print Shop)

481 (right). *A "Crack" Sloop in a Race to Windward.* Lithograph published by Currier & Ives. New York City. 1882. 19″ x 28″. The yacht *Gracie*, featured in this print, was considered to be one of the most beautiful racing boats in all America. (Kenneth M. Newman, The Old Print Shop)

482 (below). An ocean steamer stateroom installed in the White Star Building at the World's Columbian Exposition in Chicago in 1893. The official catalogue for the exposition noted: "Here we find a room, dainty in its appointments, no waste of space, yet everything in most excellent taste. The handsome brass bedstead, with its accessories of fleecy pillows and lovely spread; the port-holes draped with prettiest creton, the flowers on the stand, and the easy-chair so inviting in its roominess, are all evidences that Neptune has been dethroned, and that, in the very heart of his realm, the sovereign genius of man reigns supreme." [1] (Private collection)

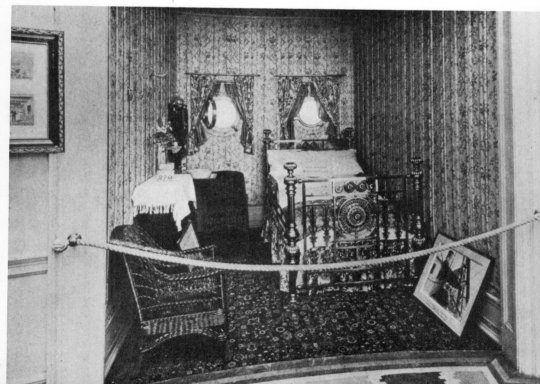

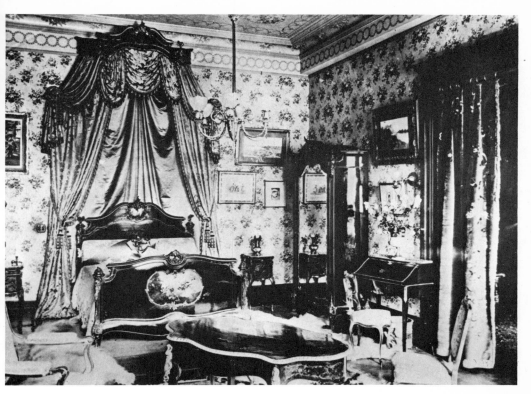

483 (above). A bedroom suite in the old Waldorf Astoria Hotel, Fifth Avenue and Thirty-fourth Street, New York City. c. 1900. Very different indeed from what one would find today! (Museum of the City of New York)

484 (left). *A Summer Outing.* Chicago. c. 1880. Oil on canvas. W. 43¾". As well as being a means of transportation, horse-drawn open buggies were a source of great pleasure. Here are several forms of amusement— children swinging, a boy with a hoop, and boys fishing. (Greenfield Village and Henry Ford Museum)

485 (left). *An Afternoon Gossip*, artist unknown. 1894. Oil on canvas. 15⅛" x 11¼". The pleasure of good company is charmingly expressed in this painting. (Private collection)

486 (below). Illustration of a sleigh exhibited at the London Crystal Palace in 1851, taken from the *Art Journal Illustrated Catalogue, The Industry of All Nations,* published by George Virtue, London, 1851. Many American firms exhibited at this first international exposition. J. Goold and Company of Albany, New York, displayed this handsome piece with runners terminating in bird's heads. The strings of bells would add an air of gaiety to any outing. (Private collection)

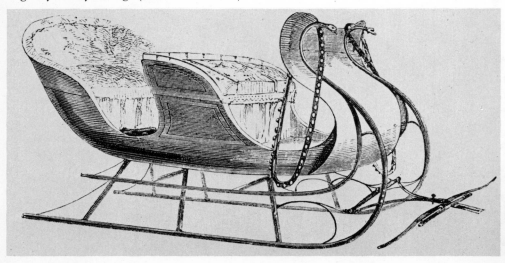

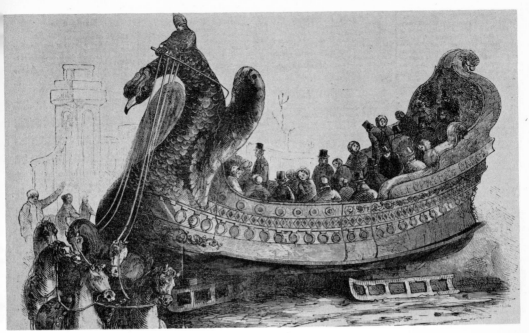

487 (above). "Ward's Celebrated Cleopatra Barge, with a Sleighing Party," wood engraving from *Gleason's Pictorial*, Boston, Massachusetts, January 31, 1852. The pleasure given by "Cleopatra's Barge" evoked the following comment in the *Pictorial*: "This magnificent barge sleigh is probably one of the finest and largest constructions of the kind in the world, and when drawn by eight spirited horses, with jingling bells, and well filled with a merry freight, it presents a most stirring and lively picture. . . ." (Private collection)

488 (below). Pleasure Carriage manufactured by Messrs. Laurence & Bradley, New Haven, Connecticut, and exhibited at the New York Crystal Palace in 1853. Illustration taken from *The World of Science, Art and Industry Illustrated* published in New York in 1853. Ambitious Victorians were forced by social pressures to trade-in carriages that were no longer stylish, much as cars are traded-in today. (Private collection)

489 (left). Steam carriage built by Sylvester R. Roper. Rochester, New York. 1863. L. 100". This is the oldest fully operative car in America. It was exhibited in country fairs during the 1860s where it was pitted against racehorses. It frequently won! (Greenfield Village and Henry Ford Museum)

490 (below). Duryea Motor Wagon made by the Duryea Motor Wagon Company, Springfield, Massachusetts. 1896. Four-horsepower, one-cylinder engine. Weight 750 lbs. L. 90". In 1896 the Duryea car was on display in Barnum and Bailey's Circus, where it could be seen in every street parade. It won the first prize in the Times-Herald Race in 1895 and in the Cosmopolitan Race on Decoration Day, 1896. It also won the Emancipation Day Run from London to Brighton, England, on November 14, 1896. The car rolled on high wheels with iron bands, noisily, uncomfortably, but definitely into American automobile history. Thirteen cars were originally built. This is the only remaining specimen of America's first production car. (Greenfield Village and Henry Ford Museum)

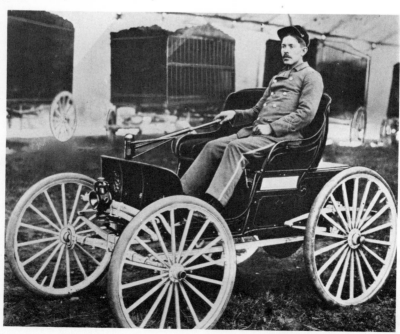

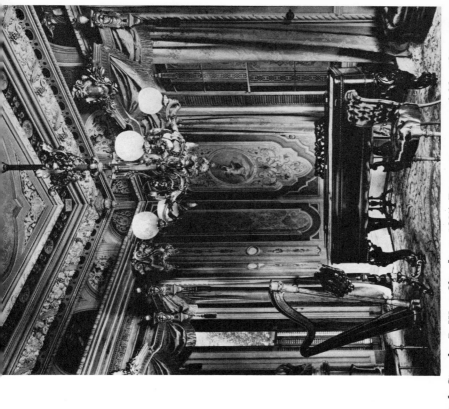

491 (above, left). Painting of West Drive in Central Park, New York City, by B. West Clinedinst. 1895. Dimensions unavailable. This spring venture for New York's elite gave them the opportunity of sporting their new riding costumes. By the mid-1890s the safety bicycle had replaced the more difficult high-wheel bicycle. In the background is a statue of Daniel Webster. (Museum of the City of New York)

492 (above, right). The music room of the Victoria Mansion, Portland, Maine, built in 1859. Few American homes of the period were more sumptuous in their appointments. A separate room was provided for nearly every social activity. The "square" piano is in the Rococo Revival style. (Victoria Mansion)

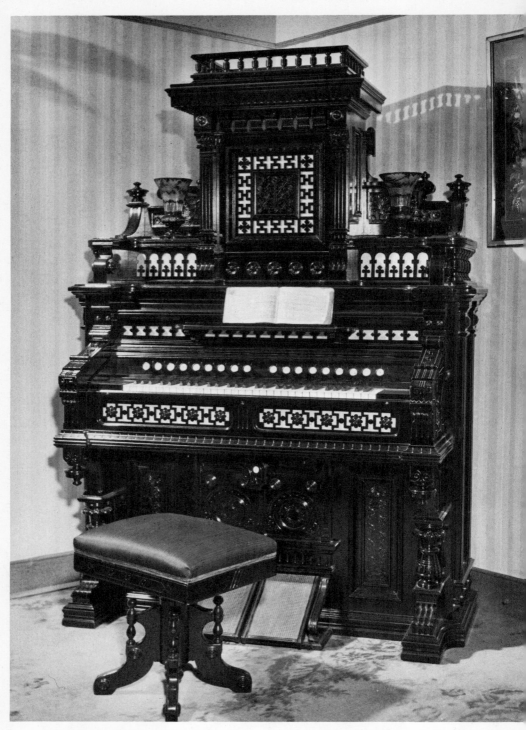

493 (above). Organ manufactured by J. Estey and Company, Brattleboro, Vermont. c. 1860. H. 79″. The use of tiny turned spindles, incised lines, pierced fretwork, and applied rosettes all relate this piece to the American Eastlake style. (Greenfield Village and Henry Ford Museum)

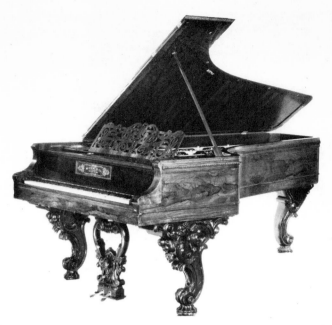

494 (above). Grand piano manufactured by Wm. Knabe & Co., Baltimore, Maryland. c. 1870. Rosewood, oak, pine, and iron. L. 100″. Although this piano dates from after the popularity of the Rococo Revival, the legs and the pedal support are in that style. It is interesting that piano manufacturers used the Rococo Revival style throughout much of the nineteenth century. (Greenfield Village and Henry Ford Museum)

495 (below). Upright piano made by Wm. Knabe & Co. Baltimore, Maryland. c. 1890. Rosewood, maple, mahogany, oak, pine, and metal. H. 57″. The inlay on this "Gold Medal" piano is especially handsome. (Greenfield Village and Henry Ford Museum)

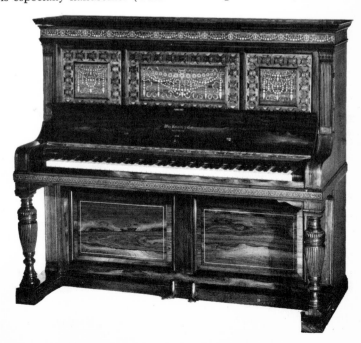

496 (above). Music sheet for *On the Sea Shore* published in 1884. Fashion dictated that even though he was strolling at a seaside pavilion, a gentleman must be dressed in a suit and tie, and the bustled ladies seldom revealed their bare arms. Risqué indeed were the plump ladies frolicking in the ocean. (Greenfield Village and Henry Ford Museum)

497 (right). Music sheet for the *Merry-Go-Round March* published by The S. Brainard's Sons Co., Chicago, Illinois. 1895. In 1825 the Common Council of Manhattan Island, New York, granted John Sears a permit to erect a covered circus for a flying-horse establishment. At first merry-go-rounds were turned by a horse, later they were propelled by steam. (Greenfield Village and Henry Ford Museum)

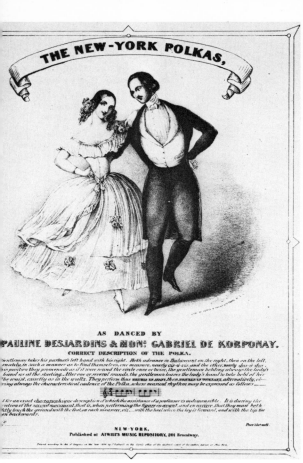

The New-York Polkas,

AS DANCED BY
PAULINE DESJARDINS & MON: GABRIEL DE KORPONAY.
CORRECT DESCRIPTION OF THE POLKA.

NEW-YORK,
Published at ATWILL'S MUSIC REPOSITORY, 201 Broadway.

498 (left). Music sheet for *The New-York Polkas,* published by Atwill's Music Repository, New York City. 1844. Although some Victorians considered dancing frivolous and even dangerous because of the close physical contact with the opposite sex, the amusement flourished in major cities as well as in the country where contredances and square dances were especially popular. (Greenfield Village and Henry Ford Museum)

499 (below). Music boxes. *Left:* Symphonion, patented in 1886 by Paul Lockman of Leipzig, Germany; *center:* Regina music box, made in Rahway, New Jersey, the first type of American music box made; *right:* Olympia music box, marketed by Sears, Roebuck & Co. Prior to the 1890s very few music boxes were made in America. Most of them were imported from Switzerland, Germany, and England. (Greenfield Village and Henry Ford Museum)

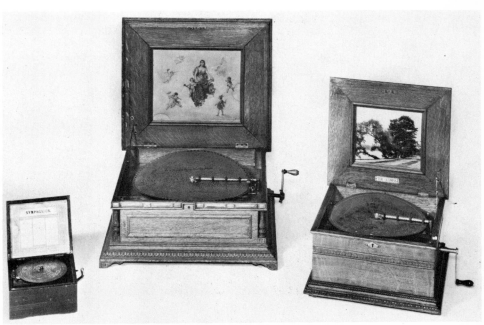

500 (left). Photograph o
Joseph Henry's library
c. 1860. Throughout the
early nineteenth century
New England was a hot
bed of literary efforts. By
the 1860s New York had
become the center of the
American publishing in
dustry. Any man of mean
and pretension felt it nec
essary to have a well
stocked library. The Henry
library is especially inter
esting, for it contains both
a wicker rocking chair and
an Elizabethan Revival
side chair. The desk i
lighted by a gas lamp fed
by a flexible rubber hose
from the chandelier above
(Smithsonian Institution)

501 (below). Magazine rac
in the Renaissance Revival
style. c. 1870. H. 31½".
Fashioned from handsome
veneers, gilt-and-ebonized
wood, and floral inlay, this
rack made a useful and
stylish addition to a
Victorian drawing room.
(Frederick Di Maio:
Inglenook Antiques)

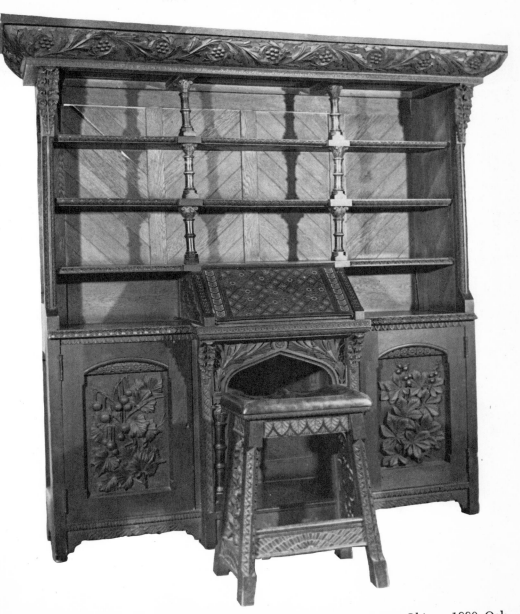

502 (above). Secretary-bookcase. Made by Benn Pitman. Cincinnati, Ohio. c. 1880. Oak. H. 60¼″. Pitman constructed his secretary-bookcase in the prevailing Eastlake style. He is best known as the man who developed the Pitman system of shorthand. (Cincinnati Art Museum; Gift of Melrose Pitman)

503 (right). *The Token or Affection's Gift*. Book with papier-mâché cover decorated with multicolored lacquers and inlaid mother-of-pearl. 1857. H. 7⅜". (Mr. and Mrs. Charles V. Hagler)

504 (below). Autograph book. Ohio. 1887–1893. Embossed paper with gold decoration. L. 5¼". The fad for collecting autographs reached a zenith during the Late Victorian period. A friend inscribed the following verse: "May your life be long and happy, May your sorrows be but few, May you find a home in Heaven, When your earthly task is through." Another sentimental friend, several years later, after the owner of the book had died, wrote: "Dear Nora, Almost 4 years since thy hand these pages turned, But in my memorie you linger yet, and as I scan these pages o're It makes me sad to think I will see you on Earth no more but Hope to meet you on that Bright Shore where Friends will meet to part no more." (Patricia Coblentz)

505 (above). Designs for needlework covers for card tables from *Beautiful Homes* by Henry T. Williams and Mrs. C. S. Jones, published in New York, 1878. (Greenfield Village and Henry Ford Museum)

506 (below). Photograph of a balloon ascension. Late nineteenth century. (Mr. and Mrs. David Claggert)

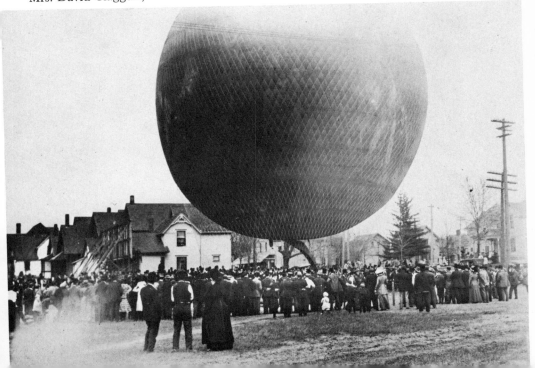

507 (left). *A Critical Move* by Frederick Waugh. Lithograph published by Carson & Simpson in 1892. L. 15½". One of the young ladies sits in a woven cane chair. A Japanese-inspired fan lies on top of the newspaper. Checkers and chess were especially popular games during the nineteenth century. (Patricia Coblentz)

508 (below). China-painting materials produced in the United States, England, and France. c. 1890. These supplies, consisting of oil paints, brushes, spreaders, needles, salt dips and a porcelain palette, were used by Nellie Bonham Foreman and her sister, May L. Foreman, of Charlotte, Michigan, to decorate blank pieces of porcelain. (Greenfield Village and Henry Ford Museum)

509 (right). Parian porcelain vase designed by Isaac Broome at Ott & Brewer Co., Trenton, New Jersey. 1876. H. 32". Baseball first appeared in the 1830s. It remained an amateur pastime until 1876 when the National League of Professional Baseball Clubs was organized. (New Jersey State Museum Collection)

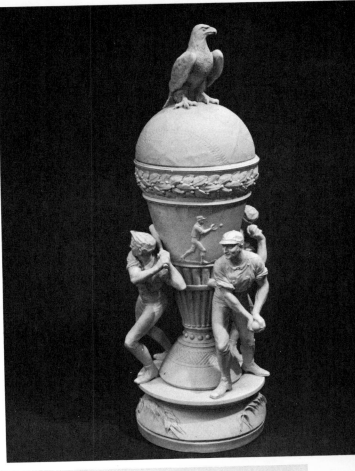

510 (below). "Pillow-Dex Tennis," racquet-and-ball game copyrighted 1897 by Parker Brothers, Salem, Massachusetts. Note the wicker chair in the foreground of the illustration being used to help support the net for this "healthful" parlor sport. Photograph courtesy America Hurrah Antiques, N.Y.C.

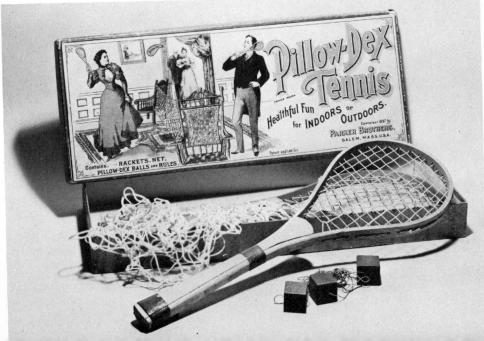

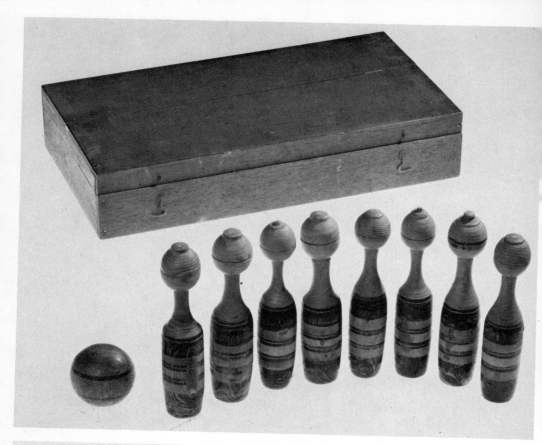

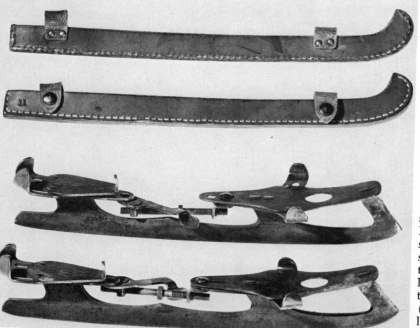

511 (above). Game of tenpins. c. 1900. Wood. H. of pins 7". Bowling and similar games of skill were first popular in New York during the seventeenth century. (Greenfield Village and Henry Ford Museum)

512 (left). Ice skates. c. 1890. L. 12½". These steel clamp-on skates were protected by the leather guards between outings. (Greenfield Village and Henry Ford Museum)

513 (left). Lithograph of Jenny Lind. Davignon & Vollmering, lithographers; L. Nagel, printer; J. F. Atwill, publisher. New York City. 1847. H. 11¼″. Jenny Lind was one of the most popular entertainers of the Victorian era. Her performances on concert tours across the United States in 1850 and 1851 were often sold out. (Greenfield Village and Henry Ford Museum)

514 (right). "These splendid specimens of Oriental beauty" were dancers at the Egyptian Theatre at the World's Columbian Exposition. The illustration is taken from *Shepp's World's Fair Photographed* by James W. and Daniel B. Shepp, published by the Globe Bible Publishing Co., Chicago, Illinois, 1893. Many visitors to the fair were scandalized by the dancers' attire; however, the Shepp brothers could not suppress their admiration: "The upper part of their bodies is covered with a light openwork garment, which gives free play to the muscles; no corsets have ever imprisoned their natural waists . . . over this garment strings of pearls and bright bangles fall, and bracelets of jingling coins clasp their wrists; the skirts are of some satiny material, usually in one color, red, blue, yellow, white and green, and over them, parti-colored sashes fall from the waist." [2] The performer most people talked about when they returned home from the fair was Fahreda Mahzar, a sleek Egyptian beauty who had come to this country with a troup of Syrian dancers engaged for the "Streets of Cairo" at the fair. She was billed as "Little Egypt, the Darling of the Nile." (Private collection)

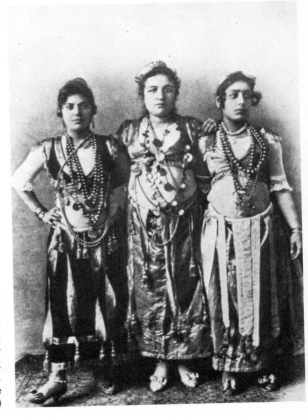

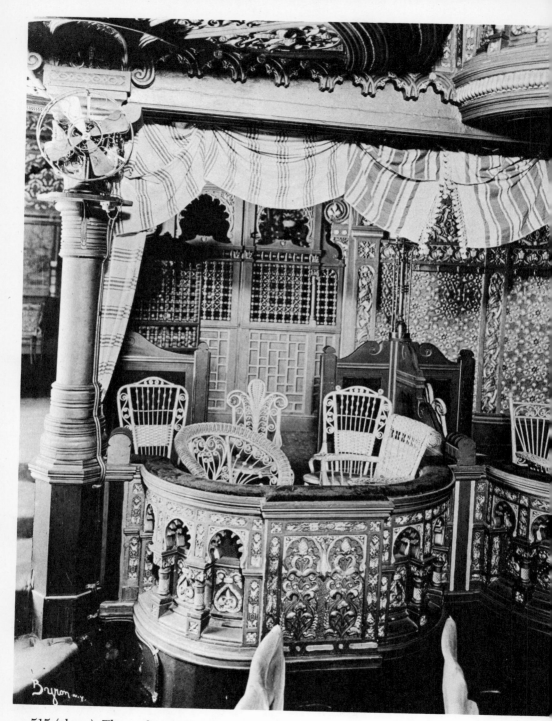

515 (above). The exuberant "Moorish" interior decor of the old Casino Theatre, Broadway at 37th Street, New York City, forms a backdrop for the equally elaborate wicker chairs in summer white. It is doubtful that the fan at the left, even in combination with many others like it in the theatre, gave much relief from New York's muggy summer heat. And what a noise they must have made! (Museum of the City of New York)

516 (above, left). Kinetoscope developed by Thomas Edison at the Edison Manufacturing Co., Orange, New Jersey. c. 1894. H. 44¾″. Thomas Edison received a patent for his kinetoscope, a forerunner of the motion-picture projector, in August 1887. His first motion-picture machine was a peep-show device in which the film ran between a light source and a magnifying lens. The pictures, viewed through a microscope, were generally unsatisfactory, but by 1894 enough improvements had been made to open a kinetoscope parlor on Broadway, New York City. (Greenfield Village and Henry Ford Museum)

517 (above, right). Stereoscope and viewers, made by the Hall and Garrison Company, Philadelphia. c. 1880. L. 23″. This combination stereoscope and viewer consists of a wooden case with a hinged lid, which, when open, supports a large round magnifying glass supported by two brass rods. The pictures were placed in the slot at the far end of the box and viewed through the eyepieces. (Greenfield Village and Henry Ford Museum)

518 (left). Circus poster for the Forepaugh & Sells Brothers' 20th Century Colossus Circus. Chromolithograph published by the Strobridge Lithographic Co., Cincinnati, Ohio. c. 1900. W. 30¾″. The first complete circus performance in America was presented by the John Bell Ricketts Company of Scotland on April 3, 1793. President George Washington attended the show on April 22 and was so fascinated that he returned many times. The circus continues to be a favorite entertainment for many Americans. (Greenfield Village and Henry Ford Museum)

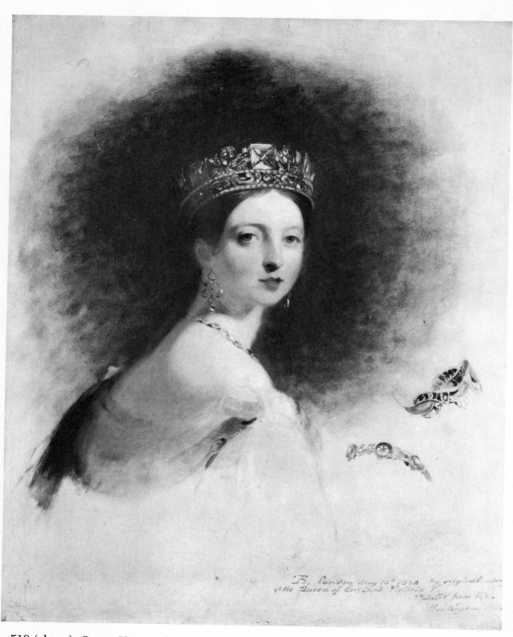

519 (above). *Queen Victoria* by Thomas Sully (1783–1872). 1838. Oil on canvas. 35¹⁵⁄₁₆″ x 28⁵⁄₁₆″. This painting is inscribed at the lower right with a monogram "TS" and "London May 15ᵗʰ 1838, My original study/of the Queen of England, Victoria 1ˢᵗ/Painted from life/Buckingham House"; on the back: "Victoria Queen of England/from her person/May 15 1838 London/Thos Sully." (The Metropolitan Museum of Art; Bequest of Francis T. S. Darley, 1914)

PICTORIAL ART

The down-to-earth, practical, Colonial Americans expressed their interest in art through the patronage of portrait artists; painters rarely found purchasers for landscapes.

At the close of the eighteenth century, history and romantic painting were imported from Europe; however, throughout the Early Victorian period American delight in portraiture continued.

In 1839 a German artist painting in America lamented:

> the Americans in general do not estimate genius. They come to me and ask what I want for my pictures, and I tell them. Then they say, "How long did it take you to paint it?" I answer, "So many days." Well, then they calculate and say, "If it took you only so many days, you ask so many dollars a day for your work; you ask a great deal too much; you ought to be content with so much per day, and I will give you that." So that, thought I, invention and years of study go for nothing with these people. There is only one way to dispose of a picture in America, and that is, to raffle it; the Americans will then run the chance of getting it. If you do not like to part with your pictures in that way, you must paint portraits; people will purchase their own faces all over the world: the worst of it is, that in this country, they will purchase nothing else.[1]

That same year there was much debate about proper attire for portrait sitters. Many artists and their patrons believed contemporary costumes and realistic settings appropriate; others leaned toward the "picturesque." Rembrandt Peale (1778–1860), well-known artist and author, declared:

> I have heard it disputed, whether a portrait ought to be habited according to the fashion of the times, or in one of those dresses which, on account of their elegance, or having been long in use, are affected by great painters, and therefore called picturesque. The question may be determined upon the principles here laid down. If you wish to have a portrait of your friend that shall always be elegant, and never awkward, choose a picturesque dress. But if you mean to preserve the remembrance of a particular suit of clothes, without minding the ridiculous figure which your friend will probably cut in it a hundred years hence, you may array his picture according to fashion. The history of dresses may be worth preserving: but who would have his image set up, for the purpose of hanging a coat or periwig upon it, to gratify the curiosities of antiquarian tailors or wigmakers?[2]

Although portraiture dominated American painting efforts during the Early Victorian era, at mid-century the landscape became a status symbol for rich patrons of the arts. The canvases of Thomas Cole (1801–1848) and his follower Frederic Edwin Church (1826–1900), the landscapes of the Hudson River School painters, and the panorama painters of the West all sang a hymn to America.

Contrasting with the homegrown painters celebrating the natural beauties of their homeland were the expatriates who traveled to Düsseldorf and other European cities where they learned the academic niceties through extensive formal training. With such experience they hoped to bring maturity to American art.

A few decades after the Civil War the American frontier, for all practical purposes, ceased to exist. Cities on the Atlantic and Pacific oceans were tied by railroads dotted with both small and large towns. Residents became conscious of European dress, manners, and art. Emulation of the Beaux Arts style of architecture was accompanied by an interest in academic European painting; diluted copies of both were frequent.

Many of the country's most popular artists during the Late Victorian period attempted idyllic paintings. Eastman Johnson (1824–1906) and William Morris Hunt (1824–1897) both sought to paint emotion-charged canvases. Their work occasionally exhibits the sentimentality so popular during the later half of the Victorian era.

Almost at the opposite end of the spectrum was the highly personal work of Albert Pinkham Ryder (1847–1917). He is most admired for his attempts to transform nature into a private, symbolic art. The realists, Winslow Homer (1836–1910) and Thomas Eakins (1844–1916), working in the last years of the nineteenth century, are among America's most lauded artists of this period.

During the Victorian era art and decoration tended to be confused in the American mind. Because a picture expressed virtue or some other ideal, regardless of its worth as a work of art, it was certain to enjoy popular success. The results of an important auction held in 1867 by Leavitt, Strebeigh & Co. in New York City are interesting for they prove that Currier & Ives prints found a more accepted place in the typical American home than original oils. At the auction many fine paintings went unsold in spite of the fact that the event

was largely attended . . . The bidding was generally very slow, and many of the pictures, including some by well-known and generally appreciated artists, were laid by without a bid. Among them, a "View in the Yo-Semite Valley," by Bierstadt, held at $1,500, received no bid at all. For the "Golden Gate, San Francisco," by the same artist, the auctioneer declined to receive a smaller bid than $1,000, and no one present seemed disposed to give that sum. "The burning of a Whaler by the Rebel Shenandoah," about 28 by 40 inches, painted by Bierstadt, to the order of the Metropolitan Insurance Company, and valued at $4,000, also found no purchaser . . . The best price obtained, and for decidedly the best picture sold, was for an "Elaine," by Leutzé, from Tennyson's poem, about 28 by 40 inches, which brought

$730. This included the price of the heavy gilt frame, said by the auctioneer to have cost $125. A landscape by Bierstadt, about 18 by 24 inches, brought $230. "Sunset," by Heade, of nearly similar size, sold for $130. "Lake Placid, Adirondacks," by H. Fueschel, brought $185, and a "Coming Storm," by Wm. Hart, $140. "A "Mendicant Friar," by C. G. Thompson, sold for $130; "Sleepy Hollow," by George Inness, $100; "The Florentine," by Thompson, $80; a landscape by Otto Sommers, $150; and a "View of Venice," by Leutzé, about 24 by 30 inches, $400.[3]

If contemporary publications and periodicals are to be believed, attitudes toward art began to change as a result of the Philadelphia Centennial Exposition in 1876. "The Exposition was the beginning of an awakening to the value of art in the United States."[4] Just how extensive the awakening truly was is questionable. The confusion between fine art and pretty, sentimental pictures remained. The later Victorian period spawned untold numbers of artistic endeavors that ranged from bright-colored, naturalistic chromolithographs and highly stylized posters to feather pictures, hair pictures, elaborate paper cutouts, woodburnings, and silhouettes. *Appleton's Journal* in 1875 noted the American tendency to settle for mediocrity.

A recent writer on modern Household Art dwells on its abuses. A good many ignorant people, he tells us, suppose that the odd, the cheap, and the peculiar, are necessarily excellent, a supposition than which nothing could be more mistaken. To make common materials attractive requires a trained taste and a mature judgment, and, as the chaff and the grain ever recur to be divided in human experience, it is not every girl nor each amateur artist who may hope to secure good results in this range of subjects more than in any other. The same writer, very sensibly, we think, condemns the indiscriminate use of cheap materials in the adornment of houses, and warns inexperienced young persons against pinning too much faith on the prescriptions for making charming apartments that are to be found in fashion-books and sensational newspapers. He tells us that deal-tables, covered with pink chintz and white cambric, though they may be attractive at the outset, soon become tawdry; and that the chromo, that looks bright and cheerful at the start, possesses fewer of the attributes for enduring charm than a plain black-and-white photograph of a fine picture or building.[5]

Victorian interest in photography was one of the reasons that portraiture declined. The daguerreotype, developed by the Frenchman Louis Jacques Mandé Daguerre, represented a novelty that caused the editor of *The Knickerbocker,* a New York periodical, to exclaim in 1839,

We have seen the views taken in Paris by the "Daguerreotype" and have no hesitation in avowing that they are the most remarkable objects of curiosity and admiration, in the arts, that we ever beheld. Their exquisite

perfection almost transcends the bounds of sober belief. Let us endeavor to convey to the reader an impression of their character. Let him suppose himself standing in the middle of Broadway with a looking glass held perpendicularly in his hand, in which is reflected the street, with all that therein is, for two or three miles, taking in the haziest distance. Then let him take the glass into the house, and find the impression of the entire view, in the softest light and shade, vividly retained upon its surface. This is the Daguerreotype! . . . There is not an object, even the most minute, embraced in that wide scope, which was not in the original; and it is impossible that one should have been omitted. Think of that! [6]

Photographic technology improved with time. The ambrotype and the tintype, both quite different from the daguerreotype, are easily distinguishable from their predecessor, which has been called "a mirror with a memory."

The daguerreotype looks like an image on a mirror. Because the plate was so fragile, it required very careful mounting.

The ambrotype, introduced in England by Frederick Scott Archer in 1851, represented a more permanent type of photograph. Not only was it easier to make but it could be produced more cheaply than the daguerreotype.

Ferrotypes, or melainotypes, more commonly known as tintypes, were introduced in 1858. The great advantage of these pictures was their durability. The tintype could also be trimmed with shears to fit into round or oval locket and watchcases. Until about 1890 it continued to be the most popular type of photograph. Because it could be produced in multiples for as little as fifty cents a dozen, it came to be referred to as the "picture for the millions."

Cameras became smaller and easier to use. By the close of the century nearly every small city boasted at least one photograph studio where newlyweds might sit amid fancy props for their portraits and where a few years later their stiffly dressed and protesting children could be preserved for posterity.

The first photograph ever taken by incandescent lamps was at the Menlo Park Laboratory in New Jersey of Thomas Edison in 1880. Edison, one of the most creative and fertile minds in the world, developed several patents related to the photographic process. The film and television industries were born at West Orange, New Jersey, in 1889 with the development of Edison's motion-picture camera.

520 (right). Memorial picture. New England. 1835–1845. Watercolor on paper. W. 16". The romantic artist who created this painting saw the grave site as a resting place in a forest glade. (Private collection)

521 (left). *The Muse—Susan Walker Morse* by Samuel F. B. Morse (1791–1872). 1835–1837. Oil on canvas. 73¾" x 57⅞". This picture is one of Morse's most skillful. He painted his eldest daughter while serving as a professor at New York University. (The Metropolitan Museum of Art; Bequest of Herbert L. Pratt, 1945)

522 (above). Cutout from gold metallic paper. Pennsylvania. c. 1835. W. 14½″. The central motifs are two hearts that enclose memorials under weeping willows. This elaborate picture is a masterpiece of the paper cutter's art. (Private collection)

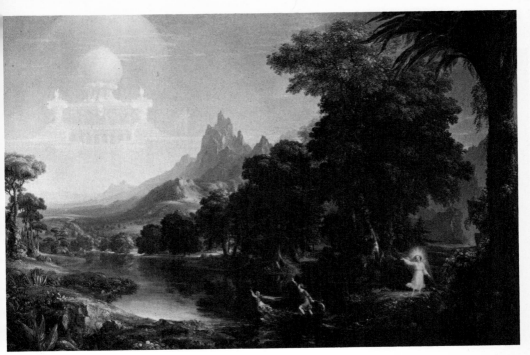

523 (above). *Youth* by Thomas Cole (1801–1848). 1840. Oil on canvas. 52½″ x 78½″. The Voyage of Life paintings were conceived by Cole during October of 1836, following the completion of his famous series, The Course of Empire. They were actually begun in 1839. The first, *Childhood*, was completed in 1839; *Youth, Manhood,* and *Old Age* in 1840. The youth guides the helm himself; a guardian spirit stands on the bank of the stream and ". . . seems to be bidding the impetuous voyager 'God speed.' " [1] (Munson-Williams-Proctor Institute)

524 (right). *Cider Making* by William Sidney Mount (1807–1868). 1841. Oil on canvas. 27″ x 34⅛″. Charles Augustus Davis, a prominent New York merchant, paid Mount $250 for this painting. Mount believed that he must "paint such pictures as speak at once to the spectator, scenes that are most popular, that will be understood on the instant." [2] (The Metropolitan Museum of Art; Purchase, Charles Allen Munn Bequest)

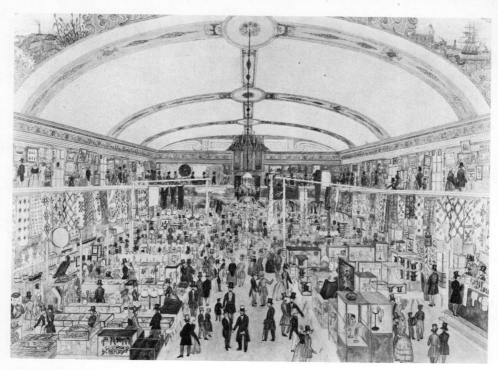

525 (above). *Fair of the American Institute at Niblo's Garden* by B. J. Harrison. c. 1845. Watercolor drawing. 10¼″ x 27½″. The second-story gallery at Niblo's Garden was hung with paintings during the American Institute Fair. (Museum of the City of New York)

526 (below). *Fur Traders Descending the Missouri* by George Caleb Bingham (1811–1879). 1845. Oil on canvas. 29″ x 36½″. This is one of four paintings by Bingham purchased for $75 by the American Art-Union, New York. (The Metropolitan Museum of Art; Morris K. Jesup Fund)

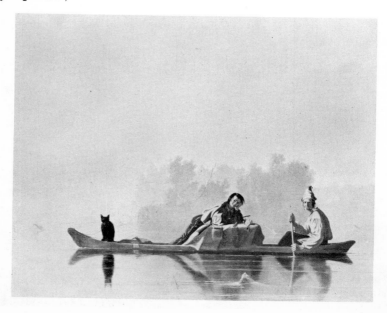

527 (left). *Evening Prayer* by E. A. Hawes. Hudson County, New Jersey. c. 1845. Needlework picture. H. 18¾". (Mr. and Mrs. Samuel Schwartz)

528 (below). *Distribution of the American Art-Union Prizes.* Lithograph published by Sarony & Major, New York. 1847. The Art-Union provided one of the best ways for American artists to market their works. (Private collection)

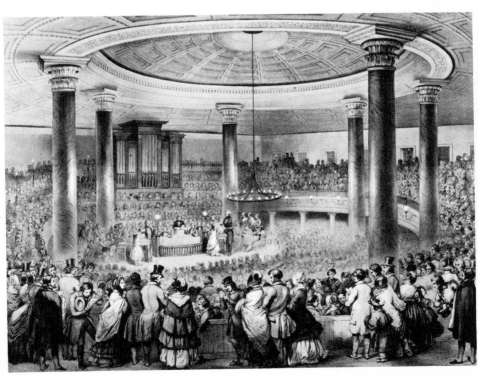

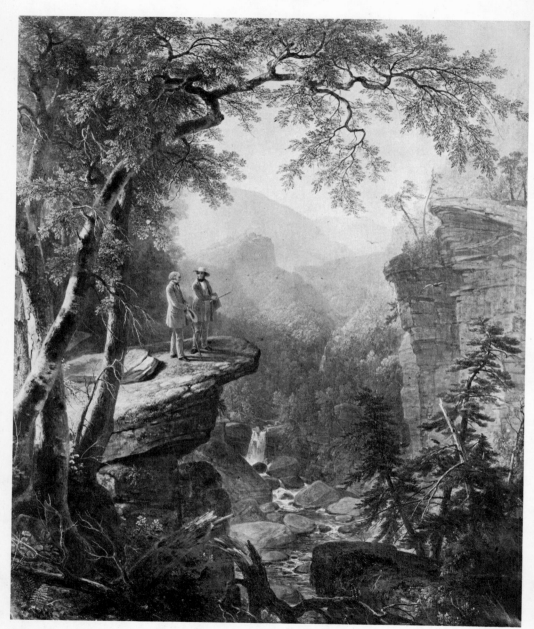

529 (above). *Kindred Spirits* by Asher Brown Durand (1796–1886). 1849. Oil on canvas. 44″ x 36″. Durand returned to New York City in 1840 after a trip to European galleries. The year after Thomas Cole's death, Durand, his friend and a co-founder of the Hudson River School, depicted Cole and the poet William Cullen Bryant contemplating nature. (The New York Public Library)

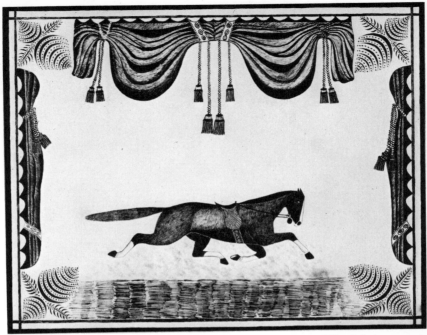

530 (above). Calligraphic drawing of the racehorse, Dexter. c. 1850. Ink on paper. W. 14″. Schoolmarms were proud of the young prodigies who could execute such an ornate piece of penmanship. (Private collection)

531 (below). *The American War Horse* by J. W. Zook. Oak Grove, Illinois. Mid-nineteenth century. Watercolor on paper. W. 25½″. This is a spirited example of patriotic American folk art. (Greenfield Village and Henry Ford Museum)

532 (above). *Washington Crossing the Delaware* by Emanuel Gottlieb Leutze (1816–1868). 1851. Oil on canvas. W. 256 1/16". Leutze was born in Germany and brought to America as a young boy. In 1841 he journeyed to Düsseldorf where he absorbed the popular academic fashion of creating vast canvases depicting historical scenes. The artist Worthington Whittredge, while visiting in Düsseldorf, posed for the steersman and for George Washington. (The Metropolitan Museum of Art; Gift of John Stewart Kennedy, 1897).

533 (below). Interior view of the New York Crystal Palace illustrated in the exhibition catalogue, *The World of Science, Art and Industry Illustrated.* In addition to several small displays of paintings, an elaborate art gallery was included in the exhibition. (Private collection)

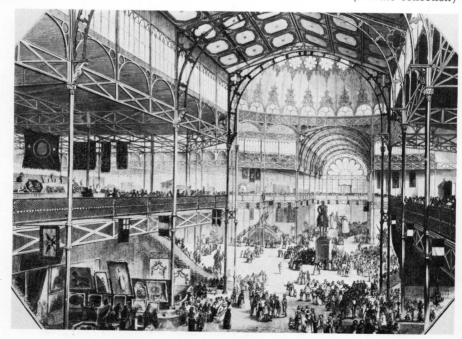

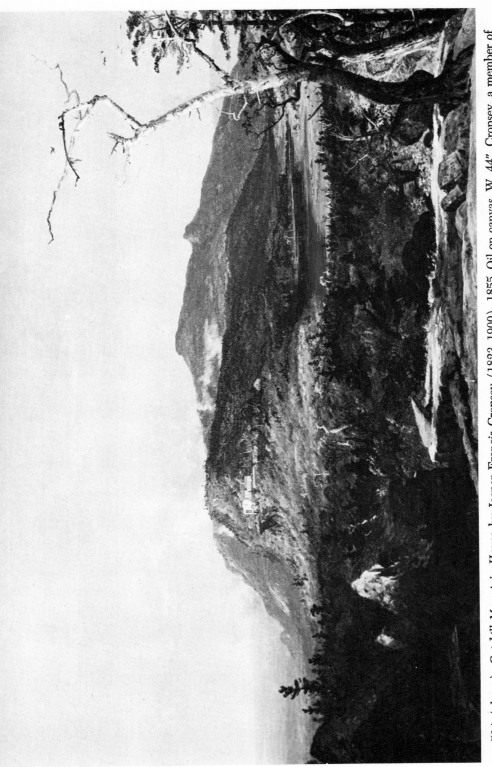

534 (above). *Catskill Mountain House* by Jasper Francis Cropsey (1823–1900). 1855. Oil on canvas. W. 44". Cropsey, a member of the Hudson River School, devoted himself to portraying naturalistic scenes. (The Minneapolis Institute of Arts; The William Hood Dunwoody Fund)

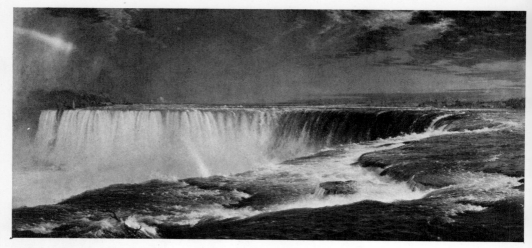

535 (above). *Niagara Falls* by Frederic Edwin Church (1826–1900). 1857. Oil on canvas. W. 90½″. The artist-explorer Church sought out natural wonders and recorded them in such minute detail that his greatest canvases become transcendent experiences. (The Corcoran Gallery of Art, Washington, D.C.)

536 (below). The Parker-Clover firm, located at 180 Fulton Street, New York City, was illustrated by Henry T. Tuckerman in his *Book of the Artists: American Artist Life,* published in 1867, where it was called the first "art-centre" in New York. Art galleries were few during this era. (Museum of Fine Arts, Boston)

FIRST ART-CENTRE IN NEW YORK.

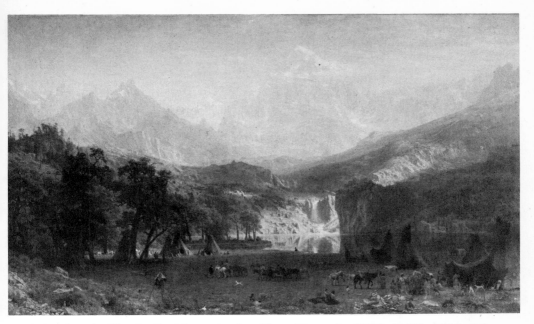

537 (above). *The Rocky Mountains* by Albert Bierstadt (1830–1902). 1863. Oil on canvas. 73¼″ x 120¾″. Bierstadt recorded in a letter from the Rocky Mountains dated July 10, 1859, ". . . the Indians are still as they were hundreds of years ago, and now is the time to paint them . . ." (The Metropolitan Museum of Art; Rogers Fund)

538 (below). *The Coming of the "Fire Horse,"* by Henry F. Farny. Nineteenth century. Gouache. W. 21¼″. One of Farny's favorite subjects was the intrusion of the white man into the Indian's way of life. This startled scouting party is fleeing the locomotive. (Cincinnati Art Museum)

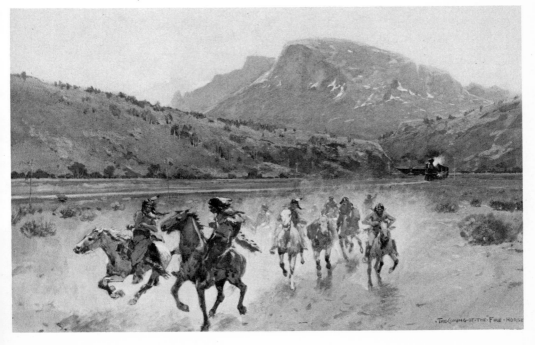

539 (left). Theorem on velvet. New England. c. 1860. W. 16¾". Finishing schools often taught young ladies the "polite" art of theorem painting. Watercolors on paper and velvet became increasingly naturalistic after the middle of the century. (Patricia Coblentz)

540 (right). *The Post Office, Pittsburgh,* by David Gilmour Blythe (1815–1865). 1863. Oil on canvas. H. 24". Blythe was apprenticed to a wood-carver in Pittsburgh at the age of 16. Between 1856 and his death he worked primarily in Pittsburgh where he painted genre scenes that earned for him the title, "The American Hogarth." (Museum of Art, Carnegie Institute, Pittsburgh)

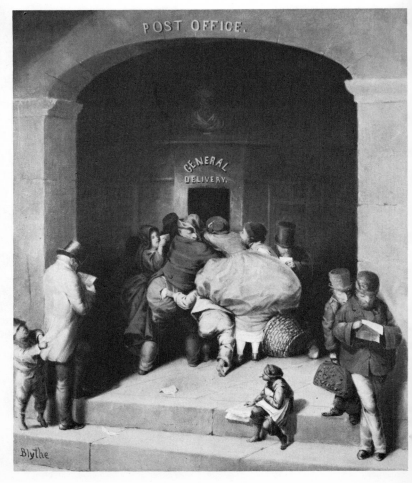

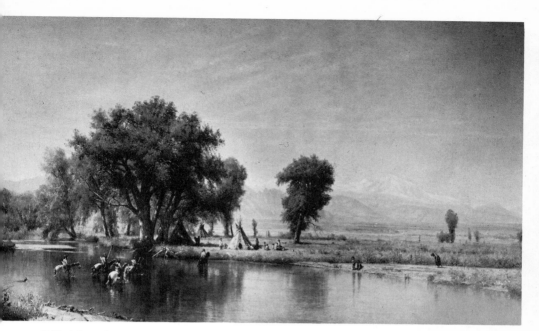

541 (above). *Crossing the Ford, Platte River, Colorado,* by Thomas Worthington Whittredge (1820–1910). Signed and dated "W. Whittredge 1868/W.Whittredge/1870." Oil on canvas. W. 68". Whittredge wrote in his autobiography, "Whoever crossed the plains at that period . . . could hardly fail to be impressed with [the] vastness and silence and the appearance everywhere of an innocent, primitive existence." (The Century Association, New York; photograph courtesy Frick Art Reference Library)

542 (below). *Lake George* by John Frederick Kensett (1816–1872). 1869. Oil on canvas. W. 66⅜". This painting, one of the artist's finest, earned him the fabulous sum of $3,000. (The Metropolitan Museum of Art; Bequest of Maria DeWitt Jessup, 1915)

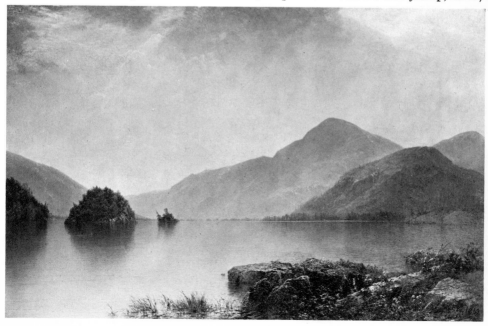

543 (above). Photograph of the Merritt Art Gallery at Lyndhurst. c. 1870. George Merritt purchased the house in 1864 and enlarged it under the direction of Alexander Jackson Davis, the original architect. Paintings were jammed together on all the available wall space. (Lyndhurst, National Trust for Historic Preservation)

544 (right).
Studio Interior by
Edwin White
(1817–1877).
1872. Oil on canvas. W. 22″. All
the trappings of a
Victorian
painter's studio
are evident in this
charming interior
scene. Drapery-
backed paintings
and armor hang
on the walls.
Sculpture sits on
a shelf and a portfolio leans against
the far wall.
(Museum of Fine
Arts, Boston;
Bequest of
Maxim Karolik)

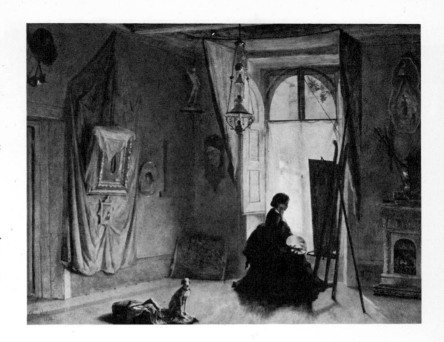

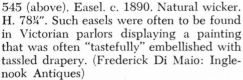

545 (above). Easel. c. 1890. Natural wicker.
H. 78¼″. Such easels were often to be found
in Victorian parlors displaying a painting
that was often "tastefully" embellished with
tassled drapery. (Frederick Di Maio: Inglenook Antiques)

546 (above). Artist's paint box. New York
State. c. 1870. L. 18¾″. Whoever owned this
box must have had as much fun creating its
polychrome decoration as he did his paintings. Photograph courtesy America Hurrah
Antiques, N.Y.C. (Private collection)

547 (above). *The Arch of Titus* by George Peter Alexander Healy (1813–1894), Frederic
Edwin Church (1826–1900), and Jervis McEntee (1828–1891). 1871. Oil on canvas. H. 73½".
The Arch of Titus was once considered to be solely the work of Healy; it is now believed to
be the work of all three artists portrayed in the picture. Frederic Church is shown seated,
sketching; McEntee, Church's pupil, is standing behind him; and Healy looks over Church's
shoulder. The man and woman passing through the arch are the poet Henry Wadsworth Long-
fellow and his daughter Edith. (The Newark Museum; Bequest of Dr. J. Ackerman Coles)

548 (above). *The Grand Canyon of the Yellowstone* by Thomas Moran (1837–1926). Signed and dated 1872. Oil on canvas. 96″ x 168″. Moran's painting was exhibited in New York and Washington in the spring of 1872, where it dazzled the amazed public. Its reception caused enthusiasm for the establishment of Yellowstone as a national park that same year. (U.S. Department of the Interior, on loan to the National Collection of Fine Arts, Smithsonian Institution, Washington, D.C.; Gift of George D. Pratt)

549 (left). *Arrangement in Grey and Black, No. 2: Portrait of Thomas Carlyle* by James Abbott McNeill Whistler (1834–1903). 1872–1873. Oil on canvas. H. 67⅜″. Whistler was considered one of the most avant-garde artists of his time. Carlyle was pleased by the portrait and credited it with "a certain *massive originality*." (Glasgow Art Gallery and Museum; Purchased from the artist by the Corporation of Glasgow, 1891)

550 (above). *The Monk* by George Inness. 1873. Oil on canvas. W. 64″. As the Victorian period progressed, more American artists chose to live abroad. Inness painted this view from inside the Barberini Villa at Albano, Italy. It reflects Inness's religious mysticism. (Addison Gallery of American Art, Phillips Academy, Andover, Massachusetts; Gift of Stephen C. Clark, Esq.)

551 (above). *Winter in Maine*. 1875–1900. Reverse painting on glass. W. 24⅜″. Reverse paintings on glass were first made popular in America by importers who brought them from China. Mother-of-pearl has been applied to the back side of the glass so that the windows in the house are reflective. Stylized floral pictures backed with silver and gold foil, called tinsel pictures, are one of the other types of reverse painting on glass. (Greenfield Village and Henry Ford Museum)

552 (above). *The Gross Clinic* by Thomas Eakins (1844–1916). 1875. Oil on canvas. H. 96¼″. This great painting displays the two tenets of Eakins's art—his concern with the human condition and his dispassionate investigation of it to its minutest detail. (The Jefferson Medical College of Philadelphia)

553 (opposite, above). *Columbus Before the Council of Salamanca* by Frank Duveneck (1848–1919). 1876. Oil on canvas. 25″ x 36″. Although Duveneck was one of the most popular painters of his day, modern critics and collectors find his canvases too dark and brooding for their taste. (Cincinnati Art Museum; Gift of the artist)

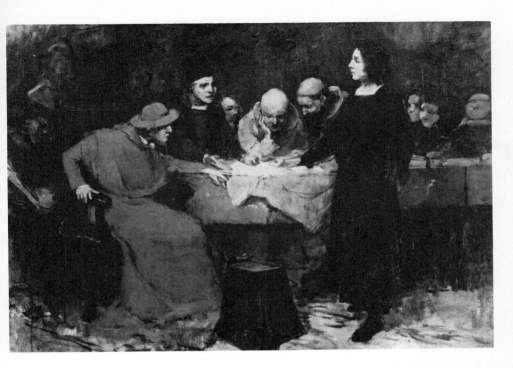

554 (below). *In the Studio* by William Merritt Chase (1849–1916). 1880. Oil on canvas. 28⅛″ x 40¹⁄₁₆″. Chase, an international traveler, jammed his colorful studio with exotic objects and aesthetic paraphernalia. (The Brooklyn Museum; Gift of Mrs. C. H. De Silver, in memory of her husband)

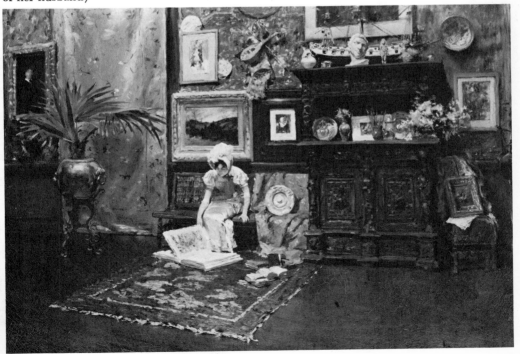

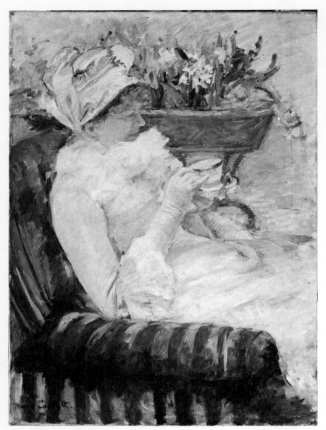

555 (left). *The Cup of Tea* by Mary Cassatt (1844–1926). 1879. Oil on canvas. H. 36⅜". Cassatt, one of America's finest impressionists, spent several years in Europe and counted among her friends many of the major French Impressionists. She is best known for her portraits of women and children. (The Metropolitan Museum of Art)

556 (right). *Hand Vase with Flowers.* c. 1880. Oil on card. 19" x 17". Popular Victorian taste would have been infinitely more satisfied with this delightful picture than with Chase's *In the Studio.* (Berry-Hill Galleries)

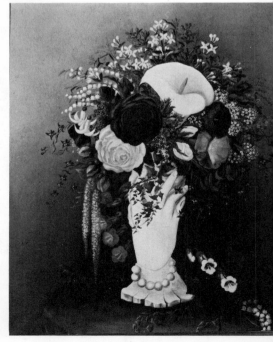

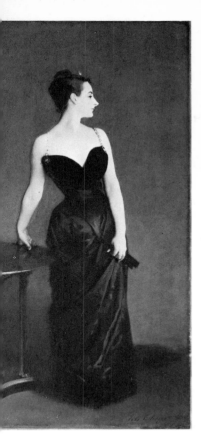

557 (left). *Madame X—Madame Pierre Gautreau* by John Singer Sargent (1856–1925). 1884. Oil on canvas. 82⅛″ x 43¼″. Judith Avegno, a New Orleans beauty, married a Parisian banker and became one of the city's most celebrated women during the 1880s. Sargent was impressed by her charms and theatrical use of heavy lavender makeup. The portrait was shown in the 1884 Salon where it was given a scathing reception by art critics who saw blatant impropriety in the woman's dress and the blue-gray color of her skin. (The Metropolitan Museum of Art; Arthur Hoppock Hearn Fund)

558 (right). *The Last Rose of Summer* by William M. Harnett (1848–1892). c. 1880. Oil on canvas. 24″ x 20″. Harnett is the best known of all the American trompe-l'oeil artists. (Cincinnati Art Museum)

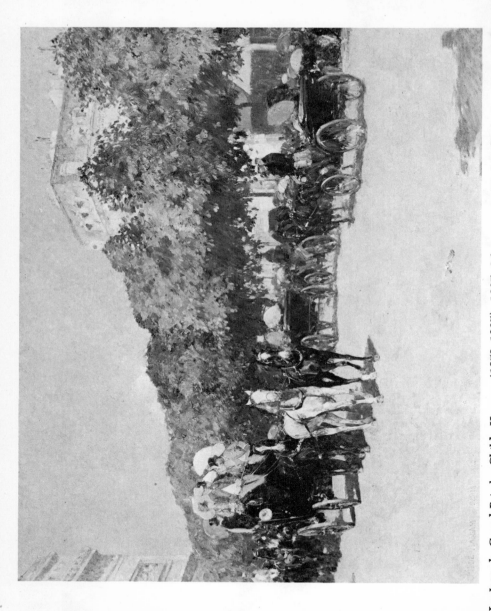

559 (above). *Le Jour du Grand Prix* by Childe Hassam (1859–1935). 1887. Oil on canvas. W. 34". Hassam was one of the leading exponents of American impressionism. In 1886 he settled in Paris where he was strongly attracted to the work of the French Impressionists. He was one of the founders of The Ten, a group of American painters. (Museum of Fine Arts, Boston; Ernest Wadsworth Longfellow Fund)

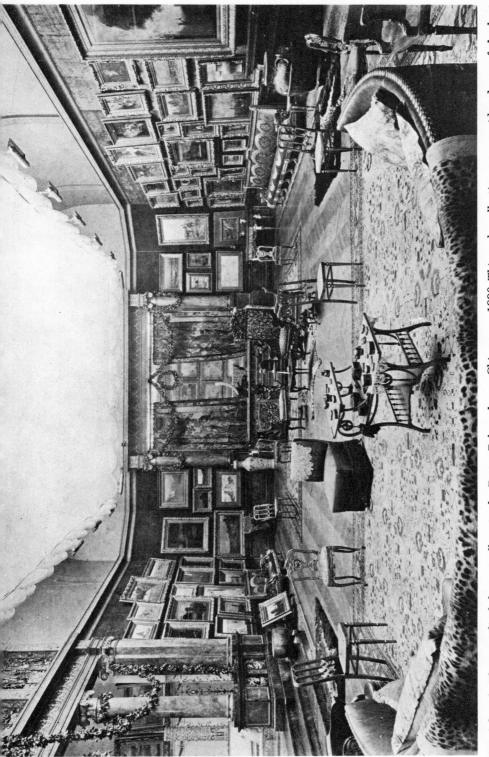

560 (above). Photograph of the art gallery in the Potter Palmer house, Chicago. c. 1890. This early collection was considered one of the best in the country. Although it contained several American canvases, European paintings predominated. (The Art Institute of Chicago)

561 (above). Illustration from the popular magazine, *Harper's Weekly*, January 24, 1891. *Opening of the Fight at Wounded Knee* by Frederic Remington (1861–1909). Remington completed this sketch after hearing a description of the action. Much of Remington's art was used for magazine and newspaper illustrations in the days before it was practical to illustrate with photographs. (Robert Hudson Tannahill Research Library, Greenfield Village and Henry Ford Museum)

562 (right). *Isabella; or, The Pot of Basil* by John White Alexander (1856–1915). 1897. Oil on canvas. H. 75½". Alexander's wonderfully lyric painting was based upon a theme from Boccaccio's *Decameron* that was popular with the Pre-Raphaelites. Isabella's peasant lover was murdered and buried in a nearby wood outside of Florence by her ambitious brothers who were intent upon her marrying a nobleman. She later unearthed the body and, mad with grief, severed the head, hid it in a garden pot and planted it with sweet basil. (Museum of Fine Arts, Boston; Gift of Ernest Wadsworth Longfellow)

563 (above). *S.S. Horatio Hall* painted by Antonio Jacobsen. 1898. Oil on canvas. L. 42″.
Jacobsen resided in Hoboken, New Jersey, where he painted pictures of ships for prosperous
owners. (Greenfield Village and Henry Ford Museum)

564 (below). *The Gulf Stream* by Winslow Homer (1836–1910). 1899. Oil on canvas. 28⅛″ x
49⅛″. This painting is based upon studies that Homer made in the West Indies during 1885.
Homer, asked to explain the painting to a questioning group of ladies, irritatedly replied,
". . . The boat and sharks are outside matters of very little consequence. *They have been
blown out to sea by a hurricane.* You can tell these ladies that the unfortunate negro who
now is so dazed & parboiled, will be rescued & returned to his friends and home & ever after
live happily." (The Metropolitan Museum of Art; Catharine Lorillard Wolfe Fund)

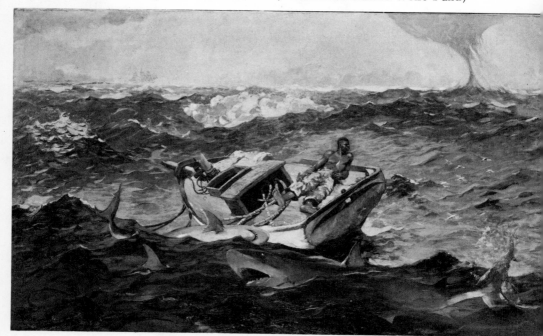

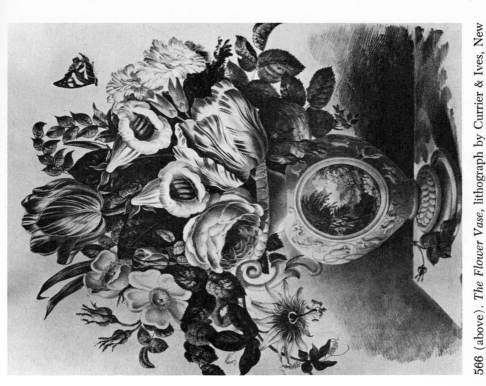

566 (above). *The Flower Vase*, lithograph by Currier & Ives, New York City. 1859. H. 14¾". Currier & Ives enjoyed prodigious success and during their years of operation published almost 7,000 separate prints. (Private collection)

565 (above). Temperance lithograph published by N. Currier, New York City. 1851. H. 14". Temptation offers all manner of evils to the upright young man who is reaching toward his Temperance sister, a model of love, purity, and fidelity. (Private collection)

567 (above). *American Hunting Scenes: A Good Chance* published by Currier & Ives, New York City. 1863. Lithograph after the painting by Arthur Fitzwilliam Tait (1819–1905). 18″ x 27″. Currier & Ives frequently commissioned popular artists to create paintings, which they in turn would issue as lithographs. They also maintained a staff of resident artists who were assigned to create special scenes that would satisfy popular demand. (Heritage Plantation of Sandwich)

568 (right).
*American Farm
Scene No. 4*
(Winter) pub-
lished by N. Cur-
rier, New York
City. F. F. Pal-
mer, Deliniator.
1853. Litho-
graph. W. 23^{15}⁄$_{16}$″.
Idealized roman-
tic views of
American country
life were espe-
cially popular
with mid-Vic-
torians. (Private
collection)

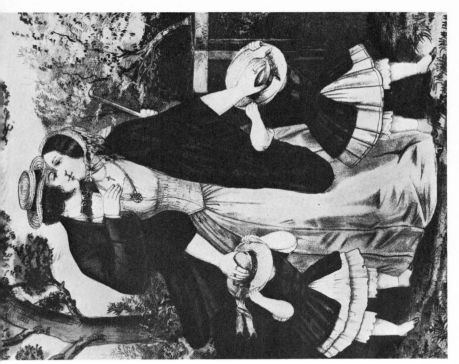

570 (above). *Kiss Me Quick*, published by Currier & Ives, New York City. c. 1866. H. 11¾". This print illustrates popular Victorian humor and is inscribed: "Children: this is the third time within an hour that I have placed your hats properly on your heads. There!!" (Private collection)

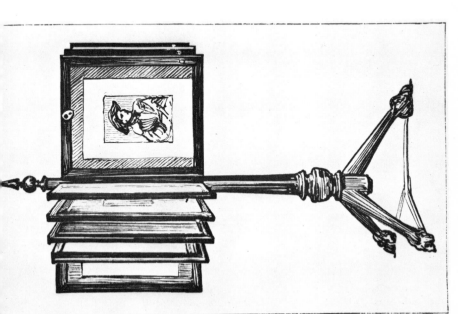

569 (above). Illustration from *The House Beautiful* written by Clarence Cook and published by Charles Scribner's Sons. 1881. Cook, an art critic and tastemaker of the 1880s, confirmed the popularity of print collecting by including this sketch of a stand for displaying prints in his book. (Private collection)

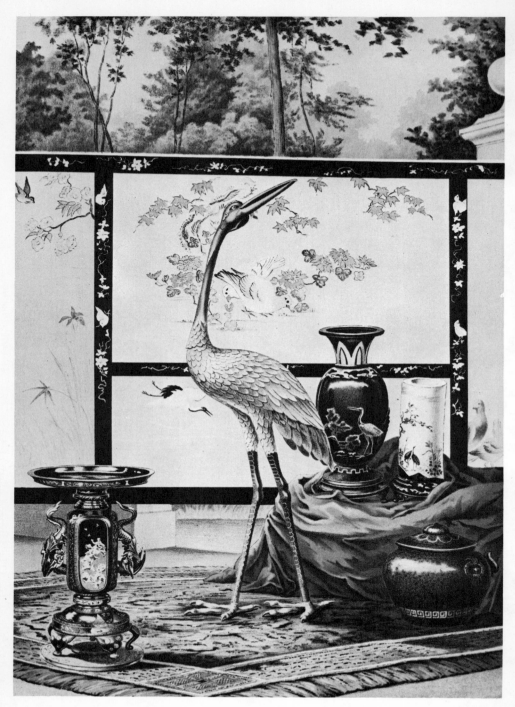

571 (above). Chromolithograph of Japanese art wares exhibited at the Philadelphia Centennial and published in *Treasures of Art, Industry and Manufactures Represented in the American Centennial Exposition at Philadelphia, 1876.* This luxurious book contained over sixteen handsome chromolithographs that were probably of the highest quality produced in America up to that time. (Private collection)

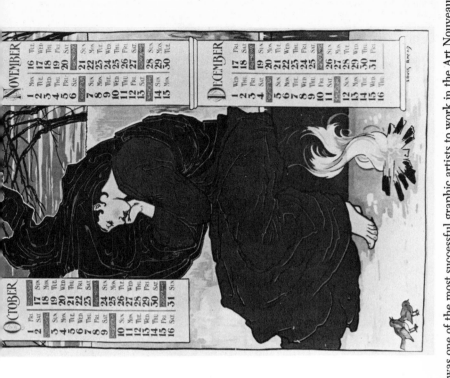

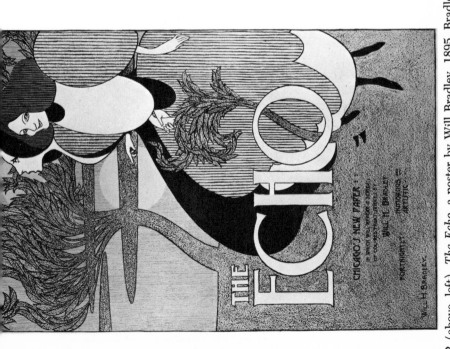

572 (above, left). *The Echo*, a poster by Will Bradley. 1895. Bradley was one of the most successful graphic artists to work in the Art Nouveau style, and his posters earned for him an international reputation. Donald Warren, writing in October 1894, noted, "In America, everyone has the chance to have a complete collection of posters. One need only begin a year back, for there is nothing before that worth collecting." Bradley, just three years later, reported, "The fad of collecting posters seems to be dying out." (The Library of Congress)

573 (above, right). A calendar for the year 1897 by Louis J. Rhead (1857–1926). 19¼" x 14⅞". Many of the poster artists turned to other media after the poster ceased to be popular. (The Currier Gallery of Art)

574 (above). Pyromania picture. c. 1876. Wood. H. 22″. This piece, one of a pair, was done by drawing with a heated stylus on a wood panel. This hunting scene is inscribed on the back, "Burned by Albert Lewis, Esq." (Greenfield Village and Henry Ford Museum)

575 (right). Feather picture. c. 1880. H. 29″. Feather pictures became popular during the late 1870s and 1880s and were inspired by similar pieces imported from the Orient. (Greenfield Village and Henry Ford Museum)

576 (right). Vase of stuffed-fabric fruit and vegetables mounted in a velvet-backed shadow box. c. 1850. 14″ x 14″. Victorian women frequently created stuffed needlework pictures. (Sotheby Parke Bernet Inc.)

577 (below). Chromolithograph published by Selmar Hess, New York City, and printed by L. Prang & Co., Boston. 1898. L. 12½″. Prang was one of America's most important lithographers. He has been called the father of the American Christmas card, for beginning in 1880 he held competitions for Christmas card designs, which he then printed, promoted, and sold. (Tony Orlando)

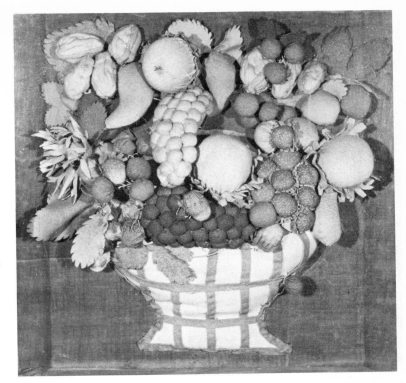

578 (right). Valentine by Louis Prang & Co. Boston. 1882. H. 7". During this period many greeting cards were bordered with an elaborate silk fringe. (Tony Orlando)

579 (below). Framed motto. 1880–1900. L. 21". This piece can be dated by the incised decoration on its original black-and-gilt frame, which relates to the American interpretation of the Eastlake style. (Greenfield Village and Henry Ford Museum)

580 (left). Mourning or memorial picture made from hair. Michigan. 1898. 18″ x 13¾″. During the Late Victorian period it was fashionable to clip strands of hair from the deceased and work them into an artistic picture that served as a memorial for the surviving loved ones. (Greenfield Village and Henry Ford Museum)

581 (below). Illustration of the Meade Art Gallery at New York City, taken from the February 1853 publication, *The Art Journal*. By the 1850s daguerrean galleries had become immensely popular and the daguerreotype had begun to phase out the need for more costly painted portraits. Samuel F. B. Morse commented at an annual supper of the National Academy of Design in 1840, "The daguerreotype is undoubtedly destined to produce a great revolution in art, and we, as artists, should be aware of it and rightly understand its influence." [3] (The Library of Congress)

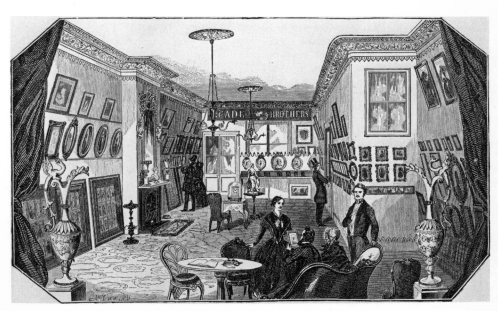

582 (above). Daguerreotype. c. 1852. 5″ x 7″ full-plate size. This photograph is remarkable for both its size and its subject. Nearly all surviving daguerreotypes are small one-quarter-plate portrait photographs of individuals. Larger group portraits and scenic and city views are far less common, and a 5″ x 7″ "portrait" of a machine is unique. This reaping machine, invented by Jearum Atkins, is parked on a wharf overlooking the Chicago River near the factory where it was made. To simulate it in operation, straw has been placed in the machine's raking mechanism and a well-dressed gentleman in a stovepipe hat sits in the driver's seat. It is perhaps one of the earliest advertising photographs ever made. (Greenfield Village and Henry Ford Museum)

583 (right). Photograph of Abraham Lincoln by Alexander Gardner made in Washington, D.C., in 1863. The armchair in which Lincoln sits, made by Bembe & Kimmel of New York City, was one of the chairs designed for use in the House of Representatives in 1857. In 1859 they were sold at public auction and at least three were purchased for use in the photographic studios of Mathew Brady and Alexander Gardner. (Greenfield Village and Henry Ford Museum)

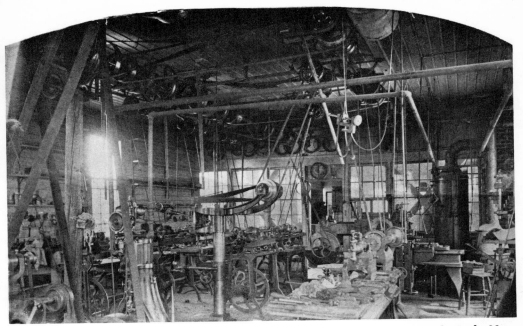

584 (above). Photograph of Thomas Edison's first machine shop at Menlo Park, New Jersey. 1877. Edison was immensely interested in photography and experimented extensively in the field. (Greenfield Village and Henry Ford Museum)

585 (below). First photograph ever taken by incandescent light. This amazing early document was taken at Thomas Edison's laboratory, Menlo Park, New Jersey, in February 1880. (Greenfield Village and Henry Ford Museum)

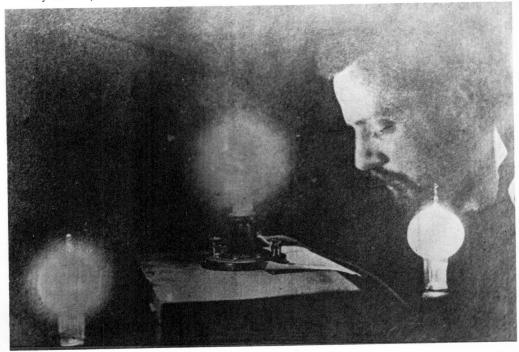

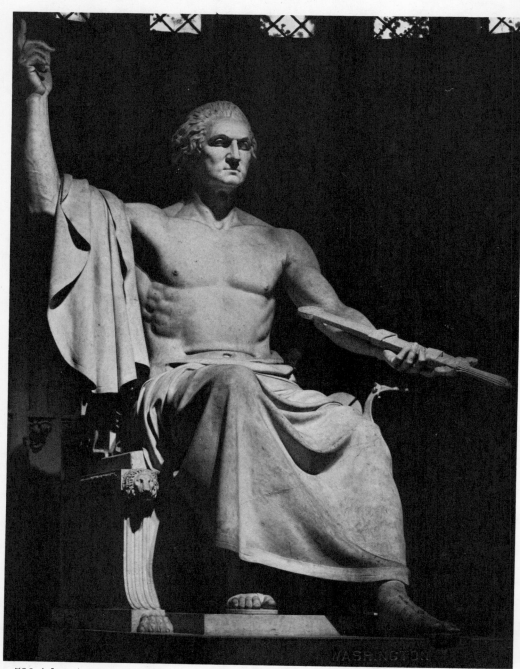

586 (above). *George Washington* by Horatio Greenough. 1832–1841. Marble. H. 132″. The artist was the first American-born sculptor to achieve an international reputation. Like many nineteenth-century artists, he lived and worked as an expatriate. (Smithsonian Institution)

SCULPTURE

During most of the Colonial period in America sculpture was chiefly the product of craftsmen who specialized in the production of grave markers and monuments. Folk artists created powerful three-dimensional images; however, native professional sculptors were virtually nonexistent.

Throughout the last half of the eighteenth century several English, Italian, and other European sculptors traveled to America and fulfilled commissions for wealthy patrons. It is not surprising, therefore, that when the famous French architect, Benjamin Henry Latrobe (1764–1820), was chosen to complete the United States Capitol, he secured the services of European artists to execute the carved decorations needed for the project.

During the first half of the nineteenth century two types of neoclassicism dominated American sculpture: the first, Greek, which demanded the idealization of the physical features of the subjects; the second, Roman, which embodied naturalism as one of its main characteristics and was especially popular in the new nation. Classical attitudes were supported by cultured American patricians like Thomas Jefferson, who believed that sculptural representations of military and national leaders such as George Washington should be clothed in antique garments, "As to the style or costume, I am sure the artist, and every person of taste in Europe would be for Roman . . . Our boots and regimentals have a very puny effect." [1]

Not everyone agreed. Homegrown types, represented by the caustic Davy Crockett, concurred with his "think American" attitude, "I do not like the statue of Washington in the State-House. They have a Roman gown on him and he was an American; this ain't right. They did the better thing at Richmond, in Virginia, where they have him in the old blue and buff. He belonged to his country—heart, soul, and body and I don't want any other to have any part of him—not even his clothes." [2]

During the 1830s and early 1840s many young Americans began to model clay portraits and idealized figures, which were then carved in marble by Italian craftsmen. Others, like the self-taught Hezekiah Augur (1791–1858), working at New Haven, Connecticut, generally crafted their own marble pieces. By the 1840s a growing sense of national pride caused American sculptors to enjoy an unprecedented success. Those that remained at home, however, seldom gained the preeminence of Horatio Greenough (1800–1852), Thomas Crawford (1813–1857), and Hiram Powers (1805–1873), the three most famous expatriates who lived in Italy, where they earned worldwide reputations.

Horatio Greenough, like American painters of the same period, derived the bulk of his income from portraiture. Many of his "ideal" or "literary" pieces were intended to be neoclassical in nature although he was most specific about the extent of his borrowings from past cultures, "I contend for Greek principles,

not for Greek things." [3] Greenough moved from neoclassicism to romanticism in later years and sentimental attitudes expressed in his *Dead Abel* (plaster cast: 1825; bronze cast unknown) replaced earlier conventionalized formulas.

Unfortunately, one of Greenough's most important pieces, his Zeus-like portrait of George Washington (1841), created for the rotunda of the Capitol, received an unenthusiastic reception. Even Philip Hone (1780–1851), an intellectually and artistically perceptive man and a former mayor of New York, observed that "It looks like a great Herculean, warrior-like Venus of the Bath . . . with a huge napkin lying across his lap . . . preparing to perform his ablutions . . ." [4]

Much of Hiram Powers' work is a naturalistic tour de force. This is not surprising, for the sculptor maintained, "It is an error to suppose that features are accidental, and nature makes them up haphazard; for the face is the true index of the soul, where everything is written had we the wisdom to read it." [5] His greatest pieces, however, are a combination of classicism and naturalism. Both *The Fisherboy* (c. 1841) and *The Greek Slave* (begun in 1842) were shown at the Great Exhibition at the London Crystal Palace in 1851 and again at the Crystal Palace in 1853. More than any other nineteenth-century artwork, *The Greek Slave* helped to establish Powers' reputation and to convince the world that America was capable of producing an artistic genius. Prudish Victorians, concerned about the nudity of the figure, were consoled by the distinguished Unitarian leader, Reverend Orville Dewey, when he commented on *The Greek Slave*: "The chasteness in this statue is strongly contrasted with the usual voluptuousness of the antique . . . It was clothed all over with sentiment, sheltered, protected by it, from every profane eye. Brocade, cloth of gold, could not be a more complete protection than the vesture of holiness in which she stands." [6]

Thomas Crawford, perhaps even more than Greenough and Powers, adhered to neoclassic principles. His "ideal" works were usually thoroughly classical, whereas his portraits possessed a vital naturalism akin to the portraits by Powers. He once described his art as an attempt "to give an antique beauty to the whole composition by keeping clear of all extravagance in the movement, and working as nearly as possible in the spirit of the ancient Greek masters." [7]

In 1844 the Boston Athenaeum, which had been a subscriber toward the purchase of Crawford's *Orpheus* (1841), mounted an exhibition of his work. This was the first significant display of sculpture by a native American son.

The second, mounted at the request of twenty prominent citizens, including the landscape artist, Frederic Edwin Church (1826–1900), and the poet, William Cullen Bryant, occurred in New York City in 1856 at the Church of the Divine Unity. Erastus Dow Palmer (1817–1904), a self-taught sculptor from Albany, New York, gained national recognition with this one-man show, which was repeated in Boston and other major American cities. Palmer, with his most illustrious contemporaries, Henry Kirke Brown (1814–1886) and Clark Mills (1815–1883), demonstrated that the sculptor need not submerge himself in European study and copy the classics to create significant art. Their efforts in a ro-

mantic-naturalistic style proved that America could produce a sculptural art on her own soil.

Palmer, possibly the most successful of the three, discovered, like Powers before him, that Victorian Americans believed the highest form of art revealed a moral in the subject it depicted. His *Indian Girl or the Dawn of Christianity* (1855) and *White Captive* (1857) were milestones in the adaptation of American themes to American sculpture.

Throughout the entire nineteenth century American sculptors dreamed of being freed from the necessity of portraiture. By mid-century, "ideal" pieces had achieved a popularity that enabled a few men like Palmer to earn a comfortable living from them.

Every sculptor looked to the national government and its lucrative commissions as a source of monumental work. Federal legislators had long been awarding prestigious commissions to European sculptors. It was not until 1832 that Congress gave its first large sculptural commission to an American, Horatio Greenough. After the completion of his *Washington* in 1841, American sculptors vied for the opportunity of adorning their nation's capital.

Despite the popularity of "ideal" or "literary" pieces that expressed a sentimental pathos and an occasional monumental government commission, most artists were faced with the unalterable fact that "Purely idea subjects must go begging in this country . . . portrait sculpture . . . is the sculptors' sole dependence." [8]

Although portraits in white marble continued to be popular, in the second half of the nineteenth century bronze became the primary sculptural medium. To supply the demand for bronzes, an ever-increasing number of American foundries, like the Ames Foundry at Chicopee, Massachusetts, began operations. It is not surprising that bronze was preferred, for it was infinitely more durable than marble.

Since casting in bronze made it easy to produce multiple casts, it became necessary for artists to copyright their works. In spite of such precautions, it was discovered on numerous occasions that pieces had been pirated and cheap plaster duplicates were being hawked by peddlers on street corners. This practice was made profitable by the art consciousness of a constantly increasing middle class that looked upon the possession of sculpture, regardless of its quality, as a status symbol.

During the years after the Civil War naturalism dominated native American sculpture and classicism was all but eradicated from three-dimensional portraiture. Sculptors like Thomas Ball (1819–1911), Anne Whitney (1821–1915), Leonard Volk (1822–1895), and John Quincy Adams Ward (1830–1910), all working in a more or less naturalistic vein, created legions of military, political, and business heroes. Some sculptors, such as Ball, developed a new kind of naturalism that in the last quarter of the century acknowledged the elegant modeling and impressionistic surfaces popular in the French schools. Most, how-

ever, were content to satisfy the consistent demands of their patrons who expected objective, naturalistic portraits and "ideal" pieces bubbling with pathos.

Ward, more than any other sculptor, turned his back on foreign styles and utilized American themes that he expressed through a straightforward naturalism; however, he knew that more was required for great sculpture: "The true significance of art lies in its improving upon nature." [9]

Following the lead of Greenough and Powers, a "second wave" of American sculptors settled in Italy between 1840 and 1870. William Wetmore Story (1819–1895), Benjamin Paul Akers (1825–1861), Harriet Hosmer (1830–1908), William Rinehart (1825–1874), and many others went abroad where they discovered the inspiration for their "ideal" works. Blatant neoclassicism gave way to a more realistic style, however, when they attempted portraits and heroic monuments.

Story, like his Victorian contemporaries, might be criticized for excessive dependence upon the past. Henry James observed that Story's *Cleopatra* (1858) "was frankly and forcibly romantic." However, the sculptor, through this and his *Libyan Sibyl* (early 1860s), "penetrated the imagination of his public as nobody else just then could have done . . ." [10]

Story's sculpture, in addition to being overtly romantic, possessed many other characteristics that were common to sculpture during the third quarter of the nineteenth century. There was a concentration upon surface design resulting in a kind of prettiness and an excessive use of decorative detail that included a multitude of props and costume accessories.

Almost to the point of obsession, Victorians were preoccupied with death. Many appear to have confused emotional reaction with aesthetic appreciation. Benjamin Paul Akers, one of the most popular sculptors of the day, understood this and his *The Dead Pearl Diver* (1857) epitomized sculptural efforts depicting melodramatic, morbid themes.

William Rinehart, the expatriate working in Florence, criticized his fellow sculptors for their excessive attention to detail, "I have made no effort to get Prettiness [for] I believe it to be unworthy of Sculpture entirely." [11]

In 1851 Randolph Rogers (1825–1892), like many before him, settled at Rome. His idealistic pieces, such as *Nydia, the Blind Girl of Pompeii* (1853), were brimming with naturalistic details that augmented his blatantly anecdotal style. At the Philadelphia Centennial Exposition in 1876, where it was exhibited, visitors were "struck mute" by their sentimental empathy with the "literary" piece. It was one of the most popular sculptures of the day and nearly one hundred replicas were made. Rogers continued to work in Rome until disabling paralysis forced him, in 1885, to ship all of his remaining plaster casts, which included many "literary" or "ideal" pieces, to Ann Arbor, Michigan.

The last quarter of the century saw many American expatriate sculptors leave Florence and Rome and settle in Paris where they assimilated the French École des Beaux Arts style. Even those who had not settled in Europe adapted the new movement to their own particular style, with the result that American

sculpture became vibrant and decorative. Naturalism was forced into a secondary position, and those who persisted in utilizing it were thought old-fashioned.

Between 1875 and 1900 sculptural imagery also changed. Americans were no longer content with marble visitors from the ancient world. They demanded an up-to-date personification of allegorical figures that they could associate with their own red-blooded history. Representations of Agriculture, Progress, Success, Industry, Bill of Rights, Justice, Independence, all became a dominant part of the sculptor's vocabulary. Unfortunately, little professional criticism existed and much of the sculpture was not judged on its artistic merits, but on its literary success or the moral it taught.

Many late nineteenth-century sculptors much admired the work of Renaissance sculptors. Several, including Larkin Goldsmith Mead (1835–1910), attempted to incorporate the principles of the fifteenth century into their work and a modest Renaissance Revival followed.

At the Philadelphia Centennial Exposition, two distinct types of sculpture were much in evidence. Many of the second-generation expatriates who had followed Greenough and Powers to Italy exhibited neoclassical pieces. The modern school, represented by Daniel Chester French (1850–1931) and the Dublin-born Augustus Saint-Gaudens (1848–1907), adhered to the French principles being taught at Paris in the École des Beaux Arts. In the succeeding years French, Saint-Gaudens, the highly individual William Rimmer (1816–1879), and Olin Levi Warner (1844–1896) attempted to infuse new life into American sculpture. Their innovative techniques, their boldness of style, and their vitality created an expressiveness that resulted in many strong emotional statements.

Augustus Saint-Gaudens studied at the École des Beaux Arts during the late 1860s with François Jouffroy (1806–1882). The noted French master's influence was to be a pivotal part of Saint-Gaudens' technique for the rest of his life. Saint-Gaudens, too, was influenced by the fifteenth-century Renaissance masters. His sculptural personifications of American ideals became increasingly abstract, and when writing about his *Silence* (1875), he referred to, "The subject being abstract, I think it better after all not to follow any exact style, for the reason that Silence is no more Egyptian than it is Greek or Roman or anything else. I think in that case 'Le Style Libre' is the best." [12]

This great artist's predilection for abstraction is perhaps most evident in his *Adams Memorial* (begun 1886 and not completed until 1891). Henry Adams (1838–1918), when he commissioned the grave memorial of his wife, Marian, sought an image that would symbolize "the acceptance, intellectually, of the inevitable." [13] When the completed sculpture was finally placed in Rock Creek Cemetery, Washington, D.C., it was accompanied by an architectural setting designed by Stanford White (1853–1906). The monument caused much interest and became something of a tourist attraction. Many who viewed the piece failed to comprehend its deep emotional content. Some, however, were more sensitive. John Hay, in corresponding with the traveling Henry Adams, in 1891, wrote, "The work is indescribably noble and imposing. It is to my mind Saint-Gaudens'

masterpiece. It is full of poetry and suggestion, infinite wisdom, a past without beginning and a future without end, a repose after limitless experience, a peace to which nothing matters—all are embodied in this austere and beautiful face and form." [14] In this monument, perhaps more than in any other nineteenth-century American sculpture, one can anticipate the abstract art of the twentieth century.

Daniel Chester French developed a style that produced pieces that were the epitome of the personification of abstract ideas. In his figures of *History* (1890s), commissioned for The Library of Congress, he anticipated by many years his most famous pieces, *Mourning Victory* (1909) and *The Angel of Death and the Sculptor* (1891). French created *Republic,* a gigantic figure, for the World's Columbian Exposition at Chicago in 1893. In conjunction with Saint-Gaudens, Karl Bitter (1867–1915), Alexander Phimister Proctor (1862–1950), Philip Martiny (1858–1927), Isidore Konti (1862–1938), and Henry Augustus Lukeman (1871–1935), he helped the grandiose "White City at Chicago" become the primary artistic event of the latter part of the nineteenth century.

This gigantic celebration was followed by the Pan-American Exposition at Buffalo, New York, in 1901. At this dazzling spectacle that heralded the twentieth century all of the sculptured efforts were part of an iconographic scheme developed by Karl Bitter. Under his guidance, the many virtues of America were given three-dimensional form. Nearly every living American sculptor of importance participated in this exposition in which, with a central theme of "America," they created a sculptural unity at which the world marveled.

Certainly no American sculptor understood popular Victorian taste more than John Rogers (1829–1904). His earliest sculptural efforts, *The Old Oaken Bucket* (1853–1854) and *The Black Knight with Friar Tuck* (1855), are typical of the genre pieces that he produced throughout his incredibly successful career. Rogers, a sculptor for the common man, never ventured into the realm of neo-classicism. His anecdotal groups told a story—the American story of the people and for the people.

> The advantage that an artist has in going to Rome or any other great center of art like that is in copying from old statues. Now I think the very reason why sculptors are so poor is on that very account. They are kept copying all the time till at last they are scarcely more able to work from their impressions of anything that is beautiful than they were in the first place . . . I have always worked from impressions alone for it gives me an immense advantage now.[15]

Scorning classical ideas, Rogers achieved a sculptural form that related to everyday American life. He imbued his sculptural pieces with life through "accessories . . . all the odds and ends that I used to put around my groups help tell the story." [16]

His group, *Checker Players*, scored one of the big successes at the World's Columbian Exposition, and mass-produced plaster copies, sold at a modest price, provided a focal point in thousands of Victorian homes.

As his pieces achieved ever greater popularity, he employed as many as sixty copyists at one time in his New York studio where the finished plaster groups were painted either gray or brown. His Civil War subjects touched the hearts of a country rent asunder. *The Wounded Scout* (1862) was presented by the sculptor to President Abraham Lincoln, which insured its popular success. *The Council of War* (1868) included a portrait of Lincoln that was considered by the president's son to be one of the best portraits ever executed of his father.

In 1893 Rogers sold the firm through which he had achieved immortality. In thirty-two years, over eighty thousand copies of his genre pieces had been created.

As the new century dawned, a movement toward a deeper appreciation of the American West matured. Begun in the mid-nineteenth century and much in evidence in the sculptural works at the World's Columbian Exposition in 1893, the interest in Indian and Western subjects was echoed again at the Pan-American Exposition in 1901. The Western genre reached maturity in the works of Charles M. Russell (1864–1926), Alexander Phimister Proctor (1862–1950), Solon Hannibal Borglum (1868–1922), Cyrus E. Dallin (1861–1944), and Frederic Remington (1861–1909). Remington depicted Western life of the 1880s and 1890s, a period that he could endow with realism because during those years he traveled extensively throughout Western America. Some years later he recalled: "I knew the railroad was coming—I saw men already swarming into the land. I knew the derby hat, the smoking chimneys, the cord-binder, and the thirty-day note were upon us in a resistless surge. I knew the wild riders and the vacant land were about to vanish forever . . . Without knowing exactly how to do it, I began to try to record some facts around me, and the more I looked the more the panorama unfolded." [17]

The bronzes of Remington and other Western artists are today among the most sought-after and collected examples of American sculpture.

587 (above). Engraving of an itinerant seller of plaster casts taken from *City Cries: Or, A Peep at Scenes in Town*. 1849. "The itinerant seller of plaster casts is a regular street figure in all our great cities. By means of a few worn-out moulds which he has brought from Italy, the poor man makes a stock of casts, and mounting them on a board, cries them about the streets. He is not at all particular about prices. If he gets a piece of silver for his piece of plaster, his object seems to be gained; so that if you really do not wish to purchase, it is rather dangerous to offer him a quarter of a dollar for the bust which he wishes you to buy at two dollars. When he has followed this street traffic for a few years, he has amassed money enough to begin business on a larger scale; and accordingly he hires a shop, and commences the making and selling of all sorts of plaster casts. He will model your bust, giving a very formidable likeness; or cast you a leaden Venus and Apollo to place on pedestals in your garden; or copy a pair of Canova's Nymphs to place in your hall. Instead of carrying a small shop on his head through the streets, he now sends forth a little army of his compatriots, poor expatriated Romans or Tuscans, regretting the glorius [*sic*] skies of Italy, while they are selling busts of the glorius [*sic*] heroes of America. When our seller of casts has made his fortune, he will go home and purchase a villa on the delightful shores of Lake Como; and tell his descendents [*sic*] what a wretched country is America." [1] (Private collection)

588 (below). *Cornelia Van Rensselaer* by Richard S. Greenough (1819–1904). 1849. Marble. H. 24¾". The artist joined his older brother Horatio in Florence in 1837. On a later trip he settled in Rome where this portrait bust was one of his first efforts. (The New-York Historical Society; Gift of Kiliaen Van Rensselaer)

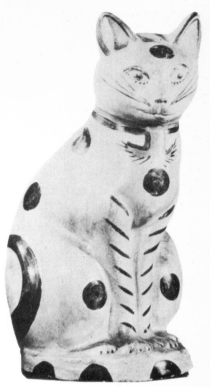

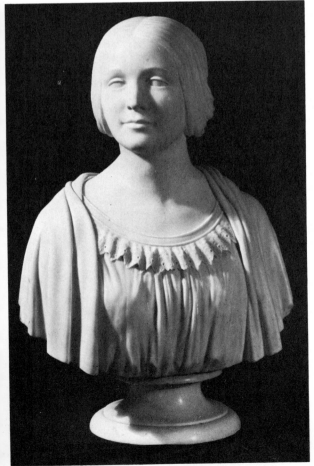

589 (above). Chalk cat. Nineteenth century. H. 17½". Plaster figures, often elaborately shaped, began to appear during the nineteenth century. They were made in molds and, after drying, were brightly painted in individual patterns. Mark Twain's Huck Finn observed on one of his eventful trips: "Well, there was a big outlandish parrot on each side of the clock made out of something like chalk and painted up gaudy. By one of the parrots was a cat made of crockery, and a crockery dog by the other." [2] (Museum of American Folk Art)

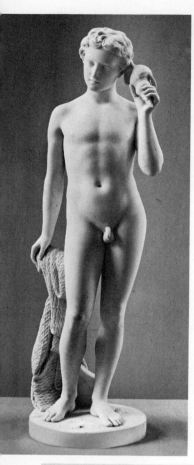

590 (left). *The Fisherboy* by Hiram Powers. 1841. Marble. H. 57″. Most Victorian sculptors supported themselves through portraiture; however, Powers's "ideal" pieces, expressing noble ideas from history and philosophy, were especially popular, and during the 1840s and later his success in this field provided a financial independence for him that few others enjoyed. (The Metropolitan Museum of Art; Bequest of the Hon. Hamilton Fish, 1894)

591 (below). View of the United States exhibit at the Great Exhibition at the London Crystal Palace from *The Crystal Palace Exhibition Illustrated Catalogue, London (1851)*. Hiram Powers's *The Greek Slave*, exhibited under a canopy, was the focal point of the display. To the right, his figure of *The Fisherboy* is visible. After its completion in the mid-1840s, Powers arranged for an American tour of *The Greek Slave*, where it earned over $23,000 in admissions. *The Union Magazine* of October 1847 reported, "It is almost curious to observe the effect produced upon visitors. They enter gaily or with an air of curiosity; they look at the beauteous figure and the whole manner undergoes a change . . . all conversation is in a hushed tone, and everybody looks serious on departing." [3] (University of Michigan Graduate Library)

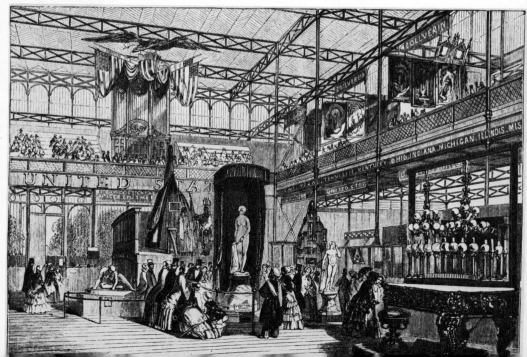

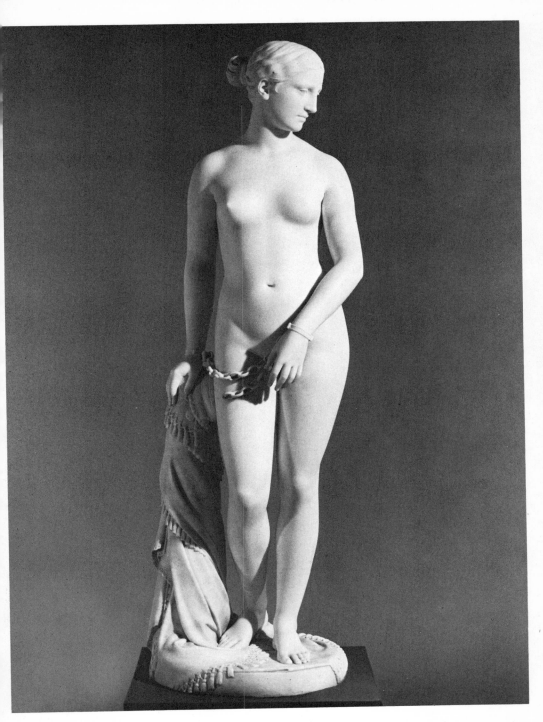

592 (above). *The Greek Slave* by Hiram Powers. 1847. Marble. H. 65½″. This is one of several replicas made by Powers of his most famous sculpture, the "beauteous figure" described on the opposite page. (The Newark Museum Collection; gift of Franklin Murphy, Jr., 1926)

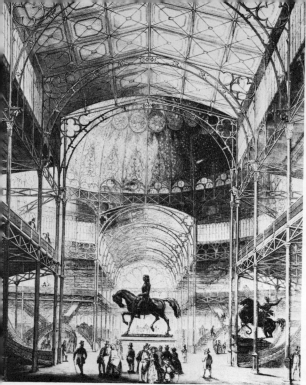

593 (above). View of the transept at the New York Crystal Palace, 1853, from *The World of Art and Industry Illustrated* by B. Silliman, Jr., published by G. P. Putnam & Co., New York City, in 1854. The equestrian figure of George Washington was created by the Baron Marochetti from London. Because artistic entries for this exhibition, formally titled "The Exhibition of the Industry of All Nations," were so numerous, the promoters were forced to construct a gigantic addition that contained a spacious art gallery. This was the first opportunity that most Americans had had for viewing fine painting and sculpture. (Private collection)

594 (right). *White Captive* by Erastus Dow Palmer. 1857. Marble. H. 66″. Many American sculptors began their careers as carvers of cameo portraits. Palmer was well known for his efforts in this genre and Henry Tuckerman, in his *Book of the Artists*, singled him out for praise. Around 1848 Palmer turned to larger pieces. Upon completion and exhibition of the *White Captive*, it was highly praised. Every American woman saw herself in this representation of the haughty, defiant maiden who had been captured by the Pawnee Indians. (The Metropolitan Museum of Art; Gift of Hamilton Fish, 1894)

595 (left). *Nydia, the Blind Girl of Pompeii*, by Randolph Rogers. 1859. Marble. H. 55″. "Story pieces" were probably the most popular of all three-dimensional art forms during the Victorian period. *Nydia* was shown at the Philadelphia Centennial in 1876, where the figure inspired sympathy in all who viewed it. As one author described her, "Poor girl! her courage was beautiful to behold! and Fate seemed to favor one so helpless. The boiling torrents touched her not . . . but spared that frail form . . . Weak, exposed, yet fearless, supported by but one wish, she was the very emblem of Psyche in her wanderings . . . of Hope, walking through the Valley of the Shadow; a very emblem of the Soul itself— alone but comforted, amid the dangers and the snares of life." [4] (The Metropolitan Museum of Art; Gift of James Douglas, 1899)

596 (below). *Dead Pearl Diver* by Benjamin Paul Akers. 1858. Marble. L. 67″. Akers, the son of a wood-carver, was born in Maine. After attempting to earn a living by painting, he turned to sculpture and in time journeyed to Rome. He created numerous "ideal" pieces, including this sculpture, which earned for him a popular reputation and financial success. Mid-Victorians were struck dumb before this representation of death. (Portland Museum of Art; Gift of Mrs. Elizabeth Akers Allen)

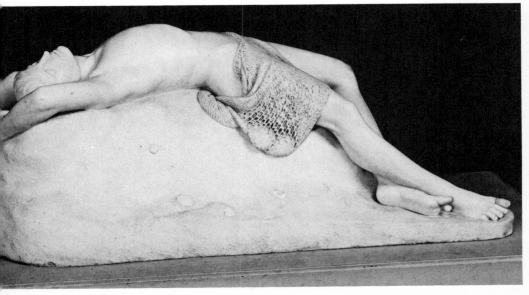

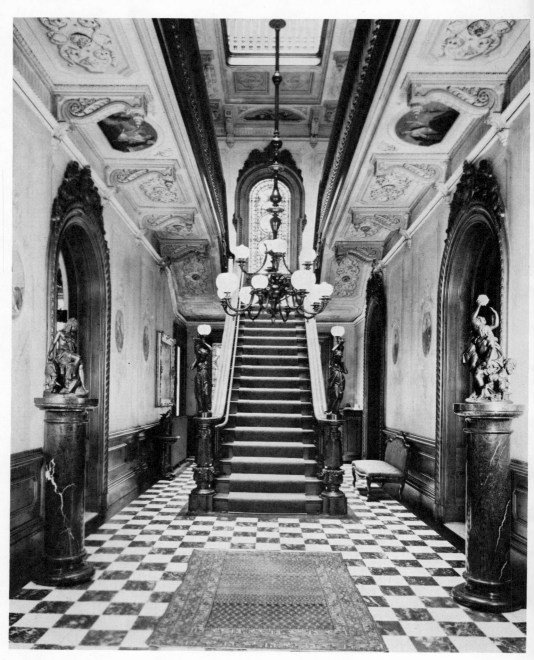

597 (above). Reception hall of the Victoria Mansion, Portland, Maine, built in 1859. French bronzes received so much attention at the Great Exhibition at the London Crystal Palace in 1851 that they became prized collectors' items. Many metal castings from France found their way to American retail shops and galleries. (Victoria Mansion)

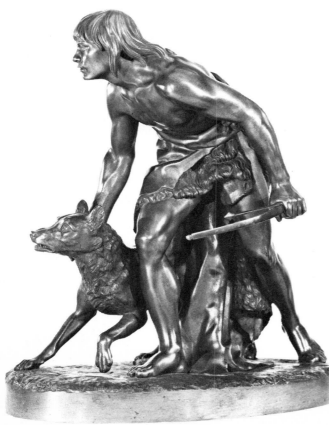

598 (above, left). Life mask and hands of Abraham Lincoln by Leonard Volk. 1860. Plaster. Nearly every sculptor who has attempted a representation of Lincoln has used Volk's sculpture. Volk recalled the casting of the life mask in *Century Magazine,* "He sat naturally in the chair when I made the cast, and saw every move I made in a mirror opposite, as I put the plaster on without interference with his eyesight or his free breathing through the nostrils. It was about an hour before the mold was ready to be removed, and being all in one piece, with both ears perfectly taken, it clung pretty hard, as the cheekbones were higher than the jaws at the lobe of the ear. He bent his head low and took hold of the mold, and gradually worked it off without breaking or injury; it hurt a little, as a few hairs of the tender temples pulled out with the plaster and made his eyes water . . ." [5] (Greenfield Village and Henry Ford Museum)

599 (below, left). *Indian Hunter* by John Quincy Adams Ward (1830–1910). 1860. Bronze. H. 16". Ward's representations of American themes in a style based upon objective naturalism earned a justified success. He spent several months with the Indians in the West and Northwest before sculpting this piece, which was purchased for $10,000 by a group of prominent New York City citizens and placed in Central Park. (The New-York Historical Society; Gift of George A. Zabriskie)

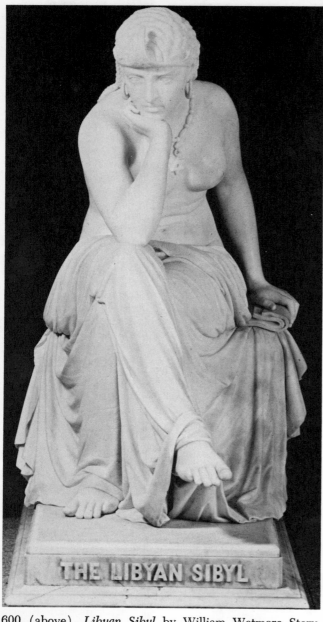

601 (below). Stove-top figure of George Washington cast by the Mott Iron Works, New York City. 1875–1900. Iron. H. 47½". (Abby Aldrich Rockefeller Folk Art Center)

THE LIBYAN SIBYL

600 (above). *Libyan Sibyl* by William Wetmore Story. 1868, after the original c. 1861. Marble. H. 49½". Story studied ancient cultures searching for exotic and heroic subjects to satisfy his romantic predilections. This sculpture, along with his *Cleopatra*, was shown at the London Exposition of 1862 where the archaeological correctness of the pieces was enthusiastically praised. (National Collection of Fine Arts, Smithsonian Institution)

602 (above). The Art Gallery in the Western Pavilion at the Philadelphia Centennial, 1876, illustrated in Volume III of *History, Mechanics, Science, Masterpieces of the Centennial Exhibition, 1876* by Joseph N. Wilson. Wealthy Americans saw the acquisition of sculpture as a visible demonstration of their sophistication. Few ever had a discerning eye, for the *New-York Daily Tribune* in the July 23, 1868, issue noted in an article on Washington, "The town is full of statues, of dwarfs, cripples, rocking-horses, and drunken Indians. Washington, nearly naked, sits out in the rain colossally, pointing to the Patent Office, where his breeches are. Lincoln is a base-ball pitcher on the top of a column. A pea-green Jefferson, deaf and dumb, is asking alms, with a paper, before the White House. Near by Gen. Jackson is riding to victory in a landscape of foaming mugs of lager-bier." [6] (Private collection)

603 (right). *Paul Revere* by Thomas Ball (1819–1911). 1883. Bronze. L. 42¾". The rage for Colonial Revival objects permeated all of American life. Heroes from the past were favorite subjects with sculptors who were working immediately before and after the Philadelphia Centennial. (Cincinnati Art Museum; Edwin and Virginia Irwin Memorial)

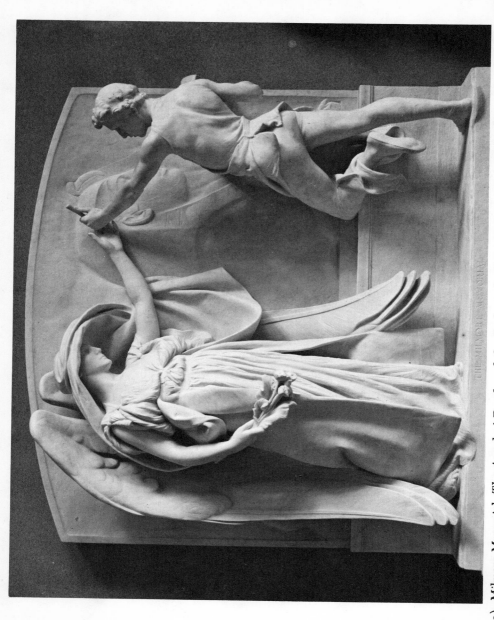

604 (above). Milmore Memorial, *The Angel of Death and the Sculptor*, by Daniel Chester French. Marble copy of the original bronze of 1891/1892. H. 92″. The curvilinear design of the angel in this memorial to Martin Milmore (1844–1881) relates to the Art Nouveau style. The original is in the Forest Hills Cemetery near Boston, Massachusetts. (The Metropolitan Museum of Art)

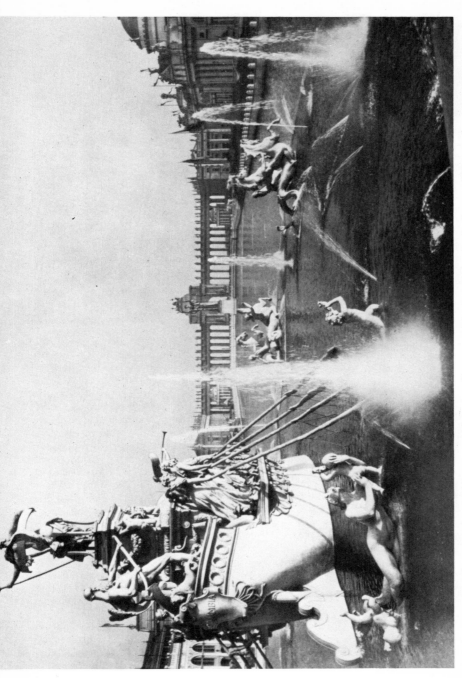

605 (above). The World's Columbian Exposition, Chicago, Illinois. 1893. Americans looked upon "The City of Light" as the termination of the nation's youth; with this exposition, they felt she had come of age. Three-dimensional personifications of her positive attributes dominated the event. *Republic* by Daniel Chester French was at the far end of the lagoon, and *Triumph of Columbia* by Frederick MacMonnies at the near end. Sculptural embellishments by Philip Martiny were included on the Agricultural Building, designed by McKim, Mead and White, at the right. (The New-York Historical Society)

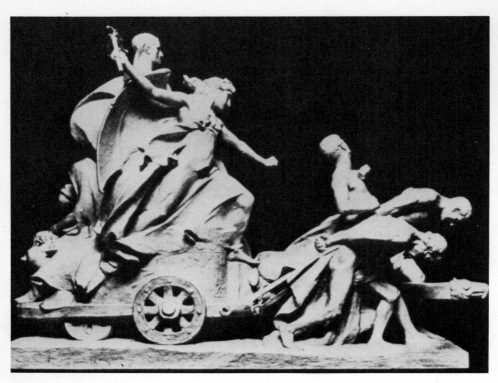

606 (above). *The Despotic Age* by Isidore Konti. 1901. This group was shown at the Pan-American Exposition in Buffalo, New York. The East Esplanade at the exposition was centered by the *Fountain of Man* by Charles Grafly. The three other sculptural groups, displayed en suite with Konti's group, were *The Savage Age in the East, The Savage Age in the West*, both by John Boyle, and *The Despotic Age* by Hermon MacNeil. (The New York Public Library)

607 (left). Nineteenth-century advertisement offering plaster groups by John Rogers. This sculptor catered to Victorian taste and his three-dimensional pieces are to formal sculpture what Currier and Ives prints are to painting. He first worked a group in clay and then usually cast it in bronze, from which seemingly endless plaster copies were made. (Greenfield Village and Henry Ford Museum)

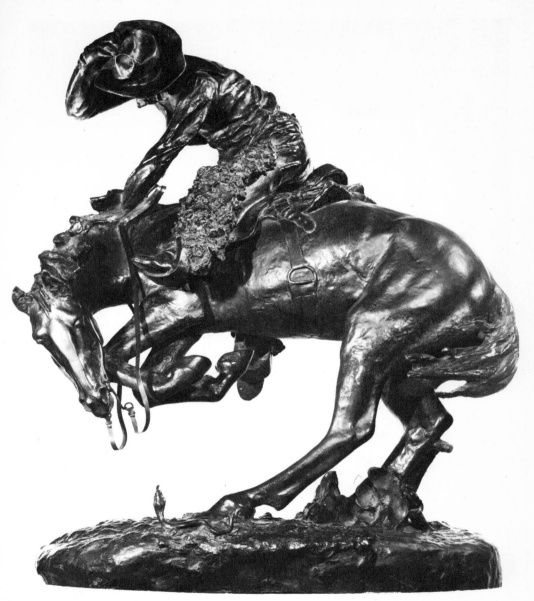

608 (above). *The Rattlesnake* by Frederic Remington. c. 1900. Bronze. H. 22″. Late nineteenth-century genre subjects dealing with the West are among the most popular pieces with American collectors today. Remington's work is consistently naturalistic. He is also known for his paintings and magazine illustrations. (Greenfield Village and Henry Ford Museum)

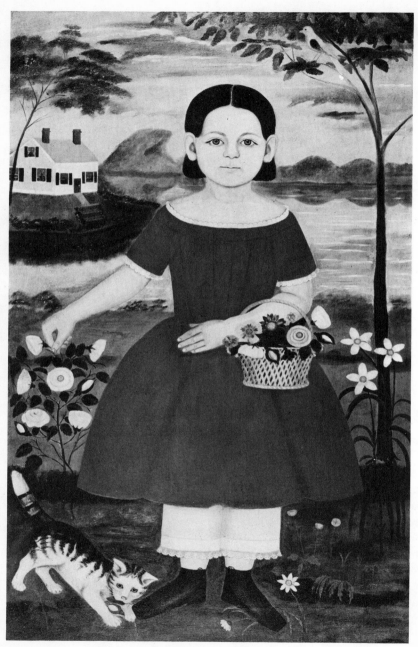

609 (above). *Picking Flowers*. c. 1845. Oil on canvas. H. 44″. Folk painting, like country furniture, often reflects rural interpretations of elegant city styles. The naïve charm of much folk painting is summed up in this handsome picture. The little girl is placed in a landscape that includes a Cape Cod–type house in the background and a playful tabby at her feet. (New York State Historical Association)

COUNTRY STYLE

In 1837 when Victoria became Queen of England, America still contained a dual society. Although part of its population lived in old, well-established East Coast cities and boom-town metropolises of the Midwest, most of America remained rural, and agriculture was the chief occupation.

A simple, modest life-style was lived by most country people. That is not to say that country folk lacked pretensions, within the folk idiom there were countless manifestations of a quest for the elegant and beautiful. This quest led to a great flowering of American folk art, which began about 1820 and lasted until the 1860s when mass production, better communications, and increased ease of transportation caused the waning of the country style.

Morris Bishop, author of "Western Style of Living," in 1846 recalled a way of life just recently past,

> When a young married couple commenced housekeeping, from thirty to forty years ago, a very small outfit sufficed, not only to render them comfortable, but to place them on an equality with their friends and neighbors. They needed a log cabin, covered with clapboards, and floored with wooden slabs, in western parlance called puncheons, and the openings between the logs closed with billets of wood and crammed with mortar, to keep all warm and dry—all of which a man could erect himself, without any mechanical training, with one day's assistance from his neighbors to raise the logs. Usually, one room answered for parlor, sitting-room, dining-room, kitchen, and dormitory, while the potato hole under the puncheons, formed, of course, by excavating the earth for mortar, was a good substitute for a cellar. As to furniture, they needed a stationary corner cupboard, formed of upright and transverse pieces of boards, arranged so as to contain upper, lower, and middle shelf, to hold the table ware and eatables. In order to comfort and convenience, it was requisite, also, to have the following articles: one poplar slab table, two poplar or oak rail bedsteads, supplied with suitable bedding, and covered with cross-barred counterpanes of homemade, one of which was for the accommodation of visitors; six split-bottomed chairs, one long bench, and a few three-legged stools were amply sufficient for themselves and friends; a half a dozen pewter plates, as many knives and forks, tin cups, and pewter spoons for ordinary use, and the same number of delft plates, cups, and saucers for special occasions; also, one dish, large enough to hold a piece of pork, bear meat, or venison with the turneps, hommony, or stewed pumpkin. All this table ware was kept in the corner cupboard, and so adjusted as to show off to the best advantage, and indicated that the family were well fixed for comfortable living. When the weather was too cold to leave the door or the window open, sufficient light to answer

the purpose came down the broad chimney, and saved the expense of glass lights; and as for andirons, two large stones served as a good substitute. The whole being kept clean and sweet, presented an air of comfort to the contented and happy inmates.[1]

Rural New Englanders and those in older, better-established areas would have been horrified by such meager domestic appointments. Although they lacked both the funds and the inclination to import elegant French and English wallpapers for their parlor walls, they were not above commissioning an itinerant wall painter or muralist to execute gaudy, bright landscapes, imaginary scenes, and stylized decorative patterns for their white-painted frame homes.

During the eighteenth and the early nineteenth centuries culturally isolated groups of immigrants produced another type of folk art. The Germans in Pennsylvania and Maine, the Swedish in the Delaware River Valley, and the Dutch in the Hudson River Valley all brought with them inherited cultural and artistic traditions that were transmitted from one generation to another. As the isolation of such ethnic settlements declined, the vitality of the folk expression became more diffused and finally was replaced by a universal Victorian expression that had sentimentality as one of its main characteristics.

When modest country goods are compared to city products of the same period, it is easy to trace the influence of the cosmopolitan artisan on the rural craftsman. The sitters in folk portraits are often posed against elaborate furniture and dressed in elegant clothes, accented by costly jewelry, that were simply not available in rural communities. Of special interest is the attempt by country craftsmen to simulate expensive imported woods and elaborately veneered surfaces on simple pine furniture through the use of paint.

While academic paintings executed by professional artists enriched the homes of city dwellers, the rural gentry usually favored the more modest pictures painted by their friends and neighbors. Young women with brush in hand turned out an endless variety of watercolors, theorem pictures, and silhouettes. Their efforts, usually romantic in nature, are often much more appreciated today than more finished paintings by professionals.

There were many folk portrait artists who earned their living by traveling from town to town and recording the likenesses of all who could afford their artistry. Perhaps no itinerant artist is better known than William Matthew Prior (1806–1873) who began his career in Bath, Maine; later moved to Portland, Maine; and finally settled at 36 Trenton Street in Boston, where he established his now famous "Painting Garrett." Prior adapted his technique to the potential sitter's pocketbook. If a prospective client possessed limited financial means, a flat likeness "without shadow" could be had for about one dollar. For more affluent subjects he would provide a surprisingly realistic portrait at twenty-five dollars. Prior also practiced the difficult art of reverse painting on glass. His many likenesses of favorite American Founding Fathers were exhibited at the Boston Athenaeum where they were enthusiastically received.

The inspiration for folk art was usually either religious conviction, a domestic need for a utilitarian object, or the desire to create an object of beauty in an effort to brighten daily life.

The religious painting or wood carving became a concrete way of expressing deep faith. Religious folk art is perhaps the strongest of all, for the conviction behind its creation is absolute.

Homemade utilitarian objects represent one of the largest categories of surviving artifacts from nineteenth-century America. Weathervanes, both wooden and metal, cookie molds, storage boxes, handwrought iron andirons, candlesticks, and other lighting devices are but a few of the pieces fashioned as substitutes for mass-produced domestic and imported goods available in larger centers.

Even rural folk felt a need for beautiful things. To satisfy this demand, which often remained unconscious, the folk artist with his usually untrained skills produced both paintings and sculpture that have become increasingly appreciated by modern-day collectors and museum curators.

The three-dimensional artifacts of religious and socialistic communities are frequently classified as folk art. The Shakers, led by Mother Ann Lee (1736–1784), an untutored English textile worker, arrived in New York in 1774. Since 1758 when she became the leader of the Shakers, this mystic lady taught that she was the daughter of God.

The name Shakers arose from meetings in which expressions of spiritual faith were manifested by seizures of shaking, whirling, and speaking in strange tongues. For the Shakers, daily life was a communal one. Conversion was the only method of propagation in a society in which members pledged themselves to celibacy and adhered to strictures against marriage as laid down by their Millennial Laws. By the time of the Civil War membership in the "United Society of Believers in Christ's Second Appearing" in America increased from the original eight to nearly six thousand brothers and sisters living in eighteen communities from Maine to Ohio. Members were required to abandon all their worldly goods and participate in a communal life, where they joined families, evenly divided by sex, and guided by Elders and Elderesses.

Shaker architecture, furniture, and tools reflect a basic belief that creativity and work were forms of worship and praise of God. Strict doctrines governed the manufacture of furniture for the members. It was decreed that bedsteads should be painted green; that headings, moldings, and cornices that were merely ornamental might not be made by Believers. Whatever was fashioned was plain and simple; unembellished by superfluities that added nothing to its goodness or durability. Only meetinghouses were painted white, only movable furniture might be varnished, and only oval or "nice" boxes might be stained reddish or yellow.

The Shaker experiment was by no means unique. At Zoar, Ohio, about halfway between Cleveland, Ohio, and Pittsburgh, Pennsylvania, German "Separatists" founded a community in 1817. Early in 1819 Joseph Baumler and other leaders recommended that all property be held in common, thus a communistic

society developed. Artifacts from the Zoar settlement appear to the untrained eye to be of German origin. The furniture recalls Continental European prototypes of the German Biedermeier style.

At Bishop Hill, Henry County, Illinois, Swedish immigrants established another communistic society. An initial settlement in 1846 was strengthened in 1848 by the arrival of new colonists. Despite the increased manpower, Bishop Hill never achieved real solvency, and in 1862 the property was divided and the commune dissolved. The paintings of Olof Krans (d. 1916) document the rural life-style that prevailed at this social experiment.

Demand for the folk artist's skills during the last half of the Victorian period declined with the proliferation of mass production made possible by the Industrial Revolution. Machine-stamped weathervanes replaced the one-of-a-kind productions of an earlier day; the camera made obsolete the canvases of the itinerant folk portraitist; and new roads made possible the delivery of factory goods at modest prices.

The Late Victorians expressed admiration for and were spellbound by the possibilities of mass production. It is no wonder that in such a social climate the folk artist failed to attract customers for his handcrafted wares.

As early as 1872 learned men expressed an awareness of the vanishing products of the American folk society. "An Eminent Corps of Scientific and Literary Men" at Hartford, Connecticut, wrote in *First Century of National Existence: The United States as They Were and Are* . . . ,

The furniture of country dwellings was scantier than now, and, on the whole, of much cheaper quality and poorer make, although that of the wealthy was often handsomely designed, well and massively made, and heavily and tastefully ornamented. Little machinery was used in manufacturing furniture, which had, therefore, to be made by hand labor. This made patterns more numerous, as one design usually served for a single side-board, set of chairs, etc., and for those made by one workman only; while now, one pattern may serve for thousands of sets. There was, therefore, greater variety, and often remarkably fine workmanship, and even artistic skill. The greater cheapness of wood, and the little use made of veneering, occasioned much furniture to be made of solid wood. Many pieces of this ancient, solid furniture now bring extravagant prices at auction, or from a second-hand store, where chance supplies a buyer with taste and means. As much as forty, or even sixty dollars each have been given for old-fashioned, carved, mahogany chairs; from twenty-five to fifty dollars for a tall clock . . .[2]

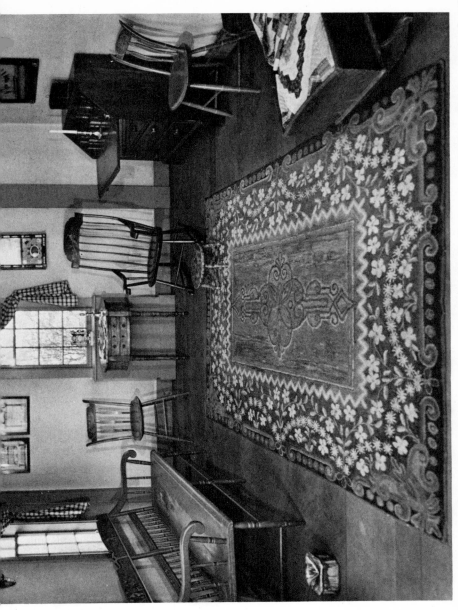

610 (above). Parlor of the Luther Burbank Birthplace built at Lancaster, Massachusetts, around 1800, and now preserved at Greenfield Village, Dearborn, Michigan. Painted furniture always adds charm to simple homes. The large hooked rug is from the second half of the nineteenth century. The Salem rocker, the painted bench, and the pair of arrow-back chairs are all typical products made by rural cabinetmakers during the 1830s and 1840s. The painted cradle with a patchwork quilt was built by Luther Burbank's father for his infant son. (Greenfield Village and Henry Ford Museum)

611 (above). Kitchen of the Luther Burbank Birthplace furnished as it might have been during the early Victorian era. The table is set with Gaudy Ironstone and Sandwich glass candlesticks. Miscellaneous implements for fireplace cooking surround the open hearth. Mocha pitchers, bowls, and mugs and painted tin, or tole, trays top the simple mantel. (Greenfield Village and Henry Ford Museum)

612 (right). Theorem. c. 1835. Watercolor on paper. W. 24″. Young ladies in seminary schools learned to paint mourning pictures and theorems. Those executed on velvet were considered especially "advanced." (Private collection)

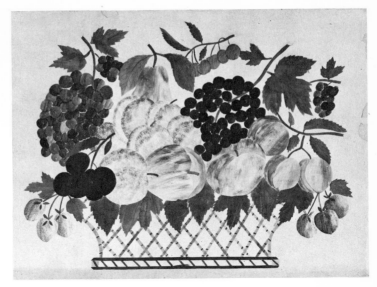

613 (left). Portrait of an unidentified gentleman by Erastus Salisbury Field. New England. c. 1840. Oil on canvas. 30½″ x 25¼″. This masterful portrait proves that folk art can also be great art. The subject sits in a painted country chair. (Private collection)

614 (left). Boston rocker. New England. c. 1832. Maple and pine. H. 45". Boston rockers were universally popular from the 1830s through the 1860s. They were usually painted, grained, and stenciled with elaborate floral motifs. (Greenfield Village and Henry Ford Museum)

615 (below, left). Child-size Boston rocker, painted and stenciled. 1840–1850. H. 26½". (Frederick Di Maio: Inglenook Antiques)

616 (below, right). Rocking chair made of tree roots. Connecticut. H. 41". This is as "rustic" a piece as you are apt to find anywhere. It is highly functional as well as artistic, for beneath the plank seat it has drawers that very possibly were used to store sewing equipment. (Pie Galinat)

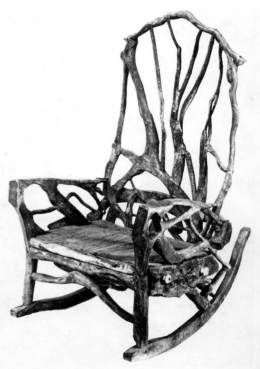

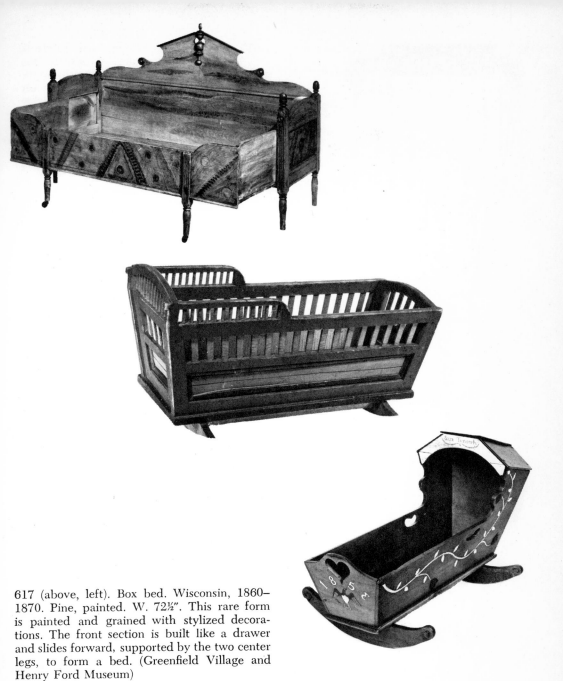

617 (above, left). Box bed. Wisconsin, 1860–1870. Pine, painted. W. 72½". This rare form is painted and grained with stylized decorations. The front section is built like a drawer and slides forward, supported by the two center legs, to form a bed. (Greenfield Village and Henry Ford Museum)

618 (above, center). Cradle. 1860–1880. Pine, painted, and maple. L. 38½". (Greenfield Village and Henry Ford Museum)

619 (above, right). Doll's cradle with whalebone inlay made by Jacob Turnerly, a barrelmaker by trade, who sailed aboard the *Sarah Sheate* and the *Barque Oriole* during the 1850s. His daughter, Sara was born near Clinton, Connecticut, in 1849, and her name is inscribed on the whalebone facing the cradle's bonnet. Dated 1853. H. 14"; L. 22". (America Hurrah Antiques, N.Y.C.)

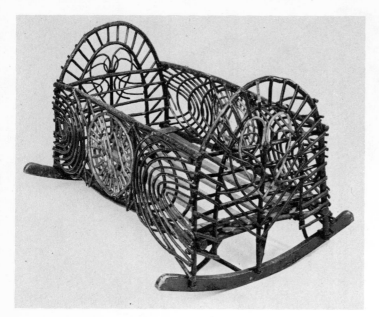

620 (left). Cradle made from tree twigs. c. 1890. New York State. L. 34½". A large heart decorates each end of this elaborate example of Victorian stick furniture. (Kelter-Malcé Antiques)

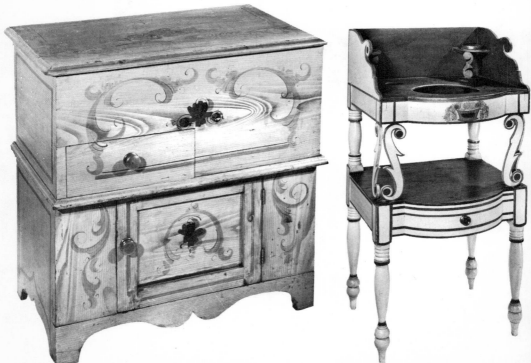

621 (above, left). Lift-top commode with single drawer and storage compartment. 1860–1880. Pine. H. 29½". This painted and grained piece is decorated with scrolls and stylized flowers in gold, red, green, and brown. Although many lift-top commodes survive, few retain their original decoration. (Greenfield Village and Henry Ford Museum)

622 (above, right). Washstand. Found in New Hampshire. c. 1830. Pine. H. 41". Few country pieces possess the great charm of this sprightly piece. The S-scroll supports are repeated under the shelves. (Henry J. Prebys)

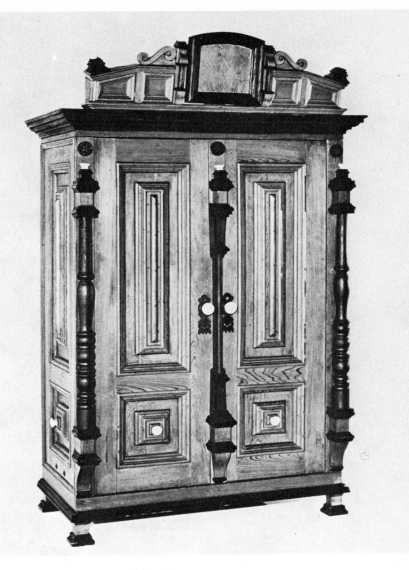

623 (above). Wardrobe. Texas. c. 1880. Cypress and pine. H. 93½". Immigrant European settlers crafted furniture that recalled the pieces they had left behind in their homeland. During the second half of the nineteenth century oak-grained furniture was especially popular. (Mrs. Charles L. Bybee; photograph courtesy *Antique Monthly*)

624 (right). Box. New England. c. 1830. Pine, painted. W. 14⅛". The elaborate raised panels on this piece are a survival of eighteenth-century taste. (Greenfield Village and Henry Ford Museum)

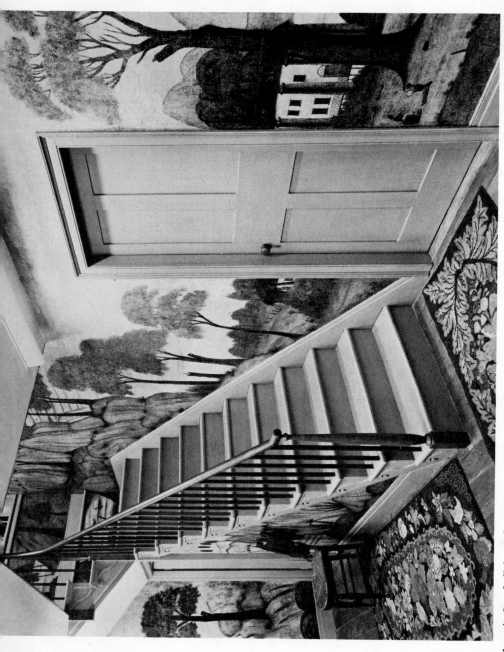

625 (above). Stairhall from the Ezra Carroll house at East Springfield, New York. Because painted wallpaper was expensive to purchase and difficult to hang, itinerant muralists, or wall decorators, were able to earn their living by traveling from community to community. Many of them stayed with their clients while they skillfully decorated the whitewashed walls with bright, colorful landscapes and scenes. (Henry Francis du Pont Winterthur Museum)

626 (below). *Portrait of a Child* by William Matthew Prior. Boston, Massachusetts. c. 1835. Oil on canvas. H. 26¾". The Shaker fireplace surround and fireboard are from Lebanon, Ohio. The pair of Shaker armchairs and the footstool probably originated in an eastern Shaker settlement. The whirligig is from New England and dates toward the close of the Victorian period. The decoy on the left is from Maine; the one on the right is from California and was fashioned from a palm frond. The carved eagle at the far right of the mantel is from Maine and bears the carved legend, "U. S. Peace Forever." (Private collection)

627 (right). Secretary-desk. Found in Foxcroft, Maine. 1840–1860. Pine. H. 84½". Elements of the Late Classical style survived in rural areas long after they had passed from fashion in the cities. Much of the best painted and grained furniture was created in and around Mount Vernon, Maine. (Henry J. Prebys)

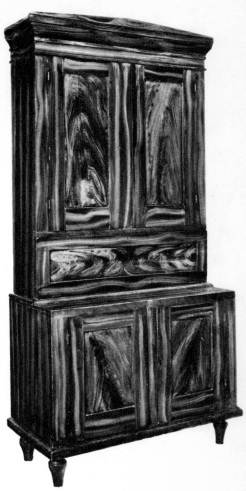

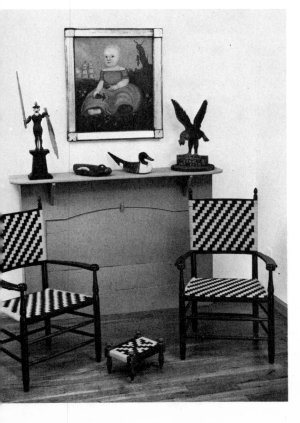

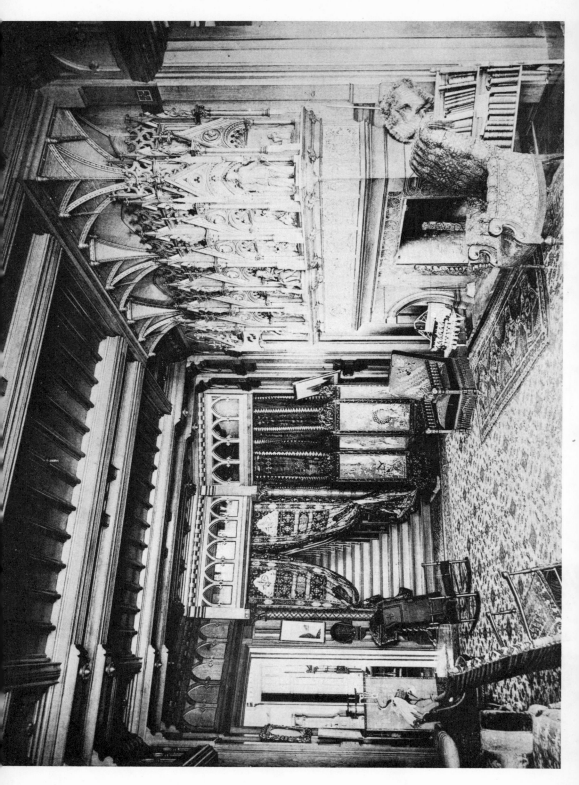

628 (opposite). The "Hall" of the residence of H. J. Willings at the corner of Rush and Ontario Streets, Chicago, in 1884. The two armchairs on the left with upholstered seats and backs were undoubtedly made by Shakers and probably acquired by Mr. Willings during a visit to one of the communities. Shaker chairs were exhibited at the Philadelphia Centennial and many photographs of the homes of America's wealthy dating from the late 1870s and 1880s include Shaker pieces. Mrs. Croly, editor of *Needle Work: A Manual of Stitches and Studies in Embroidery and Drawn Work,* commented on the variety of furnishings in the "best sort of drawing-room": "Sometimes, when waiting in the drawing-room of a friend, it is amusing to make acquaintance with the different characters of the company of chairs by which one is surrounded . . . On our left is a small color-bearer—a reception chair—a dainty gilt and blue satin affair, that tucks itself under the shadowing folds of the curtain, with regretful remembrance, perhaps, of its native home in the mirror-lined salons of Paris and Versailles . . . Beyond, there is a round table of handsome wood, on which are books and photographs; a richly-embroidered scarf, a Spanish dagger, ready to cut the leaves of the latest book, or magazine, a pilgrim-tear bottle, in yellow or blue, and many a curio, picked up in odd out-of-the-way corners of the Old World and New. We have time to see, still further away, the ebonized Oxford or stained rattan, with its comfortable cushions, without which, a few years since, no drawing-room was complete. By its side, yet shrinking into an unobtrusive corner, is a form we recognize, in spite of its unusual dress, a timid little Shaker rocking-chair, without arms, in a costume quite decorative and cheerful, of olive-green sateen and plush, embroidered with jasmine flowers . . . The Shaker chairs, of which we have spoken, are made very handsome by pieces of sateen and plush, fitted to the seat and back. These may have an outline embroidery on the sateen, which is the center part. A chequer-work pattern, with small flowers, connecting the cob-web lines, is a good fitting treatment. The flowers may be worked solidly, in light blue or light pink, and the lines in white silk. This is a good design to be worked on a foundation of olive green, maroon, or dull red. Sometimes the covering is made to go entirely over the chair, and is cut to fit like a slip cover. It becomes then a handsome little rocking chair, of convenient shape. The chairs chosen for decoration, of course, are without arms. The embroidered

covers are fastened by ribbons, to match, and *bows, where it is thought proper to put them.*" [1] (Chicago Historical Society)

629 (above), Plank-bottom side chair. Zoar, Ohio. 1850–1875. Pine and oak. H. 38½". The Zoarites lived in a religious communal society founded by Joseph Baumler, a German Separatist leader. They continued to use furniture designs that had been popular in their homeland for many centuries. (Greenfield Village and Henry Ford Museum)

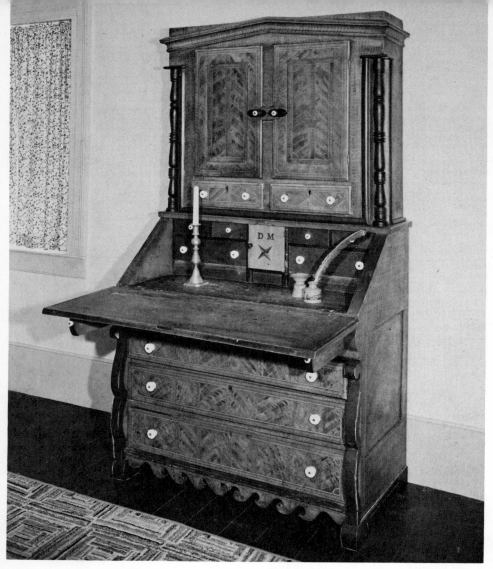

630 (above). Secretary-desk. Sugar Creek, Ohio. 1840–1850. Poplar. H. 76½″. This Amish piece retains its original painted decoration. The turned columns in the upper section relate it to early Empire pieces while the scrolls at the side in the lower section relate it to the pillar-and-scroll style. (Greenfield Village and Henry Ford Museum)

631 (right). *The Residence of Mr. Gottfried Walder of Honey Creek, Wisconsin,* painted by John Seifert. c. 1880. Watercolor on paper. L. 30¾″. (Greenfield Village and Henry Ford Museum)

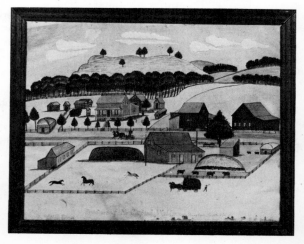

632 (below). Spotted hen weathervane. New England. 1850–1860. Pine. H. 16½″. This plump, full-bodied hen is constructed of five pieces of wood that have been nailed together. It stands on a handmade metal arrow base. Wooden vanes were always one-of-a-kind creations. (Private collection)

633 (bottom). Horse weathervane. Michigan. Late nineteenth century. Wood and metal. L. 41″. A Midwestern farmer probably lost his commercially produced horse weathervane in a storm and was able to salvage only the figure. He mounted it on a tree and fitted it with a tin fin. This weathervane is the creation of a true folk artist. (Private collection)

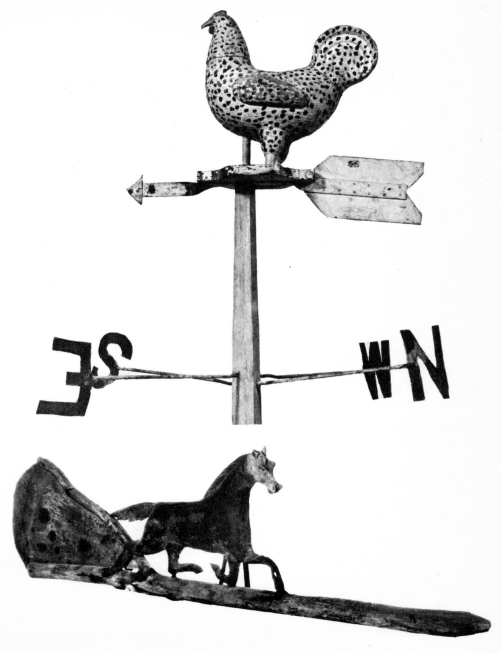

634 (right). Pie safe. Colorado. c. 1875. Pine and tin. H. 55⅛". Tin panels with decorative punched designs provided a flow of air in these cupboards used for food storage. (The State Historical Society of Colorado; photograph courtesy *Antique Monthly*)

635 (below). Flag gate. Wood and metal. c. 1876. W. 56". While city homeowners were concerned about acquiring elegant iron and bronze fences and gates for their stylish brownstones, the owner of the Darling Farm at Jefferson County, New York, installed this unique, patriotically inspired gate on his property. Country ingenuity was often responsible for the creation of masterpieces such as this one. (Museum of American Folk Art; Gift of Herbert W. Hemphill, Jr.)

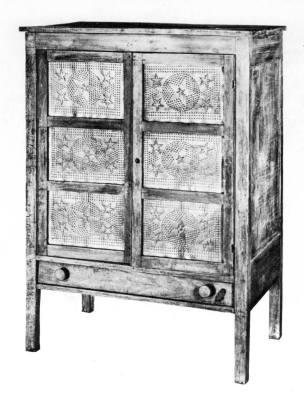

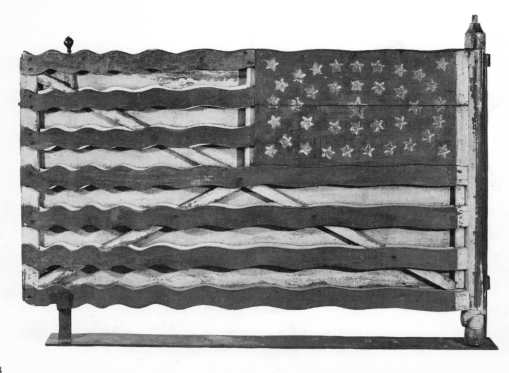

NOTES

INTRODUCTION——Text

1. "Queen Victoria," *The Lady's Book* (March 1838), pp. 97–98.
2. *The Crystal Palace Exhibition Illustrated Catalogue London (1851)* (1851; reprint ed., New York: Dover Publications, 1970), pp. II***, V***.
3. *The Illustrated Exhibitor*, June 7, 1851, p. 1.
4. C. H. Gibbs-Smith, comp. *The Great Exhibition of 1851, A Commemorative Album* (London, England: His Majesty's Stationery Office, 1950), pp. 16–17.
5. *Ibid.*, p. 137.
6. "The Progress of the World," *The American Monthly Review of Reviews* (February 1901), pp. 131–132.

ARCHITECTURE——Text

1. Almon C. Varney, *Our Homes and Their Adornments* (Detroit: J.C. Chilton, 1884), p. v.
2. Marshall B. Davidson, *The American Heritage History of Colonial Antiques* (New York: American Heritage Publishing Co., 1967), p. 9.
3. Salem, Massachusetts, *Gazette*, February 12, 1811.
4. Arthur Channing Downs, Jr., "Critical View of the Architecture of New York," *Architectural Magazine* (London, England, January 1839), p. 647.
5. Charles A. Goodrich, *The Universal Traveller: Designed to Introduce Readers at Home to an Acquaintance with the Arts, Customs, and Manners of the Principal Modern Nations on the Globe* (Hartford, Conn.: 1836), pp. 26–28.
6. Alan Gowans, *Images of American Living—Four Centuries of Architecture and Furniture as Cultural Expression* (New York: J.B. Lippincott, 1964), p. 287.
7. J. S. Buckingham, *America* (London, 1841), pp. 216–217.
8. John K. Howat, *et al.*, eds., *19th-Century America: Paintings and Sculpture* (New York: The Metropolitan Museum of Art, 1970). No. 49.
9. A. J. Downing, *The Architecture of Country Houses Including Designs for Cottages, and Farm-Houses, and Villas, with Remarks on Interiors, Furniture, and the Best Modes of Warming and Ventilating* (1850; reprint ed., New York: Dover Publications, 1969), p. 28.
10. Marshall B. Davidson, *The American Heritage History of Antiques from the Civil War to World War I* (New York: American Heritage Publishing Co., 1969), p. 312.
11. John Maass, *The Gingerbread Age* (New York: Bramhall House, 1957), p. 115.
12. P. T. Barnum, *The Life of P. T. Barnum Written By Himself* (New York, 1855), pp. 401–403.
13. Henry David Thoreau, *Cape Cod* (Boston, 1887), pp. 206–208.
14. *New York Tribune*, March 31, 1849, p. 4.
15. Sarah Wood Kane, "Twelve Mormon Homes Visited in Succession on a Journey through Utah to Arizona, 1874." Quoted in *Among the Mormons, Historic Accounts by Contemporary Observers*, ed. William Mulder and A. Russell Mortensen (New York: Alfred A. Knopf, 1958), pp. 399–400.
16. *The New York Mercury*, October 12, 1767.
17. Allen E. Forrester, "Address of John H. B. LaTrobe at the Dedication of the Baltimore City Hall, 1875," *History of Baltimore's City Hall* (1877), p. 117.
18. Richard M. Hunt, "Building-Materials," *General Report of The Judges of Group XXVI* (Philadelphia, 1876).
19. Downing, *The Architecture of Country Houses*, p. 265.
20. "A Few More Words About 'Queen Anne,'" *The American Architect and Building News*, October 6, 1877, pp. 320, 322.
21. Clay Lancaster, "Fads in Nineteenth Century American Architecture," The Magazine *Antiques* (August 1955), p. 146.
22. Arthur S. Link, ed., "Letter from Woodrow Wilson to his wife, Ellen Axson Wilson, Colorado Springs, August 1, 1894," *The Papers of Woodrow Wilson*, vol. 8 (Princeton, N.J.: Princeton University Press, 1970), p. 637.

ARCHITECTURE——Caption Footnotes

1. Marshall B. Davidson, *Notable American Houses* (New York: American Heritage Publishing Co., 1971), p. 235.
2. *Ibid.*, p. 234.
3. *Ibid.*, p. 251.
4. R. W. Shoppell, *Modern Low-Cost Houses* (New York: Co-Operative Building Plan Association, 1884), No. 163.
5. Alan Gowans, *Images of American Living—Four Centuries of Architecture and Furniture as Cultural Expression* (New York: J.B. Lippincott, 1964), p. 345.

VICTORIAN HOUSE——Text

1. C. D. Warner, *Studies in the South and West* (n.p.: Harper & Brothers, 1889), pp. 152–153.
2. "Editor's Table," *Appleton's Journal*, vol. 17 (January–June 1877), p. 473.
3. Ella Rodman Church, "How to Furnish a House," *Appleton's Journal*, vol. 17 (January–June 1877), p. 157.
4. "Housekeeper's Department," *The House Beautiful* (October 1900), p. 250.
5. U.S. Centennial Commission. *International Exhibition, 1876* (Philadelphia: J.B. Lippincott, 1878), p. 3.
6. *New York Industrial Exposition: General Report of the British Commissioners: Special Report of Mr. George Wallis* (London, 1854), p. 61.

7. Fiske Kimball and Marie Kimball, "Jefferson's Curtains at Monticello," The Magazine *Antiques* (October 1947), p. 68.

8. J. C. Loudon, *An Encyclopaedia of Cottage, Farm, and Villa Architecture and Furniture* (London, 1835), p. 279.

9. Edgar Allan Poe, *The Works of Edgar Allan Poe*, vol. 5 (New York: Raven Edition, 1904), pp. 9–18.

10. *National Standard*, Middlebury, Vermont, September 3, 1822.

11. Esther Singleton, *The Story of the White House* (New York: McClure, 1907).

12. *The Cultivator* (Albany, New York, January 1844), p. 24.

13. George Titus Ferris, *Gems of the Centennial Exhibition; Consisting of Illustrated Descriptions of Objects of an Artistic Character* (New York: D. Appleton, 1877), p. 128.

14. "Household Furnishing Department," *Godey's Lady's Book* (January 1884), p. 88.

15. Geoffrey Grigson, ed., "The Journal of Reverend Gilbert White," *The English Year* (London, 1967). Partial quote in The Magazine *Antiques* (January 1972), p. 14.

VICTORIAN HOUSE——
Caption Footnotes

1. "New York Interiors," *The Art Journal*, vol. 5 (1879), p. 47.

2. *The Decorator and Furnisher* (August 1886), p. 149.

3. "Ceiling Decoration," *The Decorator and Furnisher* (August 1886), p. 202.

HEATING——Text

1. Marshall Davidson, *The American Heritage History of Colonial Antiques* (New York: American Heritage Publishing Co., 1967), p. 13.

2. Siegfried Giedion, *Mechanization Takes Command* (New York: W.W. Norton, 1948), p. 530.

3. Sarah Anna Emery, *Reminiscences of a Nonagenarian* (Newburyport, Mass., 1879), p. 32.

4. *Sir Benjamin Thompson, Count Rumford, Complete Works*, vol. 3 (Boston, 1870–1875), p. 321.

5. Mrs. E. F. Elliott, *The New Cyclopaedia of Domestic Economy, and Practical Housekeeper* (Norwich, Conn., 1872), pp. 19–20.

6. "Some New York Interiors," *The Art Journal*, vol. 3 (1877), p. 361.

7. Clarence Cook, *The House Beautiful, Essays on Beds and Tables Stools and Candlesticks* (New York: Scribner, Armstrong, 1878), p. 113.

8. A. J. Downing, *The Architecture of Country Houses Including Designs for Cottages, and Farm-Houses, and Villas, with Remarks on Interiors, Furniture, and the Best Modes of Warming and Ventilating* (1850; reprint ed., New York: Dover Publications, 1969), p. 475.

9. Elliott, *The New Cyclopaedia of Domestic Economy*, pp. 19–20.

10. Downing, *The Architecture of Country Houses*, pp. 478–479.

11. Almon C. Varney, *Our Homes and Their Adornments* (Detroit, Mich.: J.C. Chilton, 1884), p. 93.

12. *Ibid.*

13. Catharine E. Beecher and Harriet Beecher Stowe, *The American Woman's Home: Or Principles of Domestic Science, being A Guide to the Formation and Maintenance of Economical, Healthful, Beautiful, and Christian Homes* (New York: J.B. Ford, 1869), p. 419.

14. George M. Clark & Co., *Jewel Gas Stove Catalogue* (Chicago, 1889).

15. Beecher and Stowe, *The American Woman's Home*, p. 432.

16. Jennifer Ames, "The World of Tomorrow." n.p., n.d.

HEATING——Caption Footnotes

1. The Magazine *Antiques* (January 1933), p. 31.

LIGHTING——Text

1. Marshall Davidson, *The American Heritage History of Colonial Antiques* (New York: American Heritage Publishing Co., 1967), p. 274.

2. *Boston Independent Advertiser*, January 1749.

3. Marshall Davidson, *The American Heritage History of American Antiques from the Revolution to the Civil War* (New York: American Heritage Publishing Co., 1968), p. 299.

4. Robert Michael Ballantyne, *Hudson Bay; or Everyday Life in the Wilds of North America, during Six Years' Residence in the Territories of the Hon. Hudson Bay Company* (London, 1859). Partial quote in The Magazine *Antiques* (December 1970), p. 946.

5. "Lighting Devices, 1845," The Magazine *Antiques* (June 1938), pp. 339–340.

6. Marshall Davidson, *The American Heritage History of Antiques from the Civil War to World War I* (New York: American Heritage Publishing Co., 1969), p. 290.

7. "American Art-Manufactures," *The Art Journal*, vol. 3 (1877) p. 342.

8. Annie R. White, *Polite Society at Home and Abroad* (Chicago, 1891). Partial quote in The Magazine *Antiques* (January 1973), p. 98.

9. Rushlight Club, *Early Lighting: A Pictorial Guide* (Hartford, Conn.: The Findlay Bros. Publishing, 1972), p. 82.

10. C. Malcolm Watkins, "The Whale-Oil Burner: Its Invention and Development," The Magazine *Antiques* (April 1935), p. 149.

11. James W. Shepp, *Shepp's World's Fair Photographed* (Chicago: Globe Bible Publishing Co., 1893), p. 224.

LIGHTING——Caption Footnotes
1. James W. Shepp, *Shepp's World's Fair Photographed* (Chicago: Globe Bible Publishing Co., 1893), p. 224.

FURNITURE——Text
1. John Richard, *Treatise on the Construction and Operation of Wood-Working Machines* (London, 1850), p. 3.
2. *Ibid.*, p. 4.
3. *Ibid.*, p. 17.
4. T. M. Newson, *Pen Pictures of St. Paul, Minnesota, and Biographical Sketches of Old Settlers, From the Earliest Settlement of the City, up to and Including the Year 1857* (Saint Paul, 1886), pp. 305–306.
5. *Ibid.*
6. John Hall, *The Cabinet Makers' Assistant* (1840; reprint ed., New York: National Superior, 1944), preface.
7. Edgar Allan Poe, *The Works of Edgar Allan Poe*, vol. 5 (New York: Raven Edition, 1904), pp. 9–18.
8. Sir Charles Lyell, *Travels in North America in the Years 1841–1842*, vol. 2 (New York, 1845), pp. 7–12.
9. *Godey's Lady's Book* (1850), pp. 152–153.
10. *Ibid.*, p. 153.
11. *The Art Journal Illustrated Catalogue for the Great Exhibition of the Works of Industry of All Nations, 1851* (1851; reprint ed., New York: Dover Publications, 1970), p. 65.
12. Edwin T. Freedley, *Philadelphia and Its Manufactures* (Philadelphia, 1859), p. 273.
13. *Ibid.*
14. Marshall Davidson, *The American Heritage History of Antiques from the Civil War to World War I* (New York: American Heritage Publishing Co., 1969), p. 57.
15. *The American Architect and Building News*, December 23, 1876, pp. 412–413.
16. A. J. Downing, *The Architecture of Country Houses Including Designs for Cottages, and Farm-Houses, and Villas, with Remarks on Interiors, Furniture, and the Best Modes of Warming and Ventilating* (1850; reprint ed., New York: Dover Publications, 1969), p. 415.
17. A. J. Downing, *A. J. Downing's Cottage Residences, Rural Architecture & Landscape Gardening* (1844; reprint ed., Watkins Glen, N.Y.: American Life Foundation, 1967), p. 119.
18. B. Silliman, Jr., *The World of Science, Art and Industry, Illustrated from Examples in the New York Exhibition, 1853–1854* (New York: G.P. Putnam, 1854), p. 168.

19. Davidson, *The American Heritage History of Antiques from the Civil War to World War I*, p. 102.
20. Harriet Prescott Spofford, *Art Decoration Applied to Furniture* (New York: Harper & Bros., 1878), p. 130.
21. J. S. Ingram, *The Centennial Exposition, Described and Illustrated* (Philadelphia: Hubbard Bros., 1876), p. 707.
22. H. Hudson Holly, *Modern Dwellings in Town and Country Adapted to American Wants and Climate with a Treatise on Furniture and Decoration* (New York, 1878), pp. 194–196.
23. Charles L. Eastlake, *Hints on Household Taste in Furniture, Upholstery and Other Details* (London: Longmans, Green, 1868), introduction.
24. "Some New York Interiors," *The Art Journal*, vol. 3 (1877), p. 330.
25. Gustav Stickley, *Chips From the Craftsman Workshop, Number One* (New York: printed at the Press of the Kalkhoff Co., 1906), p. 321.

FURNITURE——Caption Footnotes
1. *S. Karpen and Brothers Trade Catalogue* (Chicago and New York, 1907).
2. Berry B. Tracy *et al.*, eds., *19th-Century America: Furniture and Other Decorative Arts* (New York: The Metropolitan Museum of Art, 1970), No. 294.

GLASS——Text
1. Letter from Jacques David to Lavina Webber, dated March 27, 1821, in the collections of the Maine State Museum Commission, Augusta, Maine.
2. Elizabeth Stillinger, *The Antiques Guide to Decorative Arts in America 1600–1875* (New York: Dutton Paperbacks, 1973), p. 386.
3. Marshall Davidson, *The American Heritage History of American Antiques from the Revolution to the Civil War* (New York: American Heritage Publishing Co., 1968), p. 276.
4. Marshall Davidson, *The American Heritage History of Antiques from the Civil War to World War I* (New York: American Heritage Publishing Co., 1969), p. 136.
5. Charles L. Eastlake, *Hints on Household Taste in Furniture, Upholstery and Other Details* (1868; reprint ed., New York: Dover Publications, 1969), p. 241.
6. Davidson, *The American Heritage History of Antiques from the Civil War to World War I*, p. 234.
7. *Ibid.*, p. 235.
8. *The World of Science, Art and Industry, Illustrated from Examples in the New York Exhibition 1853–1854* (New York: G.P. Putnam, 1854), p. 31.
9. Valentine Van Tassel, *American Glass* (New York: Gramercy Publishing, 1950), p. 98.

GLASS——Caption Notes

1. Berry B. Tracy *et al.*, eds., *19th-Century America: Furniture and Other Decorative Arts* (New York: The Metropolitan Museum of Art, 1970), No. 251.
2. *Ibid.*, No. 271.

CERAMICS——Text

1. Marvin D. Schwartz and Richard Wolfe, *A History of American Art Porcelain* (New York: Renaissance Editions, 1967), p. 13.
2. Advertisement by William Greenleaf in the *Boston Gazette*, June 1, 1761.
3. Schwartz and Wolfe, *A History of American Art Porcelain*, p. 14.
4. *Boston Gazette*, April 25/May 2, 1737.
5. Schwartz and Wolfe, *A History of American Art Porcelain*, p. 16.
6. *New-York Weekly Chronicle*, March 5, 1795.
7. *Argus, Greenleaf's New Daily Advertiser*, May 12, 1798.
8. Mrs. John Farrar, *The Young Lady's Friend* (New York, 1838), p. 54.
9. "Bennington's Great Moment," The Magazine *Antiques* (April 1932), p. 162.
10. "Ceramics at Philadelphia.—IV," *The American Architect and Building News*, August 19, 1876, pp. 267–268.
11. Marshall B. Davidson, *The American Heritage History of Antiques from the Civil War to World War I* (New York: American Heritage Publishing Co., 1969), p. 127.
12. Charles L. Eastlake, *Hints on Household Taste*. (1868; reprint ed., New York: Dover Publications, 1969), p. 218.
13. Lura Woodside Watkins, "Low's Art Tiles," The Magazine *Antiques* (May 1944), p. 250.
14. *Ibid.*, p. 251.
15. *The Art Journal*, vol. 5 (1879), p. 141.
16. *Demorest's Monthly Magazine*, vol. 13 (1878), p. 93.
17. Robert Koch, "Rookwood Pottery," The Magazine *Antiques* (March 1960), p. 288.
18. H. J. Whigham, "The Best American Pottery," *The Beautiful House* (January 1892), pp. 87–88.

CERAMICS——Caption Footnote

1. Berry B. Tracy *et al.*, eds., *19th-Century America: Furniture and Other Decorative Arts* (New York: The Metropolitan Museum of Art, 1970), No. 212.

CLOCKS——Text

1. Sarah Loring Bailey, *Historical Sketches of Andover, Massachusetts* (Cambridge, 1880), p. 466.
2. Abbott Lowell Cummings, ed., *Rural Household Inventories* (Boston: The Society for the Preservation of New England Antiquities, 1964), p. 46.

3. Brooks Palmer, *The Book of American Clocks* (New York: The Macmillan Company, 1928), p. 4.
4. "Letterbook of the Nashua Manufacturing Company, 1824–1835." Manuscript. Baker Library, Harvard Business School, Cambridge, Massachusetts.
5. Clarence Cook, *The House Beautiful* (New York: Scribner, Armstrong, 1878), pp. 120–121.
6. *1902 Edition of The Sears, Roebuck, Catalogue* (New York: Bounty Books, 1969), p. 115.
7. Thomas Hamilton, *Men and Manners in America* (Philadelphia, 1833). Partial quote in The Magazine *Antiques* (November 1970), p. 736.
8. *Jewelry, Watches and Silverware. E. V. Roddin & Co. 1895, The American Historical Catalog Collection* (Princeton, N.J.: The Pyne Press, 1971), p. 36.

METALS—Text

1. Marshall Davidson, *The American Heritage History of Colonial Antiques* (New York: American Heritage Publishing Co., 1967), p. 14.
2. *The Boston News-Letter*, December 27, 1744.
3. *The Boston Gazette*, April 5, 1734.
4. *The Boston Gazette*, May 11, 1742.
5. "A Day at the Ornamental Iron-Works of Robert Wood," *Godey's Lady's Book* (July 1853), p. 6.
6. *The New-York Gazette Revived in the Weekly Post-Boy*, October 5, 1747.
7. *The New-York Gazette and the Weekly Mercury*, April 23, 1770.
8. J. Lazear, "Knife vs. Fork, or, When Did Victorians Eat?," *American Life Collectors Annual*, vol. 4 (1964), p. 105.
9. *The Art Journal*, vol. 1 (1875), pp. 371–372.
10. *Ibid.*, new series 2 (1876), p. 334.
11. Thomas Webster, *An Encyclopedia of Domestic Economy* (New York: Harper & Bros., 1845), p. 236.
12. J. L. Bishop, *History of American Manufactures from 1608 to 1860*, vol. 3 (Philadelphia: Edward Young, 1861–1868), pp. 330–331.

METALS——Caption Footnotes

1. Marshall Davidson, *The American Heritage History of Antiques from the Civil War to World War I* (New York: American Heritage Publishing Co., 1969), p. 98.
2. *Ibid.*
3. John K. Howat *et al.*, eds., *19th-Century America: Paintings and Sculpture* (New York: The Metropolitan Museum of Art, 1970), No. 79.
4. Robert Judson Clark, ed., *The Arts and Crafts Movement in America 1876–1916* (Princeton, N.J.: Princeton University Press, 1972), p. 69.

MAN'S WORLD——Text

1. Edward P. Hingston, *The Genial Showman. Being Reminiscences of the Life of Artemus Ward* (New York, 1870), p. 106.
2. Thomas Hamilton, *Men and Manners in America* (Philadelphia, 1833), pp. 29–31.
3. Mrs. Frances Trollope, *Domestic Manners of the Americans*, ed. Donald Smalley (New York: Vintage Books, 1949), pp. 47–48.
4. John K. Howat *et al.*, eds., *19th-Century America: Paintings and Sculpture* (New York: The Metropolitan Museum of Art, 1970), No. 77.
5. Holman J. Swinney, "The Collections: Firearms," The Magazine *Antiques* (September 1955), pp. 261–263.
6. Oliver Jensen, *American Album* (New York: American Heritage Publishing Co., 1968), p. 337.
7. A. G. Wilkinson, "Notes on Salmon-Fishing," *Scribner's Monthly*, vol. 12, no. 6 (October 1876), pp. 769–796.
8. Almon C. Varney, *Our Homes and Their Adornments* (Detroit, Mich.: J.C. Chilton, 1884), p. 268.
9. The Magazine *Antiques* (May 1938), p. 270.
10. *Ibid.*
11. Maurice Francis Egan, *Recollections of a Happy Life* (New York: George H. Doran, 1924), p. 67.
12. Marshall Davidson, *The American Heritage History of Colonial Antiques* (New York: American Heritage Publishing Co., 1967), p. 294.
13. Trollope, *Domestic Manners of the Americans*, pp. 58–59.
14. Marshall Davidson, *The American Heritage History of Antiques from the Civil War to World War I* (New York: American Heritage Publishing Co., 1969), p. 332.
15. Broadside printed in 1883 for Henry F. Williams, Publisher, 46 Beekman Street, New York.

MAN'S WORLD——Caption Footnotes

1. Maurice Francis Egan, *Recollections of a Happy Life* (New York: George H. Doran, 1924), p. 67.

WOMAN'S WORLD—Text

1. Harriet Beecher Stowe, *Oldtown Folks* (1869), p. 442.
2. *Godey's Lady's Book* (November 1876), p. 474.
3. Catharine E. Beecher and Harriet Beecher Stowe, *The American Woman's Home; or Principles of Domestic Science; being a Guide to the Formation and Maintenance of Economical, Healthful, Beautiful, and Christian Homes* (New York: J.B. Ford, 1869), p. 309.
4. Anne Firor Scott, ed., *The American Woman, Who Was She?* (Englewood Cliffs, N.J.: Prentice-Hall, 1971), p. 5.

5. *Ibid.*, p. 8.
6. Oliver Jensen, *The Revolt of American Women* (New York: Harcourt Brace Jovanovich, 1971), p. 41.
7. *Godey's Lady's Book*, vol. 23 (1841), p. 293.
8. James W. Shepp, *Shepp's World's Fair Photographed* (Chicago: Globe Bible Publishing Co., 1893), p. 280.
9. *Ibid.*, p. 284.
10. Dr. Lyman Abbott, *et al.*, *The House and Home: A Practical Book* (New York, 1896). Partial quote in The Magazine *Antiques* (January 1974), p. 212.
11. Maurice Francis Egan, *Recollections of a Happy Life* (New York: George H. Doran, 1924), p. 67.
12. *The Prose Works of N. P. Willis* (Philadelphia, 1845), p. 676.
13. Catharine E. Beecher and Harriet Beecher Stowe, *The New Housekeeper's Manual: Embracing a new revised edition of the American Woman's Home; or Principles of Domestic Science* (New York, 1873), p. 533.
14. W. D. Howells, "A Sennight of the Centennial," *Atlantic Monthly* (July 1876), p. 105.
15. *The Popular Science Monthly*, vol. 17 (1893), p. 807.
16. James Fenimore Cooper, *Gleanings in Europe by an American* (1837). Partial quote in The Magazine *Antiques* (August 1970), p. 184.
17. "Boston Ramblings by Miss Leslie," *Graham's Magazine* (July 1842), pp. 33–36.
18. J. S. Buckingham, *The Slave States of America*, vol. 1 (1842), pp. 163–164.
19. *Godey's Lady's Book* (1855), p. 381.
20. Mrs. Pullman, *The Lady's Manual of Fancy Work* (New York, 1859). Partial quote in The Magazine *Antiques* (October 1973), p. 588.
21. Howells, "A Sennight of the Centennial," p. 101.
22. Almon C. Varney, *Our Homes and Their Adornments* (Detroit, Mich.: J.C. Chilton, 1884), p. 260.
23. Jensen, *The Revolt of American Women*, p. 82.
24. *Ibid.*, p. 45.
25. Rose Hartwick Thorpe, *As Others See Us, or The Rules and Customs of Refined Homes and Polite Society* (Detroit, Mich., and Windsor, Ontario, Canada, 1895). Partial quote in The Magazine *Antiques* (February 1971), p. 202.
26. *Ibid.*
27. Marshall Davidson, *The American Heritage History of Antiques from the Civil War to World War I* (New York: American Heritage Publishing Co., 1969), p. 27.
28. Hubert Howe Bancroft, *The Book of the Fair, a Historical and Descriptive Presentation of the World's Science, Art and Industry as Viewed Through the Columbian*

Exposition at Chicago in 1893 (Chicago: Bancroft and Co., 1893), p. 150.
29. *Graham's Magazine*, vol. 47 (1856). Partial quote in The Magazine *Antiques* (December 1972), p. 990.

CHILDREN'S WORLD——Text
1. C. H. Gibbs-Smith, comp., *The Great Exhibition of 1851, A Commemorative Album* (London: His Majesty's Stationery Office, 1950), pp. 16–17.
2. *The New-York Gazette and The Weekly Mercury*, September 26, 1774.
3. Marshall Davidson, *The American Heritage History of American Antiques from the Revolution to the Civil War* (New York: American Heritage Publishing Co., 1968), p. 383.

PLEASURES AND PASTIMES——Text
1. Helen Nicolay, *Our Capital on the Potomac* (New York: The Century Company, 1924), pp. 406–407.
2. Mlle. Bon Ton, "The Athletic Age," *Godey's Lady's Book* (August 1884), p. 204.
3. Diary of Augustus James Pleasonton. 1838–1844, manuscript in the collections of The Historical Society of Pennsylvania, Philadelphia, Pennsylvania.
4. Anthony Trollope, *North America*, ed. Donald Smalley and Bradford Allen Booth (New York, 1951), p. 275.
5. Report of the librarian, *Proceedings of the American Antiquarian Society* (April 1861), pp. 25–26.
6. "The Arts," *Appleton's Journal*, vol. 15 (May 20, 1876), p. 668.

PLEASURES AND PASTIMES—— Caption Footnotes
1. Hubert Howe Bancroft, *The Book of the Fair, a Historical and Descriptive Presentation of the World's Science, Art and Industry as Viewed Through the Columbian Exposition at Chicago in 1893* (Chicago: Bancroft and Co., 1893), p. 274.
2. James W. Shepp, *Shepp's World's Fair Photographed* (Chicago: Globe Bible Publishing Co., 1893), p. 513.

PICTORIAL ART——Text
1. Captain Marryat, *Diary in America, with Remarks on Its Institutions* (Philadelphia, 1839), p. 135.
2. Rembrandt Peale, *Portfolio of an Artist* (Philadelphia, 1839), p. 169.
3. *New York Daily Tribune*, December 28, 1867.
4. Maurice Francis Egan, *Recollections of a Happy Life* (New York: George H. Doran, 1924), p. 87.
5. *Appleton's Journal*, vol. 14 (July 24, 1875), p. 121.
6. Floyd Rinhart and Marion Rinhart, *American Daguerrean Art* (New York: Clarkson N. Potter, 1967).

PICTORIAL ART——Caption Footnotes
1. *American Art-Union Catalogue*, 1848.
2. John K. Howat *et al.*, eds., *19th-Century America: Paintings and Sculpture* (New York: The Metropolitan Museum of Art, 1970), p. 3, fig. 53.
3. Floyd Rinhart and Marion Rinhart, *American Daguerrean Art* (New York: Clarkson N. Potter, 1967), p. 6.

SCULPTURE——Text
1. Letter written by Thomas Jefferson from Monticello, January 22, 1816. Quoted in Wayne Craven, *Sculpture in America* (New York: Thomas Y. Crowell, 1968), p. 62.
2. Albert T. E. Gardner, *Yankee Stonecutters: The First American School of Sculpture, 1800–1850* (New York: Columbia University Press, 1944), p. 40.
3. Wayne Craven, *Sculpture in America*, p. 103.
4. Diary of Philip Hone, April 1844. Quoted in Craven, *Sculpture in America*, p. 108.
5. Letter written by Hiram Powers to C. E. Lester, c. 1835. *Ibid.*, p. 112.
6. Craven, *Sculpture in America*, p. 118.
7. George S. Hillard, "Thomas Crawford: A Eulogy," *Atlantic Monthly* (July 1869).
8. Craven, *Sculpture in America*, p. 179.
9. G. W. Sheldon, "An American Sculptor," *Harper's Magazine* (June 1878), pp. 62–68.
10. Henry James, *William Wetmore Story and His Friends* (Boston: Houghton Mifflin, 1903).
11. Marvin C. Ross and Anna W. Rutledge, *William Henry Rinehart, Maryland Sculptor* (Baltimore, Md.: Walters Art Gallery, 1948), p. 39.
12. Homer Saint-Gaudens, ed., *The Reminiscences of Augustus Saint-Gaudens*, 2 vols. (New York: The Century Company, 1913), vol. 1, p. 141.
13. E. Scheyer, *Art Quarterly* (1956), p. 195.
14. Letter written by John Hay to Henry Adams, March 25, 1891. Quoted in Craven, *Sculpture in America*, p. 386.
15. Letter written by John Rogers to his mother, October 6, 1858. The New-York Historical Society.
16. Craven, *Sculpture in America*, p. 360.
17. Frederic Remington, *Collier's Weekly*, March 18, 1905.

SCULPTURE——Caption Footnotes
1. *City Cries: Or, A Peep at Scenes in Town* (Philadelphia, 1849). Partial quote in The Magazine *Antiques* (October 1971), p. 544.
2. Samuel Clemens, "Adventures of Huckleberry Finn," *The American Tradition in Literature*, ed. Sculley Bradley, Richmond Croom Beatty, and E. Hudson Long, 3rd ed.

vol. 2 (New York: W.W. Norton, 1967), p. 343.

3. *The Union Magazine* (October 1847).

4. Edward George Bulwer-Lytton, *The Last Days of Pompeii*. Partial quote in Wayne Craven, *Sculpture in America* (New York: Thomas Y. Crowell, 1968), p. 314.

5. Craven, *Sculpture in America*, p. 241.

6. *New-York Daily Tribune*, July 23, 1868.

COUNTRY STYLE——Text

1. Morris Bishop, "Western Style of Living," *The Ladies' Repository and Gatherings of the West*, vol. 6 (1846), p. 130.

2. *First Century of National Existence: The United States as They Were and Are . . . Prepared by an Eminent Corps of Scientific and Literary Men* (Hartford, Conn., 1872), pp. 249–250.

COUNTRY STYLE——Caption Footnotes

1. Mrs. Croly, ed., *Needle Work: A Manual of Stitches and Studies in Embroidery and Drawn Work* (Lynn, Mass. 1886), pp. 117–118.

COLOR PLATES

1. David C. Huntington, *The Landscapes of Frederic Edwin Church: Vision of an American Era* (New York: George Braziller, Inc., 1966), pp. 80, 82.

BIBLIOGRAPHY

Albany Institute of History and Art. *New York Furniture Before 1840.* Albany, N.Y.: Albany Institute of History and Art, 1962.

Amaya, Mario. *Art Nouveau.* New York: Dutton Vista Pictureback, 1966.

American Painting 1760–1960. Milwaukee, Wis.: Milwaukee Art Center, 1960.

Andrews, Edward D. *Shaker Furniture.* New Haven, Conn.: Yale University Press, 1937.

————. *Religion in Wood, A Book of Shaker Furniture.* Bloomington, Ind.: University of Indiana Press, 1971.

The Artist in America. New York: W.W. Norton, 1967.

Aslin, Elizabeth. *Nineteenth Century English Furniture.* New York: Thomas Yoseloff, 1962.

Baines, Anthony. *Musical Instruments Through the Ages.* London: Cox & Wyman, 1961.

————. *European and American Musical Instruments.* London: B. T. Batsford, 1966.

Bancroft, Hubert Howe. *The Book of the Fair, a Historical and Descriptive Presentation of the World's Science, Art and Industry as Viewed Through the Columbian Exposition at Chicago in 1893.* Chicago: Bancroft and Co., 1893.

Barber, Edwin Atlee. *Pottery and Porcelain of the United States.* New York: G.P. Putnam's Sons, 1909.

————. *Tulipware of the Pennsylvania German Potters.* Philadelphia: Philadelphia Museum and School of Industrial Arts, 1926.

Barber, Joel. *Wild Fowl Decoys.* New York: Dover Publications, 1954.

Barker, Virgil. *American Painting.* New York: Bonanza Books, 1960.

Barrett, Richard Carter. *Bennington Pottery and Porcelain.* New York: Crown Publishers, 1958.

————. *Blown and Pressed American Glass.* Manchester, Vt.: Forward Publishing, 1966.

Benjamin, Asher. *The American Builder's Companion.* New York: Dover Publications, 1969.

Bestor, Arthur. *Backwoods Utopias The Sectarian Origins and the Owenite Phase of Communitarian Socialism in America: 1663–1829.* Philadelphia: University of Pennsylvania Press, 1950.

The Brooklyn Museum. *Popular Art in America.* Brooklyn, N.Y.: The Brooklyn Museum, 1939.

Buhler, Kathryn C. *Masterpieces of American Silver.* New Haven, Conn.: Yale University Press, 1960.

————. *American Silver 1655–1825 in the Museum of Fine Arts, Boston.* Boston: Museum of Fine Arts, 1972.

Butler, Joseph T. *American Antiques 1800–1900.* New York: The Odyssey Press, 1965.

————. *Candleholders in America 1650–1900.* New York: Crown Publishers, 1967.

Camposantos. Fort Worth, Tex.: Amon Carter Museum of Western Art, 1966.

Carlisle, Lilian Baker. *Hat Boxes and Band Boxes at Shelburne Museum.* Shelburne, Vt.: Shelburne Museum, 1960.

————. *18th and 19th Century American Art at Shelburne Museum.* Shelburne, Vt.: Shelburne Museum, 1961.

————. *Vermont Clock & Watchmakers, Silversmiths & Jewelers.* Burlington, Vt., 1970.

Champney, Freeman. *Art & Glory, The Story of Elbert Hubbard.* New York: Crown Publishers, 1968.

Chase, Judith Wragge. *Afro-American Art & Craft.* New York: Van Nostrand Reinhold, 1971.

Clark, John E. T. *Musical Boxes.* London: Cornish Brothers, 1948.

Clark, Robert Judson. *The Arts and Crafts Movement in America, 1876–1916.* Princeton, N.J.: Princeton University Press, 1972.

Clement, Arthur W. *The Pottery and Porcelain of New Jersey.* Newark: The Newark Museum, 1947.

Clymer, Floyd. *Floyd Clymer's Historical Scrapbook of Early Advertising Art.* New York: Bonanza Books, 1955.

Coffin, Margaret. *American Country Tinware, 1700–1900.* Camden, N.J.: Thomas Nelson, 1968.

Colio, Quintina. *American Decoys from 1865 to 1920.* N.p.: Science Press, 1972.

Collins, John S. *My Experiences in the West.* Chicago: R. R. Donnelley & Sons, 1970.

Comstock, Helen. *American Furniture.* New York: The Viking Press, 1962.

Cook, Clarence. *The House Beautiful.* New York: Scribner, Armstrong, 1878.

Cotterell, Howard H. *Old Pewter, Its Makers and Marks.* New York: Charles Scribner's Sons, 1929.

Craven, Wayne. *Sculpture in America.* New York: Thomas Y. Crowell, 1968.

Crevecoeur, J. Hector St. John de. *Letters from An American Farmer.* New York: Dutton Paperbacks, 1957.

The Crystal Palace Exhibition Illustrated Catalogue London (1851). 1851. Reprint. New York: Dover Publications, 1970.

Cummings, Abbott Lowell, ed. *Rural Household Inventories.* Boston: The Society for the Preservation of New England Antiquities, 1964.

Cunnington, Phyllis. *Costume in Pictures.* New York: E. P. Dutton, 1969.

Curtis, John Obed, and Guthman, William H. *New England Militia Uniforms and Accoutrements.* Sturbridge, Mass.: Old Sturbridge Village, 1971.

Davidson, Marshall B. *The American Heritage History of Colonial Antiques.* New York: American Heritage Publishing Co., 1967.

———. *The American Heritage History of American Antiques from the Revolution to the Civil War.* New York: American Heritage Publishing Co., 1968.

———. *The American Heritage History of Antiques from the Civil War to World War I.* New York: American Heritage Publishing Co., 1969.

———. *The American Heritage History of Notable American Houses.* New York: American Heritage Publishing Co., 1971.

Dilliard, Maud Esther. *An Album of New Netherland.* New York: Bramhall House, 1963.

Domit, Moussa M. *American Impressionist Painting.* Washington, D.C.: National Gallery of Art, 1973.

Dover, Cedric. *American Negro Art.* New York: New York Graphic Society, 1960.

A. J. *Downing's Cottage Residences, Rural Architecture & Landscape Gardening.* Watkins Glen, N.Y.: American Life Foundation, 1967.

Downing, A. J. *The Architecture of Country Houses.* New York: Dover Publications, 1969.

Downs, Joseph. *Pennsylvania German Arts and Crafts.* New York: The Metropolitan Museum of Art, 1949.

Drepperd, Carl W. *Pioneer America, Its First Three Centuries.* Garden City, N.Y.: Doubleday & Company, 1949.

Durant, Mary. *American Heritage Guide to Antiques.* New York: American Heritage Publishing Co., 1970.

Earle, Alice Morse. *Two Centuries of Costumes in America 1620–1820.* 1903. Reprint. New York: Dover Publications, 1970.

Early Texas Furniture and Decorative Arts. N.p.: Trinity Press, 1973.

The Early Victorian Period 1830–1860. New York: Reynal & Co., 1958.

Earnest, Adele. *The Art of the Decoy.* New York: Clarkson N. Potter, 1965.

Eastlake, Charles L. *Hints on Household Taste.* London: Longmans, Green, 1868.

Eastlake-Influenced American Furniture 1870–1890. Yonkers, N.Y.: The Hudson River Museum, 1973.

Egan, Maurice Francis. *Recollections of a Happy Life.* New York: George H. Doran, 1924.

1875 Illustrated Catalogue and Price List of Copper Weather Vanes and Finials. New York: J.W. Fiske, 1875.

Eliot, Alexander. *Three Hundred Years of American Painting.* New York: Time, Inc., 1957.

Ewers, William, and Baylor, H. W. *Sincere's History of the Sewing Machine.* Phoenix, Ariz.: Sincere Press, 1970.

Faces and Places, Changing Images of 19th Century America. New York: Hirschl & Adler Galleries, 1973.

Fales, Martha Gandy. *American Silver in the Henry Francis du Pont Winterthur Museum.* Winterthur, Del.: Winterthur Museum, 1958.

Feder, Norman. *Two Hundred Years of North American Indian Art.* New York: Praeger Publishers, 1971.

J. W. Fiske 1893, *Copper Weathervanes, Bannerets, Lightning Rods, Stable Fixtures.* Princeton, N.J.: The Pyne Press, 1971.

Fitzgerald, Ken. *Weathervanes and Whirligigs.* New York: Clarkson N. Potter, 1967.

Flower, Milton E. *Wilhelm Schimmel and Aaron Mountz.* Williamsburg, Va.: Abby Aldrich Rockefeller Folk Art Collection, 1965.

Flynt, Henry N., and Fales, Martha G. *The Heritage Foundation Collection of Silver.* Old Deerfield, Mass.: The Heritage Foundation, 1968.

Fowler, Orson S. *The Octagon House.* New York: Dover Publications, 1973.

Freeman, John Crosby. *The Forgotten Rebel.* Watkins Glen, N.Y.: Century House, 1966.

Freeman, Larry, and Beaumont, Jane. *Early American Plated Silver.* Watkins Glen, N.Y.: Century House, 1947.

Fried, Frederick. *Artists in Wood.* New York: Clarkson N. Potter, 1970.

Fuller, Edmund L. *Visions in Stone.* Pittsburgh: University of Pittsburgh Press, 1973.

Gibbs-Smith, C. H., comp. *The Great Exhibition of 1851. A Commemorative Album.* 1950. Reprint. London: Victoria and Albert Museum, 1964.

Giedion, Siegfried. *Mechanization Takes Command.* New York: W.W. Norton, Inc., 1948.

Gillon, Edmund V., Jr. *Early Illustrations and Views of American Architecture.* New York: Dover Publications, 1971.

———. *Victorian Cemetery Art.* New York: Dover Publications, 1972.

Glusker, Irwin, and Ketchum, Richard M., eds. *American Testament: Fifty Great Documents of American History.* New York: American Heritage Publishing Co., 1971.

Gould, Mary Earle. *Early American Wooden Ware and Other Kitchen Utensils.*

Springfield, Mass.: The Pond-Ekberg Company, 1942.
———. *Antique Tin and Tole Ware*. Rutland, Vt.: Charles E. Tuttle, 1969.
Gowans, Alan. *Images of American Living*. New York: J.B. Lippincott, 1964.
Grover, Ray, and Grover, Lee. *Art Glass Nouveau*. Rutland, Vt.: Charles E. Tuttle, 1967.
Guilland, Harold F. *Early American Folk Pottery*. Philadelphia: Chilton Book Co., 1971.
Guthrie, Hugh, ed. *Library of Victorian Culture*. Watkins Glen, N.Y.: American Life Foundation, 1967.

Hall, John. *The Cabinet Makers' Assistant*. 1840. Reprint. New York: National Superior, 1944.
Hareven, Tamara K., ed. *Anonymous Americans*. Englewood Cliffs, N.J.: Prentice-Hall, 1971.
Hayward, Arthur H. *Colonial Lighting*. New York: Dover Publications, 1962.
Hipkiss, Edwin J. *The M. and M. Karolik Collection of Eighteenth Century American Arts*. Cambridge, Mass.: Harvard University Press, 1941.
Holstein, Jonathan. *American Pieced Quilts*. Washington, D.C.: Smithsonian Institution, 1972.
Hood, Graham. *American Silver*. New York: Praeger Publishers, 1971.
Hornor, William M. *Blue Book of Philadelphia Furniture*. Philadelphia: Philadelphia Craftsmen, 1935.
Horton, Rod W., and Edwards, Herbert W. *Backgrounds of American Literary Thought*. New York: Appleton-Century-Crofts, 1967.
Hough, Walter. "Collection of Heating and Lighting Utensils in the United States National Museum." *U. S. National Museum Bulletin 141*, 1928.
Howat, John K. *et al.*, eds. *19th-Century America: Paintings and Sculpture*. New York: The Metropolitan Museum of Art, 1970.

The Inner Circle. Milwaukee, Wis.: Milwaukee Art Center, 1966.
Innes, Lowell. *Early Glass of the Pittsburgh District 1797–1890*. Pittsburgh: Carnegie Museum, 1950.

Jacobs, Carl. *Guide to American Pewter*. New York: The McBride Company, 1957.
Janis, Sidney. *They Taught Themselves, American Primitive Painters of the 20th Century*. New York: Dial Press, 1942.
Jarves, James Jackson. *The Art-Idea*. Cambridge, Mass.: The Belknap Press of Harvard University Press, 1960.

Jayne, Horace Howard Furness. *Tucker China 1825–1838*. Philadelphia: Philadelphia Museum of Art, 1957.
Jensen, Oliver. *American Album*. New York: American Heritage Publishing Co., 1968.
———. *The Revolt of American Women*. New York: Harcourt Brace Jovanovich, 1971.
Jones, Harvey L. *Mathews, Masterpieces of the California Decorative Style*. Oakland, Calif.: The Oakland Museum, 1972.

Kauffman, Henry J. *Early American Ironware*. Camden, N.J.: Thomas Nelson, 1966.
———. *American Copper and Brass*. Camden, N.J.: Thomas Nelson, 1968.
———. *The American Pewterer*. Camden, N.J.: Thomas Nelson, 1970.
Ketchum, William C., Jr. *Early Potters and Potteries of New York State*. New York: Funk & Wagnalls, 1970.
Kidney, Walter C. *The Architecture of Choice: Eclecticism in America 1880–1930*. New York: George Braziller, 1975.
Kirk, John T. *Early American Furniture: How to Recognize, Buy, and Care for the Most Beautiful Pieces—High Style, Country, Primitive, and Rustic*. New York: Alfred A. Knopf, 1970.
———. *American Chairs: Queen Anne & Chippendale*. New York: Alfred A. Knopf, 1972.
Knittle, Rhea Mansfield. *Early American Glass*. New York: Century Publishing, 1927.
———. *Early Ohio Silversmiths and Pewterers, 1787–1847*. N.p., 1943.

Lane, R. W. *Woman's Day Book of American Needlework*. New York: Simon & Schuster, 1963.
Lantz, Louise K. *Old American Kitchenware, 1725–1925*. Camden, N.J.: Thomas Nelson, 1970.
Larkin, Oliver W. *Art and Life in America*. New York: Rinehart & Co., 1949.
———. *Samuel F. B. Morse and American Democratic Art*. Boston: Little, Brown, 1954.
Lee, Ruth Webb. *Sandwich Glass*. Framingham Center, Mass.: n.p., 1939.
———. *Victorian Glass*. Northboro, Mass.: n.p., 1944.
———. *Early American Pressed Glass*. Northboro, Mass.: n.p., 1946.
———. *Sandwich Glass: The History of the Boston & Sandwich Glass Company*. Wellesley Hills, Md.: Lee Publications, 1947.
Levin, David. *History as Romantic Art*. New York: Harcourt, Brace & World, 1959.

Lewis, R. W. B. *The American Adam.* Chicago: The University of Chicago Press, 1955.

Lewton, Frederick L. "The Servant in the House." *Smithsonian Institution Annual Report,* 1929.

Lindsay, Seymour. *Iron and Brass Implements of the American Home.* Boston: Medici Society, n.d.

Lipman, Jean, and Winchester, Alice. *Primitive Painters in America 1750–1950.* New York: Dodd Mead, 1950.

———. *The Flowering of American Folk Art 1776–1876.* New York: The Viking Press, 1974.

Little, Frances. *Early American Textiles.* Watkins Glens, N.Y.: The Century Company, 1931.

Little, Nina Fletcher. *Abby Aldrich Rockefeller Art Collection.* Williamsburg, Va.: Colonial Williamsburg, 1958.

———. *Floor Coverings in New England Before 1850.* Sturbridge, Mass.: Old Sturbridge Village, 1967.

———. *American Decorative Wall Painting 1700–1850.* New York: Dutton Paperbacks, 1972.

Maass, John. *The Gingerbread Age.* New York: Bramhall House, 1957.

———. *The Glorious Enterprise, The Centennial Exhibition of 1876.* Watkins Glen, N.Y.: American Life Foundation, 1973.

Mackey, William. *American Bird Decoys.* New York: E. P. Dutton, 1965.

Matlaw, Myron, ed. *The Black Crook and Other Nineteenth-Century American Plays.* New York: Dutton Paperbacks, 1967.

May, Henry F. *The End of American Innocence.* Chicago: Quadrangle Books, 1959.

Mayer, Christa Charlotte. *Masterpieces of Western Textiles.* Chicago: The Art Institute of Chicago, 1969.

McClinton, Katharine Morrison. *American Glass.* Cleveland: World Publishing, 1950.

———. *Collecting American Victorian Antiques.* New York: Charles Scribner's Sons, 1966.

———. *Collecting American 19th Century Silver.* New York: Charles Scribner's Sons, 1968.

McKearin, Helen, and McKearin, George S. *American Glass.* New York: Crown Publishers, 1948.

McKitrick, Eric L., ed. *Slavery Defended: The Views of the Old South.* Englewood Cliffs, N.J.: Prentice-Hall, 1963.

Meader, Robert F. W. *Illustrated Guide to Shaker Furniture.* New York: The Greystone Press, 1950.

Mercer, Henry C. *The Bible in Iron.* Doylestown, Pa.: Bucks County Historical Society, 1961.

Meyers, Marvin. *The Jacksonian Persuasion.* Stanford, Calif.: Stanford University Press, 1957.

Miller, Perry, ed. *American Thought: Civil War to World War I.* New York: Holt, Rinehart & Winston, 1954.

———. *Errand into the Wilderness.* New York: Harper & Row, 1956.

———. *The Life of the Mind in America from the Revolution to the Civil War.* New York: Harcourt, Brace & World, 1965.

Miller, V. Isabelle. *Furniture by New York Cabinetmakers, 1650–1680.* New York: Museum of the City of New York, 1956.

Montgomery, Charles F. *American Furniture, The Federal Period 1785–1825.* New York: The Viking Press, 1966.

Montgomery, Florence M. *Printed Textiles: English and American Cottons and Linens, 1700–1850.* New York: The Viking Press, 1970.

Montgomery Ward and Company. *Catalogue and Buyers' Guide, No. 57, Spring and Summer, 1895.* Reprint. New York: Dover Publications, 1969.

Morgan B. Brainard's Tavern Signs. Hartford, Conn.: Connecticut Historical Society, 1958.

Morgan, Edmund S. *The Puritan Dilemma, The Story of John Winthrop.* Boston: Little, Brown, 1958.

Morse, John D., ed. *Prints in and of America to 1850.* Charlottesville, Va.: University Press of Virginia, 1970.

Museum of Fine Arts, Boston. *M. & M. Karolik Collection of American Water Colors and Drawings.* Boston: Museum of Fine Arts, 1962.

The Museum of Fine Arts, Houston. *Southern Silver.* Houston, Tex.: The Museum of Fine Arts, 1968.

Nagel, Charles. *American Furniture, 1650–1850.* New York: Chanticleer Press, 1949.

National Gallery of Art. *American Primitive Paintings.* vol. 1. Washington, D.C.: National Gallery of Art, 1954.

———. *American Primitive Paintings.* vol. II. Washington, D.C.: National Gallery of Art, 1957.

The Newark Museum. *American Handwoven Coverlets in the Newark Museum.* Newark, N.J.: The Newark Museum, 1947.

———. *Classical America, 1815–1845.* Newark, N.J.: The Newark Museum Association, 1963.

Norbury, James. *The World of Victoriana.* London: The Hamlyn Publishing Group, 1972.

Norman-Wilcox, Gregor. "Pottery and Porcelain, Part I. The Wares Made in America." *The Concise Encyclopedia of American Antiques*, vol. I. New York: Hawthorn Books, 1955.

Nutting, Wallace. *American Windsors*. Framingham, Mass.: Old American Company, 1917.

Ormsbee, Thomas H. *Field Guide to American Victorian Furniture*. Boston: Little, Brown, 1952.

Otto, Celia Jackson. *American Furniture of the Nineteenth Century*. New York: The Viking Press, 1965.

Palmer, Brooks. *The Book of American Clocks*. New York: The Macmillan Company, 1928.

———. *A Treasury of American Clocks*. New York: The Macmillan Company, 1967.

The Peale Family, Three Generations of American Artists. Detroit, Mich.: The Detroit Institute of Arts and Wayne State University Press, 1967.

Pendergast, A. W., and Ware, W. Porter. *Cigar Store Figures*. Chicago: The Lightner Publishing Company, 1953.

Peters, Harry T. *Currier & Ives, Printmakers to the American People*. Garden City, N.Y.: Doubleday, Doran, 1942.

Peto, Florence. *American Quilts and Coverlets*. New York: Chanticleer Press, 1949.

Philadelphia Museum of Art. *Pennsylvania Dutch Folk Art from the Geesey Collection and Others*. Philadelphia: Philadelphia Museum of Art, 1958.

Phillips, John Marshall. *American Silver*. New York: Chanticleer Press, 1949.

Plain and Fancy, A Survey of American Folk Art. New York: Hirschl & Adler Galleries, 1970.

Rainwater, Dorothy T. *American Silver Manufacturers*. Hanover, Pa.: Everybodys Press, 1966.

Ramsey, John. *American Potters and Pottery*. New York: Tudor Publishing, 1939.

Randall, Richard. *American Furniture in the Museum of Fine Arts*. Boston: Museum of Fine Arts, 1965.

Revi, Albert Christian. *Nineteenth Century Glass*. New York: T. Nelson Publishing, 1959.

———. *American Pressed Glass and Figure Bottles*. New York: T. Nelson Publishing, 1964.

Rice, Alvin H., and Stoudt, John Baer. *The Shenandoah Pottery*. Strasburg, Va.: Shenandoah Publishing House, 1929.

Rinhart, Floyd, and Rinhart, Marion. *American Daguerrean Art*. New York: Clarkson N. Potter, 1967.

The Rushlight Club. *Early Lighting: A Pictorial Guide*. Hartford, Conn.: The Findlay Bros. Publishing, 1972.

Sachs, Curt. *The History of Musical Instruments*. New York: W.W. Norton, 1940.

Sack, Israel. *American Antiques from Israel Sack Collection*. 3 vols. Washington, D.C.: Highland House Publishers, 1969–1972.

Schiffer, Herbert F., and Schiffer, Peter B. *Miniature Antique Furniture*. Wynnewood, Pa.: Livingston Publishing Company, 1972.

Schwartz, Marvin D. *American Interiors 1675–1885*. Brooklyn, N.Y.: The Brooklyn Museum, 1968.

———, and Wolfe, Richard. *History of American Art Porcelain*. New York: Renaissance Editions, 1967.

Scott, Anne Firor. *The Southern Lady from Pedestal to Politics 1830–1930*. Chicago: The University of Chicago Press, 1970.

———, ed. *The American Woman, Who Was She?* Englewood Cliffs, N.J.: Prentice-Hall, 1971.

Sears Roebuck. *The 1902 Edition of the Sears Roebuck Catalogue*. Reprint. New York: Crown Publishers, 1969.

Selz, Peter, and Constantine, Mildred, eds. *Art Nouveau, Art and Design at the Turn of the Century*. Garden City, N.Y.: Doubleday & Company, 1959.

Shay, Felix. *Elbert Hubbard of East Aurora*. New York: Wm. H. Wise, 1926.

Shelley, Donald A. *The Fraktur Writings or Illuminated Manuscript of the Pennsylvania Germans*. N.p.: Pennsylvania German Folklore Society, 1959.

Shepp, James W., and Shepp, Daniel B. *Shepp's World's Fair Photographed*. Chicago: Globe Bible Publishing Co., 1893.

Silliman, B., Jr. *The World of Science, Art, and Industry, Illustrated from Examples in the New York Exhibition, 1853–1854*. New York: G.P. Putnam & Co., 1854.

Sloan, Samuel. *Sloan's Homestead Architecture*. Philadelphia: J.B. Lippincott, 1867.

Sonn, Albert H. *Early American Wrought Iron*. New York: Charles Scribner's Sons, 1928.

Stampp, Kenneth M. *The Era of Reconstruction*. New York: Random House, 1965.

Stickley, Gustav. *Craftsman Homes*. New York: The Craftsman Publishing Co., 1909.

Stillinger, Elizabeth. *The Antiques Guide to Decorative Arts in America 1600–1875*. New York: Dutton Paperbacks, 1973.

Swank, James M. *History of the Manufacture of Iron in All Ages*. Philadelphia: American Iron and Steel Association, 1892.

Thernstrom, Stephan, and Sennett, Richard, eds. *Nineteenth-Century Cities.* New Haven, Conn.: Yale University Press, 1969.

Three Hundred Years of New York City Families. New York: Wildenstein Gallery, 1966.

Thwing, Leroy L. *Flickering Flames: A History of Domestic Lighting Through The Ages.* Rutland, Vt.: Charles E. Tuttle, 1958.

Tocqueville, Alexis de. *Democracy in America.* abr. ed. Edited by Richard D. Heffner. New York: New American Library, 1956.

Tracy, Berry B. *et al.*, eds. *19th-Century America: Furniture and Other Decorative Arts.* New York: The Metropolitan Museum of Art, 1970.

Trollope, Mrs. Frances. *Domestic Manners of the Americans.* Edited by Donald Smalley. New York: Vintage Books, 1949.

Van Tassel, Valentine. *American Glass.* New York: Gramercy Publishing, 1950.

Varney, Almon C. *Our Homes and Their Adornments.* Detroit, Mich.: J.C. Chilton, 1884.

Warren, William L. *Bed Ruggs 1722–1833.* N.p.: Wadsworth Atheneum, 1972.

Watkins, C. Malcolm. "Artificial Lighting in America: 1830–1860." *Smithsonian Report* 4080, 1951.

Watkins, Lura Woodside. *Cambridge Glass, 1818 to 1888, The Story of the New England Glass Company.* Boston: Marshall Jones, 1930.

——. *Early New England Potters and Their Wares.* Cambridge, Mass.: Harvard University Press, 1950.

Webster, David Blade. *Decorated Stoneware Pottery of North America.* Rutland, Vt.: Charles E. Tuttle, 1971.

White, Morton. *Social Thought in America.* Boston: Beacon Press, 1947.

Wiebe, Robert H. *The Search for Order 1877–1920.* New York: Hill and Wang, 1967.

Williams, Henry T., and Jones, Mrs. C. W. *Beautiful Homes, or Hints on Home Furnishing.* New York: Henry T. Williams, 1878.

Wilson, Kenneth M. *New England Glass and Glassmaking.* Sturbridge, Mass.: Old Sturbridge Village, 1972.

Winslow, Ola Elizabeth, ed. *Jonathan Edwards: Basic Writings.* New York: New American Library, 1966.

Wish, Harvey, ed. *Ante-Bellum.* New York: Capricorn Books, 1960.

Yale University. *American Gold, 1700–1860.* New Haven, Conn.: Yale University Press, 1963.

Yates, Raymond F., and Yates, Marguerite W. *A Guide to Victorian Antiques.* New York: Gramercy Publishing, 1949.

INDEX

Page references for illustrations are in **boldface** type.